LUTHER!
95 TREASURES
– 95 PEOPLE

NATIONAL SPECIAL EXHIBITION
FOR THE REFORMATION JUBILEE
UNDER THE PATRONAGE
OF THE FEDERAL
PRESIDENT OF GERMANY

STIFTUNG
Luthergedenkstätten
IN SACHSEN-ANHALT

PUBLISHED BY THE STIFTUNG LUTHERGEDENKSTÄTTEN IN SACHSEN-ANHALT

LUTHER!
95 TREASURES
—95 PEOPLE

BOOK TO ACCOMPANY
THE NATIONAL SPECIAL
EXHIBITION

AUGUSTEUM,
LUTHERSTADT
WITTENBERG
13 MAY –
5 NOVEMBER 2017

HIRMER

TABLE OF CONTENTS

FOREWORDS

Martin Luther irritates, provokes and challenges us, even today. We may respect him for having paved the way for the standardisation of written German, which helped create a sense of national identity. We may admire him for laying the foundations for our pluralist society with its informed and politically aware citizens. We may also dismiss him for his attacks on those who disagreed with him or did not share his beliefs and for his repugnant anti-Semitism. But we cannot ignore him: if we want to understand the development of our civic ideals and democratic values, there is no way around Luther. His controversial legacy resists political hijacking and museum treatment. He demands that we explore both the light and dark sides of Reformation history and feel the reforming spirit of change down through the centuries, to the present day.

The exhibition *Luther! 95 Treasures – 95 People,* which has received funding from my office and from the federal state of Saxony-Anhalt, is devoted to these contrasting aspects of Luther's legacy. It is one of three national special exhibitions taking place under the patronage of the Federal President to mark the 500th anniversary of the Reformation in 2017. It approaches Martin Luther from two angles. First, 95 historical objects associated with the young Luther provide a very personal perspective on the world of the aspiring theologian and reformer: how did he become who he was? Second, the exhibition shows how 95 public figures from the past five centuries have responded to Luther and his teachings, reflecting his influence or taking issue with his views.

This publication illustrates how insightfully the Stiftung Luthergedenkstätten in Saxon-Anhalt has mounted this interesting and unique exhibition. Essays and articles by over 90 authors shed light on the legacy of the great reformer from various perspectives and examine how relevant this legacy remains today. Like the exhibitions and events marking the Reformation anniversary year, these essays encourage reflection, discussion and debate on what Martin Luther might have to say to us today and on our critical response to him.

With this in mind, I wish everyone who visits the exhibition and reads this publication a productive and memorable encounter with Martin Luther.

Prof. Monika Grütters,
Member of the German Bundestag
Minister of State for Culture and the Media

Martin Luther's 95 Theses changed the world and heralded the dawn of a new era. Of all the historical figures who made their mark in the fifteenth and sixteenth centuries, none ever eclipsed Martin Luther. It was Luther who left Christianity the legacy of responsible freedom. The Reformation that he initiated led to an immense wave of modernisation in almost all areas of society – with ramifications that are still tangible today.

Martin Luther is one of the most influential – and controversial – personalities in German history. Every age has its 'own' Luther; in the early twentieth century the theologian and leading church historian Heinrich Böhmer wrote that there were as many Luthers as there were books about him. That has both positive and negative implications. The image of Luther purveyed by historians has always undergone – and is still undergoing – fundamental revision. So what do we think of Martin Luther today?

Answers to this question abound in the special national exhibition *Luther! 95 Treasures – 95 People* and in this sumptuous accompanying publication. Leading scholars and renowned writers illuminate Luther's path to the Reformation and discuss the importance of the Wittenberg reformer for our own time. Together, the exhibition and publication make an important contribution to the Reformation anniversary year of 2017. It is very important – not only for ecclesiastical reasons – that every generation revisits and reassesses Luther's life, his work and his influence.

A biographical approach to history has always proved to be an indispensible key to understanding our past and our present. Besides highlighting aspects of Luther's life and work in short essayistic texts, this compendium also (re)acquaints readers with past and present figures shaped and influenced by Luther. The detailed, multi-faceted picture of the reformer that emerges provides fascinating – at times even surprising – insights into the turbulent history of the Reformation, which should be of interest to a very wide and not necessarily expert readership. This volume, published to accompany the exhibition, should greatly enrich its readers' knowledge of the Reformation.

It therefore gives me great pleasure to wish all those who delve into this book a gripping, absorbing read.

Dr. Reiner Haseloff,
Minister President of the Federal State of Saxony-Anhalt

PREFACE

The Reformation anniversary year of 2017 commemorates Martin Luther's nailing of his 95 Theses to a church door on 31 October 1517 and, indeed, the beginning of the Reformation. Although a succession of church historians over the centuries have questioned the authenticity of this legendary event, there is no denying that Martin Luther, who was still a monk in the Augustinian monastery in Wittenberg at the time, had an epiphany that unleashed his reformist ideas. This led him to formulate his 95 Theses in the building known as the Luther House, which is now a UNESCO World Heritage site managed by the Stiftung Luthergedenkstätten.

Therefore it makes sense, indeed it could hardly be otherwise, that the foundation should choose this event as the focus of its jubilee exhibition and trace Luther's progress towards it. University, the monastery and the electoral court, but also his origins in the Mansfeld area and the state of religion and the church, were all factors that shaped Luther's development. But the drama played out within him – in his fear of God's wrath, in his sense of striving in vain to earn credit for his life after death, and in his constant feeling of failure – and was only resolved after an intense period of inner turmoil by the certitude of acceptance by a gracious God. Any engagement with Luther cannot ignore these issues; indeed, only a fundamentally existential approach can do them justice. Hence the Wittenberg exhibition tells Luther's story through the medium of topics such as fear, quest, love and rebellion.

Yet the Reformation would have been no more than an episode in history had it not been for Luther's ability to connect with other people, regardless of place and time, from the sixteenth century until the present day, something that can in itself be seen as remarkable proof of the existential power of his life and influence. Thus Luther's progress to the moment when he posted his theses for all to see is illustrated in this book not only by 95 treasures but also by 95 portraits of people, who were spurred on by Luther's thinking in their lives and action. The existential impact of Luther's message is reflected in these portraits, which revolve around issues such as community, charity, work, passion, interiority and conscience.

Luther! 95 Treasures – 95 People in Wittenberg is one of a trio of exhibitions, with the other two taking place in Berlin and Eisenach: The *Luther Effect Protestantism – 500 Years in the World* is presented by the Deutsches Historisches Museum (12 April to 5 November 2017) and *Luther and the Germans* by the Wartburg-Stiftung (4 May to 5 November 2017). These three special national exhibitions, under the patronage of the Federal President of Germany, tell the story of Luther and the Reformation on three levels: individually, nationally and globally. All three presentations illuminate the 'full force of the Reformation' and invite exhibition-goers to explore the diversity of its manifestations. The curators were motivated by the knowl-

edge that Luther and the Reformation still have a powerful presence today; far from being a closed chapter in history, for the last 500 years, the Reformation has continued to exert its influence on society, culture, religion and politics. With its individual-existential approach, the Wittenberg exhibition focuses on a core Lutheran doctrine, which has had especially far-reaching consequences: Luther's doctrine of the universal priesthood of believers values each Christian as a unique individual, who shapes his or her own relationship with God and, in so doing, gains both dignity and a sense of freedom that no institutional or clerical authority can outdo. A memory culture that seeks to remain visible to the public must therefore take account of professional historians' demands for radical historicisation and for attention to be paid to the alienness and alterity of a historical figure and must accommodate these within a reflective approach that not only uses all available sources to situate past events in their rightful contexts but also extrapolates their potential relevance today.

The curators of the exhibition – Mirko Gutjahr, Benjamin Hasselhorn, Catherine Nichols and Katja Schneider, together with Daniel Leis – enthusiastically and expertly rose to the challenge of presenting Luther both as an intellectual, emotional, physical and spiritual entity and as the point of departure for an existential, effective history of the Reformation.

The exhibition itself has been greatly enriched by outstanding loans from numerous museums in Germany and abroad. The academic advisory group, led by Johannes Schilling, greatly enhanced the concept of the exhibition with numerous suggestions and adjustments. The authors who contributed to the catalogue – 96 in total, just overshooting the magic number for the year 2017 – have added their own personal viewpoints to the substance of the exhibition. However, without the generous support of the Federal Government Commissioner for Culture and the Media and of the State Parliament of Saxony-Anhalt all of this would have been no more than wishful thinking. I would therefore like to express my sincere gratitude to the many individuals who have contributed to the realisation of this project and, not least, to the visitors to the exhibition and readers of this book for embarking on the adventure of an existential encounter with Martin Luther. Dr. Stefan Rhein

Chairman and Director of the Stiftung
Luthergedenkstätten in Sachsen-Anhalt

DISCOVERING LIFE AS AN INDIVIDUAL INTRODUCTORY ESSAY

DIETRICH KORSCH

95 Theses and their author

The number 95 is not in itself symbolic – unlike 3, 7 and 12, for instance, which many would immediately associate with the Holy Trinity, the story of Creation and the disciples who followed Jesus Christ. The fact that the otherwise unremarkable '95' has become a symbol of the Reformation is purely a matter of historical chance, that is to say, it was the number of theological theses posted by Luther in 1517 for discussion in an academic disputation, which never even took place.

95 Theses – about what? About indulgences. But many may ask what does that matter today and what are indulgences anyway? In short, the Church introduced the practice of issuing indulgences in the late Middle Ages, but they were still a topic of theological debate in 1517. An indulgence, that is to say 'a remission before God of the temporal punishment due to sins whose guilt has already been forgiven', can be gained by those in a state of grace on the fulfilment of certain conditions prescribed by the Church, such as reciting prayers, fasting or giving alms to the poor. However, by Luther's time the practice of simply selling indulgences had taken hold, to a certain extent due to the intense striving for salvation on the part of the faithful , but also due to propaganda from the Church which was seeking to boost its finances. Looking at this from a historical perspective, it seems fair to ask whether that over-heated piety would actually have endured – after all, the impact of every campaign steadily reduces with time. Indulgences still exist in the Roman Catholic Church but they play a relatively insignificant part in the life of the Church today.

Thus it was not due to the theological content of the 95 Theses that they – and hence the number 95 – have become such a beacon in the context of the present Reformation anniversary. And they are much more restrained in the topics they address than one might imagine. In fact, it is impossible to fully understand them without looking at the person who wrote them and at the situation in which they arose and made their impact.

Martin Luther! Who was he? An Augustinian monk and professor of theology in Wittenberg, Luther was largely unknown when he sent his theses on indulgences to the Archbishop of Mainz, Albrecht of Brandenburg, on 31 October 1517. Up to that point all he had published was a collection of his lectures on the Penitential Psalms and a short mystical text entitled *Theologia Teutsch*. In a time when there was not only a widespread, heightened interest in fulfilling pious deeds to obtain indulgences but also targeted sales of them, it clearly took courage to raise the pressing, theological questions associated with indulgences and to accost one's own Archbishop – who encouraged these practices – with soundly argued criticism.

What made Luther do it? And why did this initially unremarkable event have such far-reaching consequences?

The five sections of the exhibition, accompanied by this catalogue, present 95 treasures and link Martin Luther to 95 people who relate to him in very different ways. The first two sections are devoted to physical objects that directly concern Luther's life and surroundings and also cast light on his persona. They give visitors to the exhibition the wherewithal to form a picture – their own picture – of Luther. However, it is only possible to grasp who Luther was and what he still means today by considering the way that his own experience as a Reformation leader has coloured the self-image and actions of human beings in the Modern era. A sense of this, at least, can be gleaned from the lives of the 95 people from diverse walks of life, who are presented in chapters three to five.

95 Treasures and Martin Luther

Endless amounts have been written about Luther as a human being – more or less equally divided between admiring and disparaging. In every age, from the early sixteenth century until the dawn of our own, there have been extremes of both approval and condemnation. However, over the centuries the reasons for different parties to admire or condemn him have changed markedly, depending on the prevailing attitudes to the relationship between Luther as a human being and his message. This in itself serves as a reminder that all biographical evaluations must be read as historical constructs. The person under investigation becomes an invisible nucleus for texts and images, sites and artefacts.

Luther took a courageous, self-confident stand when he sent his theses on the subject of indulgences to Albrecht and signed using the spelling 'Luther' rather than the hitherto customary 'Luder'. By thus alluding to the Greek *eleutheros*, a 'free man', he indicated something of his new attitude to the ecclesiastical authorities. This orthographic change did not affect the pronunciation of his name in the Upper Saxon dialect. Indeed it would be true to say that the real change took place within Luther himself. This is illustrated in the first two subsections of the first part of the exhibition, which highlight aspects of the tension between the interior and exterior. Luther, like everyone else, had his own family history, and his development as an adult was not unaffected by his starting point and beginnings, although that is not to say that the latter determined his life. The ambitions of the bourgeois mining entrepreneurs in Mansfeld, exemplified by Luther's father, and the open-minded cultural horizons of his mother all played a part in his life. And then there was also his own experience, as a young man, of having to make his way through life with a physical constitution that he could not change. Luther's school and university education pointed the way to paths that were open to him and that he could follow. He was moved by

religion, insofar as it related to the feelings of the individual. All these elements had a role in his life story and while they were the same kind of elements that would have affected people in many parts of the German-speaking world in the early sixteenth century, in Luther's case they were also individual enough for him to carve out a distinctly unique path.

At the same time, the course of Luther's life took on a profound aspect that can only properly be described in terms of religious experience, because his life story was underpinned by a hitherto unknown dimension, which introduced a very different rhythm into his life. Like many of his contemporaries, Luther also turned to religion for a decision on the value of his life as a human being. Indeed it was all but impossible to escape the ubiquitous reality of the Church's evaluation of individual lives. What counted as pious and how one could gain piety were commonplace questions at the time. Luther took a particularly serious approach to the question of the reason for living, albeit not without taking his lead from his family's own educational background; in fact he was so radical in his approach that he was prepared to defy his own family's plans for his life and enter an Augustinian monastery. But he found that the question regarding an authentically lived life, which he had so rigorously asked, was not satisfactorily answered by the teachings of the Church, according to which a person could only live a true life if they were dependent on the Church. This conflict could have led to Luther into a state of permanent crisis, if not to the point of self-destruction.

That Luther found a different way is largely due to the Bible study that his order instructed him to engage in. In the Bible – as the backdrop to ecclesiastical traditions and their casting in a critical light – he found the divine truth, which, through the Word of God, moves the human heart and fulfils it in faith. Through all the vicissitudes of his life, Luther found that, beyond the world and its dependencies, he was critically judged by God himself through the Gospel, but that, within the world, he was also more deeply and endlessly accepted by God. This life experience coloured and accompanied all his subsequent experiences. He felt he had been endowed with the wholly unexpected freedom of not needing any more worldly things; his only need was the Word of God. Luther thus gained a new, one might even say transcendental attitude to the totality of his life experiences; in other words, he gained a new attitude to life. The courageous decision to publicise his 95 Theses on indulgences and to challenge the authority of the Church was the first visible sign of this new attitude. Significantly, Luther's interest was not only in what he saw as the theologically unsound practice of selling indulgences but also, tentatively as yet, in establishing the right form for a believer's relationship with God.

Thereafter Luther's own life story took on a very different aspect. He could accept it and value it, precisely because it had lost its fateful power. From this

point on Luther's future was entirely determined by his new sense of having – already – found in God the ultimate, ever-present foundation stone of life. His path through life was now shaped by standing up for this reality, which was already transforming his own existence. In other words, his aim was to spell out his own experience of faith, which constantly supports and accompanies life, as a model for Christian life in general. And this experience of faith allowed Luther to step back from his own individual existence, which could then be used as an example of the Christian experience.

Looking at Luther one sees his external life story: early bourgeois beginnings, a change of course to the religious life of a monk, departure from the monastic rule followed by acceptance of the role of exegetist and proclaimer of the Gospel. But of course it is impossible to look inside people to see what is happening within them. And it is always possible for historians to assume that Luther may have been driven by motives and intentions other than purely religious aims and, accordingly, to adopt a very different view of Luther's life. Be it that self-seeking motives had masqueraded as religious intentions, be it that religious expression were merely a veneer intended to conceal harsh social realities – to this day there are still those who insist on recounting Luther's life story without regarding his internal, religious epiphany as decisive. It is never coincidental when Luther's experience of faith is ignored, because it is only discernible to those who expose themselves to the same conditions that set his experience in motion. It just so happens that the religious experience of faith is something utterly individual. However, if Luther's epiphany is indeed ignored, a strange contradiction ensues: the supposedly non-religious motives that prompted Luther to delve deeper into his interpretation of human existence would then have to be accorded a particular degree of certainty, thereby suggesting that those same motives were in effect religious and unconditional.

By virtue of his own religious, self-analysis, which he learnt from the Bible and which taught him that he had, through his faith, a direct relationship with God, Luther was an outstanding individual. But this is not to say he was a role model; there have been more subtle theologians, better writers, more successful political players, more sophisticated religious virtuosos and, presumably, there were also more appealing personas amongst his contemporaries. Yet by making use of his own life story, he found a way to justify the life of the individual through the Word of God. This makes him unique – in historical terms, too. However, this justification of human life through the Word of God was equally available to all human beings who question the reason for their life. The Reformation largely owed its existence to the fact that, in Luther's own time, there were other people who shared this experience.

95 Treasures: these could be described as a framework for Luther's story in the context of the early Modern era. They epitomise moments that shaped

his development. They shed light on his corporeal life. They document the beginnings and impact of his new, Bible-led, religious self-analysis. And ultimately they also illustrate the consequences that ensued from Luther's efforts, both individually and together with others. They provide an opportunity for us to look at Luther himself – and hence to look through him, as it were, to the very foundations of his life. And this gaze comes to fruition when people thereby discern the reason for their own lives, the justification for their own individuality.

95 People and the epiphany of Martin Luther

95 People are also presented in this exhibition. And this group of people could hardly be more diverse: political activists, gifted writers and artists, outstanding scientists, exceptional religious figures, modern men and women going about their daily lives. It would scarcely be true to say that they all looked or look up to Luther as a role model. On the contrary, it is very evident that many distanced themselves from him. So what connects them all and why are they presented here, side by side?

In 1520, when Luther described his own epiphany in words on paper, he identified the epitome of Christian freedom as the fact that the human soul, the centre of one's self-possession and one's self-determination, has no need of a single thing from the world for it to be free – it needs only the Word of God. He thus introduced a model of human existence that allows people of Christian faith to fundamentally set themselves apart from the world, which they nevertheless still inhabit. And it is for that reason alone that a 'Christian is a perfectly free lord of all, subject to none', as Luther puts it in his first thesis in *The Freedom of a Christian* (WA 7, 20–38; LW 31, 327–77). At the same time Luther had also recognised that this freedom grounded in God also steers one's own actions, thereby guiding human beings into mutual solidarity.

This concept of human beings allows each and every person to feel that their own individuality is grounded in God – regardless of the historical and social conditions of their lives, regardless even of their own physical and mental attributes. This in turn means that human beings (determined by God in this way) also behave as individuals in their own environments, focussing their lives here or there, intervening in this or that, now suffering more painfully, now taking action more resolutely. There is no uniformity in outward appearances, but there is very much a shared sense of responsibility.

However, Luther's concept of a free, individual believer also requires that individual take this idea on board. In other words, it is also perfectly possible *not* to accept this model, and to contradict it or decry it. But that does not mean that Luther's design for living ceases to exist. On the contrary, any such attempts to contradict it eat away at the validity of the lifestyles

that are adopted instead. These too, have to be maintained by individuals, even if — as they claim — they are talking in the name of the highest authority or all-powerful nature. Whether one agrees with his reading of the Gospel or not, Luther's anthropology of life through faith changed the humanist discourse on human life.

In that sense the 95 People very much occupy the resonance chamber of Luther's reformist ideas about human beings. All 95 are individuals — as they would wish and can and should be. All of them forged their own lives from the foundations of their existence and thus played a part in their various historical and social contexts, intervening and often suffering too. Each figure adds a different accent to the mix — be it artistic, scientific, philosophical or social. To do justice to all these individuals would mean specifically telling each one's story: how they became what they are or were; what their aims were; where they hung their hearts (WA 30 I, 133) in their own lives and in their actions. While this would not produce a gallery of role models, it would surely create a panorama of humanity and its potential when the individual, God-given independence of the foundations of personal freedom from the world in which we live is proclaimed and lived out.

The sequencing of these life stories into community, worldliness and interiority in the exhibition has been done with good reason. For it is in communal life that individuals build up their own self-image, which they subsequently use to make an impact on the world and which shapes their own inner lives. Needless to say these self-images are far from all explicitly religious in their formation and foundations. And yet each individual has, in his or her own way, responded to the challenge to make their mark both through individual expression and with social responsibility. Of course this did not by definition necessitate their following in the footsteps of Luther with all his strengths and weaknesses, his moral judgements and aesthetic preferences, and least of all his theological doctrines. But these individuals' discoveries of their own lives express what Luther first clearly recognised as a way of life founded in the Word of God. Thus, in considering Luther's life and the Reformation, the challenge today is to remember God's role as the foundation of all life.

LUTHER – AN EXISTENTIAL APPROACH CURATORIAL INTRODUCTION

MIRKO GUTJAHR, BENJAMIN HASSELHORN, CATHERINE NICHOLS AND KATJA SCHNEIDER

However monumental he might seem, the figure at the epicentre of the 2017 Reformation celebrations is, when it comes down to it, a mere human being, a man named Martin Luther, whose image has evolved over the course of half a millennium. The collective construction of this 'monumental figure', as Thomas Mann described him in the same breath as Goethe and Bismarck, began no more than 10 years after the posting of his 95 Theses, when Luther himself reflected on the historical significance of his actions and, as it were, issued an invitation to the very first Reformation jubilee. This joint creative venture, which long ago took on international dimensions and is as much interfaith as it is transcultural, has brought forth a multifaceted, highly contentious figure, an object of projection, a mirror image or mirage that has held sway over the entire spectrum of events comprising the Luther decade just now reaching its climax.

There is no disputing that Luther shook the world with his 95 Theses on indulgences. But who was this man who, in full expectation that it would cost him his life, steadfastly defended the faith that had liberated him? How did he come to move the entire world, made up as it is of countless individuals, each with their own particular concerns and priorities? These questions still lack satisfactory answers. No matter how often they have been raised over the last 500 years, it is worthwhile to address them anew, to return to the sources and re-examine them with the questions of *our own* times in mind. Without wishing 'to idolise' Luther or 'to denigrate him', the exhibition *Luther! 95 Treasures – 95 People* seeks to understand him and to 'make sense of the convulsions that he and Protestantism unleashed', as Lyndal Roper has it in her recent biography of Luther.

How, then, might we come closer to grasping Luther the man and his endeavour? Can the sediment of 500 years of Luther reception overlaying the historical events be stripped back and laid aside? Is it possible to develop a feel for what really happened at the time, to move beyond the apparent sine qua non of the legendary hammer blows? Does it make sense to adopt an 'archaeological' approach of the kind advocated in recent years by Heinz Schilling and Volker Leppin? What insights into Luther's expe-

riential world are to be gained from the results of recent research in cultural and social history, which perceive Luther as firmly rooted in the late mediaeval mentality of central Germany? Do these contribute to the creation of a more human image of the reformer and his actions, rather than portraying a lone theological superhero bestriding time and space? What might such an image look like? Why do we need it? And what does it say about us and our times that we would rather understand Luther than place him on a pedestal?

The exhibition and its companion volume investigate these and other questions over the course of five sections or chapters. Similar in structure to the acts of a drama, they look to sources from Luther's lifetime to shed light on his personality and inner conflict from an existential point of view, predominantly drawing on the voice of Luther as a younger man, as opposed to his own romanticised, if immensely evocative, accounts narrated with the benefit of hindsight. In contrast to the ideal time span for a drama prescribed in Aristotle's influential *Poetics*, the plot of *Luther!* is not compressed into the course of a single day, but rather unfolds over 500 years. And nevertheless the exhibition ultimately revolves around one day, 31 October 1517, the momentous date on which Martin Luther posted his 95 Theses on the door of the Castle Church in Wittenberg, thereby setting in motion the series of events that would become the Reformation.

The exhibition begins by tracing the evolution of the young monk Martin Luder into the reformer Luther through 95 treasures, objects which Luther owned, saw, touched or might well have used, indeed even personally created, things that influenced or astonished him, that he recognised, or may possibly have overlooked or even disregarded: the images, books, artefacts, music, sounds and experiences which constituted his world.

The first section, 'Luther's Inner Transformation', follows in the footsteps of the monk as he enters the monastery in 1505, travels to Rome in 1511, posts his theses on 31 October 1517, burns the papal bull threatening his excommunication in 1520, and appears before the Diet of Worms the following year. What connections, events and circumstances paved the way for his radical bid for a priesthood of all believers? What underpinned his prophetic self-confidence? What gave rise to the apparent contradictions in his actions, utterances and attitudes? And what prompted him to take the personally liberating and historically groundbreaking step of posting his controversial theses?

After visiting the stations of Luther's inner journey, the exhibition turns its gaze outwards to explore 'Luther's Way in the World', the external factors to have influenced his development. Here, the narrative centres on the historical context in which Luther became a reformer and the formative influence of his parental home in Mansfeld, his education, his early companions, associates and adversaries. This section culminates at the point

where the message of the Reformation begins to spread out into the wider world, represented here by Luther's German translation of the New Testament, published in 1522.

In the subsequent sections of the exhibition, 'Coexistence', 'Being in the World' and 'Inner Being', the narrative shifts towards the people in the wider world to have been affected in some formative way by Luther: 95 people, spanning 500 years of history and ranging across the globe, at once individuals and exemplars of the many people on whom Luther and his ideas have had an impact. The unique ways in which these individuals relate to Luther are each illustrated by an evocative exhibit, be it a painting, film, letter, garment, weapon or everyday, utilitarian item. As an ensemble they offer a palpable sense of the creative friction Luther has consistently generated over the past 500 years. For he has been an ongoing source of provocation and inspiration across ideological, philosophical and cultural borders. Who else in the history of the world could link such disparate figures as Astrid Lindgren and Joseph Ratzinger, William Shakespeare and Martin Luther King, or even Sophie Scholl and Julius Streicher? Luther has veritably made 'the spirits collide' (WA 15, 219; LW 40, 58).

But what did Luther himself actually hope to achieve? One answer can be found in the best known and most accessible of his writings, *The Freedom of a Christian* (1520). Here, Luther defines the new basis he believed people's lives would have as a consequence of the Reformation: freedom. Luther's freedom is a complex construct. It is a freedom acquired through faith that leads one to serve one's neighbour willingly; a freedom that is unthinkable without commitment and order; a freedom that, as with being Christian, is never complete but forever becoming. In his treatise on freedom, Luther defines the impact he wants his message to have on people. He delineates three distinct existential forms of being and acting: the 'inner' person, the 'outer' person and the 'person among other people'. Taking up these three different forms of existence and action, the three sections of the second part of the exhibition, '95 People', investigate the existential impact that Luther has had on people's social behaviour, on their relationships with the outer world and on inner life – from the sixteenth century to the present day. In the humanist tradition of a diachronic dialogue, bringing people together across time and space, each of the three chapters is subdivided into five topics of conversation drawn from Luther's writings on freedom, among them community, charity, law, interiority, language and grace.

The structure of this companion volume mirrors that of the exhibition, while also developing and expanding upon its discursive approach and existential scope. The 11 chapters comprising the first part – '95 Treasures' – trace Luther's path towards the Reformation. Each chapter opens with an essay, based on current historical research, that elucidates a particular aspect of Luther's life and concerns. Following on from this introduction, the vari-

ous themes are explored in depth within shorter, expository texts on the individual 'Treasures' and their significance for Luther.

The 15 chapters making up the second part of the book – '95 People' – examine Luther's enduring influence across the centuries. Here, too, the themes of each chapter are first addressed in an essay in which well-known authors interpret the respective subject and its associations with Luther, while considering its contemporary relevance in a rather personal, often emotive manner. The contributors were granted considerable freedom in choosing the style and structure of their individual essays, and the result is an assemblage of disparate texts, ranging from historical essays to pieces of literary prose. Following the introduction, each chapter brings together a group of people at a kind of imaginary round table. The protagonists enter into a discourse with Martin Luther, with one another and the viewer, reader or listener. Thus, for example, Apple founder Steve Jobs, contemporary artist Bruce Nauman, Baroque composer Johann Sebastian Bach, pastor Käthe von Gierke, social theorist Friedrich Engels and Brazilian liberation theologian Wanda Deifelt engage in 'conversation' on Luther's concept of work and its influence on individual existence and everyday life in the capitalist world. The conversations encourage us as interlocutors to engage in discussion with Luther, to consider what kind of person he was, how much he moves or convinces us, or whether we see him more as a questionable figure.

It is no accident that the number 95 appears twice in the subtitle of the exhibition and this accompanying book. Indeed, by consciously invoking the number of Luther's theses on indulgences, the 95 treasures and 95 people presented here can be thought of as points within an argument, the intention of which – much in the same spirit as Luther with his 95 Theses – is to stimulate discussion and critical reflection. Marking the 500th anniversary of his groundbreaking move, they embody an invitation, indeed pose a challenge, to debate the value, significance and relevance of Martin Luther in contemporary society, within and beyond Germany and Europe.

95 TREASURES

LUTHER'S INNER TRANSFORMATION

'I HAD BEEN CALLED BY TERRORS FROM HEAVEN AND BECAME A MONK.'

WA 8, 573; LW 48, 331

Like most of his contemporaries, Luther had an intense fear of the hereafter. The ever-present mediaeval depictions of death and the Devil, witches and demons and of a judgemental Christ fuelled his fear of not being able to satisfy God and failing to measure up to Christ. The plague, which was rampant at the time, exacerbated Luther's fear of a sudden death. Following the unexpected passing of two of his brothers in Mansfeld and, more notably, his haunting near-death experience during a thunderstorm near Stotternheim, in 1505 Luther decided to become a monk. He hoped that this would enable him to find a path to God and thus free himself of his fear of being unable to satisfy Him.

'MY FEARS INCREASED TILL SHEER DESPAIR'

THORSTEN DIETZ

An age of fear?

In the beginning was terror. The omnipresent imagery on the eve of the Reformation was unequivocal. Martin Luther grew up in an era in which the hereafter had an unquestionable three-dimensional reality. And this was a prospect that not only offered hope but also radiated much fear.

Imagery was always central to religion. God's judgement was a frequent theme in many churches in the late Middle Ages, and the faithful were equally familiar with graphic depictions of the agonies of hell. Dante's In-

ferno showed the kind of monstrous imagination that could be invested in describing otherworldly torments. The works of Hieronymus Bosch and Michelangelo vividly depicted the horror on the faces of the doomed. Indeed, thanks to Michelangelo's frescoes in the Sistine Chapel in Rome, the recurring image of Christ as humanity's judge is branded in the collective memory of the Western world. The ubiquitous motif of the Virgin of Mercy shows the anxious faithful, full of fear as they seek refuge, and in many versions Mary is depicted shielding them with her cloak to protect them from divine anger.

Images have an effect – and not just by virtue of their mere presence. After all, many of these motifs are still visible in churches and museums today but do not instil the same terror in us. They acquire their power when their forbidding scenes coincide with a terrifying world of experience and their plausibility is simultaneously reinforced by a corresponding communication of faith. From the outbreak of the plague in the fourteenth century, awareness of the imminent threat posed by divine anger was widespread in Europe. The crises in the Church, such as the split in the papacy and the Turkish advance in the southeast, which were caused by heretical movements, a lack of reform and other factors, left many feeling intimidated. Terrifying images were thus perceived as entirely plausible.

Luther's path to the monastery

As Luther writes in retrospect, he was called to be a monk by terrors from heaven (WA 8, 573; LW 48, 331). His move to the monastery was an unusual step for a student of law but not a unique one. In the context of the contemporaneous piety, entering a monastery was considered a safe path to salvation and the most promising approach for an anxious soul seeking peace. Faced with the fear of his own death and of hell, Luther did not see any other option for himself.

Why did the terrifying ideas of his time gain such power over Luther? Contrary to popular belief, his pious family home or an excessively strict upbringing cannot be held responsible here. The scant information that we have about Luther's childhood and youth are more indicative of an atmosphere of solemn ecclesiastical piety typical of that time. Various personal experiences in Luther's life may have coincided to contribute to his anxiety. As a student on his way home to Mansfeld, for example, Luther accidentally stabbed himself with a sword, cut an artery in his thigh and feared he would lose his life. During the years that followed, he was confronted with the possibility of sudden death on several occasions. In the years before he entered the monastery, the plague was rife in Erfurt, the city where he was studying. Several well-known lawyers fell victim to the disease and members of Luther's family also succumbed to this sudden deadly fate. Finally, one day as he made his way to Erfurt, he was caught

in a heavy thunderstorm in Stotternheim. A bolt of lightning struck the ground beside him. Interpreting this scare as a kind of final warning, a despairing Luther made a vow to enter the monastery.

Luther's anxieties initially abated in the monastery but only for a short period of time. Even his first mass proved to be a traumatic experience. The belief that God was present made him tremble and doubt his own worthiness. Looking back, he described in dramatic terms the extent to which anxiety and panic attacks plagued him during his time in the monastery: 'Thus I was bathed and baptized in my monkery and had the true sweating sickness. My God be praised that I did not sweat myself to death.' (WA 38, 148)

Offers of consolation

Can the pre-Reformation period be described as the age of fear? No, that would be misleading. Similarly, it is also a misunderstanding to see Luther's experiences as a consequence of a particularly cruel mercilessness typical of late mediaeval piety. On the contrary, the 200 years prior to the Reformation were characterised by an escalation in offers of consolation by the Church. Moreover, testimonies of assurances of salvation, a yearning for heaven and joy in God proliferated during this period.

There were different ways of coming to terms with the ubiquity of the terrifying images. The clergy were in no way indifferent to or unheeding of this mood. They relied on the fact that the faithful could suffer from serious pangs of conscience, and developed ever new offers of consolation in response. This was particularly evident in the sale of indulgences, which flourished around 1500. Luther's subsequent confrontation with indulgences must not be taken as a pretext for viewing the Reformation and indulgences as simple opposites. Essentially, they were parallel efforts at providing spiritual support. The indulgence was also promulgated and perceived as an offer of consolation for the anxious. It was a remission of the temporal punishment for sins, for which the penitent had already been forgiven, and could be applied to a person's time on earth or in purgatory. In return for a small contribution, the indulgence campaigns held out the prospect of every greater mercies – sometimes even the salvation of those who had already died – or mercy for future sins. The huge success of the early indulgence campaigns was based on the fact that they addressed a general yearning for certainty and mercy. This resulted in a veritable dissolution of the boundaries of divine grace. The indulgence was anything but an appearance of extreme justification by works. The propagation of the main plenary indulgences was a master stroke in continually easing the conditions for acquiring grace.

However, such offers of consolation were initially ambiguous, as their promise of salvation was not beyond doubt. Similarly, reformatory forces also

warned against half-heartedness and sought a revival of the earlier rigour of repentance. However, a direct assurance of salvation could not be guaranteed in any case. Such assurance was associated with either an optimistic assessment of an individual's own abilities or with great trust in the Church as an agent of divine mercy. When confidence in both the Church and individual abilities was lacking, there was no escape from the imagined horrors.

Overcoming the fear?

Luther spent his early years seeking to conquer unbearable feelings of anxiety. His experience had taught him a variety of pastoral strategies. As he explained, a chaplain had tried to dissuade him from exaggerated scruples, urging him to consider instead the people who lived confidently and did not seem to make any efforts whatsoever to attain mercy or grace – were they all to be doomed? Such offers of reassurance did not have the desired effect on Luther. Certainty could not be acquired with this type of conjecture. Others countenanced solemn penances and were consoled by the view that God would not deny mercy to those who had done everything that they could possibly do. But can one ever be certain that everything possible has been done? Why did the various offers of consolation of this era fall short for Luther? His anxiety clearly became so severe that even the possibility of inadequacy triggered panic. Such deep-seated fears also had enormous impact on this person who, nevertheless, did not break under the stress and would instead continue to search for new solutions.

Growing ever more desperate in his efforts, Luther learnt that he could not overcome his anxiety in a context of religious rules of salvation. He summarised this experience in the realisation that the *conditio* (circumstances) is the origin of all misfortune. The mere possibility of one's own inadequacy invariably leaves room for the horrific. Luther illustrated this state in the proverb: 'he that fears hell, enters it'. Fear of judgement and punishment increasingly dominated his own experience. And fear of a certain state appeared to make this practically unavoidable. The more a person seeks to avoid this experience, the more rapidly it takes possession of them. This was the 'sweat, yes anxiety bath' (WA 45, 152) as he later described his panic and despair.

Luther's subsequent insights can be seen as a radicalisation of this increase in grace. The indulgence campaigns promised grace in return for diminishing levels of religious cooperation. But the conditions of the Church's message of salvation were not questioned; they even became easier to understand. Ultimately, it still came down to the money that rattled in the box.

In grappling with the biblical texts, Luther discovered another way that upheld this programme of minimisation and at the same time radically

overcame it. He learned to read and believe biblical words of salvation as a promise of unconditional grace. Faced with the images of horror, nothing people do can help and neither can anything that the Church thinks it can promise. Other images, biblical images that promised the salvific nearness of God for the doomed in the crucified Christ, were of real help to him. The experience of unconditional grace was the end of all religious conditional logic for Luther. Overcoming the fear in this way involved turmoil that only gradually revealed its explosive power.

DEATH IN MONASTIC ROBES

LATE 15TH CENTURY LIMEWOOD, PAINT RESIDUES
103.5 × 37 × 30 CM
BADISCHES LANDESMUSEUM, KARLSRUHE

With its head tilted to one side, a skeleton gazes out from empty eye sockets, gesticulating with its bony hands. It is clad in a monk's habit, a cowl with wide sleeve openings and a hood drawn up onto its head. Traces of black paint on the garments indicate that the skeleton is wearing the monastic habit of the Benedictines. There is no saying whether this is Death approaching the viewer as a Benedictine monk or a deceased monk revisiting Earth as a revenant. The figure is open to both interpretations. In late Medieval *danse macabre* images, Death often takes on the appearance of those he has come to wrench from the world of the living. And he visits all levels of society – no-one is spared, be they ordinary mortals or members of religious orders, rich or poor, popes, emperors, or beggars. People had imagined the dead returning to this world since the beginnings of Christianity – and still did so in the late Middle Ages. As the dead encountered the living they might sometimes demonstrate their gratitude for the latter's prayers and intercessions. It was even said that princes, who had shown particular concern for these poor souls, later received help on the battlefield in the shape of armies of the dead. However, the legends of the saints also tell of revenants who violently reminded the living of their duties to the dead and of their obligation to respect the last will and testament of those no longer with us.

Death was ever-present in daily life in the late Middle Ages. The living thus kept in close touch with the dead through intense acts of commemoration and remembrance. Burials in the midst of the living underlined the presence of the dead in everybody's lives. There was also a deep-seated awareness that death could catch up with anyone at any time. People's fear of dying in a state of unpreparedness was stoked by the belief that immediately after death, each person is subjected to particular judgement by God the Father, who decides on his or her future for all eternity. The faithful were thus constantly warned that each of us will die and visibly reminded of this fact in *memento mori* images, such as the figure of Death in a monk's habit. A person's final hours were deemed crucial, and an entire genre of contemplative literature was devoted to the 'art of dying well'. These texts taught the faithful how to ward off temptations from the Devil in their last hours and how to trust the solace of angels and saints, and admonished them to truly repent of their sins, in preparation for the moment, after they had received their last rites, when they would finally stand before God. Dying in the right way could save the faithful from Hell, whereas an unprepared, sudden death could plunge them into eternal damnation. Luther, who was deeply familiar with all these fearful notions, later wrote his *Sermon on Preparing to Die* (1519). Composing texts that would bring comfort to the dying became one of the main spiritual missions of the reformers. The core message in these texts was Luther's doctrine of justification, reminding the dying of the certainty of their redemption and of the fact that God bestows His grace on human beings without presuppositions.

Susanne Wegmann

→ Further reading
Mireille Othenin-Girard: 'Helfer' und 'Gespenster'. Die Toten und der Tauschhandel mit den Lebenden, in: *Kulturelle Reformation. Sinnformationen im Umbruch, 1400–1600*, Bernhard Jussen and Craig Koslofsky (eds.), Göttingen 1999, 159–191.
Susanne Warda: *Memento mori. Bild und Text in Totentänzen des Spätmittelalters und der Frühen Neuzeit*, Cologne 2011.
Luise Schottroff: *Die Bereitung zum Sterben. Studien zu den frühen reformatorischen Sterbebüchern*, Göttingen 2012.

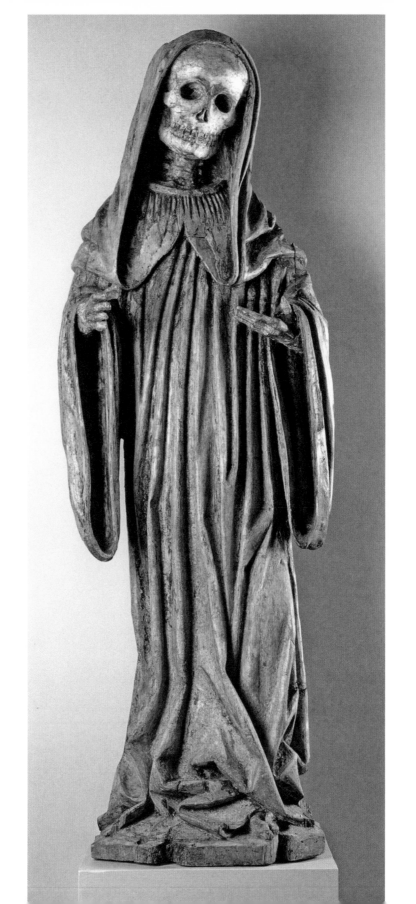

PROCESSIONAL LANTERN

15TH CENTURY SHEET IRON, PAINTED, HORN AND WOOD
HEIGHT 65.5 CM, DIAMETER C.23 CM
BAYERISCHES NATIONALMUSEUM, MUNICH

When Martin Luther was born over 500 years ago, dying was not a private matter. Deathbed assistance was part and parcel of the care that the family and other social groups provided as a matter of course to the dying and the departed. Such groups included the congregation, the village, the monastery and above all the parish to which the dying person belonged. The pastoral care administered by the parish clergy to a person on their deathbed manifested itself most obviously in the last rites. In this sacrament, the parishioner's eyes, ears, nose, lips, hands and feet were anointed with holy oil and they received the consecrated host. The priest then heard their confession and gave them absolution.

The viaticum procession made by the priest from the parish church to administer the Eucharist at the deathbed became an increasingly conspicuous public act at the end of the Middle Ages which fostered an inevitable awareness of the ever-present spectre of death. The priest conveyed the consecrated host in the usual receptacle, the ciborium, which was covered with a piece of cloth. He was accompanied by the sacristan or other altar servers, who often carried processional lanterns adorned with banners and drew attention to the approach of the procession by ringing a small bell or by singing. Passers-by were expected to stop to worship the Eucharist, to pray for the dying person or even to join the group. Episcopal and papal deeds repeatedly promised indulgences to those accompanying the priest on a deathbed visit.

Several charities existed in the late fifteenth century to fund the expense of such processions, for example the cost of wax for the candles and, particularly, the 'personnel costs' incurred for the priest's entourage. In Altenburg, a charity was established in 1483 to enable two schoolboys to accompany the priest on his pastoral visit to the dying. They each carried a banner and lanterns and sang Latin responsories. Such 'sacrament boys' are also documented elsewhere. It is not known whether Martin Luther performed a similar type of service as a schoolboy. Nevertheless, the advent of individual death, which was made known to the general public by the ritual of the viaticum procession, must have been part of his everyday experience.

The processional lantern shown here dates back to the fifteenth century and is probably of southern German origin. It has three bay-like, projecting, glazed panels, which are transparently sealed with thin sheets of horn. A holder for the candle is fitted inside the lantern; the smoke can escape through punched-out holes in the conical roof and the small dormer windows. The sheet metal is decorated with punched, undulating tendril motifs and painted mostly in black. Accentuated details in gold paint and a red painted concertina-like sleeve add further decoration. Three gold heraldic shields featuring red orles mark the transition to the pole (which is not original and was replaced at a later date). The heraldic crests cannot be identified, and it is possible that the shields are not original either. The example shown here is one of a pair of identical lanterns. The lantern itself weighs very little due to the thin sheet metal, making it easy for an altar server to carry. Hartmut Kühne and Raphael Beuing

→ Further reading
Peter Browe: Die Letzte Ölung in der abendländischen Kirche des Mittelalters, in: *Zeitschrift für katholische Theologie* 55 (1931), 515–561.
Peter Browe: Die Sterbekommunion im Altertum und Mittelalter, in: *Zeitschrift für katholische Theologie* 60 (1936), 1–54, 211–240.
Hartmut Kühne: Der Versehgang, in: *Alltag und Frömmigkeit am Vorabend der Reformation in Mitteldeutschland, Hartmut Kühne*, Enno Bünz and Thomas T. Müller (eds.), catalogue to the exhibtion *Umsonst ist der Tod*, Petersberg 2013, 86.

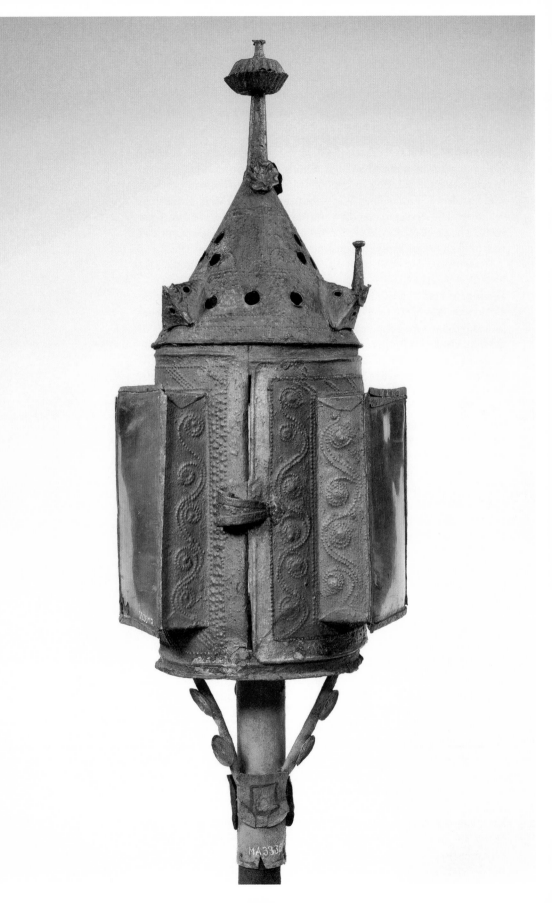

LUCAS CRANACH THE ELDER THE THREE PLAGUES

C.1516–1518 OIL ON LIME PANEL 74.5 × 56 CM
SZÉPM VÉSZETI MÚZEUM, BUDAPEST

Around 1516–18 Lucas Cranach the Elder (1472–1553) portrayed God the Father as a bowman seated on high, aiming three arrows at humankind. In prints after this painting, inscriptions can be seen on the arrows, which read 'Pestilence', 'Famine' and 'War' – the plagues that afflict human beings on Earth. The subject matter draws on various passages in the Old Testament. The prophet Habakkuk, for instance, describes his apocalyptic vision of God: 'Before him went pestilence, / and plague followed at his heels. … You stripped the sheath from your bow, / calling for many arrows.' (Habakkuk 3: 5 and 9).

Fearing the Lord's punishments, people have taken refuge under the wide cloak of the Mother of God. The group is led by the Pope, with a cardinal on his right and a bishop behind them both. But the back rows also include an emperor, another crowned monarch and several women. While Mary shelters humankind and looks up to God the Father, the Pope is directing his entreaties to Christ, who kneels on His cross, opposite His mother. Thus the Church, as an entity, appears not only to enjoy the special protection of the Mother of God, but seems also to be in a position to mediate to its members Christ's sacrifice for their salvation. The Son of God still has the crown of thorns on His head and the wounds from the Crucifixion are clearly visible, with blood flowing not only from these wounds but also from the gash in his side. Displaying the signs of His suffering, Christ gazes upwards to God the Father. The Son, who had suffered to atone for the sins of all humankind, and His Mother, who was chosen by God and remained forever immaculate, together beseech the Lord that the sinners may be reconciled with Him.

In the sermons on the Gospel of St Matthew that Luther wrote between 1537 and 1540, he speaks out against the late Mediaeval images of intercession where Mary is shown as the principle protector of the faithful: 'It is idolatry, that people are led away from Christ and towards the cloak of Mary, in the way that preaching monks have done. They depicted the Virgin Mary thus, with the Lord Jesus Christ bearing three arrows in His hand – one was pestilence, the next war and the third famine – to punish mankind. And Mary held up her cloak so that the people should not be struck' (WA 47, 276–277). Luther regards it as improper that Mary should be given a higher status here than Christ. As early as 1522 Luther had already been openly critical of the fact that Mary and other saints were 'our intercessors before God. Then we hied ourselves to Our Dear Lady, made her our mediatrix, and let Christ remain an angry judge' (WA 12, 266; LW 30, 10). Luther took the view that images of this kind did not teach people that reconciliation with God is to be achieved solely through the grace of His Son's self-surrender; moreover the Mother of God had only given her milk and even if, like Christ, she had given her blood, she was still 'far too lowly that her blood could redeem the world' (WA 47, 276). Finally, since Mary could not reconcile human beings with God, they continued to turn away in fear from their wrathful, vengeful Lord and distanced themselves from Him. Susanne Wegmann

→ Further reading
Susan Marti and Daniela Mondini: 'Ich manen dich der brüsten min, Das du dem sünder wellest milte sin!' Marienbrüste und Marienmilch im Heilsgeschehen, in: Himmel, Hölle, Fegefeuer. Das Jenseits im Mittelalter, Peter Jezler (ed.), catalogue to the exhibition of the same name, Zurich ²1994, 79–90.

Berndt Hamm: Gottes gnädiges Gericht. Spätmittelalterliche Bildinschriften als Zeugnisse intensivierter Barmherzigkeitsvorstellungen, in: Traditionen – Zäsuren – Umbrüche. Inschriften des späten Mittelalters und der frühen Neuzeit im historischen Kontext. Beiträge zur 11. Internationalen Fachtagung für Epigraphik vom 9. bis 12. Mai 2007 in Greifswald, Christine Magin, Ulrich Schindel and Christine Wulf (eds.), Wiesbaden 2008, 17–35.

Norbert Michels: Von der Himmelskönigin zur Magd Gottes. Wandel der Marienverehrung, in: Cranach in Anhalt. Vom alten zum neuen Glauben, idem (ed.), catalogue to the exhibition of the same name, Petersberg 2015, 109–149.

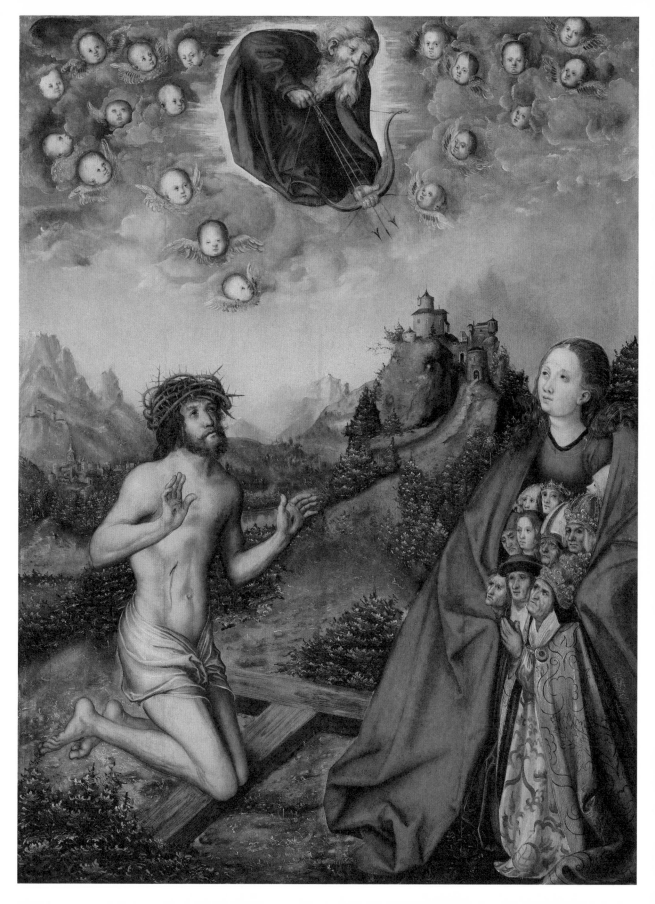

BENEDIKT DREYER (ATTRIBUTED) THRONE OF MERCY

1515–20 OAKWOOD, CARVED AND PAINTED
81.5 × 26 × 17 CM
DIE LÜBECKER MUSEEN – ST. ANNEN-MUSEUM

God the Father, standing upright, displays the ravaged body of Jesus Christ and supports the weight of His Son's upper body as it sinks lifelessly to one side. There is a fragility to this gaunt figure of the Son of God, with its protruding ribs and visible sinews and arteries. He still has the crown of thorns on His head. His arms hang limply down, with fingers cramped from His death throes. The painted finish highlights His wounds and the blood spilt for humankind. God the Father, in His silver-lined, golden robe is portrayed as a divine being, in stark contrast to His Son in His incarnation as a man. God the Father not only sacrificed His Son for humankind, He also accepted that sacrifice as a symbol of atonement and of the New Covenant. The sculptor underlines this by placing the figure of Christ inside the robe.

This sculpture from the Heiligen-Geist Hospital in Lübeck, which is attributed to Benedikt Dreyer (before 1495–after 1555), memorably exemplifies the iconography that so tellingly conveys the late Mediaeval theology of Christ's Passion: God the Father, consumed by grief, presents His Son to the faithful in the expectation that they will empathise with Him and share His pain. The belief was that empathy and emulation, which can also be accompanied by acts of penance and physical self-chastisement, could help to ensure that the faithful would be granted salvation. This belief is dramatically illustrated in the Holy Week sermons by the Dominican Henry Suso (1295–1366). Suso wanted to 'bear on his body some sign of his heartfelt sympathy for the intense sufferings of his crucified Lord'. So he constructed a wooden cross into which 'he hammered thirty iron nails. … He fastened the cross to his bare back on the skin between his shoulders and carried it day and night for eight years to praise his Lord.' In 1525 Luther delivered a sermon in which he talked of the diverse acts of penance and physical self-castigation he had carried out as a monk; however, in retrospect they seemed to him both useless and superficial. The monks 'process in grey habits and hoods, tie cords around their bodies, pray, fast and castigate themselves and observe their rule most rigorously', but 'all the works that you do in the belief that this will give you value in the eyes of God are futile and damned' (WA 17, 126–127).

Images such as Dreyer's *Throne of Mercy*, with its hyperrealistic depiction of the suffering of the Son of God, met with criticism from Luther. In a sermon he delivered in 1537, he describes the fear instilled in him by figures of that kind before the Reformation: 'When I was in the monastery in my habit, I was so hostile to Christ that whenever I saw His likeness in a painting or figure, hanging on the cross etc., I was terrified and lowered my gaze.' (WA 47, 310). But it was not so much the Mediaeval image that made the figure of the dying, tortured Christ so unbearable to Luther; it was the knowledge that, for all his most rigorous acts of penance and most abject self-humiliation, he could never justify himself before God.

Susanne Wegmann

→ Further reading
Thomas Lentes: Der mediale Status des Bildes. Bildlichkeit bei Heinrich Seuse – statt einer Einleitung, in: *Ästhetik des Unsichtbaren. Bildtheorie und Bildgebrauch in der Vormoderne*, David Ganz and Thomas Lentes (eds.), Berlin 2004, 13–73.
Birgit Münch: Luthers Werk und Cranachs Beitrag. Bildertheologie in den facettenreichen Bilderwelten zum leidenden Christus, in: *Cranach in Anhalt. Vom alten zum neuen Glauben*, Norbert Michels, catalogue to the exhibition of the same name, Petersberg 2015, 40–49.

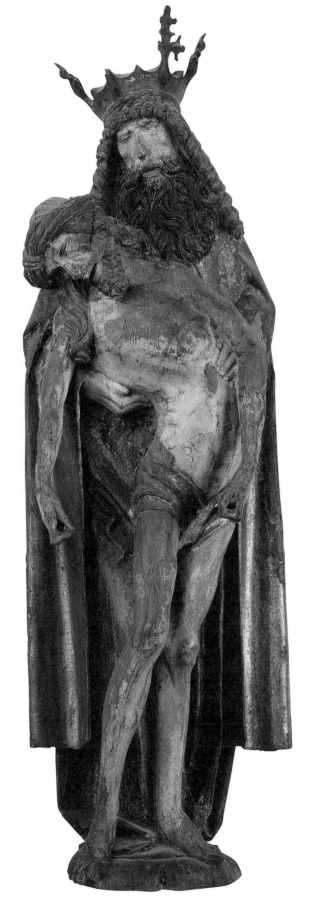

SMALL LAST JUDGEMENT ALTARPIECE

C.1475 OIL ON OAK PANELS, WOOD CARVINGS GLUED TO EXTERIOR
CENTRAL PANEL 51 × 39.5 CM, SIDE PANELS EACH 51 × 17.5 CM
PRIVATE COLLECTION

This small-format altarpiece was probably designed for use in domestic worship and during travel. On opening the two wings, which have decorative wood carvings on the outside, believers would see God, the Judge of all the Earth, seated on two rainbows with a bright aureole behind Him. The two angels at His feet are heralding the Last Judgement with their trumpets. The dead in their shrouds are emerging from their graves, seemingly aware of their fate: on the left, two rise up in hope at the sight of the heavenly apparition, while the two sinners on the right turn away in despair. Mary and John the Baptist are interceding for the human beings. The 12 apostles, praying, are also in attendance in this hour of judgement.

The side panels vividly portray the fate of human beings after their judgement. At the top on the left there are angels with opened books, sealed documents and the Instruments of the Passion. The devil figures in the same position on the right are also holding books, documents and rolled manuscripts. These motifs originate in the Book of Revelation, when John saw the dead standing before the heavenly throne: 'and books were opened. Then another book was opened, which is the book of life. And the dead were judged by what was written in the books. … And if anyone's name was not found written in the book of life, he was thrown into the lake of fire.' (Revelation 20: 12–15). However, those whose names are in the angels' books proceed towards a light and enter the kingdom of God. The symbols of Christ's Passion – the Cross, the column to which Jesus was tied during His flagellation, the lance, the nails and the crown of thorns – are presented by the angels for the salvation of the blessed. Those whose works are listed in the devil's manuscripts are dragged into the fiery inferno. Their screams and entreaties will not be met with mercy, and they will remain in Hell for all eternity.

Looking back at his earlier self, Luther realised that he had been more afraid of the Lord sitting in judgement than of the Devil. He regarded the Last Judgement as a terrible vision painted by the papacy, so that all who saw it would seek help from the Virgin Mary and the saints: ' … in the papacy Christ the Lord is painted with the terrifying picture that He shall judge us, although he surely died for us and spilt His blood for us. But why is He made so terrible, that we do not gladly see His picture? … I could only think that Christ was seated in Heaven as a vengeful judge, even if He is painted seated on a rainbow.' (WA 47, 275, 277). Luther was more critical of paintings of the Last Judgement than of any other late Mediaeval iconography: 'Such paintings should be put aside; for they have been used to frighten people's consciences and to make them think that they must fear and flee from the dear Saviour' (WA 33, 83–84, LW 23, 57). Christ was only ever portrayed in those paintings as an 'angry judge' (WA 12, 266; LW 30, 10). In so saying, Luther deliberately ignored the hope-inspiring elements of the Last Judgement iconography; his critique is one of righteousness through works and of the veneration of the saints and the Virgin Mary, which, in his view, was an obstacle to the faithful's quest for Christ. Susanne Wegmann

→ Further reading
Himmel, Hölle, Fegefeuer. Das Jenseits im Mittelalter, Peter Jezler (ed.), catalogue to the exhibition of the same name, Zurich ²1994.

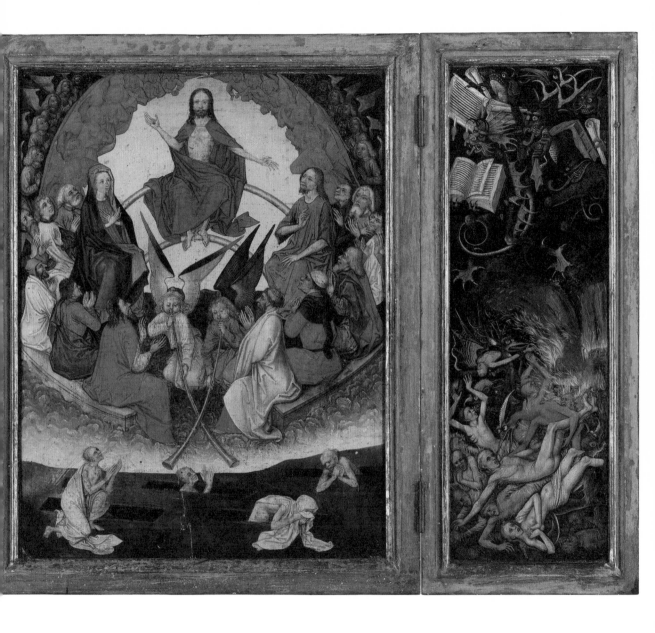

ROSARY PANEL

C.1515 OIL ON PINE PANEL 94 × 76.5 CM
BAYERISCHES NATIONALMUSEUM, MUNICH

From the fifteenth century the rosary became the most important prayer for the laity. The roses in the panel shown here symbolise the sequence of prayers to be recited when saying the rosary: 10 Hail Marys, represented by 10 white roses, are followed by one Our Father, signified by a red flower. This sequence is repeated five times and may be followed by a profession of faith. The Hail Marys were linked by various devotional phrases, which recall Mary's sorrows and joy, the life and passion of Christ, and the communion of saints.

The favours sought from Jesus, Mary and all the saints through the prayers were intended to benefit the poor souls in purgatory, who can be seen below the garland of roses in this image. The souls endure the fires of purgatory until they are cleansed of their iniquity. The prayers help to ensure that they will be consoled by angels and ultimately redeemed. In the late Middle Ages, Confraternities of the Holy Rosary dedicated themselves to this form of prayer and propagated it with pictures, prayer cards and devotional literature. The members of the Confraternity of the Holy Rosary founded in Cologne in 1475 were required to say three rosaries every week. The rosary beads – prayer beads that supplicants used as a counting aid – were often made from precious materials and were worn visibly on the clothing. The rosary panel shown here was produced around the time that Luther posted his 95 Theses. It illustrates clearly the late mediaeval concept of piety regarding the effectiveness of the laity's prayers for the poor souls. A garland of 50 white and 5 red roses encircles the hierarchically ordered heavenly estates. The Trinity of God the Father, the Holy Ghost (represented by the dove) and the crucified Son of God in the centre occupy the highest positions. Christ's cross stands on a stone pedestal directly on the ground, reminding the faithful that the Son of God humbled himself for them and suffered for their sins. Mary kneels with the infant Jesus on her lap to the right of God the Father as she receives His blessing. Looking on at the sides and lower down in the ranks are the hosts of angels and the orders of saints. These include the righteous of the Old Testament, the Apostles and Evangelists, martyrs, Church Fathers, virgins and widows. They all turn towards the divine manifestation in worship and adoration. Above the garland of roses, the viewer can see two of Christ's particularly blessed supplicants: on the left, kneeling in front of an altar, is St Gregory the Great, to whom the Man of Sorrows appears to be praying, and on the right is St Francis, who bore the wounds of Christ. In his exemplary devotion, he was able to relive the suffering of Christ, with the result that he himself becomes the image of Christ.

Luther saw these frequently repeated sequences of prayers as an externalised action without inner involvement on the part of the supplicant who hoped to receive merits by means of such prayers. According to Luther, however, the faithful could not be justified before God by their own works.

Susanne Wegmann

→ Further reading
Arnold Angenendt et al: Gezählte Frömmigkeit, in: *Frühmittelalterliche Studien* 29 (1995), 1–71.
Der Rosenkranz. Andacht, Geschichte, Kunst, Urs-BeatFrei and Fredy Bühler (eds.), calogue to the exhibition *Zeitinseln – Ankerperlen. Geschichten um den Rosenkranz*, Bern 2003. Thomas Lentes: Sterbekunst, Rettungsring und Bildertod. Rosenkranz und Todesvorstellungen zwischen Spätmittelalter und Früher Neuzeit, in: *Zum Sterben schön. Alter, Totentanz und Sterbekunst von 1500 bis heute*, Andrea von Hülsen-Esch and Hiltrud Westermann-Angerhausen (eds.), essays to accompany the exhibition of the same name, Cologne 2006, 310–320.

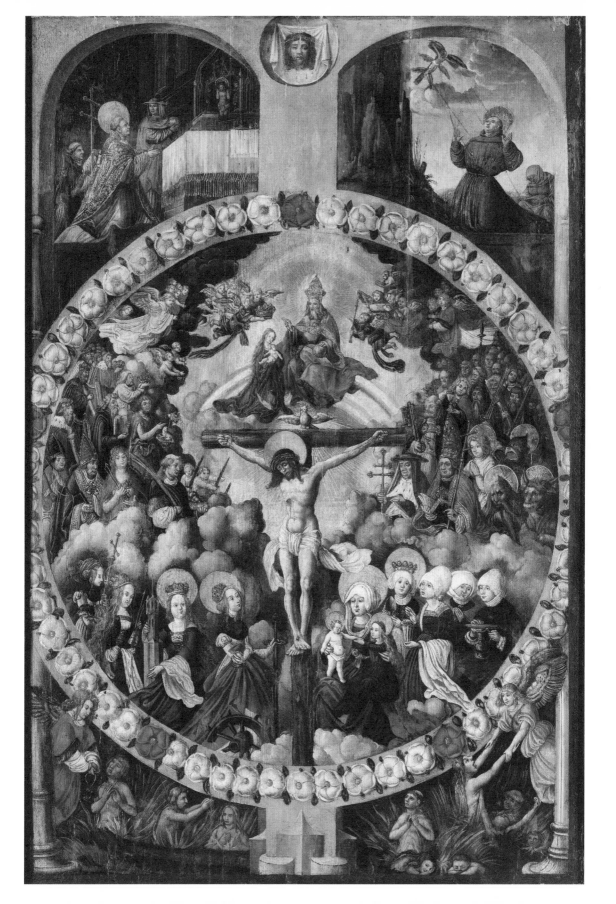

HANS BALDUNG GRIEN THE CONVERSION OF SAINT PAUL

C.1515–17 WOODCUT 29.4 × 19.5 CM
PRIVAT COLLECTION, MUNICH

On 2 July 1505, Luther was caught in a heavy thunderstorm. He found himself on the road between his native Mansfeld and Erfurt, where he had just begun his law studies, having already received a Master of Arts degree. The thunderstorm struck while he was in the village of Stotternheim; it was so violent that Luther, fearing that his life was in imminent danger, uttered a quick prayer, exclaiming: 'St Anne, save me and I will become a monk' (WA TR 4, Nr. 4707, 440). He survived the storm unscathed and just two weeks later, on 17 July 1505, he entered the monastery in Erfurt.

Luther's decision can only be understood in the context of the piety of his time. It was the fear of sudden death – which meant almost certain damnation but, at the very least, the punishment of purgatory in the next life – that drove Luther into the monastery. Moreover, it was fear of a punitive God and a judgemental Christ that led Luther not to either of them, but to a saint, a popular helper in times of need and an advocate for sinners before God. Speculation on Luther's motives for joining the monastery continue to this day. The reformer's earliest words on the subject can be found in the foreword to his work *De votiis monasticis* (1521). This was directed expressly at his father, who felt cheated of his hopes for upward social mobility following his son's entry into the monastery: '[I told you that] I had been called by terrors from heaven and that I did not become a monk of my own free will and desire' (WA 8, 573; LW 48, 332). Even earlier, during Luther's time in the monastery in Erfurt, one of his teachers had compared his thunderstorm experience to the conversion of St Paul. According to the Bible (Acts of the Apostles 9), Saul, a persecutor of Christians, was blinded by the light on the road to Damascus when the risen Christ appeared to him. This experience led to Saul's conversion and thereafter he spread the Gospel as the Apostle Paul.

The connection suggested here was strengthened further by the reformer's own subsequent and specific references to the letters of St Paul. Accordingly, when Luther's contemporaries saw images of the conversion of St Paul like the one shown here – Hans Baldung Grien's woodcut (1515–17) – they too would have been reminded of Luther's 'conversion'. Strictly speaking, of course, there is no question of a conversion here. After all, the thunderstorm in Stotternheim did not result in a return to God by Luther, but reinforced his decision to continue along the path that he had already taken – to accept the Church's offers of salvation so as to tackle his own fear of damnation. Luther's decision to join the monastery marked the beginning of his intensive search for salvation and a time of immense religious struggle. Following his decision to dedicate his life completely to his relationship with God, Luther also embarked on his path to the Reformation.

Benjamin Hasselhorn

→ Further reading
Hans Baldung Grien, prints & drawings, catalogue to exhibition of the same name, James H. Marrow and Alan Shestack (eds.), New Haven 1981
Hans Baldung Grien in Freiburg, catalogue to the exhibition of the same name, Freiburg i. Br. 2001, 156–157, No. 28.
Luther und das monastische Erbe, Christoph Bultmann, Volker Leppin and Andreas Lindner (eds.), Tübingen 2007.

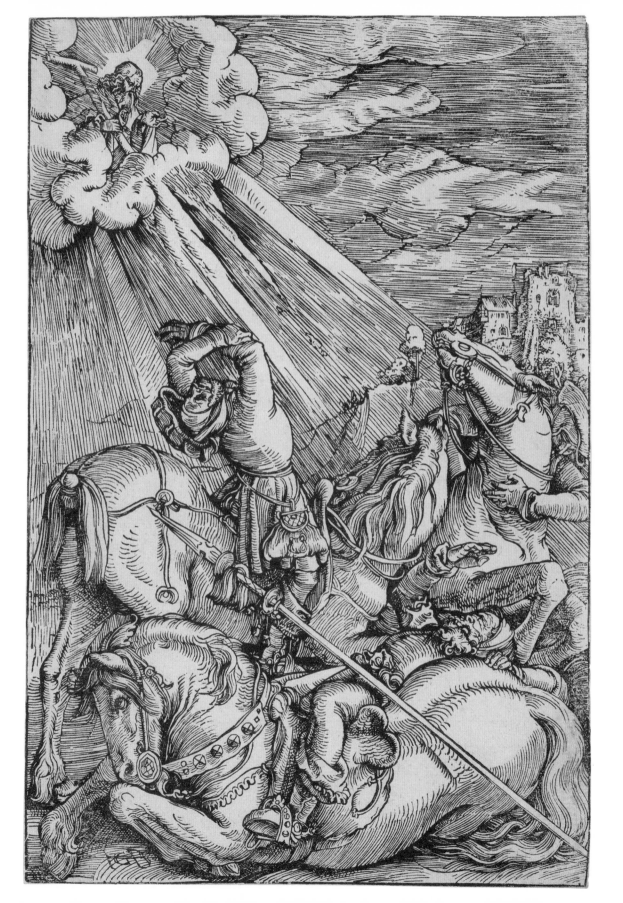

'MY SIN LAY HEAVY, NIGHT AND DAY.'

WA 35, 423; LW 53, 218

During his time in the monastery, Luther underwent a personal crisis. He perceived himself as a sinner, a hopelessly flawed individual. His excessive praying, confessing and fasting were noticed by his fellow monks, as were his intensive reading of the Bible and his relentless struggle to find the God of grace. The terrifying vision of a merciless Christ plagued him for a long time. The routes to salvation offered by the Church – especially the veneration of the saints and the sacrament of penance – were of no help, indeed they plunged him ever deeper into despair. The radical nature of his existential quest for the right penance paved the way for his challenging of the system of indulgences and, more generally, his development as a theologian.

LUTHER'S ENCOUNTERS WITH THE PRACTICE OF INDULGENCES BEFORE 1517

HARTMUT KÜHNE

Luther was a prophet aroused by God at the end of times to tear the mask from the face of the Pope seated on the Chair of St Peter, to reveal him as the Antichrist and, through the proclamation of the rediscovered Gospel, to give the world a last chance to return to God before the Last Judgement. This is how Luther's friends and students understood the great reformer's attack on indulgences. Luther himself frequently described his path as that of a simple man who blundered blindly and unwittingly into matters pertaining to the fate of the world. Looking back, he recalled that his public confrontation with indulgences came

about when many people from Wittenberg were going to Jüterborg and Zerbst to hear the indulgence preaching of Johann Tetzel, a great 'ranter' (WA 51, 539; LW 41, 231).

Luther reports that Tetzel was preaching dreadful and abominable things, including that he had saved more souls with his indulgences than St Peter with his preaching and that he could even grant forgiveness to someone who raped the Virgin Mary, as long as they put the necessary sum in the indulgence box. Luther began to preach against this, saying that people could do something better and more reliable than buying indulgences. He urged Tetzel's employer, the Archbishop of Magdeburg, to put a stop to the activities of the indulgence preacher. Receiving no reply from the bishop, he published his 95 Theses, which 'went throughout the whole of Germany in a fortnight' (WA 51, 540; LW 41, 234). Thus Luther became famous, although 'I did not want the fame, because (as I have said) I did not myself know what the indulgences were' (WA 51, 541; LW 41, 234).

Similar personal testimonies arise frequently in the final years of Luther's life. On closer investigation, the account of Luther's provocation by Johann Tetzel's extreme interpretation of papal indulgences raises questions. Since the publication of Nikolaus Paulus's seminal work on Tetzel in 1899, the notion that Tetzel was a blatant propagandist, whose intellectual dullness was coupled with an unscrupulous business sense and moral turpitude, has been re-evaluated. Researchers are also now clear that neither the doctrine of indulgences advocated by Tetzel nor the practice of the indulgence campaigns, which Luther encountered in 1517 in Electoral Saxony, were surprising or scandalous innovations. During the latter part of the Middle Ages indulgences had become a ubiquitous phenomenon that permeated all areas of public and personal religion in a variety of forms. Hence the claim sometimes made that Luther's indulgence debate was a secondary matter which sparked the Reformation more or less coincidentally is misleading. Indulgences were of central importance in religious practice, and the question regarding Luther's specific encounters with indulgences before 1517 warrants further examination.

In 1497, at the consecration of two altars in the church of St George in Mansfeld, the suffragan bishop of Halberstadt granted indulgence to all those who would hear mass at the altars in the future. This event took place shortly before Luther left Mansfeld to attend school in Magdeburg. In addition to naming the priest, a list on the back of the certificate included the town's dignitaries who had requested the indulgence, among them Hans Luder, Martin's father

This document illustrates the indulgence in its simplest and earliest form – as a reduction in punishment granted by a bishop. It was measured in days, since it originally involved reducing the number of fast days. Someone who attended a church on particular feast days and extended a helping

hand in support of its construction or furnishings could usually count this as equivalent to a 40-day fast. This form of relief from punishment, originally practised by Spanish bishops, spread throughout Latin Christendom following the canonical regulation of the Fourth Lateran Council (1215).

However, indulgences soon also became understood as a means to reduce canonical penalties after death. This was based on the idea of Purgatory as a place of punishment beyond the bounds of this world, which became generally accepted in the thirteenth century. Purgatory gave penitent Christians the prospect of rectifying in the after-life penances they may not have completed during their earthly life. This transformation in the way the system of indulgences worked had been fully implemented by 1300 at the latest. However, the episcopal indulgences measured in days now seemed inadequate in the face of Purgatory. Accordingly, there was an attempt to increase the modest indulgences by accumulation, until Pope Boniface VIII (1235–1303) proclaimed the first Holy Year in 1300 and granted plenary (full) indulgence to all those who visited Rome. Even after the Jubilee of 1300, which soon came to be celebrated every 50 years and then every 25 years, bishops continued to grant their modest indulgences for attending church and supporting religious works. By around 1500 these still accounted for the majority of indulgences.

Luther encountered indulgences in another form when he moved to Magdeburg at the age of 14. Twice a year a great display of relics was held at the cathedral there – at the time it was the most important indulgence festival in Central Germany. It was established under the pontificate (1389–1404) of Pope Boniface IX, who for the first time munificently granted other churches 'large' indulgences, which had previously only been obtainable in Rome. Thus the important Roman indulgences were 'exported' to every part of Europe and could now be purchased there. This also happened in Magdeburg, albeit in a curious way: the indulgence was calculated on the basis of the number of relics displayed during the festival. At the time when Luther was attending school in Magdeburg, there were 7,118 relics in total. This sum was multiplied by the seven years granted by Boniface IX, resulting in an indulgence of 49,826 years. The Magdeburg indulgence was also the model for the festivals of relics which Luther later encountered at the All Saints Foundation in Wittenberg and Cardinal Albrecht's Collegiate Church in Halle.

As a young student in Erfurt Luther must also have come to know what was the latest and most comprehensive form of indulgence preaching at the time and later gave rise to his 95 Theses: the indulgence campaign. In the autumn of 1502 Raimund Peraudi, who had perfected this form of indulgence and was responsible for organising it on a large scale for the first time, visited Erfurt. Seen as a pious and impeccable cardinal, he had

several times been commissioned by the Popes to preach indulgences in France and Germany and thereby raise funds for a crusade against the advancing Ottoman threat. He had sought to increase the potential of indulgences: pardon would benefit the living and the dead equally, the penitents' route to obtaining pardon was made easier, confessors were granted special powers, and the use of printed confessional privileges meant the graces of pardon could be privatised and assured for the future. Every subsequent commissioner of indulgences, right up to Johann Tetzel, implemented the concept developed by Peraudi. The proclamation of the jubilee indulgence temporarily transformed the cities of the empire into a simulacrum of Rome and galvanised the clergy to commit themselves to the ministry of this grace. Peraudi's most zealous collaborator when it came to indulgence preaching, the Augustinian monk Johann von Paltz, was then living in the monastery which Luther would join in 1505.

It is not known whether Luther had himself purchased the jubilee indulgence three years earlier. It seems odd that he never subsequently mentioned Peraudi's name. However, what is known is that Luther did benefit from a confessional letter. Under military pressure from the Grand Prince of Moscow in Livonia, the Teutonic Knights had obtained the right from the Roman Curia to hold an indulgence campaign in order to raise money for arms. Since 1504 the jubilee indulgence had been preached in various parts of the empire by the Knights' indulgence commissioners, among them the Dominican Johann Tetzel. When this indulgence was also preached in Erfurt in 1508, the Augustinian monastery acquired a confessional letter which listed the names of all 52 members of the order there, including Martin Luther.

Other leads may be pursued in the exploration of Luther's experience of the practice of indulgences, for example during his visit to Rome in 1511 or after he entered the Wittenberg monastery in 1512. However, this is probably superfluous, as it is clear that Luther would have been familiar with indulgence in all its shapes and forms and all the opportunities and threats it offered from his time in Erfurt at least: he had no need for the sermons of Johann Tetzel, which he apparently never heard in any case.

Luther's confrontation with indulgences arose from his experiences with his wounded conscience as a monk and his intellectual wrestling as a theologian interpreting the Bible. The existential experiences which played a role in this, the theological ideas he absorbed, the course of his internal development and the way his spiritual identity was shaped are subjects which have been addressed intensively by theologians and historians for 150 years, without any conclusive answers being reached. However, his theological questioning of indulgences as he sought certainty of spiritual salvation was not a one-off occurrence, as the later Luther 'vocation narrative' suggests. His challenging of indulgences had certainly begun before

1517 – indeed, one historical source suggests that Luther came across the St Peter's indulgence preached by Tetzel in Wurzen as early as 1516.

The doubts about the value of indulgences, which Luther expressed in 1517 as a result of his existential experiences and intellectual endeavours, would lead with extraordinary speed to the collapse of the whole system of the late mediaeval economy of salvation. The declining acceptance of indulgence-granting guaranteed by the Pope swiftly developed into a fundamental crisis of confidence in the Church hierarchy and conventional forms of religious practice. The Reformation's attack on indulgences discredited the historical phenomenon in its entirety. For a long time the fact that, in essence, indulgence was intended to provide solace in the face of mortal fear, an easing of the burden of conscience and enhancement of Christian life was no longer recognised. In a sense, the Reformation's revelation of grace freely given responded to precisely this concern. Thus, to adopt a long-term perspective, the way in which indulgence made an ever greater contribution to grace 'nearly' granted is closely linked to the Reformation's revelation of grace 'fully' granted. This analogy was recently clearly identified for the first time by Protestant church historian Berndt Hamm. The question is whether this insight will build bridges where the confessional view of the prophet Martin Luther created divisions.

ALMS BOX

EARLY 16TH CENTURY WOOD 28 × 18 × 39 CM
EVANGELISCHES LANDESKIRCHLICHES ARCHIV IN
BERLIN, DEPOSITUM DER KIRCHENGEMEINDE DALLMIN

The giving of offerings or alms, in the form of money or natural materials (often wax or flax), was part and parcel of churchgoing in the late Middle Ages. As testified by many accounts, in addition to serving a specific purpose, such donations were also intended to have an effect on the donor's prospects in the next life. Thus the standard wording in all letters of indulgence distributed to church attendees required that the recipient would 'not close his helping hand' but would contribute to the construction and upkeep of the church. Similarly, the performance of (or the failure to carry out) the 'seven works of mercy' relating to judgement in the hereafter, alluded to in Matthew 25:34–46, was presented to the faithful in visually powerful paintings and prints. This was something that the young Martin Luther would certainly have taken for granted.

Offerings were collected using various receptacles at several locations in the parish church and were used for a variety of purposes. Money could be deposited in securely sealed alms boxes or chests, placed on the altar during Mass or in the vestment of the priest who was celebrating the Mass, or tossed into portable collection boxes. In parish churches, the money accrued as parish income or was used for 'church construction' (*fabrica ecclesiæ*). Such money constituted a special fund that was managed by lay people, the 'church administrators', and used to construct and maintain the church and pay for liturgical equipment and lighting, for example. Added to this were special temporary collections known in German as *Botschaften* (lit. messages) held for the benefit of spiritual institutions, such as the Hospital Brothers of St Anthony. The distribution of offerings and the advantageous positioning of the collection boxes inside the church often gave rise to conflicts among the beneficiaries and thus required clear agreement.

The type of collection receptacle shown here is usually described as an 'alms box' or 'poor box'. It consists of a flat wooden drawer, half of which is fitted with a thin cover, under which the inserted coins slide if the dish is held at a slight angle, thus preventing the money from slipping out or being removed by an unauthorised party. An upright screen decorated with painted religious figures carved in relief borders the back edge. Its purpose was to make it clear that, as patrons of the Church, these religious figures were the real recipients of the donations. There is a wooden handle at the back, which was used to carry the box around. This particular receptacle was occasionally referred to as a *Rippenstößer* in German, due to the propensity of collectors to gently poke potential donors in the ribs to encourage them to contribute. It was used mainly by lay people, such as church administrators, but also by other groups authorised to collect alms, including the sick. The fact that such boxes occasionally remained in use even after the Reformation is illustrated by the example shown here. It was used until recently as a collection box in the village church of Dallmin in Brandenburg, where it was securely mounted using modern metal loops. Hartmut Kühne

→ Further reading

Martin Illi: Begräbnis, Verdammung und Erlösung. Das Fegefeuer im Spiegel von Bestattungsriten, in: *Himmel, Hölle, Fegefeuer. Das Jenseits im Mittelalter*, Peter Jezler (ed.), catalogue to the exhibition of the same name, Zurich 1994, 59–68.

Tim Lorentzen: Almosenbretter, Opferstöcke und Gemeine Kästen. Quellen zur Armenfürsorge vor und nach der Reformation, in: *Luthers Lebenswelten*, Harald Meller, Stefan Rhein and Hans Georg Stephan (eds.), Halle 2008, 369–376.

Hartmut Kühne: Sammeltafel, in: *Alltag und Frömmigkeit am Vorabend der Reformation in Mitteldeutschland*, Hartmut Kühne, Enno Bünz and Thomas T. Müller (eds.), catalogue to the exhibition *Umsonst ist der Tod*, Petersberg 2013, 243–244.

CRUTCH

VOTIVE OFFERING IN THE STIFTSKIRCHE CHEMNITZ-EBERSDORF

NOT LATER THAN 1530 WOOD 123 × 6 CM
EVANGELISCH-LUTHERISCHE STIFTSKIR-
CHENGEMEINDE CHEMNITZ-EBERSDORF

The practice of leaving votive objects as religious thank-offerings was widespread around 1500. The images, often made out of wax in the form of 'your afflicted legs, arms, eyes, head, feet, hands', as they were described by Andreas Bodenstein von Karlstadt in his treatise *On the Removal of Idols* (1522), would have been familiar to Luther from an early age. In the past supernatural explanations of votive objects as magical images were common, or they were interpreted as religious bartering with the gods, but in modern scholarship they have come to be understood as symbolic objects, figurative expressions through which people placed themselves under the protection of a patron. The public offering of a symbolic item represented a legally binding statement of trust in a divine power. The gift itself reflected the social position and wealth of the donor.

This crutch is held in the Collegiate Church of Chemnitz-Ebersdorf, originally a village parish church under the patronage of the manor of Lichtenwalde, which lay on the busy route from Rochlitz to Bohemia. The church developed into a regionally significant place of Marian pilgrimage in around 1400, as evidenced by the monumental new church erected in the early fifteenth century. At the beginning of the sixteenth century there were eight stipendiary clergy at the church. Whether the focus of the pilgrimage was a miraculous image of the Virgin Mary, as is often claimed, remains unclear. The church enjoyed the support of the Wettins. In 1421 Katharina, the wife of Margrave and later Elector Friedrich I (the Belligerent), visited the church; a surviving altarpiece depicts what is probably the princely couple as benefactors. Their son, Elector Friedrich II, requested indulgences from the Roman curia in 1435 and 1437 for visiting the church, thus highlighting its hostile position towards the Hussite 'heretics' and emphasising the miracles which had taken place there. In 1455, after the Wettin Princes Ernst and Albrecht had been liberated following their kidnap by Kunz von Kaufungen, the Elector and his wife Margaretha visited the Marian church to give thanks that their children had been saved and endowed a Marian altar. They also left clothing belonging to the princes as votive offerings, and these are still on display in the church today.

Another votive offering, donated to the church in the first half of the fifteenth century, is an exceptionally accurate replica of a northern European sea-going ship. Visitors to the church can still see the only surviving mediaeval model ship from inland Europe.

It appears that in the early nineteenth century the offerings also included 'a quantity of crutches', but this is the only one that survives. It bears the inscription: 'CRUTCH.YOU.ARE.OUT.OF.LUCK. / CRUTCH.YOU.ARE. MOST.UNLUCKY. / UNLUCKILY.FOR.ME.I.HAVE.A.FINE.CRUTCH / ODHLATHL. INRI 1530'. Local legend has it that the crutch was left here by a teacher after he invoked the Virgin Mary and his leg ailment was healed.

Hartmut Kühne

→ Further reading
Wolfgang Brückner: Volkstümliche Denkstrukturen und hochschichtliches Weltbild im Votivwesen, in: *Schweizerisches Archiv für Volkskunde* 59 (1963), 186–203 (reprinted in: idem: *Kulturtechniken. Nonverbale Kommunikation, Rechtssymbolik, Religio carnalis*, Würzburg 2000, 13–29).
Lenz Kriss-Rettenbeck: *Ex voto. Zeichen, Bild und Abbild im christlichen Votivbrauchtum*, Zurich 1972.
Kathrin Iselt: 'Feria sexta postquam Martini venit domina ad cenam, do sy geyn Ebersdorff czouch …'. Quellen und Legenden zur Wallfahrtsgeschichte der Ebersdorfer Stiftskirche, in: *Wallfahrt und Reformation. Zur Veränderung religiöser Praxis in Deutschland und Böhmen in den Umbrüchen der Frühen Neuzeit*, Jan Hrdina, Hartmut Kühne and Thomas T. Müller (eds.), Frankfurt am Main 2007, 184–199.

GEORG SPALATIN WITTENBERG RELIQUARY BOOK

PRINTER: SYMPHORIAN REINHART, WITTENBERG
WOODCUTS: LUCAS CRANACH THE ELDER

1509 SECOND EDITION LETTERPRESS AND WOODCUT
ON PARCHMENT 21 ×14.5 CM
EVANGELISCHES PREDIGERSEMINAR WITTENBERG

Mediaeval Church doctrine taught that through their good works the saints had accumulated treasure in Heaven, on which the Church could draw to mitigate the suffering of penitent sinners in Purgatory. In the central German area, the possession of relics of the saints was particularly closely linked to indulgences, and in the early sixteenth-century they played a major role in the quest for assurance of salvation. Luther was familiar with the veneration of relics from an early age. He experienced the impact of this means of salvation particularly intensely in Wittenberg, as it was there in the All Saints' Foundation that Friedrich the Wise kept his vast hoard of relics, which was displayed in public once a year. This event took place at the Castle Church, where construction began in 1496, and considerably enhanced the castle's prestige as a seat of the Saxon electors.

The annual celebration of the feast of relics and indulgences on the Monday following *Misericordias Domini*, the second Sunday after Easter, demonstrated the growing religious importance of the All Saints' Foundation. On 17 January 1503, after consecrating the still unfinished building of the Foundation's church, the papal legate Raimund Peraudi granted all those attending an indulgence of 100 days for each fragment of relic on display. This linking of indulgences to numbers of relics followed a pattern set earlier at Magdeburg Cathedral, where a similar indulgence had been declared. The Saxon electoral court had engaged in protracted negotiations with the curia in Rome to increase the Wittenberg indulgence, and this was finally granted in 1519.

Although construction of the church was still in progress, the feast of relics had already taken place, albeit in an improvised form, in 1504. Evidence shows that it became an annual event on completion of the building in 1506. From 1507, Friedrich the Wise pursued a particularly active acquisitions policy, and by 1520 the number of relics had reached a total of 18,790 fragments. According to its colophon, probably printed in 1509, the second edition of the *Wittenberg Reliquary Book* comprises images and text detailing 5,005 relic fragments preserved in 117 reliquaries. These were displayed to the public on the *Heiltumsstuhl*, a temporary wooden platform erected in front of All Saints' Church, in a series of eight ceremonial processions.

Printing of the edition shown here was entrusted to Symphorian Reinhart, originally from Strasbourg, who also worked as a wood block carver in the Cranach workshop. Reinhart also produced the woodcuts of the various reliquaries. The sequence of reliquaries and relics in the book mirrors their position in the eight processions of the annual ceremonial display. In a kind of hierarchy of salvation, they are arranged in ascending order – beginning with holy virgins and widows, moving on to the ranks of holy 'confessors', ecclesiastical figures, martyrs and apostles, and culminating in the relics of Christ, including a particularly precious relic of the Passion, a fragment of the Crown of Thorns, a gift to Duke Rudolf I from the Sainte-Chapelle in Paris. The indulgences that could be earned by attending the presentation of the relics are listed at the end of the book. Hartmut Kühne

→ Further reading

Hartmut Kühne: *Ostensio reliquiarum. Untersuchungen über Entstehung, Ausbreitung, Gestalt und Funktion der Heiltumsweisungen im römisch-deutschen Regnum (Arbeiten zur Kirchengeschichte* 65), Berlin and New York 2000, 400–423.
Livia Cardenas: *Friedrich der Weise und das Wittenberger Heiltumsbuch. Mediale Repräsentation zwischen Mittelalter und Neuzeit*, Berlin 2002.
Thomas Lang: '1 gülden 3 groschen aufs Heyltum geopfert'. Fürstliche Rechnungen als Quellen zur Frömmigkeitsgeschichte, in: *Alltag und Frömmigkeit am Vorabend der Reformation in Mitteldeutschland (Schriften zur sächsischen Geschichte und Volkskunde* 50)
Enno Bünz and Hartmut Kühne (ed.), publication to accompany the exhibition *Umsonst ist der Tod*, Leipzig 2015, 81–148, here 129–132, 135–142.

ablas in zaigung des hailigthumbs zu einem yeden gang hundert tag
Vnd von einem yeden stuck oder particfel desselben der vber etlich taus
sent seint hundert tag aplas geben Es mag auch ein yeder mensch/ der
die Stifftkirchen besucht mit seinem ynnigen gebet vnd von den altarien
ainem yeden ainen mercklichen aplas verdienen So ist auch die vilbe
melt kirchen mit dem aplas vergebung peyn vnd schuld so zu Assias
da sant Franciscus leyblich rastet des ersten tags Augusti yn der Capeln
sant Marien de angelis Jerlich ist zwen tag vor vnd noch allerheilige
tag von dem babst Bonifacio dem newnten gnedigklich begabt vnd
versehen Welcher aplas an wenige orten dan zu Assias vn diser kirche
besunden Das allen frumen christen menschen zu besserung yres lebens
Vnd merung yrer seligkait. nit hat sollen verborgen sein noch bleiben
Vnd volgt die zaigung des hailigthumbs diser mass vnd gestalt.

Der erst gang In welchem angezaigt wirdt das wirdig hailigthumbs von Jungfrawen vnd Witwen

Erstlich wirt hie
gezaigt

Ein glaß Sante Elysabeth
Eyn particfel von yrem mantel
Eyn particfel von yrem kleyd
Ein particfel von yren haren
Viij andre particfel yres hailigen
gebeins.
Zwen zehn von der haligen Eliza=
beth.

Süma riiij particfel

Zum andern Eyn prillen

Glaß mit einer zubrochen cristallein Döck
Von sant Veronica witwe .j. particfel
Von sant Justine .j. zahn
Von sant Erendrudis .j. zahn
Von sant Ludimilla .iiij. particfel
Von sant Ludimille arm ein particfel
Von den haren sant hediwigis ein particfel ein
Eptissin gewest zu Trebenitz Von yrem ge
beyn .vij. partic. Ein groß particfel. von yrem
arm Von yrem gebirn .j. particfel Von
yrem haubt ein particfel
Zwey particfel auß der gesellschafft Sant Affre
Ein particfel sante Digne eine auß der gesell
schafft sant Affre
Vß der sewl sant Affre doran sie gemartert.j. pti.
Von dem gebeyn sant Affre .ij. particfel
Von sant Hylaria ein muter sant affre iiij. pti.
Vn sant Gereonis ei königin gewest zu Cipria
Süma. xxviij.

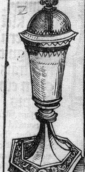

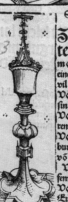

Zum drit ten ei klei

m onsfrantz mitt
einer Brillen mit
vil ecken
Von sant Eufro
sina .j. particfel
Von sant Emes
rentiana .j. part.
Von sant Not
burgis .j. partic.
vß sant Tecla j. pt
Von santt Eu
semia .j. particfel
Vom heupt sant
Eufemia .j. ptic.
Süma .vj. ptic.

Zum.iiij.

Ein kleyn silber
vbergult mon
sträz mit einer
vbergulten rose
vn rüden brille
vß sant sophia
witwe j. pti. vß
sät sophia sück
sio wn merte
rin j pti. vß sät
benigna .j. pti.
vß sät spe.j. pti.
von sant grego
ria .j. pti. Von
sät leynina.j. p
vß sant wendes
lina .y. pti. von
sät beatrice j. pt

Ein zahn sant Beatricis Süma.r. ptic.

RELIQUARY OF SAINTS COSMAS AND DAMIAN

EARLY 15TH CENTURY ROCK CRYSTAL, SILVER, GILDED, EMBOSSED,
ENGRAVED, CAST, GLAZED HEIGHT 44.4 CM
MUSEO NAZIONALE DEL BARGELLO, FLORENCE

In 1507 Elector Friedrich the Wise started to amass a vast number of relics for his collection, the 'Wittenberger Heiltum', which had already been started by the Ascanians in the late Middle Ages and ultimately amounted to some 19,000 items. According to mediaeval beliefs, even in death the saints remained connected to their earthly bodies; their relics thus created a conduit of sorts between this world and the heavenly realms. In the conviction that the saints could come to their aid and intercede on their behalf, the faithful sought to achieve the greatest possible proximity to any vestiges of the saints' earthly lives. On the basis that a saint's power was similarly present in every item associated with them, no objection was raised to the practice of dividing a relic into a number of pieces, which could be displayed and venerated in various locations. These pieces were kept in containers whose elaborate, costly construction underlined the value of the relics held in them.

From 1517 onwards, during the indulgences controversy, Luther also singled out collections of relics for criticism. Although relics from the saints had previously long served Luther as a means to seek help in his quest for salvation, he now viewed any relic as a mere 'dead thing', not worthy of veneration (WA 30 I, 145). In his view living Christians were the true saints. Luther's influence was such that the public display of relics from Friedrich the Wise's collection ceased on 26 April 1522. But it was only after Friedrich's death in 1525, when he was succeeded by his brother Johann the Constant, that almost all these precious items were secretly broken up in Torgau and sold for their material value between 1526 and 1528, and the relics disposed of. A drinking glass, reputedly once owned by St Elizabeth and the only item known for sure to have escaped destruction, ultimately found its way into Luther's household, where it was passed around to the guests at his dining table.

The only records of the 174 reliquaries that Friedrich the Wise had collected by 1518 are found in the surviving copies of a catalogue of the collection, the *Wittenberger Heiltumsbuch*, and in 83 drawings by various artists, which convey a relatively detailed impression of these treasures. These records include an illustration of a rock-crystal reliquary that is strikingly similar to an item now held in the Cappelle Medicee in Florence. In each case the reliquary has a body and lid made from rock crystal, a decorative top and two side handles in the shape of stylised dragons, whose tails end in a spiral. The reliquary now in Florence, which was presumably made in the workshop of a Venetian goldsmith and originally contained the relics of other saints, was given by Pope Clement VII to the Basilica di San Lorenzo in Florence in 1532, that is to say, shortly after the Wittenberg collection of reliquaries was dissolved, with some items seemingly surviving unscathed and being secretly sold. It was only later that relics from Saints Cosmas and Damian were placed in this reliquary, probably in 1785, when it was transferred to the Cappelle Medicee. Mirko Gutjahr

→ Further reading
Livia Cardenas: *Friedrich der Weise und das Wittenberger Heiltumsbuch. Mediale Repräsentation zwischen Mittelalter und Neuzeit*, Berlin 2002.
'*Ich armer sundiger mensch'. Heiligen- und Reliquienkult am Übergang zum konfessionellen Zeitalter*, Andreas Tacke (ed.), Göttingen 2006.
Elisabetta Nardinocchi: Reliquiario di Santi Cosma e Damiano, in: *Nello splendore mediceo. Papa Leone X e Firenze* Nicoletta Baldini and Monica Bietti (ed.), Florence 2013 552, no. 100.

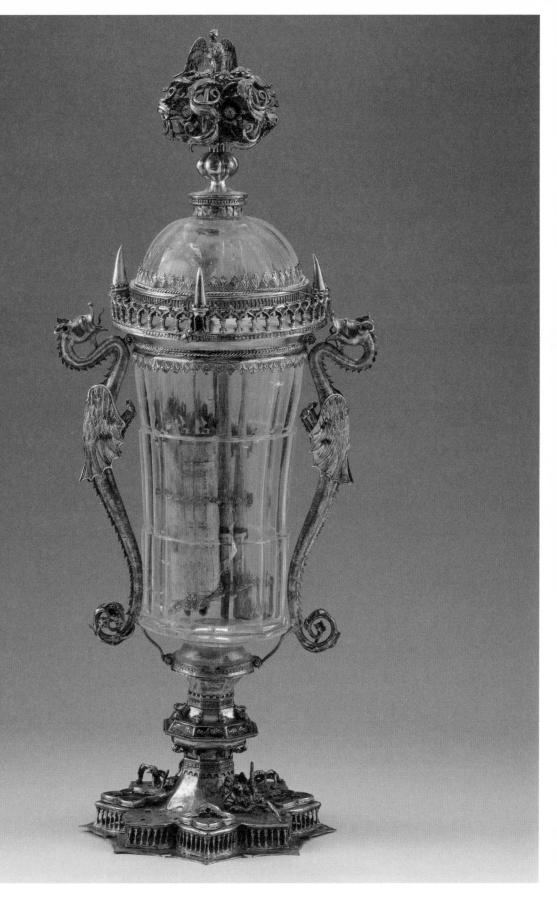

40 FIGURES OF THE CHRIST CHILD

FIRST HALF OF THE 16ᵀᴴ CENTURY EARTHENWARE, WHITE MAX. HEIGHT 13 CM
STADTARCHÄOLOGIE, KUNSTSAMMLUNGEN UND MUSEEN AUGSBURG

In 1500 the world was informed by devout religious beliefs, which extended to the most humble sections of the population. The increasing participation of the laity in ecclesiastical and non-ecclesiastical religious practice was accompanied by a deeply felt individual faith that prompted many Christians to take the initiative and dedicate themselves to looking after the own salvation. At the same time, there was a greater need to demonstrate the presence of the divine in the world. This manifested itself in the pilgrimage tradition, widespread veneration of the saints, and a stronger belief in relics and miracles. Pictures, statues and figurines also became more important as the focus of individual devotion.

Luther's Reformation theology evolved from the Christian piety of the late Middle Ages, which sought to gain personal access to Christ through His suffering on the cross. At the same time, however, the image of a stern, judgemental Christ prevailed among ordinary people. This was a figure that generated fear among the faithful and led them to seek advocates among the saints who appeared to be closer to the people. Luther also grew up with the forbidding figure of Christ, which led him to turn initially to intermediaries such as Mary, the Mother of God, or the saints Anne and Thomas, in times of need.

The figure of the Christ Child, which emphasised the human rather than the divine nature of the Redeemer, could put the fear of Christ into perspective and therefore enjoyed growing popularity in the late Middle Ages. Individual portraits of the Infant Jesus existed from around 1300 and played a role in private devotion, initially mainly as part of women's mysticism in convents but later also in bourgeois homes. The figures were also incorporated into liturgical games, in particular the *Christkindwiegen* tradition at Christmas, when the Baby Jesus was rocked in His cradle.

To meet local demand, clay figures such as those shown here were produced in great quantities by *Bilderbäcker* (figurine potters) in specialised potteries. The rubbish pit of a potter at Kitzenmarkt 11 in Augsburg, which was excavated as part of an archaeological study between 1998 and 2001, provides a good insight into what was produced. Representations of the Infant Jesus accounted for the majority (40 percent) of the 1,500 clay figures buried here since the first half of the sixteenth century. The extensive variants are all based on a standard version of a standing Christ Child, who holds a globe in one hand as a sign of sovereignty and raises the other hand in a gesture of benediction. As a result of repeated casting to produce copies, however, details became less clear and were retrospectively re-interpreted. Thus the globe could be transformed into a dove, for example, or the gesture of benediction changed into a flower held in the hand. Mirko Gutjahr

→ Further reading

Michaela Hermann: Neues von den Augsburger 'Bilderbäckern', in: *Knasterkopf 17* (2004), 27–40.

Berndt Hamm: *Religiosität im späten Mittelalter. Spannungspole, Neuaufbrüche, Normierungen*, Tübingen 2011, 516–518.

Hartmut Kühne: Tonfigürchen mit christlichen Motiven, in: *Alltag und Frömmigkeit am Vorabend der Reformation in Mitteldeutschland*, Hartmut Kühne, Enno Bünz and Thomas T. Müller (eds.), catalogue to the exhibition *Umsonst ist der Tod*, Petersberg 2013, 334–344.

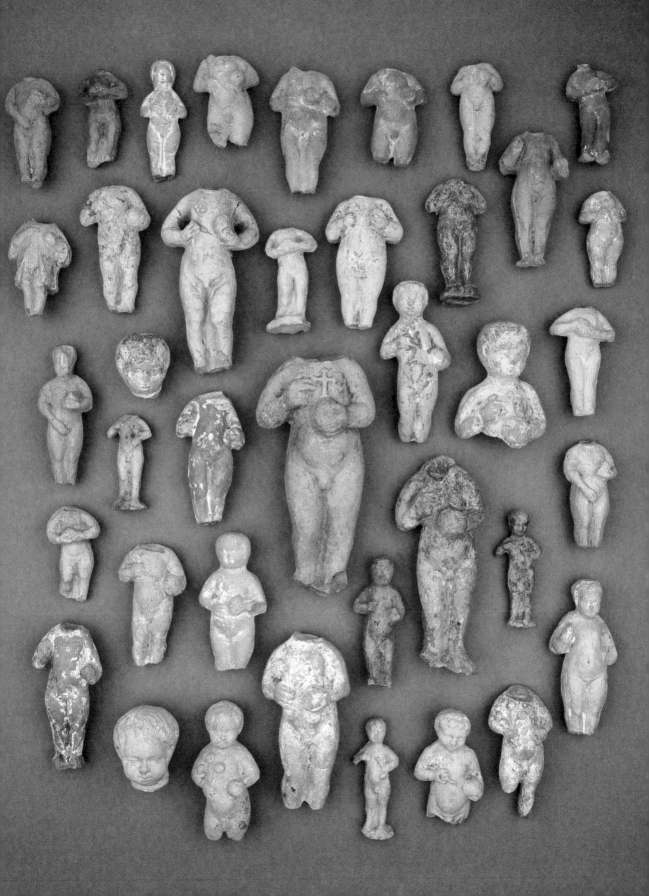

ST ANNE WITH THE VIRGIN AND CHILD

C.1520 WOOD, PAINTED IN POLYCHROME 110 × 70 × 38 CM
EIGENTUM DES LANDES SACHSEN-ANHALT, LANDESVERWALTUNGSAMT,
DOKUMENTATIONSSTELLE ZUR ERFASSUNG VON KULTURVERMÖGEN, IN
BESITZ DES FÖRDERVEREINS SCHLOSS MANSFELD E. V.

'St Anne, save me and I will become a monk' (WA TR 4, Nr. 4707, 440) – with these words Luther called on St Anne for assistance in 1505 when he felt himself in mortal danger during a thunderstorm on his way to Erfurt. The vow that Luther made in Stotternheim is one of the most famous milestones in the reformer's life. He spoke about this event 34 years later in his table talk, leaving a lasting impression on his audience. At that time, he was completely consumed by a conventional faith and on a dangerous path which he later identified as the wrong one.

In his distress, he turned to a helper who had been elevated to the status of sainthood in the late Middle Ages; Pope Sixtus IV played a key role in promoting her veneration in 1481 by including her in the Roman calendar of saints. Her legend was spread in a variety of printed materials in the fifteenth and sixteenth centuries, although – as Luther later stressed on several occasions – the Bible does not mention anything about her. Anne had also become important in mining regions: as the mother of Mary she nurtured in her womb a treasure whom the miners considered equally precious to the treasures they sought deep in the earth. In 1538 Luther recalled the rise of the cult of St Anne. Confraternities were established and churches were consecrated in her name. Mines, pits and even towns were named after her: the town of Annaberg in the Ore Mountains is just one example. As Luther saw it, this was all done solely in the hope that St Anne would generate wealth: 'As I recall it, the big event of St Anne's arrival happened when I was a boy of fifteen. Before that, nobody knew anything about her; then a fellow came and brought St Anne. She caught on right away and everyone was paying attention to her. The splendid town and church of St Annaberg were built in her honour, and anyone who wanted to be rich took St Anne as their patron' (WA 47, 383). The saint is a constant theme in Luther's recollections: he said that when he was in the monastery he preferred to hear about Anne than about Christ (WA 41, 653–654) and that the pictures of Anne would not only deprive the faithful of their money but also of their souls (WA 16, 440).

Doubts were occasionally expressed about Luther's experience in Stotternheim, however: the reformer had direct experience of the intense veneration of Anne in and around Mansfeld. Statues and reliefs also testify to the devotion to Christ's grandmother and at least two depictions of Anne can be found on the altar retables in St George's Church in Mansfeld alone. However, the *St Anne with the Virgin and Child* in Mansfeld's Castle Church can only be traced back there to 1907. Sitting in St Anne's lap are her daughter Mary and the Infant Jesus, who playfully grabs His grandmother's veil. While Mary holds out her arms to the Son of God, Anne gazes calmly and seriously at Him. The depiction of the Virgin and Christ Child with St Anne is one of the most frequently occurring themes of devotional paintings in the late Middle Ages. They also form the core group of the Holy Kinship, which, in addition to Joachim, Mary's father, also includes the two men whom Anne is said to have married following Joachim's death, and their offspring. Susanne Wegmann

→ Further reading

Angelika Dörfler-Dierken: *Die Verehrung der heiligen Anna in Spätmittelalter und früher Neuzeit*, Göttingen 1992.
Andreas Hornemann: Zeugnisse der spätmittelalterlichen Annenverehrung im Mansfelder Land, in: *Martin Luther und der Bergbau im Mansfelder Land*. Rosemarie Knape (ed.), Eisleben 2000, 307–325.
Jennifer Walshe: *The Cult of St Anne in Medieval and Early Modern Europe*, Abingdon and New York 2017

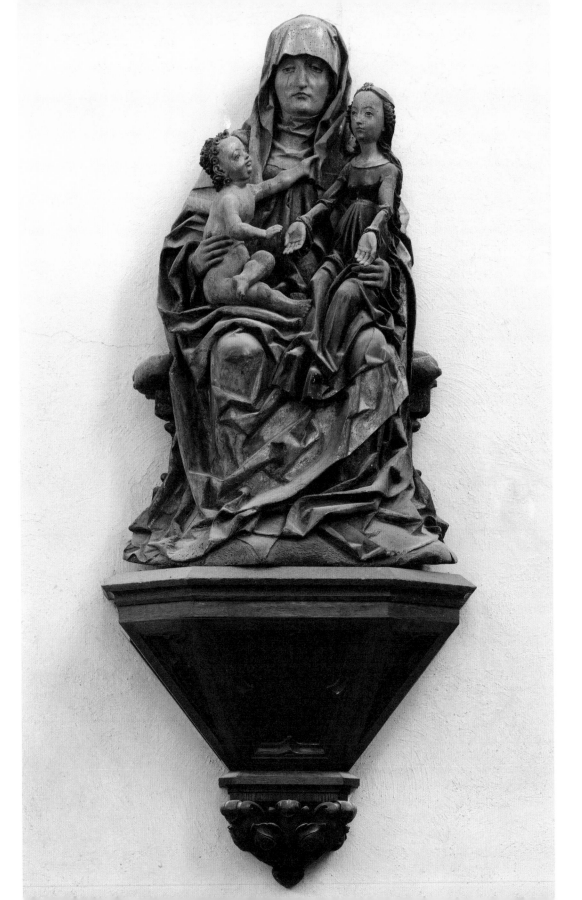

VIRGIN OF MERCY

C.1470 ULM LIMEWOOD, PAINTED AND GILDED 115 × 64 × 29 CM
STIFTUNG SAMMLUNG E. G. BÜHRLE, ZURICH

The youthful Virgin Mary holds the naked infant Jesus in her hands, displaying the Son of God made flesh, who looks to the viewer and raises His hand in blessing. To either side of the Mother of God, angels hold up the sides of her cloak, revealing human beings at prayer. On her right a pope is leading a group of men; a secular ruler gazes upward, next to him and behind them both are representatives of different clerical and secular groups. The women on Mary's left are also differentiated according to class: furthest forward a crowned monarch has her hands raised in prayer, behind her there are richer women, older and younger women, with and without covered heads. All of humankind finds shelter under the cloak of the Madonna. The possibility of seeking protection under the cloak of a superior individual had been enshrined in law since the early Middle Ages. Individuals of high rank – particularly women – could thus intercede on behalf of those in need of protection. The veneration of Mary as the mother of all people – *mater omnium* – dates back to the twelfth century. At the same time the Virgin of Mercy also represents *ecclesia*, the church, which graciously accepts the faithful into its community. Initially this version of Marian veneration was particularly promoted by the Cistercians. Caesarius of Heisterbach, a Cistercian prior, had a vision of monks gathered under the Virgin Mary's cloak. Luther associated the same legend with St Francis but changed it to fit the Franciscans' belief that they had reached such a state of perfection as to no longer need protection under Mary's cloak: 'St Francis dreamt that he entered Heaven, and Mary raised up her cloak, but he found none of his Brothers there. Since he was very shocked at this … Mary said to him: your Brothers have reached a greater degree of perfection than the others, therefore they no longer belong under this cloak' (WA 47, 276). In the late Middle Ages the image of the Mother of God protecting humankind under her cloak was particularly favoured by the Dominicans.

Luther vehemently repudiated the veneration of the Virgin of Mercy on several occasions. Particularly in the sermons he wrote between 1537 and 1540 on chapters 18 to 24 of the Gospel of St Matthew, he frequently returns to the question of the Virgin Mary's cloak and intercession by the saints. In his exegesis of Matthew 18: 11, 'For the Son of man is come to save that which was lost', he argues that Mary has been wrongly set above Christ: 'But is it not a great and terrible heresy that we placed all our trust in the cloak of Our Dear Lady. … It is idolatry, that people are led away from Christ and towards the cloak of Mary, in the way that preaching monks have done' (WA 47, 276). Moreover, Luther argues that Christ alone – having spilt His blood for human beings – can intercede with God on their behalf. He declares that the papacy, at times even the Devil himself, smeared black paint over the uplifting image of the crucified Christ, so that the faithful turned away from Him and sought protection under the cloak of the Virgin Mary. Thus the papacy, or the Devil, diverted human beings from the righteous path and lured them straight into Hell.

Susanne Wegmann

→ Further reading

Vera Sussmann: Maria mit dem Schutzmantel, in: *Marburger Jahrbuch* 5 (1929), 285–351.
Klaus Schreiner: *Maria. Jungfrau, Mutter, Herrscherin*, Munich and Vienna 1994.
Sibylle Weber am Bach: *Hans Baldung Grien (1484/85–1545). Marienbilder in der Reformation*, Regensburg 2006.

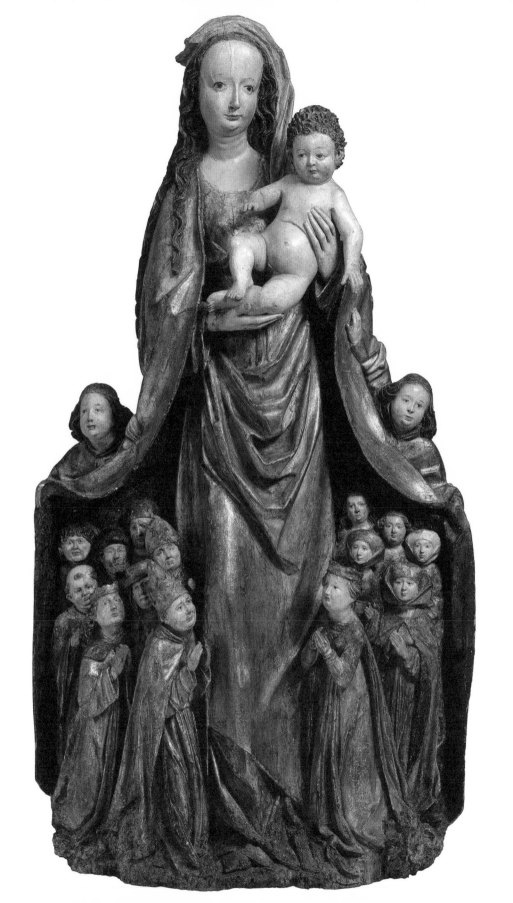

'THEREFORE, WE ARE JUSTIFIED BY FAITH, NOT BY WORKS, PENANCE, OR CONFESSIONS.'

WA 1, 544; LW 31, 106

While studying theology Luther became acquainted with a different, merciful Christ. The conversations with his mentor, Johann von Staupitz, his intensive analysis of the Bible, and his reading of Augustine and the German mystics changed his perception of Christ and the way to salvation. His doubts about the effectiveness of external works, which were sown during his 1511 visit to Rome, grew increasingly insistent. It became clear to him that the Church's offers of salvation pointed in the wrong direction: people are redeemed not through their actions, but solely by faith in God who makes them righteous through Christ. The open culture of debate at the University of Wittenberg gave Luther the courage to present his 95 Theses against indulgences for disputation. And thus the Reformation began.

FROM LUDER TO LUTHER

ANNA VIND

In 1505 the young Martin Luder chose to become a monk in Erfurt. He was 21 years old and already a well-educated man. From 1501 to 1505 he had studied for a Master of Arts degree at the University of Erfurt and thereafter, in May 1505, had been enrolled at the Faculty of Law. His father paid for his studies and imagined his intelligent son's future to be that of an enterprising lawyer surrounded by a wife and children.

Until 1505 Luder had been a part of the study circles in Erfurt. He had lived in a university college of the city and had become acquainted with the diverging trends within philosophical studies. During this time he was familiarised with and influenced by the *via moderna*, something to which he

testified himself in later memories. He adopted and made use of several viewpoints developed by the thinkers associated with this movement, which had its roots in the thought of William of Ockham, but at the same time developed his very own characteristic use of their ideas. Two things may be indicated as central points of view that he inherited and brought with him: 1) a concept of a potent God with the ability to cut across existing human notions; and 2) a radical view of how to understand and make use of language. In some senses, however, Luther's view of language was also influenced by the *via antiqua*. Unlike the moderns, the young Luder did not see words and language, including concepts, as mere tools. Inspired by the *antiqui*, although in a quite different way, Luder perceived language as the actual presence of existing reality. A pivotal notion in Luther's thought never ceased to be that truth is present in words and not beyond or contrary to them.

In the early years of his studies Luder also became acquainted with humanist thought marked by such catchwords as going *ad fontes!*, or 'back to the sources!', and a revival of classical antiquity. A restless curiosity on the part of humanist scholars sparked new interest in philology and history, literature and art, and questioned hitherto traditional scholastic methods, especially the use of logic. As was the case with scholastic philosophy, Luder carried the humanist inspiration with him and the use of the new philological, rhetorical-dialectical and historical-critical methods played a profound role in his later intensive work with the Bible. The same was the case as he embarked on a career as a debater. When he launched the reform of the University of Wittenberg in the years just prior to Melanchthon's arrival in the city in 1518, it was humanist claims and ideas that formed the foundation of the project.

We know how much Martin Luder's friends deplored his decision to become a friar. Their intelligent thought-provoking lute-playing companion, who was well-versed in literature and philosophy, chose to leave them and most of his books behind him and enter the monastery. It seems that the prospect of becoming a stern lawyer and staid husband in accordance with his father's wishes did not fulfil his dreams. Luder was deeply involved with fundamental questions of existence and he could devote himself to these as a friar. The well-known story about a thunderstorm and lightning scaring him into the convent may have served Luder more as a good excuse for his choice than as an explanation of the true motive.

Most of his own memories of life in the monastery were formulated in later days, by which time he had developed a fundamentally negative view of monastic existence. He seems to have been quite comfortable among the Augustinian hermits, both in Erfurt and later in Wittenberg. Remarkably enough, he did not abandon his monk's habit during the years of radical criticism of friars and their vows, criticism he formulated in writings such

as *De votis monasticis* of 1521 – perhaps because he was too fond of it. The habit suited him just as well as the industrious rhythm regulated by the hour, the ongoing scholarly occupation with Bible and theology, the daily celebration of mass, and the fruitful working partnerships with well-educated brothers. Not until Katharina von Bora knocked on his door, did he leave this safe harbour in 1524, initially in order to be of help to her and her fellow nuns and probably also to illustrate by his own example that a staid daily life with family, work and friends was the perfect holy life in the eyes of God.

In the Erfurt monastery Luder met his mentor, the vicar-general of the order, Johann von Staupitz. Even if Staupitz never surrendered fully to the mature Luther's ideas as they were sharpened over the years, he had tremendous importance for Luder's theological development. He served as his confessor, and in several flashbacks Luther thought back on his wise counsel. When Luder anxiously confessed his irrepressible sinfulness or his fear of damnation, Staupitz more than once advised him to seek the merciful Christ, not Christ the severe judge. And Staupitz not only guided the young brother with clemency in his spiritual wrestling but also pushed him forward in his monastic career. In 1512, when Luder had both been ordained and awarded the title of doctor on completion of his theological studies, he was appointed professor in theology at Wittenberg as Staupitz's successor. A few years later he was promoted to district vicar with responsibility for several monasteries. Staupitz made sure that the outstanding and forceful young monk had as many possibilities at hand for his future development.

Around 1511, before his final move to the small town in the Electorate of Saxony, Luder made a journey to Rome. The sources do not reveal much about this trip, neither about the aim of it, which was negotiations concerning the rule of the reformed Augustinians, nor about Luder's reaction when faced with the papal seat. In retrospect Luther deplored how he participated energetically, but in vain, in all kinds of pilgrim activities in his effort to liberate deceased relatives from purgatory (WA 51,89).

Neither Luther's works nor any other sources tell us exactly when and how he developed his characteristic theological understanding. We know that he lectured on Aristotle's *Ethics* – which he later so vehemently assaulted – in 1508–09. It is also known how he studied both the Sentences of the famous mediaeval dogmatic Peter Lombard and several of Augustine's writings before he moved to Wittenberg. Once there, he immediately began to fulfil his obligations as professor and started lecturing on the Psalms, then on Paul's letters to the Romans, to the Galatians and to the Hebrews, and finally again on the Psalms. The second series of lectures on the Psalms had to be broken off in 1521 when he travelled to the Diet of Worms. During these years he slowly took steps to move away from the traditional

approach to lecturing by means of adducing textual glosses and scholia to the students. Instead he honed a more fluent form, which allowed him to develop and articulate his own interpretation to a greater extent. Formally he made use of all the traditional tools known to him, such as ancient commentators and the Latin Vulgate, but he also supplied the students with all the fancy new aids he could get hold of: Hebrew text, Hebrew dictionaries, Erasmus's recently published version of the Greek New Testament (1516) etc. The manuscripts from these lectures are preserved and they reveal to us how Luder sought to harvest the fruits of humanist insights from early on. Two authorities came to be crucial to the professor in the years prior to 1517: Augustine's antipelagian writings and Johannes Tauler's sermons, as well as the mystical tract *Theologia Deutsch*, which Luder initially assumed also to have been written by Tauler. In his salvoes against Pelagius at the beginning of the fifth century, Augustine had enlisted Paul in his critique of the early British theologian, especially the Epistle to the Romans, seeking to argue in favour of the abiding presence of sin and the absolute necessity of grace against Pelagius's idea that the human mind is capable of willing good. And in Tauler, Luder found a strong emphasis on the relation between God and man in Christ, in whom the humility and total dependency of the human creature on the divine mercy given to men from outside, *'extra nos'*, is clearly given expression. Evidently the question of sin and God's gracious, divine saving action, centred in the person of Christ as God's word, stood out in Luder's contemplation during these and subsequent years. To our knowledge, 1516 was also the year in which he criticised Erasmus for the first time in a letter to his friend Georg Spalatin, the secretary of Frederick the Wise. Erasmus should not prefer Jerome to Augustine, writes Luder, and furthermore, he has not truly understood the concept of original sin in Romans 5 (WA BR 1, Nr. 27, 70). This is a further hint that at this point Luder had fully developed something utterly crucial within his strain of thought, namely his radical concept of sin. Not even in Augustine or the mystics had he found anything similar. No one had ever expressed themselves as profoundly as he did in his lecture on the Romans in 1515–16, when he depicted the believing Christian as at all times *'incurvatus in se'*, as bent towards himself, and thus as *'simul iustus et peccator'*, at once 'righteous and a sinner' (WA 56, 304; LW 25: 309). He never gave up these formulations but kept repeating them in the years to come with increasing sharpness. This anthropology was the necessary correlative to his emphasis on faith in Christ, the Word of God, as the only way to salvation.

In September 1517, just before Luder threw himself into the campaign against indulgences, he formulated his criticism of what he perceived to be a wrong theological mindset in his disputation with scholastic theology. Here he promoted his radical anthropology in a direct attack on the school theology of his day. In these theses he turned vehemently against all no-

tions of valid human effort in relation to God, indirectly pointing to faith in Christ as the solution. But not many contemporaries cared much for what they saw as an arcane discussion in the ivory towers of academe, even though Luder tried to spread the news. Not until he went on to attack the economic foundations of the Church by excoriating the lucrative use of the sacrament of penance, did his opponents wake up. What he meant, when he began to sign his letters with 'the free, *Eleutherius*' (which after a short time he cut down to *Luther* with the central 'th') in the autumn of 1517, following his posting of the 95 theses against indulgences, can only be answered tentatively. Maybe he felt relief that at this point he had discovered a theological foundation, which enabled him to expose what he saw as clear abuse. Such an interpretation agrees well with what he expressed in 1545, looking back on a sudden discovery that Romans 1:17 was a verse concerning the righteousness of faith, not of deeds, given by a gracious and merciful instead of a punitive and angry God (WA 54, 179–187; LW 34: 327–338). But in the autumn of 1517 he had not yet realised the likely consequences of the step he had taken.

VAULT KEYSTONE WITH ST AUGUSTINE
FROM THE AUGUSTINIAN MONASTERY ERFURT

1502–1516 SANDSTONE HEIGHT 40 CM, DIAMETER 40 CM
EVANGELISCHES AUGUSTINERKLOSTER, ERFURT

Luther's realisation that justification was by faith, a doctrine crucial to his development as a reformer, was based to a large extent on his reading of the works of Augustine (354–430). In particular, studying the Father of the Church's anti-Pelagian writings inspired Luther's conviction that a person cannot earn favour with God. This formed the basis for his new doctrine of justification, which went far beyond Augustine's point of view.

Luther joined the Augustinian monastery in Erfurt on 17 July 1505 and spent several years there. This vault keystone depicting St Augustine originally adorned the southern nave of the library annex. Construction of the latter began in 1502 and was partially funded by two indulgences granted specifically for this purpose in 1502 and 1508. Luther was probably familiar with this portrayal as he visited Erfurt and the monastery several times, even after he moved to Wittenberg in 1508. The monastery library held the works of St Augustine in the form of the 11-volume edition published by Basel printer Johannes Ammerbach in 1506. That edition may well have given Luther his first insight into St Augustine's work, especially as his teacher in Erfurt, Bartholomäus Arnoldi von Usingen, is said to have requested that the Bible be read solely from the perspective of the Church Fathers. In Arnoldi's opinion, focusing on the original text itself was the 'cause of all sedition' (WA TR 2, Nr. 1240, 6; LW 54, 128), as Luther no doubt exaggerated in a subsequent *Table Talk*.

Nevertheless, it appears that it was only in Wittenberg that Luther got around to studying the writings of Augustine in greater detail, particularly in the context of his interpretation of St Paul's Letter to the Romans. This becomes clear in his Wittenberg lecture of 1515-16 in which he refers in particular to Augustine's *De spiritu et littera* in his rejection of Scholasticism. At the Heidelberg Disputation in 1518, when Luther first defended himself publicly for his 95 Theses condemning indulgences, he appealed to the Father of the Church as Paul's 'most trustworthy interpreter' (WA 1, 353; LW 31, 39). It was only later that his enthusiasm for Augustine cooled, when he became convinced that he understood Paul better than Augustine could ever have.

On 25 February 1945, the library building in the Augustinian monastery, which had been preserved in its late Gothic form until then, was almost completely destroyed in the bombing of Erfurt. It was possible, however, to salvage a small number of architectural elements from the rubble. Among them were the vault keystones showing the four Church Fathers. Augustine, shown here with the insignia of his office, his mitre and staff, was Bishop of Hippo Regius in North Africa. His attribute, a heart pierced by an arrow, which is also shown on the keystone, can be traced back to a quotation from his *Confessions* in which he compares the love of God to arrows that have pierced the hearts of men: '*Sagittaveras cor nostrum caritate tua*' ('You have pierced our hearts with the arrow of your love').

Mirko Gutjahr

→ Further reading
Bernhard Lohse: Die Bedeutung Augustins für den jungen Luther, in: idem: *Evangelium in der Geschichte. Studien zu Luther und der Reformation*, Göttingen 1988, 11–30.
Aller Knecht und Christi Untertan. Der Mensch Luther und sein Umfeld, catalog to the exhibitions marking the 450th anniversary of Luther's death, Eisenach 1996, 176.
Manfred Schulze: Martin Luther and the Church Fathers, in: *The Reception of the Church Fathers in the West*, Irena Backhus (ed.), vol. 2, Leiden et al 1997, 573–626.

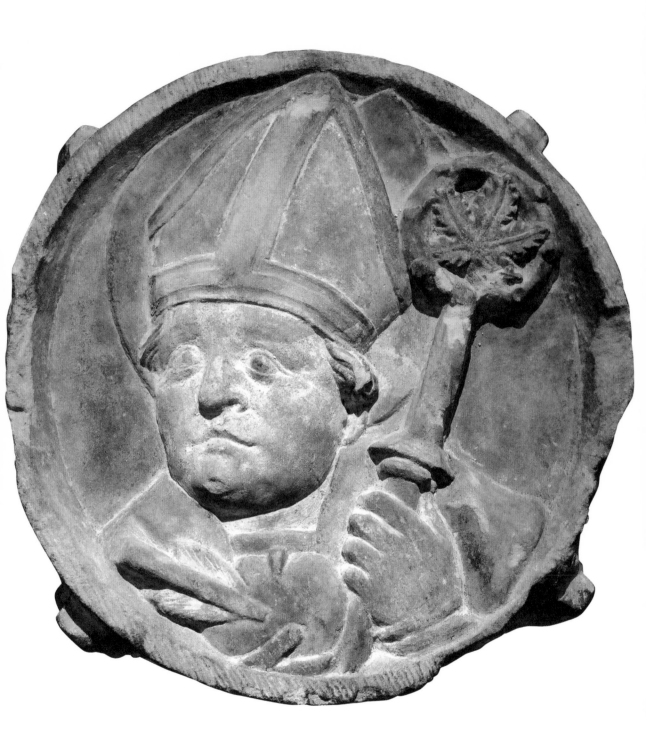

FIVE BOOK CLASPS AND FITTINGS
FROM THE LUTHER HOUSE
WITTENBERG

FIRST HALF OF THE 16TH CENTURY BRONZE 1–4 × 3.4–5.5 × 0.4–0.5 CM
LANDESAMT FÜR DENKMALPFLEGE UND ARCHÄOLOGIE –
LANDESMUSEUM FÜR VORGESCHICHTE – SACHSEN-ANHALT

Luther's path to knowledge was paved with books. 'In order for the Gospel and all knowledge to be preserved, it must be written and contained in books and documents' (WA 15, 49). Thus he recommended the establishment of both public schools and libraries.

Luther also read voraciously himself. In addition to the Bible, which, by his own account, he read for the first time as a young law student in Erfurt, he also read theology and history books, by both classical and non-Christian writers, as well as legends and fables. Accordingly, he used as much source material and secondary literature as he possibly could when preparing his lectures and debating with papal theologians. He was initially only able to avail of these works through monastery libraries, but in Wittenberg, if not earlier, he began to put together his own library, which also contained some of his opponents' works. Following his death, his extensive book collection was scattered; not even a catalogue of his books remains. As Luther also did not leave any marks of ownership on his books, only a few of them could be subsequently identified.

However, book clasps and fittings salvaged during excavations of the yard at the back of the Luther House in Wittenberg in 2004–05 provide some clues to his library. Parchment 'buckles' easily, causing the covers to flip open and making it difficult to store such books in a bookcase. To solve this problem, bronze or brass book clasps comprising metal components riveted onto broad leather straps could be used to hold books together. To close the book, a hook at the end of the clasp was inserted into a window-like eye. Typically, these clasps are elongated structures with a fan-tailed flared edge at one end and a rounded hook at the other. The visible side is decorated throughout with chip carving. The flared ends are adorned with fan-tailed patterns, featuring narrow, lattice-shaped and zigzag designs and sometimes also floral and circular motifs. Almost all of them have also retained their rear metal plate.

Book corners were protected from damage using diamond-shaped corner fittings. Two narrow flanges wrapped around the edge of the book cover and could each be secured with a rivet; there was a third flange at the opposite point of the diamond. The visible side is dominated by an embossed projection, which was clearly cast with the fitting, and volute-like ornamentation, which extends into two lateral heart-shaped perforations and two flowers facing the boss. A lot of strain was put on such clasps, especially those secured to a strap, and they were easy to lose as a result. It may be assumed, therefore, that their discovery is less indicative of the disposal of entire tomes than the fact that the metal had peeled off individual clasps and they were not worth repairing or reusing. The relatively large number of finds confirms the assumption that Luther had an extensive library and it was used intensively. Mirko Gutjahr

→ Further reading
Kristina Krüger: Archäologische Zeugnisse zum mittelalterlichen Buch- und Schriftwesen nordwärts der Mittelgebirge, Bonn 2002, 93–124.
Hans-Georg Stephan: Lutherarchäologie. Funde und Befunde aus Mansfeld und Wittenberg, in: Luthers Lebenswelten, Harald Meller, Stefan Rhein and Hans-Georg Sephan (eds.) Halle 2008, 21.
Ralf Kluttig-Altmann: Fittings and Clasps from Book Covers, in: Martin Luther. Treasures of the Reformation. Catalogue Dresden 2016, 251, nos. 245 and 246.

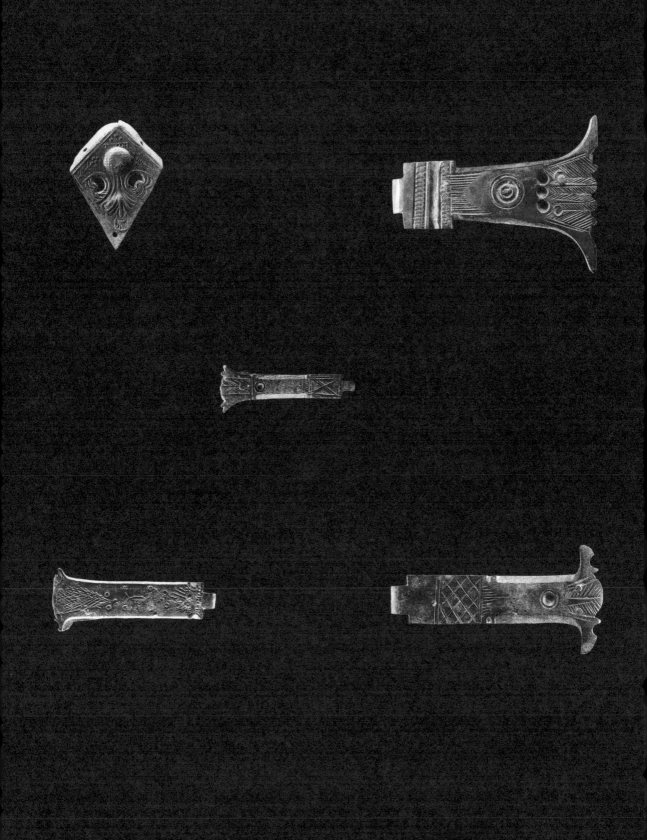

JOHANN VON STAUPITZ ON THE LOVE OF GOD

PRINTER: MELCHIOR RAMMINGER, AUGSBURG

1520 LETTERPRESS ON PAPER 20 × 14,5 × 0.5 CM
STIFTUNG LUTHERGEDENKSTÄTTEN IN SACHSEN-ANHALT

Johann von Staupitz (c.1465–1524) is one of the reform theologians of the late Middle Ages who are often only seen in the light of their later reception. Due to his intense focus on a language informed by the Bible, he paved the way for a number of reform-oriented members of the Augustinian order, especially Martin Luther. Staupitz's theology centres on the Christ who suffered for our sins and His exclusive mediating role as Saviour and is accompanied at times by a slightly anti-sacramental and anti-institutional sentiment. Influenced by Scholasticism, Staupitz absorbed many of the traditions that informed theology in the late Middle Ages, such as the mystic elements of a tangible closeness to God and an emphasis on the immediacy of the divine presence in the gift of grace. Based on his reading of the key texts in their original language, he adopted a more radical teaching of grace founded on God's mercy. Staupitz's general theological eclecticism typified the complete dedication to the proclamation of the Bible that was very much in keeping with the times.

This collection of Advent sermons, delivered in Munich, was first published in Munich in 1518 and later in Leipzig in a booklet entitled *Ain seliges neues Jahr von der Lieb Gottis* … It was hugely popular; Luther was a particular admirer. He had the booklet reprinted twice with his own endorsement, describing the work as a 'wonderful instruction'. In it, Staupitz outlines how only God's mercy in Christ prevails against the autonomous love that man has for God and which is otherwise required in evangelism. As a result, the collection remained the Augustinian theologian's most famous publication for a long time.

The work has its roots in a tradition whereby high-profile priests focused on a general theme of theological and social importance at times of fasting during the liturgical year. Most of Staupitz's work that was published posthumously originated in this way. The Munich sermons were dedicated to the erudite widow of the Bavarian Duke Albrecht IV, Kunigunde of Austria (1465–1520). The short tract consists of 21 chapters describing the love of God to the faithful and to Christians in need of consolation. This love is explained in a way that emphasises human perception but also renders it in Biblical language. The Biblical quality of the language thus informs the human experience and makes the experience of God's love the model for a direct relationship between the faithful and their Lord God. This belief does not make Staupitz a founder of Scholastic theology or a school of 'piety theology' but a pastoral exegete of the Holy Scriptures.

Markus Wriedt

⟶ Further reading
Markus Wriedt: Zur Bedeutung der seelsorgerlichen Theologie Johannes von Staupitz für den jungen Martin Luther, in: *Luther als Seelsorger*, Joachim Heubach (ed.), Erlangen 1991, 67–108.
Berndt Hamm: Johann von Staupitz (ca. 1468–1524). Spätmittelalterlicher Reformer und 'Vater' der Reformation, in: *Archiv für Reformationsgeschichte* 92 (2001), 6–42.
Berndt Hamm: Die 'nahe Gnade'. Innovative Züge der spätmittelalterlichen Theologie und Frömmigkeit, in: *'Herbst des Mittelalters'? Fragen zur Bewertung des 14. und 15. Jahrhunderts*, Jan A. Aertsen and Martin Pickavé (eds.), Berlin and New York 2004, 541–557.

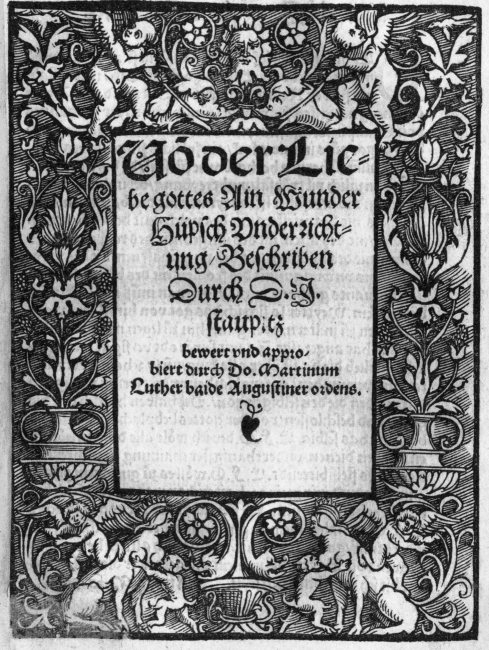

Vö der Lie=
be gottes Ain Wunder
Hüpsch Vnderricht=
ung/ Beschriben
Durch D.I.
staupitz
bewert vnd appro=
biert durch Do. Martinum
Luther baide Augustiner ordens.

LUCAS CRANACH THE ELDER
(WORKSHOP)

THE TEN COMMANDMENTS

1516 OIL ON PANEL 160 × 335 CM
STIFTUNG LUTHERGEDENKSTÄTTEN IN SACHSEN-ANHALT

From 1513–14 the monk Martin Luther was engaged as a preacher at the Town Church of St Mary in Wittenberg. Between 2 July 1516 and 24 February 1517 he preached on the Ten Commandments, decrying such transgressions as the wearing of sumptuous clothing, compulsive gambling and idleness. However, he went beyond simply delivering moralising homilies, placing his reflections in a wider theological context.

Luther did not publish these sermons but instead produced *A Brief Explanation of the Ten Commandments* (*Eine kurze Erklärung der zehn Gebote*, WA 1, 250–256) just before Easter 1518, in which he gave short interpretations of how the Commandments might be kept or broken. The publication appeared in the form of a confession manual, as people were expected to go to confession at Easter. He made it clear that confession on its own was not enough and that a personal faith in the Word and in the promise of Christ were essential. He went on to say that people are dependent on God's grace but that, in spite of their sins, they are assured of this grace. This reformatory epiphany had come to Luther partly through his engagement with the Ten Commandments, which confront us directly with our sinfulness and thus our dependence on divine grace. Through this insight, he was freed from the deep despair into which he had been cast by his realisation about human sinfulness during his time in the monastery.

The Ten Commandments by Lucas Cranach the Elder (1472–1553) illustrates how the Commandments are kept and broken. It is not known to what extent he conceived his painting as an artistic commentary on Luther's sermons or was, at least, inspired by them. Cranach painted the panel for the courtroom at Wittenberg Town Hall in 1516: thus the judges dispensing justice and the townspeople seeking it were presented with the divinely bestowed canon of rightful conduct, not least since the Commandments appeared on the panel in German. The town council of Wittenberg had been granted the right of High Justice in 1441 and in the case of serious offences could even impose the death penalty. Cranach himself was a member of the council from 1519 and as such helped to shape local politics for a period of 30 years.

The individual scenes of *The Ten Commandments* show either the commandment and its violation or just the actual transgression, with temptation personified in the figure of the Devil. The scenes are remarkable for their level of detail. They depict everyday life at the time and, through this proximity to the observer, exert great power to warn and deter. The panel was produced by Cranach's workshop; the fine underdrawings done by the master were completed by assistants from his workshop, with considerable variations in quality. *The Ten Commandments* is one of the largest surviving paintings from the Cranach workshop that was not originally designed as a church altarpiece, and the panel remains in its original frame. At each end of the rainbow that spans the individual scenes, Cranach identifies himself as a court painter: on the left-hand side with the coat of arms of the Electorate of Saxony and on the right with that of the Duchy of Saxony. Stefan Rhein

→ Further reading
Elfriede Starke: *Lukas Cranach d. Ä. Die Zehn-Gebote-Tafel*, Leipzig 1982.
Michael Wiemers: Cranach und das Recht im Bild. Anmerkungen zur Wittenberger Zehn-Gebote-Tafel, in: *Signa Ivris. Beiträge zur Rechtsikonographie, Rechtsarchäologie und Rechtlichen Volkskunde 1* (2008), 11–27.
Gerhard Begrich, Jürgen M. Pietsch and Kathrin Seupel: *Die Zehn-Gebote-Tafel von Lucas Cranach dem Älteren im Lutherhaus Wittenberg*, Spröda 2011.

ERHARD ETZLAUB ^(ATTRIBUTED) DIPTYCH SUNDIAL WITH MAP OF ROUTES TO ROME

1513 NUREMBERG BOXWOOD AND BRASS
OPEN 11.7 × 8.3 × 12.4 CM
COURTESY OF THE ADLER PLANETARIUM, CHICAGO, ILLINOIS

A journey to Rome from Wittenberg, such as the one Luther made in October 1511 in company with a fellow monk, probably Johann von Mecheln, was a considerable undertaking at that time. Not only were there constant dangers, such as attacks, illness or accidents, to contend with, finding one's way along the correct route was a considerable challenge in itself. Although the ancient Roman milestones still existed in Italy, there were very few waymarkers of this kind for long-distance, interregional routes north of the Alps. Some assistance was provided by mediaeval accounts of journeys, known as *itinerare*, which were available in printed form from the end of the fifteenth century and provided practical advice on routes to the great pilgrimage destinations of Rome, Santiago de Compostela and Jerusalem. By the time he set out, it is likely that Luther would have used a copy of the earliest printed map of routes to Rome, entitled 'This is the way to Rome from mile to mile', which was first published by Erhard Etzlaub in Nuremberg shortly before 1500 and much valued by contemporary travellers for its geographical accuracy. It shows the principal pilgrim routes as lines of dots, with each dot representing a German mile (c.7.4 kilometres). At the lower border, along with a ruler and instructions for calculating distances between the towns marked on the map, there are further instructions on using the map with the aid of a compass.

Two of these instruments, which were probably made by Etzlaub himself, are known to survive; this example, from the collection of the Adler Planetarium in Chicago, dates from 1513. It is remarkable for a unique element on the outer surface of its upper leaf, where a map reminiscent of Etzlaub's Rome map is inscribed; this particular map also shows most of Europe and parts of North Africa. When the sundial is open, a thread known as a *polos* is stretched taut between the two hinged leaves. If the instrument is positioned in a north-south orientation with the aid of the compass inset in the lower leaf, the shadow of the thread on the scale, also on the lower leaf, indicates the time of day.

Luther's mission, which took him on his only journey abroad, was to participate in negotiations within his Augustinian order over attempts to unite monasteries in Saxony and Thuringia that interpreted the monastic rule with varying degrees of strictness. The monks followed traditional pilgrimage and trade routes on their way to Rome: they crossed the Alps via the Septimer Pass and then travelled on through Milan, Bologna and Florence to the Eternal City. It took them almost two months to cover the 1,600-kilometre route. On the return journey, due to armed conflict in northern Italy, they separated in January 1512; Luther's route then took him to Genoa, southern France and back through Switzerland. Although he did not appear to be particularly impressed by either the landscape or the architecture of Italy, with hindsight, Luther regarded his travels to Rome as a significant stage in his internal path towards the Reformation: after all, he had himself experienced the Roman form of piety that he would later so vehemently condemn for its secularised character. Mirko Gutjahr

→ Further readin
Arnold Esch: *Wege nach Rom. Annäherungen aus zehn Ja
hunderten*, Munich 2003.
Hans Schneider: Martin Luthers Reise nach Rom. N
datiert und neu gedeutet, in: *Studien zur Wissenschafts- u
Religionsgeschichte*, Akademie der Wissenschaften zu G
tingen (ed.), Berlin 2011, 1–157.
Mareike Wöhler: Das Einüben neuen Ordnungswisse
im 16. Jahrhundert. Mit Straßenkarte, Zirkel, Fäden u
Sonnenkompass gen Süden durch Europa, in: *Rom seh
und sterben … Perspektiven auf die Ewige Stadt, ca. 1500–2*
Bielefeld 2011, 39–48.

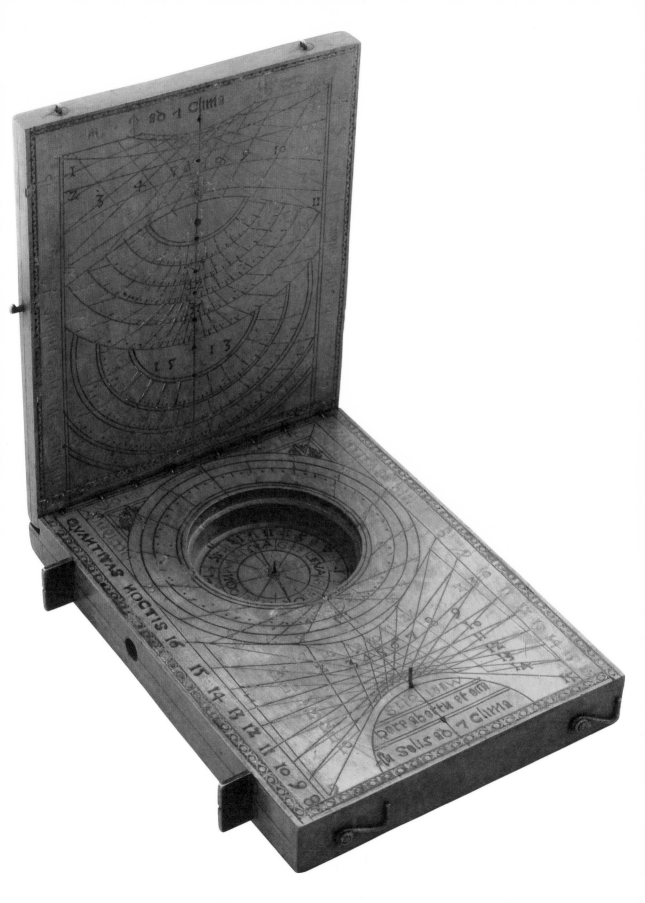

1501 LETTERPRESS AND WOODCUT ON PAPER 13.5 × 10 CM
STIFTUNG LUTHERGEDENKSTÄTTEN IN SACHSEN-ANHALT

Christians had been making pilgrimages to Rome since the early Middle Ages, but after Pope Boniface VIII declared the first 'Holy Year' in 1300, their numbers increased sharply with each successive jubilee. Every year thereafter, thousands of pilgrims had made their way to the Eternal City to visit the holy sites and earn the indulgences associated with them. Numerous guides to Rome were available, initially in manuscript form and from the fifteenth century as printed books, to help them find their way around the city. Among these was the *Mirabilia Romae* shown here, a compilation of nine different Latin publications in all, comprising descriptions of the sites of ancient Rome and its emperors and lists of important churches and relics, as well as a calendar with dates for celebration of masses. It has woodcut illustrations of coats of arms, saints and several of the main churches of the city, including a depiction of St Peter's Basilica during the annual ceremonial display of the Veronica, a veil used to wipe sweat from the face of Jesus. This had been one of Rome's most important *mirabilia* since the twelfth century, as it was claimed to be a Vera Icon, bearing the true image of Christ.

Luther would also have used a pilgrim guide of this kind during his visit to Rome in 1511–12; in any case it seems that a copy of a similar publication was found in his belongings after his death. Although Luther's journey was on official business – he apparently accompanied Johann von Mecheln, his fellow monk, as *socius itinerarius* on his visit as a delegate to the leadership of the order of Augustinian Hermits – during his four-week stay he took the opportunity to visit the sacred sites so that he and his relatives could benefit from a share in their treasury of grace. As well as the seven main pilgrimage churches, he also visited the catacombs of the early Christian martyrs and the Scala Santa, which he ascended on his knees. The opulence of the Church, the unseemly jostling before the altars and the superficial zeal of the Roman clergy, who hurriedly gabbled their way through masses, repelled the young monk: 'I was in Rome (for a short time), where I said so many masses and also saw so many masses said, that I shudder when I think of it. … Besides, it also disgusted me very much that they could say mass so confidently and efficiently and in such haste as if they were engaged in juggling.' (WA 38, 212–213: LW 38, 166).

Despite his subsequent criticism of the situation in Rome, when looking back he voiced no regrets at having been there: 'I wouldn't take one thousand florins for not having seen Rome because I wouldn't have been able to believe such things if I had been told by somebody without having seen them for myself.' (WA TR 5, Nr. 5484, 181: LW 54, 427). The insights he gained in Rome into the failings in the meantime played a significant part in Luther's gradual change of perspective; his journey to Rome was therefore crucial to his recognition of the need for reform.

Mirko Gutjahr

→ Further readin

Volkmar Joestel: Mirabilia Romae, in: *Luthers Schatzkammer. Kostbarkeiten im Lutherhaus Wittenberg*, idem (ed.), D ßel 2008, 24.
Jürgen Krüger and Martin Wallraff: *Luthers Rom. Die ew ge Stadt in der Renaissance*, Darmstadt 2010.
Hans Schneider: Martin Luthers Reise nach Rom. Ne datiert und neu gedeutet, in: *Studien zur Wissenschafts- un Religionsgeschichte*, Akademie der Wissenschaften zu G tingen (ed.), Berlin 2011, 1–157.

Mirabilia Rome.

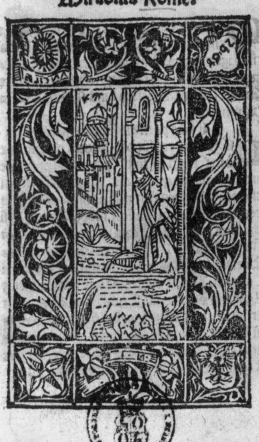

ALBRECHT OF BRANDENBURG
ARCHBISHOP OF MAINZ

LETTER OF INDULGENCE
FOR THE BENEFIT OF BUILDING ST PETER'S BASILICA IN ROME

1517 LETTERPRESS ON PARCHMENT 14.5 × 18.9 CM
HERZOG AUGUST BIBLIOTHEK WOLFENBÜTTEL

This document was part of the indulgence campaign which gave rise to Luther's 95 Theses. It is commonly known as a 'letter of indulgence', but would be better described as a 'confessional privilege' (*confessionale*), since it entitled the beneficiary to choose any priest as confessor. The confessor then acquired powers which extended beyond those of an ordinary confessor and were usually reserved for the discretion of the papal authorities, such as revoking particular ecclesiastical penalties or commuting vows. In addition, the confessor was accorded the facility to confer full indulgence on the penitent after granting them absolution; once afforded this grace, they could die without fear of the punishments of Purgatory. The possibility of granting indulgences expanded considerably over the course of the fifteenth century. Initially indulgence was only granted once in a person's life, at the hour of their death, but eventually plenary indulgence could be obtained in any case of mortal danger (*totiens quotiens*). Since the confessional privilege was only meant to apply in the future, this led to the later Protestant misunderstanding that people were purchasing indulgences for sins they had yet to commit.

From the fourteenth century confessional privileges were obtained from the Apostolic Penitentiary in Rome, but papal legates were also granted the authority to issue them. The indulgence campaigns of the fifteenth century saw the sale of indulgences become a mass phenomenon. Printing facilitated the inexpensive production of the many necessary forms, which only required the name of the 'purchaser' to be entered before they were sealed. The confessional privileges were available for a fixed price. In the case of the St Peter's indulgences sold from the end of 1516 by Albrecht of Brandenburg, Archbishop of Mainz (1490–1545), the price was a quarter of a guilder, roughly equivalent to two days' wages for a tradesman. This price was considerably lower than the payments made to the Apostolic Penitentiary for the same pardon.

The confessional privilege shown here was issued to 'Meckel [Mechthild] Relicta [Widow] Rodta Peders Et Adam Rodt' in Göttingen on 1 July 1517. Adam Rodt may have been the widow's son; couples with children and even entire monasteries often obtained a confessional privilege jointly. This one was issued for the St Peter's indulgence by sub-commissioner Johann Breidenbach acting on behalf of Archbishop Albrecht in Eichsfeld and the easterly part of the diocese of Mainz. Breidenbach was a former Dominican monk who, in 1517, was a priest in Grebenau, in Hesse. There are numerous sources documenting his indulgence preaching – far more, in fact, than exist in relation to Johann Tetzel, who was engaged in the same venture for the same purpose in the diocese of Magdeburg. Breidenbach continued his activities into early summer 1518, when he preached the St Peter's indulgence many times in Göttingen, Northeim, Nordhausen, Mühlhausen, Heiligenstadt and Duderstadt. A total sum of 74 guilders was raised in Göttingen that year, from which the sub-commissioner deducted eight guilders for his expenses and gave seven for the support of the city's parish and monastery churches. Hartmut Kühne

→ Further reading

Hans Volz: Der St. Peter-Ablaß in *Göttingen 1517/18*, in: *Göttinger Jahrbuch 6* (1958), 77–87.
Peter Wiegand: Gedruckte Beichtbriefe (Confessionale) in: *Alltag und Frömmigkeit am Vorabend der Reformation in Mitteldeutschland*, Hartmut Kühne, Enno Bünz and Thomas T. Müller (eds.), catalogue to the exhibition *Umsonst ist der Tod*, Petersberg 2013, 363–365.
Andreas Meyer: Der Ablass vor der päpstlichen Kanzlei. Beobachtungen zu den Beichtbriefen, in: *Ablasskampagnen des Spätmittelalters, Luthers Thesen von 1517 im Kontext* (Bibliothek des Deutschen Historischen Instituts in Rom, 132), Andreas Rehberg (ed.), Berlin 2017, (in press).

Albertus dei z Apłice sedis gřa.sčě Mogūtineñ sedis.ac Magdeburgeñ.ecčłe Archiepūs. Primas.z sacri Ro imperij in ger=
mania Archicãcellari°.Princeps:elector ac administrator Halberstatteñ.Marchio Brãdeburgeñ.Stettineñ.Pome=
ranie.Casfuboꝛ.Sclauoꝛũꝗ dux.Burggrauℓ° Nurenbergeñ.Rugieꝗ pnceps.Et Guardian° fratrũ ordinis minoꝛ.de obseruātia ꝗuctus
Mogūtiñ.Per sctiſſimũ dñm nřm Leoně papã decimũ.ꝗ puincias Mogūtineñ.ac Magdeburgeñ.acillarũ z Halberstatteñ.ciuitates z
dioceſ.necnon terras z loca illustriſſimi et illustrium Principũ dñoꝛum Marchionum Brãdeburgeñ.tpał dño mediate vel immediate sub
iecta nũcij z cõmiſſarij:ad infra septa specialiť depurati. Vniuersis z singulis pntes łras inspectur Salutě in dño. Notũ facim° ꝗ Sctiſ=
simꝰ dñs noster Leo diuia.puidētia Papa decim° modern°.oibus z singuł ytriuſꝗ sexus christifidelib.ad reparatõně fabrice Basilice pnci=
pis aploꝛ scti Petri de ꝟbe.iuxta ordinatõně nřam man° poꝛrigětib, adiutrices:vltra plenisſimas indulgētias ac alias gřas z facultates ꝗs
christifideles ipi obtinere poſſunt.iuxta łraꝛ Apłicaꝛ desuẜ pfectarũ ꝑtinētiã mitcoꝛdiť etiã in dño indulsit atꝗ ꝑceſſit.vt idoneũ poſſint elige=
re pfeſſoꝛě pſbyterũ seclarě.vł cuiusuis etiã mendicātii oꝛdis regłarě.ꝗ eoꝛ pfeſſiõe diligěter audita.p cõmiſſis p eligětě delict,z exceſſib,: ac
petis ꝗbuslibet.ꝗntūcūꝗ grauib,z enoꝛmib,.etiã in dicte sedi reſuać,casib,.ac cēsuꝛ,ecclesiasticℓ.etiã ab hoie.ad alicu° instātiã latis.de pſensu
alioꝛ supioꝛ ꝑlatoꝛ.z iniectõis manuũ violētaꝛ i illos aut alios ꝑlatos.Falsificatõis łraꝛ apłicaꝛ.Delatõis arm.oꝛ.z alioꝛ ꝓhibitoꝛ ad
ꝑtes infideliũ:ac śniaꝛ z cēsuraꝛ occaſiõe aluminũ tulfe apłice de pñtib, iſideliũ ad fideles ꝓtraꝗhibitõne apłicã delatoꝛ.icursaꝛ semel i vita
et i moꝛt,articło ꝗties ille iminebit.licꝗ moꝛs tũc nõ subseꝗuřEt i nõ reſuať.casib,totiēs ꝗties id petierit plenarie absoluere z eis pniam salu=
tarě imūgere.Necnõ semel i vita z i dicto moꝛt,articło.plenariã oim pctoꝛ indulgēã z remiſſiões impedere.z eucharistie sačrm(excepto die
pasca,z moꝛt,articło)ꝗbusuis anni tpib, mistrare.Necnõ p eos emiſſa p tpe vota ꝗcūꝗ(vltra mařito.visitatõis liminũ aploꝛ z scti iacobi
incõpostella:religioſis z castitat, voꝛ, dūtaxat exceptℓ)i alia pietat, opa cõmutare auctoritate apłica poſſit z valeat.Indulsit ꝗꝫ idě scriſſimus
dñs ñ.pfatos biñfactoꝛes.eoꝛuꝗ pentes defūctos ꝗ cũ charitate deceſſerũt i pcïb,suffragijs.elemoſ, nis.ieiunijs.oꝛatõib,.miſſis.hoꝛ, canonicℓ
disciplinis.pegriatõib,.et ceter, oib, spūaliƀ bonis ꝗ fuir z fieri poterūt i tota vłi sacroscťa eccła militãte.z oib, mēbis eiusdě in ꝑpetuũ pticī=
pes fieri.Et ꝗa deuot. ad ipam fabricã z necesſariã instauratõeꝛ iuẜ dicte ba=
silice principis apostoloꝛ.iuxta scriſſimi dñi noſtri Pape intētioně z nřam ordinatõně de bonis suis contribuendo se grat...... exhibu.....
et libera.... in cuius rei signum pntes litteras a nōbis accep..... Ideo eadem auctoritate apłica nob cõmiſſa.ꝗ q̃ sugimur i hac pte
ipſa..ꝗ dict,gřijs z idulgětijs vti z eidě gaudere poſſit z valeat p pntes ꝑcedim° z largimur.Datũ sub sigillo per nos
ad hec ordinato.Die Mēsis Anno domini.M.cccc.xvij.

Forma absolutionis totiens quotiens in vita

Misereatur tui ꝛc.sa.et tibi conceſſa:ego te absoluo ab oīb, peccatis tuis.In noie patris z filij z spiritus sancti Amen

Forma absolutionis z pleniſſime remiſſionis:semel in vita z in moꝛtis articulo

Misereat tui ꝛc.ꝛe absoluo.Prio ab oī sentētia excõicatõis maioꝛis vł minoꝛis si quã incurriſti.Deide ab oib, pctis tuis:pferědo tibi
pleniſſimã oim pctoꝛ tuoꝛ remiſſiõeꝛ:remittēdo tibi etiã penas purgatorij inꝗtũ se claues sctě mřis ecčłe extēdūt.In noie pťis z fi.z ſſ.Amē.

MARTIN LUTHER

DISPUTATION AGAINST SCHOLASTIC THEOLOGY

PRINTER: JOHANN RHAU-GRUNENBERG, WITTENBERG

1517 LETTERPRESS ON PAPER 32 × 24.5 CM
HERZOG AUGUST BIBLIOTHEK WOLFENBÜTTEL

In discussions revolving around the 95 Theses, doubts have often been raised as to whether any of Luther's disputation theses were ever printed on paper. However, since 1983 we have positive proof that this did happen, in the shape of an original document printed in Wittenberg by Johann Rhau-Grunenberg, which was discovered in the Herzog August Bibliothek library. The document in question contains Luther's first known list of theses for a disputation, which he himself chaired on 4 September 1517. The occasion was the examination of a certain Franz Günther, who was a student of Luther's. In the summer semester of 1517, Luther was dean of the Theology Faculty. He formulated 97 theses, which later came to be known as the *Disputatio contra scholasticam theologiam*, that is to say, the *Disputation against Scholastic Theology*. Günther had to defend the theses, which he clearly did successfully, as he was subsequently awarded his *Baccalaureus biblicus*.

Whereas the 95 Theses that Luther posted a few weeks later address the matter of indulgences, the 97 theses are an attack on the entire system of Scholastic theology. They stand as a powerful polemic against the central authority of the old teachings, that is to say, against Aristotle in particular. In Luther's view Aristotle had crucially influenced the scholastic theology of men such as Gabriel Biel and Duns Scotus, whose thinking he vehemently challenged. Luther regarded Aristotle's work as a hindrance to a true theology, which led him to the conclusion, in Thesis 44, that 'Indeed, no one can become a theologian unless he becomes one without Aristotle'. Luther spurns Aristotle's entire philosophy, as he declares with trenchant directness in Thesis 50: 'Briefly, the whole Aristotle is to theology as darkness is to light. This in opposition to the scholastics'. Luther particularly took issue with Aristotle's portrayal of human beings, namely his suggestion that humans could achieve justification through morally correct behaviour and were thus able to increase their chance of salvation by their own efforts. At the heart of this is the question of free will, which Luther – drawing on Augustine and the Bible – countered with the assertion that human beings cannot do good of their own free will: without the grace of God human beings only do evil.

Luther's disputation against scholastic theology was his first public assault on the dominant theology. He disputed the validity of the scholastic admixture of theology and philosophy; instead he put his own trust in biblical truth, which became the basis of his own theology, that is, his doctrine of the justifying grace of God, without which every act of the law is in itself sinful. Luther wanted this debate not to be conducted solely within the confines of Wittenberg University, the Leucorea; he wanted it to have a much wider impact. He therefore sent his theses to other towns, including Erfurt and Nuremberg, from where they were sent on to Cologne and Heidelberg. Luther's 97 Theses were in effect an early battle cry: in his view the study of theology could only be reformed if the hitherto dominant authorities no longer held sway. Aristotle and the scholastics had to be replaced by the Bible and the Church Fathers. Stefan Rhein

→ Further readin

WA I, 224–228, LW 31, 14 (See also, Martin Luther: Disput tion against Scholastic Theology, in: *Martin Luther's Bas Theological Writings*, Timothy F. Lull (ed.), Minneapoli 1989, 13-20).

Theodor Dieter: *Der junge Luther und Aristoteles*, Berlin un New York 2001.

Ingo Klitzsch: Autoritätenverwendung in der 'Disputati contra scholasticam theologiam', in: *Reformatorische The logie und Autoritäten. Studien zur Genese des Schriftprinzip beim jungen Luther*, Volker Leppin (ed.), Tübingen 20 39–86.

¶AD Subscriptas conclusiones Respondebit Magister Franciscus Guntherus Nordhusensis
pro Biblia.Presidente Reuerendo patre Martino Luder Augustinen.Sacræ
Theologiæ Vuittenbergen,decano loco & tempore statuendis.

i Dicere cp Augustinus cõtra hæreticos excessiue loquitur.Est dicere Au/
 gustinum.fere ubiq; mentitum Contra dictũ cõe.
ii Idem est pelagianis & oibus hæreticis tribuere occasionẽ triumphandi
 immo victoriam.
iii Et idẽ Est oim ecclesiasticos,doctorum authoritate illusioni exponere.
iiii Veritas itaq; ẽ:cp hõ arbor mala factus:nõ põt nisi malũ uelle & facere
v Falsitas ẽ.cp appetitus liber potest in utrũq; oppositiõq;.immo nec liber
 Sed captiuus est. Contra cõmunem
vi Falsitas est.cp uoluntas possit se conformare dictamini recto na/
 turaliter. Contra Sco :
vii Sed necessario elicit actũ difformem & malũ:sine gratia dei
viii Nec ideo sequit.cp sit naturalit mala.i.natura mali lgm Manicheos
ix Est tñ naturaliter & ineuitabiliter mala & uitiata natura
x Conceditur.cp uoluntas nõ est libera ad tendendũ in quodlibet.lgm
 rationem boni sibi ostensum. Contra Sco: Gab:
xi Nec est in potestate eius uelle & nolle.quodlibet ostensum
xii Nec sic dicere.est cõtra.B.Aug.dicente.Nihil ẽ ita i ptãte uolũtatis sicut
 ipsa uoluntas.
xiii Absurdissima est cõsequentia.homo errans põt diligere creaturã super
 omnia ergo & deum. Con:Sco: Gab:
xiiii Nec est mirũ,cp põt se conformare dictamini erroneo & nõ recto:
xv Immo hoc ei propriũ est ut tantũm erroneo sese cõformet & non recto:
xvi Illa põt? ẽ cõsequentia.hõ errans põt diligere creaturã:ergo impossibile
 est ut diligat deum.
xvii Nõ põt homo naturaliter uelle:deum esse deũ.Immo uellet se esse deũ.
 & deum non esse deum.
xix Diligere deũ sup oïa nãlit Est termius fict?.sicut Chymera Cõ:cũ:fere
xx Nec ualet ratio Scoti de forti politico rempub:plusq; seipm diligente
xxi Actus amicitiæ.nõ est.naturæ.sed gratiæ præuenientis. Contra Gab:
xxii Non est in natura nisi actus concupiscentiæ erga deum.
xxiii Omnis actus concupiscentiæ erga deũ est mala,& fornicatio spũs
xxiiii Nec ẽ uerũ cp actꝰ cõcupiscẽtiæ possit ordinari p uirtute ſpei Cõ:Gab:
xxv Quia ſpes ñ uenit ex meritis,ſz ex paſſiõis' menta deſtruẽtib? Cõuerſa ĩ ſoqz
i Actus amicitiæ.nõ est perfectiſsimus modus faciendi quod est in ſe.
ii Nec est dispositio perfectiſsima ad grãm sed est modus conuertendi &
 appropinquandi ad deum.
iiii Sed est actus iam ſpectẽ cõuerſiõis.tempe & natura poſterior gratia
v Illꝯ authoritates Conuenimini ad me.& cõuertar ad uos.Itẽ appropin/
 quate deo & appropinquabit uobis Item Q uærite & inuenietis.Item.Si
 quæſieritis me inuenietis a uobis .Si ſis ſimiles.Si dicantur.Q̃ unum na/
 turæ alterꝰ gñæ ſit,Nihil aliud q̃ q̃ pelagiani dixerũt,aſſeritur
vi Optima & infallibilis ad grãm ꝓparatio & unica diſpoſitio.ẽ æterna dei
 electio & prædestinatio.
vii Ex parte aũt hõis.nihil niſi indiſpoſitio imo rebellio græ,grãm ꝓcedit
viii Vaniſsimo cõmento dicitur.ꝓdestinatus põt dãnari in ſenſu diuiſo.Sed
 non in cõposito. Contra Scholaſt:
ix Nihil quoq; efficitur.per illud dictũ.prædestinatio est neceſſaria neceſſi/
 tate conſequentiæ Sed non conſequentis
x Falſũ & illd ẽ.cp facere qd ẽ i ſe.ſit remouere obstacula grẽ Cõ:quoſdã
xi Breuiter.Nec rectũ dictamen habet natura:nec bonã uoluntatem
xii Nõ ẽ uerũ cp ignorantia inuincibilis a tono excuſat Cõ:oẽs ſcholaſt:
xiii Quia ignorantia dei & ſui & boni opis.est naturæ ſemp inuincibilis.
xiiii Item illa i ope ſpecietem'& foris bono.int?neceſſario glorial & ſuꝑbit
xv Nulla est uirtus moralis ſine uel ſuꝑbia uel triſticia.i peccato
xvi Nõ ſumus dñi actuũ nrōq;.a principio uſq; ad finẽ.Sed ſerui
xvii Nõ efficimur iuſti iuſta opando ſed iuſti facti opamur iuſta Cõ:ꝓhōs
xviii Tota fere Ariſtotelis Ethica:peſſima eſt grã inimica Contra ſcholaſt,
xix Error est Ariſtotelis ſententiam de felicitate,nõ repugnare doctrinæ
 catholicæ. Contra Morales
xx Error ẽ dicere,ſine Ariſtotele nõ fit theologus Cõtra dictũ cõe
xxi Immo theologus nõ fit.niſi id fiat ſine Ariſtotele .
xxii Theologus nõ logicus est mõſtroſus hæreticus. Est mõſtroſa & hære/
 tica oratio. Contra dictũ cõe
xxiii Fruſtra fingitur logica fidei.Suppoſitio mediata extra terminum &
 numerum Contra recen:dialect.
xxiiii Nulla forma ſyllogiſtica tenet in terminis diuinis Contra Card:
xxv Nõ tamen ideo ſequitur.ueritatem articuli trinitatis repugnare formis
 ſyllogiſticis Contra eoſdem Card: Ca:

i Si forma ſyllogiſtica tenet i diuis.articulꝰ trinitatis erit ſcitꝰ & nõ creditꝰ
ii Breuiter Totus Ariſtoteles.ad theologiã Est tenebre ad lucẽ Cõ:ſcholt:
iii Dubiũ est vehemẽs.An ſentẽtia Ariſtotelis ſit apud latinos
iiii Bonũ erat eccleſiæ.Si theologis natus nõ fuiſſet Porphyri? cũ ſuis vlib?
v Viſitationes diffinitiones Ariſtotelis.uidentur petere principium
vi Ad actũ meritoriũ ſatiſ ẽ coexiſtẽtia græ.aut coexiſtẽtia nihil ẽ Cõ:Ga:
vii Gratia dei nũq̃ ſic coexiſtit ut ocioſa.Sed ẽ uiuꝰ:mobilis.& opoſuſ ſpũs
viii Nec per dei abſolutã potentiã fieri põt.ut actus amicitiæ ſit & gratia dei
 præſens non ſit. Contra Gab:
ix Nõ põt deus acceptare hominẽ ſine gratia dei iuſtificãte cõ:Occã
x Periculoſa ẽ hæc oro.lex ꝓcipit.cp actus ꝓceptis fiat i grã dei Cõtra
 Card:& Gab:
xi Sequitur ex ea.cp gratiã dei habere .ſit iam noua ultra legẽ exactio
xii Ex eadẽ ſequitur.cp actus præcepti poſſit fieri ſine gratia dei.
xiii Item ſequitur cp odioſior fiat gratia dei q̃ fuit lex ipſa.
xiiii Nõ ſequitur.lex debet ſeruari & impleri in gratia dei cõtra Gab:
xv Ergo aſſidue peccat,qui extra gratiã dei eſt.Nõ occidẽdo,nõ mechãdo,
 non furando &c.
xvi Sed ſequitur.peccat.non ſpiritualiter legem implendo
xvii Spũaliter .nõ occidit.nõ mechat,nõ furat.qui nec iraſcit nec cõcupiſcit.
xviii Extra gratiã dei adeo impoſſibile est.Nõ cõcupiſc:ut nec in
 gratia ſatis id fieri poſſit ad legis perfectionem
xix Hypocritarũ est iuſtitia ope & foris non occidere nõ mechari &c.
xx Gratiæ dei est nec concupiſcere.nec iraſci.
xxi Impoſſibile est.legem impleri ſine gratia dei ullo modo
xxii Q uin etiã magis deſtruitur per naturam ſine gratia dei
xxiii Lex bona neceſſario fit mala.uoluntati naturali
xxiiii Lex & uoluntas ſunt aduerſarii duo.ſine gratia dei impacabiles
xxv Q d lex uult.ſemp uolũtas nõ uult:niſi timore uel amore ſimulet ſe uelle
i Lex est exactor uolũtatis.qui nõ ſupatur:niſi p paruulũ q̃ natus ẽ nobis
ii Lex facit abũdare pctm quia irritat & retrahit uoluntatẽ a ſeipſa
iii Gratia aũt dei facit abũdare iuſtitiã p Iheſū Chriſtũ.q̃ facit placere legẽ
iiii Oĩe opꝰ legis ſine grã dei foris apparet bonũ.ſed itus ẽ pctm Cõ:ſcho:
v Semp auerſa uoluntas.& cõuerſa manus ſunt in lege dñi ſine gratia dei
vi Cõuerſa uoluntas ad legem ſine gratia dei eſt affectu cõmodi ſui talis
vii Maledicti ſunt oẽs.qui opantur opera legis
viii Benedicti ſunt oẽs.qui opantur opera gratiæ dei
ix Cap:falſas de pe:diſt.v.cõfirmat opa extra gratiã nõ eſſe bona ſi nõ falſe
 intelligatur.
x Non tantum cæremonialia ſunt lex nõ bona & præcepta in quibus non
 uiuit Contra mul:docto:
xi Sed & ipſe decalogus & quicqd doceri,dictãriq; intus & foris põt.
xii Lex bona ẽ.qua uiuit.charitas dei eſt ſpũſancto diffuſa i cordib? nr̃is
xiii Volũtas cuiuſlibet.maller(ſi fieri poſſet)eſſe nulla legẽ & ſe oino liberã
xiiii Volũtas cuiuſlibet:odit ſibi legem poni:aut amore ſui cupit poni
xv Cũ lex ſit bona:non ſɇ uolũtas eius inimica:eſſe bona
xvi Et ex illo clare patet.cp oĩs uoluntas naturalis est iniqua & mala
xvii Neceſſaria est mediatrix gratia.quæ conciliet legem uoluntati
xviii Gratia dei datur ad dirigendũ uoluntatem ne erret etiam in amando
 deum Contra Gab:
xix Nec datur.ut frequentius & facilius eliciatur actus. Sed quia ſine ea non
 elicitur actus amoris Contra Gab:
xx Inſolubile est argumentũ ſuperfluã eſſe charitatem . ſi homo naturaliter
 põt in actum amicitiæ Contra Gab:
xxi Subtile malũ est dicere.eundẽ actũ eſſe fruitionem & uſum contra
 Occam : Contra Gab:
xxii Item q̃ amor dei ſtet ex dilectione & delectatione creaturæ.etiã intenſa
xxiii Diligere deũ.ext? ſeipſum odiſſe.& ſter deum niſil nouiſſe
xxiiii Tenemur uelle.nr̃m oino cõformare diuinæ uoluntati. cõtra Card:
xxv Nõ tñ qd uult nos uelle. Sed prorſus,quodcũq; de? uult . uelle debem?.

¶In hiis nihil dicere uolumus:nec dixiſſe nos credimus
quod non ſit catholicæ eccleſiæ & eccleſiaſticis
doctoribus conſentaneum .
·1517·

RÖRER'S NOTE

MARTIN LUTHER'S ANNOTATED PERSONAL COPY OF 'DAS NEUE TESTAMENT DEUTSCH' (1540)

WITH A HANDWRITTEN NOTE BY GEORG RÖRER ON THE POSTING OF THE THESES

C.1544 LETTERPRESS AND MANUSCRIPT ON PAPER
21.9 × 17.6 × 8.9 CM
THÜRINGER UNIVERSITÄTS- UND LANDESBIBLIOTHEK JENA

The various reformers in Wittenberg who knew Martin Luther made an effort at a very early stage to preserve the memory of the Reformation and its most important protagonists. Accounts of different events were shared among the group and with the public and made their way into the annals of world history through theological interpretations. None of the Wittenberg theologians – apart from Luther, Justus Jonas, Johannes Bugenhagen, Philipp Melanchthon and Caspar Cruciger come to mind here – doubted that their work would ensure that God's Gospel would be duly proclaimed throughout the world. Given this mindset, the significance of the posting of the Theses in 1517 as the event that triggered the Reformation soon became apparent. The fact that none of those who later wrote about this historic date were present at the time proved problematic. For this reason, accounts of that event only surface in the context of Luther's death.

In addition to Philipp Melanchthon's biographical recollections of the great reformer, the records maintained by the deacon of Wittenberg's parish church Georg Rörer (1492–1557) contain several notes about the posting of the Theses, all of which originate from the period after 1540. Rörer belonged to Luther's immediate circle; he routinely wrote methodical notes on Luther's lectures and was responsible for the regular printing of his writings in Wittenberg's print shops. As secretary, he was involved in all the revisions of Luther's Bible from 1531. While working on these revisions, Rörer also came across Luther's annotated copy of the New Testament from 1540, as he was charged with checking that the corrections entered in the translation were copied correctly to the new edition of the Bible. On this occasion, Rörer made a note at the end of the volume, which is considered important evidence today of the historicity of the posting of the Theses. Rörer noted: 'On the evening before All Saints' Day [31 October] in the year of our Lord 1517, theses about letters of indulgence were nailed to the doors of the Wittenberg churches by Doctor Martin Luther.' Rörer also noted that Melanchthon came to Wittenberg in 1518. Rörer's record indicates that Luther's Theses were affixed or nailed to the door of the Castle Church, which was used by the university as a notice board, and on the door of the parish church. Posting theses in this way was nothing out of the ordinary, as it allowed members of the university to prepare for a disputation. Rörer's note does not tell us, however, whether Luther posted his Theses himself. The one certainty is that Luther sent his Theses to the Archbishop of Mainz and Magdeburg, Albrecht of Brandenburg, and possibly also to Bishop Hieronymus Schulze von Brandenburg, on 31 October 1517. He probably also contacted other bishops, such as those from Merseburg or Meißen. It was only later that the Theses were printed and distributed far beyond Wittenberg. Rörer's note, probably written while Luther was still alive, connects this date to the posting of the Theses – and thus to the start of the Reformation. Stefan Michel

→ Further reading

Der Reformator mit dem Hammer. Zur Wirkungsgeschichte von Luthers 'Thesenanschlag' bis 1917, Lutherhalle Wittenberg (ed.), Wittenberg 1992.
Luthers Thesenanschlag. Faktum oder Fiktion, Joachim Ott and Martin Treu (eds.), Leipzig 2008.
Stefan Michel: Die Kanonisierung der Werke Martin Luthers im 16. Jahrhundert, Tübingen 2016.

*In pass. Jo. Boun. der mang wir vnd
raus für gedruck solen / Oder vnd meist
wen wis durcken solt.*

Register.

*Anno dom̄ 15|7 in profesto om̄ Sanctor̄ , p̄
Witberge in salue templor̄ proposita sunt
dr Judulgantys, a d Mart Luth*

*Anno
1518
postrate Bartholome riea fora so
Jnt: Mol
prima franj
Wittberga*

Gedruckt zu Wit-
temberg durch
Hans Lufft.
M. D. XL.

MARTIN LUTHER LETTER TO THE ARCHBISHOP OF MAINZ, ALBRECHT OF BRANDENBURG

31 OCTOBER 1517 WITTENBERG MANUSCRIPT ON PAPER
31 × 21 CM
RIKSARKIVET, STOCKHOLM

A document of great courage – this is the letter which Luther wrote on 31 October 1517, on the eve of the feast of All Saints, to Archbishop Albrecht of Brandenburg (1490–1545), the Elector of Mainz, in whose name indulgences were being sold across large swathes of the Empire. An 'unworthy son' presumed to bind his ecclesiastical superior, the highest spiritual dignitary in the Empire, to his pastoral office and hold him to account before God's judgement for the consequences of his actions or failure to act.

The letter is a rhetorically flawless piece of writing. Luther begins with a humble attestation; he describes the practice and preaching of indulgences and laments 'the gross misunderstanding… [that] the poor souls believe that when they have bought indulgence letters they are then assured of their salvation'. He then goes on to write that no man can be assured of his salvation through pardon granted by a bishop, and that the poor souls gain nothing from false stories and promises. Instead of selling indulgences, he believes that the bishops should be ensuring that 'the people learn the Gospel and the love of Christ'.

Moreover Luther vehemently opposes the instructions for the indulgence agents, the *instructio summaria*, which had been published under Albrecht's name. He rails against their provisions and promises and entreats the Archbishop to remove the book from circulation for fear of worse to come: 'If this is not done, someone may rise and, by means of publications, silence those preachers and refute the little book. This would be the greatest disgrace for Your Most Illustrious Highness.'

Luther enclosed with his letter a copy of his theses on indulgences, so that the Archbishop could see 'how dubious is this belief concerning indulgences, which these preachers propagate as if it were the surest thing in the whole world'. Unlike the autograph manuscript of the letter, this copy of the Theses has not survived.

The letter is signed: 'Your unworthy son, Martinus Luther, Augustinian, called Doctor of Sacred Theology'. This signature is of profound significance: for the first time in his life the 33-year-old Wittenberg monk and professor used a form of his name which expressed a transformed, new conception of himself. Born Martin Luder and recorded in the Erfurt university register as 'Martinus Ludher ex mansfelt', through his study of the Bible he had come to a new understanding of Christian freedom. When writing to humanist friends in the months following this letter he would also use the name 'Eleutherius', meaning 'the free' or, more precisely, 'he who has become free through the Gospel'. By writing 'Luther' for the first time on 31 October 1517, he used the 'th' to incorporate this newly acquired freedom into his name. He would continue to use this form of his name for the rest of his life. Never again did he sign a letter with his old name and on the title pages of his printed writings, which began to appear in ever greater numbers and with increasing rapidity from 1518, he always used this name. From 31 October 1517 he was Luther. Johannes Schilling

→ Further reading
WA BR 1, Nr. 48, 108–113; LW 48, 46-48. (See also: Timothy J. Wengert: *Martin Luther's Ninety-Five Theses, with Introduction, Commentary and Study Guide*, Minneapolis 2015, 27–36).
Bernd Moeller and Karl Stackmann: *Luder Luther Eleutherius. Erwägungen zu Luthers Namen*, Göttingen 1981.
Reinhard Schwarz: Martin Luther. Bereit zur Rechenschaft: 31. Oktober 1517, Brief an Erzbischof Albrecht von Mainz, in: *Luther 61* (1990), 109–121.

Gratiam et misericordiam dei et quicquid pot. et est. parve mihi: & una in Chro pr̄
princeps Illustrissime. & ego tuae honorem, tantū dubio temeritate, ut ad Celsum tui
sublimitatem ausus fuerit rogare Epistolam. Testis e mihi deus Ihesus. & meae pravitatis
& improbitatis mihi conscius. diu̅ me distuli, q̄d iam perfricata fronte epistolam. motus
q̄ maximē officio fidelitatis meae, qua me tibi p̄ in christo debere me agnosco. Dignetur̄
itaq̄ tua interim celsitudo, oculum ad pulverem vm̄ inicere & votis meam
pro mea & pontificali clementia intelligere. Circumferuntur indulgentiae papales sub
tuo preclarissimo titulo, ad fabricam S. petri. In quibus non adeo arguo pr̄dicatorum
exclamatores, quas non audivi. Sed dolo. falsissimas intelligentias ppl̄i. ex illis
conceptas. quas vulgo undiq̄ iactant. videlicet. q̄ redeunt miseriores animae, si litteras
indulgentiaru̅ redemerint fuerint sunt de salute sua. Item & animas de purgatorio statim
evolent. ubi contributum in cistam coiecerint. Dein tantus est hic ḡria. ut
nullum sit adeo magnum pec̄m. ut (ut aiunt) si p̄ impossibile ipse matre dei violasset
quiu̅ posset solui. Item & homo p̄ istas indulgentias liber sit ab om̄ pena & culpa
o deus optime. Sic erudiuntur aie christianae animae optime p̄ tempesta[?] ad mortem. Et sic
no[n?] presul[?] durissima ratio tibi reddenda sup̄ ovibus est: crescere tacere hic impietas no[n]
potui. Non eni fit hoc p̄ totum aui[?] ḡ es secura de salute. cum non p̄ ḡria nisi pax[?]
dei fiat securi. Sed si in timore & tremore iubet nos operari salutem nram Aplus.
Et iustus vix salvabitur. Demiq̄ tam arcta e via. quae ducit ad vitam. ut duos p̄
scripturas Amos & zacharias. saluandos appellet turres raptos de incendio Et vbiq̄ dn̄s
difficultatem salutis denunciat. Quod ergo p̄ illos falsas vanas fabulas & promissiones
securos pplos securum & sine timore? Cum indulgentiae prorsus nihil boni conferant
animab[us] ad salutem aut sanctitatē. Sed hū p̄na expiatoria olim canonica imponi solitam
auferant. Demiq̄ opa pietatis & charitatis sunt in infinitū meliora indulgentiis.
Et t̄n̄ hec no tanta pompa nec tanto studio praedicant. imo propter venias silentio
illa tacent. In hoc om̄ epos. hoc sit officium primum & summum. ut iste Euangeliū discat
& charitatē chris[?] Nusq̄ em̄ chrs̄ praecepit indulgentias praedicari. sed Euangelium vehementer
praecepit praedicari. Quae ergo horror e iustu̅ periculu̅ epi. si taceto tua ipsi. non nisi praedicatas
indulgentias. permittat in ppls̄ suos. Et hos prius curet q̄ Euangel[?] Nonne dicet illis
chrs̄ Coluistes culicem & glutientes camelum? Arrecto ad hoc ut me ipsi
m[?] du̅. & in instructione illa co̅issario[?]. Sed mi p̄. nominis etiam. Doctoris
(Cuiq̄ sine hoc p̄. vis. & sententia & consensu) Vestrae p̄principalitati ḡtiae est. Domini
Alb[erti?] dei incestimabile. si reconiliari bono deo & om̄ pena debiturum purgatorii
M & no sit nra cautio ipsis. q̄ om̄ vel co̅fessionalia redimunt. Sed q̄d faciam?
optime prsl̄ & Illustrissime princeps. Nisi q̄ p̄ vra̅ Illm̄ chtem. te vrȳ vra̅ p̄ orem
Illm̄ custum iter̄ meam dignetur advertere. & emos libellos penitus tollere. &
praedicatoribus venias imponere aliam p̄dicādi formā. Ne forte aliquis omnis exurgat
qui istos libellos. & illos & libellos illos gʔ[?] salet. ad refellen̄ secund̄. Illustrissimae tuae
sublimitatis ḡd ego verebundus q̄d fieri verebor. & in futurum timore nisi tibi
suvenerit[?] H̄c meae pietate fidelia officia rogo ego Illustrissime princeps
Dignetur accipe no p̄principali & Episcopali velle clementissime. sic ego in exhibeo
deo nostr̄ inclination͡e + vrȳ p̄ mysterium Amen. Et Wittenberge 1517.
Vigilia om̄s sctor̄. Si + vrȳ p̄ placet petere hos meos dispnta[?] scrip[?] velle
ut intelligat q̄ Dubia res sit. indulgentiaru̅ opinio: quā illi ut certissimā affirmant

Indignus filius.
Martinus Luther
August. Doctor Scto[?]
vocatus

MARTIN LUTHER'S 95 THESES WITH A HANDWRITTEN NOTE BY JOHANN LANG

PRINTER: JACOB THANNE
LEIPZI

1517 LETTERPRESS AND MANUSCRIPT ON PAPER 40 × 28 CM
GEHEIMES STAATSARCHIV PREUSSISCHER KULTURBESITZ

Whether or not they were posted on 31 October 1517, Luther's theses on indulgences indisputably marked the beginning of a period which would later come to be known as the Reformation. Yet 500 years later we still ask whether the reformer nailed his 95 Theses to the door of Wittenberg's Castle Church or simply enclosed them with letters to his superiors, Archbishop Albrecht of Brandenburg and probably also Bishop Hieronymus Scultetus (Schulze). Or, perhaps the most likely scenario: he did both. One thing is certain – Luther himself saw this date as epoch-making: on 1 November 1527 he drank a toast to the fact that a decade had passed since indulgences had been 'trampled into the ground' (WA BR 4, Nr. 1164, 275). However, Luther had originally been aiming for less comprehensive changes – he merely wished to prompt the issuing of a theological definition of indulgences. By writing his list of theses he chose the customary form of the disputation used by doctoral students defending their theses. In this process candidates used their theses to show they could defend their position against opponents who had prior knowledge of the points at issue. Luther expanded this process for clarifying academic questions by inviting external theologians to submit their opinions on the power of indulgences, as the matter had not yet been established dogmatically. However, the criticisms contained in the list of theses made the theologians he approached extremely wary of engaging in the proposed academic disputation: in addition to questioning religious practice that was too focused on appearances and the effectiveness of purchasing indulgences for the attainment of salvation, Luther also challenged the Pope's authority to exercise power in relation to indulgences.

Thus, although they did not ultimately form the basis of an academic disputation, Luther clearly touched a nerve with his Theses. Without his involvement they were reprinted twice and distributed widely, with the result that, in early 1518, owing to the rumours abounding among the public, he felt himself compelled to reiterate his point of view. He did this in German, so it would be more generally comprehensible, through the *Sermon on Indulgences and Grace*, a publication which reached an even wider audience and with greater effect.

The first edition of the Theses was evidently printed by the workshop of Jacob Thanner in Leipzig, which was primarily engaged in the printing of academic literature. On 11 November 1517 Luther sent a copy of this edition to his friend and fellow monk, Johann Lang (1487–1548), in Erfurt, and asked him to undertake a theological evaluation of the Theses (WA BR 1, Nr. 52, 121–123).

The letter, now preserved by the Geheimes Staatsarchiv Preußischer Kulturbesitz, includes a handwritten note by Lang: '*Anno 1517 ultimo Octobris vigilie Omnium sanctorum indulgentie primum impugnatae*' – 'In the year of 1517 on the last day of October, on the Eve of All Saints, indulgences were challenged for the first time'. The Leipzig printing, of which only two other copies survive, in Wrocław and Zeitz, may have been intended to be displayed on the door of Wittenberg's Castle Church and was probably also enclosed in the letter to Albrecht. Mirko Gutjahr

→ Further readin
Martin Treu: Urkunde und Reflexion. Wiederentdecku
eines Belegs für Luthers Thesenanschlag, in: *Luthers T*
senanschlag. Faktum oder Fiktion, Joachim Ott and Marti
Treu (eds.), Leipzig 2008, 59–68.
Wolfgang Thönissen: Luthers 95 Thesen gegen den Abla
(1517). Ihre Bedeutung für die Durchsetzung und W
kung der Reformation, in: *Meilensteine der Reformatio*
Schlüsseldokumente der frühen Wirksamkeit Martin Luthe
Irene Dingel and Henning P. Jürgens (eds.), Munich 20
89–90.
Volker Leppin and Timothy J. Wengert, Sources for ar
against the Posting of the Ninety-Five Theses, in: *Luth*
an Quarterly 29 (2015), Baltimore 2015, 373–398.

¶ Amore et studio elucidande veritatis, hec subscripta disputabuntur Wittenburge Presidente R.P. Martino Luther Eremitano Augustiniano Artiũ et S. Theologie Magistro, eiusdemq̃ ibidem lectore Ordinario. Quare petit vt qui non possunt verbis presentes nobiscum disceptare / agant id literis absentes.
In Nomine dñi nostri Ihesu Christi, Amen.

1 Dñs et magister noster Ihesus Christus, dicendo penitẽciã agite 2c. omnẽ vitam fidelium, penitentiam esse voluit.

2 Q̃ verbũ de penitẽtia sacramẽtali (.i. cõfessionis et satisfactionis que sacerdotum ministerio celebratur) non potest intelligi.

3 Nõ tñ sola interiorẽ : immo interior nulla est, nisi foris operetur varias carnis mortificationes.

4 Mãnet itaq̃ pena donec manet odiũ sui (.i.penitẽtia vera intus) sc̃z vsq̃ ad introitum regni celorum.

5 Papa nõ vult nec põt, vllas penas remittere, preter eas, q̃ arbitrio vel suo vel canonum imposuit.

6 Papa nõ potest remittere vllã culpam, nisi declarando et approbando remissã a Deo. Aut certe remittendo casus reseruatos sibi, quibus contẽptis culpa prorsus remaneret.

7 Nulli prorsus remittit deus culpã, quin simul eũ subijciat, humiliatũ in omnibus, sacerdoti suo vicario.

8 Canones penitentiales solũ viuentibus sunt impositi, nihilq̃ morituris frñ eosdem debet imponi.

9 Inde bñ nobis facit Spũssanctus in papa, excipiendo in suis decretis semper articulum mortis et necessitatis.

10 Indocte et male faciũt sacerdotes ij, qui morituris pñias canonicas in purgatorium reseruant.

11 Zizania illa de mutanda pena canonica in penas purgatorij, videtur certe dormientibus Episcopis seminata.

12 Olim pene canonice nõ post, sed ante absolutionẽ imponebanr, tãq̃ tentamenta vere contritionis.

13 Morituri per morte omnia soluunt, et legibus canonũ mortui iam sunt : habẽtes iure earum relaxationes.

14 Imperfecta sanitas seu charitas morituri, necessario secum fert, magnũ timorem, tantoq̃ maiorem : quanto minor fuerit ipsa.

15 Hic timor et horror, satis est se solo (vt alia taceã) facere penã purgatorij, cũ sit proximus desperationis horrori.

16 Videnr infernus, purgatoriũ, celũ differre, sicut despatio : q̃ despatio, securitas differunt.

17 Necessariũ videt aiabus in purgatorio sicut minui horrorẽ, ita augeri charitatẽ.

18 Nec probati videtur vllis, aut rõnibus aut scripturis, q̃ sint extra statũ meriti, seu augende charitatis.

19 Nec hoc probatum esse videt, q̃ sint de sua beatitudine certe et secure saltem omnes, licet nos certissimi simus.

20 Igitur Papa per remissionẽ plenariã oim penarũ, nõ simpliciter oium intelligit, sed a seipso tantummodo impositarum.

21 Errant itaq̃ indulgẽtiarũ pdicatores ij, qui dicunt per Pape indulgẽcias, hominem ab omni pena solui et saluari.

22 Quin nullam remittit aniabus in purgatorio, quã in hac vita debuissent, frñ Canones soluere.

23 Si remissio vlla oim omnino penarũ, potest alicui dari, certum est eam non nisi perfectissimis, .i. paucissimis dari.

24 Falli ob id necesse est, maiorẽ pte populi, per indifferentẽ et magnificã penarũ solute promissionem.

25 Qualẽ potestatẽ habet Papa in purgatoriũ generaliter : talẽ habet, quilibz Episc̃ et Curatus in sua Diocesi et parochia specialiter.

26 Optime facit Papa, q̃ nõ potestate clauis (quã nullã bz) sed per modũ suffragij dat animabus remissionem.

27 Hominem predicant, qui statim, vt iactus nũmus in cistam tinnierit : euolare animã dicunt.

28 Certum est nũmo in cistam tinniente : augeri questũ et auariciã posse : suffragiũ aũt ecclesie est in arbitrio Dei solius.

29 Quis scit si omes anime in purgatorio velint redimi, sicut de S. Seuerino et paschali factum narratur.

30 Nullus securus est de veritate sue cõtritionis : multo minus de consecutione plenarie remissionis.

31 Ut rarus est vere penitens : tã rarus est vere indulgẽcias redimẽs. i. rarissimus.

32 Damnabuntur ineternũ cũ suis magistris : qui p̃ lras veniarum securos sese credunt de sua salute.

33 Cauendi sunt nimis, qui dicunt venias illas Pape, donum esse illud Dei inestimabile, quo reconciliatur homo deo.

34 Gratie eñ ille veniales, tantũ respiciũt penas satisfactionis sacramentalis ab homine constitutas.

35 Non christiana pdicant, qui docet, q̃ redempturis animas vel confessionalia nõ sit necessaria contritio.

36 Quilibet Christianus vere cõpunctus, habz remissionem plenariam a pena et culpa, etiam sine literis veniarum sibi debitam.

37 Quilibet verus christianus siue viuus siue mortuus, habz participationem omnium bonorum Christi et ecclesie, etiã sine literis veniarum a Deo sibi datã.

38 Remissio tamen et participatio Pape, nullo modo est cõtemnenda, quia (vt dixi) est declaratio remissionis diuine.

39 Difficillimũ est etiam doctissimis Theologis, simul extollere veniarum largitatẽ et cõtritionis veritatem coram populo.

40 Contritionis veritas penas querit et amat. Veniarum autem largitas relaxat, et odisse facit saltem occasione.

41 Caute sunt Apostolice pdicande : ne populus false intelligat, eas preferri ceteris bonis operibus charitatis.

42 Docendi sunt christiani, q̃ Pape mens nõ est : redemptionem veniarum vlla ex parte comparandã esse operibus misericordie.

43 Docendi sunt Christiani, q̃ dans pauperi, aut mutuans egenti, melius facit, q̃ si venias redimeret.

44 Quia p opus charitatis crescit charitas et fit homo melior : sed per venias nõ fit melior, sed tantummodo a pena liberior.

45 Docendi sunt christiani, q̃ qui videt egenũ et neglecto, dat pro venijs non indulgentias Pape, sed indignationem dei sibi vendicat.

46 Docendi sunt christiani, q̃ nisi superfluis abundent, necessaria tenentur domui sue retinere, et nequaq̃ p̃ter venias effundere.

47 Docendi sunt Christiani, q̃ redemptio veniarum est libera : non precepta.

48 Docendi sunt Christiani, q̃ Papa sicut magis eget, ita magis optat : in venijs dandis p se deuotam orõnem, q̃ promptam pecuniam.

49 Docendi sunt Christiani, q̃ venie Pape sunt vtiles : si nõ in eas cõfidant : sz nocentissime : si timorem dei per eas amittant.

50 Docendi sunt Christiani q̃ si Papa nosset exactiones venialiũ pdicatorũ, mallet Basilicã S. Petri in cineres ire, q̃ edificari : cute carne z ossibz ouiũ suarũ.

51 Docendi sunt Christiani, q̃ Papa sicut debet ita vellet : etiã vẽdita (si op' sit) Basilicã S. Petri, de suis pecunijs dare illis : a quorũ plurimis quidã concionatores veniarum pecuniam eliciunt.

52 Vana est fiducia salutis p literas veniarũ etiã si Cõmissarius : immo Papa ipse suam animã p illis impignoraret.

53 Hostes Christi et Pape sunt ij, qui propter venias pdicãdas verbũ dei in alijs ecclesijs penitus silere iubent.

54 Iniuria sit vbo Dei : dũ in eodẽ frñe : equale vel longius tps impenditur venijs q̃ illi.

55 Mens Pape necessario est q̃ si venie (q̃ minimũ est) vna cãpana : vnis põpis et ceremonijs celebrantur.

56 Euãgeliũ (q̃ maximũ est) centũ cãpanis : cẽtũ põpis : centũ ceremonijs pdicetur.

57 Thesauri ecclesie : vnde Papa dat indulgentias : neq̃ satis nominati sunt : neq̃ cogniti apud populum Christi.

58 Temporales certe nõ esse patet q̃ nõ tam facile eos p̃fundũt : sed tantummodo colligunt multi Concionatorum.

59 Nec sunt merita Christi et sanctorũ : qr hec semp sine Papa : operantur gratiam hominis interioris : et crucẽ mortem infernũq̃ exterioris.

60 Thesauros ecclesie S. Laurentius dixit esse : pauperes ecclesie : sed locutus est vsu vocabuli suo tempore.

61 Sñ temeritate dicim' claues ecclesie (merito Christi donatas) esse thesaurũ istũ.

62 Clarũ est eñ q̃ ad remissionẽ penarũ et casuũ sola sufficit ptãs Pape.

63 Verus thesaurus ecclesie est sacrosanctũ Euangeliũ glorie et gratie Dei.

64 Hic aũt est merito odiosissimus : quia ex primis facit nouissimos.

65 Thesaurus aũt indulgẽtiar merito est gratissimus : q̃ ex nouissimis facit prios.

66 Igitur thesauri Euãgelici rb. tia sunt : quibus olim piscabãt viros diuitiarũ.

67 Thesauri indulgentiar rbetia sunt : quibus nũc piscabãtur diuitias virorum.

68 Indulgentie : quas Concionatores vociferantur maximas gras : intelligunt vere tales : quo ad questum pmonendum.

69 Sunt tamẽ re vera minime ad gratiam Dei et Crucis pietatem compate.

70 Tenentur Epi et Curati veniariũ Apostolicariũ Cõmissarios cũ oim reuerentia admittere.

71 Sed magis tenenr oibus oculis intendere : oiñbz auribus aduertere : ne p commissione Pape sua illi somnia pdicent.

72 Contra veniarũ Aplicarũ veritatẽ : qui loquit : sit ille anathea et maledictus.

73 Qui vero cõtra libidine ac licentiã verbor Concionatorũ veniarũ : curam agit : Sit ille benedictus.

74 Sicut Papa iuste fulminat eos : qui in fraude negocij veniarum : quacũq̃ arte machinantur.

75 Multo magis fulminare intendit eos : qui per veniarum p̃textum in fraude sancte charitatis et veritatis machinantur.

76 Opinari venias papales tantas esse vt soluere possint hominẽ etiã si quis p impossibile Dei genitricem violasset : Est insanire.

77 Dicim' cõtra q̃ venie Papales : nec minimũ venialium peccatorum tollere possunt : quo ad culpam.

78 Quod dicit : nec si S. Petrus mõ Papa esset : maiores gras donare posset : est blasphemia in S. Petrum et Papam.

79 Dicimus cõtra : q̃ etiã iste et quilibet Papa maiores bz : sc̃z Euangelium : virtutes : gras curationũ 2c. vt .i. Corin. 12.

80 Dicere crucem armis Papalibus insigniter erectam : Cruci Christi equiualere : Blasphemia est.

81 Rationẽ reddent Epi : Curati : et Theologi : Qui tales sermones in populũ licere sinunt.

82 Facit hec licentiosa veniarũ pdicatio : vt nec reuerentiã Pape facile sit etiam doctis viris redimere a calũnijs : aut certe argutis questiõibus laicorum.

83 Scz cur Papa nõ euacuat purgatoriũ p̃ter sanctissimã charitatẽ et summã animarũ necessitatẽ vt cãm oim iustissimã : Si infinitas animas redimit p̃ter pecuniam funestissimã : ad structurã Basilice vt causam leuissimam.

84 Itẽ cur permanent exequie et anniuersaria defunctorũ : z nõ reddit : aut recipi pmittit bñficia p illis instituta : qr iam fit iniuria p redemptos orare.

85 Itẽ que illa noua pietas Dei et Pape : q̃ impio et inimico p̃ter pecuniã concedunt : animã piam et amicam dei redimere : Et tñ p̃ter necessitatẽ ipsiusmet pie et dilecte anime : nõ redimunt eam gratuite charitate.

86 Itẽ cur Canones pñiales : reipa et nõ vsu : iã diu in semet ipso abrogati et mortui : adhuc tñ pecunijs redimunr p concessione indulgẽtiar : tãq̃ viuacissimi : cui.

87 Itẽ Cur Papa cuius opes hodie sunt opulentissimis Crassis crassiores nõ de suis pecunijs magis q̃ pauper fidelis struit vnã tñ Basilicã S. Petri.

88 Item : Quid remitti : aut pticipat Papa his : qui p cõtritione p̃fectam : ius habent plenarie remissionis et participationis.

89 Item : Quid adderetur ecclesie boni maioris : Si Papa sicut semel facit : ita centies in die cuilibet fidelium has remissiones et participationes tribueret.

90 Ex quo Papa salutem querit animar p venias magis q̃ pecunias : Cur suspendit literas et venias iam olim cõcessas : cũm sint eque efficaces.

91 Hec scrupulosissima laicor argumẽta : sola ptãte cõpescere : nec reddita rõne diluere : Est ecclesie et Papã hostibus ridendos exponere et infelices christianos facere.

92 Si ergo venie frñ spiritum et mentem Pape pdicarentur : facile illa omnia soluerentur immo non essent.

93 Valeat itaq̃ oẽs illi pphete : q̃ dicũt populo Christi : pax pax : et nõ est pax.

94 Bñ agat oẽs illi : q̃pete qui docuit populo Christi : Crux crux : et nõ est crux.

95 Exhortandi sunt Christiani vt caput suum Christũ per penas : mortes : infernosq̃ sequi studeant.

96 Ac sic magis per multas tribulationes intrare celum : q̃ per securitatem pacis confidant.

1517.

'MY CONSCIENCE HAS BEEN FREED, AND THAT IS THE MOST COMPLETE LIBERATION.'

WA 8, 575; LW 48, 33

After posting his 95 Theses, Luther completely transformed his concept of faith, starting from its very foundations. Aided by lively exchanges of ideas with colleagues and disputes with his adversaries, he developed his new understanding of faith over a period of a few years. Luther experienced these new insights as immensely liberating and saw his path to public recognition as a coming of age. However, his radical idea of the universal priesthood of believers, which was already heralded in his theses against indulgences, provoked a strong reaction from the church authorities. His activities in the public sphere, above all at the Diet of Worms in 1521, reinforced Luther's sense of freedom. His religious liberation brought with it a new attitude to life and the world.

'I AM TAKING THE LIBERTY...'

ATHINA LEXUTT

1. Freedom: a central concept of the Reformation

'I am taking the liberty' – we often say this with a twinkle in the eye and an engaging smile to indicate that we are deliberately choosing to do something that may well fly in the face of convention. A hint of inner authority and autonomy is also discernible here, along with a measure of humility.

'I am taking the liberty' – in this specific sense, the phrase could also serve as a watchword for Luther's chosen path through life, as it should for all Protestant Christians who have experienced and truly understood the message of Scripture, which Martin Luther reformulated and established at all levels of theological and church doctrine and life.

The discovery of freedom is undoubtedly among the most momentous events of the Reformation. The philosophical, political and social upheavals which continued throughout the Enlightenment certainly had their roots in a process set in motion by the Reformation. Indeed, the modern understanding of freedom is almost inconceivable without Luther.

However, precisely because this concept is of such great significance, it is highly sensitive and has been – and continues to be – misunderstood and misused in several respects. So what did Luther mean when he declared

that 'One thing, and only one thing, is necessary for Christian life, righteousness, and freedom. That one thing is the most holy Word of God, the gospel of Christ' (WA 7, 50/33–35; LW 31, 345)? Here, Luther makes a crucial point perfectly clear: 'freedom' is not a concept that can be considered in isolation but must be understood within a wider context. 'Life', 'righteousness' and 'freedom' form an indissoluble whole which has its sole foundation in the Word of God. But what exactly does this mean?

2. Inner freedom

'Here I felt that I was altogether born again and had entered paradise itself through open gates' (WA 54, 186/8 f.; LW 34, 337). Looking back, this is how Luther describes his own breakthrough to the realisation that it is not he who must strive to be righteous in order to please God and be able to face His divine judgement, but that God shows him mercy and grants him his righteousness, which human beings can never attain for themselves. This is how Luther describes his understanding of justification. This is how he describes his inner freedom. Prior to this, he had done all that tradition provided to placate God and to obtain His grace. Despite this, he felt an increasing lack of freedom, and was driven ever deeper into depression and despair. Nothing he did to appease his conscience – and his life as a monk provided him with ample opportunity – could reassure him that he could bring enough evidence before God's judgement to be found righteous and be permitted to enter paradise. He read Scripture over and over again and became angry at this God who demanded righteousness in the actions of humans in the full knowledge that they could never achieve it. Until, that is, he reread Paul together with the prophet Habakkuk and finally understood that it is not human righteousness that is important. What matters is God's righteousness. And what this means is that God makes humans righteous – without any human action. Indeed, even in spite of their actions. This liberated Luther from the vicious circle in which he had been trapped – and led him to mount a campaign for his new understanding of freedom.

3. Freedom through Scripture

Luther could not keep his inner experience of freedom to himself. It caused him to denounce the contemporary practice of selling indulgences, which lulled his confessants into a false sense of security and tempted them to give no further thought to their relationship with God, human sin and divine mercy, but to regard the entire justification procedure as an automated process which could be simplified by financial means. The renowned 95 Theses of 1517, in which he called on the Pope to put a stop to a practice which he must surely also perceive as wrong, make it clear that Luther had begun to break free from the established authorities: henceforth, the scope

of his argumentation would be determined not by the Church Fathers, conciliar tradition or ecclesiastical decrees but by Holy Scripture. Over the course of several academic disputations, the argument intensified. Momentum gathered to expose as fundamentally unchristian previously uncontested items of doctrine, which could not be clearly demonstrated as deriving from Scripture or even contradicted it outright, and to declare recourse to Scripture to be the only valid way to pursue theology. This emancipation from the tradition reached its zenith at the Leipzig Disputation in 1519, in which Luther contrasted the fallibility of popes and councils with the clarity and unambiguous nature of Scripture. In his response to the papal bull of excommunication in 1520, Luther reaffirmed this scriptural principle, which is fundamental to all reforming movements. Theological thinking, what is said and how to act are grounded solely in Scripture. No other text or person, no other declaration of belief, however significant, and no dogmatic Church rulings have such binding authority.

In the longer term, this distinction between binding Scripture and entirely authoritative but ultimately non-binding confessions was founded on an intensive engagement with Scripture, which gave rise to the historical-critical exegesis that reached its peak in the nineteenth century. Based on this, Protestant theology can engage in discussion with other sciences, is open to debate, and free to continually submit its own declarations to critical analysis and assess them in the light of new research findings. Theology can and, indeed, must be a free science to be able to fulfil its functions: i.e. to provide care for the people entrusted to it, among other things. In the immediate context, in particular for Luther himself, this meant that in matters of religious controversy he had to obey neither pope nor emperor, but only Scripture and his own conscience.

4. Freedom of conscience

Luther specifically invoked his freedom of conscience at the imperial Diet of Worms in 1521. Called on to renounce those of his writings which had been declared heretical, he insisted that they be refuted, where possible, on the basis of Scripture. He declared that in any case he could not act against his conscience and deny what he recognised in Scripture as the divine Word, not even in the face of certain death, the penalty awaiting him as a notorious heretic. In the period that followed, Luther drew immense strength from this, strength that would sustain him through the maelstrom of the Reformation.

He had already summed this up in *The Freedom of a Christian* (1520): in faith, Christians are answerable to God alone. As God – made visible and understandable in the Christ event – has absolved them and freed them from sin, death and the Devil through the Cross, they have freedom of conscience, which might be described as the location of anticipated judgement.

Even when subjected to imprisonment or any other internal or external tribulation, they remain free. In faith, they are given freedoms which offer comfort, affirm the grace of God, and sustain them through internal affliction and external hostility. For Luther, to restrict this freedom again, for example through monastic vows, was tantamount to the betrayal of God's gift of freedom. However, freedom does not mean the absence of all obligation.

5. Freedom in obligation

Luther's writings on freedom not only assert freedom through faith in God, but also the obligation to love one's neighbour. Freedom in faith or conscience does not lead to autarchy and arbitrariness, but to freedom to work for the needs of one's neighbour. Christians are truly free to do this as they must no longer strive to please God through their good works. Through God's grace they can now concentrate fully on the needs of their neighbours and the challenges of the world, not on themselves but on others. It is no coincidence that the Reformation rediscovered social welfare as an area of church activity, and that Protestantism made pioneering contributions in this field, particularly in the nineteenth century. But something much more profound is evident here. The Protestant understanding is that humans are not made to be solitary beings. They live in and from relationships and communication with each other. The world must be affirmed, and this includes affirmation through partnership, marriage, family and community, finding joy in and with others, caring for them and supporting them. Christian freedom, as Luther understood it, does not release humankind from the obligations of this world, but establishes and shapes them. Luther himself was a living example of this: his joy in his wife and children, his joy in food and drink, his joy in conversation with his friends and students were all expressions of this new-found freedom. This freedom also calls for political, social and cultural engagement, for the establishment of a relationship with state authorities, and for alertness to developments in the spirit of the times.

6. Freedom of guilt

Therefore, freedom is not freedom *from* acting, but rather freedom to act. However, Luther's understanding of justification warns against the great fallacy that, by virtue of their Christianity, Christians can clearly distinguish between good and bad actions and can choose the good. Sin, according to Luther, is just as present within him as God's promise. Christians perceive sin everywhere and trust in deliverance. Even their greatest powers, reason and will continue to be subject to sin, that is, subject to the tendency towards autarchy and lack of commitment. So it does not matter what Christians decide; they have no clear criterion for determining good

and evil, and their actions will never be good in an absolute sense. So would it be better not to act? On the contrary, liberated from the compulsion to find the best way to act and thereby possibly missing the opportune moment to do so, they can begin to act immediately, fully conscious of three conditions: first, to be ready to accept guilt; second, to confess guilt; and third, to be able to hope for forgiveness. Freedom is the basis of the Christian ethos and accommodates a Christian ethic in which ethical principles are not rigidly formulated, and which strives to make it possible to act in a way that serves life, when necessary. In this regard, almost all Luther's texts read as recommendations for the moment. Hence, we are free today to engage with them as witnesses of their times and as witnesses of a foundation discovered in freedom through the Word of God, grounded in the promise of God's grace and love.

7. 'I am taking the liberty...'

Luther himself lived and formulated his theology in the awareness of his liberation by God and, at the same time, with a sense of humility: he felt that the gift of freedom he had received was undeserved and was constantly under threat. With bold self-assurance and an attitude of humorous self-distance, he could stand up firmly for God's Word and expose those who appeared to be its adversaries. Everyone, not just Christians but all others too, would do well to keep this freedom in mind and to strengthen its presence in their own lives, in gratitude for God's grace and with a sense of responsibility for the world.

THE MASS OF ST GREGORY WITH CARDINAL ALBRECHT OF BRANDENBURG

1520–30 OIL ON PANEL 150.2 × 110 CM
BAYERISCHE STAATSGEMÄLDESAMMLUNGEN, ASCHAFFEN-
BURG, STAATSGALERIE IN SCHLOSS JOHANNISBURG

A legend well known since the fourteenth century tells of a special gift of grace granted to Pope Gregory the Great (c.540–604), whose intense devotions on the Passion of Christ at an altar in the church of Santa Croce in Rome were rewarded when Christ appeared before him as the Man of Sorrows. Accounts of this event were widely disseminated, particularly in pictorial form: in the fifteenth and sixteenth centuries, until the Reformation, St Gregory's Mass was one of the most popular motifs for memorial panels, ecclesiastical murals, altarpieces, panel paintings, broadsheet prints and prayer-book illustrations. Towards the end of the fifteenth century, the Pope's devotions at the altar became ever more closely associated with the celebration of mass. Viewed in this context, the appearance of Christ confirmed the late mediaeval belief in his real presence during the mass.

In this work, commissioned by Cardinal Albrecht of Brandenburg, an unknown master of the school of Lucas Cranach the Elder depicts Gregory's prayers on the Passion. Attended by a deacon and subdeacon, the Pope kneels before an altar. On the altar table, next to various liturgical objects, is the papal tiara. The Man of Sorrows rises from a sarcophagus on the altar, while above Him hangs a cloud in which putti and *arma Christi*, the Instruments of the Passion, symbolising individual stages of the Passion, can be seen. A ewer and basin and two hands represent Pilate washing his hands; the column and scourge are reminders of the flagellation of Christ and the ladder of the descent from the Cross; the head of St Peter, turned towards a woman, and the cockerel recall Peter's denial of Christ. The bust of Judas, a purse hanging round his neck, kisses the cheek of Jesus, recollecting the betrayal of Christ. In the background, a choir sings, while seated before them are Cardinal Albrecht of Brandenburg, a bishop and a second cardinal. In front of these three dignitaries of the Church are a cardinal's hat, prayer book and rosary beads, symbols of their piety and ecclesiastical status. The Man of Sorrows, who takes suffering upon himself for the salvation of humanity, turns towards these three representatives of the Roman Church, indicating that they are receiving the privilege of the grace of Jesus Christ.

Pope Gregory's mass vestments are embellished on the pearl-encrusted collar with the face of Christ as Vera Icon and on the back with an embroidered representation of the crucifixion. The papal robes are bearers of the true image of Christ and the cross, with its promise of salvation. Both depictions of Christ look out directly at viewers, so that their first intimation of the sacrifice Christ made for them is conveyed through the Pope as he celebrates the mass. It is thus made clear to mediaeval believers that salvation cannot be attained outside the Church, and that they can only obtain the blessing of God's grace mediated through officials of the Church. Luther refuted the sacrificial character of the mass and developed a new understanding of the function of the Church, which differed from that of the late Middle Ages. He taught that believers receive blessing directly from Christ, with no need for any intermediary authority.

Susanne Wegmann

→ Further readin
Christian Hecht: Die Aschaffenburger Gregorsmesse
Kardinal Albrecht von Brandenburg als Verteidiger de
Meßopfers gegen Luther und Zwingli, in: *Der Kardin*
Albrecht von Brandenburg. Renaissancefürst und Mäzen, v
2: Essays, Andreas Tacke (ed.), Regensburg 2006, 80–11
Esther Meier: *Die Gregorsmesse. Funktionen eines spätm*
telalterlichen Bildtypus, Cologne 2006.
Das Bild der Erscheinung. Die Gregorsmesse im Mittelalt
Thomas Lentes and Andreas Gormans (eds.), Berlin 200

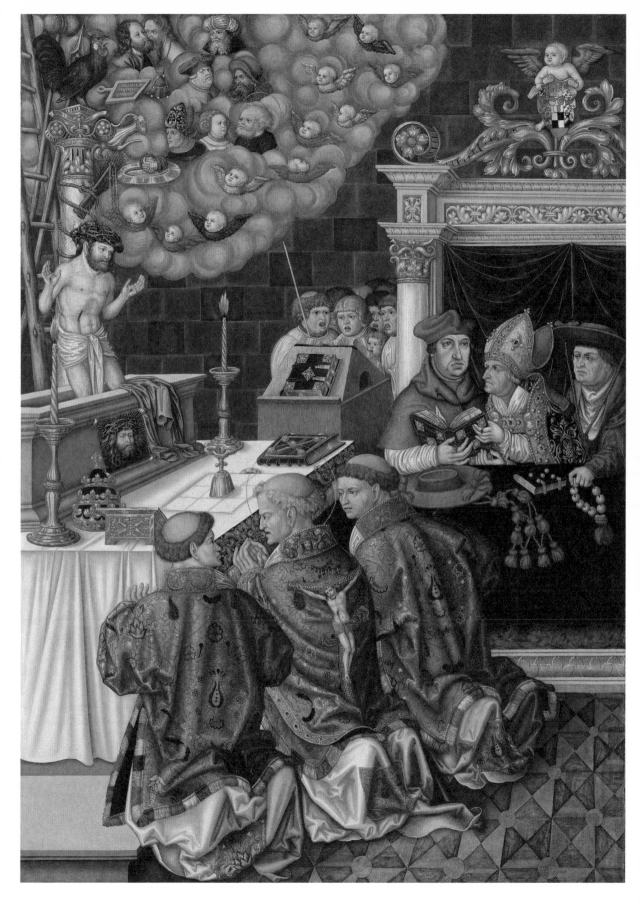

C.1540 OIL ON PINE PANEL 55 × 59.2 CM
WALLRAF-RICHARTZ MUSEUM &
FONDATION CORBOUD, COLOGNE

'Through the law comes knowledge of sin. The law brings wrath. The sting of death is sin, and the power of sin is the law.' These quotes from St Paul's epistle to the Romans and from his first epistle to the Corinthians are inscribed on a black block in the foreground of this painting. Their implicit warnings all relate to the left half of the composition, where Moses and two Old Testament prophets are shown pointing to the tablets of the law in front of a half-withered, half-flourishing tree. Human beings' recognition of their own sinfulness, which comes to them through the law, drives them into the depth of Hell. Like Adam and Eve, they are not able to do justice to the divine law by their works, with the result that Death and the Devil triumph and Christ appears as the implacable judge.

It is only in the right half of the painting that the sinner will find the path to salvation. John the Baptist points to the crucified Christ: 'Behold, the Lamb of God, who takes away the sin of the world!' These words encourage human beings to seek refuge in Christ, who will wrestle with and defeat Death and the Devil for their sakes. In the same way that the faithful Israelites were saved by looking at the bronze serpent put up on a pole by Moses, sinners could achieve salvation through their faith in Christ.

The first paintings illustrating Luther's doctrine of justification in this way were produced by Lucas Cranach's workshop in Wittenberg around 1529. No doubt the reformers and theologians in Cranach's circle had a direct influence on this painting. It proved to be the most successful Lutheran composition, which became widely known in particular through its use on the title page of Luther's translation of the Bible. On altars and epitaphs, on pulpits and in stained glass windows, it spread the word of Luther's doctrine of salvation through faith alone. The image, which was also reproduced on items in everyday use – book bindings, stove tiles, chests, tapestries, stoneware tankards – found its way into all areas of daily life. No other composition so vividly conveyed Lutheran faith, no other composition carved out such a firm place for itself in Lutheran beliefs or did so much to reinforce Lutheran identity.

This panel painting is attributed to the Hamburg artist Franz Timmermann (c.1515 – after 1540). In 1538 the Hamburg city fathers had sent him to train, on a scholarship, at the Cranach workshop in Wittenberg. The Reformation had already had a firm foothold in Hamburg since 1528, and the following year the city introduced Johannes Bugenhagen's church order. Evidently the hope was that Cranach and his assistants would instruct Timmermann in iconographies that were suited to Lutheran doctrine and its dissemination. Timmermann's variants on Cranach's motifs mainly featured half-length figures, which allowed the viewer to relate all the more directly to the depicted consequences of the law and grace. The influence of Cranach is always evident in Timmermann's paintings, creating a visible link with Wittenberg as the original locus of the Reformation.

Susanne Wegmann

→ Further readin

Himmel, Hölle, Fegefeuer. Das Jenseits im Mittelalter, Pet
Jezler (ed.), catalogue to the exhibition of the same nam
Zurich ²1994, 311–312.

Heimo Reinitzer: *Gesetz und Evangelium. Über ein reform
torisches Bildthema, seine Tradition, Funktion und Wirkung
geschichte*, Hamburg 2006.

Miriam Verena Fleck: *Ein Tröstlich Gemelde. Die Glauben
allegorie 'Gesetz und Gnade ' in Europa zwischen Spätmittela
ter und Früher Neuzeit*, Korb 2010.

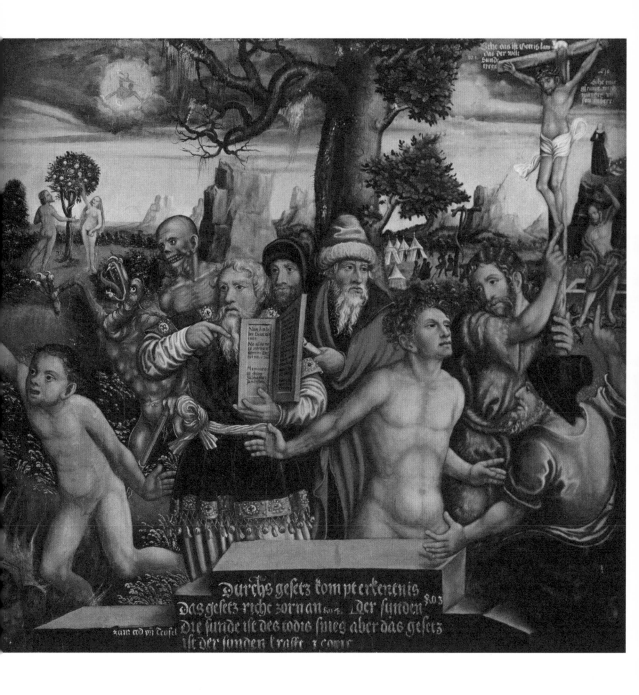

Durchs gesetz kom pt erkentnis
Das gesetz riche zorn an so 4. der sunden
Die sunde ist des todts spies aber das gesetz
ist der sunden krafft 1 cor15

ALBRECHT DÜRER MAN OF SORROWS BY THE COLUMN

1509 COPPER ENGRAVING 11.9 × 7.5 CM
 KUNSTSAMMLUNGEN DER VESTE COBURG

Just a few months before he posted his 95 Theses, Luther wrote to his theologian friend Johann Lang: 'Our theology and St Augustine are progressing well, and with God's help rule at our University. Aristotle is gradually falling from his throne' (WA BR 1, Nr. 41, 99; LW 48, 42, letter no. 14). Luther was a staunch opponent of the mediaeval Scholasticism that drew primarily on the teachings of the Classical Greek philosophers. His thinking around this time developed into a counter theology. In early 1518 he used the term *theologia crucis* ('theology of the cross') (WA 1, 363; LW 31, 41) for the first time to describe this theology. He explained what he meant by this in greater detail at the Heidelberg Disputation in April 1518. Luther used the term in an explicitly polemical sense to contrast it with the Scholastic concept of *theologia gloriae* ('theology of glory') (WA 1, 362; LW 31, 53). The theology of glory recognises God from Creation and yet is only too happy to suppress Christ's suffering and cross. Luther saw the weak, suffering, crucified Christ as being at the centre of theology rather than a rational, philosophical knowledge of God or even the triumphant, victorious, risen Christ. For him, it was not about proof of the existence of God or Easter, but about Good Friday.

He considered the theology of the cross to be closely connected to his teaching of grace, a point of view that he also developed in a strongly worded polemic against the Roman belief in justification by works. Luther argued that Christ's cross represented the Christian's cross; he believed that Christ's suffering showed that even the Christian life was an experience in suffering, in other words a passive ordeal. Human works were therefore of no value to Luther; they fell silent before the spectacle of the martyred Christ.

Luther did not consider it at all necessary to find new pictorial motifs to illustrate this view. He could simply turn to existing works, images that had already played a role in pre-Reformation piety and which Luther once again made the centre of attention and learned how to explain in a different way. Thus visual portrayals of the suffering Christ, such as the motif of the Man of Sorrows, assumed greater significance for Luther. *The Man of Sorrows by the Column* (1509) shown here comes from Albrecht Dürer's 'Engraved Passion' series. *Man of Sorrows* is the first plate in this series of copper engravings, which takes the story of the Passion as its theme. It shows Christ, who has already been crucified (as evidenced by his wounds) and presents the attributes of the Passion: Christ wears a crown of thorns, carries a scourge and birch, and stands at the column. Golgatha and the crosses can be seen in the background through the window. The motif does not reproduce the story of the Passion but rather symbolises a theological dogma – Christ's divinity. Christ's human nature has already died, his divine nature lives on. While Luther had feared such images, including the sight of Christ's maltreated body, in his earlier life, they now gave him consolation. The punishment administered by God in Christ was no longer to the fore; the compassionate, solidary Christ was his main concern.

Benjamin Hasselhorn

→ Further reading
Paul Althaus: *Die Theologie Martin Luthers*, Gütersloh 196 (English translation: *The Theology of Martin Luther*, Mir neapolis 1966).
Bernhard Lohse: *Luthers Theologie in ihrer historischen En wicklung und ihrem systematischen Zusammenhang*, Götti gen 1995.
Albrecht Dürer. Das druckgraphische Werk, Rainer Schoch Matthias Mende and Anna Scherbaum (eds.), vol. 1: Kuɪ ferstiche, Eisenradierungen und Kaltnadelblätter, Munich 2001.

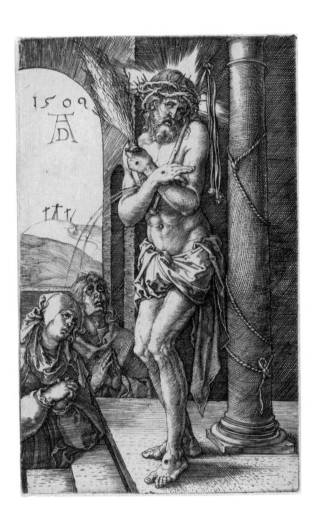

PRINTER: JOHANN FROBEN, BASEL

1519 SECOND EDITION LETTERPRESS ON PAPER
32.5 × 25 × 5 CM
STIFTUNG LUTHERGEDENKSTÄTTEN IN SACHSEN-ANHALT

In his calling and life Luther was always guided by the Bible. From the early days of his study of the Bible in the monastery in Erfurt, he strove to understand the Holy Scripture correctly. The basis of his reading of the Bible was always his own religious existentialism. But, in order to deepen his understanding, he also drew on philological and exegetic aids, on commentaries by the Church Fathers and medieval glosses, and also on the latest relevant publications, such as Erasmus's philological research into the Bible. As a professor in Wittenberg, Luther was thus able to draw on the work of his humanist predecessors in his study of the original text of the Bible.

The humanists' determination to unearth the real facts by investigating original sources (*ad fontes!*) involved 'cleansing' the language, that is to say, renewing the Latin texts in the light of their reception by exemplary, classical authors. Beyond the language, the humanists also focused on the contents, with research and teaching in disciplines such as rhetoric, natural history, geography and philosophy being renewed through the study of classical authors such as Cicero, Tacitus, Plato and Aristotle. Theology was similarly affected by the focus on the original sources. For humanist theologians this primarily meant engaging with the text of the Bible and with the writings of the Church Fathers in Latin and Greek.

Erasmus of Rotterdam (c.1466–1536) moved to Basel in 1514, where he embarked on a highly productive collaboration with the printer Johann Froben. Indeed it was Erasmus's intense research into and exegesis of the New Testament that ushered in the flowering of humanist Bible research. His critical edition of the New Testament, which provided readers with the full Greek text, side by side with a Latin translation, appeared in 1516. News of this publication soon reached Wittenberg and it became the basis of Luther's translation of the Bible into German. No less influential were Erasmus's *Annotationes* in his publication; these contained his philological, historical and theological arguments for the decisions he made as editor and translator. In these arguments there are passages that question the traditions and precepts of the Church with regard to its biblical foundations – passages that the Wittenberg reformers read as confirmation of their own position.

Erasmus's humanist Bible studies found a wide readership, which is reflected, for instance, in the number of new, enlarged editions of his *Annotationes* that were published in 1519, 1522, 1527 and 1535, not to mention the many reprints. Erasmus acted not just as a philologist, but above all as a teacher seeking enlightenment for his readers, often addressing them directly and giving them the facts in the hope of guiding them towards independent thought.

Luther's own intense reading of the Bible and his reformist thinking were grounded in Erasmus's edition and exegesis of the New Testament. The break between Erasmus and Luther ensued when Luther set out his theology of justification by faith, when he rejected the notion – supported by Erasmus and other humanists – that human beings can play a part in their own salvation, as opposed to relying solely on the grace of God.

Stefan Rhein

→ Further readin

Edition in: *Opera omnia Desiderii Erasmi Roterodami ,* vol. VI-5, VI-6 and VI-7, Petrus F. Hovingh (ed.), Amste dam 1999, 2003 and 2011.

Erika Rummel: *Erasmus' Annotations on the New Testame From Philologist to Theologian,* Toronto, Buffalo and Lo don 1986.

Silvana Seidel Menchi: Desiderus Erasmus von Rotte dam. Bibelhermeneutik, in: *Handbuch der Bibelhermene tiken. Von Origenes bis zur Gegenwart,* Oda Wischmey (ed.), Berlin and Boston 2016, 285–296.

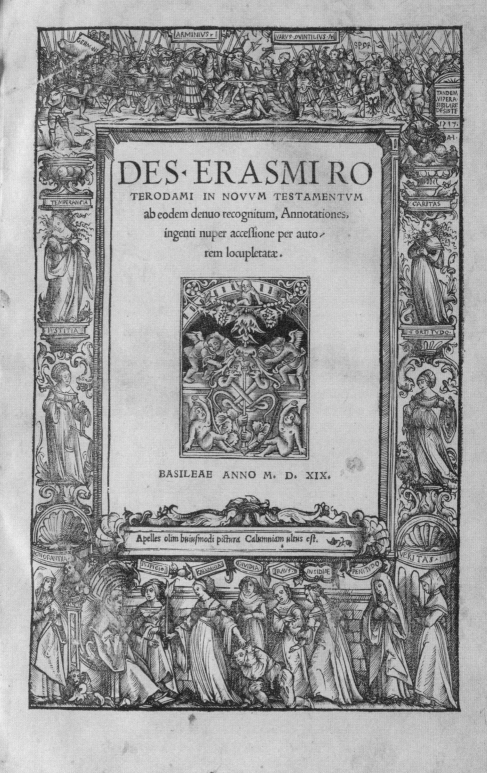

ARMINIVS·I· VARVS·QVINTILIVS·M·

SPQR

TANDEM VIPERA SIBILARE DESISTE

1217

TEMPERANCIA

CARITAS

IVSTITIA

FORTITVDO

DES·ERASMI RO

TERODAMI IN NOVVM TESTAMENTVM
ab eodem denuo recognitum, Annotationes,
ingenti nuper accessione per auto-
rem locupletatæ.

BASILEAE ANNO M. D. XIX.

VERITAS

IGNORANTIA

Apelles olim huiusmodi pictura Calumniam ultus est.

SVSPICIO CALVMNIA INVIDIA FRAVS INSIDIÆ PENITVDO

ECCLESIA AND SYNAGOGA

13TH CENTURY STONE AND PLASTER 190, 192 × 49, 44 × 40, 38 CM
MUSEUM AM DOM, TRIER

In 1515–16 Luther gave a lecture at the University of Wittenberg on St Paul's Letter to the Romans (WA 56; LW 25). Paul speaks about the relationship between Judaism and Christianity several times in this letter. Luther's interpretation of these passages in Paul was in keeping with Church tradition which held that the people of Israel were God's chosen people but that God blinded Israel, as evidenced by the fact that Israel did not acknowledge Jesus as the Messiah. It was believed that the status of chosen people passed therefore from Israel to the Church.

The extent to which this view corresponded to Church tradition can be seen in the prevalence of the motif of Ecclesia and Synagoga. The pair depicted here are faithful replicas of the original figures on the Church of Our Lady in Trier, which date from the thirteenth century. Israel and the Church are shown as the contrasting allegorical female antitypes of Synagoga and Ecclesia, with Ecclesia triumphing over Synagoga. The latter is holding the tablets with the Ten Commandments in one hand and a broken staff in the other. Her crown is slipping off her head and her eyes are bound – she has been struck blind. Ecclesia is wearing the Roman crown and originally dispayed the Christian insignia of chalice and cross-topped staff. These pairs of figures first appeared during the High Middle Ages; by the early sixteenth century they would have been widespread and well-known. It is likely that Luther would at least have seen the versions at the cathedrals of Erfurt, Magdeburg and Worms.

In the context of the commonly expressed views of the time, Luther's early remarks about Judaism were surprisingly positive. He defended the scholar Johannes Reuchlin in 1514, when he was charged with heresy after criticising the burning of the Talmud (WA BR 1, Nr. 7, 23–24). In 1519 he complained that people had their priorities wrong on Good Friday when, instead of thinking about their own sinfulness for which Christ had died on the Cross, they vilified the Jews as murderers (WA 2, 136–142; LW 42, 3-14). In 1521 he drew attention to Jesus's Jewish origins and rejected any use of violence when proselytising among the Jews (WA 7, 601–603; LW 21, 350-354). He reiterated this view in his essay *That Christ was born a Jew* (WA 11, 314–336; LW 45, 195-229), which was published in 1523. He wrote that there was no reason to crow over the Jews, instead Christians should start by behaving like true Christians. Only then, and especially in the light of the Gospel recently rediscovered by Luther in all its clarity, would the Jews convert to Christ in droves.

Nevertheless, Luther left no doubt that he strongly rejected Judaism on theological grounds – not just because of the denial of Christ, but also because of the specific nature of Jewish spirituality: indeed, with his teaching of salvation by grace through faith, he opposed both the Catholic righteousness of works and Jewish 'devotion to the law'. It may have been the absence of mass conversions by the Jews which eventually led Luther to abandon his earlier tolerant attitude in his later years and to call for the severest reprisals against the Jews. Benjamin Hasselhorn

→ Further readin
Ecclesia und Synagoga. Das Judentum in der christlichen Kun
Herbert Jochum (ed.), catalogue to the exhibition of t
same name, Ottweiler 1993.
Reinhard Schwarz: Luther und die Juden im Lichte d
Messiasfrage, in: *Luther 69* (1998), 67–81.
Thomas Kaufmann: Luthers Juden, Stuttgart ²2014 (E
lish translation: *Luther's Jews. A Journey into Anti-Semiti*
Oxford 2017).

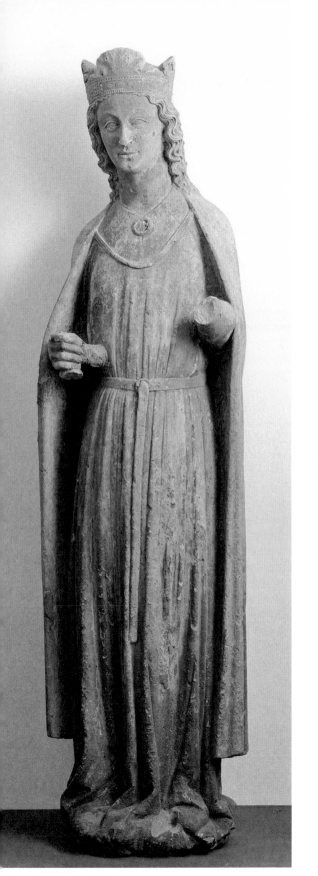

MARTIN LUTHER'S PERSONAL COPY OF A **HEBREW BIBLE** WITH ANNOTATIONS

PRINTER: GERSOM BEN MOSHE SONCINO, BRESCIA

1494 LETTERPRESS ON PAPER 17 × 11.5 × 7 CM
STAATSBIBLIOTHEK ZU BERLIN – PREUSSISCHER KULTURBE-
SITZ, HANDSCHRIFTENABTEILUNG

Ad fontes – back to the sources: this was the call of the humanists. In the context of studying the Holy Scriptures it meant consistently returning to the languages of the Scriptures – Hebrew and Greek.

Luther applied himself energetically to both languages, and it is interesting to consider how he went about it. Very few books from his library have survived, but among the small number that have is an edition of the first Hebrew primer to be published in Germany: *De rudimentis Hebraicis*, by the Pforzheim scholar, Johannes Reuchlin (1455–1522). It now belongs to Rostock University Library.

Luther's Hebrew Bible was printed in Brescia in 1494 and probably bound in the Stuttgart area between 1512 and 1515. The Bible had two previous Jewish owners before it came into Luther's possession some time between 1515 and 1519, where it remained until the end of his life. Luther's grandchildren sold the Bible, together with other books from his estate, to Joachim Friedrich von Brandenburg in 1594–95, from whom it later went to the Berlin State Library.

As evidenced by numerous notes in the margins, especially in the Book of Genesis and the Major Prophets, Luther clearly used this book intensively. However, it did not form the main basis for his translation of the Bible, although he did make use of it in his work on the translation of the Old Testament.

In his work as a professor, Luther focused principally on interpretations of the books of the Old Testament. He began his lecturing in the period from 1513 to 1515 with an exegesis of the Psalter. Between 1519 and 1521 he chose the Psalms again and after this turned to individual Prophets and, most exhaustively, the First Book of Moses, Genesis. An integral part of his translation of the Bible is formed by his prefaces to each book, in which he describes its content, recommends how it may be used and interprets its meaning. The Psalter was one of his favourite books – after his great lectures and individual interpretations he repeatedly presented it throughout his life as a 'little Bible'.

Luther read the Old Testament in the light of the New, a practice which set him apart from the Jews: it was in the Hebrew Bible that he sought and found the Annunciation of the Messiah and thus the 'Gospel'. For this reason he saw in the Old Testament of the Hebrew Bible an indispensable treasure of the Christian Church. However, he was convinced that it should be read in the knowledge of Christ and in anticipation of Him, in order to fully reveal its truth – after the coming of the Messiah in Jesus of Nazareth, he could not imagine any other reading of the Old Testament. This led him to see the Jews as stubborn people, unwilling to acknowledge the truth of their own Holy Scripture. It is this view that was at the root of the way in which, after promising beginnings of an accommodation in his publication *That Jesus Christ was born a Jew* (1523), Luther turned vehemently and, even for those times, intolerably against the Jews in his later years.

Johannes Schilling

→ Further readin
WA 60, 240–307 (publication of annotations).
Thomas Kaufmann: *Luthers Juden*, Stuttgart 2014 (Engli
translation: *Luther's Jews, A Journey into Anti-Semitism*, C
ford 2017).
*Meilensteine der Reformation. Schlüsseldokumente der früh
Wirksamkeit Martin Luthers*, Irene Dingel and Henning
Jürgens (ed.), Gütersloh 2014, 62–69, 70–78, 254–257.

עשרה שנה ושמנה מאות שנה ויולד בנים ובנות ׃ ויהיו כל ימי
אנוש חמש שנים ותשע מאות שנה וימת ׃
ויחי קינן שבעים שנה ויולד את מהללאל ׃ ויחי קינן אחרי הולידו
את מהללאל ארבעים שנה ושמנה מאות שנה ויולד בנים ובנות ׃
ויהיו כל ימי קינן עשר שנים ותשע מאות שנה וימת ׃
ויחי מהללאל חמש שנים וששים שנה ויולד את ירד ׃ ויחי
מהללאל אחרי הולידו את ירד שלשים שנה ושמנה מאות שנה
ויולד בנים ובנות ׃ ויהיו כל ימי מהללאל חמש ותשעים שנה ושמנה
מאות שנה וימת ׃ ויחי ירד שתים וששים
שנה ומאת שנה ויולד את חנוך ׃ ויחי ירד אחרי הולידו את חנוך
שמנה מאות שנה ויולד בנים ובנות ׃ ויהיו כל ימי ירד שתים
וששים שנה ותשע מאות שנה וימת ׃ ויתהלך חנוך
חמש וששים שנה ויולד את מתושלח ׃ ויתהלך חנוך את האלהים
אחרי הולידו את מתושלח שלש מאות שנה ויולד בנים ובנות ׃ ויהי
כל ימי חנוך חמש וששים שנה ושלש מאות שנה ׃ ויתהלך חנוך את
האלהים ואיננו כי לקח אתו אלהים ׃ ויחי
מתושלח שבע ושמנים שנה ומאת שנה ויולד את למך ׃ ויחי
מתושלח אחרי הולידו את למך שתים ושמנים שנה ושבע מאות
שנה ויולד בנים ובנות ׃ ויהיו כל ימי מתושלח תשע וששים שנה
ותשע מאות שנה וימת ׃ ויחי למך
שתים ושמנים שנה ומאת שנה ויולד בן ׃ ויקרא את שמו נח לאמר
זה ינחמנו ממעשנו ומעצבון ידינו מן האדמה אשר אררה יהוה ׃
ויחי למך אחרי הולידו את נח חמש ותשעים שנה וחמש מאות שנה
ויולד בנים ובנות ׃ ויהיו כל ימי למך שבע ושבעים שנה ושבע מאות
שנה וימת ׃ ויהי נח בן חמש
מאות שנה ויולד נח את שם את חם ואת יפת ׃ ויהי כי

וחל האדם לרב על פני האדמה ובנות ילדו להם ׃ ויראו בני
האלהים את בנות האדם כי טבת הנה ויקחו להם נשים מכל אשר
בחרו ׃ ויאמר יהוה לא ידון רוחי באדם לעלם בשגם הוא בשר והיו
ימיו מאה ועשרים שנה ׃ הנפלים היו בארץ בימים ההם וגם אחרי כן
אשר יבאו בני האלהים אל בנות האדם וילדו להם המה הגברים
אשר מעולם אנשי השם ׃ וירא יהוה כי רבה רעת
האדם בארץ וכל יצר מחשבת לבו רק רע כל היום ׃ וינחם יהוה
כי עשה את האדם בארץ ויתעצב אל לבו ׃ ויאמר יהוה אמחה את
האדם אשר בראתי מעל פני האדמה מאדם עד בהמה עד רמש
ועד עוף השמים כי נחמתי כי עשיתם ׃ ונח מצא חן בעיני יהוה ׃

פ פ פ

אלה תולדת נח נח איש צדיק תמים היה בדרתיו את
האלהים התהלך נח ׃ ויולד נח שלשה בנים את
שם את חם ואת יפת ׃ ותשחת הארץ לפני האלהים ותמלא הארץ
חמס ׃ וירא אלהים את הארץ והנה נשחתה כי השחית כל בשר את
דרכו על הארץ ׃ ויאמר אלהים לנח קץ כל
בשר בא לפני כי מלאה הארץ חמס מפניהם והנני משחיתם את
הארץ ׃ עשה לך תבת עצי גפר קנים תעשה את התבה וכפרת אתה
מבית ומחוץ בכפר ׃ וזה אשר תעשה אתה שלש מאות אמה ארך
התבה חמשים אמה רחבה ושלשים אמה קומתה ׃ צהר תעשה לתבה
ואל אמה תכלנה מלמעלה ופתח התבה בצדה תשים תחתים שנים
שנים ושלשים תעשה ׃ ואני הנני מביא את המבול מים על הארץ
לשחת כל בשר אשר בו רוח חיים מתחת השמים כל אשר בארץ
יגוע ׃ והקמתי את בריתי אתך ובאת אל התבה אתה ובניך ואשתך
ונשי בניך אתך ׃ ומכל החי מכל בשר שנים מכל תביא אל התבה
להחית אתך זכר ונקבה יהיו ׃ ומהעוף למינהו ומן הבהמה למינה ומכל

PANEL FROM THE VLINEVES ALTAR WITH ST ADALBERT AND JAN HUS

AFTER 1510 OIL ON PANEL, TRANSFERRED TO CANVAS 68 × 48.5 CM
THE LOBKOWICZ COLLECTIONS, NELAHOZEVES, PRAGUE

'I have taught and held all the teachings of John Hus, but thus far did not know it. [Johann von Staupitz] has taught it in the same unintentional way. In short we are all Hussites and did not know it. Even Paul and Augustine are in reality Hussites.' (WA BR 2, Nr. 254, 42; LW 48, 152-153). Thus, in early 1520, Luther lauded Jan Hus (c.1370–1415) as his forerunner. While this period was otherwise dominated by deprecatory polemics against the Czech heretic, it gradually became clear to Luther that, with their common focus on the Bible as the sole source of truth, he and Hus were in agreement. Moreover, Hus's esteem for the laity, together with his criticism of the Papal Church, seemed to Luther to be a legacy worth preserving. He described Hus several times as St Johannis, believing that such reverence was well deserved due to the strength of faith Hus showed at the Council of Constance when he was declared a heretic, sentenced to death and, on 6 July 1415, burned at the stake.

Luther's encounter with Hus's thinking dates back to his years in the monastery at Erfurt. As he later recalled, his novice master, Johann Greffenstein, and his father confessor, Johann von Staupitz, had recounted to him the unjust fate of the executed theologian. In October 1519 Luther obtained a manuscript of Hus's principal theological work, *De ecclesia*, which made a profound impression on him, as it contained early formulations of some of the central conclusions of his own theological thinking: the scriptural principle, criticism of the idea that the grace of God could be purchased through the sale of indulgences, the polemic against the increasing secularisation of the papacy and the call for the communion of bread and wine for all lay people.

Luther saw himself as a successor to Hus and his posting of the 95 Theses as a direct continuation of his work: 'He was burnt in the year 1415. The strife here with the indulgences began in the year 1517' (WA DB 11 II, 88). Therefore, in fulfilment of his own prophesy, Hus was later generally portrayed in the context of the Reformation as the goose burned at the stake who would be followed by the swan – seen in retrospect as Luther – whose singing could not be silenced.

In pre-Reformation art Hus appears predominantly as a martyr at the stake. However, there were also depictions of him as a priest and religious teacher, particularly in his native Bohemia. The panel pictured here is from the high altar of the church in Vliněves, near Mělník, and has been part of the Lobkowicz Collections since 1847. Hus can be seen standing on the right, behind Saint Adalbert of Prague. He is identifiable by the red cloak of the martyr and the heretic's crown decorated with devil figures, his most frequent attribute. In his hand he holds an open book, the Canon of the Mass, and is shown assisting Saint Adalbert, who is still revered today as the patron saint of Bohemia. Adalbert is administering the Eucharist to the faithful in both kinds, bread and wine – in keeping with the Hussite position. His chasuble is decorated with the crucified Christ which links the two, since both Hus and Christ experienced suffering. Stefan Rhein

→ Further readi

Jan Royt: Hussitische Bildpropaganda, in: *Kirchliche formimpulse des 14./15. Jahrhunderts in Ostmitteleuropa*, W fried Eberhard and Franz Machilek (eds.), Cologne 20 341–354.

Armin Kohnle: Vorreformator, Reformator vor der Re mation, Wegbereiter oder Vorläufer Luthers. Ein Beit zum Johannes-Hus-Gedenken 2015, in: *Luther (2016)*, 75–

Milena Bartlová: Iconography of Jan Hus, in: *A Comp on to Jan Hus*, František Šmahel (ed.), Leiden and Bos 2015, 325–341.

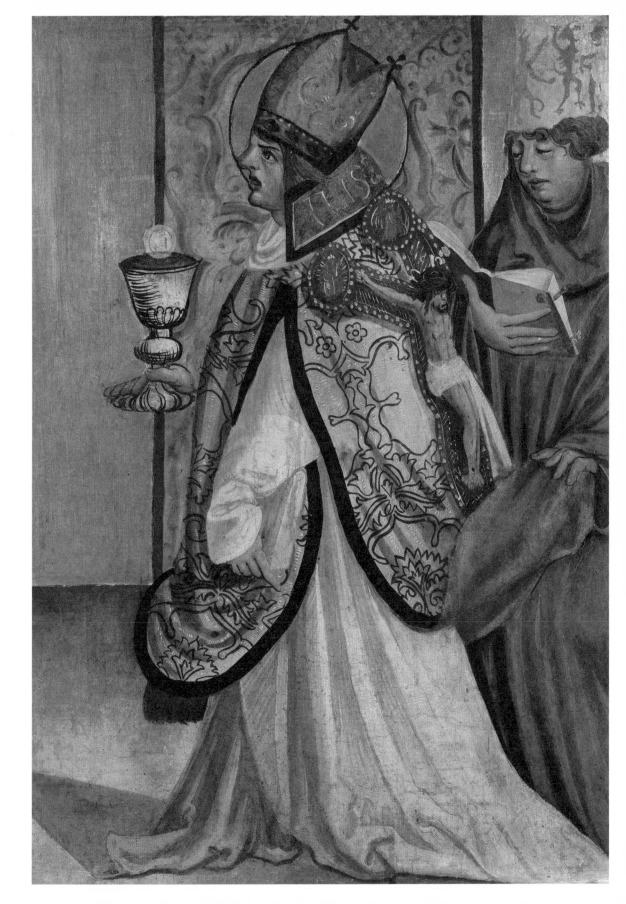

MARTIN LUTHER ON THE FREEDOM OF A CHRISTIAN

PRINTER: JOHANN RHAU-GRUNENBERG, WITTENBERG

1520 LETTERPRESS ON PAPER 19.8 × 15 × 0.5 CM
STIFTUNG LUTHERGEDENKSTÄTTEN IN SACHSEN-ANHALT

'Unless I am mistaken, however, it contains the whole of Christian life in a brief form, provided you grasp its meaning.' (WA 7, 11; LW 31, 343). The all-encompassing meaning of Christian life summed up in 12 neat pages: it does not get more concise. Any author who dares to do this cannot only draw the necessary courage from his own self-confidence; it must not be so much given to him as wrested from him. Even if the circumstances surrounding its composition were anything but fortuitous, this short letter, written late in the autumn of 1520, is a treasure among Luther's publications. The Roman trial against the Augustinian monk had been approaching its climax since the summer with the circulation of the papal bull of excommunication. It would have to be followed automatically by formal excommunication if Luther did not avail of one last chance to retract. His letter was certainly not a retraction. Instead, it was a call to observe the fundamentals of faith – sent simultaneously in Latin, accompanied by an open letter, to Pope Leo X, and in German to the people. Anyone who seeks to convince must express themselves succinctly, speak pointedly but not polemically, and argue eloquently yet precisely. In this text, Luther concentrates more intensively than ever before on the freedom that comes from faith. In doing this, he uses a keyword that was in vogue in the Holy Roman Empire of the German Nation, especially among the knights and burghers of the imperial towns. But he gives this theme an incredible and unpredictable twist. The freedom is based on sharing in Christ: in the here and now and not only in the hereafter – now, completely and utterly, and not mediated by a religious path through life, the successful outcome of which must be awaited.

The reason for the provocation on this occasion was the initial hypothesis that the Christian was a free lord and subject to nobody and at the same time a dutiful servant, subject to everyone. Luther's text aims to understand the unity of this opposition. It is based on the belief that the Christian – in community with Christ in faith – becomes like Christ, who is the servant of all. The individual freedom of faith in the relationship with God and the moral reciprocity among human beings are thus recognised in a uniquely coherent manner as an anthropological unit – as the freedom of the Christian.

The treatise was not effective as an intervention against Luther's imminent excommunication; it presented instead a religious profile that reveals how wrong the Roman judgement against the Wittenberg professor and preacher was. Apart from the translation of the Bible, the freedom text is Luther's most famous treatise. Its impact continues to be felt today.

Dietrich Korsch

→ Further readi
WA 7, 20–38, LW 31, 327-377
Reinhold Rieger: *Von der Freiheit eines Christenmensche
De libertate christiana*, Tübingen 2007.
Martin Luther: *Von der Freiheit eines Christenmenschen,*
etrich Korsch (ed.), Leipzig 2016. (English version: M
tin Luther: *The Freedom of a Christian 1520: The Annota
Luther Study Edition*, Timothy J. Wengert (ed.), Minne
olis 2016)

Von der Freyheyt eynisz Christen menschen.

Martinus Luther.

Vuittembergae.
Anno Domini
1 5 2 0.

MARTIN LUTHER ON THE BABYLONIAN CAPTIVITY OF THE CHURCH

PRINTER: MELCHIOR LOTTER THE YOUNGER, WITTENBERG

1520 LETTERPRESS ON PAPER 21.2 × 15.4 × 0.5 CM
STIFTUNG LUTHERGEDENKSTÄTTEN IN SACHSEN-ANHALT

De captivitate Babylonica ecclesiae is ranked as a work of fundamental dogmatic importance in the field of scientific theology. In this treatise Luther distances himself unmistakably from the papal Church of the late Middle Ages and introduces his own reforming concept of the sacraments of the Church.

Luther had already made the premises for his criticism of indulgences known in several popular tracts on Penance, Baptism and the Lord's Supper, which were known as '*Sermone*' and published in 1519 and 1520. They were based on the understanding of the sacraments as a direct encounter between human life and the Word of God, which establishes the sacraments, and as a visible sign accompanying the Word. Thus the sacraments were dissociated from the lifelong series of ecclesiastical rites promising salvation that were customary at that time. *De captivitate Babylonica ecclesiae* formulates the foundations of Luther's doctrine of the sacraments positively and critically through learned argumentation. However, he was opposed to Thomas Murner's translation of his original Latin treatise into German, which would later be used in polemics against him.

Luther's image of the Babylonian captivity of the Church signifies that the extent, purpose and practice of the original biblical sacraments had been falsified by the papal Church and subjugated to its own pretensions to power. This is reflected first in changes in the understanding of the sacraments, which would lie thereafter in the mediation of God's grace through the Church. As a result, further rites intended to ensure lifelong spiritual guidance and supervision by the Church – Confirmation, Matrimony, Extreme Unction – were added to the sacraments of Baptism and the Lord's Supper (and, less explicitly, penance) established by Christ in the New Testament. The distortion of the biblical concept of the sacraments is particularly obvious in the seventh sacrament, Holy Orders. This means that only priests appointed by the Church are authorised to administer the sacraments; Luther regards this as the second major error in the Church's traditional sacramental doctrine.

Luther argues instead for a return to the meaning of the sacraments established by Christ. In this approach, Penance, Baptism and the Lord's Supper share an identical structure. They are, in fact, the symbolic affirmation of God's words of promise. From this perspective, increasing the number of sacraments from three to seven is open to criticism: it is not only unbiblical, it is also absurd. The true nature of the sacraments is particularly highlighted in the Lord's Supper: it is the will and testament in which Christ definitively bequeaths to His people everything that He is. By this yardstick, the understanding of the Lord's Supper as a sacrifice performed by the Church cannot be justified. Accordingly, the notion of transformation of the elements of the Lord's Supper in the mediaeval doctrine of transubstantiation, in which bread and wine are changed by the words of a priest into the body and blood of Christ, also falls away. Finally, Luther argues, withholding the chalice from the lay congregation, as was customary at that time, could no longer be justified. Dietrich Korsch

→ Further readin
WA 6, 297–573; LW 36, 3–136
Reinhard Schwarz: *Martin Luther. Lehrer der christlichen*
ligion, Tübingen ²2016, 491–516.

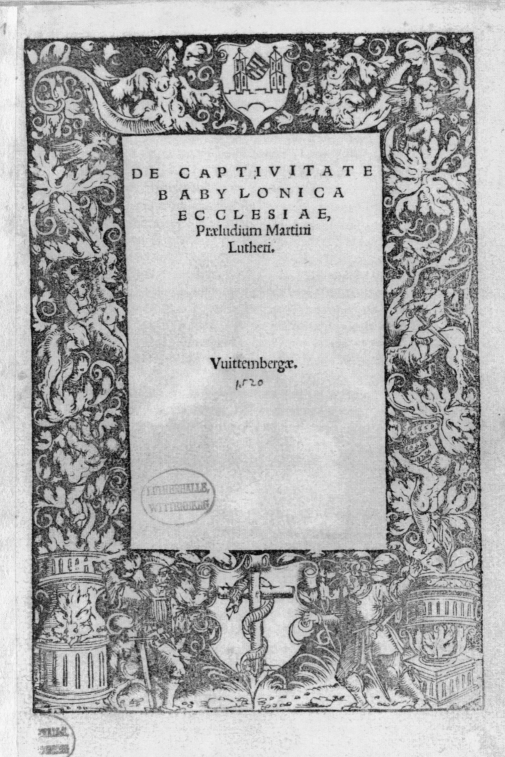

DE CAPTIVITATE
BABYLONICA
ECCLESIAE,
Præludium Martini
Lutheri.

Vuittembergæ.
1520

PRINT OF PAPAL
BULL 'EXSURGE DOMINE'

15 JUNE 1520 PRINTER: GIACOMO MAZZOCHI, ROME
LETTERPRESS ON PAPER 18.8 × 14 CM
LANDESARCHIV THÜRINGEN – HAUPTSTAATS-
ARCHIV WEIMAR

The reaction to the publication of Luther's 95 Theses may well have been more intense than Luther had foreseen – and not at all what he had expected. Archbishop Albrecht of Brandenburg sent his copy on to Rome, where it did not receive any attention until the summer of 1518, at which point Luther's critique of the Church was immediately interpreted as an assault on the Pope himself. The authorities in Rome embarked on preparations for a heresy charge against Luther, but these came to a halt in 1519 due to the sudden death of Emperor Maximilian I and the ensuing problem of who should succeed him: Friedrich III, Elector of Saxony – Luther's home state – was the candidate favoured by Pope Leo X (1475–1521) for the vacant imperial throne. In spring 1520, when Karl V was in fact elected to the throne, the lawsuit against Luther was set in motion again. The verdict went against Luther and he was presented with an ultimatum: either he had to remove 41 'heretical' statements from his writings within 60 days (including his core theses on indulgences, confession, purgatory, justification, the authority of the Pope and of the Councils) or he and his followers would face excommunication. After opening with an allusion to Psalm 7 and Psalm 80, 'Exsurge Domine' ('Arise, O Lord') – by which this Papal Bull has come to be known – the Pope exhorted Christ, the saints and the entire Church to resist the spread of doctrinal errors in the Holy Roman Empire, which had for the most part already long been condemned. The Pope enjoined Luther to desist from preaching until he had recanted these statements and forbade all Christians to own, read or reproduce Luther's works, which were to be publicly burnt.

Manuscript versions of this Bull and printed copies produced in Rome found their way to Germany, where they were distributed to princes and bishops. The copy shown here, printed in Rome by Giacomo Mazzocchi, was sent by theologian Johannes Eck to Wittenberg University. However, the university took this Bull as an attack on its own institution and questioned its authenticity, since it had not been sent through the usual channels. Friedrich III – Luther's own regional ruler – also refused to comply with the Bull for technical reasons, because Eck had distributed it in Saxony without the Elector's knowledge. Luther ignored the ultimatum and on 10 December 1520 – exactly 60 days after the Bull had arrived in Wittenberg – he went to the Elster Gate in Wittenberg and demonstratively threw the Bull and some other church documents onto a fire, in response to the previous burning of his works in various towns in Germany. The burning of the Papal Bull – which was long regarded as a more powerful symbolic act of defiance than the posting of the 95 Theses – finalised the schism between Luther and Rome. On 3 January 1521 the Pope at last issued the Bull 'Decet Romanum Pontificem' ('It behoves the Roman Pope'), which enacted the threatened excommunication of Martin Luther.

Mirko Gutjahr

→ Further readin
Wilhelm Borth: *Die Luthersache (Causa Lutheri) 1517–152*
Die Anfänge der Reformation als Frage von Politik und Re
Lübeck and Hamburg 1970.
Peter Fabisch and Erwin Iserloh: *Dokumente zur Cau*
Lutheri (1517–1521), Bd. 2: Vom Augsburger Reichstag 1518
zum Wormser Edikt 1521, Münster 1991.
Natalie Krentz: *Ritualwandel und Deutungshoheit. Die f*
he Reformation in der Residenzstadt Wittenberg, 1500–15
Tübingen 2014, 125–128.

Bulla contra errores .Martini Lutheri ҭ sequacium.

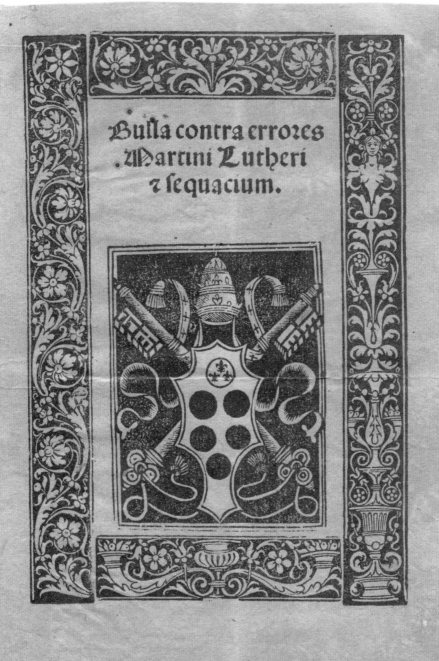

LUTHER'S COWL

FIRST HALF OF THE 16TH CENTURY WOOLLEN CLOTH LENGTH 145 CM
STIFTUNG LUTHERGEDENKSTÄTTEN IN SACHSEN-ANHALT

When Luther attended the Diet of Worms in 1521, he was still a staunch member of the (Catholic) Church and used this position as the basis for his demands for truth. In wearing his monk's cowl he gave an unequivocal sign that here was someone who wished to reform the Church from its core. However, as soldier of fortune Georg von Frundsberg, leader of the *Landsknecht* mercenaries, is believed to have said to Luther, 'Little monk, little monk, you are treading a difficult path!' To this day, the cowl symbolises the global historical significance of the path taken by one individual in confronting the might of both state and Church.

Luther entered the monastery in Erfurt on 17 July 1505. He was accepted as a novice in September of that year, shed his student garb and donned the habit of his order. For the next 19 years of his life, the monk's habit defined his appearance in the public sphere. After a one-year novitiate, a monk's clothing was blessed with incense and holy water – as a symbol of entry into the special state of dedication to God. The hooded cowl of the Augustinian order was made of black woollen cloth, and encircled by a leather girdle. This identified the wearer as a member of the order and had to be worn outside the walls of the monastery and during church services. Beneath this the monks wore a short-sleeved robe, split at the sides, known as a scapular, and a woollen shirt and white underpants as undergarments. The Augustinian monastery in Wittenberg was known as the 'Black Monastery', after the colour of the habit, to distinguish it from the town's two other Franciscan and Antonite monasteries.

In the Wittenberg monastery, founded in 1502 and still a relatively new establishment, Luther took on a myriad of tasks, which he described thus in a letter of 26 October 1516: 'I am a preacher at the monastery, I am a reader during mealtimes, I am asked daily to preach in the city church, I have to supervise the study [of novices and friars], I am a vicar (and that means I am eleven times prior), I am caretaker of the fish [pond] at Leitzkau, I represent the people of Herzberg at the court in Torgau, I lecture on Paul, and I am assembling [material for] a commentary on the Psalms.' It is hardly surprising that he felt the need for two secretaries. Two of these tasks were of particular significance in the development of his ideas on reform. As supervisor of general studies, he influenced the theological ideas of many young monks, who would later play a role in disseminating his thought. Through his preaching in the Town Church, he became familiar with the spiritual plight of members of the congregation and the practice of selling indulgences and its abuse, which added pastoral concerns to his theological reasons for taking a stand.

Luther continued to wear his cowl long after 1517. Although he temporarily stopped wearing monastic dress during his stay in the Wartburg in 1521–22, when he had to disguise himself as a soldier of fortune, it was not until the autumn of 1524 that Luther finally discarded his cowl, as his insistence on wearing it appeared increasingly incongruous to those around him. Looking back later on, he condemned it as a 'dreadful vestment' (WA TR 4, Nr. 4414, 304: LW 54, 338). Stefan Rhein

→ Further readin
Volkmar Joestel: *Luthers Mönchskutte* (unpublished ma uscript, Stiftung Luthergedenkstätten in Sachsen-Anha Lutherstadt Wittenberg).
Gerd Zimmermann: *Ordensleben und Lebensstandard. D Cura Corporis in den Ordensvorschriften des abendländische Hochmittelalters*, Münster 1973 (reprint: Berlin 1999).
Luther und das monastische Erbe, Christoph Bultmann, Vol er Leppin and Andreas Lindner (eds.), Tübingen 2007.

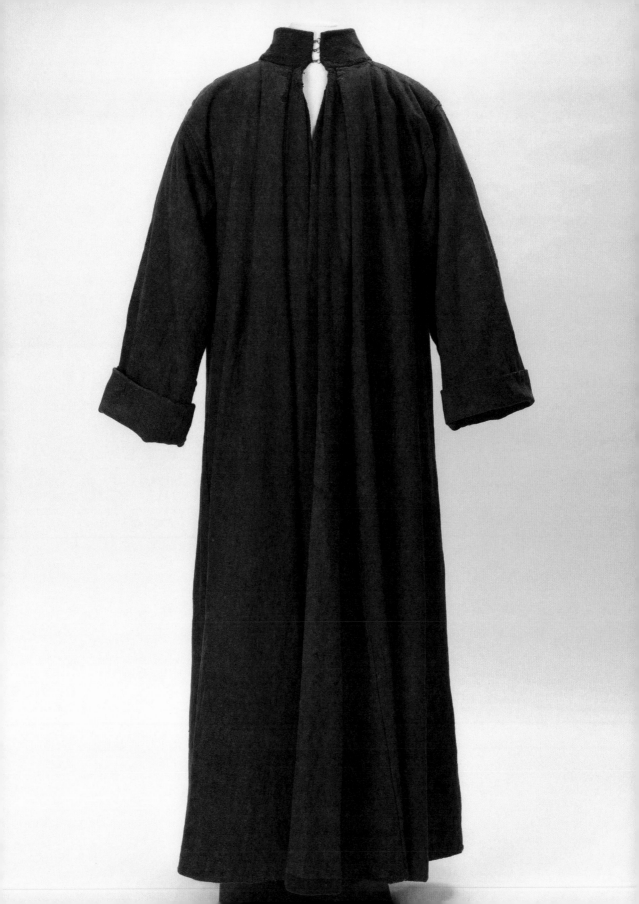

95 TREASURES

LUTHER'S WAY IN THE WORLD

'I WAS BORN, BY THE WAY, AT EISLEBEN.'

WA BR 1, NR. 239, 610; LW 48, 145

Luther's inner journey towards the posting of his 95 Theses intertwined with his way in the world. As a young man, he was influenced as much by his family background and life story as by his spiritual struggle for God's grace. However, apart from Luther's own and other – not always reliable – later accounts, including in his letters and *Table Talk*, little is known about his childhood experiences, his parental home and his everyday life in the late Middle Ages. Nevertheless, there is evidence of the piety and superstition of his family, their social status and economic situation, and their expectations and aspirations. Luther's extensive education played a particularly significant role in his formation, leading him into the spiritual world of the late Middle Ages – and ultimately, far beyond.

HOW DOES A MAN BECOME WHAT HE IS?

DIETRICH KORSCH

How is an individual character, comprising self-image, world view and communication with others, formed? It is shaped by a complex of impressions and influences, challenges and stimuli, advice and role models – assuming that these are internalised and assimilated. Assimilation of the circumstances of a person's life is the eye of the needle that alone leads to self-formation. Properly understood, the formative process is, therefore, interaction between an individual life and the wider context of that life.

Such processes need time, the limits of which are determined by historical conditions. However, the result is always an adult personality that can make connections from its own perspective between the various situations in which it finds itself. The formative process is regarded as complete if the prerequisites for this kind of approach to life are fulfilled and have been put to the test, at least initially.

However much individual life stories may differ, it is unlikely that their course is determined in an entirely coincidental or arbitrary fashion. Specific patterns governing the way the circumstances of life are internalised and assimilated can be identified in every era. For this very reason, those

crucial junctures in history when a new form of self-understanding emerges are particularly interesting. These occur when individuals of forceful character internalise contemporary historical conditions and reshape them through the medium of their own lives. In examining Luther's character formation, we are dealing with an outstanding example of an individual of this kind, and one whose life is of epochal significance.

Parents are the first to instil motivation and set challenges in a person's life. As the first-born son of a peasant farmer from Möhra, Luther's father, Hans Luder, was not entitled to inherit the family farm and instead took up copper mining, at that time a burgeoning industry in Saxony. He ventured away from his familiar home surroundings and settled in Mansfeld, where he would later earn considerable success and respect. Luther's mother, Margarethe Lindemann, who came from an educated, middle-class urban family in Eisenach, took an active part in securing the family livelihood. Both parents brought the traditions and experience of their original families to their joint household. His father's ability to leave a familiar milieu and begin his own life in a different place and in a new occupation was firmly grounded in self-reliance. From his mother's side came experience of life in an urban family, with access to information and opportunities for education and familiarity with a wider social sphere. In Mansfeld, Luther's parents' backgrounds merged and developed into a form appropriate for their survival and advancement in their new situation. At this time, the town was an expanding centre of the mining industry in Saxony and benefitted from the economic upswing in the region – although, admittedly, the Luders' progression towards recognition and status was not always easy. Thus Martin experienced challenges and demands that would lead to his involuntary crossing of boundaries. That advancement of this kind could only be achieved through inner discipline and determination was a crucial factor. Martin's clearly very strict upbringing was not, therefore, simply the outcome of customary repression but a prerequisite for the success of the family in its new life. There was a close association between economic renewal and moral, and perhaps also religious, rigour. For those who can commit to such discipline, there is undoubted potential to develop a spirit of innovation and ability to adhere to principles: Martin proved to have great capacities in this respect.

In terms of Luther's own formation, in addition to the experienced gained within the family, the approaches to understanding the world he encountered at school and university were of major significance. The by no means inconsiderable investment in what was, at that time, the best available education for their eldest son is indicative of the middle-class aspirations of Luther's family. It was for this reason that Martin moved from the local elementary school in Mansfeld in 1497, first to the cathedral school in Magdeburg and the following year to St George's Latin school in Eisenach.

This transformed the circumstances of his life in several respects. First, the 14-year-old had to leave his childhood home, to which he would never again return on a permanent basis: thus he could only carry with him mental images of his upbringing and the purpose for which they had shaped him. Second, he learned the necessity of self-preservation. Third, his social, intellectual and religious horizons expanded. Not only did the content of the new subjects he was taught extend his horizons, but from the outset he encountered this expanding knowledge in the context of the new movement of humanism; this sparked his interest in debates beyond the school environs and fostered both his musical talents and a keen interest in lay spirituality. It is clear that although the adolescent Luther was confronted by new challenges, he had no problem in seizing the opportunities they offered. This could only have served to strengthen and enhance the traits of openness and self-reliance already instilled in him within his family environment.

The University of Erfurt, to which 17-year-old Luther moved in 1501, also reinforced these tendencies considerably. It should be borne in mind that, at that time, Erfurt was an important urban centre, comparable in size to Augsburg. Over the course of his academic education, the direction for his future life as set in train by his family and their social situation acquired an increasing sense of urgency, legitimised by internal and external circumstances but also underpinned by reasoned argument.

Matters came to a head when a decision on study in a 'higher faculty' had to be taken: the choice of profession this entailed would determine the course of his life. With his entire life at stake, this was a crisis point for Luther. His father's plans for his eldest son were clear: he should become a lawyer. Studying the law would provide an opportunity to rise above the status of urban small-business owners and enter the world of free imperial cities and princely courts and their administrative structures – at that time law was a profession with excellent prospects, answering as it did a rapidly growing need in the social order. In addition, Hans Luder obviously had his eye on a prospective bride for his son. It is against this background that the transformation in Luther's life associated with the name 'Stotternheim' took place.

On 2 July 1505, after a visit to his parents, Luther was returning on foot to Erfurt, where he had been studying law for six weeks. Near Stotternheim, he was caught in a violent thunderstorm and narrowly escaped being struck by a bolt of lightning. As he later related, he cried out to St Anne for aid and in return for her intervention vowed to spend his life as a monk (WA TR 4, Nr. 4704, 440). When considered in the context of Luther's educational history, this event loses something of its apparent late-mediaeval outlandishness. Viewed as a direct confrontation with death, the storm and the bolt of lightning raise the issue of the 'whole life', which will face God's

judgement on death. Luther's response, which shaped the rest of his life, was unambiguous: a human life can only become a recognisable whole through God. The unconditional nature of personal responsibility, experienced through personal life events, acquired direct authenticity in the decisions he took on his own way of life. Entering a monastery was how he put this response into effect – in search of his own life.

Thus the monastery of the Augustinian Hermits in Erfurt was the next, but not final, formative influence on Luther. Although, on one hand, Augustinian monastic life had links with life in the familiar secular sphere – it was regulated methodically, without luxury, and, as with other mendicant orders, was lived in an urban context – on the other hand, it was dominated by a constant preoccupation with the relationship between the individual's own life and God and was thus fundamentally separated from the life of the outside world. So how does what can and must be done in human life to become whole before God relate to what one must expect as God's judgement? Luther's experience was that these two aspects, the way one conducts one's own life and God's final judgement, could not be reconciled and united in a single whole. And this remained the case if one exploited the possibilities offered by monastic life to the full, reflected intensively on the errors and deviations in one's own life, and examined and expiated these thoroughly through confession. Despite all this, an insurmountable residue of guilt, which precluded God's approval, remained. This raised the question of whether it was even possible to achieve the goal of a whole life. Was one not condemned instead to continue to live in despair at this impossibility? Or should one forgo the rigours of self-judgement and thus abandon the pursuit of an unconditional life? It is important to consider here that this aporia could have remained unresolved, and we do not know how Luther's life would have continued under these circumstances.

That things turned out otherwise has much to do, again, with the contingent circumstances that influenced Luther as an individual. His order soon recognised his intellectual abilities and after his ordination as a priest not only directed him to study theology, for which he was awarded a *baccalaureus biblicus* degree in 1509, but also entrusted him with work on interpretation of the Bible. His intensive engagement with the language and horizon of meaning of the Bible provided the key that enabled Luther to resolve his dilemma of the 'whole life'.

Looking back many years later, Luther condensed what had been the result of a long process into a single revelatory experience. He directly linked the change in his self-perception that gave him a path back to life with the 'righteousness of God' (*Preface to the Complete Edition of Luther's Latin Writings (1545)*, (WA 54, 179–187: LW 34:323–338)). Indeed, if one takes as a starting point the human approach to God, which the course of his own

life, in its search for authenticity, suggests, this phrase precisely conveys the perception of God presiding in final judgement over the whole of life. However, if one understands that righteousness is not a barrier to access to God, but that God is the source of all human righteousness, then the approach is reversed. It is God who bestows righteousness on humans and, accordingly, the way to achieve a whole life. God's gift alone is the condition under which a human life, whatever its future course on earth might be, can now – and for all time – become whole. 'Here I felt that I was altogether born again and had entered paradise itself through open gates.' (WA 54, 186/8 f.; LW 34, 337). This declaration cannot be improved on. It also marks the culmination of what we understand here as Luther's formation. This realisation is so fundamental that it not only had crucial significance for Luther himself, but can also be regarded as a new model for human self-understanding in general. For Luther's insight into the conditions for the path to his own whole life can become the experience of every human being: that, regardless of how one's future life develops, an authentic complete personal life exists if that life receives its defining formative influence through God, who gives to all of us everything we have, with all that He is and has. Luther himself experienced this as a transformation of his self-perception: from morally-directed personal responsibility for his own life against the background of the spiritual awakening of the early modern period to a new self-understanding through God. This deeper understanding extends beyond Luther's historical place and time. It holds true as long as human beings continue to assert their claim to a life of their own.

PIGGY BANK

LATE MIDDLE AGES EARTHENWARE, GREEN GLAZE
10 × 4 × 3.5 CM
LANDESAMT FÜR ARCHÄOLOGIE SACHSEN

In an account in his *Table Talk*, recorded by his students, Luther claimed to have been brought up in poor circumstances, declaring that: 'In his youth my father was a poor miner. My mother carried all her wood home on her back. It was in this way that they brought us up.' (WA TR 3, Nr. 2888 a/b, 51: LW 54, 179). This claim, if it was indeed correctly transmitted, is more likely to refer to the way that thriftiness was instilled in Luther's parental home, rather than to any real poverty. Architectural history and archaeology research carried out in recent years has shed light on the relative prosperity enjoyed by the Luther family in Mansfeld. As the son of a prosperous family with a large farm in Möhra, his father, Hans Luder, had sufficient capital resources to invest in the flourishing copper-mining industry in Mansfeld and to acquire a property in the expanding mining town.

Nevertheless, the family also made an effort to accumulate savings: a hoard of 300 silver coins, probably the contents of a purse or money-box deliberately placed in the domestic rubbish pit of his parental home in Mansfeld, was rediscovered during excavations in 2003. As still happens today, in the Middle Ages money was saved in ceramic receptacles, into which it was inserted through a coin slot. These were made either in simple, rounded shapes or in the form of animals, as in the example shown here. The pig was particularly popular, as its abundant fertility and function as a provider of meat meant that it had been regarded as a symbol of good fortune since ancient times. There were also certain parallels between fattening and killing a real pig and filling and 'killing' a piggy bank. The green-glazed pig shown here was found during excavations in Dresden in 1953.

As a reformer, Luther stressed the need for sound economic management. In his 95 Theses, he called on his fellow-Christians to 'reserve enough for their family needs and by no means squander it on indulgences.' (These 46; WA 1, 235: LW 31, 30, Thesis 46). In addition to his struggle to eliminate the abuses within the Church, from an early stage he also campaigned for the eradication of poverty, which the old Church had completely failed to achieve, and which he now regarded as a task for society as a whole. Luther believed that it was entirely acceptable for Christians to have money and possessions, as they were impelled by their faith to act compassionately and mitigate the poverty of their fellow beings. Nevertheless, he warned against the evils of Mammon, which caused the wealthy to lose their fear of God and cast the needy into despair. He condemned usurers and businesses focused entirely on profit as unchristian and damaging to society as a whole. Mirko Gutjahr

→ Further readi»
Andreas Pawlas: *Die lutherische Berufs- und Wirtschaftset»
Eine Einführung*, Neuenkirchen-Vluyn 2000.
Martin Treu: *Martin Luther und das Geld. Aus Luthers Sc↓
ten, Briefen und Tischreden*, Wittenberg 2000.

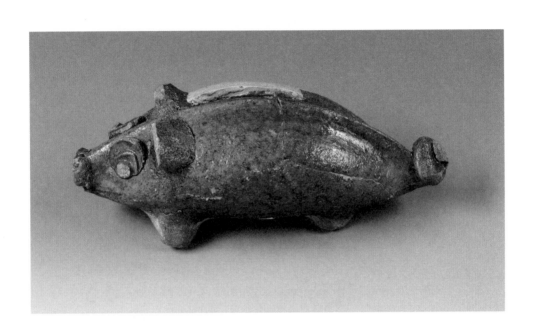

TOUGH-PITCH COPPER INGOT

16TH CENTURY　COPPER, DIAMETER　C.47–49 CM
MANSFELD-MUSEUM IM HUMBOLDT
SCHLOSS HETTSTEDT

Luther was born into a family which was in the process of social advancement in the late fifteenth century. His father, Hans Luder, came from a prosperous peasant farming family and learned about mining from an early age. Armed with inherited capital, he invested in the burgeoning copper mining industry in the area around Mansfeld. After a short period in Eisleben, where he apparently failed to gain a foothold, he moved to Mansfeld with his young family in 1484 and leased several smelting ovens from the Mansfeld counts.

The development of the new Saiger smelting method meant that from around 1470 new mining districts were opened up in the area. With this process it was possible for the first time to extract the silver contained in the Mansfeld crude copper, but it required large quantities of charcoal. Thus the smelting operations were located in the Thuringian forest where there were plentiful supplies of the necessary raw materials, although this meant that the crude copper had to be transported over long distances. *Reißscheiben* or tough-pitch copper ingots, like the one shown here, were the end product of the laborious Saiger process for extracting silver from the copper through the addition of lead. What was left was relatively pure copper which was cast in disc-shaped ingots and sold. This lucrative business was controlled by the corporations, largely based in Nuremberg, which exerted pressure on the smelting masters in the mining areas by charging them ever higher fees. As a result, and compounded by inflation, higher investment costs and declining profits from the mines, the Mansfeld smelting masters increasingly found themselves in economic difficulties. This also affected Hans Luder: having previously been in a position to provide loans to the Mansfeld counts, he eventually had to give up his business and ended up working for one of the corporations for an annual salary of just 50 guilders, not much more than a miner's wage. He did at least manage to separate his business and private assets, enabling him to leave his children an impressive inheritance of 1,250 guilders when he died in 1530.

His son, Martin, who pursued his own path from 1505 and a rather different one from that envisaged for him by his father, viewed mining with scepticism. With his father's example in mind, when the Elector offered him a share in the Saxon mines in order to cover his living costs, he declined and declared it to be 'play money' (WA TR 5, Nr. 5675, 314). Nevertheless, the influence of the family mining tradition could be discerned throughout the Reformer's life in the way his sermons and writing were peppered with mining expressions, such as 'seam', 'yield' and 'bringing something to light'. Luther was also fully aware of the economic importance of mining for his homeland: 'For where there is a slump in mining, there lies the country, and all its foes laugh aloud' (WA BR 10, Nr. 3724, 11). He was exercised by mining to the last: his final journey took him to Eisleben in early 1546, where he had been asked to mediate in a dispute over the Mansfeld smelting ovens. He also went on behalf of his brother, Jakob, who had taken on their father's occupation. Mirko Gutjahr

→ Further readi
Ulrich Wenner: 'Fundgrubner, Berckhauer und Schla
treiber'. Montanwortschatz bei Luther, in: *Martin Lu*
und der Bergbau im Mansfelder Land. Aufsätze, Rosema
Knape (ed.), Eisleben 2000, 205–218.
Michael Fessner: Die Familie Luder und das Berg- u
Hüttenwesen in der Grafschaft Mansfeld, in: *Luthers*
benswelten, Harald Meller, Stefan Rhein and Hans-Ge
Stephan (eds.), Halle 2008, 235–243.

TRIPOD COOKING POTS FROM MARTIN LUTHER'S BIRTH HOUSE

C.1500 EARTHENWARE, GLAZED HEIGHT 16–20 CM, RIM DIAMETER 14–16.5 CM,
 BASE DIAMETER 16–20 CM, LID: HEIGHT 6 CM, DIAMETER 13 CM
LANDESAMT FÜR DENKMALPFLEGE UND ARCHÄOLOGIE – LANDESMUSEUM
FÜR VORGESCHICHTE – SACHSEN-ANHALT

The 2003 excavations at Luther's parental home in Mansfeld provided detailed insight into the everyday realities and living conditions of his family. Contrary to the conclusions of earlier research into Luther, the family household was relatively well-to-do. After he moved from Eisleben to the flourishing, economically attractive mining centre of Mansfeld, Hans Luder, the father of the later reformer, invested considerable resources in the mining and smelting of the area's copper deposits and rebuilt and extended a substantial property at the eastern gate of the town. At least initially, his investment was so profitable that he could, among other business activities, provide loans to the Counts of Mansfeld. He also attained high social status in the town, and, after 1492, gained prominence as one of the *Vierer*, representing his home district as an adjunct to the town council. Luther's later observation, recorded in his *Table Talk*, that his father had been 'a poor miner' (WA TR 3, Nr. 2888 a/b, 51: LW 54, 179) should probably be interpreted as more of a modesty topos than as a description of the real-life situation: in fact, he grew up in financially secure, middle-class circumstances. The relative prosperity of the family is reflected in the results of archaeological investigations, which, as well discovering fragments of domestic interior equipment and fittings, including a tiled stove, also brought evidence of costly items of clothing to light.

However, in comparison to the fine quality tableware, including expensive drinking vessels and numerous knives, found in middle-class homes, the kitchen equipment among the finds from the Luther household seems relatively modest. What is surprising here is the large number of ceramic cooking utensils, which is estimated at several hundred in all. The most numerous type of vessel among these is the tripod pot or pipkin, which by the late Middle Ages had become the classic cooking pot, used in households of all social classes. Food was cooked over open wood fires on raised hearth blocks below masonry smoke vents. The stability of this type of three-legged pot meant that it could be safely positioned on or beside the embers either to cook food slowly or keep it hot. A characteristic feature of these pots is thus the charring caused by the heat of the fire on the sides opposite the handles. Several dozen lids sized to fit the almost standardised shape of these tripod pots were also found. The pots were probably made in local potteries and were obviously inexpensive enough to discard and replace even if they had only minor damage. Tripod pots made of non-ferrous metals, which were usually larger and more robust, were a more expensive option. Mirko Gutjahr

→ Further readi
Björn Schlenker: *Luther in Mansfeld. Forschungen am
ternhaus des Reformators* (*Archäologie in Sachsen-Anhalt, S
derband* 6), Halle 2007.
Björn Schlenker: Grapen. Der Kochtopf der Zeit, in: *Fu
sache Luther. Archäologen auf den Spuren des Reformators*,
rald Meller (ed.), Halle 2008, 172, No. C 15.
Mirko Gutjahr: Aus gutem Hause, in: Gaby Kuper a
Mirko Gutjahr: *Luthers Elternhaus. Ein Rundgang durch
Ausstellung*, Aschersleben 2014, 10–30.

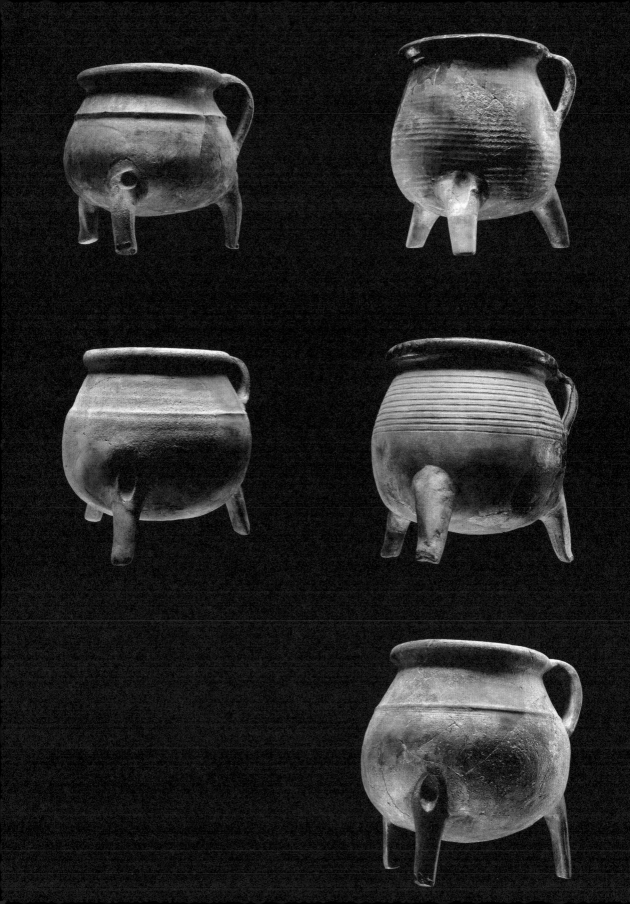

TWO WITCHES COOKING UP A STORM

1489 LETTERPRESS AND WOODCUT ON PAPER 21.3 × 13.8 CM
HERZOG AUGUST BIBLIOTHEK WOLFENBÜTTEL

In the sixteenth century, people generally believed that magic could be used to harness demonic forces. Martin Luther was not free of such notions either: as his mother held beliefs of this kind, he had been aware of them from early childhood. Luther's ideas also had a biblical foundation: invoking the exhortation of Exodus 22:18 'You shall not permit a sorceress to live', he demanded that women convicted of witchcraft be put to death. However he viewed the practice of widely used, everyday magic much more leniently. This illustration depicts two women in the process of brewing up a storm, adding a cockerel and snake as ingredients to the flames already licking from their cauldron. The results of their endeavours can already be seen in the sky above their heads – large hailstones raining down from roiling clouds. Although the two women are wearing normal contemporary clothing and have no other identifying attributes, they nevertheless appear as witches. The intention here is to show that witches cannot be identified by ill-favoured countenances, humped backs or their form of dress, but are only recognisable by their deeds – this meant that suspicion could, in principle, fall on anyone during witch hunts. Brewing up hailstorms and inflicting disease were among the most common charges in witch trials.

The advent of book printing caused belief in magical powers to spread more widely and rapidly than ever before. A malign reciprocal effect developed, resulting in ever more frequent witch hunts, although it is not clear whether the widespread witch mania gave rise to large numbers of related publications, or it was the publications that fanned the flames of witch mania. Among the most important of these books were Johannes Nider's *Formicarius* (1475) and, in particular, *Malleus maleficarum* (*Hammer of Witches*) by Heinrich Kramer and Jakob Sprenger, first published in 1487 and running to many later editions. Ulrich Molitor's work, written in Latin, was the first to contain illustrations, and was probably first printed in 1488 in Konstanz, where the author was a lawyer for the diocesan curia. He may well have drawn on his experience of witch trials for the book: as records of discussions among Archduke Sigismund of Tyrol, Conrad Schatz, the mayor of Konstanz, and Molitor himself show, it was most probably intended as a legal commentary on the numerous witch trials of the time. Whatever the intention, the book was extremely successful, appeared in around six further editions in subsequent decades, and in 1493 in a German translation, *Von Unholden und Hexen*; it continued to be published until the late sixteenth century. The illustrations undoubtedly played a major part in its popularity, as they provided the reader with an immediate and striking visual impression. Although around a quarter of those accused of witchcraft were men, illustrations of women as witches predominate. Around the beginning of the sixteenth century, renowned artists, including Albrecht Dürer, Albrecht Altdorfer and Hans Baldung Grien, created works depicting witches. Motifs for these erotic, sometimes pornographic, images included witches anointing their naked bodies with 'flying salve' and engaging in fornication with the Devil. Daniel Leis

→ Further readi◗

Jane P. Davidson: *The witch in northern European art, 14 1750*, Freren 1987.

Ulrich Molitor: *Von Unholden und Hexen*, Nicolaus E amicus (ed.), Diedorf 2008.

Wolfgang Behringer: *Hexen. Glaube, Verfolgung, Verma tung*, Munich 2009.

De lanijs et phitonicis mu

lieribus ad illustrissimū principem dominum Sigismun
dum archiducem austrie tractatus pulcherrimus.

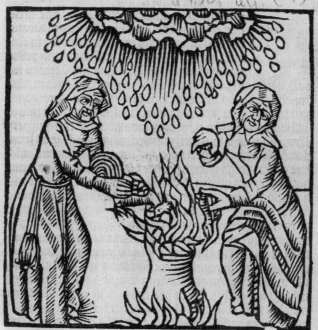

FIGURE OF THE CHRIST CHILD FROM MARTIN LUTHER'S BIRTH HOUSE IN EISLEBEN

FIRST HALF OF THE 16ᵀᴴ CENTURY EARTHENWARE, WHITE 4.3 × 2 CM
LANDESAMT FÜR DENKMALPFLEGE UND
ARCHÄOLOGIE – LANDESMUSEUM FÜR
VORGESCHICHTE – SACHSEN-ANHALT

The late fifteenth century and early sixteenth century was a time when broad swathes of the population lived with great religious uncertainty. Luther came from a family whose religious convictions were more or less in keeping with the time. According to a story told by Luther, his father Hans Luder once refused to donate to a church charity by referring to the financial support needed by his own family. He also ostensibly despised monks (WA 47, 379; LW 44, 711). However, this should probably not be seen as a blanket anticlerical or even anti-religious attitude. On the contrary: Luder appeared as a member of the congregation of '*Unser Lieben Frauen Gezeiten im Thal Mansfeld*', a charity that sponsored an altar for St George's parish church, which had been rebuilt in 1498 following a fire. The successful mine owner generally displayed the small-town piety typical of the time, which fulfilled both religious and important social functions. When Luther entered the Augustinian monastery in Erfurt in 1505 against his father's wishes, Hans Luder is believed to have even invoked the fourth commandment as a theological argument: according to the Biblical principle of obedience, a son must comply with his parents' wishes (WA 44, 712).

Even less is known about Luther's mother's religious practice. Nevertheless, Margarethe Luder clearly passed on her belief in witches, common at the time, to her son. Later, when he was already famous, Luther is believed to have called for the condemnation of alleged witches in Wittenberg. Evidence also suggests that Luther's parents were influenced by the deep popular piety of the late Middle Ages in which Christian beliefs mingled with superstitious ideas.

This is the background to this pipeclay Christ Child figurine which was salvaged during archaeological excavations at the house in Eisleben where Luther was born. These statuettes were very common in the first half of the sixteenth century. They were made by specialist potters known as *Bilderbäcker* (figurine potters) and given as presents, particularly at New Year. They also featured in devotions and religions plays. One example was *Christkindwiegen* or 'rocking the Christ Child's cradle' – a tradition that was so well known that Luther mistakenly derived the German word for Christmas (*Weihnachten*) from the word *Wiegenachten* (WA 37, 48–49). The figurines, together with miniature cradles, some of which were elaborately decorated, initially served as devotional objects, particularly in convents and secular female religious communities, but – together with the corresponding Christmas songs – they soon also became very popular outside these institutions in private households. Such figures made the Christmas mystery of the incarnation of God more comprehensible and provided a sensory experience for the laity. Mirko Gutjahr

→ Further readi
Christian Matthes: Die archäologische Entdeckung originalen Luther-Geburtshauses, in: *Martin Luther Eisleben*, Rosemarie Knape (ed.), Leipzig 2007, 73–86.
Martin Treu: *Martin Luther und Eisleben. Ein Rundg durch die Ausstellung im Geburtshaus*, Wittenberg 2007

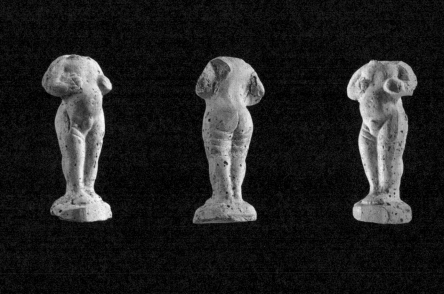

MARBLES AND BIRD-SHAPED WHISTLE
FROM MARTIN LUTHER'S BIRTH HOUSE

C.1500 EARTHENWARE DIAMETER MARBLES C. 1.1–1.5 CM, HEIGHT BIRD-SHAPED WHISTLE 6.5 CM
LANDESAMT FÜR DENKMALPFLEGE UND ARCHÄOLOGIE – LANDESMUSEUM FÜR VORGESCHICHTE
SACHSEN-ANHALT

Comparatively few comments by Martin Luther about his childhood sur-vive and they largely relate to exceptional situations, such as punishments meted out by his parents. In addition, where they do appear it is always in the context of more general statements focused on the present, for instance demands for reforms in education or child-rearing. In contrast, the archae-ological finds discovered in the vicinity of the Luder family's Mansfeld home in 2003, dating back to around 1500, provide very direct insights into their everyday lives.

Despite the fact that they were involved in the family's working life from a young age, children in the early sixteenth century still had opportunities to play. In addition to role-play games with toy figures and dolls, which imi-tated the world of the adults around them, contests and more active games were very popular, as they continue to be today. Playing with marbles was not solely the preserve of children: a number of pictures from the period show that young adults evidently also passed the time playing one another at marbles, usually made from clay. The examples found during the exca-vations in Mansfeld were probably shaped by a child's hand and then fired, perhaps in the domestic hearth. It is not known what rules would have been used in games of marbles during Luther's childhood, but they may well not have differed much from the games played today. Pictures from the same period illustrate how shallow depressions or knives stuck in the ground served as targets.

Making music and other noises has also always been a favourite activity for small children. As well as rattles and shakers, excavations of mediaeval and early modern sites often reveal instruments for making whistling sounds. Less common are discoveries of figurines like this bird whistle which was also found in Mansfeld. Reconstructed from numerous fragments, the fig-ure of a bird is made of a pale, fired clay, with a small head and squat, hol-low body in which lines have been scored to represent wings. It may have been a rattle but seems more likely to have been formed as a whistle: by fill-ing it with water and blowing into it, it would have been possible to make trilling sounds like the twittering of a songbird. In contrast to the marbles, this toy may have been made by a professional potter and bought by a mem-ber of the Luther family for one of the children.

Finds like these and other toys cast a different light on Luther's childhood in Mansfeld which was clearly not solely characterised by hardship and pri-vation, as earlier Luther research suggested. Mirko Gutjahr

→ Further readi
Björn Schlenker: Luther in Mansfeld. *Forschungen am ternhaus des Reformators (Archäologie in Sachsen-Anhalt, derband 6)*, Halle 2007.
Mirko Gutjahr: Aus gutem Hause, in: Gaby Kuper a
Mirko Gutjahr: *Luthers Elternhaus. Ein Rundgang durch Ausstellung*, Aschersleben 2014, 10–30.
Louis D. Nebelsick: Marbles, Bird-shaped Whistle, *Martin Luther. Treasures of the Reformation*. Catalogue, [den 2016, 22, no. 2, 24, no. 4.

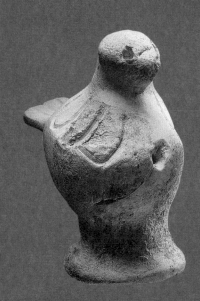

PUNISHMENT PADDLE

14TH CENTURY WOOD LENGTH 53 CM
DIE LÜBECKER MUSEEN – ST. ANNEN-MUSEUM

References to corporal punishment and strict discipline abound in Luther's accounts of his childhood and youth. His parents beat him so severely for minor misdemeanours that he once fled the family home and took refuge in a nearby monastery (WA TR 3, Nr. 3566 a, 415; LW 54, 235). Early biographers sought to extrapolate a traumatic childhood and distorted father-son relationship from these accounts, suggesting that these affected his later development and character. But in Luther's day corporal punishment was taken for granted as a normal part of child-rearing, and he himself even spoke out in favour of it in his discussion of children's education – as long as it was proportionate. His comments confirm that he agreed that there must be rules for children's behaviour, although any force used should never be excessive or unjustified. That must be the subtext to his later assessment of his own parents' insistence on discipline – 'they only ever meant well'. However, as he goes on to point out, punishment and reward should always be in balance: 'One must punish in such a way that the rod is accompanied by the apple' (WA TR 3, Nr. 3566, 415–416; LW 54, 235). Luther believed that since original sin, which is passed from one generation to the next, is also part of the make-up of 'innocent' children and inevitably leads to bad behaviour, punishment and duress could never change anyone. Nevertheless, it was necessary to implement sensible rules and discipline as a damage limitation exercise and to protect society.

At school Luther had to endure yet more unjustified beatings. He recounts that the teacher punished him and other boys because they didn't know certain things that he hadn't even asked them to learn. With tit-for-tat denunciations at school and secret lists, known as 'wolf's lists', old offences were regularly punished, no doubt long after the miscreants had forgotten all about them. Luther later criticised this kind of education and in his text *To the Councilmen of All Cities in Germany* (1524) he recommended that public schools should be established with the kind of teachers that could replace the anxiety usually felt in lessons with a striving for success.

However, the teacher still needed a rod, and no illustration of a teacher in the late Middle Ages or early Modern era failed to include one. While most teachers favoured flexible hazelnut switches, which the pupils sometimes had to cut from the bushes themselves before the school year began, there were other means to quell unruly children. When the latrines at the St. Jacobi municipal school in Lübeck were excavated in 1886, the finds included not only wax writing tablets, a stylus, reckoning pennies and ink bottles but also six late mediaeval punishment paddles. These implements were shaped like large spoons: at the end of a rod – the thickness of a broomstick – there was a flat, disc-like hitting surface. Pupils were also often disciplined using whips or implements that pierced and cut their skin. Besides the physical injuries caused by these brutal items – bruises, cuts and open wounds – they could of course also cause long-term damage to the pupil's psyche. Mirko Gutjahr

→ Further readi
Doris Mührenberg and Alfred Falk: *Mit Gugel, Pritsch*
und Trippe. Alltag im mittelalterlichen Lübeck, Lübeck 20
Edmund Hermsen: *Faktor Religion. Geschichte der Kind*
vom Mittelalter bis zur Gegenwart, Cologne 2006.
Kinder, Krätze, Karitas. Waisenhäuser in der Frühen Neu
Claus Veltmann and Jochen Birkenmeier (eds.), H
2009, 148, No. 1.21.

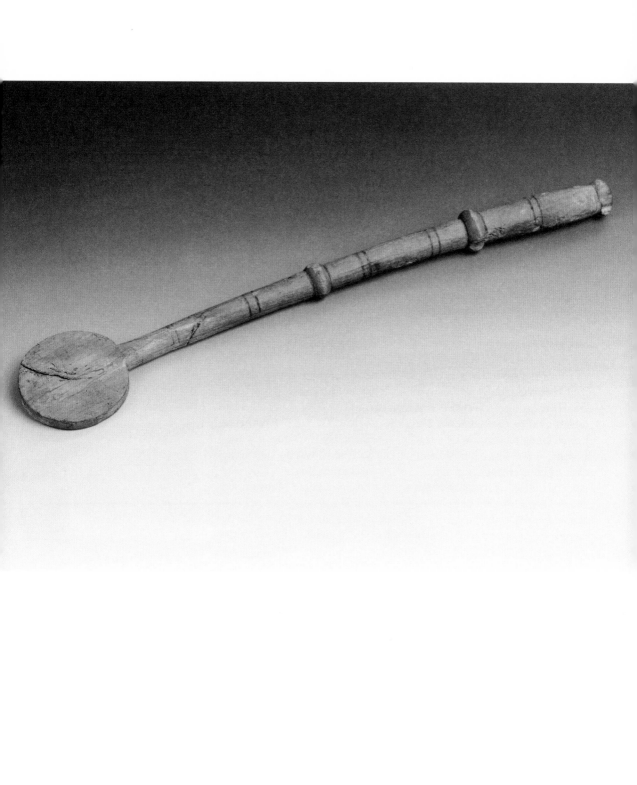

EPITAPH FOR MARTIN LUTHER'S TEACHER JOHANNES LEDENER

1505 NON-FERROUS METAL 22 × 34 × 0.5 CM
EVANGELISCHE KIRCHENGEMEINDE MANSFELD

In the year of the Lord 1505, the 19th day of September /
saw the passing of the honourable and cordial man, /
Mister Johannes Ledener, /
Pastor of this church and Rector. /
May his soul rest in peace.

Luther's education began at the *trivium* school in Mansfeld. Thus as a child
he already served in church, because both pupils and teachers participated
in liturgical duties and requiem masses at the nearby Church of St. Georg.
The pastor at the church – Johannes Ledener during Luther's schooldays
– was the school principal and presumably also taught there. When Luther
enrolled in 1488 he first learnt to read and write, and was taught the rudi-
ments of Latin. After that he studied for the *trivium* exam, which tested the
candidate's knowledge of grammar, rhetoric and logic. The young Luther
was not impressed by his teachers' methods, because they were too brutal
and idiosyncratic and left no room for children to develop: 'It's a bad thing
if children and pupils lose their spirit on account of their parents and teach-
ers. There have been bungling schoolmasters who spoiled many excellent
talents by their rudeness' (WA TR 3, Nr. 3566, 416; LW 54, 235). Luther re-
ported being hit 15 times by a teacher – presumably the same Johannes
Ledener – wielding a punishment paddle because he was not able to de-
cline a Latin verb, although it had not yet been covered in class. Neverthe-
less, the much disparaged methods at the *trivium* school in Mansfeld did
enable Luther to continue his education, first in Magdeburg, then in Eisen-
ach and lastly at the University of Erfurt, and set him on his way to be-
coming an academically trained theologian, who could keep abreast of the
most advanced scholarship of his own time.

Luther worked his negative experiences at school into two of his program-
matic, reformist texts – *To the Councilmen of All Cities in Germany* (1524) and
A Sermon on Keeping Children in School (1530) – in which he insisted on the
need for municipal teaching institutions with progressive teaching meth-
ods. And in order that children, both boys and girls, from less wealthy
homes should also have the chance to be educated, Luther proposed that
the authorities should set up public schools, so that talented children should
no longer remain undiscovered due to their parents' poverty. Furthermore
he proposed that more attention should be paid to history and its narra-
tives, to singing, music and mathematics, for which school libraries would
also be needed. In addition he felt that languages should be taught, not by
merely forcing pupils to decline and conjugate from memory, but rather
by awakening pupils' interest in the language itself – without resorting to
harsh punishments and intimidation. However, Luther's proposals for ed-
ucational reform ultimately always had a theological aim. In his view all
education and knowledge had just one goal: to equip people to read and
interpret the Holy Scriptures so that they could live according to God's
will and commandments. Mirko Gutjahr

→ Further readi
Marilyn Harran: *Martin Luther. Learning for Life*, St. L(
Missouri 1997.
Markus Wriedt: Bildung, in: *Luther-Handbuch*, Albre
Beutel (ed.), Tübingen 2005, 231–236.
Mirko Gutjahr: Aus gutem Hause, in: Gaby Kuper
Mirko Gutjahr: *Luthers Elternhaus. Ein Rundgang durch*
Ausstellung, Aschersleben 2014, 10–30.

WENDELIN TIEFFENBRUCKER, LUTE
AKA VENDELIO VENERE

C.1580 PADUA MODIFIED: JOSEPH JOACHIM EDLINGER, PRAGUE, 1732
WOOD, GUT STRINGS AND IVORY 112.5 × 35 × 35 CM
MUSEUM FÜR MUSIKINSTRUMENTE LEIPZIG

For the reformer Martin Luther, music came a close second in importance to theology. However, this order was chronologically reversed in his life history: from an early age, Luther grew up with music, which he loved long before he learned and came to love theology. As a pupil in the elementary school in Mansfeld, he was a choirboy. In Eisenach he sang with the *Kurrende*, a 'strolling choir' which went from door to door, singing songs in return for payment; their repertoire included both traditional secular songs and spiritual motets. While at university in Erfurt, he studied music as one of the seven liberal arts in the curriculum, although this focused mainly on the theoretical principles of music rather than its performance. Luther was familiar with the music of his contemporaries, and he particularly esteemed the work of the Franco-Flemish composer Josquin Desprez (c.1450/55–c.1521), whom he later praised as an outstanding example of how the Gospel could be preached through music. (WA TR 2, Nr. 1258, 11–12: LW 54, 130).

Luther could also play musical instruments, including the transverse flute, but he was above all a skilful lutenist. According to Luther himself, he first learned to play the lute as a student in Erfurt in 1503 or 1504, while recovering from an injury. (WA TR 5, Nr. 6428, 657). He makes specific reference to *Absetzen*, a method where the lute strings are plucked using several fingers, enabling polyphonic lute accompaniment for singing. This demanding technique, introduced to Germany around 1500, required regular practice: as a constantly busy reformer, in later years it is doubtful whether Luther would even have found time to play the lute. However, he retained a lifelong appreciation for music, particularly when well understood and performed: 'But when [musical] learning is added to all this and artistic music which corrects, develops, and refines the natural music, then at last it is possible to taste with wonder (yet not to comprehend) God's absolute and perfect wisdom in his wondrous work of music.' (WA 50, 372: LW 53, 324).

We do not know which type of lute Luther played. Indeed, very few instruments of this kind made in the first half of the sixteenth century still survive. The example shown here, from the Museum of Musical Instruments in Leipzig, was made around 1580 in Padua by Wendelin Tieffenbrucker. Made in the traditional style of the major lute-making centre of Füssen, in Bavaria, the back of the lute is formed from 33 yew ribs, with inlaid double stringing in ebony and ivory. The instrument was modified in 1732, when additional bass strings were fitted. Benjamin Hasselhorn

→ Further readi
Martin Treu: Laute, in: *Das Luther-Lexikon*, Volker ▮
pin and Gury Schneider-Ludorff (eds.), Regensburg 2◦
377–378.

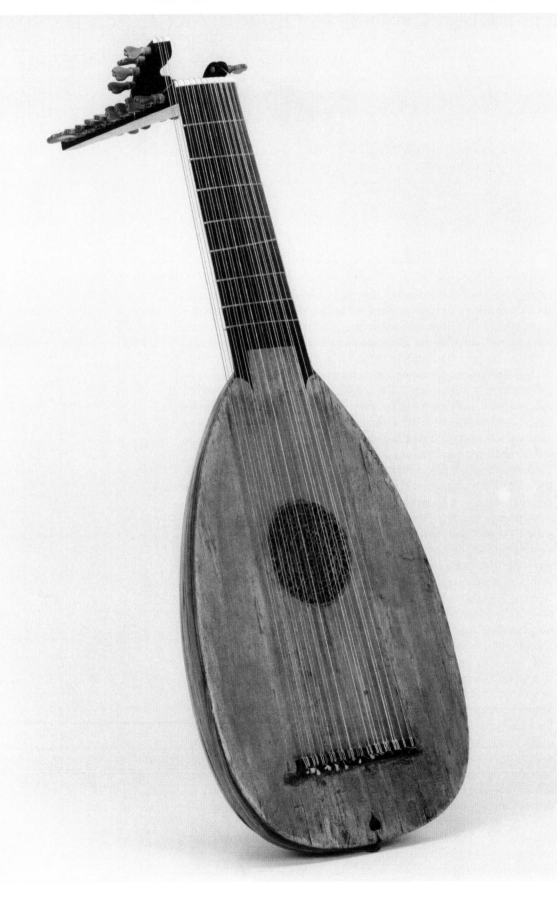

PAUL MÜLLNER THE ELDER
(ATTRIBUTED)

LARGE SCEPTRES FROM THE UNIVERSIT OF WITTENBERG

1509 NUREMBERG SILVER, PARTLY FIRE-GILDED
LENGTH 87 CM EACH
ZENTRALE KUSTODIE DER MARTIN-LUTHER-
UNIVERSITÄT HALLE-WITTENBERG

In 1501 Luther was enrolled as a student at the University of Erfurt, the institution closest to his home town. Thus he initially went along with the plan devised by his father who was investing in his family's social advancement through the academic education and professional career of his son. Luther studied the *Artes liberales*, the seven liberal arts of grammar, rhetoric, logic, arithmetic, geometry, astronomy and music. He gained his master's degree in 1505 and immediately enrolled in the Faculty of law, but his time as a law student was to last just a few weeks. As he travelled back to Erfurt from his native Mansfeld on 2 July 1505, he was caught in a heavy thunderstorm during which he feared for his life, an experience that would radically alter the course of his life.

The vow he made in the storm near Stotternheim and his subsequent entry into the Augustinian monastery at Erfurt interrupted his studies for two years. Following his ordination as a priest and at the instigation of his religious superior, Johann von Staupitz, he resumed them in the summer semester of 1507, but this time in the Faculty of Theology. It was probably also Staupitz who in 1508 put Luther forward as a stand-in for the philosophy lectureship at the University of Wittenberg, which had been founded in 1502. After being temporarily posted back to Erfurt, Luther became Professor of Theology at Wittenberg in 1511 and obtained his doctorate of theology in 1512. This academic title contributed significantly to Luther's self-image in the theoretical disputes that would follow: he challenged the aberrations of the Church not as an ordinary monk, but as an established Doctor of Theology. These disputes were also closely linked to Luther's opposition to Scholasticism and his championing of the introduction into universities of humanist ideas of teaching and education.

The university sceptres pictured here were probably made by Paul Müllner the Elder (1475– after 1530) in 1509 and represented the academic authority of the University of Wittenberg. Their design was common up to the 18th century and notable for the fact that they are shaped like maces and topped by a knob decorated with floral scrollwork. According to the university statues they were carried by bedels on ceremonial occasions, such as processions and the matriculation of new students. When awarded their doctorate, graduates would place two fingers on the insignia as they swore their oath. Martin Luther would have done this when he received his doctorate in 1512. The two sceptres were made on the orders of the university's founder, Elector Friedrich the Wise. Mirko Gutjahr

→ Further readi

Markus Matthias: Me auspice – Unter meinem Sch in: *Emporium. 500 Jahre Universität Halle-Wittenberg*, G nar Berg et al (eds.), Halle 2002, 137–163.

Das ernestinische Wittenberg. *Stadt und Universität (1. –1547)*, Heiner Lück (ed.), Petersberg 2011.

Michael Ruprecht: Small Scepters of Wittenberg Uni sity, Large Scepters of Wittenberg University, in: *Ma Luther. Treasures of the Reformation*. Catalogue, Drese 2016, 148–150, nos. 137 and 138.

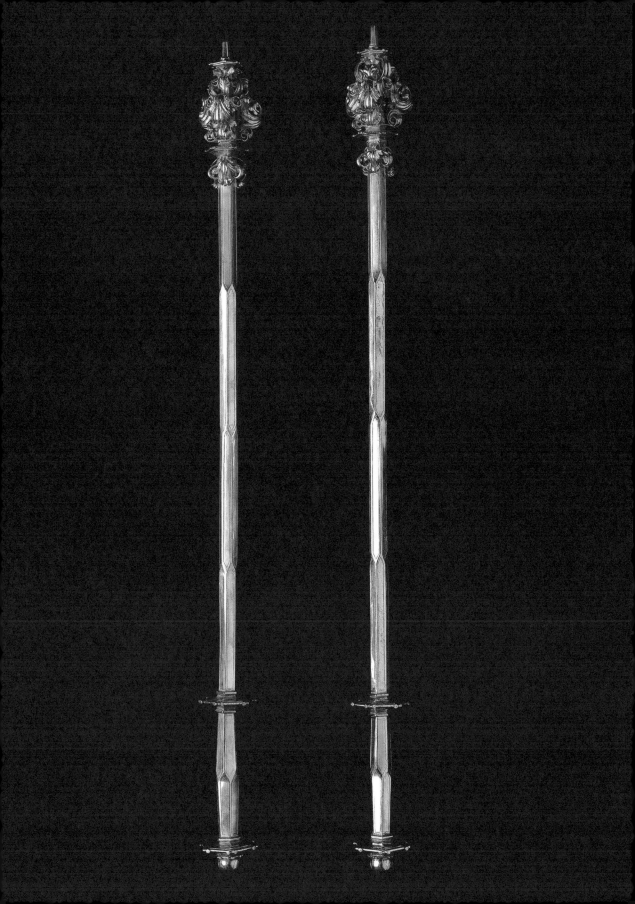

'THERE IS ONLY ONE THING LEFT: MY POOR WORN BODY, WHICH IS EXHAUSTED BY CONSTANT HARDSHIPS.'

LW 48, 69

Luther had a sensual, even hearty relationship with his own flesh and bones, and he often expressed his deepest feelings or theological beliefs in images derived from the human body. At the same time Luther's own bodily experiences reinforced his conviction that human beings were in a state of dereliction, that indulgences were a chimera, and that celibacy led to debauchery and perversion. The source of much of Luther's own personal charisma was his physical presence, his reassuring corpulence. His unashamedly uncomplicated, if anything, accommodating attitude to all things corporeal, to the pleasures, needs and afflictions of physical existence, made him a down-to-earth, deeply human hero – in his opponents' eyes the very embodiment of all that is diabolical.

'YET IN MY FLESH I SHALL SEE GOD': ON LUTHER'S CORPOREALITY

CATHERINE NICHOLS

The Reformation was all about sex: Thomas More, Luther's contemporary and adversary, was sure of it. In highly alliterative torrents of abuse, he accused Luther of 'open lying in lechery with his lewd leman the nun', declaring that the miscreant loved his wife 'with such a lewd lousy love as the lewd lousy lover in lechery loveth himself'. It may well be that the English humanist and statesman's insults said more about his own inclinations than those of the young monk – More was notorious for his libido – yet in a sense they were not so far off the mark. For Luther's hopelessly ruinous, troubled body was indeed at the core of his epiphany, evolution and experience as a reformer.

Luther, that sack of 'maggot-fodder' (WA 8, 685; LW 45, 71), as he described himself many times, was a key topos for his contemporary allies and opponents alike. For a long time, however, his physical being was of little interest to Reformation scholars. One notable exception is the ongoing discussion of the (possibly very private) location of Luther's epiphany, his realisation that, in God's eyes, human beings only attain righteousness through faith. After the biographical sermons delivered by Johannes Mathesius (1504–1565) and the invective penned by Johannes Cochlaeus (1479–1552), it would be several hundred years before Luther's body sparked any interest again. With the exception of Heinrich Denifle, author of *Luther and Lutherdom* (1904; English translation 1917), who painstakingly researched his suspicion that Luther had merely sought theological legitimation for his 'lust of the flesh', it is only relatively recently that scholars have revisited the question as to whether Luther's corporeality may have influenced his subjectivity and, hence, the events of the Reformation. The first move in this direction was made by Heiko Oberman. In his biography *Luther: Man between God and the Devil* (1982; English translation 1989), he made the case for an end to 'monkish priggishness' in the reception of Luther's works. But this only fully bore fruit some 20 years later, when scholars of theology and early modern history, led by Lyndal Roper, began to take an interest in the 'embodied' subject.

Be it Luther's sexuality or his ailments, his corpulence or his body language, 'corporeal' analyses of his ideas, his persona and his impact generally focus on the period after 1517. This has much to do with the sources available to scholars: although Luther already referred to some complaints before 1517, it was really only in the years after the 95 Theses that his body began to feature more prominently in his writings. Take sex, for instance. Whereas the young Luther barely seemed to give it a thought, from 1519 he devoted considerable attention to the subject. Despite at times equating desire with leprosy or epilepsy, he openly declared that, for him, sexual gratification was 'more necessary than sleeping and waking, eating and drinking, and emptying the bowels and bladder' (WA 10 II, 276; LW 45, 18). In texts such as his *Sermon on the Estate of Marriage* (1519), *De votis monasticis iudicium* (1521) and *The Estate of Marriage* (1522), all written when he was still living as a monk, he spoke out against celibacy and expounded the advantages of marriage. He supported his argument by citing the creation story, which he investigated in depth from around 1519, in his *Scholia in librum Genesis* and in several series of sermons. With the exception of unbridled lust, which Luther considered a consequence of the fall from grace, sexuality was, in his view, clearly part of God's divine plan. Yet he remained true to his vows as a monk until 1525. It was not that he felt no bodily or sexual desires – as he told Georg Spalatin, he was made from neither wood nor stone. But he felt that, since he would soon be overtaken by the 'death and the punishment

due to a heretic', he would do better to remain alone (WA BR 3, Nr. 800, 394; LW 49, 93). From 1535, in his major lectures on Genesis, he once again turned to the topic of sexuality and humankind's fall from grace. By then, however, he had been married to Katharina von Bora for ten years and was speaking against the backdrop of his evident sexual fulfilment.

Few of the sources that relate to Luther's many ailments, including digestive problems, constipation and haemorrhoids, precede the 95 Theses. Nevertheless, there are indications that Luther's multiple afflictions in later life may have been a consequence of his early monastic existence. Luther often referred to the fact that he had martyred his body with some 20 years of praying, fasting, freezing and keeping vigils in the monastery (WA 48, 482). However, reliable records of his medical disorders are only available after 1521. In letters to his friends Philipp Melanchthon and Georg Spalatin, he talks of the intolerable moments when God relentlessly assaulted his abdomen (for instance WA BR 2, Nr. 407, 332–33; LW 48, 215). It now seems that Luther had Roemheld syndrome, whereby infections in the gastrointestinal tract trigger cardiac and circulation problems. Luther first suffered these symptoms in 1518, on the journey to Augsburg, where he was to be interrogated on his 95 Theses by the pope's emissary, Cardinal Thomas Cajetan. He had another particularly severe attack in 1521 on his way to the Diet of Worms and also during the period he spent in hiding at the Wartburg. From 1523 onwards, after dramatically losing consciousness on one occasion, Luther also complained of dizziness, headaches and a rushing sound in his ears. It seems that, from 1527, he was frequently troubled by attacks of that kind, which often also affected his stomach. These symptoms have generally been diagnosed as Ménière's disease, a disorder of the inner ear that is often linked to tension and emotional stress. Although Luther was familiar with the theory of the four humours, his own explanations for his maladies were purely theological: irrespective of the symptoms, he read his complaint as a manifestation of the fall from grace and his body as a battlefield for God and the Devil. By contrast Jesus Christ was the physician who could bring healing, and Holy Communion was the remedy for both the body and the soul.

Like Luther's ailments, it was only after he posted his 95 Theses that his physical appearance also became a matter of public debate. In 1519, after the first Leipzig disputation, Petrus Mosellanus, a professor at the University of Leipzig, wrote a report containing the first reference to the then still 'gaunt Martin' and to his 'body exhausted by cares and study'. The first faithful likeness of Luther dates to the year after that. It was made by Lucas Cranach the Elder, who chose to portray him as an ascetic-looking figure, very much in the tradition of Catholic saints. Not long afterwards this first depiction was replaced with a more robust, manly image, and by 1522, at the latest, Hans Holbein the Younger completed his woodcut of Luther as a cudgel-

wielding *Hercules Germanicus*, a 'berserk Hun', as Thomas Kaufmann puts it, getting even 'with the intellectuals representing the ecclesiastical *ancien régime*'. That same year, when Luther was living incognito at the Wartburg, Lucas Cranach the Elder portrayed him as Junker Jörg – here, too, he has a virile, down-to-earth look. Having been declared a heretic at Worms, Luther had assumed an alias inspired by St George the dragon slayer and had disguised his appearance by growing a beard and not shaving a tonsure. In likenesses from around 1530, Luther suddenly appears much more corpulent: he is stout and has a paternalistic, magisterial air, akin to the worldly rulers of his time. As Lyndal Roper concluded, his changing physical appearance and his charismatic body language became a key vehicle for the Reformation.

Even Luther's characteristically 'physical' language – an idiolect ranging from the eloquent to the obscene – only really took flight after 1517. Luther's often strikingly anal imagery, which provided easy pickings for twentieth-century psychoanalysts such as Erik H. Erikson and Erich Fromm, was fully in tune with the apocalyptic atmosphere of the late Middle Ages. In fact Luther was already talking in scatological terms as a young man. Heiko Oberman cites a particularly colourful example of this from Luther's sermon to members of his own Augustinian order in Gotha on 1 May 1515, in which he describes slander as chewing and sniffing at other people's excrement (WA 1, 50). But the scatological imagery favoured even by the scholars of the day, which Luther both brilliantly mastered and readily deployed as a weapon, truly blossomed in his polemical pamphlets, most notably *Against Hanswurst* (1541), and the *Table Talk* (recorded from 1531). Indeed for preference Luther fought his quotidian long-running battles against the Pope and the Devil in the realm of his bowel: farts and faeces were his – and humanity's – weapon against the Devil relentlessly riding his back and breathing fire into his flesh (WA 2, 125; LW 42, 75), metaphorically and presumably literally, too, as the reformer's retrospective description of his 'tower moment' suggests (WA 54, 179–187; LW 34, 323–38).

Luther's later corporeality no doubt sheds light on his earlier condition. All the symptoms, opinions and strategies described above were already presaged and prefigured in the life of the young monk. And yet, when it comes to Luther's life- and world-changing development as a theologian, it is specifically his early years that come into play. But what insights into his evolution as a reformer can be gleaned from the few sources relating to the intertwinement of corporeality and theology in the life of the young Luther? Luther's reformist theology was rooted in the conclusions he drew from the ambivalent nature of the human body and the incarnation of God the Father. This is already evident in his writings from before 1517. Of particular interest are Luther's many marginalia, from around 1509–10, on St Augustine. These reflect his incipient doubts regarding the role of 'good works'

in the Scholastic concept of sin and also point to his exploration of the question of the incarnation of not only the Holy Spirit but also the human spirit. Luther set out these ideas in 1513 in his lecture on the Psalms, in which he alludes, for the first time, to the liberating effect of the incarnation, that is, the body of God. Luther tells his listeners that 'Christ's coming is our goodness, for He has taken away, first from our conscience, the punishments which are our evils, and then He will also remove them from the body' (WA 4, 336; LW 11, 458). In another lecture Luther considered St Paul's Epistle to the Romans, in which Paul regarded his own recalcitrant body as an education. Luther's studies reinforced his conviction that people should be regarded as thoroughly sinful beings who are dependent on God's grace. Moreover his studies also taught him that salvation was not to be attained through good works but in the incarnation: it was only in the tormented and resurrected body of Christ that God could be tangibly present.

Luther's belief that God loves not only the sun and the stars but also those sacks of maggot-fodder otherwise known as human beings was derived partly through his own body, but above all through the body of Jesus Christ. In the same way that Luther's corporeality influenced his theology, his reformative teaching also had a positive impact on his own physical well-being. While his spiritual aspirations had little to do with his sexual inclinations, sex nevertheless rapidly became the *cause célèbre* of the Reformation. And, as time passed, Luther, too became acquainted with the unique eroticism to be found in the certainty of grace. It appears that Thomas More was not that far off the mark after all.

LUCAS CRANACH THE ELDER

MARTIN LUTHER WEARING A DOCTOR'S CAP

1521–24 MIXED MEDIA ON PANEL
40.3 × 26.5 CM
PRIVATE COLLECTION

In March 1522, after Luther had spent nearly a year incognito at the Wartburg, where he went by the name of Junker Jörg, he returned to Wittenberg and once again donned the black habit of an Augustine monk and had his hair tonsured. Cranach's painting of him as a learned monk with a doctor's cap could mark the very moment of his return. Luther's curls have grown and his face is fuller after the good life at the Wartburg – even if there may be a degree of idealisation here, this is no longer the ascetic monk seen in a copper engraving dating to 1520.

In 1521 Lucas Cranach the Elder (1472–1553) and the electoral court had very deliberately published a second portrait-print of Luther, now showing the Augustine monk in profile with a doctor's cap, as a demonstration of the learned theologian's bold rebellion against the Pope. A woodcut of Luther as the urbane Junker Jörg with fashionable moustache and whiskers may well have been made immediately after Luther's return from the Wartburg, resolutely calming the troubles kindled by his comrade-in-arms Andreas Bodenstein von Karlstadt. This portrait of Junker Jörg was also executed in oils.

It may be that Cranach's painting of Luther as an Augustine monk wearing a doctor's cap was intended as an alternative to Junker Jörg but then not pursued further as a motif. In those tempestuous times Luther struggled for recognition as a doctor of theology. It is said that on a visitation trip to Orlamünde in Thuringia, when he found that Karlstadt had exchanged his doctor's cap for a felt hat, Luther demonstratively kept his own doctor's cap on his head at the reception there. He clearly regarded it as a symbol of his status as a man of learning.

If the presumed early date of this painting is correct, that would make it one of the first portraits of Luther to be painted in oils. The year 1517, added later in the upper left, can only be a reference to the date when Luther posted his 95 Theses. All that remains of what is evidently an authentic date, by Luther's right shoulder, are the first two digits: '15'. It is clear that this portrait cannot have been painted before 1520, because details of Luther's physiognomy derive from the lost drawing that Cranach did for the first portrait of Luther as an ascetic monk, which is known from reverse-prints of the engraving.

In these early portraits Cranach devised a finely nuanced, tactical iconography of Luther imagery, which is poised somewhere between heroisation and sacralisation. After 1525, along with the serially published marriage portrait and the companion-piece portraits of the reformers Luther and Melanchthon, these portraits changed medium from prints to oil paintings. Surely there can be no emperors or even scholars who were depicted so often – and so symbolically in later life – as Luther. It is also remarkable that Luther, a German theologian, was portrayed in profile and in the half-length portraits that had hitherto been the preserve of monarchs and princes.

→ Further readi
Daniel Hess und Oliver Mack: Luther am Scheideweg c
Fehler eines Kopisten? Ein Cranach-Gemälde auf d
Prüfstand, in: *Original – Kopie – Zitat. Kunstwerke des*
telalters und der Frühen Neuzeit, Wolfgang Augustyn
Ulrich Söding (eds.), Passau 2010, 279–295.
Thomas Kaufmann: *Der Anfang der Reformation. Stu*
zur Kontextualität der Theologie, Publizistik und Inszenier
Luthers und der reformatorischen Bewegung, Tübingen 2
266–267 (Die Heroisierung Luthers in Wort und B
472 (Vestimentäre Konversionen).
Wolfgang Holler: Cranach zeigt Luther. Eine Bildstrat
der Reformation, in: *Weimar und die Reformation. Lut*
Obrigkeitslehre und ihre Wirkungen, Christopher Sp
Michael Haspel and Wolfgang Holler (eds.), Leipzig 2
83–103.

Katja Schneider

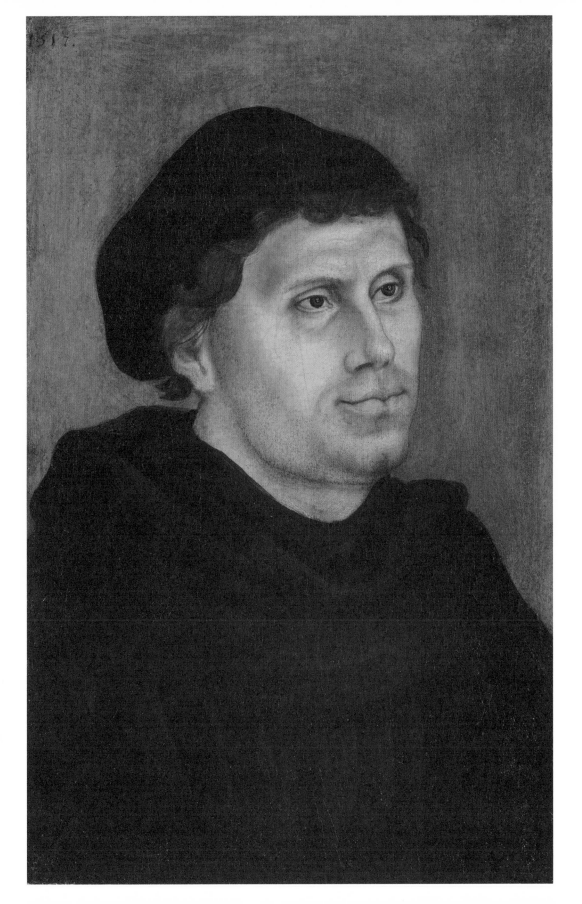

POMANDER

LATE 15TH CENTURY SILVER, PERFORATED, ENGRAVED, PARTIALLY
GILDED, AND ENAMEL DIAMETER 5 CM
BAYERISCHES NATIONALMUSEUM, MUNICH

In the late Middle Ages diseases were regarded as evidence of *status corruptionis*, that is, the state of corruption that human beings had inhabited ever since their fall from grace. The sin committed by Adam and Eve was deemed to be the source of human beings' current transgressions, which then brought sickness upon them as divine retribution. Luther shared this belief. Like St Augustine before him, he regarded Jesus Christ the Saviour as *Christus medicus*, as the 'true physician' (WA TR 3, Nr. 3580, 428; LW 54, 238). However, for Luther, Christ's healing specifically came through the Word of God. In his view healing was above all a spiritual matter and consisted in reinstating the right relationship between the sick person and God. At the same time – as a man of his own time – Luther also viewed diseases as attacks by the Devil, although the Devil did not act purely on his own account, but with the means supplied to him by God (WA TR 1, Nr. 722, 347). It was against the backdrop of this traditional notion of diseases and how to ward them off that pomanders became popular – in this case a silver sphere that opens out into four sections. In the centre there is a figure of the Mother of God standing under a canopy with the infant Jesus. The hinged segments that open outwards are decorated with saints identified in banderoles as 'Dorothea, Johannes, Barbara, Andreas, Magdalena, Paulus, Katharina, Petrus'. These segments, which close with special sliding mechanisms, can be filled with either plant- or animal-based aromatic substances – such as the ambergris that gave the object its English name (from Medieval Latin *pomum de ambra*) – and release the fragrances through their external perforations.

This little object, which could be worn on a rosary or on a chain attached to a belt or around the neck thus provided a two-pronged defence against disease. On one hand the aromatic substances prevented the transmission of pestilences such as bubonic plague, which were thought to spread via 'bad air'; on the other hand the images of the saints would shield the wearer from supernatural beings such as demons and witches, who were also blamed for spreading diseases. The pomander shown here was probably made in the Rhineland or in northern Germany in the late fifteenth century and is one of the earliest surviving examples of its kind. It seems that Luther received just such a pomander as a gift from Johann Friedrich, Elector of Saxony, in 1543, which he then passed on to his wife and children.

Mirko Gutjahr

→ Further readi
Medicine and the Reformation, Ole Peter Grell and And
Cunningham (eds.), Abingdon 1993.
Jürgen Helm: 'Medicinam aspernari impietas est'. Z
Verhältnis von Reformation und akademischer Medi
in Wittenberg, in: *Sudhoffs Archiv 83* (1999), 22–41.
Karin Tebbe: Bisamapfel, in: *Spiegel der Seligkeit. Priv*
Bild und Frömmigkeit im Spätmittelalter, Frank Mattl
Kammel (ed.), catalogue to the exhibition *Spiegel der S*
keit. Sakrale Kunst im Spätmittelalter, Nürnberg 2000, 2
288, No. III.

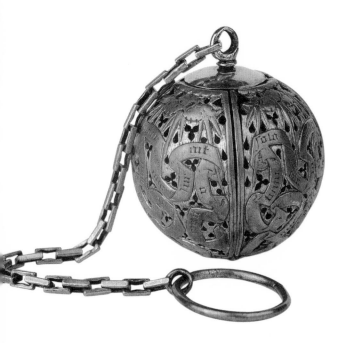

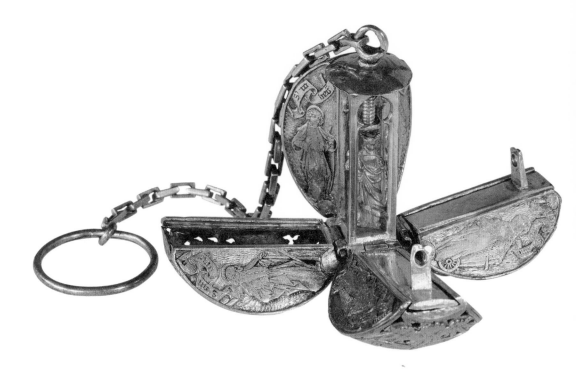

ANIMAL BONES FROM MARTIN LUTHER'
BIRTH HOUSE

FIRST HALF OF THE 16TH CENTURY 2.2–11.2 CM
LANDESAMT FÜR DENKMALPFLEGE UND ARCHÄOLOGIE –
LANDESMUSEUM FÜR VORGESCHICHTE – SACHSEN-ANHALT

The numerous archaeological finds that have been excavated from Luther's parental home – including animal bones – provide a wide range of information on the everyday diet of the Luder family around 1500. The few bones from beef cattle were in all likelihood left over from the soup meat that was sold by the portion at stalls in the town. In the early Modern era meat stock formed the basis for many dishes. It seems that the tender – expensive – meat of young swine was a particular favourite in the Luder household. Around 60 percent of the mammal bones found are from domestic pigs, which the Luders may have kept themselves, or they could equally well have bought pork from nearby meatsellers. This unusually high percentage compared to other bourgeois households suggests that the family was comfortably off. The bones of sheep and goats are so similar as to be barely distinguishable, but together certainly account for around a third of mammal bones found at the dig.

There were three times as many goose bones as bones from other fowl in the family's rubbish pit. Considering that geese are only slaughtered between late autumn and the new year, roasted goose must have been on the menu unusually often when it was in season. It also seems that the family frequently ate chicken throughout the year, preferably young birds. It is highly likely that the family bred their own geese and chickens.

Fish was often eaten on fast days. Besides freshwater fish from close to home, such as carp, bass, perch and eel, the family also ate salted or dried herring and cod, which could be transported relatively inexpensively from the Baltic Sea. The dig also uncovered a remarkably large number of small bones from song birds. Although song birds had little flesh on them these 'small game' were prized as special delicacies that ordinary citizens from the middle and lower classes were allowed to catch and eat. Birdcall whistles suggest that members of the Luder family may well have gone out hunting with nets and sticks smeared with glue, catching song thrushes in large numbers, but also robins and chaffinches.

The menu in the Luder household depended not only on the food that was in season but also on the passage of the liturgical year. During the times of year when the faithful were not fasting, the family ate much more game and pork than beef or lamb. Milk was processed to make cream cheese, which kept longer than fresh milk. Fish was often eaten on the abstinence days stipulated by the Church. Grains, fruit and vegetables could be enjoyed all year round, some of which were probably grown in the family's own kitchen garden. The family drank wine and home-brewed beer, which – as 'small beer' with a very low alcohol content – was served with all their meals.

All his life Luther had fond memories of the kitchen in Mansfeld, which meant 'home' to him in the deepest sense. Mirko Gutjahr

→ Further readi
Hans-Jürgen Döhle: Schwein, Geflügel und Fisch –
Luthers zu Tisch, in: Luther in Mansfeld. Forschungen
Elternhaus des Reformators (Archäologie in Sachsen-An
Sonderband 6), Harald Meller (ed.), Halle 2007, 169–
Alexandra Dapper: Zu Tisch bei Martin Luther, Halle 2
Mirko Gutjahr: Aus gutem Hause, in: Gaby Kuper
Mirko Gutjahr: Luthers Elternhaus. Ein Rundgang durch
Ausstellung, Aschersleben 2014, 10–30.

TOILET SEAT

LATE MIDDLE AGES WOOD 117.5 × 32 CM
ARCHÄOLOGISCHES LANDESMUSEUM
BADEN-WÜRTTEMBERG, KONSTANZ

It is said in the *Table Talk* that Martin Luther was '*in cloaca*' – in the latrine in the turret extension at the Augustine monastery in Wittenberg – when the Holy Ghost communicated the realisation that led him to a new understanding of justification as a gift from God to the faithful, which in turn culminated in the 95 Theses (WA TR 2, Nr. 1681, 177; 3, Nr. 3232 b, 228). Of course doubts have been raised as to the authenticity of this account and the significance thus attached to Luther's 'turret moment', particularly since any such realisation could not have been a sudden occurrence but in all likelihood the outcome of a process that took years. Nevertheless, this story is entirely in keeping with Luther's own use of scatological imagery. Human digestion and egestion served Luther as symbols not only of diabolical processes but also of the basest aspect of God-made human beings: 'God placed the midden, the cloaca, in the centre of the human face' (WA TR 4, Nr. 4309, 210). He even once described Rome as the '*Cloaca diabolorum*' because 'all the devils shit into it' (WA 47, 411). Looking back later he commented that, as a monk, he had been in the '*cloaca*' that was the Roman Church, which he had only escaped through his new reading of the Gospel. That new perception gave Luther access to his most important conclusion of all – namely that God's grace is only to be attained through faith – and it came to him in that most lowly of places.

At the same time, in Luther's worldview 'excremental' matters were not only symbolic of the Devil, they were also a suitable weapon to use against him (Lyndal Roper). When words and writing failed, filth – or so the medieval mind believed – could be deployed as apotropaic backup. In Luther's publications this is often found in combination with the literary fashion for Grobianism that first emerged in Sebastian Brant's *Ship of Fools* (1494) and particularly took flight in the works of Lutheran-minded writers such as Friedrich Dedekind. Luther believed that Satan, who was very much part of daily life at that time, could be frightened off by a fart, in the same way that 'devilish' opponents could be quashed by scatological invective.

No doubt there is a grain of truth to the story of Luther's turret moment – in the floor below Luther's study in Wittenberg there was in fact a single latrine, as opposed to the communal monastery latrine in the garden. During the excavations in Wittenberg, when the foundations of the turret extension on the south side of the Augustine monastery were discovered, the dig also revealed a brick-built shaft in the south wall of the turret, with grooves at either side to accommodate a wooden seat (no longer extant). It presumably had a circular lid. Medieval lavatory seats are rarely seen so well preserved as this one, which was discovered in Augustinergasse in Konstanz. Mirko Gutjahr

→ Further read
Reinhard Schmitt and Mirko Gutjahr: Das 'Schw
Kloster' in Wittenberg. Bauforschung und Archäol
im und am Kloster der Augustiner-Eremiten und W
haus Martin Luthers, in: *Fundsache Luther. Archäologe.
den Spuren des Reformators*, Harald Meller (ed.), Halle
132–139.
Lyndal Roper: Martin Luther's Body: The "Stout Do
and His Biographers, in: *The American Historical Re*
vol. 115, no. 2 (April 2010), 351–384
Ulrich Knapp: Latrinenanlagen in Klöstern, in: *A*
*im Mittelalter und der Frühen Neuzeit. Bauforschung -
chäologie – Kulturgeschichte*, Olaf Wagener (ed.), Peters
2014, 247–256.

UNGUENTARIA FROM THE LUTHER HOUSE
WITTENBERG

16TH CENTURY STONEWARE HEIGHT 4.8–6.5 CM, DIAMETER 3.1–5.4 CM
LANDESAMT FÜR DENKMALPFLEGE UND ARCHÄOLOGIE – LANDES-
MUSEUM FÜR VORGESCHICHTE – SACHSEN-ANHALT

In 2004 the excavations at the Luther House in Wittenberg turned up a considerable number of small cylindrical and conical stoneware apothecary's jars, of the kind that were used between the sixteenth and eighteenth centuries to store and transport remedies. They would originally have been sealed with a piece of parchment or fabric, which was secured with twine just under the rim. In all probability they were only discarded in the abandoned yard and not re-used for fear of contamination because they would still contain the residue of the original prescription – that would account for the large number of mainly well preserved jars that were found. Presumably these came from what was then the only apothecary in Wittenberg, at 1 Schlossstrasse, which Luther's friend Lucas Cranach the Elder was granted the right to run, by Electoral Privilege, in 1520. Whereas simple remedies could be prepared by a physician or at home, 'exotic' medications could only be procured from an apothecary.

To judge by Luther's own comments on the state of his health, he frequently needed medication, which he used with a clear theological conscience. While it is often difficult to relate his descriptions of bouts of ill health to present-day medical diagnostics, there are certain ailments he suffered that can be identified on the basis of his own accounts. It seems that he was troubled by Roemheld syndrome all his life, a condition in which maladies in the gastro-intestinal tract lead to cardiac irregularities. Luther first presented with symptoms of that kind in 1518 en route to Augsburg; they were particularly severe on the journey to Worms and during the months he subsequently spent at the Wartburg in 1521. Later he also suffered life-threatening bouts of renal colic and Ménière's disease, which causes rotational vertigo and fainting episodes. Some of his complaints, such as his gout attacks, were no doubt brought on by his rich diet and high levels of alcohol consumption; he was well aware of the consequences of his diet and prepared to live with them: 'I eat what I like and suffer afterwards, which I am perfectly capable of' (WA TR 3, 594, 18–19). He generally interpreted his ailments as attempts by the Devil to stop him from working, or as tests set by God. There are frequent references in the *Table Talk* and in Luther's letters to his health issues, but although he regarded these as obstacles, they never seriously hampered his immense productivity as a writer. At the same time Luther took the assaults on both his body and his mind as confirmation that he was on the right path, since the Devil is particularly keen to strike the true believers: 'For as soon as God's Word takes root and grows in you, the devil will harry you, and will make a real doctor of you and by his assaults will teach you to seek and love God's Word' (WA 50, 660; LW 34, 287). Mirko Gutjahr

→ Further readi
Ursula Kranzfelder: *Zur Geschichte der Apothekenabg und Standgefäße aus keramischen Materialien, unter beso rer Berücksichtigung der Verhältnisse in Süddeutschland 18. bis zum beginnenden 20. Jh.* (doctoral dissertation mitted to the Faculty of Chemistry and Pharmacy of L wig-Maximilians-Universität Munich), Munich 1982.
Ralf Kluttig-Altmann: *Von der Drehscheibe bis zum Si benhaufen. Leipziger Keramik des 14. bis 18. Jahrhundert Spannungsfeld von Herstellung, Gebrauch und Entsorg. (Veröffentlichungen des Landesamtes für Archäologie mit desmuseum für Vorgeschichte, Bd. 47)*, Dresden 2006.
Lea McLaughlin: Unguentaria, in: *Martin Luther. Treas of the Reformation*. Catalogue, Dresden 2016, 251–252, N 249–253.

POLYCHROME STOVE TILE WITH DEPICTION O EVE FROM THE LUTHER HOUSE WITTENBER

FIRST HALF OF THE 16TH CENTURY HAFNER WARE, GLAZED GREEN, BLUE, WHITE AND TAN
19 × 16 × 6.2 CM
LANDESAMT FÜR DENKMALPFLEGE UND ARCHÄOLOGIE –
LANDESMUSEUM FÜR VORGESCHICHTE – SACHSEN-ANHALT

This image of Eve from the Bible, with flowing locks and a simple gown tied at the waist with green tendrils, is one of a number of images on stove tiles that were found in 2004–05 in the back garden of the Luther House in Wittenberg. The motif is based on a series of *Twelve Women from the Old Testament* (1530–31) by Erhard Schön (c.1491–1542), one of the group of Little Masters in Nuremberg.

The finds retrieved from the Luther House include more fragments from tiles in this series, including one with an image of Rebecca. In all probability these items, along with other polychrome tiles decorated with portraits and coats of arms, came from a tiled stove in Luther's parlour. Two fragments are dated 1536, indicating when they were made.

Eve is seen here after the fall from grace, after she and Adam have been expelled from the Garden of Eden. In one hand she has the forbidden fruit from the Tree of Knowledge, in the other she is holding Adam's skull. However, since his skull was believed by many Christians to have been at the foot of the Cross of Jesus Christ – the new Adam – this indicates that humankind's original sin has already been redeemed. Luther regarded Eve as one of the female protagonists in the Old Testament who understood and implemented God's plan in their own lifetimes. In his lectures on Genesis Luther recounts the story, not found in the Bible, that after Adam and Eve had been driven from Paradise, Eve comforted her husband with the promise that after death they would be raised to a new and eternal life (WA 42, 148; LW 1, 202).

Luther grew up in a world where the sexual restraint practised in monasteries was regarded as a shining ideal. As a young man he entered the Order of Saint Augustine and lived a celibate life, as the rule dictated. However, after developing his reformist views he rejected celibacy on the grounds that it was not demanded anywhere in the Bible; it now seemed to him a prime example of the arrogance of the Church, which – entirely on its own account and contrary to the express instructions of the Holy Scriptures – had ruled that the clergy and members of monastic orders should be celibate, falsely maintaining that this was necessary for their salvation. Luther now asserted that the story of Adam and Eve in the Book of Genesis already clearly demonstrated God's will that men and women should enter into sexual relationships. Having sexual desires and acting on them was therefore legitimate, although only within the confines of marital love. Moreover, both partners should always be willing participants in conjugal relations, otherwise there was a danger that one or the other might become unfaithful. Spouses who refused to meet the needs of their partners thus fail in their duty to those closest to them and expose them to the dangers of illicit desire and adultery (WA 10 II, 267–304; LW 45, 11–49). Mirko Gutjahr

→ Further readi

Jane E. Strohl: Luther's New View on Marriage, Sexua and the Family, in: *Lutherjahrbuch* 76 (2009), 159–192. Volker Leppin: Ehe bei Martin Luther. Stiftung Go und 'weltlich ding', in: *Evangelische Theologie* 75/1 (2 22–33.
Louis D. Nebelsick and Susanne Kimmig-Völkner: I chrome Stove Tile Depicting Eve, in: *Martin Luther. sures of the Reformation.* Catalogue, Dresden 2016, 258 no. 262.

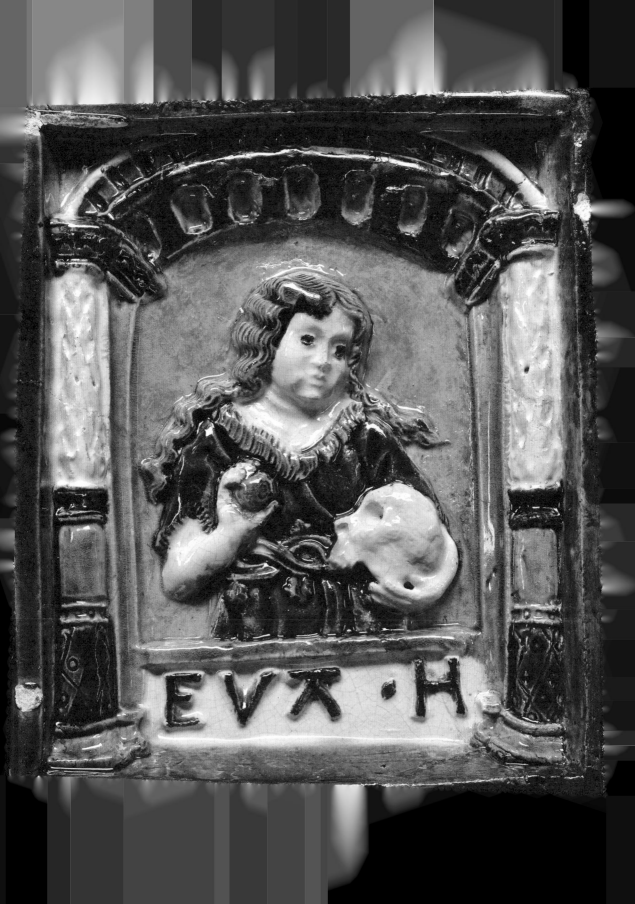

MARTIN LUTHER ON MONASTIC VOWS

PRINTER: MELCHIOR LOTTER THE YOUNGER,
WITTENBERG

1521 LETTERPRESS ON PAPER 21 × 15 × 1 CM
STIFTUNG LUTHERGEDENKSTÄTTEN IN SACHSEN-ANHALT

Luther's work on the monastic way of life and the vows on which it was based drew its conclusions from his understanding of freedom, which he had formulated in *The Freedom of a Christian* in 1520. In this treatise, he recognised that a direct relationship with Christ made a person free and thus reversed the focus for gaining human salvation through God. Salvation was no longer based on successful physical or mental behaviour and always a case of mastering or suppressing physical desires. Instead, salvation was a matter of faith. Faith provides a link to God through Christ and liberates the conscience, with the result that all subsequent behaviour arises from this freedom. A liberated conscience is capable of perceiving the adversities faced by fellow human beings and satisfying mutual needs.

In contrast, the life goal of perfection that was sought through self-restraint led to a contradictory situation of concentrating primarily on the body's resistance to the religious and moral life. Given that it is based on the vows of chastity, poverty and obedience to the order's authorities, the monastic way of life seemed to ease the road to salvation. Compared to the life of ordinary people, the monastic state thus conferred the special status of being one of the chosen. According to Luther, however, this presumed sense of security was misleading. After all, the commandments laid down by God, to which everyone was bound, could not be outdone by vows, which amounted to nothing more than 'evangelical advice' intended to connect those who took the vows to Jesus. Instead, the belief in the success of the vows conflicted with the claim of God's Word to be accepted in faith. Provided that faith, as recognition of God, already fulfils the first commandment, the commandments do not act as demands whereby non-compliance is met with punishment. Instead they are guidelines for a life of faith; there cannot be and does not need to be voluntary commitments over and above them. It is precisely in the abandonment of these vows that the Christian freedom to live completely in trust in God becomes apparent. This revealed another way of approaching the corporeal life to Luther that is not seen as a threat or obstacle to true piety but as a representation and fostering of Christian life in harmony with the Creator of body and soul.

This interpretation of Christian freedom became necessary as a result of the action inspired by Luther's interpretation of freedom in Wittenberg, particularly when it came to the marriage of priests. In the letter dedicated to his father included in this work *De votis monasticis iudicium*, Luther reflects on his own history. He describes it as a search for his own life before God, which he found in faith as opposed to a monastic existence.

Dietrich Korsch

→ Further readi
WA 8, 573–669; LW 44, 251-400
Brief an den Vater. Martin Luthers Widmungsbrief zu
votis monasticis iudicium [1521], Johannes Schilling (ed.)
Luther 80 (2009), 2–11.

DE VO

TIS MONASTICIS,
MARTINI LVTHE
RI IVDICIVM.

·

VVITTEMBERGAE.

'WHETHER I WISH IT OR NOT, I AM COMPELLED TO BECOME MORE LEARNED EVERY DAY

WA 6, 497; LW 3

Luther was born in turbulent times. Travelling merchants and explorers, but also missionaries, extended the geographical knowledge of Europeans beyond the boundaries of their continent. In many parts of Europe, the Church was engaged in a process of renewal, and the Ottoman Empire continued to expand and conquer new areas. However, these upheavals at the dawn of the modern era do not appear to have held much interest for Luther. Even on his journey to Rome, penance and grace seem to have been more important to him than the effects of the Renaissance on art, literature and architecture. The human need for salvation was his paramount concern. Beyond his personal experience of life in the central German region, the Bible was his principal source of worldly knowledge.

LUTHER'S EDUCATION

ANDREAS STEGMANN

Luther's education began long before he went to school. His parental home in Mansfeld provided his earliest learning experiences: there he learned the German language, began his religious socialisation, and absorbed the middle-class value system of his surroundings and time. Parents, relatives and acquaintances all played a part in establishing the lifelong foundations underpinning his knowledge and understanding of the world and, although the sources on this are scant, it would be difficult to overestimate their effects. Luther's fondness for the many proverbs and sayings he knew, and which he later delighted in sharing with others, is an indication of these early influences. According to an account in Luther's

Table Talk (WA TR 4, Nr. 4801, 521), in 1541, for the edification of his household, Luther chalked a biblical verse, 'One who is faithful in a very little is also faithful in much, and one who is dishonest in a very little is also dishonest in much.' (Luke 16:10), on the wall behind the tiled stove in his living room in Wittenberg. He also added several pertinent proverbs from his rich store, including 'Who will not keep a penny, shall never have many'.

Next to St George's Church in Luther's home town of Mansfeld there was a Latin school, which Luther attended from around 1491 when he was eight years old. Even elementary school education was by no means a matter of course in the late Middle Ages. At that time, two types of school existed and, as a rule, only in towns: German schools, where a wider range of pupils – including some girls – learned the basics of reading, writing and arithmetic, and the Latin schools, which taught the subjects of the *trivium* (the 'threefold path' of grammar, logic and rhetoric). In Mansfeld, Luther's teachers concentrated principally on grammar, which meant learning how to read, write and speak Latin; logic and rhetoric were treated at best as secondary subjects in the Latin school. The ability to speak fluent Latin was a prerequisite for further progress in education, as all academic learning of the time was recorded in Latin in the works of the ancient world and the Middle Ages. Latin was the medium for the transmission of knowledge, scholarship and debate and was the international language of the educated classes throughout western Europe. In schools, Latin was learned by rote and taught through incessant practical spoken and written exercises. The subject matter of the Latin textbooks and source texts used in class imparted wider knowledge, encouraged further thought, and helped to develop the pupils' personalities and expand their horizons. Thus, over the course of his schooling Luther became familiar with the late classical aphorisms ascribed to Cato and Aesop's fables, which were a source of basic moral instruction. As spiritual verse and passages from the Bible were included in the teaching material for Latin instruction, the young Luther also extended his religious knowledge through his language learning. In general, religion permeated the entire school curriculum. Religious instruction was not taught as a separate subject – instead, religious texts and topics were constantly studied and discussed. Daily prayers, hymns and choral singing by the Latin scholars in the Mansfeld town church imposed a religious framework on school life and a thorough musical training was an integral element of the curriculum as a result.

Around 1497, Luther left his home town to further his education in more prestigious schools. He later related that he attended school in Magdeburg with the Brethren of the Common Life – a religious community in the Dutch tradition of the *devotio moderna*. One of the tasks assumed by the Brethren was the spiritual guidance of children and young people in towns and cities. Although the Magdeburg Brethren did not run their own school,

they provided lodgings and care in a religious community for children who came from elsewhere to attend the cathedral city's schools. Why Luther changed schools again after only a year in Magdeburg is unknown. Whatever the reason, he moved to Eisenach, where he attended St George's school from 1498 to 1501. It is possible that this school was chosen because of its proximity to his mother's relatives, the highly respected Schalbe family, who led a life of Franciscan piety and with whom Luther was able to lodge. Although there is relatively little information about his time in Eisenach, it is known that one of his teachers, whom he greatly respected, was Wigand Güldenapf, that Luther – in common with his fellow pupils – earned money by singing outside the houses of prosperous citizens of the town, and that the Eisenach priest Johannes Braun introduced him to his religiously inclined and intellectually open-minded circle. However, during his time in Magdeburg and Eisenach Luther's main task was to perfect his knowledge of Latin.

In 1501, after ten years at Latin school, the 17-year-old Luther had completed the first stage of his formal education. He could now understand university lectures delivered in Latin and speak, read and write this exacting academic language. The classical writings which formed part of the curriculum of Latin schools must also have aroused his interest in history and geography. The process that had been initiated and enabled by his education in the Latin schools – the acquisition of the academic knowledge of the time – would reach its culmination in his university studies. Erfurt was the obvious choice of location as this meant that Luther could remain near to his family home while pursuing his studies at a renowned university. He was accommodated there in a student hostel, possibly the Collegium Amplonianum, where the students led a strictly regulated communal life firmly based on religious principles. Between 1501 and 1505, Luther studied in the Arts Faculty, where he repeated the *trivium* and went on to study the *quadrivium* (arithmetic, geometry, astronomy and music) and, above all, learned the fundamentals of philosophy (logic, in particular dialectics, natural philosophy, metaphysics and moral philosophy). These subjects were so comprehensive in their individual scope that together they covered all the fundamentals of secular learning in the universities of the late Middle Ages. They were taught through the interpretation of classical works, including the philosophical writings of Aristotle, which Luther studied intensively, and through commentaries on these by the Erfurt academics (followers of the Ockhamist school of philosophy, among them Jodokus Trutvetter and Bartholomäus Arnoldi von Usingen), which he also eagerly absorbed. It is likely that he also had access to several well-stocked libraries in Erfurt. It was here too that he first encountered humanism, a movement that began to establish itself in German universities around 1500. During his time in the Arts Faculty, Luther proved to be a diligent student; he read

assiduously and learned much, passing his examinations with increasing levels of success. In 1502 he passed the *baccalaureus* examination and while continuing his own studies also began to teach; in 1505 he was awarded the degree of Master of Arts.

When Luther completed his master's degree in 1505, the time had come to make use of the educational capital he had accumulated thus far. Luther's father decided that his newly graduated son would not go to work immediately, but would progress to further study in the Law Faculty, where he would acquire specialist knowledge to equip him for a career in the law. Luther would soon abandon these studies, however, as the search for spiritual perfection seemed more important to him than worldly success. Although entering a monastery did not cause a complete break in his education, it meant a marked change in its orientation. Religion now became the central focus of Luther's studies: from 1505 to 1507 he immersed himself in the traditions of Augustinian monasticism and intensive study of the Bible in the monastery of the Augustinian Hermits in Erfurt, and from 1507 onwards he studied in the Theology Faculty of Erfurt University, where he acquired a thorough knowledge of Scholastic theology.

With great speed and determination, Luther completed the theology course, which provided an introduction to mediaeval biblical interpretation and Church doctrine. He passed both theological baccalaureate examinations in 1509 and began to teach and to preach. As was the case in the Arts Faculty, teaching in the Theology Faculty took place through the medium of interpretation of classical texts, from the Bible and the Church Fathers through to the Scholastics; in this, the Erfurt theologians also followed the Ockhamist school of thought. As a Master of Arts, Luther also continued to teach in the Arts Faculty – including as a temporary lecturer in Wittenberg in 1508/9 – and never lost touch with the world of secular learning. In 1512, after he moved to Wittenberg to take up his appointment as professor of theology, the path his studies had taken through the educational institutions of the late Middle Ages culminated in his attainment of the highest academic degree, the title of Doctor of Theology.

Based on the standards and possibilities of his time, Luther's school and university education made him a particularly well-educated man – although he was far from being the polymath that Philipp Melanchthon, his subsequent friend and colleague, would become. Over the years that followed, Luther the theologian remained open to the world and eager to learn and acquire knowledge. Throughout his life, he constantly sought to learn more – through the many journeys he undertook, through the letters and writings sent to him by others, through contact with his Wittenberg colleagues and visitors to the Black Monastery, and through his work on the translation of the Bible. The continuous acquisition of knowledge was particularly important to him as he knew that in order to play a part in shaping

the world responsibly, it was essential to know about it. For Luther, the history of the world and salvation was a textbook from which lessons for the present could be learned. Conscious of the demands on him in the political sphere, Luther took great pains to broaden his horizons. His letters, occasional writings and table talk show how much he knew about history and how closely he followed political developments. The positions he took on numerous contemporary issues, from the right to resist to economic policies, bear witness to his efforts to gain a proper understanding of current problems and to formulate his advice in an appropriately practical way. However, he always remained aware of his limitations: despite his many educational attainments, as a theologian his specialist fields were faith and the Bible, not history and politics.

Luther also strove to pass on the benefits of his extensive education and knowledge to others: as a university teacher to his students, as an author to his readers and as the father of a family to his children. His realisation that both individuals and the human community as a whole needed education was a source of motivation for him. Further impetus came from his insight that linguistic and theological knowledge was essential for the revelation of God in the words of the Bible to be interpreted correctly and proclaimed to humankind. He believed that regular religious instruction should be given within families, and that parents should ensure schooling for their children. Towns and church communities should develop local education provision in the spirit of humanism and the Reformation, and territorial rulers should provide support for schools and universities and for scholars. As was typical for his time, Luther did not value education purely for its own sake but rather as an aid to living as a Christian and shaping the world with a Christian sense of responsibility. Just as his own educational path had led him to God, those of all people should ultimately also lead them to God.

MARTIN LUTHER'S UNIVERSE

As a child of the late Middle Ages Luther felt that he was firmly in God's hand. The Creation story was a matter of course. In the beginning of his universe was the Word, not the Big Bang. And the Word was God. Light and darkness, day and night, the Earth, humans and animals were all the work of the Almighty.[1, 2] But by the late Middle Ages, the end of the universe seemed nigh. Indeed, the frequent outbreaks of the plague, the many famines and wars had a profoundly unsettling effect on Luther and his contemporaries.

At that time the Earth was widely assumed to be situated at the centre of the universe, with God and the angels floating up on high.[3] Within Luther's lifetime Nicolaus Copernicus showed that our planet in fact orbits around the sun.[4] However, the reformer disregarded Copernicus's calculations as mere figments of his imagination, as 'pure folly'.

When Luther was born in 1483, only three continents were known: Asia, Europe and Africa. Anyone today looking at the maps that were available then quickly loses any sense of orientation. For the direction is given not

1 Giovanni di Paolo, *The Creation of the and the Expulsion from Paradise*, 1445
2 Lucas Cranach the Elder (workshop), *T ation of the World*, 1534
3 *The Seventh Day of Creation*, from: Hart Schedel: *Liber chronicarum*, 1493
4 *Nicolaus Copernicus*, 16th century

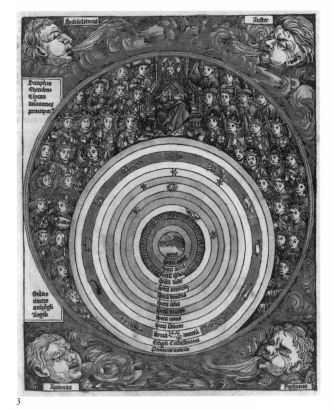

2

3

4

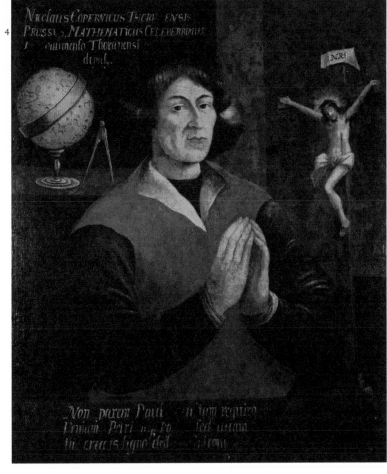

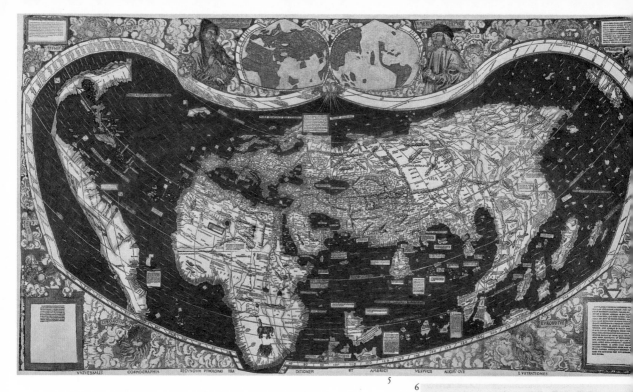

by north and south, east and west, but by the mythical sites of the Christian salvation story, with Jerusalem invariably located at the centre. The fourth continent, America,[6] was discovered in 1492 and it featured prominently in Martin Waldseemüller's new world map of 1507.[5] There is no saying whether the young monk Luther ever set eye on this Renaissance masterpiece. Yet he most likely had some knowledge of the letter that Christopher Columbus sent from the New World in 1493, since Columbus's report rapidly became a bestseller throughout Europe, and Elector Friedrich the Wise held a printed copy in his library in Wittenberg. Even so, Luther's interest was limited. He alluded to the 'discovery' of the new 'islands' but three times in his writings, each time only in passing (WA 62, 16; 10 III, 139; 53, 169). As late as 1530 he included a world map in his preface to the Book of Daniel that completely omitted America.[7]

Although Luther's imagination knew no bounds when it came to the unknown or even exotic landscapes and creatures referred to in the Bible, it would seem that the foreign countries and peoples of his own world held little appeal for him. Even Albrecht Dürer's much-reproduced woodcut of a *Rhinoceros* (1515) did not pique Luther's curiosity. In his eyes, the pachyderms so popular at that time were little more than symbols of power. Indeed, to him, the elephant that his adversary, Pope Leo X, had been given by the King of Portugal, was the mere embodiment of the secularisation and corruption of the curia.[8]

5 Martin Waldseemüller, *Map of the World,*
6 *Landing on Espanola,* from: Christopher
 lumbus: *Epistola Christofori Colom,* 1493
7 *Daniel's Dream,* from: Martin Luther: *Pr*
 to Daniel, 1530
8 Raphael (school), *Hanno the Elephant,* no
 lier than 1516

7

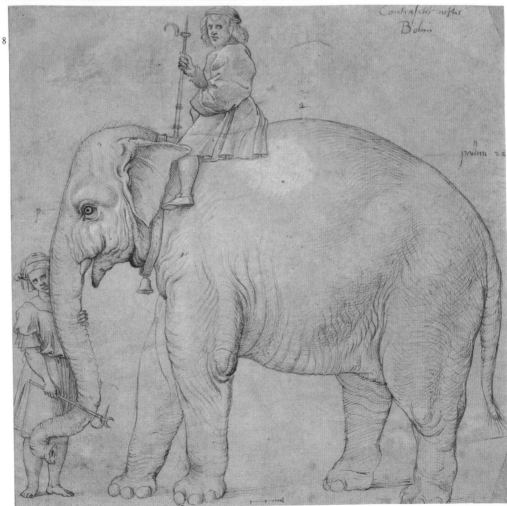

8

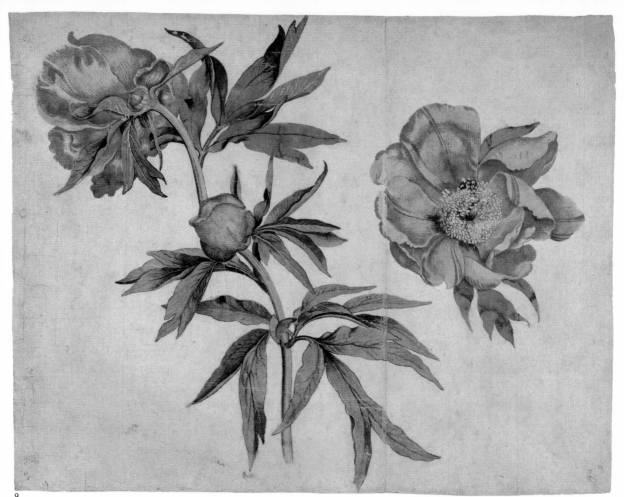

9

By contrast, the wonders of Creation[9] that Luther encountered while he was growing up truly captured his imagination. As a child he must have been a keen observer of the natural world, as suggested, say, by his interest in the fossils unearthed in his father's mining works.[10] Although petrified forms had long been regarded as the products of mystical forces, Luther – in a manner surprisingly modern – understood them to be the remains of creatures from the distant past and liked to use them as evidence of the Flood.

Luther only travelled abroad once, walking to Rome in 1511 at the behest of his order.[11] His main memories from that trip were of the splendour and self-indulgence of the papacy, then in the throes of erecting the magnificent St Peter's Basilica. Although Luther did register both the impact of the Renaissance and the ubiquitous traces of antiquity during his sojourn in the Eternal City,[12] his primary concern in Rome was the same as at home: Christian salvation.[13, 14]

Luther was hardly a cosmopolitan. He thought of himself as a son of Mansfeld and of central Germany as his turf. However, considering that most people in those days lived out their lives within a radius of 40 kilometres at the most, Luther was a comparatively well-travelled man. Yet he covered significantly greater distances in his letters, for instance corresponding with Erasmus of Rotterdam on matters of faith. He was also in contact with King Henry VIII in England, with the Basel reformer Johannes Oekolampad and with King Gustav I Vasa in Sweden

10

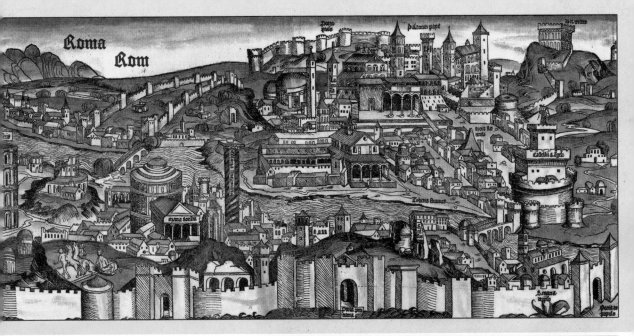

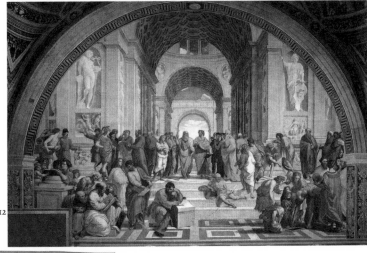

Martin Schongauer, *Study of Peonies*, c.1472–73
Fossils, from: Ulisse Aldrovandi: *Musaeum me-
tallicum in libros IIII distributum*, 1648
Michael Wohlgemut, *Rome*, from: Hartmann
Schedel: *Liber chronicarum*, 1493
Raphael, *The School of Athens*, 1510–11
Antoine Lafréry and Étienne Dupérac, *Map of
Rome with the Seven Churches*, 1575–1577
Lucas Cranach the Younger, *The Conversion of
Saul*, 1549

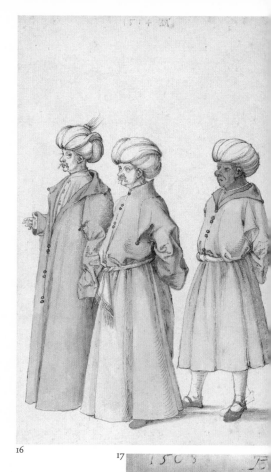

15

But what did the young Luther know about humankind in general – beyond his own four walls? Prior to 1517 he had given little thought to sociopolitical issues and had had next to no contact with different cultures. He was not even properly acquainted with the Jews who lived in Saxony and Brandenburg, such that most of his opinions relied on hearsay and rumours, [15, 19] some of which he later perpetuated. Most of his encounters with people from other countries would have been among the many pilgrims in Rome. He may have seen faces from Asia and Africa in pictures, [16, 17] and he had certainly heard of the 'heathen peoples' in the New World. Yet he was not particularly drawn to people from other cultures, although he did show some interest in fitting them into his Salvation narrative. His anthropology was largely informed by the first human beings, Adam and Eve, and their Fall from Grace. [18]

Luther's often sceptical view of the thirst for knowledge [20] was similarly rooted in his belief in the Bible. Adam and Eve's fateful blunder at the Tree of Knowledge was enough to make one wary. Yet for all his doubts, Luther took an active interest in many scholarly disciplines – from geometry to grammar to music. He particularly loved rhetoric and logic, literature and languages. [21] Yet certainty was something he only ever found in his faith, [22] which is why he confined his explorations to biblical worlds for the most part. Throughout his life the Books of the Bible were his main source of knowledge and by far his most important point of reference.

Catherine Nichols

15 *On the Wondrous People*, from: Konrad von Megenberg: *The Book of Nature*, c.1442–1448
16 Albrecht Dürer, *Three Orientals*, c.1496–97
17 Albrecht Dürer, *Head Study of an African*, 1508
18 Albrecht Dürer, *Adam and Eve*, 1504
19 *The Martyrdom of Simon of Trent*, from: Hartmann Schedel: *Liber chronicarum*, 1493
20 *Anatomical drawing*, from: Andreas Vesalius: *corporis humani fabrica libri septem*, 1543
21 Albrecht Dürer, *Jesus among the Doctors*, 1506
22 Burgundian Master, *The Last Judgement* (detail: cession of the Blessed), 1490

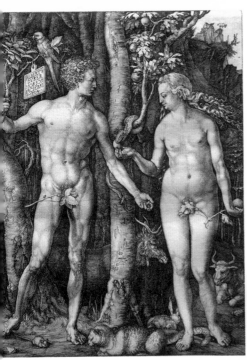

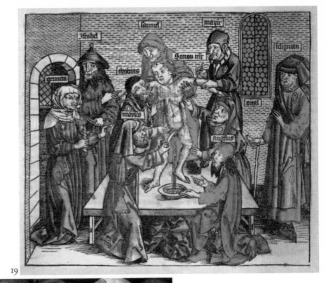

19

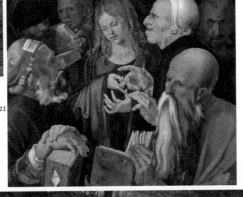

21

22

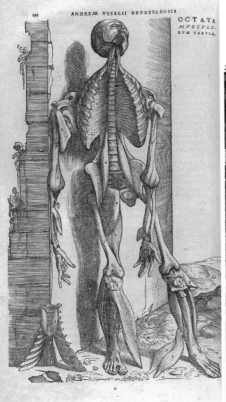

'LOVE DOES NOT SEEK ITS OWN, BUT THAT OF ITS NEIGHBOUR.'

WA 7, 38; LW 31, 372

Despite his general mistrust of human nature, Luther frequently expressed his love for his close friends and companions. He referred equally often to the affection and loyalty he received from those close to him, a love that sustained him in his quest for truth and gave him courage to engage in sometimes dangerous activities. While he was still living as a monk, Luther also commended the benefits of marital and erotic love – only when practised within marriage, of course. However, it was the love of God he most valued and underpinned his drive to transform society. He came to see it as both the paradigm and prerequisite for love between people.

RECIPROCAL GIVING

BO KRISTIAN HOLM

How can one fully give oneself? And to whom? Luther was intensely preoccupied with these questions. In his time, the answer to the second one was simple: sixteenth-century Christianity, like most other religions, taught that one must give oneself completely to God; to Him, who has given everything, one must give one's all in return. The key question is: how does this commitment to God actually work, how can one give oneself fully to Him? This central concern of mediaeval piety was what plagued the young Luther: how, he asked himself continually, how can I love God fully with all my heart and all my soul?

The traditional way to seek an answer to this question was to enter a monastery, renounce worldly life and give oneself over entirely to God. Luther also embarked on this path, forsaking conviviality, lute-playing and a promising career. He gave up his law studies and donned the monk's habit. To regard a life of God as a love relationship was not new, indeed it was a central notion in the teaching of Jesus: 'You shall love the Lord your God with all your heart and with all your soul and with all your strength and with all your might.' (Luke 10:27, Deut. 6:5) Thus begins the greatest of the commandments to the Israelites. However, for Luther the question of how to achieve this became an *Anfechtung*, a challenge of the most intense and distressing kind that would ultimately lead to his crucial reformatory turning point.

All his endeavours to meet his God with complete and selfless love failed, driving Luther ever deeper into despair. When he finally recognised that the demand for absolute love could never be fulfilled, he added a new dimension to the fundamental religious question of the mediaeval period, pairing it with the essential Reformation question: how can I find a merciful God?

The understanding of love has changed with the passage of time – not least due to the Reformation. For Luther, the paradigm was still formed through the Gospel by the God who gave Himself on the cross. Love was therefore equated with self-giving. Accordingly, although there was still no automatic response to the question of the merciful God, it is possible to discern from Luther's early writings how he gradually developed a message of hope from this notion of the self-giving God – until it finally became clear to him that in giving Himself on the cross, God revealed Himself as the merciful One. God gave Himself on the cross not to increase our guilt, but to relieve us of its burden.

The metaphor of marriage, a long-standing and well-known topos in Christian tradition, helped Luther to make this divine mercy understandable and to illustrate the new understanding between God and human beings: where humans, trusting in God, receive Christ as the reality of the living God, there too they enter into the closest relationship with God. For Luther, faith became the place where humans could give themselves to God – as a specific result of their recognition that this was all they had to give. According to Luther, God ultimately wants nothing from humans but themselves – in their recognition of God and their trust that God is simply God. It is this recognition and this trust that make faith what it is. This means that Luther's criticism of the trade in indulgences can also be justified by his desire to repudiate the notion that, instead of giving themselves in their relationship with God, humans can use a substitute – in this instance simply by buying indulgences. Luther realised that the corollary to this self-giving in faith was a complete reorientation of human perception, away from the

self and the search for salvation and towards their neighbours: all goods and all works, everything that is not faith in God can – and indeed must – benefit their fellow humans.

Luther's perception of faith as the expression of the loving gift of oneself to God marked a watershed in the history of Christian piety. This had been enabled by an earlier significant change in the mediaeval understanding of love during the twelfth century. At that time, in both the worldly sphere of courtly love poetry, such as Gottfried von Strassburg's *Tristan*, and in monastic theology, including that of Bernard of Clairvaux, there was a shift away from the Ancient World's ideal of male friendship to an understanding of love as something between man and woman. Whereas in the Ancient World the notion of two souls becoming one through reciprocal giving applied only to male friendship, in the Middle Ages it was extended to the ideal of heterosexual love – both in the passionate imaginations of poets and minnesingers and purely metaphorically in monastic theology.

This significant cultural-historical shift in the concept of ideal love is what underpins Luther's application of the marriage metaphor to the relationship between Christ and the soul. In his theology, Luther construes this allegory to mean that Christ gave Himself, with everything that He is and has, to humankind. The concept of divine love as divine self-giving was later expanded by Luther in his doctrine of God's threefold self-giving as Father, Son and Holy Spirit, thereby encompassing the entire understanding of God from the creation through to consummation.

Luther understood that it is through faith that humans can respond to and reciprocate God's love, and can, in the union with Christ, love God in faith. However, this necessitates a differentiation between faith and love. Humans do not achieve salvation through love, understood as actively carrying out works, but through a 'receiving faith'. This was not only significant for Luther's concept of the human relationship with God. His perception of love between humans also changed accordingly: if humans are already united with God in faith, they do not need to escape from the world to come closer to God. Monasteries and pilgrimages are therefore superfluous.

Love for God and worldly loving relationships were no longer in competition with each other. On the contrary, Christian life should indeed be lived in the world. Luther could thus commend marital love while he was still a monk. Erotic love too, as long as it was within marriage, was valued as an expression of life in creation, and not solely for begetting children.

After Luther married the former nun Katharina von Bora in 1525, his outlook on the world and worldly love changed once again. He now experienced in practice what had previously only been a theoretical notion, that a natural way of life in marriage with a family was the life God specifically intended for humans. Along with the perception that God the Father also gave himself in the creation, Luther further developed his understanding

of the life of Christians in the world as a life with the loving God in the world. Accordingly, there are many examples, particularly in his letters and table talk, which demonstrate the reformer's own loving approach to the world: his house was notable for its hospitality; he tolerated, and sometimes even welcomed, children playing in his work room; he showed concern for his close friends and companions and gave them comfort; and last but not least, he repeatedly praised his wife and openly expressed his love for her.

Through Luther's derivation of his entire understanding of authority from the Fourth Commandment, 'Honour your father and your mother' (Exod. 20:12), the family became the fundamental social ideal: all humans are subordinate to the authority of a father, be he the head of a domestic household or a sovereign ruler. He must be obeyed and honoured and loved; and in reciprocation the father must take loving care of his household. In the hierarchies of the world too, without which Luther could not conceive of an ordered society, love – fatherly love – should provide direction. Power should be exercised with love and within a loving relationship.

Love should be the keynote of all human co-existence. Luther expressed this idea in his renowned *Confession Concerning Christ's Supper* of 1528, in which, perpetuating the tradition of his time, he referred to the doctrine of the three estates, but ultimately wished all estates to be understood as a hierarchy of Christian love. 'The common order of Christian love' (WA 26, 505; LW 37, 365) is superior to all others in the world. For Luther, that meant that Christians should subordinate their own rights and support those of their neighbours.

As already mentioned, the self-giving of Christ as the matrix for a life of faith underpins Luther's understanding of Christian love. All Christians must be as Christ for their neighbours, as he affirms in *The Freedom of a Christian* (1520). This can clearly be seen in Luther's interpretation of the Ten Commandments in the *Small Catechism* (1520). Here, the negative prohibitions of the decalogue are interpreted as positive commands. The prohibition 'You shall not kill' becomes a command to help one's neighbour, to 'help and befriend him in every necessity of life' (WA 30 I, 287), while the prohibition 'You shall not bear false witness against your neighbor' also becomes the command to excuse one's neighbour of everything, to 'speak well of him, and interpret charitably all that he does' (WA 30 I, 288).

Luther interprets these commandments in the firm belief that human nature, despite justification, is not yet free of sin or of the strong instinct for self-interest, and is thus ultimately self-seeking in all things. Despite this pessimistic perception of humankind, in Luther's view, Christians should nonetheless regard their fellow-sinners with mercy and, taking Christ as their role-model, treat their sins in such a way as to transform them lovingly into better people than they are.

Luther's respect and appreciation for human feelings is also evident in this focus on successful interpersonal life. Faith for him was something which changed one's view of the world, so that one could respond to the world with trust and love. This fundamental trust, which should in no way be construed as naïve – Luther appears to have been extremely sensitive to the tribulations of life at all times – meant that on more than one occasion and despite imminent danger to his own life, he chose not to flee but to attend to his duties instead and concern himself with the welfare of his fellow human beings.

C.1516–18 OIL ON HARDWOOD PANEL 41 × 28 CM
KUNSTSAMMLUNGEN DER VESTE COBURG

God's demonstration of His love for humankind in the death of Christ on the Cross filled Luther with both gratitude and horror. The Father who sacrificed His own Son to save humankind and the Son who willingly gave His life for the sins of humankind redeemed and shamed the believer. In Luther's view human beings' ever imperfect, neighbourly love was a mere trifle compared to God's infinite love.

In his exegesis of the Fifth Petition in the Lords' Prayer – 'Forgive us our debts, as we also have forgiven our debtors' – Luther returned to this fact, telling his readers that Jesus Christ commanded people to make this petition, which serves 'God's purpose to break our pride and keep us humble.' (WA 30 I, 207). Who, he asked, ever forgives those who have sinned against them as generously as they hope the Lord will forgive them? Thus Luther felt that the love of God vividly demonstrated to human beings how imperfect they were. At the same time, however, the love of God was also liberating, because it was freely given by God and empowered individual human beings to freely submit and turn to their neighbours in love. Luther's liberating concept of love, which expressly accepts its 'worldly' aspect, is thus rooted in the love of the triune God, who gives Himself to humankind.

This self-sacrificing love of God was already symbolised in the Holy Trinity by mediaeval artists. In these compositions God the Father is often seen displaying Christ on the Cross. Around 1400 a variant evolved, known in German as 'Not Gottes', in which God the Father is holding His Son's dead body. Luther was familiar with both. Lucas Cranach the Elder (1472–1553) first engaged with this motif in 1512 in a woodcut for a book by Adam von Fulda, a song-writer who taught in Wittenberg; between 1515 and 1518 Cranach used both versions on altar panels in churches – including the Wittenberg Castle Church – and in smaller formats for private worship.

The version shown here is an example of the later variant: God the Father, wearing the triple crown symbolising His omnipotence, is holding the body of His Son, after it has been taken down from the Cross. Floating up above an idealised landscape with the silhouette of a town and a fortress high up on sheer rock, the figures are surrounded by a gloriole of angels. This work was painted close to the time when Luther posted his 95 Theses, which raises the possibility that Cranach's interpretation of this motif was influenced by Luther and the doctrine of grace and justification that he was currently developing in his lectures on St Paul's Epistle to the Romans. This possibility is reinforced by the figure of Christ in the centre of the composition, by the attributes pointing towards Him in the hands of two angels – the cross and the scourging column – and not least by the grief expressed in the face of God the Father, who gazes directly at the viewer, reminding all and sundry of their shared responsibility for the Death of Christ. During the course of the sixteenth century this motif came to be known as the Throne of Grace – a term coined by Luther – which points to the immensity of what Christ did: His death on the Cross made it possible for human beings to receive the grace of God. Benjamin Hasselhorn and Katja Schneider

→ Further read
Bo Kristian Holm: *Gabe und Geben bei Luther. Das Ve nis zwischen Reziprozität und reformatorischer Rechtfert slehre*, Berlin 2006.
Lucas Cranach der Schnellste, Rainer Stamm (ed.), catal to the exhibition *Lucas Cranach in Bremen*, Bremen 31–32, no. 32.
Gloria L. Schaab: *Trinity in Relation. Creation, Incarn and Grace in an Evolving Cosmos*, Winona, Minnesota

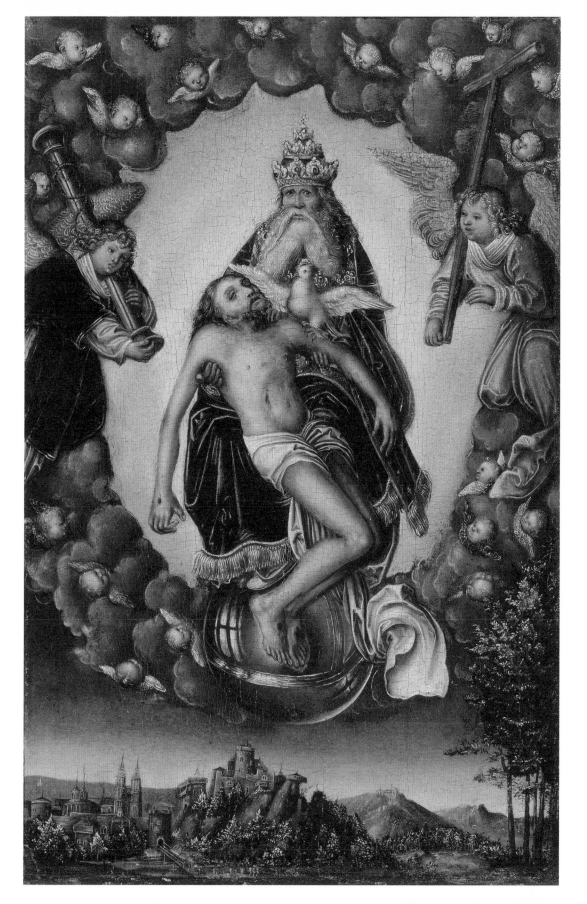

JOHANN VON STAUPITZ

16TH CENTURY TEMPERA ON PANEL 52 × 41.7 CM
KUNSTSAMMLUNGEN DER ERZABTEI
ST. PETER

'Everything I have I got from Doctor Staupitz.' (WA TR 1, Nr. 173, 80). Martin Luther's sweeping statement of his esteem for Staupitz had an enduring impact on the historical reconstructions of their relationship. It was Staupitz, his Augustinian superior, who showed him the way to a merciful God: 'Had Doctor Staupitz, or rather God through Doctor Staupitz, not helped me out, I would have drowned in this and long been in Hell.' (WA BR 9, Nr. 3716, 627). Although his fundamental theological approach may have been broadened by Luther's questioning, Luther's development after 1517 probably went too far for Staupitz. Their final letters attest to both enduring respect and increasing estrangement.

Johann von Staupitz (c.1465–1524) probably first met Martin Luther in 1506, when he became his spiritual advisor. Little is known about this only surviving portrait of Staupitz, which dates from his later years as abbot of the Benedictine abbey of St Peter's in Salzburg. The first historical record of Staupitz, who was born in Mottewitz, Saxony, around 1465, dates from his matriculation at Cologne University in 1483, where he gained the *baccalaureus* degree in 1484. He then moved to Leipzig for a year, before receiving his *Magister Artium* degree in Cologne in 1489. Staupitz joined the order of the Augustinian Hermits in Munich in 1490. It is known that he taught Augustinian theology at Tübingen University from 1497, where he began the lecturing duties prescribed for students in higher faculties at the end of October 1498. Although his lectures do not survive, 34 extant drafts on the Book of Job, written in 1497–98, give insight into his profoundly Scholastic education. Staupitz became a Doctor of Theology in Tübingen in 1500.

Staupitz was appointed prior of the Augustine monastery in Munich in 1502 or 1503. Shortly after, Friedrich the Wise of Saxony summoned him to his newly established electoral university in Wittenberg, where he taught *lectura in biblia*, and by 1503 had been appointed dean of the Theology Faculty. In the same year, the chapter of the reformed Augustinian order elected him as their vicar-general. Along with these new duties, he continued to teach at Wittenberg University, and served the elector as advisor and diplomat. In the winter of 1512, he handed over his professorial chair to Martin Luther. Staupitz was also regularly invited to Nuremberg and Salzburg as a Lenten preacher.

Once the 'Luther affair' had begun to take its course, the burden of office pressed ever more heavily on Staupitz. He gave up his post as vicar-general to the Lutheran theologian Wenzeslaus Linck in 1520 and moved to Salzburg at the invitation of Bishop Matthäus Lang. When he received dispensation from Rome to transfer to the Benedictine order in 1521, he entered St Peter's abbey, where he was elected abbot in 1522. Staupitz died while travelling on 28 December 1524 in Braunau am Inn. Several collections of sermons from his time in Salzburg were published posthumously, but his works were put on the index of prohibited books due to Tridentine censorship measures. It is only thanks to Protestant dissidents and nonconformist groups that his work has not been entirely forgotten.

→ Further read
Markus Wriedt: *Gnade und Erwählung. Eine Untersuc zu Johann von Staupitz und Martin Luther*, Mainz 199
Franz Posset: *The Front-Runner of the Catholic Reform The Life and Works of Johann von Staupitz*, Aldershot 2
Markus Wriedt: Johann von Staupitz OSA/OSB (1524). Gelehrter – Diplomat – Seelsorger, in: *Studien Mitteilungen zur Geschichte des Benediktinerordens und Zweige 127* (2016), 309–329.

Markus Wriedt

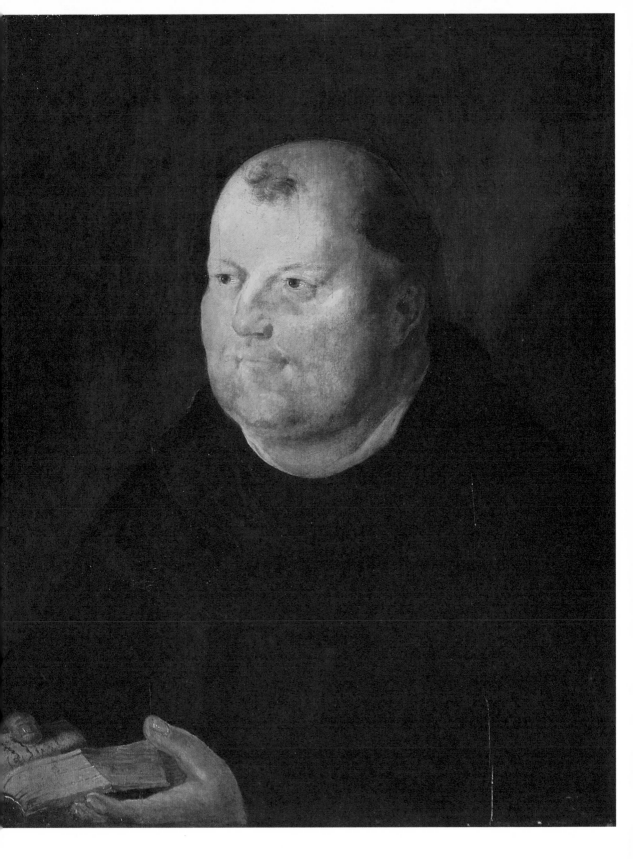

AFTER 1536 OIL ON PANEL 50.2 × 33 CM
MUSÉE NATIONAL D'HISTOIRE ET
D'ART LUXEMBOURG

Luther's ideas on reform brought with them a change in perspective on love of neighbour or charity. He had already stressed in his 95 Theses that active neighbourly love took unconditional precedence over concern for one's own salvation. He went even further in his tract *The Freedom of a Christian* (1520), liberating it from any 'meritoriousness': Luther saw neighbourly love as a gift of God through faith alone. He did not view it as a gift poured in to humans – as the Scholastics taught – but as a fruit of faith. At the same time, he emphasised the practical significance of selfless, Christian charity, which should be demonstrated in the here and now, and has no power to affect salvation of the soul after death.

Lucas Cranach the Elder (1472–1553) highlighted Luther's new interpretation of neighbourly love in this personification of *Caritas*, Charity, whose naked body also hints at the ideals of the ancient world and the arguably more humanistic views of Philipp Melanchthon, who was more strongly influenced by ancient philosophy than Luther. Melanchthon had earlier assigned the task of illustrating the philosophical virtue of temperance to Cranach, and he also personified this quality as a naked woman with a transparent veil in that work.

The nude figure of Charity, seated on a tree stump, is embraced from behind by a small boy leaning against her shoulder, and whom she firmly supports with her left arm. Her head is inclined slightly forward; a transparent veil, draped over her smoothed-back hair, falls over her forehead to her almond-shaped eyes, which gaze out with a dreamy expression at the viewer. Another child perches on her right thigh, suckling at her right breast. A girl, approaching from the left, bites into an apple in her left hand and holds another in her right. To the right of Charity, a boy sits on the ground in front of the tree stump, looking to the left and holding an apple in his left hand. In the upper left quadrant of the painting a castle perched above precipitous cliffs and a town on the banks of an expanse of water can be seen in the distance. The artist's insignia, a winged serpent, is clearly visible near the lower right edge of the panel.

From 1529 at the latest, many versions of the Charity motif were painted in the Cranach workshop, over a dozen of which still survive. They all depict personifications of Charity, either completely naked or draped with a transparent veil.

Cranach's *Charity* is a mother who suckles her children selflessly and without thought for her own benefit – just as the apple tree freely gives of its fruit. By depicting neighbourly love as solely focused on one's own children, Cranach consciously breaks with its customary position among traditional virtues and vices. The repeated renderings of scarcely veiled nudity are also a conscious departure from traditional representations of theological virtues. These breaks with long-standing pictorial tradition are closely related to the links between the *Charity* images of the Cranach workshop and Luther's redefinition of the concept of *charity*, his recategorisation of care and love for one's neighbour as the primary force of faith.

Michel Polfer

→ Further read

Dieter Koepplin: Cranachs Bilder der Caritas im th‹ gischen und humanistischen Geiste Luthers und Mel‹ thons, in: *Cranach der Ältere*, Bodo Brinkmann (ed.), logue of the exhibition of the same name, Ostfildern 2007, 63–70.

Berthold Hinz: Aktmalerei bei Cranach. Ein neue‹ schäftszweig, in: *Die Welt des Lucas Cranach. Ein Kü‹ im Zeitalter von Dürer, Tizian und Metsys*, Guido Mes‹ (ed.), catalogue to the exhibition *L'Univers de Cra‹* Tielt and Brussels 2010, 42–53.

Caritas. Nächstenliebe von den frühen Christen bis zur G‹ wart, Christoph Stiegemann (ed.), catalogue to the ‹ bition of the same name, Petersberg 2015, No. 86 (te‹ Michel Polfer), 516–518.

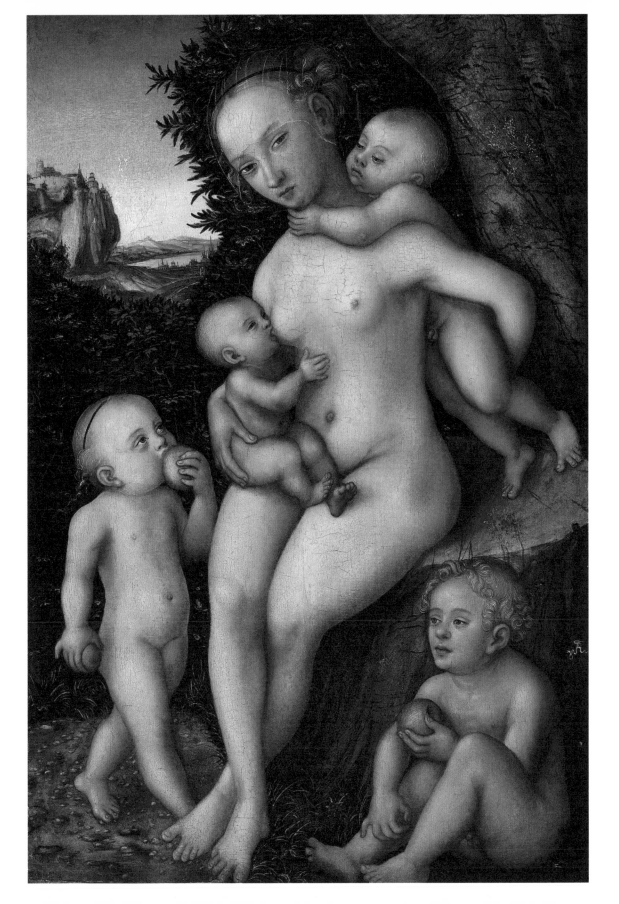

SAINT ELIZABETH

C.1510 ASCHAFFENBURG LIMEWOOD, CARVED AND PAINTED IN
POLYCHROME HEIGHT 107 CM
MUSEEN DER STADT ASCHAFFENBURG

In a letter to Georg Spalatin in 1519 Luther referred to St Elizabeth (1207–1231) as 'our saint'. Elizabeth was the daughter of a Hungarian king and was canonised just four years after her death. Having lived in Thuringia from the age of four, she was married just ten years later to Landgrave Ludwig (1200–1227) and was indeed Luther's saint. She was already important in his early youth, and he felt especially close to her throughout his life. For Luther, Elizabeth was a paragon of active charity – she dedicated her life to caring for the poor and the sick, she founded hospitals and, after the death of her husband, spent her last years nursing in the hospital in Marburg. In mediaeval imagery she is often seen as a personification of *Caritas*, and Luther held her in high esteem because, in his view, she did not engage in acts of charity for the sake of her own salvation but selflessly, as a true disciple of Christ.

The sculpture shown here, which dates to around 1510, came from the Katharinenspital in Aschaffenburg. It depicts Elizabeth as she was venerated in the Middle Ages and as Luther imagined her, with a loaf of bread and a pitcher as attributes of her charitable works. Originally she would also have been wearing a crown as a reminder of her rank in society, which made her rejection of worldly and courtly extravagance and her humble asceticism all the more inspiring. Luther therefore specifically cited Elizabeth, in his *Lent Postil* of 1525, as an example of virtue for all those in power: 'How remarkable it would be if we should see kings and princes, queens and princesses serving impoverished beggars and outcasts, as we read of St Elizabeth' (WA 17 II, 101).

In 1516, when Luther delivered a series of sermons in Wittenberg on the Ten Commandments, he criticised the cult of saints as a transgression against the First Commandment: 'Thou shalt have no other gods before me.' Yet he cited Elizabeth as an example of the acceptable veneration of saints. Elizabeth, he told his congregation, was blessed because she had faith. The sweet flavour of divine grace had flowed into her; if the faithful recognise this and taste of the goodness of God, they will take fire in divine love. Luther was particularly aware of the memory of Elizabeth at the Wartburg, where she lived until she left – some say she was driven out – after the death of her husband. In his *Christmas Postil* of 1522 he recounted an incident in the life of Elizabeth, the 'anti-Papist', that the Papists in his own time would have condemned as blasphemous, in the same way that they now condemned Luther's views (WA 10 I/1, 257–58).

A telling example of Luther's own veneration of saints is seen in his use of a relic of St Elizabeth that he himself owned: a drinking glass that was said to have belonged to Elizabeth and had come to Wittenberg in the collection of relics owned by Elector Friedrich III. When it was still in the Elector's collection the glass also contained a lock of the saint's hair and fabric from her cloak and a dress. When Elector Johann 1 (1468–1532), 'the Constant', started to break up the collection in 1526, the drinking glass went to Martin Luther, who used it as his own glass and even allowed his guests to drink from it. Susanne Wegmann

→ Further read
Bernd Moeller: Eine Reliquie Luthers, in: *Jahrbuch de burger Landesstiftung 28* (1983), 253–262.
Thomas Fuchs: Das Bild der heiligen Elisabeth im neuzeitlichen Protestantismus. Formen des protes schen Elisabethbildes in der Reformation, in: *Elisa von Thüringen. Eine europäische Heilige*, Dieter Blume Matthias Werner (eds.), collection of essays accompan the exhibition of the same name, Petersberg 2007, 459-
Volker Leppin: 'So wurde uns anderen die heilige beth ein Vorbild'. Martin Luther und Elisabeth von ringen, in: *Elisabeth von Thüringen. Eine europäische lige*, Dieter Blume and Matthias Werner (eds.), essay accompany the exhibition of the same name, Peters 2007, 449–458.

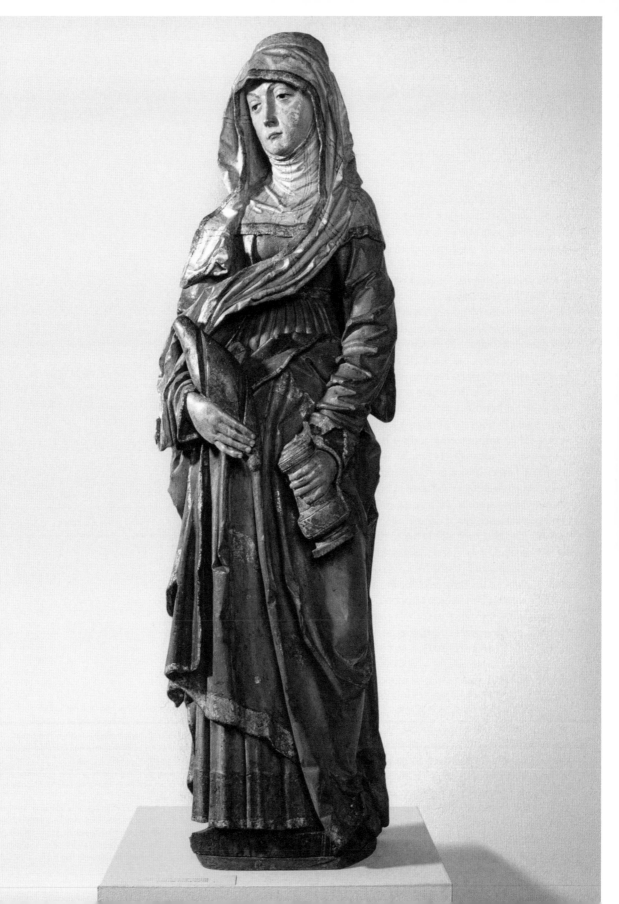

1503 LETTERPRESS ON PAPER
21.5 × 16 CM
UNIVERSITÄTSBIBLIOTHEK LEIPZIG

'Ovid is a fine poet who surpasses all others in his wisdom … he can express the most beautiful words of wisdom in his verse.' Luther corroborated this praise of Ovid, expressed in a *Table Talk* of 1537, by quoting from his book of love poetry, *Amores*: 'Night, Love, and wine to all extremes persuade.' (WA TR 3, Nr. 3616 a, 459).

There were so many humanists active at Erfurt University in the period around 1500 that they have been described as the Erfurt Humanist circle. As a young student in the Faculty of Arts from 1501 to 1505, Luther was inspired by their ideas and, not least, further developed his knowledge of the great classical writers. He became particularly interested in Cicero and thus in rhetoric, a passion that would contribute to the later reformer's linguistic virtuosity. Luther also made an intensive study of the Latin poetic tradition. From his early years his lifelong favourite was Virgil, a volume of whose works – along with one by Plautus – he took with him into the monastery as a souvenir of his student years; he even mentioned Virgil's poetry on his deathbed. Luther obviously found something in these ancient classical authors that was lacking in the learned Scholastics he encountered in his theology studies – worldly wisdom based on practical experience.

Ovid was also a constant companion throughout his life: Luther quoted him in his lectures on Paul's Letter to the Romans in 1515–1516, and in his table talk on numerous later occasions. He even spoke of Ovid's didactic poem *Remedia amoris*, his 'cure for love' containing advice on the end of love affairs, in one of his early sermons in 1519, which was delivered on the second Sunday after Epiphany, traditionally the day for preaching on marriage. His theme was resistance to sexual temptation: drawing obviously on his own reading experience, Luther declared that the ancient text was no help in this, in fact, on the contrary, it was more of a provocation: 'There are entire books on how to behave so as to abstain from such unclean acts with a woman. Ovid's *Remedia amoris* should also serve for this, but instead excites one yet more. For when temptation comes and the flesh burns, and even when the woman is not fair, you are already blind. Those without water to quench the fire will use dung.' (WA 9, 215).

At this time Luther was still completely captive to monastic concepts of chastity, which, for example, forbade conversing alone with a woman or looking too long at a woman. However, in his writings on reform, Luther soon made a positive re-evaluation of sexuality: it was a gift of nature and, as he wrote in the *Large Catechism*, 'flesh and blood remain flesh and blood' (WA 30 I, 162), thus sexual arousal and its gratification are inevitable. However, this was only pleasing to God if it took place within marriage. After 1525, Luther, who was no stranger to 'burning flesh', experienced the joys of sexuality with his 'dear' Katherina. S t e f a n R h e i n

→ F u r t h e r r e a d
Reinhard Schwarz: Beobachtungen zu Luthers Bek
schaft mit antiken Dichtern und Geschichtsschreiber
Lutherjahrbuch 54 (1987), 7–22.
Tilmann Walter: *Unkeuschheit und Werk der Liebe. D*
se über Sexualität am Beginn der Neuzeit in Deutschland
lin 1998, 102–127.
Volker Mertens: Lebendige Stimme und tote Schri
scheinungsform und Selbstverständnis von Luther
digt, in: *Predigt im Kontext*, idem, Hans-Jochen Sch
Regina Dorothea Schiewer and Wolfram Schneider-L
(eds.), Berlin and Boston 2013, 257–280.

Publii Ovidii Nasonis
de Remedio amoris liber primus.

L Egerat huius amor titulu: nomenqz libelli:

Bella mihi video: bella parantur: ait.

Parce tuum vatem sceleris damnare Cupido:

Tradita qui toties: te duce: signa tuli:

Non ego Tytides a quo tua saucia mater

In liquidum rediit ethera Martis equis.

Sepe tepent alii iuuenes: ego semper amaui:

Et si quid faciam nunc quoqz queris: amo.

Quinetiam docui: qua possis arte parari:

Et nunc quod ratio est: impetus ante fuit.

Nec te blande puer: nec nostras prodimus artes:

Nec noua preteritum musa retexit opus.

Si quis amat: quod amare iuuat: feliciter ardet:

Gaudeat: et vento nauiget ille suo.

At si quis male fert indigne regna puelle:

Ne pereat: nostre senciat artis opem.

A ij

1530 MIXED MEDIA ON BEECH PANEL 58 × 38 CM
STATENS MUSEUM FOR KUNST, KOPENHAGEN

Contrary to the claims of his adversaries, Luther did not leave the monastery on account of his sexual desires but as a consequence of his own new doctrine of justification, which led him to reject the notion of celibacy as righteousness by good works. He accepted the idea of erotic love, since it was envisaged for human beings at their creation and was in keeping with God's will. Nevertheless, erotic love had to be kept within the bounds of marriage, where it protected against the harmful consequences of lust. It was wrong to seek to pursue sexual life outside marriage or to let erotic love become stronger than the love of God. The latter could only lead to the self-interest that God always sought to suppress. While Luther still believed in 1519 that chastity was a virtue worth striving for and that people should only marry if they 'felt unable to sustain their virginity' (WA 9, 215), he soon came to believe that hardly anyone can avoid sexuality, since it had already been implanted in the first human couple before they fell from grace. It was, Luther concluded, a natural inclination that he could therefore respond to. Indeed, he was capable of speaking freely and humorously about his own sexuality. Writing to his friend Wenzeslaus Linck, a theologian in Nuremberg, about the joys of his own married life, he commented – playing on the similarity between his wife's name (Katharina, or Käthe, von Bora) and words meaning 'chain' and 'bier' – that he was 'tied by chains and captive, lying on a bier' (WA BR 3, Nr. 906, 549). When his friend Georg Spalatin married, Luther suggested they should each lie with their wives at the same time, thanking God for the joys of love and thus sending long-distance greetings to each other (WA BR 3, Nr. 952, 635). But Luther was also well aware of the dangers of sexual desire, which could lead to human beings damaging each other.

Warnings of the dangers of erotic love were also contained in paintings produced in the workshop of Lucas Cranach the Elder (1472–1553); after 1525, in the wake of the Reformation, Cranach's workshop increasingly addressed humanist topics and in so doing set new standards for the treatment of artistic subjects in the German Renaissance. During the Reformation period, motifs from classical mythology also provided artists with an opportunity to portray female nudes in a moralising context, as in this depiction of Cupid as a honey thief, who – pursued by a swarm of angry bees – is seeking comfort from Venus, his mother. However, she is pointing out to him that his love arrows have brought much greater pain to human beings than he is now suffering from the bee stings. The four-line Latin verse – a translation of the Greek poem 'Keriokleptes' ('The Honey Thief') by Theocritus – was the work of one of the Wittenberg reformers, probably Georg Sabinus, who studied under Philipp Melanchthon. The juxtaposition of image and inscription reminds viewers that they always have to choose between the right path and the wrong one. The tension between aesthetic appeal and intellectual depth in this painting, which is one of a series of at least 30 variations on this theme, suggests that it was aimed particularly at members of the educated upper classes.

Mirko Gutjahr

⟶ Further read
Jane E. Strohl: Luther's New View on Marriage, Sexu
and the Family, in: Lutherjahrbuch 76 (2009), 159–192
Julia Carrasco: Venus mit Cupido als Honigdieb, in:
und Botschaft. Cranach im Dienst von Hof und Reform
catalogue to the exhibition of the same name, Heidel
2015, 210, no. 60.
Julia A. Schmidt-Funke: Reformation und Geschle
ordnung. Neue Perspektiven auf eine alte Debatte, ir
gative Implikationen der Reformation? Gesellschaftliche
formationsprozesse 1470–1620, Werner Greiling, A
Kohnle and Uwe Schirmer (eds.), Cologne 2015, 29–

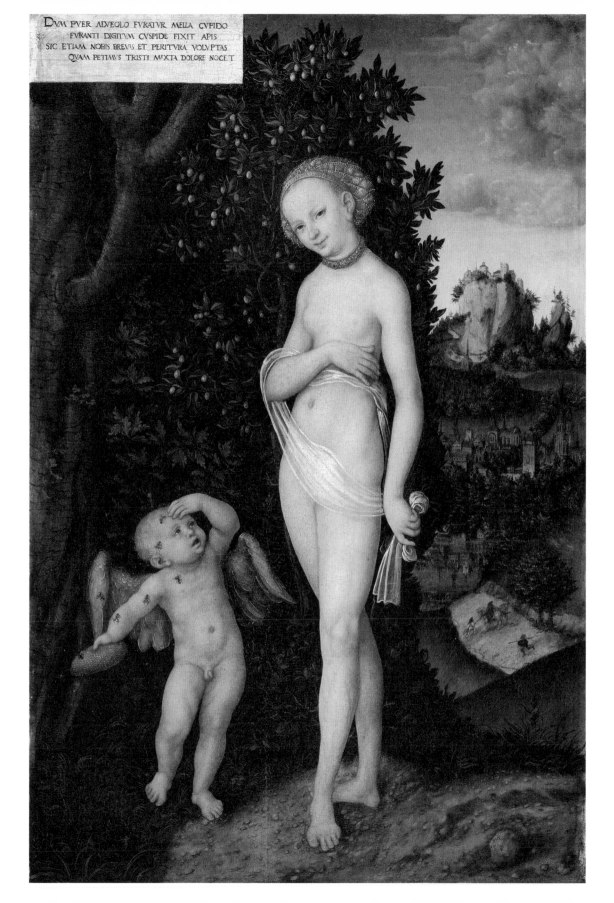

DVM PVER ALVEOLO FVRATVR MELLA CVPIDO
FVRANTI DIGITVM CVSPIDE FIXIT APIS
SIC ETIAM NOBIS BREVIS ET PERITVRA VOLVPTAS
QVAM PETIMVS TRISTI MIXTA DOLORE NOCET

ALBRECHT DÜRER MADONNA AND CHILD AT THE BREAST

1503 OIL ON LIME PANEL 24.1 × 18.3 CM
KUNSTHISTORISCHES MUSEUM WIEN,
GEMÄLDEGALERIE

This small-format painting by Albrecht Dürer (1471–1528), probably intended for private worship, shows the Mother of God nursing the Christ Child. Smiling pensively, she bows her head towards the infant in her arms, but does not look directly at Him. The child is touchingly fingering the neckline of her dress with one small hand. Mary's wavy hair is lying on her left shoulder, the skin tones in her face are delicate, her pale head-covering is in a simple fabric, as is her red undergown. Everything here tells of the close relationship of a mother and her child. The 'close-up' view and the dark, neutral background heighten the charm of the figure and the intimacy of this moment of tender humanity. If the composition were not clearly identifiable as a '*Maria lactans*', with the Mother of God suckling her child, it could be a painting of any ordinary woman with her baby, an archetypal image of motherhood.

This small panel by Dürer was to be the first in a series of remarkable images of the Madonna, in which – long before Luther cast doubt on the Marian cult – he portrayed the Virgin Mary not as the Queen of Heaven and the angels, not as a throned saint with a halo, but as a human being, a holy woman and devoted mother. Yet this painting does not infringe any of the iconographic essentials of this subject matter, for here, too, the Mother of God is shown as the advocate of humankind. This is underlined by a line from a hymn to the Virgin Mary cited on the back of the painting: 'Only the Virgin suckled with a breast filled by Heaven'.

As Luther pursued his new, reformist ideas, he also came up with a radically different image of the Virgin Mary in keeping with his doctrine of divine grace, which he set out in 1520–21 when he translated the Magnificat – the hymn of praise to Mary in the Gospel According to St Luke – from the original Greek into German and expounded it in an entirely new way (WA 7, 544–604; LW 21, 295–358). He now told his readers that the Latin Bible, the *Vulgata*, was wrong to suggest that the Mother of God could dispense grace; on the contrary, the Virgin Mary had herself received the gift of God's grace and had not been chosen for her virtuous humility but rather for her selfless, acquiescent faith. Luther vehemently repudiated the transfiguration of Mary as a 'co-saviour' and her veneration as a mediator between the faithful and God on His throne of judgement. He sought to reinstate the Biblical-historical truth of her story and characterised her as a simple, lowly young woman from a poor family. And Luther lauded this authentic Madonna as the 'tender Mother of God', as the 'Blessed Virgin Mary', as an exemplary Christian and loving mother (WA 7, 545–46; LW 21, 299).

Luther found solace in images of the Madonna with the incarnated Son of God, in their combination of the grace of God and Mary as both virgin and mother. He himself owned an image of the Virgin Mary, probably not by Dürer but possibly from the Cranach workshop; he refers to it in a *Table Talk* in connection with the excesses of the Pope: '"The little child", he said (pointing with one hand to a painting on the wall), "sleeps in Our Lady's arms; when He awakes He will ask us how we have done!"' (WA TR 2, Nr. 1755, 207). K a t j a S c h n e i d e r

→ F u r t h e r r e a d
Christoph Burger: *Marias Lied in Luthers Deutum*
Kommentar zum Magnifikat (Lk 1,46b–55) aus den
1520/21, Tübingen 2007.
Dürer: His Art in Context, Jochen Sander (ed.), cata
to the exhibition *Dürer – Art – Artists – Context*, M
London and New York 2013, 248–249.
Nobert Michels: *Von der Himmelskönigin zur Magd*
Wandel der Marienverehrung, in: *Cranach in Anhalt*
alten zum neuen Glauben, idem (ed.), catalogue to th
bition of the same name, Petersberg 2015, 109–149.

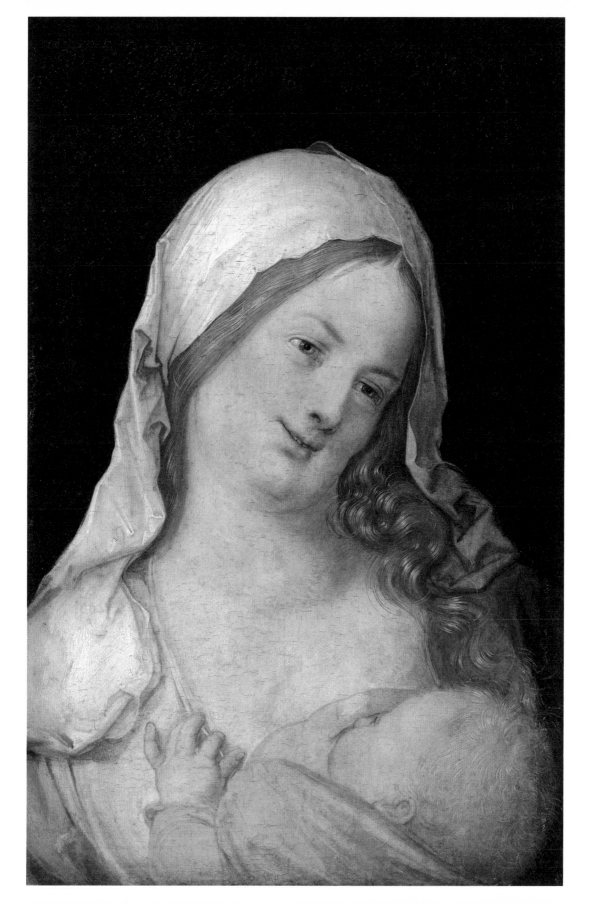

LUCAS CRANACH THE ELDER KATHARINA VON BORA

C.1525 OIL AND TEMPERA ON BEECH PANEL DIAMETER 11 CM
STAATLICHE MUSEEN ZU BERLIN, GEMÄLDEGALERIE

This small tondo by Lucas Cranach the Elder (1472–1553) depicts Katharina von Bora (1499–1552), Luther's wife. She initially lived as a nun in the convent in Nimbschen. Inspired by Luther's writings criticising convent and monastery life, however, she fled to Wittenberg with some of her sister nuns. The most important of these texts was probably his *Sermon on married life* (1522). In this, Luther stressed that marriage was a divinely ordained state and in no way inferior to celibacy: 'One should not regard any estate as better in the sight of God than the estate of marriage' (WA 10 II, 302; LW 45, 47). It was not until 1525, however, that Luther took the decision to get married himself; he had discarded his monk's habit the previous year. By this time, many monks and priests already shared Luther's view on celibacy and had married.

Von Bora looks out from the painting directly at the viewer but without registering any recognisable emotion. Her serious expression is emphasised by the high collar of her dress and the indeterminate dark blue background of the painting. Her hair is carefully parted and combed back; a gold-embroidered, netted cap holds her hair in an artistic but severe style at the back of her head. Even the plucked eyebrows and the high forehead, exemplifying the ideal of beauty at the time, seem to underline the austerity of the painting.

This is no coincidence: this is an image of a newly-wed who is fully aware of the seriousness of her new status. The painting is one in a series of portraits of Luther and Katharina von Bora that were produced from 1525 on and mark the beginning of the serial production of Luther paintings. This marriage was much more than a private alliance between the two spouses. The harmonious and loving relationship that was to develop between Luther and his wife over the years could not have been predicted at the time of their wedding. They did not marry for love, theirs was a marriage of convenience. Above all, however, it was a public declaration by the reformer against celibacy. The portraits were also more than mere private souvenir pictures of the couple, they documented and visually propagated the controversial marriage of a priest. Thus they provided evidence of the rupture with the old Church. Although there is no counterpart for this painting in the form of a portrait of Luther, it is possible that one existed. An example of a double portrait of Katharina von Bora and her husband in the form of two tondos by Cranach can be found in the Kunstmuseum Basel.

Lucas Cranach, one of the few witnesses to the marriage, and his workshop set about their task of documenting the union with great care. He chose a visual vocabulary for the subjects that corresponded to the convention of marriage portraits at the time. It would be immediately clear to the contemporaneous viewer, therefore, that they were a married couple. His choice of the tondo format also alluded to the medal, which was considered a highly prestigious Classical art form during the Renaissance. More importantly, however, because the medal could be easily reproduced, it was also considered an important means of proselytising. Daniel Leis

→ Further readi
Katharina von Bora, die Lutherin: essays to accomp
the exhibition '*Lieber Herr Käthe*'. *Katharina von Bora
Lutherin*, Martin Treu (ed.), Wittenberg 1999.
Gunnar Heydenreich: *Lucas Cranach the Elder. Pain
Materials, Techniques and Workshop Practice*, Amster
2007.
Sabine Schwarz-Hermanns: Die Rundbildnisse Lu
Cranachs des Älteren. Mediale Innovation im Spannu
feld unternehmerischer Strategie, in: *Lucas Cranach
2003. Wittenberger Tagungsbeiträge anlässlich des 450 T
jahres Lucas Cranachs des Älteren*, Andreas Tacke (ed.),
zig 2007, 121–134.

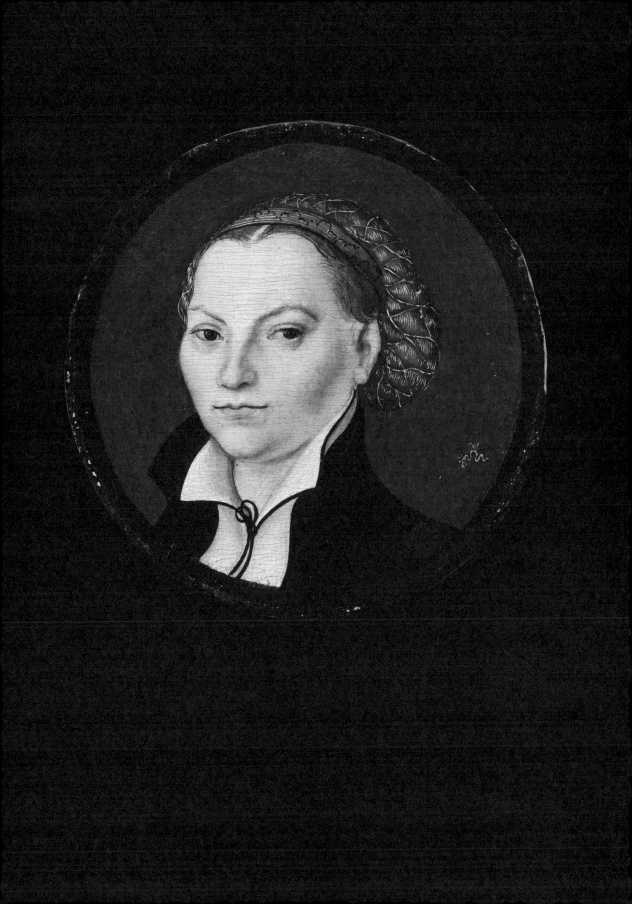

GOLD RING FROM THE LUTHER HOUSE WITTENBERG

FIRST HALF OF THE 16TH CENTURY GOLD, CAST AND WITH REPOUSSÉ DECORATION
HEIGHT 2.4 CM, DIAMETER 1.9 CM
LANDESAMT FÜR DENKMALPFLEGE UND ARCHÄOLOGIE –
LANDESMUSEUM FÜR VORGESCHICHTE – SACHSEN-ANHALT

Luther believed that the way to God's mercy was not through love but through faith. If, however, a person had asked for God's mercy through faith, they were released from all concerns about themselves and could turn their heart selflessly towards their neighbour in 'spontaneous love' (WA 7, 35; LW 31, 359). According to Luther, the person closer than any neighbour was a spouse. Luther, who initially was a sceptical opponent of the institution of marriage, was convinced by 1522 at the latest that it was divinely ordained and rooted in nature, as his *Sermon on married life* from that year illustrates. Through their partnership, and particularly through their children, married couples would become the proclaimers of the Word of God within their family and in society. While Luther recognised that women were equal to men in the eyes of God, he did not concede this same status to them in society, as they were conditioned differently by nature. By virtue of their innate inferiority, such as their weakness in the face of temptation, they had to subordinate themselves to men (WA 10 II, 267–304).

Up to late 1524, despite his endorsement of marriage, Luther had no intention of entering into such a union himself, even though many priests and former monks of his acquaintance were already married. As the reformer stated, this was not because he did not feel the urge of the flesh or the desire for sex – after all he was not made of wood or stone – but that he had to live in fear 'every day of death and punishment as a heretic' (WA BR 3, Nr. 800, 394). However, just a few months later, on 13 June 1525, he married the runaway nun Katharina von Bora at her suggestion after his efforts as matchmaker proved to be in vain when he failed to find her a suitable husband. While she was not his first choice either – years later, he admitted that his gaze had initially fallen on Ava von Schönfeld, considered a beauty, who had fled from the Cistercian convent in Nimbschen in Saxony together with Katharina – the bond between Katharina and Luther clearly developed into a very happy relationship.

The gold ring found in the garden behind Luther's house in Wittenberg during archaeological excavations in 2004–05 could have belonged to a lady of high status, possibly even Katharina von Bora herself. The simple gold ring with a claw setting, which probably would have held a blue or red stone, resembles a ring that Luther's wife wears in a portrait painted by Lucas Cranach the Elder in 1526, shortly after their wedding. However, it may instead be the piece of jewellery that the Strasbourg theologian Wolfgang Capito gave to Katharina as a gift. However, she lost this ring just a short time later as Luther explained in a letter to Capito (WA BR 8, Nr. 3162, 98–99; LW 50, 174). Katharina's unauthorised escape from the convent, her self-confident choice of husband and her considerable influence on her husband's decisions makes her an important symbolic figure as an evangelical wife. Mirko Gutjahr

→ Further readi
Lyndal Roper: *The Holy Household. Women and Mora
Reformation Augsburg*, Frankfurt am Main 1995.
Jane E. Strohl: Luther's New View on Marriage, Sexu
and the Family, in: *Lutherjahrbuch* 76 (2009), S. 159–1
Louis D. Nebelsick: Gold Ring, in: *Martin Luther. Trea
of the Reformation*. Catalogue, Dresden 2016, 242, no.

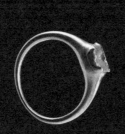

'THE MORE FURIOUS MY ADVERSARIES, THE MORE I ADVANCE

WA BR 1, NR. 65,

Time and again, at crucial moments, Luther rebelled against authority: in 1505 he entered a monastery against his father's wishes; in 1517 he posted his 95 Theses against indulgences; in 1520 he burned the papal bull threatening him with excommunication; and the following year, at the Diet of Worms convened by Emperor Charles V, he refused to retract his views. His many adversaries spurred him on and influenced the course he would take in the various disputes and confrontations he engaged in. However, Luther consistently defended against all opposition the God-given authority of temporal rulers and that of their archetype and model, parents. According to Luther, the highest authority of all was Holy Scripture: resistance could only be permitted if the Gospel were under threat.

LUTHER THE REBEL?

CHARLOTTE METHUEN

Was Luther a rebel? For many historians of the Reformation, including Heinz Schilling, who regards Luther as 'a rebel in an age of upheaval' whose 'prophetic force compelled his age to take decisions on fundamental existential questions of religion and faith', this is indisputable. Volker Reinhardt claims that Luther had a 'marked urge to topple those in authority and to take their place'. For Lyndal Roper, Luther is a renegade, but also a prophet, a maverick and misfit, who, almost as a matter of principle, flouted the rules. Luther is understood as a religious revolutionary, as an heir of mystical traditions (according to Volker Leppin), and as a dreamer and visionary reformer, who could fulfil his theological vision in founding a new Church (Scott Hendrix).

At crucial junctures, time and again Luther rebelled against authority. Despite the plans and expectations of his father, in 1505, at the age of 21, Luther entered a monastery. This drastic step was in itself a demonstration of his

ambivalent attitude: while he opposed the wishes of his father by becoming a monk, he then submitted to authority of a different kind – the prior of his monastery, the Augustinian order and the Catholic Church. His refusal to accede to his father's plans set a pattern for his later confrontations with significant authority figures, including the Pope and the emperor. As Lyndal Roper observes: 'His ability to speak out against such figures had to come from within, and the first step was the rebellion against his father.' Luther was a zealous monk, who nevertheless constantly felt that he was unable to meet the spiritual requirements of monastic life. As a theologian and preacher, he challenged mediaeval scholastic theology and the influence of Aristotelian philosophy and favoured a more Augustinian view of theology, grounded in biblical texts. By the spring of 1517 he could write that 'Our theology and St. Augustine are progressing well ...' (WA Br 1, Nr. 41, 99: LW 48, 42). He also questioned established church practices. Outraged and disturbed that the widespread trade in indulgences deluded many people into a false perception of salvation, in late October 1517 he wrote his 95 Theses attacking the practice of indulgences and sent them to the Archbishop of Mainz, the most powerful churchman in the Holy Roman Empire. At the Leipzig Disputations in 1519, Luther, who had been accused of heresy by Rome, denied both the authority of the Pope and the power of Church councils whenever he believed that their decisions contradicted Holy Scripture. In 1520, he wrote three crucial Reformation treatises: *To the Christian Nobility of the German Nation* (in German), in which he rejected the sole right of the Pope and the Roman Curia to interpret Holy Scripture; *On the Babylonian Captivity of the Church* (in Latin), which drastically reduced the number of sacraments defined by the Church, first to three and finally to two – baptism and the Lord's Supper; and *The Freedom of a Christian* (in both Latin and German), in which he defined the spiritual freedom of every Christian, declaring that '[a] Christian is a perfectly free lord of all, subject to none.' (WA 7, 21: LW 31, 345). In these pivotal writings, Luther formulated a theology that overturned much of the fundamental doctrine of mediaeval theology. In December 1520, when he received notice from Rome of imminent excommunication, accompanied by a group of student supporters, Luther publicly burned the papal bull threatening excommunication outside the Elster Gate in Wittenberg. At the Diet of Worms, invoked by Emperor Charles V in the spring of 1521, he refused to retract his views. His criticisms of the trade in indulgences and of the Church gave voice to the deep resentment felt by many Germans at the injustice of the 'Roman yoke' and his rebellion made him a popular hero.

Yet despite all this dissent and disobedience, Luther warned his fellow reformers – Andreas Bodenstein von Karlstadt among them – against too radical and precipitous an introduction of reformatory changes. At the same time, he consistently defended the authority conferred by God on sec-

ular rulers and the existing (class-based) social order. Luther was constantly dependent on the support and protection of Friedrich the Wise, Elector of Saxony, who pursued his own independent line in imperial politics and Church matters. In the early years of the sixteenth century, even before Luther was sent to Wittenberg in 1511, the spiritual power wielded by Friedrich as the founder and head of the All Saints' Foundation in the town often brought him into conflict with the Bishop of Brandenburg. The town of Wittenberg was so frequently subject to interdict – an episcopal ban on holding mass and administering the sacraments – that this became 'the rule rather than the exception' (Natalie Krentz). In 1517, Friedrich the Wise and his cousin Georg, Duke of Saxony, forbade any preaching within their territories of the indulgences campaign initiated by the Archbishop of Mainz – the Archbishop also concurrently held the office of Archbishop of Magdeburg and was thus the superior of the Bishop of Brandenburg. It was only due to the intervention of the Elector that – despite excommunication and 'a contravention of imperial law that was difficult to circumvent' (Thomas Kaufmann) – Luther received a hearing at the Diet of Worms. Thus Friedrich's protection of Luther was a continuation of his earlier policies in relation to the Church and imperial political authority.

Luther regarded secular authority and the existing social order as ordained by God: for him, the freedom of a Christian was not political, but rather intellectual and spiritual. In 1520, he stressed that 'all Christians are truly of the spiritual estate, and there is no difference among them except that of office' (WA 6, 407: LW 44, 127). In matters of redemption and salvation every baptised woman and every baptised man is equal before God. However, this did not erode the social hierarchy in any way, indeed, it only served to confirm it. Luther firmly consigned to their long-established position in the hierarchy both the peasants, who sought in part to invoke Luther's concept of freedom in 1524–25 to underpin their demands for improvement in their social and political status, and the women who at that time felt called by his theology and writings to preach the Word of God. The reformer had no wish to ignite social or political revolution, but sought only spiritual transformation. Nevertheless, this inevitably entailed social and political change, which Luther firmly believed should be defined and brought about by the existing secular authorities. As Luther stressed in his interpretation of the Ten Commandments in the *Small Catechism* (1529), the domestic household, and above all parents, served as the archetype and model for the social order: 'We should fear and love God, and so we should not despise our parents and superiors, nor provoke them to anger, but honor, serve, obey, love, and esteem them.' (WA 30 I, 286). Disobedience or insurrection can only be permitted if the Gospel is under threat. Luther was entirely convinced that his interpretation of Holy Scripture was correct. Although all Christians have the right to read and interpret

Scripture, as he declared in 1520, he also implied that the meaning of Scripture was in any case clear and unambiguous. The problematic aspects of this concept became particularly obvious in his dispute with the Zurich reformer Huldrych Zwingli over the nature of the Eucharist. Luther interpreted the words of Christ at the Last Supper – '*Hoc est corpus meum*' ('This is my body', Matt. 26:26) – to mean that the body and blood of Christ is physically present in the bread and wine. Although he rejected the doctrine of transubstantiation in which the words of institution uttered by a priest transform bread and wine into the body and blood of Christ, he retained theological continuity by affirming the real presence of Christ in the bread and wine. In contrast, Zwingli argued for a symbolic interpretation of the same biblical text. According to Zwingli, what Christ meant by the words '*Hoc est corpus meum*' was 'this bread represents my body'. Although Luther and Zwingli concurred that 'the spiritual partaking of the same body and blood is especially necessary for every Christian' (WA 30 III, 169: LW 38, 89), the physical presence of Christ remained a contentious issue. Despite the efforts of the Strasbourg reformer Martin Bucer and, in later years, John Calvin in Geneva, the Reformation movement split over this issue, a division that would not be reconciled until the Leuenberg Concord of 1973. This dispute clearly showed that Martin Luther would brook no opposition to his theology, which he believed was the truth of the Gospel. He regarded any resistance to his formulation of the truth as the work of the Devil. At the same time, his many adversaries spurred him on, gave him a clearer sense of direction – for, according to Luther, 'the devil and the world are so spiteful against the Gospel' (WA 40 I, 54: LW 26, 15) – and reinforced his sense of prophetic self-assurance.

His rebellion was a source of inspiration for many. Church historian Thomas Kaufmann finds in the early Reformation a powerful impetus – that would be lost in later years through the consolidation and entrenchment of the reform movement within the structures of a new Church – which he characterises as 'a vision of church organisation conceived and implemented by the community … a Christianity in ferment, sustained and decisively shaped by ardent, concerned lay Christians of both sexes; a daring, militant evangelical spirituality'. What Luther the rebel had set in motion also encouraged others to protest and rebel. Admittedly, however, as Dominic Erdozain recently observed, Luther's earlier belief that faith cannot be imposed is offset by the later introduction of the requirement to attend church. Thus, the former rebel eventually evolved into an overseer and supervisor.

LUCAS CRANACH THE ELDER PORTRAIT OF HANS LUTHER

1527 BODY COLOUR ON OIL-SOAKED PAPER 19.6 × 18.3 CM
ALBERTINA, VIENNA (NOT ON DISPLAY)

In 1527 Luther's parents visited their son Martin and his family in Witten-berg, presumably for the baptism of their new grandchild, Elizabeth. It must have been during this visit that they sat for Lucas Cranach the Elder (1472–1553), who made a brush-and-ink drawing that later formed the basis of his renowned painting of the aged Hans Luther with a fine fur collar (Wartburg-Stiftung Eisenach). The drawing, even more so than the oil painting, exemplifies Cranach's approach to portraiture, which evolved under the influence of humanism. The lack of detail in the sitter's clothing, for instance, draws attention to his deeply lined face and his expression, which is both imperious and fragile. This tension attests to Cranach's abil-ity to feel his way into the complex character of his subjects and to portray it so vividly that, as in the case of Luther's father, their presence is still pal-pable today.

That Luther even had a corporeal father may have come as a surprise to some of his contemporaries, as his reformist ideas prompted persistent ru-mours that he was almost certainly the son of Satan. Indeed there were even some scholars who claimed that Luther's mother had brought this dangerous, self-styled reformer into the world after dallying with the devil in a bath house. Yet Martin Luther knew only too well who his father was: Hans Luder, a mining entrepreneur, loving, but above all strict and author-itarian. He was the first and, besides God, the most important of several father figures in Luther's life to have left their mark on him and whom he tried to live up to: men – such as Johann von Staupitz – who served him on his path to the Reformation as role models, authority figures and some-times provocateurs, but also as a source of love and protection. Moreover in times of crisis they could confirm the legitimacy of his lineage, in both biological and theological terms. Unlike the portraits of Martin Luther and Philipp Melanchthon, which were reproduced on a grand scale and widely disseminated in the cause of the Reformation, the portraits of Luther's par-ents are one of a kind. While the portrait of Luther's father was certainly not painted with propaganda or legitimation in mind, it will not have done any harm to be able to demonstrate that the reformer was the son of a decent man – with no horns at all.

As to Luther's relationship with his birth father and his spiritual or even heavenly Father, not to mention the ecclesiastical fathers in Rome led by the Pope – it was not always harmonious. In 1505, when Luther became a monk against his father's will, he had closed his heart to his father and his father's word, as he later recalled (WA 8, 574; LW 48, 332). Time and again he felt compelled to resist patriarchal authority. Although he was mostly con-vinced that he had been called by Heaven to act as he did, there were many occasions when he struggled with his own decisions and above all with the loss of whichever 'father' he had thus rejected. In 1530, when Luther – at the Veste Coburg – learnt that Hans Luther had died, he was deeply shak-en. For it was through this loving man, whom he so closely resembled, that the Creator had given him 'all that I am and have' (WA BR 5, Nr. 1584, 351; LW 49, 316). Catherine Nichols

→ Further readi
Dieter Koepplin and Tilman Falk: *Lukas Cranach. Ge
de, Zeichnungen, Druckgraphik*, vol. 2, Stuttgart and B
1976, 693, no. 615.
Cranach der Ältere, Bodo Brinkmann (ed.), catalogue tc
exhibition of the same name, Osterfildern-Ruit 2007,
Michael Hofbauer: *Cranach. Die Zeichnungen*, Berlin
250–251, 272–273, no. 125.

1519 LETTERPRESS ON PAPER 18.5 × 13.5 × 2 CM
FORSCHUNGSBIBLIOTHEK GOTHA DER UNIVERSITÄT ERFURT

A lavishly illustrated *Schwankroman* (comic novel), which rapidly enjoyed huge popularity and is now firmly established in the German literary canon, was published during Luther's lifetime. It featured 96 stories about Till Eulenspiegel, a socially critical vagrant and trickster from Lower Saxony. Eulenspiegel was cunning and witty, obscene, and at times malicious. His life story, which began with 'three baptisms' and ended with his burial in an upright coffin, is told in a series of anecdotes. Of the three earliest known editions, the Gotha edition shown here, printed in Strasbourg in 1519, is the only complete, unabridged version.

It is quite likely that Luther had a copy – the Wittenberg reformer referred to the book and the eponymous hero on several occasions. These references were usually made in the context of Luther's pronouncements on power. For Luther, Eulenspiegel epitomised the rogue, as indicated by an explanatory note in the margin of Ecclesiastes 19:5 in his German translation of the Bible. Luther also seized on the figure as a legendary example of negative behaviour in his 1528 work *Von Priester Ehe des widrigen herrn Licentiaten Steffan Klingebeyl* (WA 36, 530–533). In this, he denigrates the defendants of clerical celibacy as 'unconscionable knaves'. According to Luther, their type of criticism was 'exactly as if an uncouth Eulenspiegel had positioned himself in the middle of the market and defecated and, while doing so, pointed to a house where a child was secretly and modestly answering a call of nature and tried to make jokes about the child and make everyone laugh at him' (533). Using this anecdote, which he came up with himself, Luther insinuates that his adversaries, particularly the Pope, are guilty of hypocrisy. In *Against the Roman Papacy: An Institution of the Devil* (1545; WA 54, 206 –299; LW 41, 263–376), perhaps his coarsest treatise, both verbally and figuratively, he argues using similarly pointed comparisons: while he and his allies, who were vilified as heretics, based their theological views on the Holy Scripture, their opponents and self-proclaimed Christians read comic novels, 'the pope's filth and stench, which is the same thing and even worse' (288; 363).

However, Luther's relationship with the Eulenspiegel figure was rather ambivalent. While he used the notorious prankster as a vehicle for his devastating criticism of the Roman church, Eulenspiegel also gave him the strength to cope with his internal afflictions. Luther thus recommended talking about farcical figures when spiritual crises surfaced: 'The best cure for any internal affliction is to ward off any thoughts of it, in other words to talk about other things, about Markolf, Eulenspiegel and their ridiculous antics, which do not make any sense or serve any purpose, so that you forget that heavy thought and instead make your way directly to prayer and to the words of the Gospel' (WA TR 1, Nr. 1089, 548). Hence comedy helps us to overcome melancholy and to adopt a positive and confident attitude, which Luther considered to be a sign of internal faith. Daniel Gehrt

→ Further readi
Anneliese Schmitt: *Ein kurzweilig lesen von Dil Ulensp* Kommentar zur Faksimileausgabe, Leipzig 1979.
Anna Mühlherr: Ulenspiegel, in: *Die deutsche Literatu Mittelalters.* Verfasserlexikon, vol. 9, Berlin and New Y ²1995, col. 1225–1233.
Reinhard Tenberg: *Die Deutsche Till Eulenspiegel-Rezep bis zum Ende des 16. Jahrhunderts*, Würzburg 1996.

Ein kurtzweilig lesen von Dil Ulen
spiegel geboren vß dẽ land zů Brunßwick. Wie er sei lebẽ volbracht hat. xcvi. seiner geschichten.

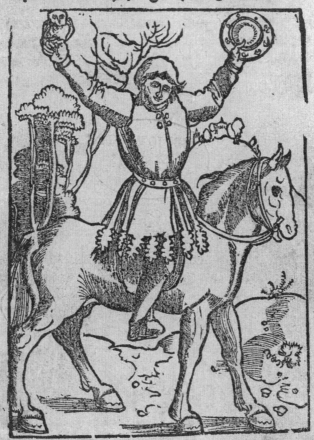

ST GEORGE FIGHTING THE DRAGON

BEFORE 1497 LIMEWOOD (RELIEF) AND OAKWOOD (CASE)
132 × 132 × 24 CM
EVANGELISCHE KIRCHENGEMEINDE MANSFELD

The relief panel of St George on horseback fighting the dragon, first documented in 1724, hung above the north portal of St George's Church in Mansfeld for centuries. One of several remarkable late mediaeval works of art in the church, it is carved from limewood and originally had polychrome decoration. The familiar motif of the battle between knight and dragon is depicted in two sections. In the foreground lies the dragon, already transfixed by a broken lance, while the knight raises his sword (no longer extant) to deliver the fatal blow. To the left, the maiden he has just rescued from the dragon watches events unfold. In the background, the shapes of a town and its fortifications loom over the scene below.

The relief was most probably part of the high altar dedicated to St George in 1497, which was damaged by fire the following year, and replaced in 1503 by another, also dedicated to the saint. This tentative identification is based on evidence in rediscovered foundation charters dating from 1497, 1502 and 1503. The county, town and church of Mansfeld adopted St George, one of the fourteen Holy Helpers, as their patron saint and protector, and he became identified with local legend: the fight with the dragon was relocated to an area of Mansfeld castle hill known as the Lindberg, and the sainted knight was proclaimed first Count of Mansfeld.

Martin Luther came to know this legend during his childhood in Mansfeld and it was integrated as a matter of course in the pious conventions of his religious practice. After the spiritual breakthrough that led him to the Reformation, and despite his resolute rejection of the cult of saints, the reinterpretation of the legends surrounding St George provided him with useful material for moral and biblical-allegorical exegesis.

It could hardly be coincidence that, during his sojourn in the Wartburg in 1521–22, Luther used the pseudonym Junker Georg which, as documentary evidence verifies, was the everyday vernacular equivalent of a (here, latter-day) noble knight George. In addition, the creatures that Cranach depicts in his illustrations for the Book of Revelation in the 1522 first edition of Luther's New Testament translation, known as the September Testament, are particularly striking. Three dragon-like beasts wearing papal tiaras are unmistakable embodiments of the pope and the papacy as the Antichrist, and are thereby characterised as the enemy of the Church in the last days before the Apocalypse. The image of the Christian dragon-slayer, familiar to Luther from early childhood, could thus be seen as a symbol for his rebellion against the 'Babylonian captivity of the Church' by the papacy: by 1521 at the latest, he had extended the metaphor into this particular apocalyptic dimension – although Luther himself held the view that the battle for salvation of individual Christians and Christianity as a whole should not be fought with armed force but with the Word of God.

For conservation reasons, this limewood relief was moved inside the church in the 1990s, and will be returned there to hang in the choir.

Matthias Paul

→ Further read
Thomas Hübner: Luthers Drachenkampf. Die refo
orische Deutung der Georgslegende, in: *Mansfeld.
hier ist die Wiege des großen Luthers!' Beiträge zum Ref
tionsjubiläum 2017*, commissioned by the Protestant p
of Mansfeld-Lutherstadt, Matthias Paul and Udo vo
Burg (eds.), Weimar 2016, 9–32.

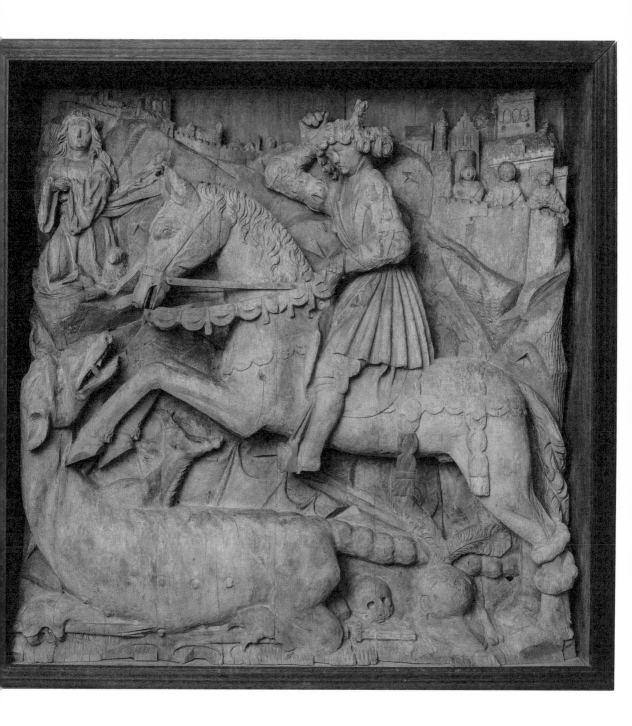

HANS HERMAN
AFTER A DRAWING BY
HANS HOLBEIN THE YOUNGER

MARTIN LUTHER AS HERCULES GERMANICUS

1519 OR 1522 WOODCUT, COLOURED, WITH LETTERPRESS 34.5 × 22.6 CM
PASTED INTO: HEINRICH BRENNEWALD AND JOHANNES STUMPF:
SCHWEIZER CHRONIK, ZENTRALBIBLIOTHEK ZÜRICH

Wielding a gnarled, thorny club, Luther the monk strikes down key figures in canon law, traditional theology and ancient philosophy. The body of the strangled pope dangles on a cord leading from his firmly closed lips – possibly an allusion to the eloquent *Hercules Gallicus*, who, as described by the ancient Greek writer Lucian, led his followers by a cord attached to his tongue. With his left hand, Luther holds down the Dominican monk and papal inquisitor, Jakob von Hoogstraten. At his feet, already laid low by the mighty club, are the intellectual greats Aristotle, Thomas Aquinas, Peter Lombard, William of Ockham, Robert Holcot, John Duns Scotus and Nicholas of Lyra. The Latin text in this only surviving copy of the leaflet admonishes the godless of Rome to acknowledge their equal in Luther, the German Alcides (an epithet for Hercules), who destroys the hordes of his enemies with the ferocity of a Cerberus, as if they were rabid dogs or the many-headed serpent Hydra.

The advent of Hercules as a symbolic figure in humanist discourse is indicated by an anonymous leaflet produced some two decades earlier, depicting the young King Maximilian as *Hercules Germanicus* (Vienna, Albertina, Inv. no. 1948/224). The image by Hans Holbein the Younger (c.1497–1543) also reflects humanist ideas and is even believed to originate from an erudite conversation with Erasmus of Rotterdam in the Basel workshop of the printer Johann Froben, at which Holbein was present. However, the source for this information, a letter of 1522 from the writer Ulrich Hugwald to the Swiss scholar and reformer Joachim Vadian, is open to more than one interpretation. This work, produced for an unknown patron in a style which indicates it might date from as early as 1519, shows signs of a certain distance from Luther, also expressed in humanist circles after the Leipzig Disputations of that same year. The emphasis in the reformer's passionate rhetoric on predestination evinced almost polemical traits, as although Luther rejected the Scholastics, he retained unequivocal admiration for the church father Augustine. Luther also remained relatively close to Nicholas of Lyra, using the more than usually literal interpretations of Scripture of the latter's fourteenth-century biblical commentaries: this gave rise to the well-known Latin couplet '*Si Lyra non lyrasset, Lutherus non saltasset*' ('Had Lyra had not played his lyre, Luther would not have danced'). Luther's diatribes, not only against highly significant philosophical and theological traditions, but even aimed at authors he could have relied on for support, cast his rebellious ideas and gestures in an unfavourable light. Concealed within the *Hercules Germanicus* lay a brutishly violent *Hercules furens*.

Luther's overwhelming superiority was also highlighted in numerous other illustrations in pro-Reformation leaflets, where he appeared less as a rebel against oppression of all kinds, but more as a soon-to-be-triumphant superhero about to deliver salvation: he was not in revolt against temporal authority but bent on destroying the papacy, to which he and his followers were no longer prepared to pay even the slightest degree of respect.

Klaus Weschenfelder

→ Further read
Theophil Burckhardt-Biedermann: Über Zeit und A
des Flugblattes *Luther als Hercules Germanicus, in: B*
Zeitschrift für Geschichte und Altertumskunde 4 (1905), 38
Hans Holbein the Younger: The Basel Years, 1515–1532, ca
gue to the exhibition of the same name, Munich 2
125–127.
Translating Nature Into Art: Holbein, the Reformation, an
naissance Rhetoric, Jeanne Nuechterlein, Pennsylvania

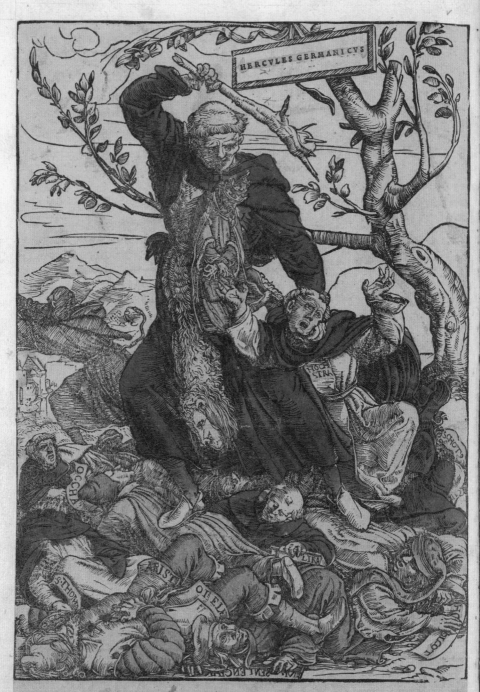

HERCVLES GERMANICVS

Germanum Alcidem tollentem monstra Lutherű,
Hostem non horres impia Roma tuum?
Nónne uides, naso ut triplicem suspenderit unco
Geryonem, & lasset pendula crista caput?
Ecce tibi insanos feriat qua mole sophistas,
Vrgeat & rabidos seuerior claua canes:

Ecce cadit male sana cohors, cui cerberus ipse
Cedit, & in fauces fertilis hydra nouas.
Quin igitur fortem agnoscis dominumq; pd remq;
Tendisti uictas cui semel icta manus?
Erratum, mihi crede, satis, sape, teq; repurga,
Aut Lernæ insanæ te sacra flamma mouet.

1524 OIL ON LIME PANEL, CRADLED 121 × 56.5 CM
MUSEEN DER STADT ASCHAFFENBURG

The primary addressee of Luther's critique of indulgences was Albrecht (1490–1545), Margrave of Brandenburg, Archbishop and Elector of Mainz, Archbishop of Magdeburg, Administrator of Halberstadt, and Cardinal (after 1518). In the works of art Albrecht funded and commissioned, he often had himself portrayed as one of a number of saints. These images reveal much about Albrecht's own view of himself. He frequently appears as St Erasmus, who – as the patron saint of the House of Hohenzollern-Brandenburg – represents both the office of bishop and Albrecht's genealogical origins. He was also often depicted as St Jerome, who – as a Church Father and translator of the Bible – lent particular authority to the ecclesiastical rank of Cardinal.

In the Aschaffenburg panel Albrecht sought to associate himself and his office with the benevolence of Bishop Martin of Tours. The Cardinal, as Martin, gives a beggar some pieces of gold. The beggar, in rags and supporting himself on a crutch, is kneeling before the Bishop, who is clad in rich, pontifical vestments and appears to be gazing somewhere above the beggar's head. Close examination has revealed that Albrecht is seen here not only in bishop's robes but also with the scarlet cardinal's *zucchetto* or skullcap under his mitre. The mitre, the bishop's crozier, the borders of the cope made from precious, golden brocade, the agraffe, and even the pontifical gloves are all ostentatiously decorated with strikingly large gemstones and richly embroidered with pearls. On the undergarment there are yet more appliquéd pearls, forming the coats of arms of Albrecht's bishoprics: Mainz, Magdeburg and Halberstadt.

Reformers were also seen in 'identification portraits' in the guise of past role models. Martin Luther and Philipp Melanchthon were portrayed as disciples at the Last Supper, as an indication of the special affinity between their teachings and Jesus Christ. Albrecht, who soon emerged as one of the main opponents to the Reformation and whom Luther referred to in ruthlessly direct terms, only damaged his own credibility by having himself portrayed in these roles. Albrecht's self-identification with exemplary, saintly figures and the wealth associated with him in these portraits increasingly came to be seen as contradictory. The supporters of the Reformation no longer viewed such sumptuous robes and regalia as an ennoblement of the Church and its role. They no longer saw the glitter of gold, pearls and gemstones as a prefiguration of the Kingdom of God that is yet to come here on Earth. On the contrary, they saw it as evidence of the Church's decadent negligence of its real duties.

In 1540 Albrecht had to leave his residence in Halle and went into exile in Mainz. He took with him most of the elaborate, decorative pieces that he had had made for churches in Halle. Of the few items that he left behind, the identification portraits, such as that of himself as Pope Gregory the Great on the pulpit of the Stiftskirche, were destroyed or – as in the Marktkirche in Halle – daubed with commentaries. In the Marktkirche, where Albrecht was portrayed as St Erasmus, he was now decried as a false prophet.

Susanne Wegmann

→ Further read

Andreas Tacke: Albrecht als heiliger Hieronymus. D 'der Barbar überall dem Gelehrten weiche!', in: *Der* *nal Albrecht von Brandenburg. Renaissancefürst und M* *Bd. 2 Essays*, Andreas Tacke (ed.), Regensburg 2006, 117 *Cranach im Exil. Aschaffenburg um 1540. Zuflucht – S kammer – Residenz*, Gerhard Ermischer and Andreas (eds.), catalogue to the exhibition of the same nam gensburg 2007.

Martin Schawe: *Cranach in Bayern*, catalogue to the bition of the same name, Munich 2011.

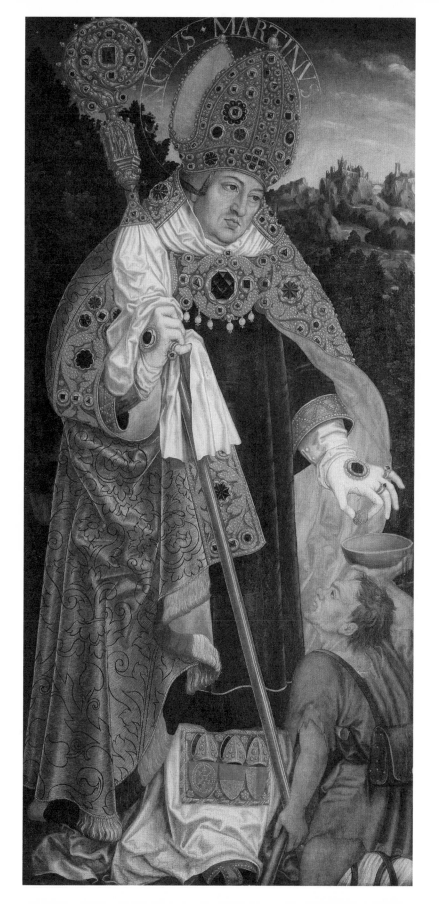

POPE LEO X

1520 PARCHMENT MANUSCRIPT 39.6 × 26.6 CM
THE MORGAN LIBRARY AND MUSEUM, NEW YORK

In 1513, one year after Luther left Rome, Giovanni de' Medici (1475–1521) was elected to the pontifical throne as Leo X. His father Lorenzo de' Medici, the Magnificent, had decided early on that Giovanni should enter the Church and had succeeded, by dint of political manoeuvrings, in having his son made a cardinal at the age of 13. The election of a Florentine nobleman with a humanist education raised widespread hope of a reformative renewal of the Church. Luther, too, was initially well disposed towards the young Medici pope and spoke highly of his learning and integrity. He regarded Pope Leo X as a victim of circumstances and blamed the failings of the Church on the curia's reluctance to countenance reform: 'He [Leo] is worthy of having become pope in better times, or of having better times during his pontificate' (WA 1, 573; LW 31, 156). However, like those of his predecessors, Leo X's eight years in office were dominated by power politics and the interests of his own family. Although he did oversee the conclusion of the Fifth Council of the Lateran, which lasted from 1512 to 1517, and made provision for a number of cautious reforms, they had little impact in practice.

Leo's personal interest in the fine arts coincided with his desire to give aesthetic expression to the Church's claims to power, which led to real progress in the rebuilding of St Peter's Basilica, the expansion of the holdings of the Apostolic Library and the renewal of certain elaborate liturgical celebrations. However, ongoing military campaigns against France and preparations for a Crusade were a huge drain on the papal coffers. Like his predecessor, Pope Julius II, Leo regarded the sale of indulgences and ecclesiastical privileges as an acceptable way of refinancing the Holy See. However, his agreement with Albrecht of Brandenburg that the latter could sell 'St Peter's indulgences' in Germany to help to repay the sum he owed for being granted three bishoprics (contrary to ecclesiastical law) ultimately sparked off the indulgences controversy.

Despite the barbed attacks Luther later launched at Leo X, whom he even described as the 'Antichrist' in *To the Christian Nobility of the German Nation* (WA 6, 453; LW 44, 169), up until the end of 1520 Luther still officially strove for reconciliation with Leo, 'most blessed father' (WA 7, 3; LW 31, 335). In the open letter that he included with one edition of his text on *The Freedom of a Christian* (1520), he exhorted the Pope to instigate comprehensive reforms and to limit the powers of the curia. However, Luther's critique did not persuade Leo X of the need for reform; it only succeeded in prompting him to condemn Luther's writings as a heretical attack on the office of the Pope and ultimately led to his excommunication.

The courtly pomp favoured by Leo X is reflected in the richly illuminated manuscript *Praeparatio ad missam pontificalem*, which was made for him around 1520 in Rome. Besides the prayers for inner composure that are said during preparations for the mass, the manuscript also includes an illustration of Leo X, before the mass, engaged in the ritual act of donning the pontifical shoes that are part of the papal regalia.

Mirko Gutjahr

→ Further read

John Plummer: *Liturgical Manuscripts for the Mass an vine Office*, New York 1964, 30, no. 35.
Der Medici-Papst Leo X. und Frankreich. Politik. Kultur Familiengeschäfte in der europäischen Renaissance, Göt diger Tewes (ed.), Tübingen 2002.
Volker Reinhardt: *Luther der Ketzer. Rom und die Refe tion*, Munich 2016.

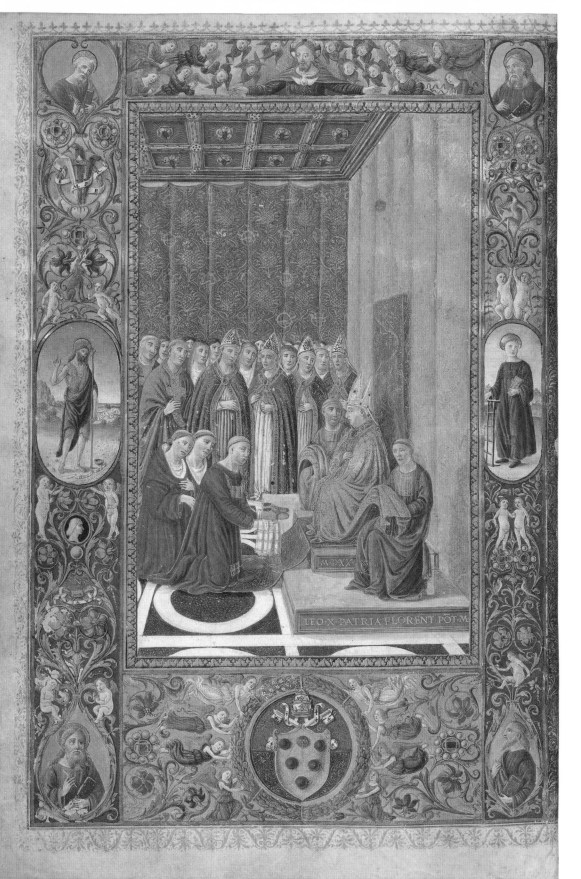

LEO·X·PATRIA·FLORENT·PŌT·M·

M·LXX

C.1535 OIL ON WOOD 42.2 × 33.6 CM
BAYERISCHE STAATSGEMÄLDESAMMLUNGEN, MUNICH

At the Diet of Worms in April 1521, Martin Luther – already excommunicated but still wearing the habit of an Augustinian monk – came face to face for the first and last time with Karl V (1500–1558), who had recently been crowned Holy Roman Emperor. In a text addressed to the German nobility (1520), Luther gave a glowing description of the 20-year old Emperor, who had been brought up in the Burgundian Netherlands: 'God has given us a young man of noble birth as head of state, and in him has awakened great hopes of good in many hearts' (WA 6, 405; LW 44, 124), in the hope that, even now, he might win Karl over to his side at Worms. However, Karl V, unable to speak German and not interested in theological argument, only wanted a swift political solution to the *causa Lutheri* and fully expected the reformer to recant.

Luther's brilliant defence of his position, in which he explicitly cited his conscience 'caught' in God, which prevented him from going back on his claims, both outraged and impressed Karl V. The Emperor responded by having a statement he had written himself read aloud. Citing the authority of time-honoured tradition, in particular the Catholic legacy of his ancestors, to which he was beholden, Karl refused to be accused of fallacies by Luther. His vision of a universal empire, emulating the ideal of the Roman Empire in Antiquity, required unity amongst Christians and the Church. As the grandson of the last knight, Maximilian I, and as Grand Master of the Order of the Golden Fleece, he regarded it as his duty – like the champions of Christianity in the past – to wield his sword against enemies of the faith. His idealistic self-image as a knight of old led him into a series of religious wars; the last was in Schmalkalden (Thuringia) in 1547, when he temporarily defeated the Protestants – only Luther was no longer alive by then.

Barthel Beham (c. 1502–1540), one of three 'godless painters' in Nuremberg, who were banned for 'reformist activities', was appointed Court Painter to Wilhelm IV, Duke of Bavaria, in 1527. In 1530, Karl V spent a short time in Munich, when he was on his way from Bologna (where he had been crowned Holy Roman Emperor by the Pope) to the Imperial Diet in Augsburg. It was on that occasion that Barthel Beham made portraits of both Karl V and his brother, Ferdinand. The lost drawing of Karl survived not only in a large-format copper engraving but also in a number of paintings. One of those paintings, done by an anonymous copyist in the workshop of Barthel Beham, was part of the 'Small Wittelsbach Series' in the castle of the Count Palatine Ottheinrich in Neuburg an der Donau – a series of family portraits plus the portraits of important potentates, such as the Habsburg brothers, Karl and Ferdinand, that Duke William IV had given to his cousin with his own, larger-format, ancestral portraits in the Residenz in Munich in mind.

This close-up bust of Karl V depicts him as a mature man, wearing a small beret and a simple, dark robe. His heavy-lidded gaze is focused on a point in the distance. Unusually, his emblem of the Order of the Golden Fleece – symbolising unconditional loyalty to the Roman Catholic Church – is worn on a ribbon, rather than a collar. K a t j a S c h n e i d e r

→ F u r t h e r r e a d

Alfred Kohler: *Karl V. 1500–1558. Eine Biographie*, Mu
1999.

Kurt Löcher: *Barthel Beham. Ein Maler aus dem Düre* (*Kunstwissenschaftliche Studien, Bd. 81*), Munich and B
1999.

Albrecht P. Luttenberger: Die Religionspolitik Karls Reich, in: *Karl V. Neue Perspektiven seiner Herrschaft ropa und Übersee* (*Zentraleuropa-Studien, Bd. 6*), A Kohler, Barbara Hader and Christine Ortner (eds.), na 2002, 293–343.

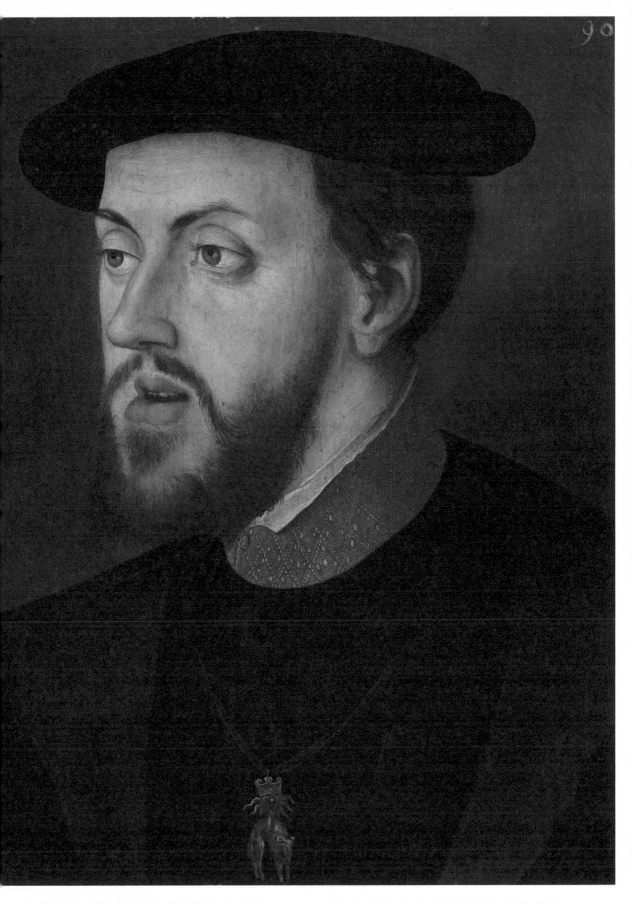

LUCAS CRANACH THE ELDER

GEORGE THE BEARDED, DUKE C SAXONY

1534 OIL ON RED BEECH PANEL 63.8 × 43.3 CM
MUSEUM DER BILDENDEN KÜNSTE LEIPZIG

Georg the Bearded (1471–1539), Duke of Saxony and ruler of Albertine Saxony, was a cousin of Elector Friedrich the Wise. Initially Georg was one of the potentates who responded positively to Luther's 95 Theses. He had a thorough grounding in theology, as he had originally prepared for a life in the Church, and he sympathised with the new, interior piety of lay people and welcomed the opportunity to discuss failings in the Church and to resolve the indulgences controversy. In 1519 it was Georg the Bearded who facilitated Luther's participation in the disputation with theologian Johannes Eck in Leipzig. But this also led to a significant disagreement. When Luther cast doubt on the primacy of the Pope and the papal councils, declaring that not all the Hussites' opinions were wrong, Duke Georg leapt up and cried, 'God help us, the pestilence!' From that moment on Georg regarded Luther's ideas as Hussite heresies and became his embittered opponent. At the same time as the Reformation was under way, Duke Georg developed a programme of church reform, based on orthodox beliefs. He kept aloof from the issues surrounding indulgences, the veneration of relics and the cult of saints and turned his attention instead to reinforcing the morals and mores of his subjects. He set up visitations, trained clergymen, renewed the laws of ecclesiastical justice, sanctioned 'defectors' and banned Lutheran texts. He also actively engaged in anti-Lutheran propaganda. It was not only his court chaplain, Hieronymus Emser, who published anti-Lutheran texts; Duke Georg also penned texts of his own, which were published under a pseudonym. In 1527 he instructed Emser to make his own translation of the New Testament – although Emser frequently consulted Luther's version and was subsequently accused of blatant plagiarism. The correspondence and hostile exchange of publications between the English king, Henry VIII, and Luther was also conducted via Emser's printing press. In 1534 – possibly in the wake of the Leipzig disputation between Philipp Melanchthon and representatives of Cardinal Albrecht and Duke Georg – Lucas Cranach the Elder (1472–1553) painted a portrait of the Duke. It was developed from a study of the Duke's head, no longer extant, which was also the basis for his portrait as patron on the altar retable in Meissen Cathedral and for many other individual portraits. In the later versions of these portraits he is seen with very natural-looking renderings of the substantial beard that he grew after his wife's death and led to his moniker. He is seen here in the customary, majestic pose of Saxon rulers, with his hands clasped and clad in a damask robe. The insignia of a Knight of the Golden Fleece – a 32-link collar with the fleece suspended from it, which he received in 1531 from Karl V, the Grand Master of the Order, for his services to the preservation of the Catholic faith – denotes its wearer as a soldier of Christ. But his facial expression is embittered and careworn, as though he already senses that his homeland would not remain Catholic for much longer. In April 1539, just a few months after Georg's death, his brother and successor, Heinrich the Pious, ensured that Albertine Saxony became a Reformation state. Katja Schneider

→ Further read
Glaube und Macht. Sachsen im Europa der Reformatior
Harald Marx and Eckhard Kluth (ed.), catalog and e
to the exhibition of the same name, Dresden 2004.
Christoph Volkmar: Reform statt Reformation. Die Ki
politik Herzog Georgs von Sachsen. 1488–1525, Tübi
2008.

JOHANN AGRICOLA SATIRE ON MARTIN LUTHER'S ADVERSARIES
PRINTER: WOLFGANG STÖCKEL, LEIPZIG

1522 LETTERPRESS AND WOODCUT ON PAPER 19.5 × 15.1 × 0.5 CM
STIFTUNG LUTHERGEDENKSTÄTTEN IN SACHSEN-ANHALT

Once it was clear that Luther's reformist publications had triggered the gravest of crises in the Western Church, orthodox theologians became increasingly vocal in their resistance. Luther found the debate with them extremely burdensome; the unbridgeable chasm between the two sides led to increasingly polemical exchanges.

Thanks to the medium of book printing, the adversaries' publications reached readers throughout Europe. And they did not confine themselves to academic tracts, they also turned to popular forms such as satirical verse and caricature, the latter also being accessible to those unable to read. The vilification of one's opponents as animals and monsters had its roots in the allegorical interpretations of animals in the *Physiologus*, a widely read, early Christian bestiary, which attributes human characteristics and behaviours to individual animals.

The text '*Eyn kurtze anred zu allen missgünstigen Doctor Luthers und der Christlichen freyheit*' ('A Short Address to all Begrudgers of Doctor Luther and Christian Freedom'), printed in 1522 by the Luther-supporter Johann Agricola (1494–1566), probably in at least four editions, is illustrated on the title page with a composite woodcut bringing together important opponents of Luther around the time of the Diet of Worms. Agricola drew partly here on *Murnarus Leviathan* (1521), a pamphlet, published under a pseudonym, that was directed against Thomas Murner, an opponent of Luther in Strasbourg. Murner, a Franciscan monk, is depicted as Leviathan with a cat's head, in an allusion to apocalyptic symbolism. Agricola translated part of the text of *Murnarus Leviathan* into German and borrowed two images – Murner as an eschatological monster and the Strasburg lawyer, Weddel, as a pig, which appear in the background in the pamphlet's title picture. In the foreground there are four opponents of Luther who were better known and more significant in Saxony: Johannes Eck, Franziskus Tham, Hieronymus Aleander and Hieronymus Emser, all of whom are described in the accompanying satirical poem. Depicted as animals surrounded by insects and two magpies, they are clearly agents of the Devil.

Johannes Eck, a theologian from Ingolstadt – seen here with donkey's ears – had already opposed Luther at the Leipzig disputation in 1519 and, in Rome in 1520, played an important part in the formulation of the Papal Bull threatening the reformer with excommunication. The Dominican monk, Franziskus Tham from Freiberg, had written an anti-Luther satirical poem, which prompted Agricola to portray him with a donkey's head and a fiddle. In 1520 Pope Leo X sent Hieronymus Aleander, a papal nuncio, to the court of Karl V, where he was to ensure that the Emperor condemned Luther and the Reformation. Aleander largely composed the Edict of Worms, which banned Luther's writings and declared him a heretic and enemy of the state. His depiction as a lion (*leo* in Latin) symbolises his function as an emissary of the Pope. Hieronymus Emser, whose coat of arms included a ram, had been at loggerheads – in print – with Luther since 1519. His criticism of Luther's translation of the Bible ultimately resulted in the publication of a specifically Catholic, German translation of the Bible in 1527. Mirko Gutjahr

→ Further read
Steffen Kjeldgaard Pedersen: *Gesetz, Evangelium und .*
Theologiegeschichtliche Studien zum Verhältnis zwischen
jungen Johann Agricola (Eisleben) und Martin Luther, Le
1983.
Thomas Kaufmann: *Der Anfang der Reformation. Stu*
zur Kontextualität der Theologie, Publizistik und Inszenie
Luthers und der reformatorischen Bewegung, Tübingen :

Eyn kurtze anred zu allen mißgüstigen Doctor Luthers vnd der Christenlichen freyheit

'I AM IN THE HANDS OF GOD AND OF MY FRIENDS.'

WA BR 1, NR. 116, 260

From his friends at school and university to the powerful Elector of Saxony, Friedrich the Wise, Luther benefited from the support of colleagues and allies throughout his journey to the Reformation. In Georg Spalatin he found an advocate at the court of Electoral Saxony, a passionate communicator of his writing and ideas and, above all, someone who was able to set wheels in motion to protect him from his enemies. Other friends, such as Philipp Melanchthon and initially also Andreas Bodenstein von Karlstadt, provided Luther with a sounding board and, at times, a stimulating source of friction which motivated and challenged him spiritually. Melanchthon, among others, helped him to accomplish his most important project: the translation of the Bible.

'GREETINGS FROM ALL THE FRIENDLY SODALITY': LUTHER'S WITTENBERG NETWORK

STEFAN RHEIN

I n his will of 6 January 1542, Luther confidently sees himself as chosen by God. He describes how God the Father entrusted the Gospel to him so that he became a teacher of the truth, despite all opposition from the Pope, the Emperor, kings and clerics, indeed despite the anger of all the devils. He writes of himself as God's notary and witness of his Gospel. Posterity has preserved this emphatic stance through the popular cult of Luther, turning the reformer into a prophet, a man of wonders, and this paved the way for him to become the hero who saved the Church and

later the nation. Similarities can be seen in the imagery around Luther. In about 1520 he is depicted by Hans Holbein the Younger as a German Hercules wielding a heavy club to fight against Scholastic authority figures, such as Aristotle and Thomas Aquinas, and contemporary inquisitors, such as the Dominican monk, Jakob van Hoogstraten. Almost 400 years later, on a field postcard from the First World War, painter and print-maker Karl Bauer portrays Luther in an energetic pose, nailing his 95 Theses to the door of Wittenberg Castle Church, while at the bottom of the picture St Michael kills a dragon and morale-boosting lines from Luther's hymn, 'A mighty fortress is our God' are quoted: 'Though devils all the world should fill, All eager to devour us. We tremble not, we fear no ill, They shall not overpower us.'

Luther, the warrior, alone against the rest of the world – this is the image which dominates the monumentalisation of the great reformer, who lives on in posterity in scenes of solitary isolation: alone nailing the Theses to the door, alone at the Diet of Worms proclaiming his 'Here I am, I cannot do otherwise' and alone at the Wartburg translating the Bible. A solitary hero in an uncomprehending, hostile world, a hero who leaves everything behind and goes forth with a clear vision. This raises the question of whether, as we seek to draw closer to him, we find ourselves confronting an unapproachable, antisocial Steppenwolf.

The earliest surviving description of Luther's appearance comes from professor of Greek, Petrus Mosellanus, and was written in 1519 at the Leipzig Disputation. Luther is portrayed as an angular man of medium height with a clear voice, often too polemical and caustic in his argumentation but, despite his 35 years, still youthful in appearance: 'In his life and behaviour he is very courteous and friendly… In a social gathering he is gay, witty, lively, ever full of joy, always has a bright and happy face, no matter how seriously his adversaries threaten him.' So anyone who pictures Luther as a solitary scholar or holy warrior, as portrayed in many monumental statues, is clearly mistaken. Luther was well acquainted with solitude and the risks of being cast upon one's own resources and wisely sought contact with others to counteract it: 'I, too, often suffer from severe trials and sorrows. At such times I seek the fellowship of men, for the humblest maid has often comforted me.' (WA TR 3, Nr. 3754, 593; LW 54, 268).

Nonetheless, Luther himself encouraged the image of the lonely reformer. When he looks back on his life and experiences, the focus is very much on his own path, which leads firmly into the 'I', without taking account of the accompanying 'we' and its influence. Thus, in the preface to his Latin writings published in 1545 he writes about how, while reading Romans 1:17, he was struck by an insight into the righteousness of God. The situation he describes is one of a solitary insight and this is later consolidated in the notion of the 'Tower Experience', denoting a life-changing moment (WA 54,

179–187; LW 34, 323-338). However, Luther's patterns of thought were far more complex and protracted, so that his evolution to reformer is more accurately described as a process rather than an event, and can only be understood as resulting from an intellectual exchange with the world around him.

This complex interaction is very clearly illustrated in the translation of the Bible, which was initiated not by Luther but by Philipp Melanchthon who first gave his colleague the idea and, it appears, strongly urged him to make a start on this challenging task. The quality of the translation owes its philological precision and accuracy (derived from the use of primary sources) to intensive collaboration by an editorial team consisting of Wittenberg professors from different disciplines who, under Luther's leadership, wrestled with the meaning of the text and how best to express it. The group met on a weekly basis for years, as even already published editions were constantly revised. Thus the reputed 11-week one-man marathon in the isolation of the Wartburg in 1521–22 became a decades-long team effort, wrestling with the text. The Luther Bible becomes the Wittenberg Bible, as is made clear on the title page of the first printed translation of 1522, 'The Wittenberg German New Testament', predating the later reductive tendencies in relation to its authorship.

Indeed, even the beginning of the Reformation was the result of intensive collaboration at the University of Wittenberg. Luther became a professor at the Theology Faculty shortly after gaining his doctorate in October 1512, succeeding his mentor, Johann von Staupitz. Founded in 1502, the university was still a young institution without rigid, antiquated structures and thus allowed a lively climate of debate to develop. The common goal was to reform the academic programme and to instigate change in terms of authority, methods and content: out with the Scholastics and Aristotle, the author of their fundamental principles, and in with the Fathers of the Church and the Bible; out with a combination of philosophy and theology and in with a Bible-centred theology of the grace of God.

These reforming efforts were shared by an intellectual 'discussion group' (Jens-Martin Kruse). In addition to Luther its members included theologians such as Bartholomäus Bernhardi, Nikolaus von Amsdorf and Andreas Bodenstein von Karlstadt, who were also striving to develop a new theology through writing and disputations. Of particular importance to Luther in these early years was his fellow monk, Johann Lang, with whom he had already enjoyed a close friendship at the Augustinian monastery in Erfurt. Lang was a few years younger than Luther and, like him, was active in Wittenberg from 1511 onwards. He had had a humanist education and, in addition to his lectureship in moral philosophy, taught Greek. In June 1515 he published two letters by Church Father, Jerome, with a polemical preface opposing the Scholastic authorities. He also argued the case in his lectures for giving precedence to the Holy Scriptures and the Fathers of the Church.

The group of theologians who had taken up the cause of reforming the academic programme soon sought to go public. Bartholomäus Bernhardi took this step when he set out his theses on human will and divine grace on 25 September 1516. Many years later Luther recounted that Bernhardi seized the initiative in order to counter the chatter at the university with a public debate (WA TR 5, Nr. 5346, 76). Bernhardi was also an Augustinian monk and enjoyed a close relationship with Luther, four years his senior, as pupil and friend. For his disputation theses he had adopted numerous ideas and formulations from Luther's lecture on Romans (such as criticising the abuse of the veneration of the saints) and presented them for public debate for the first time.

After an initial and vigorous rejection of these ideas, Andreas Bodenstein von Karlstadt read Augustine on Luther's recommendation, changed his mind and thus went on to become a member of the Wittenberg discussion group. Whereas Luther's focus at that time was on the spoken word in the form of lectures and sermons and he had thus far only expressed himself through his exposition of the Penitential psalms and in writing the short preface to the *Theologia Teutsch*, Karlstadt was the second person after Bernhardi to make the Wittenbergers' theological programme public; he summarised it in 151 theses which specifically described the conflicts with Scholasticism and articulated key theological views such as the concept of fundamental human sinfulness. Furthermore, Karlstadt was the first to petition Georg Spalatin, the humanist confessor of Elector Friedrich the Wise, to advocate discussion of the new Wittenberg theology in other towns and universities. On 26 April 1517 he posted his theses. They can be seen as a forerunner of the events of 31 October that year, for this first posting of theses (notably also a single-handed venture, as Karlstadt stressed: 'I posted' ('*affixi*')) also took place in response to the display of relics at the Castle Church in Wittenberg.

Luther's early period in Wittenberg was supported and accompanied by a network of theologian friends who were close to him in age and like-minded in their thinking; indeed, in a letter he extends greetings 'from all the friendly sodality' ('*omnis amica sodalitas*'; WA BR 1, Nr. 38, 94). Later, too, he had trusted colleagues with whom he engaged in activities such as writing joint opinions, sharing everyday concerns and intellectual topics in his *Table Talk* and producing joint publications. He worked particularly closely with Philipp Melanchthon and Johannes Bugenhagen, and together they were perceived as the Wittenberg triumvirate and imbued with particular authority.

Looking back in 1540, Luther talks of having been alone at the beginning of the Reformation, but that a '*Schola Wittebergensis*' developed over the course of the years. He describes how he was part of its community and how, as a communal authority, it watched over the true proclamation of

the Gospel (WA TR 4, Nr. 5126, 674). Evidently, Luther had felt particularly isolated during his time as a monk and perceived himself to have been cast on his own resources during his theological agonising, with the result that his 'we' experiences faded in his memory and he tended to emphasise his early 'solo' efforts. Yet at that time too he was accompanied by colleagues who were friends and who helped to shape his theology and convincingly communicate it to the outside world.

Over time the tight-knit group of reformers expanded and, in addition to Bugenhagen and Melanchthon, included Justus Jonas and Caspar Cruciger. Luther nonetheless consistently remained the dominant focus, especially in the early years, as many people were first caught up in the momentum of the new theology and anthropology through direct contact with him. However, with advancing age Luther's authority kept the people around him at a distance. Certainly, no pen ever conveyed a familiar *'Mi Martine'* or *'Mi Luthere'*.

Luther was no unworldly academic – even during his time in the monastery he had to demonstrate management qualities as district vicar and subprior, and as preacher at the Town Church he was a public figure with pastoral responsibilities. Since the university, where he sought to reform the study of theology, was a sovereign institution founded under the aegis of the Elector, he had to lobby influential people, such as Georg Spalatin, about his concerns. From early on Luther was called on to write reports for the electoral court, for the first time in spring 1514 when he pleaded for academic freedom in relation to Jewish literature (WA BR 1, Nr. 7, 23–24). A few years later, in 1520, he had left the narrow confines of his monastic existence far behind when he published his *To the Christian nobility of the German nation concerning the reform of the Christian estate*, in which he addressed the highest secular representatives, the Emperor and the nobility, challenging them to undertake far-reaching reforms in many areas of life. Luther the political adviser knew that, without the approval of the authorities, there could be no reformation of either theology or life.

1530 NUREMBERG BRASS, GILDED (CASE AND DIAL) AND IRON
MOVEMENT 5.3 × 4.8 × 5 CM
THE WALTERS ART MUSEUM, BALTIMORE

The Wittenberg Reformation was not the work of a single individual – it evolved through the cooperation of a group which brought together different talents and skills. Martin Luther was, without doubt, at the heart of the group. Even before he posted his 95 Theses, he was part of a discussion circle with theologians Johann Lang (1487–1548), Bartholomäus Bernhardi (1487–1551), Nikolaus von Amsdorf (1483–1565) and Andreas Bodenstein von Karlstadt (1486–1541), which was working on reforms to the study of theology. Their aim was to develop a theology based on the Bible, rather than the authorities of Scholasticism.

From 1518 one of the foremost members of the group of reformers was Philipp Melanchthon (1497–1560). Luther valued him as an equal and praised his colleague in glowing terms, writing in the preface to Melanchthon's exegesis of the Epistle to the Colossians that he would rather have 'Master Philipp's books than mine' (WA 30 II, 68). Luther expressed particular admiration for Melanchthon's *Loci communes* (1521), considering it to be the best book after the Bible.

Melanchthon was born in Bretten and after attending school and university in Pforzheim, Heidelberg and Tübingen he was appointed Professor of Greek at Wittenberg University, or the Leucorea as it was known. He arrived at his new home on 25 August 1518 at 10 am, as attested in a handwritten record by Luther's private secretary, Georg Rörer. As soon as he heard his new colleague's inaugural address, Luther, 13 years his senior, was positively euphoric in his reception of Melanchthon. A few months after they started working together he reaffirmed his enthusiasm: 'Our Philipp Melanchthon, a wonderful man, in whom everything is almost supernatural; and yet he is the friend and confidant of my heart.' (WA BR 1, Nr. 120, 269). Under Luther's influence Melanchthon immediately began to study theology and just one year later, on 9 September 1519, he presented his Baccalaureate theses, which formulated the scriptural principle of the Reformation for the first time – the Holy Scripture as the sole statute of faith against the authority of the Councils. Luther was deeply impressed: 'If it is Christ's wish, this man will surpass many Martin Luthers' (WA BR 1, Nr. 202, 514).

Melanchthon has 'lived on' principally in a multitude of writings. However, among his personal possessions a brass pomander watch has also survived. It is believed to be the oldest dated mechanical watch in the world today. Between its feet is an engraved inscription: 'Phil[ipp] Mela[nchthon] / God. Alone. / be.Honour. 1530'. It was given to him in 1530, probably in Nuremberg, where the watch, known as a Nuremberg egg, originated. Melanchthon broke his journey there between 26 and 28 April on his way to the Diet of Augsburg and on his return journey between 27 and 29 September. In contrast to Luther, Melanchthon had been very interested in mathematics, astronomy and horology since his student days in Tübingen. He was in communication with the Nuremberg instrument maker, Georg Hartmann, to whom he wrote a letter of thanks for a sundial in August 1535.

Stefan Rhein

→ Further read
Thomas Eser: *Die älteste Taschenuhr der Welt? Der He Uhrenstreit*, Nuremberg 2014.
Stefan Rhein: Von Freunden und Kollegen. Martin L und die Wittenberger Mitreformatoren, in: *Martin L Aufbruch in eine neue Welt*, Landesamt für Denkmalp und Archäologie Sachsen-Anhalt et al. (eds.), Dre 2016, 192–198.
Heinz Scheible: *Melanchthon. Vermittler der Reform* München 2016.

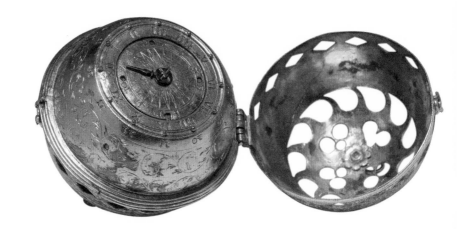

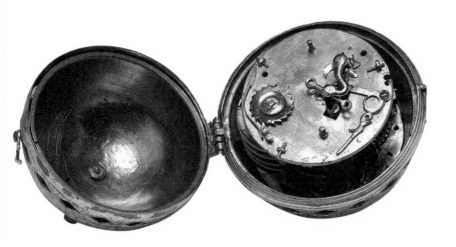

1521 LETTERPRESS AND WOODCUT ON PAPER 19 × 14.5 × 0.5 CM
STIFTUNG LUTHERGEDENKSTÄTTEN IN SACHSEN-ANHALT

Luther's appearance before the Diet of Worms on 17 and 18 April 1521 is the first event in the history of the Reformation for which contemporary pictorial records are available. By far the best known of these is the woodcut illustration on the title page of Georg Spalatin's translation, published in the same year, of the transcript of Martin Luther's public hearing, which was held in Latin. The image shows the principal participants: in the centre is the Emperor on his throne, flanked by secular and ecclesiastical electors. In the foreground, the two adversaries, Luther and Johann von der Ecken, a representative of the Archbishop of Trier, face each other across a towering pile of the Wittenberg reformer's works.

As the close confidant of Friedrich the Wise, Georg Spalatin (1484–1545) accompanied the elector to Worms and was an eyewitness to proceedings at the imperial diet. He was born in Spalt in Franconia, went to school there and in Nuremberg, studied law and theology in Erfurt and Wittenberg, and was ordained as a priest. In 1508, he was appointed tutor to the princes at the Wittenberg electoral court, and later became court chaplain and father confessor to the Elector. He rose rapidly to the position of Elector Friedrich's most important adviser. As Friedrich's intermediary between the electoral court and the university, from 1514 onwards he was in close contact with Luther. They developed a relationship of trust that is reflected in over 430 letters that still exist; these date mainly from the years after 1525, when Spalatin was pastor and superintendent in Altenburg. However, Spalatin was not only well-versed in political and administrative matters, but also a highly-educated humanist and theological scholar. His main interest was history: among his publications in this field was a three-volume Saxon and Thuringian chronicle, and he wrote biographies of both his sovereigns, Friedrich the Wise and John the Steadfast.

Although the much-quoted words put into the mouth of Spalatin, 'Had it not been for me, Luther and his teachings would never have come so far', have only come down to us through secondary sources, there is a great deal of historical justification for this statement. Spalatin played a crucial role in the reform of Wittenberg University, acted as Luther's advocate at the electoral court and could thus further the policy of Friedrich the Wise in regard to Luther. His writings made a considerable contribution to the history of the Reformation and, through his translations of works by Luther and Philipp Melanchthon, to the development and dissemination of Protestant teachings.

In the volume on the Diet of Worms shown here, Spalatin describes the course of events at the hearings and provides German translations of Luther's famous speeches before the Emperor and the powerful of the Holy Roman Empire, thereby giving Luther access to a wider public. Luther's self-confident words, in which he insisted on freedom of conscience and on the Word of God as the sole authority for faith, are rendered in Spalatin's translation as: 'Councils may err and have erred, this is as plain as day and will be proven. So help me God. Amen. Here I stand.' (WA 7, 877).

Stefan Rhein

→ Further read
Deutsche Reichstagsakten unter Kaiser Karl V., Adolf W (ed.), vol. 2, Gotha 1896, 581–582.
Irmgard Höß: *Georg Spalatin (1484–1545). Ein Leben Zeit des Humanismus und der Reformation*, Weimar 19 *Georg Spalatin. Steuermann der Reformation*, Armin Kc Christina Meckelnborg and Uwe Schirmer (eds.), I 2014.

Doctor Martini Luthers offen=
liche Verhör zü Worms im Reichs tag/
Red/ Vnd Widerred Am.17.tag/
Aprilis/ Im jar 1 5 2 1
Beschechen

Copia ainer Missiue/Doctor Martinus Luther nach sei=
nem abschid zü Worms zü rugck an die Churfür
sten/ Fürsten/ Vñ stend des Reichs da selbst
verschriben gesamlet hatt.

MARTIN LUTHER'S TRAVEL SPOON

C.1525 SILVER, GILDED, WITH HORN PLATE INLAY LENGTH 13 CM
WARTBURG-STIFTUNG EISENACH

One of the most stunning, extant personal items connected with Luther is a gilded travel spoon, which has been at the Wartburg since 1937. It opens out on a hinge – ideal for use when travelling. In addition to an illustration of the Crucifixion, it is covered with Hebrew and Latin renderings of biblical texts such as 'The Lord is our righteousness' and 'If God is for us, who can be against us?'.

Luther gave this travel spoon to Caspar Aquila (1488–1560), who lived in Wittenberg at three stages in his life: firstly, from 1513 to 1516 as a theology student after spending time in prison for 'reformist activities', secondly, in 1520–21 to further his studies, and, thirdly, from 1524 to 1527 after the death of his Evangelical patron Franz von Sickingen. Aquila was highly respected, above all for his comprehensive knowledge of biblical languages. In 1542, Friedrich Myconius – a theologian in Gotha – described him in his *Geschichte der Reformation* ('History of the Reformation') as 'well versed in Hebrew and Greek and very proficient in the text of the Bible'. Aquila's philological erudition led him to become one of the team working on the translation of the Bible. The travel spoon is thus often regarded as a token of Luther's appreciation of Aquila's participation in the translation project. However, the suggestion that Caspar Aquila was part of the Wittenberg translation team was only made at a later date by his son David (1540–1614). David Aquila reported that his father had preached at the Castle Church in Wittenberg, that he had taught Hebrew in private colleges and that he had 'been used by Luther on the translation of the Holy Bible'. It is not possible to say whether this might be no more than the words of a proud son. It was also David who talked of Luther's admiration for his father's vast knowledge of the Bible, which was said to have been recorded in a Bible dating to 1545: 'If this Bible were burnt or no longer to be found anywhere in the world, I could still find it through Aquila' (WA DB 10 II, XX). Nevertheless, the letters that Luther and Philipp Melanchthon exchanged with Aquila do illustrate the respect the Wittenbergers had for the future Superintendent in Saalfeld. There would have been numerous occasions when Luther might have given Aquila a present of some kind, and their work on the Bible translation would have been just one of them. At one stage Aquila even conveyed a letter from one of the Wittenberg reformers to the other: in 1530, when he travelled from the Augsburg Imperial Diet to meet Luther at Coburg Fortress, he brought with him news from the Diet and from Melanchthon, who was in Augsburg at the time. In Luther's *Table Talk* there is also a reference to a meal with Aquila, by then pastor in Saalfeld, who bemoaned the ingratitude of the members of his congregation (WA TR 5, 660). Whenever and however Luther gave the travel spoon to Aquila, it visibly and tangibly documents Luther's appreciation of his colleague's knowledge of philology and theology. Stefan Rhein

→ Further read

Günter Schuchardt: *Die Kunstsammlung der Wartbur* gensburg 1998, 27.

Caspar Aquila. Schriften und Lebenszeugnisse des Saa Reformators, Heinz Endermann (ed.), Hildesheim 2

Stefan Michel: Eine gründliche Lutherlektüre. C Aquila (1488–1560), in: *Aus erster Hand. 95 Porträts z formationsgeschichte. Aus den Sammlungen der Forschu liothek Gotha*, Daniel Gehrt and Sascha Salatowsky Gotha 2014, 9.

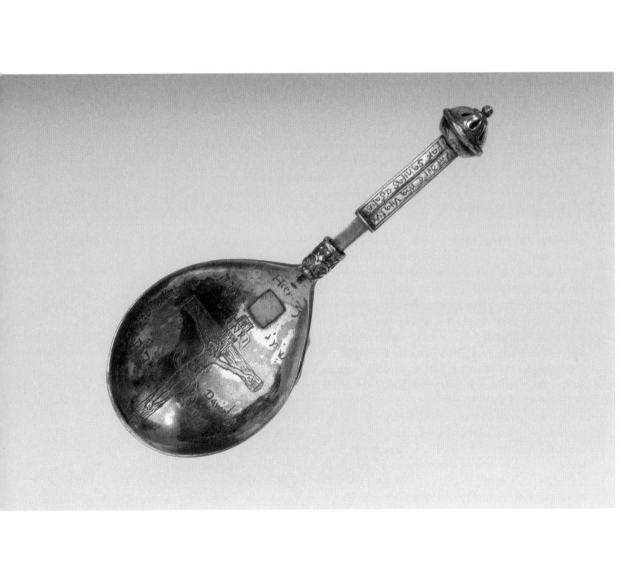

1520 3RD STATE, PULLED AFTER 1570 COPPER ENGRAVING
14.1 × 9.7 CM
STIFTUNG LUTHERGEDENKSTÄTTEN IN SACHSEN-ANHALT

In 1520, three years after Luther posted his 95 Theses and a year before the Diet of Worms, Lucas Cranach the Elder (1472–1553) created the first 'public' portrait of Luther. It is a striking bust of a hollow-cheeked monk with a tonsure and a strong brow, thoughtfully and resolutely gazing into the distance. Lifelike and powerfully modelled, Luther is seen above a panel with an inscription reflecting the artist's humility in the face of the reformer: 'The eternal likenesses of his spirit are brought forth by Luther himself, his immortal features by the wax of Lucas.'

Authentic yet stylised, this real-looking portrait confirms the comments from Luther's contemporaries who described him as gaunt, exhausted 'by cares and by his studies'. The stylisation of his features places him in the same mould as classical, heroic figures. The addition of an inscription, in the humanist tradition, ennobles the portrait, turning it into a document for all time.

This portrait marks the beginning of a targeted, image-based propaganda campaign reflecting Luther's growing prominence and developments in the political arena. The Augsburg hearing, the Leipzig Disputation and the papal bull threatening excommunication suddenly propelled Luther into the limelight in 1519–20. The Wittenbergers adeptly exploited the potential of the new print media to reach a mass-audience. The Elector's private secretary, Georg Spalatin, masterminded the campaign; Luther provided the texts and Cranach composed images with suitable iconographies. Luther now also increasingly tended to have his disputations printed. They flew off the shelves so rapidly that the Papal Nuncio, Hieronymus Aleander, soon disgruntledly remarked: 'Every day there is another shower of Luther texts in German and Latin.'

It was a sermon by Luther, printed during the Leipzig disputation, that first appeared with an image of the reformer, that is to say, a generic image of a monk that was, however, identifiable as Luther by the 'Luther rose' from his seal and by the writing around the medallion. Clearly Luther's popularity led to demands for an image to go with his words. The idea of creating an authentic portrait actually came from Albrecht Dürer: aflame with the new thinking of the reformers and eager to create a likeness of Luther, Dürer sent his engraving of Cardinal Albrecht to Spalatin, as an example of his skill as a portraitist. A copy of that engraving came into Cranach's hands, who responded not only by making a copy but also by creating his first portrait of Luther.

This first likeness seems only to have been printed as a proof copy in 1520. It was only after Luther's death that it was published in different states and in large editions. It may be that the belligerence of Luther's expression did not seem politic to the Saxon court at the time. Cranach already altered the image that same year, in 1520, softening Luther's features and showing him in front of a rounded-arch niche with a Bible in his hand, spreading the Word of God. That version was widely disseminated – as an individual sheet, a flyer and as a frontispiece to texts by Luther, and was subsequently also modified by other artists, including Hans Baldung Grien.

Katja Schneider

→ Further readi
Martin Warnke: *Cranachs Luther. Entwürfe für ein Im* Frankfurt am Main 1984.
Ilonka van Gülpen: *Der deutsche Humanismus und die he Reformations-Propaganda 1520–1526. Das Lutherpor im Dienst der Bildpublizistik*, Hildesheim 2002.
Cranach, Luther und die Bildnisse, Günter Schuchardt (catalogue to the exhibition of the same name, Regensb 2015.

AETHERNA IPSE SVAE MENTIS SIMVLACHRA LVTHERVS
EXPRIMIT·AT VVLTVS CERA LVCAE OCCIDVOS·

·M·D·X·X·

MARTIN LUTHER

LETTER ABOUT ANDREAS BODENSTEIN VON KARLSTADT

28 MARCH 1517 MANUSCRIPT ON PAPER, FRAGMENT 15.1 × 9.5 CM
STIFTUNG LUTHERGEDENKSTÄTTEN IN SACHSEN-ANHALT

Luther came up against opponents and enemies throughout his life, some of whom he viewed as such from the outset, while others evolved to become adversaries or were cast in this role by him. His relations with some of his early companions became strained over time, leading to rejections and breaches, including in the case of his former Wittenberg colleague, Andreas Bodenstein von Karlstadt.

Andreas Rudolf Bodenstein was born in Karlstadt am Main in 1486. He studied in Erfurt and Cologne from 1499, came to Wittenberg in 1505, was ordained priest in 1510 and was subsequently awarded a doctorate in theology. As Archdeacon at the All Saints Foundation he held one of the chairs in the Theology Faculty. When Luther gained his doctorate in 1512, Karlstadt was dean of the faculty. After a period in Italy in 1515–16 he became a Doctor of Both Laws (*iuris utriusque*).

In the letter pictured here Luther expresses his joy about the fact that Karlstadt is now on his side and is seeking to oppose the sophists and jurists. This fragment, which was discovered in 2009, is of great importance in understanding the early Reformation; only a handful of Luther's letters from the epoch-making year of 1517 have survived – just 22 in all. Luther still signs himself 'Luder' here, meaning that his use of the new name, 'Luther', derived from 'Eleutherius' ('the free'), can be dated to the period immediately around his posting of the 95 Theses.

The letter also serves as evidence of the theological transformation that Karlstadt had recently undergone. This was triggered by Johann von Staupitz, who had encouraged Karlstadt to read the anti-Pelagian writings of Augustine who emphasised the individual's complete dependence of the individual on divine grace. Karlstadt in turn dedicated his commentary on Augustine's writings, *De spiritu et littera*, to Staupitz in November 1517. At the very beginning of the Reformation Luther and Karlstadt cooperated closely. Together they confronted theology professor, Johannes Eck of Ingolstadt, at the Leipzig Disputation in 1519. In addition, the publication of *Karlstadt's Wagon* (1519) saw the medium of the woodcut employed for the first time for a cartoon criticising scholastic theology.

However, the two men's shared purpose came to an end while Luther was staying at the Wartburg in 1521-22. Karlstadt became a proponent of the establishment of 'divine law' in Wittenberg, rejecting imagery and music in church and disputing the validity of celibacy. In order to calm the storm thus unleashed, Luther returned to Wittenberg and urged a transitional period of consideration for the weak. In 1523 Karlstadt gave up his professorship and moved to Orlamünde as pastor where he implemented his own reformation at the congregational level. The following year he was involved in disputations with Luther and was expelled from Electoral Saxony. After returning periodically to Wittenberg, Karlstadt had to flee Electoral Saxony in 1529 and, after various stops in Kiel and East Frisia, ended up in Zurich in 1530. In 1534 he moved to Basel where he was professor of Old Testament theology until his death in 1541. Johannes Schilling

→ Further read

WA BR 18, Nr. 4341, 139–145.
Alejandro Zorzin: *Karlstadt als Flugschriftenautor*, G
gen 1990.
Volkmar Joestel: *Andreas Bodenstein von Karlstadt*, W
berg 2000.

apud nos · retinere · ‹›·p· & reditum apud
vos ... cum uiro doct. Andreas Carlstad
doctus & ... quos uocat Philosophos doctorum
... in Collegio. Si ergo hic Theologi admit...
domicrum. Dicito eis adhuc ...
... Joh.
... de Magdeburgk Si quid
uel uerus Carlstadii ... in gaudio ...
... Benedictus dei
... p
... fuere. Sunt uobis x flor. apud
... & ad nos ... gratissimum est...
... ... a deo ... Et
... ... &
... quo ...
... ... Ex Wittenbergk ... Kl. Aprilis

 ꝉ Martinus Luther
 ... Wittenbergk
...
Non ...

LUCAS CRANACH THE YOUNGER

C.1532–1539 OIL ON PANEL 72.8 × 39.7 CM
TOLEDO MUSEUM OF ART

Far from being alone in his efforts to reform the Church, Luther had a wide support network. He was able to rely not only on academic colleagues from Wittenberg University who, one by one, came over to his way of thinking, but also increasingly on secular authorities, led by the Saxon Electoral family and closely followed by other potentates he was on friendly terms with, such as Count Albrecht of Mansfeld and Georg III of Anhalt. By 1525 at the latest, after the Peasants' War, it was clear that Martin Luther was not seeking to overturn the worldly order with its different estates; on the contrary he regarded the existing worldly order as a reflection of God's will and legitimised by the Holy Scripture. Luther himself declared that the rulers of the day had to take to arms to defend that order, if necessary, using 'not a wreath of roses or a flower of love, but a naked sword' (WA 18, 389; LW 46, 70). Luther was in no doubt that the Reformation could only be implemented 'from above'.

While Elector Friedrich the Wise did much to ensure that Luther's new teachings took hold in Saxony, they were supported even more actively by Friedrich's successors, first his brother Johann and then the latter's son, Johann Friedrich. This public support for the Reformation was reflected in a series of group portraits showing the Elector with a gathering of advisors and notable reformers. The earliest composition of this kind has only survived as a fragment; painted by Lucas Cranach the Younger (1515–1586), it shows Johann Friedrich the Magnanimous with Martin Luther, Philipp Melanchthon, Georg Brück, Georg Spalatin and other advisors. The superior status of the Saxon Elector is highlighted by his elaborate dress and sheer size, and by his hands, one clasping a sword and the other a dagger. He is flanked by Melanchthon and Luther, although the latter – largely hidden by the Elector – has almost been pushed into the background. Melanchthon is much more prominent, seen in full-length with a scroll and one finger raised as he proffers advice. The figures jostling in the background – not all of whom can be identified – represent the spiritual and intellectual authorities under the leadership of the Elector, as he liked to think of it. This fragment, now in the collection of the Toledo Museum of Art but known to have been in England up until 1923, was originally part of a much larger painting or triptych, possibly a depiction of the Baptism of Christ in Jordan or of the Crucifixion of Christ, which must have been painted in the 1530s. Evidently it had already been cropped to this size before 1640, because it was in 1640 that Edward Hyde, the First Earl von Clarendon, had a large-format copy made of the cropped original. In the mid-seventeenth century Clarendon, who rose to the position of Lord Chancellor and later wrote a history of the life of Henry II, built up an extensive collection of historical portraits, which formed the basis of what was to become one of the most important collections of portraits in the United Kingdom. The Clarendon copy has been in the ownership of the Plymouth City Museum and Art Gallery since 2010. Mirko Gutjahr

→ Further readi
The Toledo Museum of Art. European Paintings, Toledo, C
1976, 45, PL. 66.
Ruth Slenczka: Johann Friedrich von Sachsen und die
tenberger Reformatoren, in: Luther und die Fürsten. Selbs
stellung und Selbstverständnis des Herrschers im Zeitalter
Reformation, Dirk Syndram, Yvonne Wirth and Iris Yv
Wagner (eds.), catalogue to the exhibition of the same na
Dresden 2015, 102, no. 40.

LUCAS CRANACH THE ELDER

FRIEDRICH THE WISE AND JOHANN THE STEADFAST

1525 MIXED MEDIA ON RED BEECH PANEL DIAMETER 11, 11.7 CM
STAATLICHE KUNSTHALLE KARLSRUHE

Friedrich the Wise, Elector of Saxony (1463–1525), is reputed to have once said, 'I have and know no friend on Earth other than my brother.' He was referring to his younger brother Johann the Constant (1468–1532). For almost 40 years, from 1486 until Friedrich's death in 1525, the two brothers ruled the Ernestine territories of the House of Wettin. While the older brother had been first in line of succession to the Electorate and, as such, often led the way, he always consulted his younger brother on any significant decisions. Georg Spalatin, their close confidant and biographer, described their relationship as 'fraternal and harmonious'.

This special alliance is clearly reflected in the two tondo portraits from 1525, now in Karlsruhe, which are reminiscent of companion portraits of married couples. The medallion portraits of Martin Luther and Katharina von Bora were painted shortly after their wedding the same year. Lucas Cranach the Elder (1472–1553) and his workshop reproduced both pairs of portraits in various mediums, as paintings, and also, in the case of the brothers, as woodcuts. These portraits went out into the world from Wittenberg, often, it is assumed, as special gifts to allies. As such, they were part of Friedrich the Wise's strategic policy of self-representation through portraiture, which was continued by his successors and soon amounted to very real visual propaganda.

On 5 May 1525, at the height of the Peasants' War, Friedrich the Wise died. Johann the Constant now succeeded him as Elector and sole ruler of the territory they had hitherto divided between them. Whereas the brothers had previously treated Luther with caution, Johann now decisively took sides with him. Johann, who had always been closer to Luther than Friedrich, established Lutheran worship in his territories and openly championed the Reformation. These two likenesses, with their echoes of portrait medallions, were made in a time of great upheaval.

That may also explain the striking differences between the two images: the portrait of Friedrich is much more finely worked than that of Johann, and there is also a considerable difference in the background colours. It may be that Friedrich's portrait – the first to show the Elector with greying hair and beard – was done during his lifetime and never intended to be one of a pair. Johann possibly then had his own portrait painted after Friedrich's death, as a symbol of their brotherly concord and dynastic continuity. The two paintings may not entirely match because Cranach did not have the first to hand when he painted the second. Some years later this pair of portraits became the prototypes for an astonishing series: in 1532 Johann the Magnanimous, Johann the Constant's son and successor, commissioned sixty pairs of portraits of his predecessors. In all of these the two Electors are depicted gazing towards each other, stocky and determined, with full beards, pleated shirts, black doublets, fur-trimmed cloaks and berets. It was in the Karlsruhe portraits that this schema was first realised.

Holger Jacob-Friesen

→ Further read
Sabine Schwarz-Hermanns: Die Rundbildnisse I
Cranachs des Älteren. Mediale Innovation im Spann
feld unternehmerischer Strategie, in: Lucas Cranach
2003. Wittenberger Tagungsbeiträge anlässlich des 450.
jahres Lucas Cranachs des Älteren, Andreas Tacke (ed.).
zig 2007, 121–134.
Anna Moraht-Fromm: Das Erbe der Markgrafen. Die S
lung deutscher Malerei (1350–1550) in Karlsruhe, Ostfi
2013, 374–377.
Christian Winter: Kurfürst Friedrich der Weise und
Bruder Herzog Johann, in: Kurfürst Friedrich der Wei
Sachsen (1463–1525). Contributions to the conference
4 to 6 July 2014 at Schloss Hartenfels in Torgau, Dir
dram, Yvonne Fritz and Doreen Zerbe (eds.), Dr
2014, 28–38.

MARTIN LUTHER TO THE CHRISTIAN NOBILITY OF THE GERMAN NATION

PRINTER: MELCHIOR LOTTER THE YOUNGER, WITTENBERG

1520 LETTERPRESS ON PAPER 21 × 15.7 × 0.5 CM
STIFTUNG LUTHERGEDENKSTÄTTEN IN SACHSEN-ANHALT

To the Christian Nobility of the German Nation is possibly the most popular of Luther's writings of the eventful year of 1520. Published in August of that year, it anticipates the consequences of the threat of excommunication already on its way to Luther from the curia in Rome. In this work, Luther argues that, by claiming power over temporal rulers, asserting sole authority over the correct interpretation of the Bible and even declaring its control over Church councils, the papacy demonstrated that it no longer had a legitimate claim to leadership of the Church. Therefore, according to Luther, responsibility for the Church now lies with the 'Christian nobility', by which he means all temporal rulers – from the emperor to local figures in authority, including those in free imperial cities.

He calls on those who exercise temporal authority to assume responsibility for the Church by sharing in the work of the Reformation, because, as Christians, they had through Baptism become 'priest, bishop, and pope'. Baptism had brought them into such a close relationship with God that this, like the relationship of a child with its father, could not be overridden. This is the meaning of the doctrine of the 'priesthood of all believers', which is comprehensively argued and justified in this work. If popes and bishops fail in their duty, then responsibility shifts to all Christians in general. In this context, Luther also describes the pope as the 'Antichrist'. This is not intended as a moral judgement, but is a claim that the Church's purpose of salvation has been destroyed by the pope, who presumes himself to be above the Word of God.

In the second part of the work, Luther addresses demands for fundamental reform of the Church. This includes a general reduction of the powers of the Church and its property. In doing this, Luther associates himself with objections to political intervention by Rome that had already been expressed before his time at several imperial diets in the *Gravamina der deutschen Nation*. However, Luther goes even further, extending his criticism to the spiritual sphere and to many institutions in the areas of social welfare and religious orders and foundations. Finally, he is not sparing with his disapproval of customary German practices and habits, criticising errors in economic and social development, including moneylending and the greed underlying this business.

Luther's address to the nobility shows the importance he attached to gaining the commitment of the temporal authorities as a way of ensuring that the religious fundamentals of the Reformation were given due respect in shaping society and the Church. The impact of his motivation and the foundations he laid continued to exert their influence, particularly in regard to the concept of the universal priesthood of all believers.

Dietrich Korsch

→ Further read

WA 6, 404–469; LW 44, 115-217

Thomas Kaufmann: *An den christlichen Adel deutsch tion von des christlichen Standes Besserung,* (Komment Schriften Luthers, vol.3), Tübingen 2014.

Martin Luther: *An den Christlichen Adel teutscher N Studienausgabe,* Armin Kohnle (ed.), Stuttgart 2015 lish version: Martin Luther: *To the Christian Nobility German Nation, 1520: The Annotated Luther Study E* James M. Estes, Timothy J. Wengert (eds.), Minne 2016).

An den Christlichen Adel deutscher Nation: von des Christlichen standes besserung: D. Martinus Luther.

Wittenberg.

(1520)

vergl. Panzer fur. 974 bis 9, in andern Ausgaben

QUENTIN MASSYS PORTRAIT MEDAL OF ERASMUS OF ROTTERDAM

1519 BRONZE, CAST DIAMETER 10.67 CM
HMB – HISTORISCHES MUSEUM BASEL

The medal shown here has a threefold association with Erasmus of Rotterdam (ca.1466–1536). First, on the obverse is a portrait in profile of the great humanist, around which there are inscriptions in Ancient Greek ('His writings will show him better') and Latin ('An image taken from life' and 'Er[asmus] Rot[erdamus]') and the date (1519) near the lower rim. Second, this particular medal was retained by Erasmus, who was not satisfied with the quality of the cast, made after the lead model by Antwerp painter and medallist Quentin Massys (1465/66–1530), and decided not to present it as a gift. Third, in 1974, when his grave was rediscovered during excavations in Basel Münster (cathedral), this medal was found close to his right hand with the Erasmus portrait facing upwards.

In 1520, Erasmus presented a medal bearing his portrait to Georg Spalatin, the close confidante of Friedrich the Wise. In the early years of the Reformation, the Wittenberg reformers saw the foremost European scholar of his time as someone who was on their side. For it was his 1516 edition of the Greek New Testament, which replaced the Latin Vulgate as the definitive version, that cleared the way for their access to the original text of the Bible – in the spirit of the rallying cry shared by both humanists and reformers, *ad fontes*!, back to the sources! Philipp Melanchthon's preface to Luther's commentary on the Psalms, published in March 1519, made this point of view clear, thus we have Erasmus to thank for the study of Greek and Latin, access to the New Testament and for our knowledge of the writings of the church father Jerome. The Wittenberg reformers regarded the 'prince of humanists', dubbed 'light of the world' by some admiring contemporaries, as an ally in their struggle against the prevailing state of the Church. Erasmus himself judged Luther's criticism of the Church to be at least partly justified, although at this time, according to a letter he wrote to Melanchthon in April 1519, he had not yet read any of Luther's writings.

However, the differences with Erasmus became clearer with each new work of Luther's that was published, particularly in matters of style. For Erasmus, Luther was too aggressive in his approach or, as he wrote to Spalatin, Luther should be more moderate, remain quiet for a while and further the cause of the Gospel without emotion: one need not always proclaim the truth so stridently, how one goes about doing this is by no means insignificant. Luther and Erasmus also exchanged letters, but they only served to exacerbate the rift between them, as their differing positions on the papacy, among other issues, became clearer. Luther's fierce polemics against Erasmus's stance on leaving the power structure of the papal Church intact and reforming it from within increased their lack of mutual understanding. The conflict escalated, and a fiery dispute over free will raged between 1524 and 1526, its flames fanned by the publication of numerous attacks and counter-attacks. Whereas Erasmus asserted that humans have free will, Luther likened the will to a horse that is either ridden by the Devil or driven by God, as the fate of every human is predestined. Stefan Rhein

→ Further read
Erasmus von Rotterdam. Vorkämpfer für Frieden und Tol. Historisches Museum Basel (ed.), catalogue to the e:
tion of the same name, Basel 1986, 113–115, 272–273 (te
Elisabeth Landolt).
Heinz Scheible: Melanchthon zwischen Luther und
mus, in: idem: *Melanchthon und die Reformation. Forsc*
beiträge, Gerhard May and Rolf Decot (eds.), Mainz
71–196.
Johannes Schwanke: Freier oder unfreier Wille? Die
troverse zwischen Martin Luther und Erasmus von R
dam, in: *Martin Luther und die Freiheit*, Werner Zager
Darmstadt 2012, 41–58.

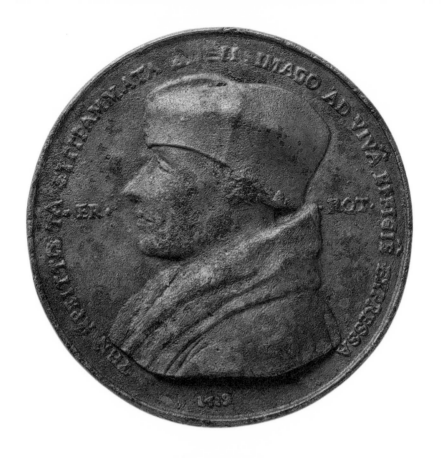

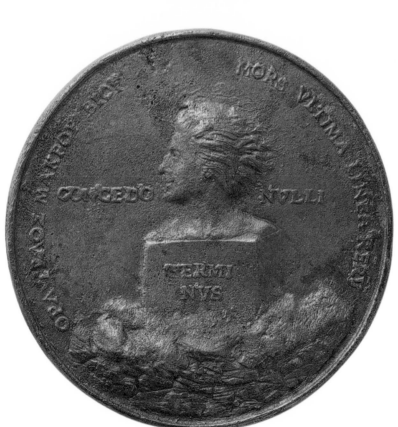

'I SHALL NOT BE SILENT.'

WA BR 2, NR. 242, 408; LW 48, 343

Luther addressed his 95 Theses to his academic colleagues. However, in the months and years that followed, he increasingly targeted a wider audience. He wanted as many people as possible to hear his message about the freedom of being a Christian. Luther focused on the new opportunities offered by printing as one way of spreading his ideas. He also set great store by spreading the Gospel using vivid and accessible language. His writings, sermons and hymns played an important role in this mission, as did the many paintings and graphic works that were produced in cooperation with Lucas Cranach the Elder and his workshop. In this way the Reformation message spread from Wittenberg out into the world.

THE SPREAD
OF THE REFORMATION

HERFRIED MÜNKLER

The Reformation began as an internal academic dispute: it is irrelevant whether, as the story goes, Martin Luther nailed his 95 Theses to the door of Castle Church in Wittenberg, or whether he circulated it as a type of discussion paper among his colleagues – he initially addressed his thoughts to the community of scholars with whom he wanted to discuss his understanding of divine justice, divine mercy and human endeavours to satisfy God's demands. Of course, Luther also wanted to address

the role of money and the sale of indulgences. He was initially interested in the practice of academic dispute as it had evolved in the scholarly world in isolation from the rest of society since the High Middle Ages. Such disputes did not usually concern social and political life. There were virtually no channels of communication between the world of scholars, the monastery, and, from the twelfth or thirteenth century, the university and the rest of society, i.e. the farmers, townspeople and nobility. Luther's theological preoccupations culminated in the Reformation when the dispute erupted into the scholarly world and subsequently developed into a social issue. A specific problem within the Theology Faculty became an issue that affected everyone. How was that possible?

Luther had long been interested in the philosophical question of active and passive righteousness, centring on the issue of whether human beings justify their own conduct before God or whether, as this is impossible, God looks mercifully on human beings. This particular issue acquired a sense of urgency in Saxony and Brandenburg due to the widespread practice of selling indulgences, the literal capitalisation of the church's treasury of merits, which also served to provide the church authorities with a magnificent lifestyle. In Rome, Giovanni de' Medici, a member of a Florentine banking dynasty, was elected Pope. Leo X, as he called himself, needed money, a lot of money, to be able to fund the lavish lifestyle of a Renaissance prince. This would be financed by the sale of the treasury of merits.

Thus there were (at least) two communication channels through which a specific theological problem became an issue that upset the social and political order: the importance of cash payments for the purpose of reducing the period of time spent in Purgatory and the notorious flow of money out of Germany to Italy, which for decades played a role in the *Gravamina nationis Germaniae*, the grievances of the German nation. While Luther viewed his theological concerns in the light of the socio-political order, he transformed the subject of an internal academic dispute into his reform mission. This gave him the power and impetus necessary to bring about a new social and political order. This was certainly not Luther's intention when he published his 95 Theses in October 1517. However, as the reform process gained momentum, he faced up to the associated challenges and pressed ahead with the Reformation with his inherent decisiveness and stubbornness, with courage, linguistic brilliance and literary power, and with remarkable political discretion.

Two documents in particular, both written in 1520, show Luther's determination to transform an internal theological issue into a social and political challenge, thus justifying his mission. The documents in question were *To the Christian nobility of the German nation* and the relatively short tract *On the freedom of a Christian*. In the first of these works, he linked his concern

for reform with the widespread national resentment felt by Germans towards the imperious Romans, and in this way created a new community of followers and supporters. In the second, he tore down society's dividing lines between the spiritual and worldly realms, creating space for the development of social models that were no longer determined by the theologians' terms of reference. Both acts amounted to a reorganisation of the Christian community. Luther's mission, as he saw it, was to reorganise the community of all Christians in two ways: first, the previous fundamental difference between spirituality and secularism was replaced by the concept of a kingdom of priests of all Christians, according to which there was no privileged access to God by virtue of status, and, second, the universal unity of Christianity would be supplemented at least by national affiliations.

Moreover, whether and how a person led a Christian life was no longer of importance for the social order. Luther reflected on the consequences of these changes in his 1523 treatise *On secular authority*. In this work, he radically separated the political order from the community structures of Christian life. By combining the desire for reform with the widespread anti-Roman feeling in Germany, he had already replaced the generally universal idea of Christianity with that based on a specific order of European nations. His translation of the Bible, in particular, illustrates how closely the two are connected: the language of the universal academic community was Latin; it acted as a unifying force for scholars, irrespective of their country of origin and mother tongue. But it also separated them from everyone else who had not mastered this language of learning and celebration of holiness and could not, therefore, contribute as much as a single word to the debate. Luther's translation of the Bible into German accomplished what he had demanded and signalled in his Reformation polemics: the creation of a new community which was not determined primarily by corporatist structures but by cultural idiosyncrasies and differences vis-a-vis other national cultures. Luther's self-imposed aspiration to translate the New Testament in such a way that people noticed that 'we are speaking German to them', as he expressed it in his *Open letter on translating* (1530, WA 30 II, 637; LW 35,189), is itself a vector of this change in the idea of community from vertical to horizontal terms of reference.

On various occasions Luther compared himself to the Cherusci chieftain Arminius (or Hermann, the German name by which he was known in Wittenberg circles). Luther referred to him as a *Harzländer* (a man from Harz) and loved him 'with all my heart' (WA TR 5, Nr. 5982). Arminius/Hermann had fought back against the Romans when they were at the height of their power. Luther saw an analogy with the events taking place during his time. The difference was that the correct and logical interpretation of the Gospel, which 'the Romans' had corrupted, took the place of actual weapons

on this occasion. By the time Luther had characterised himself in this combative role, the Reformation was already well under way, and an internal academic dispute had long since become a controversy that was unfolding in society at large, and on which the territorial rulers in Germany were forced to take a stand.

Luther was lucky to find strong political backing in his Saxon ruler, Frederick the Wise. Without him, he probably would not have survived the Diet of Worms in 1521, which had declared him an outlaw. Moreover, without his powerful works and his courageous appearance in a series of public disputes, Luther would not have received the support of broad swathes of the population, which prompted the Saxon prince and others to cast their lot in with him.

However, even with the support of some of the authorities in Germany, Luther's mission was by no means complete. On the contrary, the authorities initially only provided a safe space where Luther could pursue his project of renewing the Christian faith and returning to its fundamental principles in the Gospel. After 1525, the convulsions of the German Peasants' War and the strengthening of the aristocracy following their suppression of the rebellious peasants led to a 'depoliticisation' of the reform mission and Luther's growing focus on consolidating and developing what had been achieved: the restructuring of the school system, the examination of socio-economic issues such as the legitimacy of lending and interest, the shaping of civic life and the oversight of the initially unruly forms of the new ecclesiastical practice.

It would be wrong therefore to declare 1525 the dividing line between a 'revolutionary' and a 'conservative' Luther, however the fact remains that the turbulent phase of the reform mission came to an end and the consolidation of the Reformation began after that year. This was a period characterised by 'the travails of the plains', to use Bertolt Brecht's words. Not to put too fine a point on it, it can be said that Luther the outspoken author of one polemic after another, who was caught up in the slipstream of radicalisation and the escalation of his position, was increasingly eclipsed by Luther the writer of hymns, which dealt with the expression of introspection and the securing of the inner life through its external expression and its associated experience of community.

Thus Luther's mission did not come to an end with the triumph of the Reformation; however, it did change its thrust and its framework. In doing so, it did not lose its combative dimension, but this was now no longer Luther's main concern. Lucas Cranach the Elder still produced pamphlets in his workshop that continued the battle against the papacy, monasticism and everything related to these aspects of Catholicism, but the portraits of Luther, Philipp Melanchthon and all of the other people associated with the Reformation project, which were produced by Cranach and his employ-

ees to illustrate the formation of a new community and thus consolidate the cohesion of the Reformation, were probably far more important. Aggressive enforcement was replaced by internal consolidation, and the Reformation would probably not have endured if Luther had not skilfully managed this part of his mission.

LUCAS CRANACH THE YOUNGER

AFTER 1537 OIL ON PANEL 47 × 38 CM
COLECCIÓN BANCO SANTANDER, MADRID

Lucas Cranach the Younger (1515–1586) depicts John the Baptist in a make-shift pulpit, standing on the stump of a felled tree, with a branch laid between two other trees serving as his handrail. Cranach's signature – a winged serpent – is visible on the tree stump, staking his claim as the originator of the scenario for St John. John the Baptist gesticulates to the crowd that has gathered in a narrow clearing – three horsemen in armour, men and women of various ages, dressed both poorly and more lavishly. In the foreground there is a mercenary sporting a leather doublet and extravagantly slashed, red-yellow sleeves and hose, with a sword at his left hip and a feathered hat in his right hand. Representatives of all levels of society, whose clothing dates this scene to the sixteenth century, have collected to hear John the Baptist preach.

Two of the women in the crowd and the youngest of the horsemen are glancing towards the viewer, who is thus drawn into the event as a witness to this sermon, which has no need of an elaborately embellished pulpit or a sanctified church building. The true Church exists where the faithful are gathered together in the name of the Lord, listening to the Word of God as it is proclaimed to them. It is the Word of God that sanctifies the place and the participation of the congregation.

Luther regarded John the Baptist as the ideal preacher for his concentration on his central duties to his congregation. He comforted his flock, he commanded them to repent and atone for their sins, and he instructed them and strengthened their faith. St John was thus the exemplary Lutheran preacher and embodied Lutheran ministry more perfectly than anyone else. As the herald of Christ his entire focus was only ever on the Saviour, on the Lamb of God. The preacher in this painting does not seek the limelight, he is fully engaged in telling his listeners of the Saviour. St John specifically described himself as a voice heralding the coming of the Redeemer. The words that he spoke were not his own, they were only ever the words of the Lord. He always clung to the Word of God, never deviating from it, neither elaborating nor interpreting it, since it exists in its own right and is immediately comprehensible to all who hear it.

Luther himself found solace in the mediaeval images of John the Baptist pointing to the Lamb of God, which he felt that the Roman Catholic Church had no longer fully understood. He had seen many images of this kind in Erfurt, at the west door of the cathedral and in the Severikirche. In Wittenberg, in the Elector's collection of sacred objects, there was a reliquary with a depiction of John the Baptist pointing to the Lamb. In Lutheran churches an image of John the Baptist is often prominently displayed on the pulpit for both the congregation and preacher – as a reminder to preachers of their duties and as warning to the congregation to ignore false witness and never to stray from God's Word. Susanne Wegmann

→ Further read
Joachim W. Jacoby: 'Er hatte desfals die dreistigkeit .
gende starke sprüche anzubringen'. Die Johannespre
Lucas Cranachs d. J. im Herzog Anton Ulrich-Mus
in: *Niederdeutsche Beiträge zur Kunstgeschichte 26* (1
83–104.
Christoph Markschies: 'Hie ist das recht Osterla
Christuslamm und Lammsymbolik bei Martin Lu
und Lucas Cranach, in: *Zeitschrift für Kirchengeschicht*
(1992), 209–230.
Susanne Wegmann: Der vereinnahmte Prediger. Di
hannespredigt und der Erfurter Pfeilerbilderzyklus
lutherischer Sicht, in: *Kontroverse und Kompromiss. De
lerbildzyklus des Mariendoms und die Kultur der Bikonf
nalität im Erfurt des 16. Jahrhunderts*, Eckhard Leuscl
Falko Bornschein and Kai Uwe Schierz (eds.), catalc
to the exhibition of the same name, Dresden 2015, 116

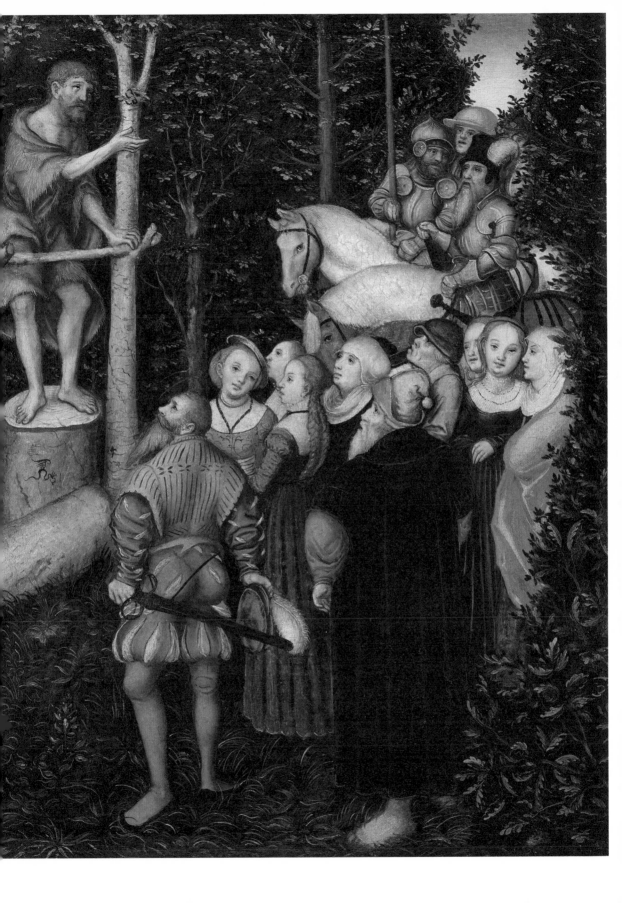

MARTIN LUTHER'S PULPIT

SECOND HALF OF THE 15TH CENTURY WOOD (LIME AND OAK), TURNED, CARVED AND PAINTED
246.5 ×89 ×90 CM
EVANGELISCHE STADTKIRCHENGEMEINDE WITTENBERG

Martin Luther first started preaching in around 1511 at his monastery, and by 1514 at the latest the Council of Wittenberg had assigned him the duty of preaching regularly at the Town Church. More precise details about his preaching are only known from his later years – for example, that he tended to speak slowly and that his sermons lasted for around an hour. What is certain is that from early on preaching was of great importance to Luther. The early Reformation was first and foremost a reading and preaching movement. In the pithy words of German theologian, Bernd Möller, the Reformation was typically sparked in towns by a 'Preacher… generally prompted by reading Lutheran books, entering the pulpit with Reformation teachings, causing a stir with his sermon and carrying his listeners along with him, with manifest consequences.' This did not mean, however, that the German sermon originated with the Reformation. It had already flourished in the second half of the fifteenth century, and the sermon in the vernacular was an established part of the church service on Sundays and feast days. This was complemented by the preaching of members of the mendicant orders, who were active in the towns and also provided pastoral care and preaching in the villages. In addition, preacherships were common in civic churches so that university-educated theologians like Luther could be appointed as preachers to raise the level and frequency of spiritual instruction. The increased importance of the sermon in the fifteenth century can also be seen in the acquisition of pulpits. This simple wooden pulpit used in Wittenberg by Luther dates from the end of the fifteenth century. It originally stood in the Town Church on the north side of the nave, against the eastern pillar. The limewood rostrum rests on an oak pedestal in the shape of an inverted cup. This six-sided pillar extends to a decorative circle of carved thorns and continues up to the base of the rostrum. The remains of what were once arabesques can be seen at the upper edge of the rostrum: of the panels only the two depicting the Evangelists Matthew and John at their writing desks have survived.

Early in the Reformation period, this 'wine glass' pulpit was replaced in the Town Church by the 'Great Pulpit', but it survived as a memento. Despite the importance of the pulpit as a 'Luther relic' in which 'the feet of the blessed Doctor Luther… stood many hundreds of times', it was demolished when the French army was billeted in Wittenberg in 1806 and the remains ended up in the church attic. When preparations were being made for the opening of the Luther House in 1883 the pieces were rediscovered, restored and reassembled, and put on display there as one of the central exhibits.

Hartmut Kühne

→ Further read
Fritz Bellmann, Marie-Luise Harksen and Roland V (eds.): *Die Denkmale der Lutherstadt Wittenberg*, W 1979, 177 und 273.
Helmar Junghans: Wittenberg und Luther – Luth Wittenberg, in: *Freiburger Zeitschrift für Philosoph Theologie* 25 (1978), 104–119.
Bernd Möller: Was wurde in der Frühzeit der Refo on in den deutschen Städten gepredigt?, in: *Archiv formationsgeschichte* 75 (1984), 176–193 (reprinted in: *Luther-Rezeption. Kirchenhistorische Aufsätze zur R tionsgeschichte*, Göttingen 2001, 91–107).

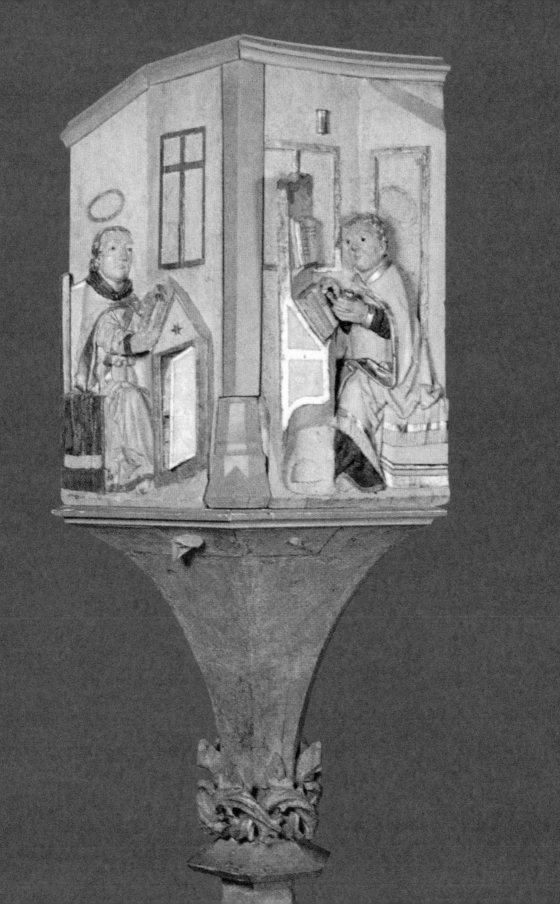

CHALICE AND PATEN FROM TORGAU CASTLE CHAPEL

1504 SILVER, GILDED AND ENGRAVED
CHALICE HEIGHT 27.5 CM, PATEN DIAMETER 18.7 CM
EVANGELISCHE KIRCHENGEMEINDE TORGAU

The Castle Chapel in Torgau is one of the world's first specifically Luther-an sacred buildings. In commissioning its construction, Elector Johann Friedrich made a clear declaration of his adherence to Lutheran teachings, and underlined his claim to leadership of the Protestant alliance and his concern for the dissemination and protection of the message of the Refor-mation. The chapel attracted particular attention in 1544, when it was ded-icated by Luther himself. In his sermon of dedication, still widely known today, Luther explained the true essence of worship in Protestant churches thus: 'the purpose of this new house may be such that nothing else may ever happen in it except that our dear Lord himself may speak to us through his holy Word and we respond to him through prayer and praise.' (WA 49, 588: LW 51, 334). Since then, Protestant church services have been under-stood as communication between the congregation and God; God speaks through his Word, as expressed in preaching and sacrament, and the con-gregation responds through prayer and song.

The silver-gilt chalice pictured here stands on a hexafoil foot, and has a cush-ion knop with six projecting lozenges and a large bell-shaped bowl. The coats of arms of Duchess Sophie von Mecklenburg, of her husband, Duke Johann, and of electoral Saxony are engraved on the foot; alongside these is a small cast relief of a crucifix with the figures of the Virgin Mary and St John. The coats of arms and the date (1504) engraved on its stem suggest that the chalice was acquired either for the tomb of the Duchess, or possibly for the altar foundation associated with her. Along with the accompanying paten for offering the Host during the Lord's Supper, it would clearly have been used for altar service by the chaplain holding the benefice of the altar of St Anne.

The art historians Peter Findeisen and Heinrich Magirius have surmised that a 1504 accounting entry for purchase of a chalice to the value of 17 gul-den for the St Martin Chapel at Schloss Hartenfels refers to this particular chalice. The chalice in the Castle Chapel was handed over to the treasurer in 1601. However, no definite conclusion can be drawn as to whether this was in fact the same vessel, as this assumption presupposes that the chalice came to St Mary's Church in Torgau when the altar foundation was estab-lished and was later returned to the Castle Chapel when the foundation was dissolved.

Although in 2004 the chalice was still thought to be the work of Saxon gold-smiths, Sven Hauschke has since pointed out that the workmanship exhib-its strong similarities with a chalice from St Laurence's Church in Gross-gründlach, near Nuremberg, which dates from 1495 and was made in a Nuremberg goldsmith's workshop. It may be assumed that this attribution could also apply to the Torgau chalice and paten, and that the monumen-tal plaque and candelabra for the tomb of the Duchess also came from the same maker. Hartmut Kühne and Benjamin Hasselhorn

→ Further read
Peter Findeisen and Heinrich Magirius: *Die Denkm*
Stadt Torgau, Leipzig 1976, 249.
Glaube und Macht. Sachsen im Europa der Reformatio
Harald Marx and Eckhard Kluth (eds.), catalogue ●
Second Saxon State Exhibition in Torgau, Dresden
41, no. 3 and 4.
Alltag und Frömmigkeit am Vorabend der Reformat
Mitteldeutschland, Hartmut Kühne, Enno Bünz and
mas T. Müller (eds.), catalogue to the exhibition *Un*
ist der Tod, Petersberg 2013, 101–106.

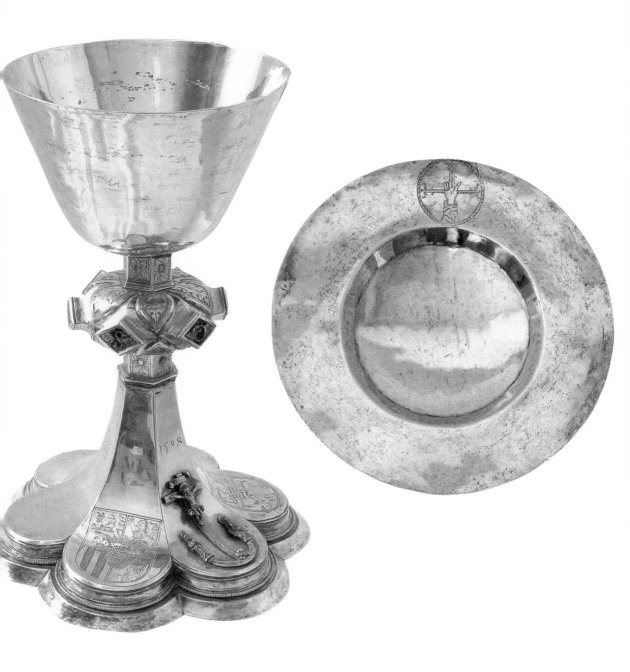

A STUDENT'S NOTES FROM MARTIN LUTHER'S SECOND LECTURE ON THE PSALMS
PRINTER: MELCHIOR LOTTER, LEIPZIG

PRINTED: 1518 HANDWRITTEN NOTES: 1519 WITTENBERG
LETTERPRESS AND MANUSCRIPT ON PAPER
29.5 × 21 × 1.3 CM MOTB

Sermons and publications were not the only means by which Luther's reformist ideas were disseminated. His theology also made an impact through the lectures he gave. He began his exegesis of the Bible in Wittenberg with the Psalter. This would not be surprising to any member of a monastic order, since the Psalter is used in all the acts of worship in a monastery, from the dawn vigil to compline in the evening. Besides the Gospels, the Psalms provide the most direct route into Christian beliefs. Unlike the Gospels, which are intended for public witness, the Psalms reflect the internal stirrings of the heart and lay them before God. This is where lamentations and praise are heard, this is where believers express their awareness of God as a distant judge and as the Saviour at their side.

Luther delivered his first lectures on the Psalms between 1513 and 1515. To this end he had a Latin translation of the Psalter specially printed. Luther's copy of this edition has survived, with his own handwritten glosses on the text and its literary structure. The main body of his exegesis, which expands on individual glosses, has also survived. In his work on the text of the Psalms, Luther – in keeping with tradition – first explores the literal meaning, the *sensus literalis*. This then forms the basis of the allegorical interpretation, which, in the thinking of mediaeval scholars, leads from mere words to the spiritual meaning. This spiritual interpretation relies on the ideas contained in the text (*sensus typologicus*), considers its application for humans (*sensus tropologicus/moralis*) and is ultimately directed towards the fulfilment of all meaning on the Day of Judgement (*sensus anagogicus*). In these lectures Luther already paid special attention to the sensus tropologicus, with a particular emphasis on piety.

In his second series of lectures on the Psalms, which he embarked on in 1519 but had to break off (at Psalm 22) in 1521, before setting off to attend the Diet of Worms, Luther largely abandoned the practice of allegorical interpretation. He now took the view that the literary meaning of a Psalm could speak directly to human beings, without the need of a detour via its presumed spiritual content. This view was founded in his theological belief that the incarnation of God means that all spiritual phenomena also take on an Earthly form, the form within which we humans live. In these 'works on the Psalms' (*Operationes in Psalmos*, as he called them), Luther no longer makes a distinction between explanations of words and of meaning; instead he examines the Psalms, line by line, adding explanatory commentaries from time to time. His aim, through this method, was to do better justice to the original meanings of the Psalms.

The student's notes on Psalm 1, taken in 1519, are written into one of the copies printed specially for Luther's lectures. The comments dictated by Luther are written by hand between the lines of the printed text. Psalters printed in similar styles to this copy from 1518 had been produced by various printers in Leipzig since 1511. While they reflect the importance of the Psalter in the study of theology, the introductory texts also connect them with ecclesiastical tradition. Later on Luther, too, preceded his translations of the Biblical texts with explanatory prefaces. Dietrich Korsch

→ Further read

The exemplar shown here: *Psalterium summi fuditoris e gii cytharedi Dauidis p'phete excelletissimi filij Jesse*, Leipzi The authoritative English edition of the second led on the Psalms: *Luther's Works, Volume 11* (Lectures c Psalms II), Minnesota 1956 (German edition: *Opera in Psalmos. Archiv zur Weimarer Ausgabe der Werke M Luthers. Texte und Untersuchungen*, Cologne 1981).
Gerhard Ebeling: *Lutherstudien*, vol. 1, Tübingen 1971,

Ter quinquagenos Dauid canit ordine psalmos
Versibus bis mille:sex centos sex canit ille.

Psalmoꝝ distinctio triᵽ
plex sit ᵽpter tres statꝰ
religiosis christiane sig=
nificandos.

Presens volumen Da=
uidis dicitur liber.

In orationibus triplex
est attentio.

Primus status est penitentie. In qua ʒ in prima psalmoꝝ
quinquagena terminatur scʒ Miserere mei deus.
Secundus iusticie:in qua ʒ secda quinquagena terminatur
scʒ Misericordiã et iudiciũ cantabo tibi
Tertius status vite eterne. In cuiꝰ laudē tertia quinqua=
gena finis:scʒ Omnis spiritus laudet dñm.

Psalmorum {
Hymnorum {
Soliloquioꝝ Dauid {

Aliqui ad singula vba respiciũt
et dicuntur scrupulosi.
Alteri ad effectũ generale veniũt
orationio vel versus.
Tertiu qui primo intuitu sciunt
qd in se continet tota materia.

Boni {
Et isti sit { Meliores
Optimi {

PROLOGVS SANCTI HIERONYMI PRESBY/ TERI IN PSALTERIVM INCIPIT.

Psalterium Romæ dudum positus emendaram:et iuxta septuagin=
ta interpretes:licet cursim:magna illud tñ ex parte correxeram.
Quod quia rursum videtis o Paula et Eustochiũ scriptoꝝ vitio
deprauatũ:plusꝗ antiquũ errore ʒ noua emendatione valere:me cogi=
tis, vt veluti quodã nouali scissum iam aruũ exercea:et obliquis sulcis, re=
nascentes spinas eradicem:æquũ esse dicentes:vt quod crebro male pul=
lulat:crebrius succidat. Vnde consueta præfatiõe cõmoneo:tam vos qui=
bus forte labor iste desudat:ꝗ eos qui exēplaria istiusmodi habere volue=
rint; vt quæ diligēter emendaui:cũ cura et diligētia transcribant. Nótent
sibi vnusquisꝗ, vel incente linea:vel radiãtia signa:id est obelos:vel aste=
riscos:et vbicunꝗ viderit virgulã precedentē:ab ea vsꝗ ad duo puncta
que impressimus:sciat in septuaginta translatoribꝰ plus haberi. Vbi aũt
perspexerit stellæ similitudinē:de hebreis voluminibus additum nouerit
æque vsꝗ ad duo puncta:iuxta Theodotionis dũtaxat editionem: qui sim=
plicitate sermonis a septuaginta interpretibus non discordat. Hæc ergo
et vobis et studioso cuiꝗ fecisse me sciens:non ambigo multos fore, qui
vel inuidia, vel supercilio malint cõtemnere videri præclara ꝗ discere:et
de turbulento magis riuo ꝗ de purissimo fonte potare.

Authoꝛ psalmi putatur Esdras legis repara=
toꝛ post transmigrationem. Et est psalmus de Christi siue de viri iusti perfectione
et felicitate:impioꝝ vanitate et damnatione. Psalmus.j.

Beatus vir qui nõ abijt in
consilio impioꝝ:ʒ in via peccatoꝝ
nõ stetit:ʒ in cathedra pesti=
lentie nõ sedit. Sed in lege
domini voluntas eiꝰ:et in le=
ge eiꝰ meditabiꝷ die ac nocꝫ
te. Et erit tãꝗ lignũ qd plã=
tatũ est secꝰ discursus aqua=
rũ:qd fructũ suũ dabit in
tpe suo. Et foliũ eiꝰ nõ de=
fluet:ʒ omnia quecũꝗ faciet
ꝓsperabunꝷ. Non sic impij
nõ sic:sed tãꝗ puluis quē
ꝓijcit ventꝰ a facie terre. Ideo nõ resurgũt impij in iudicio:neꝗ pecca=
tores in cõcilio iustoꝝ. Qum nouit dñs viã iustoꝝ:et iter impioꝝ peribit.

Authoꝛ psalmi istius propheta Dauid. Titu=
lus psalmus Dauid. Et est psalmus de conuentu infideliũ contra Christum in sua
passione:et de regni Christi institutione et dilatatione. Psalmus.z.

Quare fremuerũt gentes:et populi meditati sunt inania? Asti=
terũt reges terre et principes cõuenerũt in vnũ aduersus dominũ:
et aduersus christũ eiꝰ. Dirumpamꝰ vincula eoꝝ: ʒ ꝓijciamꝰ anobis
iugũ ipsoꝝ. Qui habitat in celis irridebit eos:et dñs subsannabit eos.
Tunc loqueꝷ ad eos in ira sua:et in furoꝛe suo conturbabit eos. Ego aũt
constitutus sum rex ab eo super syon montem sanctũ eiꝰ: predicans pre=
ceptũ eius. Dominus dixit ad me:filius meꝰ es tu:ego hodie genui te.
Postula a me:et dabo tibi gentes hereditatẽ tuã:et possessionẽ tuã ter=
minos terre. Reges eos in virga ferrea:et tãꝗ vas figuli cõfringes eos.
Et nunc reges intelligite:erudimini qui iudicatis terrã. Seruite domi=
no in timore:et exultate ei cũ tremore. Apprehendite disciplinam: nequã=
do irascatur dominus:et pereatis de via iusta. Cum exarserit in breui

B ij

1519 LETTERPRESS ON PAPER 21 × 15.5 × 0.5 CM
STIFTUNG LUTHERGEDENKSTÄTTEN IN SACHSEN-ANHALT

By 1516 the Ten Commandments, the Lord's Prayer and the sacraments of Confession, Holy Baptism and Holy Communion were already a particular focus of Luther's thinking. He thus specifically turned his attention to the aspects of Christian piety that concern the believer's actual relationship to God. While the Ten Commandments set out God's will for human beings, the Lord's Prayer – as spoken by Jesus Christ – teaches human beings how to enter into the right relationship with God. The three sacraments, which Luther regarded as being rooted in Christ's teachings, shape the believer's relationship with God in such a way that God's activity is always at the centre of his or her life: the forgiveness of sins in Confession, the founding of a new life with God in Holy Baptism, and the fellowship through the Body of Christ in Holy Communion.

However, in the sermons he delivered in Wittenberg and in the populist texts he published, Luther was also concerned that Christian believers should devise their own piety through direct contact with God – and, in so doing, specifically comply with God's will. For Luther, the act of addressing God as Father through the Lord's Prayer oriented the whole of the individual believer's life towards God, so that he or she would expect everything of God. Christian living is formed through the Lord's Prayer. Towards the end of the text illustrated here Luther presents this idea as a plea to God: 'Fashion your dear Son, Jesus Christ, the true heavenly bread, in our hearts so that we, strengthened by him, may cheerfully bear and endure the destruction and death of our will and the perfecting of your will' (WA 2, 129; LW 42, 80).

All the petitions of the Lord's Prayer are thus part of this new conception of Christian life; they relate to believers' relationships with God, to their fundamental relations with other human beings, and to their own internal discipline. Since it is the critical reformulation of human living that is at stake here, Luther points out that the Christian is not praying correctly if he or she hopes to gain by prayer. This is not just a failure in God's eyes, prayer of that kind will lead human beings into an unrighteous life: 'It would be better for you to pray one Lord's Prayer with a devout heart and with thought given to the words, resulting in a better life, than for you to acquire absolution through reciting all other prayers.' (WA 2, 83; LW 42, 22). Luther's text on the Lord's Prayer, from 1519, was specifically intended to set out the spiritually edifying meaning of reformist teachings. Ten years later Luther incorporated his exegesis of the Ten Commandments, the Lord's Prayer and the Sacraments – plus his analysis of the Creed – into his *Large Catechism* and *Small Catechism*, which explain the rudiments of Christian faith for individual believers and have since become the bedrock of Evangelical piety in Lutheran congregations. Dietrich Korsch

→ Further read[ing]

WA 2, 80–130; LW 42, 19-81
Gunther Wenz: *Theologie der Bekenntnisschriften der [evan]gelisch-lutherischen Kirche*, vol. 1, Berlin and New York [...], 333–347.
Dietrich Korsch: *Einführung in die evangelische Dog[matik.] Im Anschluss an Martin Luthers Kleinen Katechismus*, [Leip]zig 2016, 203–245.

Auslegüg deutsch

des Vater vnser fuer die ein=
feltigen leyen Doctoris Martini Luther
Auguftiner tzu Wittenbergk.

MARTIN LUTHER'S WRITING BOX

SECOND QUARTER OF THE 16TH CENTURY ADDITIONS 2012
BEECHWOOD AND IRON 13.5 × 21.5 × 15.5 CM
ANGERMUSEUM ERFURT

The *Reformations-Almanach für Luthers Verehrer auf das evangelische Jubeljahr 1817* – an almanac for admirers of Martin Luther published to mark the anniversary of the Reformation in 1817 – has a detailed report on the history of a box in the collection of the Angermuseum Erfurt, which was said to have been amongst Luther's possessions. According to that report, in February 1546 – when Luther stopped in Halle because of floods, on his last trip to Eisleben – he stayed at the Goldenes Schlösschen, home to the salinist Joseph Tentzer. He left some of his luggage with Tentzer; besides a sword cane and an 'old parchment dish', there was also a small wooden writing box. Since he died in Eisleben just a few days later and his heirs never came to collect his effects, these items remained in Halle. In 1752 the box made its way via the Leopoldina Academy of Sciences (located in Erfurt at the time) to the Augustinian monastery in Erfurt, where it was displayed in the Luther Cell until 1952.

This beechwood and iron box, with a (still extant) key to keep its contents safe from prying eyes, has numerous sections and compartments for quills, ink, sealing wax and other writing utensils. New dendrochronological investigations into the wood used in its construction – conducted by Karl-Uwe Heußner specifically for the purposes of this exhibition – showed that not only was the tree in question felled 'after 1500', it also has many characteristics in common with the wood used for various panels that came from the workshop of Lucas Cranach the Elder. These panels were painted between 1526 and 1528; there is a particularly striking similarity between the wood from which the writing box was made and the panel used for the *Portrait of H. Melber* (1526). Since the wood used for the picture panels and for the writing box must have come from the same source in Wittenberg, it seems that the legend of the writing box is true, and that it really was once owned by Luther.

Many of Luther's texts came into being when he was on his travels – far from his study at home in Wittenberg. His first-hand contact and correspondence with German-speakers in various regions, who spoke numerous different dialects, seems to have convinced him, during the course of the 1520s, that if he wanted to reach as many readers as possible, he had to settle for a language that would be understood by everyone. He thus chose the administrative language that was widely used in east and central Germany: 'My German is not any particular language, but rather a general one, so that people in both Upper and Lower Germany can understand me. I use the language of the Saxon chancellery, which all the princes and kings of Germany emulate' (WA TR 2, Nr. 2758 b, 639). Although Luther did not invent High German, which continued to develop for the next two centuries, his imaginative neologisms and his increasingly consistent grammar and orthography certainly had a major influence on the standardisation of formal German. Mirko Gutjahr

→ Further read
Friedrich Kayser: *Reformations-Almanach für Luthers rer auf das evangelische Jubeljahr* 1817, Erfurt 1817.
Otto Ludwig: *Geschichte des Schreibens. Von der Ant zum Buchdruck*, Göttingen 2005.

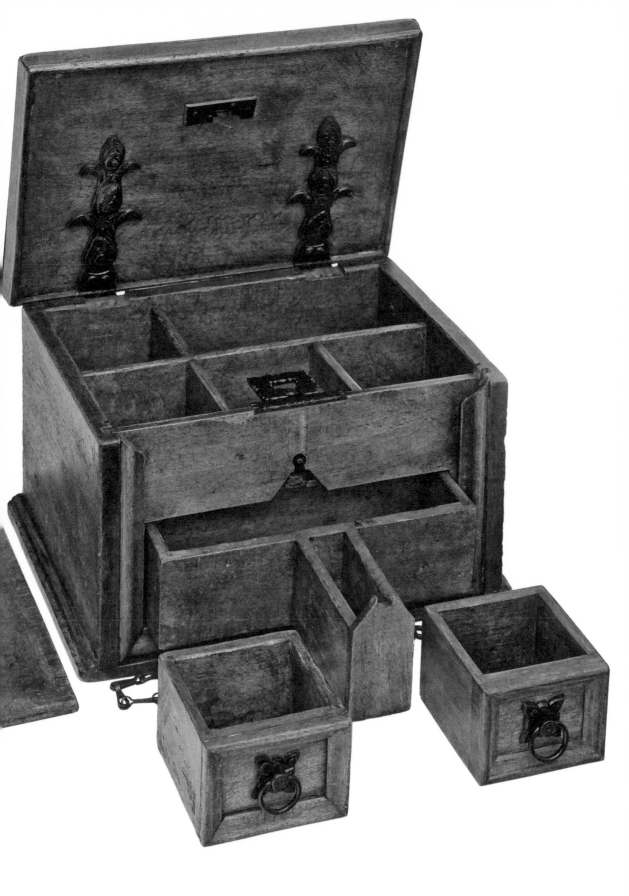

MARTIN LUTHER'S WRITING SET

FIRST HALF OF THE 16TH CENTURY (ADDITIONS) GREEN-GLAZED EARTHENWARE
HEIGHT 5 CM, DIAMETER 23 CM
LANDESAMT FÜR DENKMALPFLEGE UND ARCHÄOLOGIE
LANDESMUSEUM FÜR VORGESCHICHTE – SACHSEN-ANHA

Luther was a prolific writer, to say the least. Besides approximately 350 publications, around 2,600 letters by him have also survived. From the outset letters were an important medium for the reformers – from Luther's accompanying letter on his 95 Theses, which was sent to Archbishop Albrecht of Brandenburg on 31 October 1517, to the correspondence between a network of Reformation supporters throughout Europe. In keeping with humanist traditions, Luther regarded letter-writing as more than the simple exchange of ideas on an individual level; the letters he wrote were ultimately always intended for a wider literary and political readership, particularly in the years up until 1525, when – in the same vein as the Apostle St Paul – he sent numerous 'epistles' to the new Protestant congregations. After 1525 he increasingly wrote to individuals in his capacity as spiritual advisor, providing written guidance in political, ecclesiastical and private matters. Since Luther rarely employed a scribe to assist him, he must have spent several hours on his correspondence each day. At the same time Luther wrote numerous texts intended for publication, and due to the high demand for texts by him, he would often send manuscripts to the printers section by section.

Although Luther's writings primarily reached the public as printed publications, the image of Luther with a quill pen and ink pot is still firmly lodged in the popular imagination. Be it in the first depiction of Luther posting his 95 Theses, that is to say, in Conrad Grahle's *Dream of Friedrich the Wise* (1617), which shows Luther writing on the church door with an oversized quill that is simultaneously toppling the Pope's crown from his head in Rome, or be it in the legend of Luther driving the Devil away by flinging an ink pot at him, Luther's activities as a writer are always associated with the production of hand-written manuscripts. Any writing accoutrements reputed to have been owned by Luther would thus have been highly prized collector's items.

However, there is no doubting that large fragments of earthenware trays found during excavations to the south of the Luther House in Wittenberg are indeed from Luther's immediate surroundings and came from at least four writing sets. With the exception of their bases, they all have green glazes and relatively low rims, which were crudely crimped by hand. Assembled on the trays are liver-shaped supports, small, shallow bowls and little conical pots with narrow tops. The oblong containers were presumably used for the safe storage of quills and quill-knives, while the conical pots contained ink and could easily be closed by placing a stopper or cork in the narrow top. The wide bowls may well have been used for the blotting sand that was indispensible for speeding up the drying of ink. The wide base of the writing set would prevent it from being tipped over.

Mirko Gutjahr

→ Further read
Otto Ludwig: *Geschichte des Schreibens. Von der Ant
zum Buchdruck*, Göttingen 2005.
Mirko Gutjahr: Schreibset, in: *Fundsache Luther. A
logen auf den Spuren des Reformators*, Harald Meller
Halle 2008, 296, no. E 143.
Louis D. Nebelsick: Two Ceramic Inkstands, in: *M
Luther. Treasures of the Reformation*, Catalogue, Dr
2016, 245–247, nos. 239 and 240.

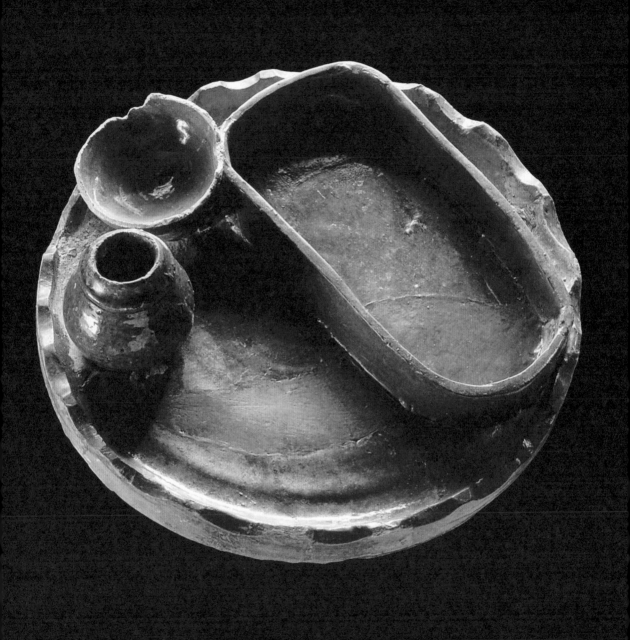

MOVEABLE AND MUSICAL NOTATION PRINTING TYPES

MUSICAL NOTATION
PRINTING TYPES: AFTER 1538 LAST QUARTER OF THE 16TH CENTURY
LEAD 2–3 × 0.2 × 1.1–1,3 CM (MUSICAL NOTATION PRINTING TYPES),
2.5 × 0.1–0.5 × 0.5 CM (MOVABLE PRINTING TYPES)
LANDESAMT FÜR DENKMALPFLEGE UND ARCHÄOLOGIE – LANDES-
MUSEUM FÜR VORGESCHICHTE – SACHSEN-ANHALT

Just 70 years after the invention of book printing using moveable type by Johannes Gutenberg in the mid-fifteenth century, there was a surge in publication in Central Europe, the like of which had never been seen before. And it emanated from the small town of Wittenberg, which had just one printing press in 1517 – producing poor quality work, according to Luther (WA BR 2, nos. 427, 379–380). The fact was that the disputes fuelled by Luther's critique of the sale of indulgences increasingly played out in the media of the time, which led to a huge increase in publications of all kinds. A single printing press could not meet demand, so numerous additional print shops were set up. Luther astutely distributed his manuscripts between various local printers so that they could offset the high production costs of lengthy books against those of the pamphlets and flyers that were much cheaper to print and sold in large numbers. By the mid-sixteenth century, as a centre of printing, Wittenberg could hold its own with major centres of book production such as Paris and London.

Besides the many publications surviving from that time, telling evidence of Wittenberg's outstanding importance in this field has been provided by archaeological excavations in the town. In 1997, during a dig at 5 Bürgermeisterstrasse, a filled-in latrine turned out to contain over 500 pieces of moveable lead type from the last quarter of the sixteenth century. Besides the Roman typeface used mainly for Latin texts, there are also isolated examples of the Schwabacher typeface and blackletter typeface that were above all used for German-language publications. Of particular interest are the few type pieces with Greek and Hebrew letters, which indicate that humanist works were printed here. Both the location and the dates of the finds in the latrine suggest that these lead letters came from the printing press owned by Johannes Krafft the Younger.

Sheet music also played an important in the propagation of the reformers' message. In 2012 pieces of moveable type for musical notation were discovered at the site of the former Franciscan monastery in Wittenberg. These bear witness to an important technical innovation: hitherto music had either been printed using specially cut wood blocks or in two stages, with notes added to pre-printed staves. The latter method in particular was prone to inaccuracies if the printing blocks were not perfectly aligned. By contrast the Wittenberg finds combine a note and the stave on a single piece of type; this process, which had been invented in Paris around 1525, was first used in Nuremberg in 1534. Although the frequently visible joins and slight mismatches of this method detracted from the overall appearance of the score, the much less complicated process had huge economic advantages. The first print shop to use type pieces of this kind in Wittenberg – from 1538 onwards – was owned by Georg Rhau. To judge by both the location of these finds and by surviving examples of music printed by Rhau, it is highly likely that these pieces of music type came from his workshop.

Mirko Gutjahr

→ Further read

Daniel Berger and Sophia Linda Stieme: Untersuchu zum frühneuzeitlichen Buchdruck an Bleilettern aus tenberg, in: *Mitteldeutschland im Zeitalter der Reform* Harald Meller (ed.), Halle 2014, 236–243.
Daniel Berger, Mareike Greb and Holger Rode: *Note den Reformator? Zur Untersuchung der Drucktypen aus Wittenberger Franziskanerkloster und ihr Zusammenhan dem Musikaliendruck der Reformationszeit*, Halle 2014.
Daniel Berger: Seven Musical Notation Printing T in: *Martin Luther. Treasures of the Reformation*. Catal Dresden 2016, 293–294.

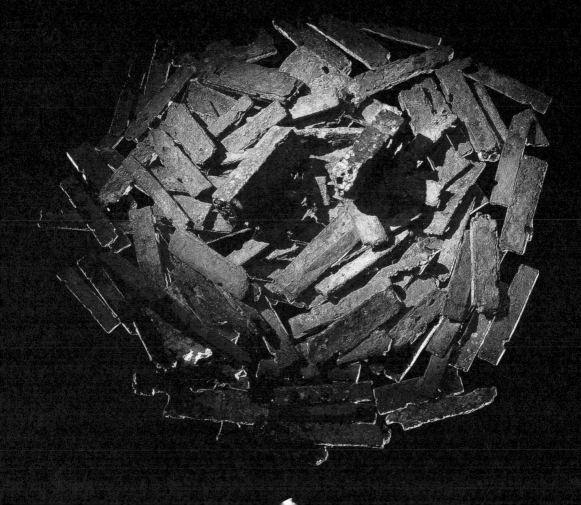

1537 LETTERPRESS AND MANUSCRIPT ON PAPER
14.9 × 19.9 × 0.3 CM
BIBLIOTHÈQUE ROYALE DE BELGIQUE, BRUSSELS

Luther had been thinking about using Biblical psalms as the basis for German hymns since 1523: by the end of that year, in a letter to his Wittenberg colleague and friend, Georg Spalatin, he wrote of his desire to compose sacred songs, 'so that the Word of God may be among the people also in the form of music' (WA BR 3, Nr. 698, 220; LW 49, 68-69). Luther wrote numerous hymns during an initial burst of productivity, and from 1524 they were circulated in the form of songbooks, together with poems by other writers. At first these books contained just a small number of songs and were published in Nuremberg and Erfurt, but they were later expanded to include arrangements of early Christian hymns and songs 'by our own', that is members of Luther's circle, and were published in all the foremost centres of printing in the empire. Luther continued to write spiritual songs until well into his later years. Among them, 'Out of the Depths I cry to Thee' (Psalm 130), 'A Mighty Fortress is our God' (Psalm 46) and the Christmas carol, 'From Heaven above to Earth I come', became particularly well-known. Luther's hymns provided the model and yardstick for the ensuing tradition of Lutheran hymn-writing which still endures today. After the Bible the hymnal remains the most important book in the religious lives of Lutheran Christians.

Luther also expressed his theories about music many times. He saw music first and foremost as a gift, a God-given gift in creation capable of reaching out to the whole person and bringing both pleasure and comfort. He believed that music was a 'mistress and governess of … human emotions' (WA 50, 370; LW 53, 323) and thus able to reach people again and again, at different stages of their lives, influencing them, doing them good and touching their souls.

In addition to Josquin Desprez (c.1450/55–1521), he particularly admired the Bavarian court composer, Ludwig Senfl (c.1490–1543) and he even praised the Bavarian dukes, opposed though they were to the Reformation, for the fact that they took such care to have good music at their court. In a letter from October 1530 Luther expressed his high regard for Senfl, asked him for a composition and explained that the reason he was so extraordinarily devoted to music was that it produced what could otherwise only be achieved by theology, namely 'a calm and joyful disposition' (WA BR 5, Nr. 1727, 639; LW 49, 428).

It is therefore no surprise that Luther possessed this copy of eight Magnificat settings by Senfl, printed in Nuremberg in 1537. He received the book as a gift from his longstanding confidant and companion at the Veste Coburg fortress in 1530, the Nuremberg theologian, Veit Dietrich (1506–1549), who added a handwritten dedication: '*Reverendo P.[atri] D.[omino] Martino Luthero Vitus Diethrich*'. Johannes Schilling

→ Further read
WA 35 / Archiv zur Weimarer Ausgabe der Werke Luther.
Johannes Schilling: 'Die Musik ist eine herrliche ¶
Gottes'. Luther und die Reformation der Musik, in: ¶
Das Evangelium in der Geschichte der Frömmigkeit, L[
2016, 187–201.
Martin Luther: Geistliche Lieder, Johannes Schilling[
Jürgen Heidrich (eds.), Stuttgart 2017.

❧ TENOR ❧

MAGNIFICAT OCTO TONO‑
RVM AVTORE LVDO‑
VICO SENFLIO
HELVETIO‑

Cum priuilegio Cæſaræ atꝗ Regiæ maieſtatis ad ſexennium.

MARTIN LUTHER FROM HEAVEN THE ANGEL TROOP CAME NEAR

NOT LATER THAN 1543 MANUSCRIPT ON PAPER 23.4 × 17 CM
ÖSTERREICHISCHE NATIONALBIBLIOTHEK, VIENNA,
SAMMLUNG VON HANDSCHRIFTEN UND ALTEN DRUCKEN

Thanks to Luther's love of music, the Reformation was also a musical move-
ment that proclaimed the new doctrines in song. Protestant hymn-singing
now became an integral part of the pious believer's life not only in church
but also in schools and in the home. Drawing on his own musical educa-
tion, Luther encouraged the composition and arrangement of Evangelical
church music and personally wrote the words of at least 35 hymns – around
half of which he himself set to music. At the same time he also commis-
sioned new compositions and took an active interest in the production of
hymnaries to be used in worship.

The manuscript shown here, from the holdings of the Austrian National
Library in Vienna, is one of just two surviving hymn texts in Luther's
hand, in this case 'Vom Himmel kam der Engel Schar' ('From Heaven the
Angel Troop Came Near') of 1543. In effect this is a variant of Luther's own
'Vom Himmel hoch da komm ich her' ('From Heaven on High I Come to
You'), which is still an essential part of every Lutheran Christmas Eve ser-
vice. When it was first published 'Vom Himmel kam der Engel Schar' fol-
lowed directly after 'Vom Himmel hoch' under the rubric 'Another Chris-
tian song / to the previous tune' (WA 35, 472). Both of these hymns by Luther
are rhyming accounts of the Nativity as it is told in the second chapter of
the Gospel According to St Luke. Whereas 'Vom Himmel hoch' starts with
the angel delivering the message of good tidings in the first person, 'Vom
Himmel kam der Engel Schar' is a narrative account, with the throng of
angels' words in reported speech. In both cases the clear, didactic aim is to
communicate the Christmas story in words that are readily understood
and, above all, easily remembered.

It is thought that Luther wrote the hymn 'Vom Himmel hoch' when he
wanted to tell his own children about Christmas and the Nativity. Both
hymns are amongst those that Luther wrote to fit melodies that already ex-
isted, in this case the song 'Mit Lust tret ich zu diesem Tanz'. It was not un-
usual for Luther to write a 'spiritual' text to fit the melody of a 'secular' song.
The combination of powerful, memorable words, that are so typical of
Luther, and very singable tunes did much to disseminate Lutheran hymns
and the Reformation message in an accessible form. Mirko Gutjahr
and Benjamin Hasselhorn

→ Further read
Jürgen Heidrich: Der Einfluss der Reformation au
Musik, in: *Klang der Frömmigkeit. Luthers musikalisc
ben in Westfalen*, publication to accompany the exhib
of the same name, Bönen 2016, 23–38.
Luthers Lieder. Double CD with all 35 hymns by Lu
Stuttgart 2016.

Von hymel kam der Engel schar
erschein den hirten offenbar Alle ij
sie sagten ihn ein kindlein zart
das ligt dort ynn der krippen hart Alleluia

Zu bethlehem ynn dauids stad
Wie Micha das verkundet hat All
do ist der herre Jhesu Christ
der euer aller heiland ist All

des solt ihr billich frölich sein
das Gott mit euch ist worden ein All
heut geborn euer fleisch vnd blut
euer bruder ist das ewig gut All

Was kan euch thun die sund vnd tod
ihr habt mit euch den waren Gott All
last zürnen teuffel vnd die hell
Gotts son ist worden euer gesell All

Er will vnd kan euch lassen nicht
Setzt ihr auff ihn euer zuuersicht All
es mügen euch viel fechten an
dem sey trotz: das nicht lassen kan All

Er laßt sich nicht yhr doch haben recht
ihr seid nu worden Gotts geschlecht All
des dancket Gott ynn ewigkeit
Gedult frölich Allezeit All

Vel Jn tono A solis ortus Jn tono
 Vel Von hymel hoch
Sed pro prosa sit in tono
huic Natus in Bethlehem

Sed sunt nomine meo
Braüdelin Vnd brot

Ein lied auff den Christ Tag

Autogr. 13/43-1 (3)

CHRISTOPHER COLUMBUS LETTER ABOUT THE 'DISCOVERY' OF AMERICA PRINTER: HEINRICH PE[...] BA[...]

1533 LETTERPRESS ON PAPER 33–31 × 22 CM
THÜRINGER UNIVERSITÄTS- UND LANDESBIBLIOTHEK JENA

Bound in a collection of theology manuscripts in the Elector's library (Bibliotheca Electoralis), which was later moved from Wittenberg Castle to Jena, was a copy of the Basel print of the letter from Christopher Columbus, written on 15 February 1493, in which he talks of the 'recently found islands', that is to say, his 'discovery' of America. His short travelogue, initially in Latin and later translated into German, had already reached Germany by the end of the fifteenth century. As someone with access to the Elector's library, Luther may well have been familiar this copy of Columbus's report, printed in 1533. However, Luther's references to newly discovered 'islands and land' in the *Advent Postil* of 1522 (WA 62, 16) and again in a sermon he delivered on 29 May 1522 (WA 10 III, 139) could be cautiously interpreted as evidence that he had already been aware of the discovery of America at that point and even felt at liberty to assume that his listeners would also have heard the news. For Luther, the idea of newly discovered island was only of interest in connection with his own deliberations as to whether Christ's sacrifice on the cross also redeemed those peoples who only heard of His existence centuries later: '... recently many islands and land have been found, wherein nothing of such grace has appeared in fifteen hundred years.' He answered his own question in the affirmative: in his view the sending out of the Apostles to spread the Word of God would continue unabated until the Day of Judgement.

A later reference in the historical tables of his *Supputatio annorum mundi* (his 'Reckoning of the Years of the World', published before 1545) points rather more clearly to the discovery of America: *Novus morbus Gallicus, alias Hispanicus cepit, ex insulis novis repertis in Occidente (ut dicitur) invectus Europae, Unum de signis ante diem Extremum.* – 'A new disease has broken out, the French, others call it the Spanish disease, which has befallen Europe from the newly discovered islands (as people say) in the West. One of the signs before the Day of Judgment' (WA 53, 169). Once again, in this third reference Luther's interest is not in the 'newly discovered islands'; his focus is on the 'French disease' that has supposedly been transmitted from there as an unmistakable sign that the end of the world is approaching. Luther's view of the world was rooted in the Bible. He therefore took an eschatological view of the recent 'discovery' of America and other lands and peoples, and made a connection with the proclamation of Gospel: 'When the Gospel has been preached in all the world and heard and proclaimed, then the message will have been fulfilled and delivered everywhere, and then the Day of Judgement will come' (WA 10 III, 139–40). Mirko Gutjahr

→ Further read

Karl Holl: Luther und die Mission, in: idem: *Gesam[...] Aufsätze zur Kirchengeschichte, Bd. 3: Der Westen*, Tüb[...] 1928, 234–243.

Christopher Columbus: *Epistola de insulis nuper i[...]* translated by Leandro di Cosco, Frank Egleston Ro[...] Indiana 1966.

Sabine Wefers: Wissen in Fässern und Kisten. Von W[...] berg nach Jena, in: *Johann Friedrich I. Der lutherisch[...] fürst*, Volker Leppin, Georg Schmidt and Sabine W[...] (eds.), Gütersloh 2006, 191–207.

CRISTOPHERI CO-

LOM DE INSVLIS NVPER INVENTIS IN MA-

RI INDICO SVB FERDINANDO REGE HISPANIA
rum epistola, ad magnificum dominum Raphaëlem
Sanxis: deinde per Alexandrum de Cosco
latinitate donatum.

VONIAM susceptæ prouinciæ rem perfectam me
consecutum fuisse, gratum tibi fore scio: hac constitui
exarare, quæ te uniuscuiusq; rei in hoc nostro itinere ge
stæ inuentaq; admoneant. Tricesimotertio die post-
quam Gadibus discessi, in mare Indicum perueni, ubi
plurimas Insulas innumeris hominibus inhabitatas re
peri, quarum omnium pro feliciffimo Rege nostro præconio celebrato,
& uexillis extensis, contradicente nemine possessionem accepi, primæq;
earum, diui Saluatoris nomē imposui, cuius fretus auxilio, tam ad hanc
quàm ad cæteras alias peruenimus: Eam uero Indi Guanahanyn uocant.
Aliarum etiam unamquãq; nouo nomine nuncupaui. Quippe aliam in-
sulam Sanctæ Mariæ Conceptionis, aliam Fernandinam, aliam Hysabel
lam, aliam Iohannam, & sic de reliquis appellari iussi. Quam primum in
eam Insulam (quam dudum Iohannā uocari dixi) iuxta eius
litus occidentem uersus aliquantulum processi, tanq; eam maguam nul
lo reperto fine inueni, ut non insulam, sed continentem Cathay prouinci
am esse crediderim, nulla tamen uidens oppida, municipiáue in mariti
mis sita confinibus, præter aliquos uicos & prædia rustica, cum quorum
incolis loqui nequibam, quare simul ac nos uidebant surripiebant fugam.
Progrediebar ultra, existimans aliquam me urbem uillásue inuenturum.
Deniq; uidens quod longe admodum progressis, nihil noui emergebat,
& huiusmodi uia nos ad Septentrionem deferebat (quod ipse fugere ex
optabã, terris etenim regnabat bruma) ad austrúq; erat in uoto conten
dere, nec minus uenti flagitantibus succedebāt: cō stitui alios non operiri
successus, & sic retrocedēs, ad portum quendam (quem signaueram) sum
reuersus, unde duos homines ex nostris in terram misi, qui inuestigarēt,
esset ne Rex in ea prouincia, urbésue aliquæ. Hi per tres dies ambularūt
inueneruntq; innumeros populos & habitationes, paruas tamen & abs
que ullo regimine, qua propter redierunt. Interea ego iam intellexeram à
quibusdam Indis, quos ibidem susceperam, quomodo huiusmodi prouin
cia & Insula quidē erat: & sic perrexi Orientem uersus, eius semper strin
gens littora usque ad milliaria CCCXXII. ubi ipsius insulæ sunt extrema,
hinc

hinc aliam insulam ad orientem prospexi, distantem ab hac Iohanna mi
liaribus LIIII. quam protinus Hispanam dixi, in eamq; concessi, & direxi
iter quasi per Septentrionem: quemadmodum in Iohanna ad orientem,
milliaria D·LXIIII. Quæ dicta Iohāna & aliæ ibidem Insulæ quàm fer
tiliffime existunt, hæc multis atq; tutiffimis & latis, necaliis quibus unquã
uiderim comparandis portibus est circundata: multi maximi & salubres
hanc interfluunt fluuij: multi quoq; & eminentiffimi in ea sunt montes.
Omnes hæ insulæ sunt pulcherrimè & uariis distinctæ figuris, peruiæ, &
maxima arborum uarietate sydera labentium plenæ, quas nunquam fo
liis priuari credo: quippe uidi eas ita uirētes atq; decoras, ceu mēse Maio
in Hispania solent esse, quarū aliæ florētes, aliæ fluctuosæ, aliæ in alio sta
tu, secundum uniuscuiusq; qualitatem uigebāt, garriebat Philomena, &
alij passeres uarij & innumeri, mense Nouembri quo ipse per eas deam
bulabam: Sunt præterea in dicta insula Iohanna, septem uel octo palma
rum genera, quæ proceritate & pulchritudine (quemadmodum cæteræ
omnes arbores, herbæ, fructusq;) nostras facile exuperant. Sunt & admi
rabiles pinus, agri & prata uastissima, uariæ aues, uaria mella, uariáq; me
talla, ferro excepto. In ea autem quàm Hispaniam supra diximus nūcupa
ri, maximi sunt montes ac pulchri, uasta rura, nemora, cāpi feraciffimi, se
ri pascisq; & condendis ædificiis aptiffimi. Portuum in hac insula commo
ditas & præstantia fluminum, copia salubritate admixta hominum, quæ
nisi quis uiderit, credulitatem superat. Huius arbores pascua & fructus,
multum ab illis Iohannæ differunt. Hæc præterea Hispana diuerso aroma
tis genere, auro metallisq; abundat: cuius quidem & omnium aliarū quas
ego uidi & quarum cognitionem habeo incolæ utriusq; sexus, nudi sem
per incedunt, quemadmodū eduntur in lucem: præter aliquas fœminas:
quæ folio frondéue aliquo, aut bombicino uelo, pudenda operiunt, quod
ipsæ sibi ad id negotij parant. Carent hi omnes (ut supra dixi) quocūq; ge
nere ferri: carent & armis, utpote sibi ignotis, nec ad ea sunt apti: nō pro
pter corporis deformitatem (cum sint bene formati) sed quia sunt timidi
ac pleni formidine, gestant tamen pro armis arundines sole perustas, in
quarum radicibus, hastile quoddam ligneum siccum & in mucronem at
tenuatum figunt, neq; his audent iugiter uti: nam sæpe euenit cum mise
rim duos uel tris homines ex meis ad aliquas uillas, ut cum earum loque
rentur incolis, exiisse agmen glomeratum ex Indis, & ubi nostros appro
pinquare uidebant fugam celeriter arripuisse, despretis à patre liberis, &
econtra, & hoc non quod cuipiam eorum damnum aliquod uel iniuria il
lata fuerit, imó ad quoscunq; appuli, & quibus cum uerbum facere potui,
quicquid habebam sum elargitus, pannum aliásq; permulta, nulla mihi sa
cta uersura, sed sunt natura pauidi ac timidi. Cæterum ubi se cernūt tutos,

P omni

MARTIN LUTHER MANUSCRIPT OF THE OLD TESTAMENT TRANSLATION

1523–24 MANUSCRIPT ON PAPER OPEN 22 × 33.5 CM
LANDESARCHIV SACHSEN-ANHALT, DESSAU-ROSSLAU

In September 1522, directly after the publication of the translation of the New Testament, Luther started work on a German translation of the Old Testament. In so doing he knew he could rely not only on the latest literary reference works on Hebrew but also on support from colleagues in Wittenberg. These included Philipp Melanchthon (polymath humanist), Matthäus Aurogallus (expert in Hebrew) and the theologians Caspar Cruciger, Justus Jonas and Johannes Bugenhagen. The translations of the narrative texts in the Old Testament, that is to say the Pentateuch, Judges, 1 Samuel and 2 Samuel, progressed much more speedily than work on the poetic texts, particularly those in the Books of the Prophets. Consequently the first complete German translation of the Bible by Luther was not published until 1534.

The work process was organised as follows: Luther would deliver the initial translation, which was then checked and corrected by the rest of the team. That is to say, the translation of the Old Testament in particular consists of a series of reworked texts – which is in fact not unlike the process that led to the Hebrew translation of the Old Testament shown here. The translation manuscript by Luther, illustrated here, has copious changes and suggestions added in red pencil

Translation, like comprehension, is a potentially endless process. It is not just about finding equivalents for words and their syntactical interaction, it is about considering the topic from the point of view of the source language and then reformulating that same topic in one's own language, the target language. It is impossible to find the perfect equivalents in two languages, not to mention the unbridgeable gap between different eras. Moreover, the shape of a language changes with time and constantly needs to be adjusted to suit the present day. These issues are only satisfactorily resolved if the topic at the heart of all this is rendered comprehensible to the present-day reader.

Luther took an anthropological approach to the meaning of the Bible; he regarded its mode of address to its readers, using the linguistic forms of the demand and pledge, as the fundamental function of the text of the Bible. This duality of law and gospel provides the means whereby the Word as it is found in the Bible can be related to the lives of human beings. The 'demand' and 'pledge' forms cannot be ascribed individually to either the Old Testament or the New Testament, each is found in both parts of the Bible. The unity of the Holy Scripture, as in both the Old and the New Testament, is thus seen in the figure of Christ, who integrated both a promise and a demand into his sermon on the Kingdom of God that has come and thus leads believers to confession. This hermeneutic approach to the Bible does not change its wording, but allows the substance of the biblical text to shine forth brightly, namely, the critical and edifying encounter of human beings with God. The revisions – particularly of the Old Testament translation – by the Wittenberg team of editors were solely directed towards the religious appropriation and dissemination of the Bible as the Word of God. Dietrich Korsch

→ Further read
Johannes Schilling: Martin Luthers Deutsche Bib
idem: *Das Evangelium in der Geschichte der Frömn*
Kirchengeschichtliche Aufsätze, Leipzig 2016, 121–138.

regieren ... und ... gerichtliche richten

In ... in meiner ... bis des ersten der
... und in ... vor in
meiner ... (das ist der acht mond) ward das haus be-
reit nach allen seinen ... und recht ...
... vor das ... vor dem ...

Das sibent capitel

A ... er ist an seinem ... haus Salomo dreizehen ...
... sein ...

Er baut auch ein haus von wald libanon. hundert ellen
lang, funfzig ellen weit, und dreyssig ellen hoch ...
... ... und ... aber ...
... und machte die deck von ... eben ...
... auf den eben ... auch fünf mit
... ... fünfzehn ...
... die drei und alle thür und pfosten
... ...

Und machet ein halle von ... funfzig ellen lang
und dreyssig ellen weit ... Und nach eine halle
für gericht ... und mit ... und in
... zum königsstul daryner man gericht ...
... und machte sie zur gericht halle. und ... machte
... deck von ... von boden an die ... zum boden
... sein haus, daryner er wohnt. ... ein ander
... das haus der halle. nach gleichem ... Und
macht auch ein haus der tochter pharao vor der halle.
die Salomo zum weib genommen hatte.

Dis alles waren kostliche steyn, nach der mass ...
hauen von ... und von aussen

MARTIN LUTHER DECEMBER TESTAMENT

PRINTER: MELCHIOR LOTTER THE YOUNGER, WITTENBERG

1522 LETTERPRESS AND WOODCUT ON PAPER 30.5 × 20.5 × 5.5 CM
STIFTUNG LUTHERGEDENKSTÄTTEN IN SACHSEN-ANHALT

Even before Luther – since the mid-fifteenth century – various German translations of the Bible had been published. These were done on the basis of the Latin Bible, the Vulgate, and contained passages of the Holy Scripture needed for the liturgy; in addition to that, there were 14 High German and four Low German translations of the entire text of the Bible. However, aside from all kinds of linguistic infelicities, these translations all lacked a specific, theological intention.

Not so Luther's translation. His theological convictions told him that the heart of the Bible, as the Word of God, was the gospel of Jesus Christ, which every person needed to hear and understand in order to come to faith. Thus, he argued, it was vital that the Bible in German-speaking lands should also exist in German. Moreover, through Jesus Christ divine meaning had entered human words and could be comprehended as coming from God to each person and transforming them in faith. The yearning for spiritual authenticity in faith had already underpinned Luther's theses on indulgences. Subsequently he had adjusted the sacraments of Confession, Holy Baptism and Holy Communion to comply with the re-establishment of human life as coming from God. In 1520, in his text *The Freedom of a Christian*, he had expounded the fundamental significance of the Word of God to human lives. As such his project to translate the Bible into German was entirely consistent with his deepest convictions.

Luther's opportunity to devote himself to realising his plan came during his sojourn at the Wartburg in 1521–22. In just 11 weeks he translated the entire New Testament. He worked from the Greek edition of the New Testament that Erasmus of Rotterdam had published in 1516. Of course he always also had the Latin text of the Vulgate in his ear and in his mind. On one hand Luther, who had studied Greek as an undergraduate in Erfurt, was thus able to tap into the latest humanist scholarship; on the other hand he was determined that the text should also be appropriated for religious purposes. He was therefore at pains to ensure that the German translation should be as widely comprehensible as possible. After all, his aim was that all Christians should be able to read it and to understand it.

In September 1522, around six months after Luther had returned to Wittenberg from the Wartburg, the first edition of the New Testament was published in a high print-run of 3,000. Clearly the publishers, Lucas Cranach the Elder and Christian Döring, hoped it might do well for them – rightly so. Just two months later, in December, the German translation of the New Testament went into a revised second edition. It is highly likely that straight after the publication of the first edition, Luther and Philipp Melanchthon – a fine scholar of Greek – went through the translation with a fine-tooth comb.

The translation of the Old Testament came next, with the collaboration of several of Luther's Wittenberg colleagues, but it required much longer to complete. The first full translation of the Bible by Luther was not published until 1534. Dietrich Korsch

→ Further read
Heimo Reinitzer: *Biblia deutsch. Luthers Bibelüberse und ihre Tradition*, publication to the exhibition of the name, Hamburg 1983.

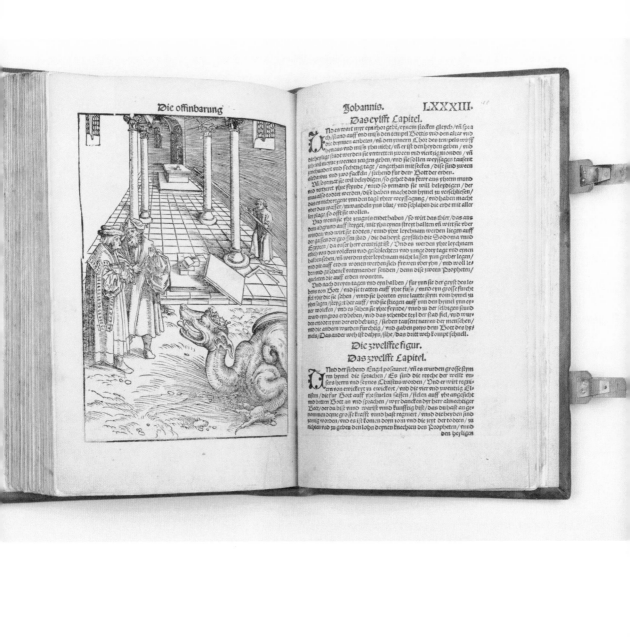

Das eylfft Capitel.

Nd es wart myr eyn rhor gebē/eynem stecken gleych/vñ spra
ch/stand auff vnd miß den tempel Gottis vnd den altar vnd
die drynnen anbeten/vñ den ynnern Chor des tempels wirff
hynaus vnd miß yhn nicht/vñ er ist den heyden geben/vnd
die heylige stadt werden sie vertretten zween vnd viertzig monden/vñ
ich wil meyne zweenen zeugen geben/vnd sie sollen weyssagen tausent
vnd zwohundert vnd sechtzig tage/angethan mit secken/dise sind zween
oleba wen vnd zwo fackeln/stehend für den Gott der erden.

Vnd so yemant sie wil beleydigen/so gehet das fewr aus yhrem mund
vnd vertzeret yhre feynde/vnnd so yemand sie wil beleydigen/der
mus also todtet werden/dise haben macht den hymel zu verschliessen/
das es nicht regene vnn den tagē yhrer weyssagung/vnd haben macht
vber das wasser/zuwandeln ynn blut/vnd schlahen die erde mit aller
ley plage/so offt sie wollen.

Vnd wenn sie yhr zeugnis endet haben/so wirt das thier/das aus
dem abgrund auff steyget/mit yhn eynen streyt hallten vñ wirt sie vber
winden/vnnd wirt sie todten/vnnd yhre leychnam werden liegen auff
der gassen der grossen stad/die da heyst geystlich die Sodoma vnnd
Egypten/da vnser herr creutzigt ist/Vnd es werden yhre leychnam
etlich von den volckern vnd geschlechten vnd zunge drey tage vnd eynen
halben sehen/vñ werden yhre leychnam nicht lassen ynn greber legen/
vnd die auff erden wonen werden sich frewen vber sie/vnd wolllebē
vnd geschenck einander senden/denn dise zween Propheten/
queleten die auff erden woneten.

Vnd nach dreyen tagen vnd eyn halben/für ynn der geyst des le
bens von Gott/vnd sie tratten auff yhre fuss/vnnd eyn grosse furcht
fiel vbir die sie sahen/vnnd sie hoeten eyne laute stym vom hymel zu
yhn sagen/steyget her auff/vnd sie stiegen auff ynn den hymel ynn ey
ner wolcken/vnd es sahen sie yhre feynde/vnnd zu der selbigen stund
ward eyn gros erdbeben/vnd das zehende teyl der stad fiel/vnd wur
den ertodtet ynn der erdbebung/sieben tausent namen der menschen/
vnd die andern wurden furchtig/vnd gaben preys dem Gott des hy
mels/Das ander weh ist dahyn/sihe/das dritt weh kompt schnell.

Die zwelffte figur.

Das zwelffte Capitel.

Und der siebende Engel posaunet/vñ es wurden grosse stym
ym hymel die sprachen/Es sind die reyche der welt vn
sers herrn vnd seynes Christus worden/Vnd er wirt regni
ren von ewickeyt zu ewickeyt/vnd die vier vnd zwentzig El
tisten/die für Gott auff yhre stuelen sassen/fielen auff yhr angesicht
vnd beten Gott an vnd sprachen/wyr dancken dyr herr almechtiger
Gott/der du bist vnnd warist vnnd kunfftig bist/das du hast an ge
nomen deyne grosse krafft vnnd hast regniret/vnnd die heyden sind
zornig worden/vnnd es ist komen deyn zorn vnd die zeyt der todten/zu
richten vnd zu geben den lohn deynen knechten den Propheten/vnnd
den heyligen

MARTIN LUTHER'S LAST WILL AND TESTAMENT

6 JANUARY 1542 MANUSCRIPT ON PAPER 34 × 21 CM
EVANGÉLIKUS ORZÁGOS MÚZEUM, BUDAPEST

The will pictured here does not date from the end of Luther's life; he drew it up on 6 January 1542, over four years before his death. He was compelled to write it partly because of the numerous health problems that had plagued him since the mid-1520s: kidney stones, heart trouble, painful tinnitus, fainting spells, depression and gout. In addition, he was fearful of political developments, for instance he believed he might be caught up in a religious war and taken prisoner, since as an outlaw he did not enjoy any legal protection.

The thought of his own death caused Luther to consider his family, especially his wife, whose continued dignity and prosperity he wished to do everything possible to preserve. The ascetic monk had become a loving husband and father, and the will bears striking witness to this, as it made his wife sole heir and named her as the legal guardian of their children. Luther felt that she would be far more solicitous of the children's welfare than appointed guardians. This view would be shared by everyone today, but in the sixteenth century it rendered the will an unlawful document. At that time women could only inherit their dowry and a few personal items, such as clothing and jewellery, and only a man could be appointed guardian.

Luther's esteem for women, and indeed his well-balanced relationship with his own wife, would become a model for Protestantism in the future which, with its paradigm of the universal priesthood of believers, would tend towards a perspective that was anti-hierarchical and supportive of women's liberation. In this will, witnessed by his closest colleagues, Philipp Melanchthon, Caspar Cruciger and Johannes Bugenhagen, Luther made arrangements for the continued survival of his family and, at the same time, made himself an epochal figure, presiding over the dawn of a new age, with the confident claim that he was a 'teacher of truth' and, thanks to the mercy of God who had entrusted the Gospel to him, 'God's notary and witness in his Gospel' (WA BR 9, Nr. 3699 a, 574; LW 34, 295-297).

When Luther died in the early hours of 18 February 1546, a legacy began which may be described as unique – and not only in terms of German history. Even in the sixteenth century, the dates of his birth and death were already celebrated with public speeches and sermons. The house in Eisleben where he died became an early place of pilgrimage and thus the first memorial site dedicated to an individual in German cultural history. The Luther memorial which was erected in the marketplace in Wittenberg in 1821 was the first to commemorate a 'civilian' in the form of a public monument. The unique character of Luther commemoration can be seen not least in the celebration of the posting of the 95 Theses, an event which is still marked today by a public holiday in several German federal states and also abroad in countries such as Slovenia and Chile.

Luther's will of 6 January 1542 was bought at an auction in Helmstedt in 1804 from the estate of the Protestant scholar, Johann Benedikt Carpzov, by Hungarian collector Miklós Jankovich, who later gifted it to the Evangelical Lutheran Church in Hungary. Stefan Rhein

→ Further read

Tibor Fabiny: *Martin Luthers letzter Wille. Das Testament* *Reformators und seine Geschichte*, Bielefeld 1983.
Pauline Puppel with Stephan Buchholz: Zur Recht lung der Katharina von Bora, in: *Katharina von Bora Lutherin*, Martin Treu (ed.), Wittenberg 1999, 33–51.
Ketzer, Held und Prediger. Martin Luther im Gedächtni Deutschen, Marcel Nieden (ed.), Darmstadt 2017.

Ich D. Martinus Luther doctor zeuge hie mit mit dieser meiner eigen handschrifft, das ich meiner lieben und treuen hausfrawen Katherin gegeben habe zum leibgedinge (oder wie mans nennen kan) auff yhr lebelang, damit sie yhres gefallens und zu yhrem besten gebaren möge. Und gebe yhr das zum krafft dieses brieues, gegenwertiges und künfftiges eygthu

Nemlich, das gütlin Zülßdorff, wie ichs selb gekaufft und zugericht habe, aller dinge wie ichs bis daher gehabt habe.

Zum andern das haus Bruno zur wonung, so ich unter meins Wolffs namen erkaufft habe

Zum dritten die becher und kleinot, als ringe, ketten, oder was golden und silbern ist, welchs ungeferlich solten bey tausent gülden werd sein. Das thu ich darumb

Erstlich, das sie mich als ein from treu ehlich gemahl allzeit lieb, werd und schon zu halten. Und mir durch reichen gottes segen funff lebendige kinder (die noch für handen) gott gebe lange, zu geborn und erzogen hat.

Zum andern, das sie die schuld, so ich noch schüldig bin (wo ichs sie nicht bey leben ablege) auff sich nemen und bezalen sol. Welcher mag sein, so gefer mir bewust, cccl fl. Mügen sich villeicht wol mehr finden

C.1530 OIL ON OAK PANEL, CRADLED 75 × 103.5 CM
NASJONALMUSEET FOR KUNST, ARKITEKTUR OG DESIGN,
OSLO

In the early sixteenth century, the humanist ideal of a Golden Age as it had been depicted by the poets of the ancient world, with men and women enjoying peaceful, carefree lives in the natural world without laws and judges, became a popular vision of the future. And this same ideal also prevailed at the court in Wittenberg, where the Ernestine electors, who were educated as humanists, took an active interest in the arts and the sciences. Around 1530 Lucas Cranach the Elder (1472–1553) created a painting that depicts just such a paradisiacal state of innocence. Unashamedly naked, couples dance, bathe, rest, eat and caress each other in a garden protected from the rest of the world by a wall. No enforced activities interrupt their leisure. And apart from the fox, all the animals in the painting are portrayed as couples. Water emerges from a natural source in a rock grotto and swells to become a stream leading into a lake. Both humans and animals will find food aplenty in the luscious vegetation, with berries and flowers of all kinds and many fruit-bearing trees, including an apple tree and a cherry tree as the trees of knowledge and of life.

This scene combines a Garden of Eden filled with joyous love, a life-giving source as a reminder of God's work saving humankind through Jesus Christ, and a *hortus conclusus* – an enclosed garden – as a metaphor for the immaculate purity of the Virgin Mary. All the lives and activities represented here are allegorical. Thus the ideal age envisaged by classical poets is transformed by Christian beliefs and recast as a new Golden Age that is dawning in the here and now. The outside world is shown as a mountain landscape with two castles perched high up on the rocks. While one is only just visible in the distance, the very detailed architecture of the other immediately identifies it as Castle Hartenfels in Torgau. Reaching up into the heavens, the residence of the Saxon Electors – the defenders and champions of Protestant Christianity – becomes a symbol of God's fortress and introduces a political-religious dimension into the painting, suggesting that the humanist, Protestant reign of the Ernestines brings with it the prospect of peace and harmony, as in the Golden Age described by classical poets.

However, Luther did not share the humanists' longing for a Golden Age. In his view history and the affairs of the world could only be understood in terms of eschatology and the salvation of humankind. After the Creation the world had to go through three stages: the first lasted from the expulsion from the Garden of Eden up until the Flood; the second saw the need for laws to be established, since sinful acts and transgressions made it necessary for society to be regulated; and the third, which promised salvation through the revelation of God made man in His Son, was also determined by the Devil's dominance over the world. Now that the Church was claiming the faithful would be safe if they obtained indulgences, Luther was convinced that the end of time was approaching. For Luther a new Golden Age would only dawn with the second coming of Christ and a new Creation. Until then, all that could be done was to try to save the souls of human beings by preaching the Gospel. Katja Schneider

→ Further read

Edgar Bierende: *Lucas Cranach d. Ä. und der deutsche F nismus. Tafelmalerei im Kontext von Rhetorik, Chronike Fürstenspiegeln*, Berlin 2002.
Matthias Müller: *Das Schloß als Bild des Fürsten. Herr liche Metaphorik in der Residenzarchitektur des Alten* (1470–1618), Göttingen 2004.
Cranach der Ältere, Bodo Brinkmann (ed.), catalog the exhibition of the same name, Ostfildern-Ruit 2c

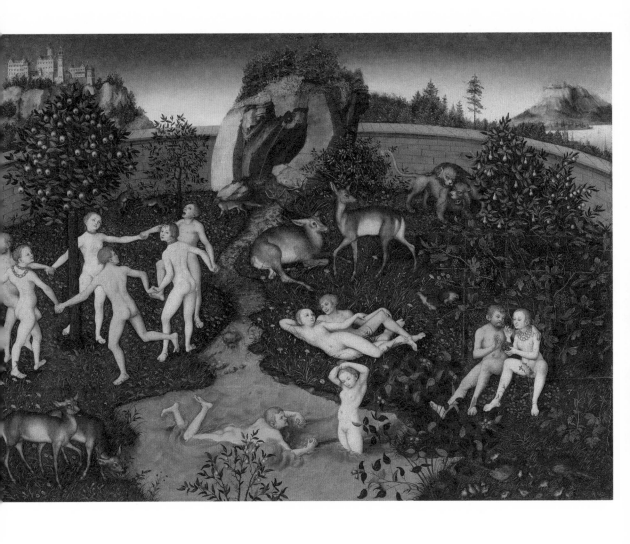

95 PEOPLE
COEXISTENCE

'A MAN DOES NOT LIVE FOR HIMSELF ALONE IN THIS MORTAL BODY TO WORK FOR IT ALONE BUT HE LIVES ALSO FOR ALL MEN ON EARTH.'

WA 7, 34

The aim of Luther's reformatory action was to renew the Church. He considered the authority of the institution to be less important than the community of the faithful that comprised it. Yet Luther was only able to establish this community at the cost of a permanent schism in Western Christendom. Nevertheless, people have consistently sought to make Luther's ideas relevant to their time, even outside the realm of religion. Some aim to apply the reformer's drive for freedom to the arena of politics – an approach he himself rejected. Others strive to overcome the division of the Church or see Luther's 'battle against Rome' as an ideal to be emulated. Even the question of whether or not Christianity binds people together in a community is debated in the light of Luther's ideas.

ON LUTHER,
IN TREPIDATION

MARTIN MOSEBACH

My Christian name was chosen for me in the spirit of ecumenical compromise. My mother, who was not a fervent Catholic, but who could never have imagined abandoning the Catholic Church, voted for Martin, after Saint Martin of Tours, who was especially venerated in her native city of Cologne, above all in the splendid Romanesque Great Saint Martin Church (Gross Sankt Martin) – with the accent on the second syllable of Martin! My Protestant father was contemplating paying homage to Martin Luther, but my mother ensured that I was baptised in the hospital immediately upon my arrival, despite the fact that (or

because) my father was not there – she clearly preferred not to risk becoming embroiled in any denominational debates. According to family legend I screamed dreadfully throughout the proceedings. 'No wonder, if he's called Martin,' remarked my father, who only met me once I was already a baptised Catholic. But it was the Roman legionnaire born in Pannonia, the hermit monk in Italy, the bishop in Roman Gaul and the visitor to the imperial court in Trier who would colour my life, not the German Doctor Martinus. It was through the figure of St Martin of Tours, one of the founding fathers of the Western world, that the universal Roman church of the first millennium won my heart. As I steadily increased my knowledge of church history, one thing above all – that had nothing to do with theological or political issues – puzzled me about the other Martin, the great reformer: how could one profess Christianity without Rome and Constantinople, without the liturgy and the music of the first thousand years, without the monastic traditions from Egypt, without St Benedict, St Francis or St Dominic, without Romanesque basilicas and the Gothic cathedrals of France? How could one call oneself a Christian without the legacy of Jerusalem, Alexandria and Athens? Wasn't that an ahistorical Christianity, dreamt up in the provinces in order to keep a tight rein on any links to the opulence of the past and the no less opulent present-day cultures of lands beyond Germany? In Luther's day the Popes were integrating new continents into the Church, even as he was setting about cutting off a large part of Germany from the main currents of civilisation.

So I cannot bring myself to see Luther's impact as anything other than an enduring national catastrophe for Germany. Although I lack the historical-philosophical pathos of one such as East Prussian poet and translator Rudolf Borchardt, who converted from Judaism to Protestantism and accused Luther of having betrayed Germany's historical mission, which (in his view) consisted in the *translatio* and continuation of the Roman empire, there is no doubt that it was Luther who dealt the fatal blow to the Holy Roman Empire, that supranational commonwealth and unique German-European creation. The spiritual division of our nation into regions colonised by Rome and the barbarian remainder, which the medieval emperors, the French Cistercians and the Knights of the Teutonic Order had previously healed, now became a permanent fixture. And it is no comfort – nor would it have been to Luther – that the religious divide in this nation has faded, because the indifference that has caused it to fade is itself a product of division. The fact is that, as a religion that is guided by the notion of the recognisability of truth, Christianity can demand unusual sacrifices, including the misery of a nation, if that is what the spirit of truth demands. But what is the religious yield of the Lutheran revolution that set out to shatter the entire edifice of the ancient Church with its apostolic foundations? What did the struggle against a whole tradition gain? What kind of

freedom for Christian peoples was created when the faithful were deprived of the guidance of a distant Pope only to be subjected to the rule of the local territorial prince? What kind of freedom is it that denies the free will of the individual human being? Was it really necessary for Luther's justification theology to jettison ecclesiastical unity? It is true that, in its day, righteousness through good works took on a superstitious aspect in popular religion – it is worth remembering, in passing, what a wealth of magnificent architecture and painting, how many hospitals and charity organisations we owe to religious foundations set up to save human souls – but the doctrine of the papal church never approved of the simple trade in souls. In the holy masses that Luther often celebrated as a monk, the prayers citing grace as the prerequisite for every good deed are so plentiful that he need only have recalled the spirit of the ancient liturgy as a means of confronting the ills of his own time. The Mass contains the words 'In our weakness, we can do nothing without your help', there are repeated references to 'prevenient grace' and to the fact that all good works 'are begun by God and completed by Him', and the hope is even expressed that God may 'gently steer our rebellious will to Him'. The liturgy that Luther did away with makes no mention of an opposition between grace and works.

In his fundamental opposition to the Church as it had evolved over the centuries, Luther wanted to rely solely on the Holy Scriptures; that he could not know (given his particular level of knowledge) that the Scriptures were themselves a product of tradition and that there was thus no conflict between the Scriptures and tradition, may be forgivable – but there is no forgiving what he did with the Scriptures that he now deemed to be the ultimate authority. He poured scorn on St Jerome, but he could have learnt much from the patron saint of translators. St Jerome was so deferential towards the original Greek of the Scriptures that he preferred to write incorrect or unclassical Latin rather than blurring the true sense of an expression by adopting a smoother formulation, which he could easily have done. The brilliant writer Luther knew no such humility towards literal meaning. If something was at odds with his own theological intentions, he did not hesitate to intervene, not only in the infamous use of *'allein durch den Glauben'* ('through faith alone') for *per fidem* in St Paul's Epistle to the Romans but also when he dismissed an entire canonical letter, describing it as 'dry as straw' because it did not correspond to his own ideas. It is a constant source of astonishment to discover the high-handed, apodictic ease with which the defender of *sola scriptura* ignores the express teachings of Jesus, which are set out again by St Paul. It was certainly not in the Bible that he found the idea that marriage is a 'worldly matter'. May it suffice to cite just one very short example, among countless others, for the way that it marks out the arrogant translator, who mistrusts the original text and feels the need to dramatise it. In Matthew 22, Luther translates ' … *quod silentium*

imposuisset Sadducaeis' ('… that he had put the Sadducees to silence') as 'that he stopped the Sadducees' maws'. This formulation conjures up the irascible dogmatist, who would have loved to have stopped the whole world's maws; it seems to hint at the resentment of the astounding autodidact towards the superior civilisation of Rome; moreover, it also reveals something of the ranting brutality of the German Expressionists, who later regarded Luther as their founding father. One need only glance at the equivalent passage in the King James Bible (cited above) to see what reverential restraint in the approach to a sacred text should look like.

When I expounded ideas of this kind, my father always became very uneasy. He preferred not to contradict me, but his relationship to Luther went far beyond evaluating or weighing up the latter's achievements and failings. With his passionate, wild heart, the human being Martinus Luther stood before my father amid a huge mass of personal testimonials; the immoderacy of the man was to his credit. My father felt that, when it came to matters of religious belief, the cool style of the Roman Curia was not appropriate – who could remain impassive in discussions of love and salvation, sin and hope? He was positively in love with Luther and advised me, above all, to study Luther the mystic, the heir to the mystic fifteenth century, who rediscovered and published the *Theologia Teutsch* of the mysterious 'Franckforter'. That was good advice, because Germans have to live with Luther – however much they may wish otherwise. In the same way that we have to reconcile ourselves to our forebears – be they good or evil, dull-witted or clever – because we were formed from them, we have no option: there is no escaping the past. My dream of a Germany without Luther is therefore strangely insubstantial. It would also be a Germany without Goethe and Hölderlin, without Johann Sebastian Bach and Richard Wagner, without Johann Georg Hamann and Friedrich Nietzsche. And even if Protestant culture has remained deeply alien to my nature, even if I never feel a part of it, I nevertheless have to admit that this alien thing is part of me. Incidentally, my father was ultimately drawn to the Greek Orthodox Church. Since Luther never knew it, he was also never able to damn it – so there was a way out for my father.

MIKAEL AGRICOLA REFORMER, FINLAND, C.1510–1557

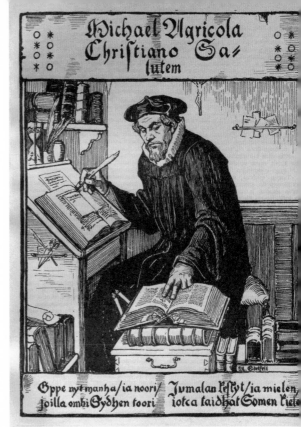

Every year, on 9 April the Finns celebrate Finnish Language Day. It is also known as Mikael Agricola Day, in honour of the reformer Mikael Agricola, who died on 9 April 1557. Mikael Agricola is known as the 'father of literary Finnish' and he played a crucial part in the emergence of a sense of community in Finland. In the early sixteenth century Finland, which had already been part of the Swedish empire for hundreds of years, had no written language of its own. It was not until the nineteenth century that the country gradually developed its own national identity, and the Finnish language gained in importance until it could hold its own with Swedish as a literary language. Mikael Agricola's activities and impact substantially reinforced the nation's sense of self and laid the foundations for Finnish society as we know it today.

Mikael Agricola – baptised Mikael Olavinpoika in Pernaja (Pernå) in around 1510 – appears to have been equally fluent in Finnish and Swedish. He received an outstanding education, first at the Latin school in Vyborg (Viipuri) and then at the cathedral school in Turku. He was ordained in 1528 and in 1531 adopted the surname 'Agricola'. In 1537 he and ten other students were sent abroad to study in Wittenberg by Martin Skytte, the first Lutheran Bishop of Turku. In Wittenberg Agricola mainly attended Philipp Melanchthon's lectures on the New Testament; he also participated in Martin Luther's disputations. A letter written when Agricola was still a student shows that he had already started to translate the New Testament into Finnish by then. One of his chief motivations was his own conviction that even his compatriots who only spoke Finnish should be able to read the Word of God. In 1539 Agricola returned to Finland, now as a *Magister* with a letter of recommendation from Martin Luther to King Gustav I of Sweden. Following his

consecration as Bishop of Turku, Agricola successively im[...]mented what he had learnt in Wittenberg. Agricola's tra[...]tion of the New Testament came out in 1548, but before [...] he had already published a reading primer now known as [...] *ABC Book* (*Abckiria*, 1543), which was also the first book t[...] printed in Finnish. Agricola was not ultimately able to t[...] late the whole of the Bible. It was not until 1642, when Qu[...] Christina of Sweden was on the throne, that a complete F[...] ish translation of the Bible was published. For his part Ag[...] la did, however, publish other religious texts for the educa[...] and edification of the people of Finland, although these [...] above all intended for the Finnish clergy. These publicat[...] included Old Testament psalms, liturgical handbooks for [...] most important Christian ceremonies, and a prayer book [...] a preface in which Agricola thanks, amongst others, his teac[...] Martin Luther, Philipp Melanchthon and Erasmus of R[...] dam. Mikael Agricola died in 1557 on the return journey f[...] a diplomatic mission to Russia. He was buried with the hig[...] honours in Vyborg Cathedral. Alexander Wißmann

→ Further read[...]

Jaakko Gummerus: *Michael Agricola, der Reformator Finn[...] Sein Leben und sein Werk* (Schriften der Luther-Agricola [...] schaft in Finnland 2), Helsinki 1941.
Kirchengeschichte Finnlands, Simo Heininen and Markku [...] kilä (eds.), Göttingen 2002.
Marja Itkonen-Kaila: Michael Agricola als Übersetze[...] Neuen Testaments, in: *Jahrbuch für finnisch-deutsche Litera[...] ziehungen* 39 (2007), 81–92.

Mikael Agricola, *ABC Book*, c.1549

Abckiria.

Michael Agricola
Christiano Sa-
lutem.

Oppe nyt wanha/ia noori /
joilla ombi Sydhen tóori.
Jumalan keskyt / ia mielen /
iotca taidhat Somen kielen.
Laki / se Sielun hirmutta /
mutt Cristus sen tas lodhutta.
Lue sijs hyue Lapsi teste /
Alcu oppi ilman este.
Nijte muista Elemes aina /
nin Jesus sinun Armons laina

AUGUST HERMANN FRANCKE
THEOLOGIAN AND PEDAGOGUE, GERMANY, 1663–1727

Many of August Hermann Francke's followers regarded him as the 'post-Reformation reformer', a 'second Luther'. But in the eyes of his Lutheran orthodox contemporaries he was no more than a 'Catholicising pietist'. In fact Francke was one of the most important figures in Pietism, the most significant renewal movement in the Lutheran Church after the Reformation. Having been appointed to a chair at the University of Halle in 1692 and to the position of pastor in the suburb of Glaucha, over the next 35 years he built up what he himself called a 'city of God', which had a widely diverse, global ripple effect.

His first move was to set up an orphanage funded by donations, the core of a cosmos of education and instruction – a 'nursery garden' – that was open to *all* children and was intended to lead to 'a real improvement in all social classes within and outside Germany, in Europe and all the other parts of the world'. The education of children from all social backgrounds was one of the prime objectives of the reform pedagogue Francke, not least with specific reference to Luther. However, unlike Luther, Francke's ideas and actions had global dimensions. This led, among other things, to the founding of the first Protestant mission, the Tranquebar Mission, in South India in 1706. Francke's clarion call was 'change the world by changing people' and the Bible was the source and yardstick for this ambition.

Following in Luther's footsteps, the Pietists in Halle saw themselves as members of a Bible movement. They believed that everyone, even the poorest Christians, should have Bibles of their own. To this end, in 1710 Carl Hildebrand von Canstein, a friend of Francke, founded the world's first Bible institute in the Franckesche Stiftungen in Halle. In the spirit of Luther, in his Preface to the Epistle of St Paul to the Romans, Francke drew inspiration for his activities from his conviction that faith 'changes us and makes us to be born anew' … 'in heart and spirit and mind and powers' (WA DB 7, 10; LW 35, 371). He lieved that he had rediscovered Luther's dynamic concep justification by faith, had advanced it in keeping with his c time and was now implementing it. Yet his notion of faith in danger of becoming restrictive. He did not share Luth generosity of attitude towards the 'joys of the world'. Fran expected to see the visible fruits of faith, and he responde his Lutheran orthodox opponents by asking 'Where is Luth faith? Where is Luther's joy? Where is Luther's strength?' took the view that a weak theology, which sidestepped so need with pious platitudes, amounted to the suggestion grace could come cheaply and conveyed a false sense of se ty. 'We do wrong to think we are so firmly ensconced on G lap that we cannot fall out of favour with Him.' Post-Refo tion churches owe Francke and the Halle Pietists a lot in te of faith and reforms. But Francke's aspirations were not fined to the Lutheran Church. On the contrary, he felt the true church of Jesus Christ was supra-confessional. M over, it was not solely the teachings of Luther that made church a true church; this was only to be achieved thro living and hence dynamic faith. Helmut Obst

→ Further read
Erhard Peschke: *Studien zur Theologie August Her Franckes*, 2 vols., Berlin 1964/66.
Gustav Kramer: *August Hermann Francke. Ein Leben* 2 vols., Hildesheim 2004 (new edition).
Helmut Obst: *August Hermann Francke und sein* Halle 2013.

Where is Luther's faith? Where is Luther's joy?
Where is Luther's strength?

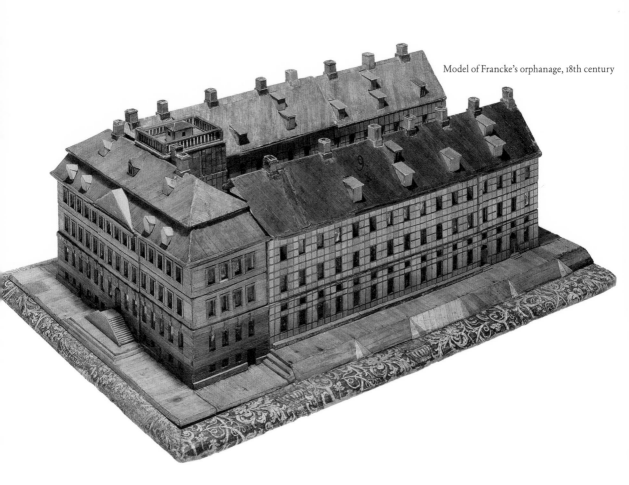

Model of Francke's orphanage, 18th century

FYODOR DOSTOYEVSKY

WRITER,
RUSSIA, 1821–1881

The one – and only – reference to Martin Luther in a literary text by Fyodor Dostoyevsky comes in his novel *The Brothers Karamazov* (1879–80). In a hallucinatory conversation with the devil, Ivan Karamasov throws a tea glass at Satan, who responds with the comment: 'He remembers Luther's inkstand!' This reference to Luther appears in an extremely complex context, which revolves around individual and public attitudes to guilt.

Dostoyevsky actually addressed the topic of Luther in theological terms in the notes to his novel *Demons*, although he did not include these in the definitive version (1873). Moreover, these notes do not properly reflect Luther's theological position: Luther's teachings describe Christ as no more than a 'simple human being and noble philosopher', not, as Dostoyevsky would have it, as the foundation and source of 'living life'.

Dostoyevsky was no Lessing, and nothing could have been further from his mind than religious tolerance. After the publication of *The House of the Dead* (1860) on the life of convicts in a prison camp, Dostoyevsky's attitudes – in his five great novels and *A Writer's Diary* – were firmly rooted in Russian Orthodoxy, and he took a dismissive, deeply hostile stance towards Judaism, Roman Catholicism and, ultimately, Islam too (in light of the Russo-Turkish War of 1877–78). In this context it is striking that Dostoyevsky viewed Protestantism in entirely positive terms, albeit with reservations that clearly arose from a misapprehension.

In Dostoyevsky's view the character of the Russian people was grounded in the beauty and truth of the Russian Orthodox faith. And he was convinced that, if Russia understood its mission correctly, the Orthodox faith would halt the 'atheist monster' spawned by Socialism-cum-Catholicism. He felt that Protestantism set a fine example in its anti-Roman struggle –

from Arminius to Luther. Nonetheless, however powerful repudiated old and new Rome, its precepts and consequen it would not be able to defeat the hostile allies, Catholic and Socialism, because the idea of Protestantism – which cording to Dostoyevsky, was only supported by Germany – entirely negative. Furthermore, Protestantism was depend on its enemy, namely Catholicism; if that enemy ceased to e then so, too, would Protestantism, because (in Dostoyevs view) it thrived solely on protest. On its own it would neve able to offer the faithful a new Word. That new Word, w would, in a positive sense, open the way to the future, c only come from the Russian Orthodox Church, which di ed its imperialism of love towards the whole world.

Against this backdrop Dostoyevsky's references to Ma Luther – which are particularly prominent in *A Writer's D* (1873–81) – take on a special importance as weapons aga atheism, albeit bearing in mind that Luther could never l defeated atheism, because he did not have the assistance o Russian Orthodox Church. Horst-Jürgen Gerigk

→ Further read
Wolfgang Kasack: *Dostoyevsky. Leben und Werk*, Fran am Main and Leipzig 1998.
Fyodor Dostoyevsky: *A Writer's Diary*, Evanston 199
Horst-Jürgen Gerigk: 'Da ist ihm Luthers Tintenfass fallen!' Dostoyevskyj und Martin Luther, in: *Dosto Studies. New Series. The Journal of the International Dosto Society 21* (for publication in 2017; extended version o text).

Luther as anti-Rome protester: Fyodor Dostoyevsky, *A Writer's Diary*, not earlier than 1873

KARL MAY
WRITER, GERMANY, 1842–1912

Over to the most famous hero in German fiction – a Native American: 'Winnetou', he says, referring to himself, 'loves all men, regardless of their name or colour.' And his white blood brother, Old Shatterhand, explains why this is the perfect attitude when he is travelling in the Orient as Kara Ben Nemsi: 'Allah created all men and decreed that they be brothers to each other.'

The family of man as one great community under God. And what always resonates in Karl May's 'travelogues', which have been devoured by countless millions of readers worldwide, comes across all the more clearly in his less known late works: 'In the moment when the Son of God came down to Earth, divine love was incarnated as human love.' This sentence occurs in Karl May's *Und Friede auf Erden!* The exclamation mark in the title, which translates as 'And Peace on Earth!', clearly expresses an intention or hope.

As the new century dawned and imperialism was still in full flow, May was publishing works in which symbolism and spirituality intersect and he became an advocate for better communications between different peoples, regardless of their origins and creed. He demanded the 'same space and same rights for every individual in the human race' and he declared that 'races and religions are different, but all human hearts are one and the same'. And from that innermost core one could understand human beings' relation to the God who connects all realities and for whom the differences between time and eternity are as nothing, like those between death and life. Views such as this prompted a later-born kindred spirit, Arno Schmidt (1914–1979), to describe May as the 'as yet the last great mystic of our literature'.

Karl May made few direct references to Luther, yet his thinking was deeply rooted in his own evangelical socialisation. He successfully worked for Catholic journals and publishers, and was even personally appointed by bishops, until they realised that he was not a member of the Catholic Church. Finding himself under theological attack during the last decade of his life, he insisted in his letters that it was impossible to be a 'good Christian or a good Israelite, without first being a good person'.

May's life could be seen as the perfect example of how human misfortune can be turned to advantage and how writing, as 'therapy', can help to restore lost equilibrium. The gifted so 'penniless weavers' in Saxony, the failed assistant teacher charity school, onetime petty criminal and jailbird, who, a age of 33, earned a crust by editing shilling shockers, ultim ly created a world filled with his own, all-powerful fant. However, when reality and his own self-dramatisation bec all but indistinguishable, everything collapsed. Neverth his humanitarian utopia was to grant him one last pers triumph. 'Upwards into the Realms of Human Nobility!' the title of a lecture Karl May delivered in Vienna to an ence of 'over 3,000 members of the middle and upper cla Eight days later, on 30 March 1912, Karl May died in Rade near Dresden. Hans-Rüdiger Schwab

→ Further read

Hans-Rüdiger Schwab: Karl Mays Atheisten, in: *Ja der Karl-May-Gesellschaft* 2005, 105–163.
Helmut Schmiedt: *Karl May oder Die Macht der Pha Eine Biographie*, Munich 2011.
Zwischen Himmel und Hölle. Karl May und die Re Christoph F. Lorenz (ed.), Bamberg ²2013.

Winnetou is a Christian

Winnetou (Pierre Brice) dies in the arms of Old Shatterhand (Lex Barker), scene from: Harald Reinl, *Winnetou III*, 1965

r Max Fuchs, Winnetou's Silver Gun, 1896, 1920

WILHELM II EMPEROR, GERMANY, 1859–1941

Kaiser Wilhelm II.

Wilhelm II, the last German emperor and King of Prussia, reigned for 30 years (1888–1918). Although the country was at peace for at least 25 of those years, he has often only been judged by the last four years of his reign, when the German Empire was at war. For a long time there was talk of a 'special German path' (*Sonderweg*), embodied in the figure of Wilhelm II, which led Germany into a world war and plunged Europe into catastrophe. However, in light of more recent research conducted in the last 20 years, the *Sonderweg* theory has been all but abandoned, and new, more level-headed investigations, based on international and transnational comparative analyses, have provided important new insights into both the last German Empire and Wilhelm II.

These investigations have shown, among other things, that Wilhelm II had a particular interest in religion. He engaged with religious issues not only because he was, as King of Prussia, head (*summus episcopus*) of the Prussian Evangelical State Church but also because, as a Christian believer, he cared about the future of his church. Luther was a role model for Wilhelm II, who regarded him as one of those 'great men' (Heinrich von Treitschke) who shaped the course of world history – from Hammurabi to Wilhelm I, who never came to be known as 'William the Great', despite his grandson's best efforts. In 1892 Wilhelm II triumphantly completed the restoration of the Castle Church in Wittenberg, which his father had initiated. This restoration project was just one of hundreds of church-building projects that Wilhelm II supported in one way or another. Along with the Kaiser Wilhelm Memorial Church in Berlin (1896), Berlin Cathedral (1905) and the Lutheran Church of the Redeemer in Jerusalem (1898), the restoration project in Wittenberg was intended, in a wider religious-political sense, to send out a signal of unity to Protestantism, with its many internal divisions, and to serve as a standard bearer for unity.

But the Emperor was also greatly concerned by the 'fundamental' division of western Christianity into Catholicism and Protestantism that ensued after the Reformation. One of his core aims as a ruler was the reconciliation of social and religious differences between the two belief systems. The means to achieving this was to be the community of the nation, which would arise from the resolution of all other discrepancies. In real terms Wilhelm II was most successful in his pursuit of these aims with regard to German Catholics, who became better integrated in the nation by dint of symbolic and actual patronage (appointments to civil service posts and financial assistance for church restoration projects and new buildings). Some commentators even appeared to believe that Wilhelm II was seriously considering converting to Catholicism. But, as in so many things, here too, Luther proved to be an enduring role model. Having been freed from the responsibilities of a sovereign by the country's defeat in war, the former emperor continued with his quest to resolve internal differences within Protestantism – but thereafter had little more than polemics for members of the Catholic Church. Benjamin Hasselhorn

→ Further read:

Wilhelm II. und die Religion. Facetten einer Persönlichkeit und ihres Umfelds (Forschungen zur Brandenburgischen und Preußischen Geschichte, Beiheft 5), Stefan Samerski (ed.), Berlin 2000.

Christopher Clark: *Kaiser Wilhelm II. A Life in Power*, Harlow 2000.

Benjamin Hasselhorn: *Politische Theologie Wilhelms II.* (Quellen und Forschungen zur Brandenburgischen und Preußischen Geschichte 44), Berlin 2012.

Symbolic ecumenism: protector medal of the Evangelical Order of St John
with Catholic Marian Cross from the estate of Wilhelm II, 1913

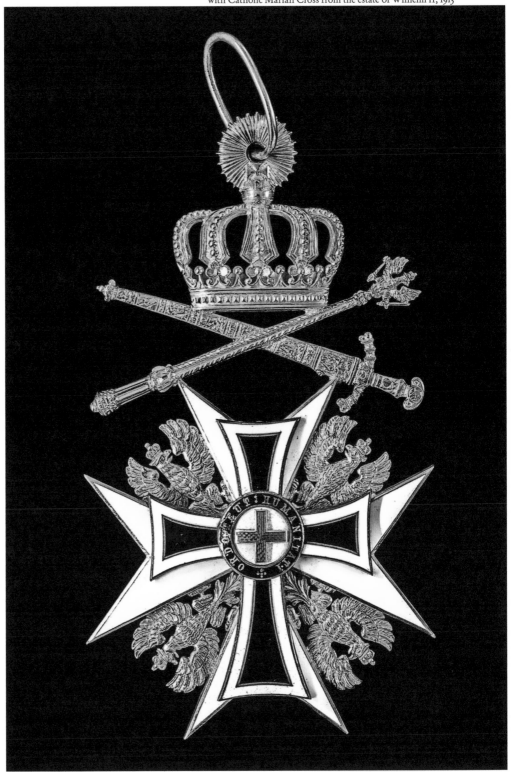

FRIEDA KEYSSER
MISSIONARY,
GERMANY/ AUSTRALIA,
1875–1957

Friederike Keyßer v
Strehlow geb.31.8.1

Frieda Keysser, who was born in Upper Franconia in 1875, met Carl Strehlow, a mission seminarian, in 1892 and they married in 1895. That same year the missionary couple were sent from Neuendettelsau, in Middle Franconia, to Central Australia. There they worked side by side at the Hermannsburg Mission until 1922. Following an extended trip home to Germany in 1910–12, five of the couple's six children remained in Germany for formal schooling. Only Theodor, known as Ted, travelled back to Australia with his parents. He later became an anthropologist and linguist, who studied the language and culture of the indigenous Australians of that region. Carl Strehlow died in Horseshoe Bend on the way to Adelaide in 1922, and was buried there. Frieda Keysser returned to Germany in 1931 and spent the rest of her life in Neuendettelsau, where she died in 1957.

From 1894 to 1922 Carl Strehlow led the Hermannsburg Mission in Australia, which had been founded by members of the Lutheran mission at Hermannsburg in Germany. This was the first mission station in the Northern Territory in the homeland of the Aranda people. Along with Alice Springs, it was one of the largest European settlements in Central Australia. The Strehlows tried to improve the local population's dire social conditions and health. Carl Strehlow learnt the language of the indigenous population and translated the Bible into Aranda. He also documented the languages of the Aranda and the Luritja peoples and, together with Moritz Freiherr von Leonhardi, published a seven-volume treatise on the culture of the Aranda and the Luritja.

When Frieda Keysser first arrived in Australia, the official view of the missionaries was that the indigenous peoples were in the process of dying out. The Strehlows resisted this idea, believing in the future of the Aboriginal Australians. Diaries kept by Frieda Keysser show that they had to contend with a largely hostile environment. She and her husband Carl were often confronted with negative, misanthropic attitudes on the part of farmers, police officers and anthropologists, who regarded the missionary work as naive and culturally destructive.

The meals prepared in Frieda Keysser's kitchen were not just her own family, but also for the pupils at the mission school, workers, and the old and infirm living at the mission compou The Aranda had been decimated by diseases such as syph high levels of child mortality, child neglect and random sh ings. A fundamental sense of hopelessness led the Aborigi to lose interest in their own future generations. Fried Keysse garded the battle against infant mortality and caring for yo mothers as by far her most important tasks. And her efforts v not entirely in vain: the numbers of children surviving to a hood in Hermannsburg soon started to increase again.

An Paenhuysen

→ Further read
T. G. H. Strehlow: *Journey to Horseshoe Bend*, Adelaide
John Strehlow: *The Tale of Frieda Keysser. Frieda Ke and Carl Strehlow. An Historical Biography*, Vol 1: 1875– London 2011.
Anna Kenny: *The Aranda's Pepa. An Introduction to Strehlow's Masterpiece Die Aranda- und Loritja-Stämm Zentral-Australien (1907–1920)*, Canberra 2013.

I am very happy that I'm allowed to travel to the heathens

Frieda Keysser's diary 1898–1957, abridged version

Frieda Keysser's diary 1898–1917

ELISABETH NOELLE-NEUMANN

OPINION RESEARCH PIONEER,
GERMANY, 1916–2010

Elisabeth Noelle grew up with her three siblings in an upper-class Protestant family in Berlin. Her father, a lawyer, was the managing director of (among other things) the film production company Tobis. Her mother was the daughter of the sculptor Fritz Schaper, whose works include the statue of Martin Luther in Erfurt.

From 1935 onwards Elisabeth Noelle studied newspaper science, history and philosophy in Berlin, Königsberg and Munich. It was during a study trip to the USA in 1937–38 that she first encountered the practice of conducting representative opinion polls, which she further investigated for her doctoral thesis. After her graduation in 1940, she worked as a journalist for papers such as the *Deutsche Allgemeine Zeitung, Das Reich* and the *Frankfurter Zeitung.* Certain passages in her articles were later seen as evidence of National Socialist sympathies. However, there is also documentary evidence of her coming into conflict with the Reich Ministry of Propaganda.

In 1947 she and her first husband, Erich Peter Neumann, founded the Institut für Demoskopie in Allensbach on Lake Constance; in 1964 she was appointed to the Chair of Journalism at the University of Mainz and from 1978 she was a guest professor at the University of Chicago. For decades she devoted her research to the formation of public opinion, how it is influenced by the media and 'opinion leaders', and how the pressure of public opinion affects the willingness of individuals to reveal their own thinking. Elisabeth Noelle-Neumann did not regard the pressure to conform to public opinion as necessarily negative, since human coexistence always requires a balance between individualism and integration. However, she was critical of the influence of the mass media and, in the 1970s, she blamed them for the increasing reluctance in the wider population to publicly pledge allegiance to bourgeois values, the nation and religion. She showed that, with the help of the mass media, a highly vol-

uble minority can silence the disconcerted majority, althou strong personas, who are not daunted by potential social lation, can withstand the pressure of public opinion. No Neumann achieved international renown for her identificat of this 'spiral of silence' (*Schweigespirale*), which was ground in both empirical social studies and the history of ideas. She cited Luther as a historical figure who embodied the ab to withstand social pressure and change public opinion. Fr her home in Allensbach overlooking the Carolingian mona island of Reichenau in Lake Constance, Elisabeth Noelle-N mann observed the population's changing attitudes towa religion and the church until her death. Luther played a cen part in some surveys conducted by her institute – from arou 1957 as an indicator of the general level of historical and gious awareness in Germany. The majority of those survey usually gave the correct answer to the question 'Do you hap to know whether Luther lived before or after the Thirty Ye War?' Norbert Grube and Ralph Erich Schmid

→ Further readi
Elisabeth Noelle-Neumann: *Die Schweigespirale. Öffent. Meinung – unsere soziale Haut,* Munich 2001 (6th., exter edition) (English translation: *The Spiral of Silence. Public (ion – Our Social Skin.* Chicago 1984).
Elisabeth Noelle-Neumann: *Die Erinnerungen,* Munich 2 *The Spiral of Silence. New Perspectives on Communication Public Opinion,* Wolfgang Donsbach, Charles T. Salmon Yariv Tsfati (eds.), New York and London 2014.

Whoever does not fear isolation
can overthrow the order of things

Elisabeth Noelle-Neumann, *Die Schweigespirale*, 1980 →
Luther as avant-gardist: Elisabeth Noelle-Neumann, *Die Schweigespirale*, before 1980

MARTIN LUTHER KING JR.

CIVIL RIGHTS LEADER,
USA, 1929–1968

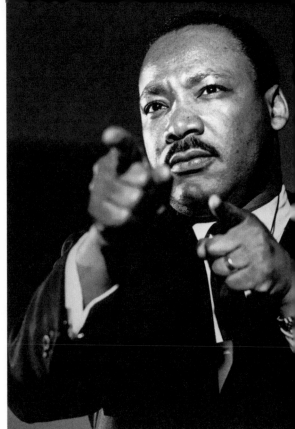

On 10 July 1966, when Martin Luther King Jr. affixed his list of demands for social justice to the door of the Chicago City Hall, he knew exactly what he was doing. By echoing Luther's legendary nailing of 95 Theses to a church door, King sought to imbue his own demands with something of the power of Luther's groundbreaking propositions.

By 1966 the Baptist minister was already internationally renowned. Three years earlier, in Washington, he had memorably told the world of his dream that one day all of his country's citizens, black and white, would enjoy equal rights. The following year he was awarded the Nobel Peace Prize for his non-violent resistance to the segregation of African Americans in the USA. In 1966 King extended this struggle to social issues and moved with his family to the black ghetto in Chicago. Once again he organised unarmed resistance and peaceful protest marches, still decrying the discrimination against America's black citizens and highlighting their social and economic marginalisation.

In his capacity as a Baptist minister, King fought against the legal system and the machinations of the state as he strove to realise his vision of a just society. As he knew only too well, this could not be achieved by Lutheran respect for authority. Despite the two men sharing the same name, the theology of the church reformer was not a factor in the activities of the black civil rights leader. There are few traces of any connections to Martin Luther in King's estate. If anything he found inspiration in the theology of Walter Rauschenbusch and the non-violent protest of Mahatma Gandhi.

Yet King did bear the name of the 'great reformer', as he described Martin Luther during his sermon in East Berlin in 1964. He did not chose the name himself, but was given it, at the age of five, by his father (born Michael King), who adopted the names Martin Luther to signify his calling as a preacher. From then on he used the name Martin Luther King Sr., and his eldest son became Martin Luther King Jr.

In the past white slave owners had reserved the right to ch their slaves' names. After slavery was abolished the act of c ing one's own name came to be regarded as a visible sign o determination. Ironically Martin Luther King Sr. named self and his son after a white theologian, who had endorse violent persecution of the Anabaptists – which would prob also have included the Baptists for their practice of credo tism.

Unlike his namesake, Martin Luther King Jr. became far for never seeking to justify violence. His vision was of a pea society, in which neither the skin colour nor the class of a dividual would influence their treatment. In King's estate is a short quote from Martin Luther's *Lectures on Genesis* in w he explains that, after the Fall from Grace, human beings no longer able to directly experience God, and the Gospe human beings' only point of contact with the image of King dreamed of a society that truly believed human b were made in God's image and that was free of racism. A strove to achieve his aim, the supreme orator readily availed self of famous symbols from history, such as Luther's 95 T nailed to a church door. Robert Kluth

→ Further rea
Taylor Branch: *America in the King Years*, 3 vols, New York 1988·
Clayborne Carson: *The Martin Luther King, Jr., Encyclopedia*, We
Connecticut 2008.
Gerd Presler: *Martin Luther King, Jr. Mit Selbstzeugnissen und* ·
kumenten, Reinbek bei Hamburg 1987.

I have a dream ...

Posting of Martin Luther King's list of demands on the door of Chicago City Hall, 10 July 1966

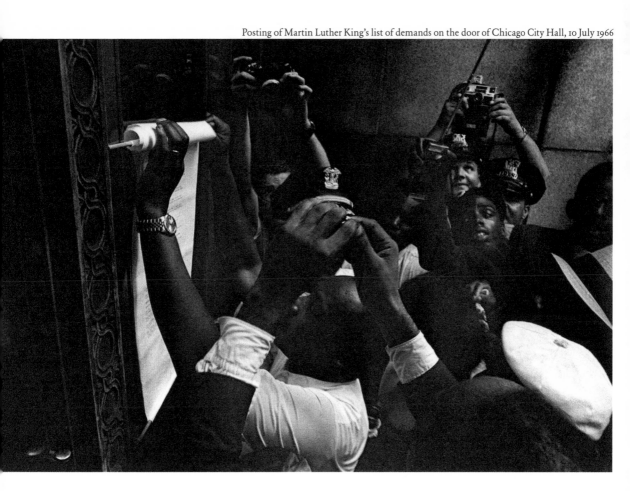

'WHOEVER HAS THE OFFICE OF PREACHING IMPOSED ON HIM HAS THE HIGHEST OFFICE IN CHRISTENDOM IMPOSED ON HIM.'

WA 11, 415; LW 39, 314

Luther saw preaching as his most important duty, believing it was how the Word of God was proclaimed. His language was always evangelistic in style, both in his sermons and elsewhere: he passed on the message he perceived to be the truth to his readers and listeners in the certain expectation that they would be won over to it. Thus Luther also saw himself as a prophet and numerous people have sought to emulate him, though their evangelism may differ in terms of content. Lutheran evangelism comes in a variety of forms – art, music, missions and church planting, theology and preaching, and even radio evangelism. How significant is evangelism today? Can it still be liberating or do we tend to feel manipulated by it?

THE POWER OF THE WORD

KATHRIN OXEN

1. A Church of the Word

The *Place of the Word (Ort des Wortes)* is the title of a light installation at the Town Church in Wittenberg. At the front of the nave, on the left where the pulpit originally stood, projections of quotes from Martin Luther commemorate the fact that this is the church in which Luther used to preach. The original pulpit still exists, but is now to be found at the Luther House museum where, standing in the soft glow of carefully regulated museum light, it appears unexpectedly fragile. It is hard to imagine that the great reformer, always described as a rather substantial man, could have climbed up and preached from it; you can practically hear the wood creaking as you look at it.

Or perhaps it was the case that Luther always preached in the attitude of statuesque serenity depicted in the famous predella of the Wittenberg *Reformation Altar*, underpinning, as it were, the portrayals of Baptism, the Eucharist and Confession visible above. His left hand rests on the Bible, while his right points to the crucified Christ. It is as though Luther is mere-

ly a channel through which something flows which does not come from the preacher himself, but which enters the curiously empty space between the people of the congregation and their preacher and paints a picture of the crucified Christ before their eyes.

The Place of the Word in the birthplace of the Reformation has symbolic significance. A central element of Protestantism's perception of itself is based on evangelism – and not only in the iconographic programme of the *Reformation Altar*. It is a key aspect, in both the broader sense – as the propagation of the Gospel, the 'Good News' – and the narrower sense of the sermon as evangelism's central linguistic form. The Lutheran Church still sees itself as the 'Church of the Word'. During the Reformation period the sermon became the heart of Lutheran liturgical practice and still remains its 'flagship product', to use the language of economic discourse. Five hundred years later its importance in the self-conception of Lutheran clergy is still rarely questioned. Proven competence as a preacher is essential for both the self-image and the public image of the pastoral profession. At the same time, in addition to the 'traditional' form of evangelism through the sermon, many other manifestations have developed, albeit often still adhering to the medium of the spoken word. Martin Luther also exploited the potential of the new media of the day for the purposes of proclaiming his message, for example when he published his *Church Postil*, which contained ready-made sermons to be used by other preachers and was disseminated throughout the land.

The spoken word as the living voice of the Gospel (*viva vox evangelii*) remains the most effective way of proclaiming it. Luther was well aware of its unparalleled impact and preached as often as he could until shortly before his death. Even his last words were notes for a sermon he planned to preach. The much-quoted line, 'We are beggars: this is true' (WA 48, 421), does not refer to the transitory nature of all that is material, as might initially be assumed. Instead it relates expressly to the impossibility of coming even close to adequately understanding and communicating the riches contained in the Bible.

2. Cultivating faith in the Word

In the preface to the complete edition of his Latin writings of 1545 Martin Luther looks back at his Reformation epiphany. 'At last, by the mercy of God, meditating day and night, I gave heed to the context of the words… Here I felt that I was altogether born again and had entered paradise itself through open gates' (WA 54, 185–186; LW 34, 337). Luther's existential experience of liberation after years of scholarly work on Biblical texts was first and foremost the experience of being 'spoken to' by a text, not merely at the cognitive but also at the emotional level. This personal experience was the basis for all Luther's reflections on the power of the Word and the im-

portance of its proclamation in church. Indeed, Lutheran ecclesiology later went so far as to understand the institutionally constituted Church as a 'Creation of the Word' (*creatura verbi*).

However, in relation to the sermon itself as well, Luther's faith in the power of the Word was virtually boundless. This can be seen, in particular, in his *Invocavit Sermons* of spring 1522. Highly effective in political terms, they put an end to the Wittenberg disturbances which had arisen in the wake of the Reformation. Luther allowed nothing but words to follow the actions, such as the iconoclasm that had taken place in Wittenberg. This was entirely in line with the later formulated Reformation precept of *sine vi sed verbo* – not by force but by the Word. He faced the prevailing agitation calmly. In his sermons he commented, 'I opposed indulgences and all the papists, but never with force. I simply taught, preached, and wrote God's Word; otherwise I did nothing… the Word did everything.' (WA 10 III, 18–19; LW 51, 78). Luther's faith in God here and elsewhere is first and foremost faith in the Word.

In today's media society, the impact of the purely spoken word, compelled to get by without the power of images, is much questioned. And yet at the same time just a few words or a single speech are often sufficient to discredit or label a person permanently.

In light of Luther's pivotal experience, to have been touched existentially by written texts or spoken words has become the personal prerequisite for all forms of evangelism. People who read and write still attach great importance to personal experiences of the effectiveness of words which are not merely understood cognitively but are also experienced emotionally. Only someone who has experienced the power of words and texts, of language itself, can then evoke this power in others. And to do so it is essential to use language to convey both persuasive ideas and arguments and also experiences and feelings.

At times, there is a fundamental mistrust of powerful rhetoric which, in the German context, may be regarded as historically determined, and this detracts from endeavours to give words great impact. Particularly with respect to the performative aspect, the spoken word risks not only being stripped of all effect, but also of appearing deliberately orchestrated due to the rhetorical strategies used. This kind of mistrust can, in turn, have a considerable impact on 'faith in the Word'. It rapidly brings the proclamation of the Word to the limits of its potential effectiveness and, indeed, brings it fundamentally into question – there can be no such thing as proclamation of the Word without deliberate intent.

3. Developing the power of language

The exceptional power of Luther's language extends through his Bible translation far beyond the bounds of theology and the Church. As an ar-

tistic force it has helped to shape the evolution of the German language, often independently of its spiritual content. Even critics of the Christian faith were unable to escape its impact, as evidenced by Friedrich Nietzsche or later Bertolt Brecht.

During the work to produce a revision of the Luther Bible to mark the 2017 Anniversary of the Reformation, it became clear that a new awareness of the linguistic quality and language-shaping power of the Luther translation has recently emerged. Luther traced his own theological theory of language in his *Open letter on translation* (1530), and it can also be found in the available transcripts of his sermons.

The *Invocavit Sermons* can again be held up as an example here: in terms of the richness of their imagery and the power of the language used, they have lost nothing of their potency. Luther chooses strikingly sensory images to convey his theological points. For example, when he devises the 'Parable of the Nurturing Mother' to describe how everyone can be encouraged to proceed along the path of new freedom, he talks of gruel and eggs and the mother's breast (WA 10 III, 6–7; LW 51, 72). Love becomes an active agent; Luther wants to 'win' hearts (WA 10 III, 16; LW 51, 77) and speaks of God as a 'glowing furnace of love' (WA 10 III, 56; LW 51, 96), a powerful verbal image of the nature of God, even with its ambivalent implication of both attraction and danger.

Luther's belief that a prerequisite for effective preaching is to align the message with human experience, including in relation to the language used, clearly draws its inspiration from a comparison with the preaching of Jesus, in particular from the way the parables work: 'It is not necessary to preach and parade valiantly with big words used flamboyantly and elaborately, just to show people how learned one is and to seek honour. There is no place here for that. One should adapt to suit the listeners; and that is the common mistake made by all preachers, that they preach in such a way that the poor folk are little edified by it. To preach simply is a great art, Christ understood it and practised it. He speaks only of the ploughed field, of the mustard seed, and uses only common comparisons from the countryside.' (WA TR, Nr. 4719, 448).

4. Revealing the personal

With regard to Reformation preaching practice, from Martin Luther's time personal experience became an essential element of the sermon. Luther's sermons expressed the 'I', and still more the 'you', with previously unheard intensity. This unequivocal form of address should be reclaimed in the modern age. It will have to avail itself of emotional impact and may, on occasion, have to go beyond what is acceptable for the individual to say.

'Faith comes from hearing' (Romans 10:17) is one of the quotes from the Luther Bible projected by *The Place of the Word* in Wittenberg's Town

Church. It is a reminder that, in terms of 'physical' proclamation, every sermon, every personal speech of this type is an unrepeatable occurrence which owes its power to the synergy between the individual who is speaking and the specific circumstances of those listening. It is fundamentally unrepeatable. Through church preaching the living voice of the Gospel becomes audible, just as, in the great, powerful speeches of our time, values and visions are captured for a moment and put into words. The fading of the spoken word, its essentially ephemeral nature, is and continues to be suited and, therefore, tailored to the long-term effect on the hearts and minds of those who hear it. Five hundred years after the Reformation, faith in the word, the power of language and the personal form the basis of all types of evangelism, as Martin Luther once poignantly summarised it: 'It is remarkable that God has committed to us preachers the task of proclaiming his word by which we are to rule over human hearts, but hearts we cannot look into. This is God's task and he says to us, "You preach, and I will give the increase. I know the human heart." This should be our comfort, even if the world laughs at us and the message we preach.' (WA TR, Nr. 3492, 356).

ALBRECHT DÜRER

ARTIST,
GERMANY, 1471–1528

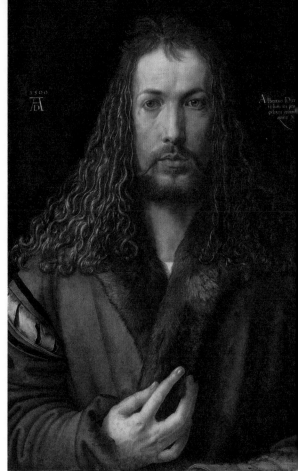

Around 1500 when Nuremberg was one of the most important cities in the Holy Roman Empire, it was home the to richest merchants, the finest craftsmen and instrument makers, and generations of humanists with exceptional libraries. This was where Albrecht Dürer was born on 21 May 1471. Debates with other humanists, whose circles he had joined by 1496, and trips abroad kept him abreast of the intellectual advances of his time. Luther's dramatic display of his 95 Theses in 1517 marked the beginning of church reforms that Dürer and his friends had long hoped for. Before the year was out Kaspar Nützel had translated the Theses into German and published them in Nuremberg; Nuremberg humanist Lazarus Spengler published a defence of Luther the following year. Dürer himself made reference in his notes to 16 texts by Luther and reported that they helped him through times of great distress. Before long the majority of the population in Nuremberg were followers of Luther's teachings. In 1521 Dürer heard with horror of Luther's 'disappearance' after the Diet of Worms and turned to God in prayer: 'Oh God, if Luther be dead, who will henceforth expound to us the holy Gospel with such clarity?'

In his woodcut *The Last Supper* (1523), Dürer gave particular prominence to the chalice, the bread basket and the wine pitcher, as pointers to the elements of the Lutheran Eucharist (bread and wine), which was first celebrated in Nuremberg that same year. The rigour of the composition, which marks a departure from the traditional iconography, is clearly influenced by Luther's *Treatise on the New Testament, that is, the Holy Mass* (1520). The particular moment during the Last Supper when this scene occurs is indicated by the absence of Judas – Jesus has already told the disciples of His imminent betrayal and has identified the traitor. He is now taking leave of the disciples.

In 1526 Dürer made a portrait drawing of Luther's friend and most important collaborator, Philipp Melanchthon. By now radical defenders of the Reformation, such as Andreas Bodenstein von Karlstadt, who had dedicated a pamphlet to Dürer a year earlier, not only advocated the prohibition of images in church-

es, but had already started to destroy works of art. This m have been deeply disturbing to Dürer, as it posed a threa his life's work. In the introduction to his *Instruction in Mea ment* (1525) Dürer defends the visual arts against associat with idolatry and declares he is certain that 'paintings soo bring betterment than vexation'.

In March 1525 Dürer participated in the six meetings of th called Nuremberg Religious Conversations, in which the in the Church was already making itself felt. Although D was on friendly terms with Melanchthon and in full agreen with Luther's teachings, there is no clear commitment anyw in his writings to the regional Protestant churches that v founded shortly before his death. Dürer's main declaratio allegiance to the reinstatement of the Holy Scriptures by Lu is seen in the two panels he painted in 1526, with life-size d tions of the Apostles St Peter, St John, St Paul and the Eva list St Mark. He donated them to the City Council in Nu berg as a cautionary gift. Eugen Blume

→ Further read
Albrecht Dürer. *Schriften und Briefe*, Ernst Ullmann
Leipzig 1973.
Fedja Anzelewsky: *Dürer. Werk und Wirkung*, Stuttgart
(English translation: *Durer, his art and life*, Michigan
Albrecht Dürer, Klaus Albrecht Schröder and Maria
Sternrath (eds.), Vienna 2003.

Oh God, if Luther be dead, who will henceforth expound to us the holy Gospel with such clarity?

Albrecht Dürer, *The Last Supper*, 1523

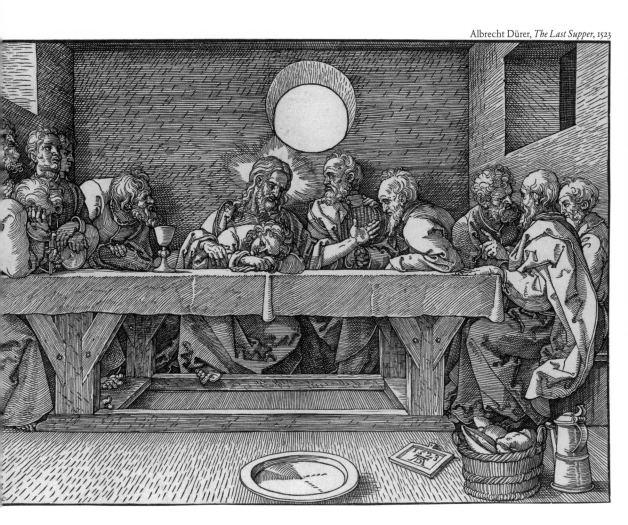

LUCAS CRANACH THE YOUNGER
ARTIST, GERMANY, 1515–1586

Lucas Cranach the Younger was born in Wittenberg in 1515. Thus he belonged to the first generation to experience the Catholic liturgy as its power was fading. In his youth he lived through the exciting years when Luther precipitated the debate on the sale of indulgences and proclaimed his new interpretation of Scripture through his preaching and the printed word. His father, the court painter and councillor Lucas Cranach the Elder, had supported Luther since 1520, initially as portraitist, later as designer and illustrator of his pamphlets, polemics and Bible translations, and finally as creator of images for his reformation messages. Using novel media, including letterpress printing and an effective artistic reproduction strategy, he was able to market his works widely, thus making the world aware of Luther's likeness and reforming views. In this stimulating atmosphere, and with his son as his partner and successor from 1537, he expanded his workshop, developing it into the foremost image factory of the Reformation. After the deaths of his father (1553) and Luther (1546), it was the younger Cranach who gave prominence to themes from the Gospel on altarpieces and memorial panels, thus spreading Luther's teachings even more widely. It was only through his paintings that the new faith became a real visual presence in churches and public spaces, where it reached ordinary people.

Luther had realised the power of the painted image some years earlier. On his visit to Rome in 1511, he was impressed by the realistic work of Italian painters, who depicted the 'true form' of limbs and gestures so that it seemed 'as if they lived and moved' (WA TR 6, Nr. 7035, 349). During his dispute with the theologian Andreas Bodenstein von Karlstadt over iconoclasm, Luther observed that he himself thought in images: '… when I hear of Christ, an image of a man hanging on a cross takes form in my heart.' (WA 18, 83: LW 40, 100). Although he did not regard images as an essential aid to gaining salvation, he nevertheless felt they were useful in introducing the ignorant to Holy Scripture, as long as their motifs were appropriate. Images were justified by their pedagogical value. Next to Luther's preaching, hymns and printed works, Cranach's paintings were an important medium for proclaiming the Word. It is difficult to assess the extent of the mutual inspiration between the theologian and the painter, but Cranach certainly reinforced Luther's mes through both the symbolism and the realism of his image The Man of Sorrows shown here is one of the motifs freque produced by the Cranach workshop. Its small format indic it was intended as a private devotional image. Christ in h ony, with his bleeding wounds, crown of thorns, scourge twigs, gazes intensely at the viewer: Cranach has used the ditional imagery of the late Middle Ages to focus closely Christ's physical suffering. In accordance with Luther's i the image should not be perceived as terrifying, but as a der stration of God's grace, expressed in the sacrificial death of son – Luther saw the Man of Sorrows as an image of con tion. The Coburg painting, which is dated after 1537, is tho to be the work of Cranach the Younger. Katja Schnei

→ Further read
Cranach: [Gemälde aus Dresden], Harald Marx and I Mössinger (eds.), catalogue to the exhibition of the name, Cologne 2005.
Ruth Slenczka: Cranach als Reformator neben Luth *Der Reformator Martin Luther 2017. Eine wissenscha und gedenkpolitische Bestandsaufnahme* (Schriften de torischen Kollegs 92), Heinz Schilling et al. (eds.), 2014, 133–157.
Lucas Cranach der Jüngere. Entdeckung eines Meister land Enke, Katja Schneider and Jutta Strehle (eds.) logue to the exhibition of the same name, Munich 2

I wonder which stories from Holy Scripture
would be the best to paint?

Lucas Cranach the Younger, *Man of Sorrows*, after 1537

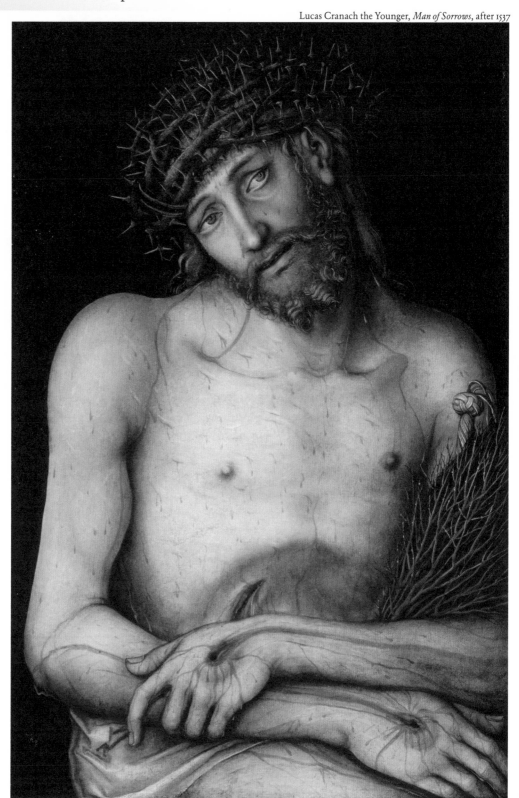

HENRY MELCHIOR MUHLENBERG PASTOR, GERMANY, USA, 1711–1787

Henry Melchior Muhlenberg grew up in Einbeck, a small town in the electorate of Hanover, where he was confirmed in the Lutheran church in 1723. In 1735 he entered the University of Göttingen, where he studied Greek, Hebrew, mathematics, logic and theology. From there he went to the Francke Institutions in Halle, the centre of Lutheran Pietism. He was ordained a Lutheran minister in 1739 and went to serve a congregation in the Saxon village of Grosshennersdorf. Henry thought of going to India as a missionary but in 1741 accepted a call to Pennsylvania, where he arrived in 1742. For the next 45 years, Muhlenberg devoted himself to establishing the Lutheran Church in the United States, taking '*Ecclesia plantanda*' as his motto.

Muhlenberg was a skillful administrator who adapted well to the colonial Pennsylvania government's abstention from religious affairs and the increased prominence of laypeople in America versus the Old World. The Lutheran population was widely dispersed with great distances between congregations and few churches or ordained ministers. Initially Muhlenberg had to wrest control of his three congregations (Trappe, New Hanover and Philadelphia) from various interlopers, who had stepped in during the absence of a minister and included the leader of the Moravian Church, Nikolaus Ludwig von Zinzendorf. In 1745, Muhlenberg married Anna Maria Weiser (1727–1802) in a strategically important union for the Lutheran Church. Her father, Conrad Weiser (1696–1760), was not only the primary government liaison with the Native Americans but also a leading figure in the German-speaking community. Although raised as a Lutheran, Weiser had lived for some time at the Ephrata Cloister and was also affiliated with the Moravians. After the wedding Muhlenberg moved swiftly to bring the Weisers into the Lutheran fold and prepare his new in-laws for Confirmation and Communion.

In 1748, Muhlenberg helped establish the Lutheran Min[ister]um of Pennsylvania, which had the authority to ordain [minis]ters, make church constitutions and try offenders against c[hurch] discipline. At its first meeting the group adopted a stan[dard] liturgy. At the 1760 meeting the Ministerium gathered [at] Muhlenbergs' home, where Henry noted in his journal tha[t he] received 'nourishment for soul and body from Karl Hei[nrich] von Bogatzky's *Schatzkästlein* and from my patriarchal [house]hold'. In 1761–62, in a remarkable sign of collaboration be[tween] pastors and laypeople, Muhlenberg helped the Philadelph[ia con]gregation draft a constitution.

Near the end of his life Henry Muhlenberg helped comp[ile the] first American Lutheran hymnal, for which he wrote th[e pref]ace and assisted in the selection of hymns. Published i[n 1786,] it included hymns by Martin Luther and Paul Gerhard[t and] many others from the Halle and Marburg hymnals. H[e died] the following year. In recognition of his devoted ministry, [Henry] Melchior Muhlenberg is known as the Patriarch of the L[uther]an Church in America. Lisa Minardi

→ Further rea[ding]
Lisa Minardi: *Pastors & Patriots: The Muhlenberg F[amily of]
Pennsylvania*, Collegeville 2011.
*The Transatlantic World of Heinrich Melchior Mühle[nberg in]
the Eighteenth Century*, Hermann Wellenreuther, [Thomas]
Müller-Bahlke and A. Gregg Roeber (eds.), Halle [2013.]
Hermann Wellenreuther: *Heinrich Melchior Mühlen[berg und]
die deutschen Lutheraner in Nordamerika, 1742–1787. [Wissen]-
stransfer und Wandel eines Atlantischen zu einem Am[erikani]-
schen Netzwerk*, Münster 2013.

From the estate of Henry Mühlenberg: Carl Heinrich von Bogatzky, *Güldenes Schatz-Kästlein der Kinder Gottes*, 1761

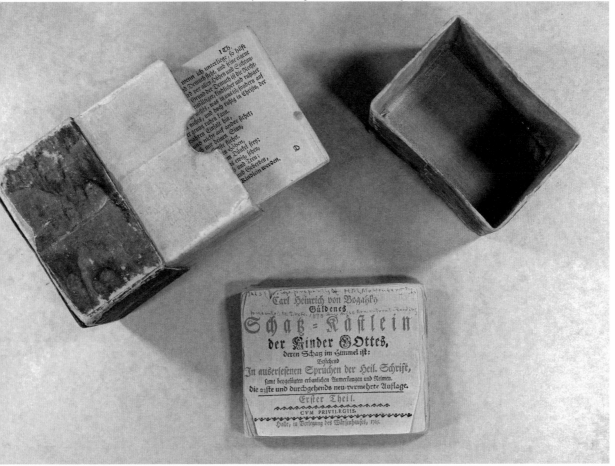

10. Sept. 253.

Und der HErr zog vor ihnen her, des Tages in einer Wolken=Säule, daß er sie den rechten Weg führete, und des Nachts in einer Feuer=Säule, daß er ihnen leuchtete zu reisen Tag und Nacht 2c. (und so wich er niemals von ihnen.) Und die Wolken=Säule trat hinter sie, und kam zwischen das Heer der Aegypter, und das Heer Israel: (und so konten sie nicht zusammen.) Und die Kinder Israel gingen hinein mitten ins Meer aufm trocknen, und das Wasser war ihnen für Mauren, zur rechten und zur linken. 2 Mos. 13, 21. c. 14, 19=22. Und ganz Israel ging trocken durch (den Jordan). Jos. 3, 17. Wir wissen, daß denen, die GOtt lieben, alle Dinge zum Besten dienen.* Wegen des Fleisches sichern Ausschweifung muß man täglich seine Plage, Last oder Schranken und Mauren haben. Kommt nun eine Noth, denke: Das ist heute meine Last oder Mauer, daß ich nicht ausschweife, und der Feind mir schade.

Du schaffst, HERR, daß mir Noth und Tod nicht schädlich sey,
Es dient vielmehr zur Maur, womit ich werd umschränket,
Daß Satan, Sünd' und Welt mich nicht zu tode kränket.
Nun hilf durch alle Fluth! hilf durch die Wüsteney!
Und solls zum Jordan gehn; so stärke du mich wieder, *Röm. 8, 28.
Ach! steh mir da nur bey, und hilf mir wohl hinüber.

FELIX MENDELSSOHN BARTHOLDY
COMPOSER, GERMANY, 1809–1847

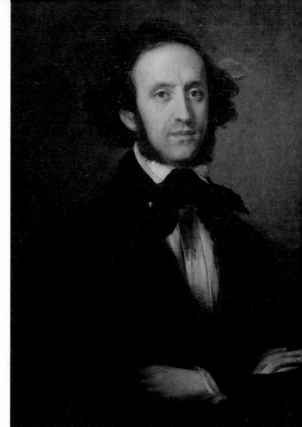

A child prodigy, Felix Mendelssohn Bartholdy was born on 3 February 1809 in Hamburg, baptised into the Protestant Reformed Church as a seven-year-old in Berlin and a celebrated composer by the age of 17. At 20 he crucially rediscovered the almost forgotten work of Johann Sebastian Bach, whose *St Matthew Passion* he revived to great acclaim with the Berlin Singakademie.

As a piano virtuoso, who had grown up in the open-minded milieu of upper-class, assimilated Jews, Felix Mendelssohn was at ease with all musical genres, but had a particular interest in one above all others: sacred music in the Lutheran tradition. Yet his famous a cappella works are merely small sparkling jewels compared to the epoch-making sacred works, which – having gone through periods of ideologically-biased vilification and disregard – have now resumed their rightful place as firm favourites of music lovers all over the world. Their popularity can be attributed, above all, to Mendelssohn's melodies, which mark him out as the most Classical of the Romantics. Yet, for all the seeming effortlessness and harmonic equilibrium of his compositions, they are also immensely complex and grounded in the past, showing their maker to be the perfect combination of genius, scholar and herald of things to come.

In 1833 Felix Mendelssohn Bartholdy took up the position of General Music Director in the Catholic city of Düsseldorf. Not long before that he had completed one of his most important symphonies, the *Reformation Symphony*, op. 107, which was composed for the 300th anniversary of the *Confessio Augustana*. The fourth and last movement is based on Martin Luther's 'A Mighty Fortress Is Our God'. Mendelssohn's theological interest is seen at its height in the oratorio *St Paul*, op. 36, which was first performed in 1836 and includes chorales 'in exactly the manner of Bach's Passions'. By this time Mendelssohn was already Kapellmeister at the Gewandhaus in Leipzig. In addition to his roles as composer, conductor, pianist and organist,

he was also an impresario and teacher. It was on his initia that the first music conservatoire in Germany was opene Leipzig in 1843.

Felix Mendelssohn Bartholdy also spent four years in Be (1841–45). Friedrich Wilhelm IV appointed him as chief su visor of music in the cathedral. Mendelssohn, who made n listic distinction between his own sacred and secular comp tions and who had the greatest respect for the church musi the past – because it had never subordinated its aesthetic rations to the needs of liturgical functionality – had high ho of reinvigorating those same aesthetic aspirations. Howe his time at the cathedral proved to be rather sobering.

While his great oratorios have taken their place on the pr sional concert stage, Mendelssohn's small-scale motets suc *Herr, nun lässest du deinen Diener in Frieden fahren*, op. 69, (composed in Leipzig shortly before his untimely death November 1847) and his setting of Luther's *Verleih uns Fri gnädiglich* are performed by choirs across the globe. Motet this kind, which speak so directly to listeners, revealed a erto unknown musical realm that created an entirely new guage for the emotion of religious experience.

Klaus-Martin Bresgott

→ Further read

R. Larry Todd: *Mendelssohn, A Life in Music*, Oxford and New York
Johannes Popp: *Reisen zu Felix Mendelssohn Bartholdy. Stationen Lebens und Wirkens*, Berlin 2008.
Martin Geck: *Felix Mendelssohn Bartholdy*, Reinbek bei Hamburg

Every word is crying out to be set to music

Felix Mendelssohn Bartholdy, *Symphony No. 5, Op. 107 'Reformation'*, 1830 →
Metronome from the estate of Felix Mendelssohn Bartholdy, 19th century

Felix Mendelssohn Bartholdy, *'Verleih uns Frieden gnädiglich'*, 1831, chorale cantata, MWV A 11

FRIEDRICH NIETZSCHE
PHILOSOPHER,
GERMANY, 1844–1900

Friedrich Nietzsche was born on 15 October 1844 in Röcken, in the Prussian province of Saxony. His father and his grandfather were pastors, his mother was a pastor's daughter. As a young man Nietzsche enrolled to study classical philosophy in Bonn with Friedrich Wilhelm Ritschl; he also initially studied theology. His watershed moment as a philosopher came when he encountered the work of Arthur Schopenhauer. Nietzsche also developed a deep interest in the music of Richard Wagner. In 1869, even before he had completed his degree, Nietzsche was appointed to the Chair of Classical Philology in Basel. However, in 1879 the university dismissed him on the grounds of poor health. For the next ten years he led an unfettered yet lonely life. In December 1888 he suffered a breakdown in Turin and was diagnosed with progressive paralysis, probably as a result of syphilis. Nietzsche died on 25 August 1900 and was buried close to the church wall in Röcken. No pastor attended his burial and the entry in the church records reads: 'Born in Röcken … to Pastor Nietzsche, of that time, and hence Evangelical, but anti-Christian on account of his philosophical works.'

Nietzsche read almost nothing by Luther, aside from possibly the *Large Catechism* and of course his Bible translation; his view of Luther's writings relied heavily on the misleading picture presented by Johannes Janssen in his history of the German people (1878–94). Janssen regarded 'the Lutheran Reformation' as a 'peasants' revolt of the intellect'. Moreover, he suggested that since Luther had destroyed ordinary people's illusions, which had previously justified the church's role as a human power base, the Reformation had marked the beginning of the decline of the Church as a force to be reckoned with. Furthermore, he had also temporarily reinstated the Church in its original (life-denying) Christian mode and had prevented the self-destruction of Christianity during the course of the Renaissance.

Post-Zarathustra (after 1882), Nietzsche only had praise for Luther as the translator of the Bible and architect of the German language: 'the Bible has hitherto been the best German book.'

In his view, Luther, Goethe and Nietzsche-Zarathustra ma[...] the three main stages in the perfection of the German langu[...] 'There was, after Luther and Goethe, a third step still to tak[...] Like Luther, Nietzsche saw himself as a prophet of true[...] Given that it already had been shown that life has no pre-[...]ing meaning, a new gospel had to be spread. Nietzsche descr[...] *Also sprach Zarathustra* as the fifth gospel, as 'good tidings[...] 'from the future'.

His own writing in *Zarathustra* echoes the language and [...] rhythms of Luther's translation of the Bible, particularly i[...] often stylised, prophetic tone. Since Zarathustra is prese[...] as an anti-Christian saviour, Nietzsche had no choice bu[...] reference and rework the Lutheran language of the Bible[...] his own mighty message. For his new gospel, which told o[...] splendour of the self-creation of Man after the death of [...] he used the terminology that was already the bedrock of C[...] tian belief: salvation, blessing, atonement, resurrection, sa[...] ty, justification – albeit always in an anti-Christian sense.

Tom Kleffmann

→ Further read[...]
Heinz Bluhm: Nietzsche's Final View of Luther and the [...]
mation, in: *PMLA* 71, No.1 (Mar, 1956), 75–83.
Tom Kleffmann: Die Notwendigkeit menschlicher Selb[...]
götterung – bei Luther und Nietzsche, in: *Luthers Erben*, N[...]
Slenczka and Walter Sparn (eds.), Tübingen 2005, 193–204[...]

> There was, after Luther and Goethe,
> a third step still to take.

Nietzsche family's Luther Bible, 1818

Friedrich Nietzsche, *Also sprach Zarathustra*, 1908

Die Bibel,

oder

die ganze

Heilige Schrift

des

alten und neuen

Testaments,

nach

der deutschen Uebersetzung

D. Martin Luthers.

L. Nietzsche.
1825.

Die CXXVII Auflage.

HALLE,
in der Cansteinischen Bibel-Anstalt.
1818.

Nietzsche's library: volume nine of the collected
s of Johann Wolfgang von Goethe, 1854

Goethe's

sämmtliche Werke

in vierzig Bänden.

Vollständige, neugeordnete Ausgabe.

Neunter Band.

Unter des durchlauchtigsten deutschen Bundes schützenden Privilegien.

Stuttgart und Augsburg.
J. G. Cotta'scher Verlag.
1854.

ALSO SPRACH
ZARATHUSTRA
EIN BUCH FÜR ALLE UND KEINEN

FRIEDRICH
NIETZSCHE

ERSCHIENEN 1908
IM INSEL-VERLAG
LEIPZIG

PAULINA DLAMINI
MISSIONARY,
ZULULAND,
C.1856–1942

As a child Paulina Dlamini was known by her given name, Nom-guqo, meaning, 'the kneeling one'. She was born into a highly influential family, which had connections to the royal house of Swazi and to Mzilikazi, the founder of the Ndebele kingdom. In 1872 Dlamini was sent to the court of the Zulu crown prince, who later became King Cetshwayo. She became one of his private servants and *isisgodlo* (concubines) in his *umuzi* (home estate). However, the Zulu War of 1879 was a catastrophe for the royal *umuzi*, and some of the isisgodlo, including Dlamini, fled and returned to their homes. Hunger drove many to barter cattle for maize from traders. One of those traders was Shede Foloyi (Gert van Rooyen) who took Dlamini and her family with him to Natal, where they registered as refugees and worked for him. Three years later Dlamini twice had the same dream, which ultimately led to her conversion to Christianity. In her dream she saw a figure in a white robe, who said to her 'Paulina, arise and accept this Bible. Go forth to where the sun rises and teach my people, the old and the young'.

Her dreams attracted considerable attention, since the figure in white was believed to be Jesus. Following these occurrences Foloyi sent her to study with the Lutheran missionary Johannes Reibeling. A year later she returned to Foloyi, who had bought a farm in Zululand in the meantime. They both then worked as lay preachers and led the worship in Christian services. Following her conversion Dlamini took the name Paulina, after the apostle St Paul.

In the 1920s Paulina Dlamini met the Hermannsburg missionary Heinrich Filter, who accompanied her for the next six years, during which time he recorded the story of her life and conversion in Zulu and translated it into German. In 1939, when Dlamini was already in her early eighties, he took her to his mission station in Nazareth so that he could finish his acc of her life there. It was only long after their deaths – Pau Dlamini died in 1942 and Heinrich Filter in 1969 – that her ry was translated into English. *Paulina Dlamini. Servant of Kings* was first published in South Africa in 1986; the Ger version was published in 2002. Paulina Dlamini's life story so remarkable in that not only were there very few black E gelists, there are even fewer verbatim records of their ideas experiences.

As an Evangelist Dlamini enjoyed a degree of independe which allowed her to remain unmarried, for instance. She came known as the 'Apostle of Northern Zululand'. She deeply influenced by the traditions of Lutheranism in mannsburg and set up several mission stations. Paulina Dla preacher and teacher, was a driving force of Christianisatio her own region. An Paenhuysen

→ Further read

Heinrich Filter: *Ich diente zwei Herren. Paulina Dlamini erzä Leben*, Hermannsburg 2002 (English translation: *Servant o Kings*, Durban 1986).

Kirsten Rüther: Kannte Luther Afrika? Afrika kennt L in: *Luther zwischen den Kulturen*, Hans Medick and Peer Sch (eds.), Göttingen 2004, 337–372.

Frieder Ludwig: Das 'ge-filterte' Leben der Paulina Dlami 1865–1942. Einführende Überlegungen zur Biographie der stelin in Nordzululand', in: *'Die Mission ist weiblich'. Frau der frühen Hermannsburger Mission*, Jobst Reller (ed.), Berlin 115–124.

> I kindled a fire in the hearts of the people;
> this spread and grew in intensity.

Heinrich Filter, typescript of the German edition of *Servant of two Kings*, before 1969

V o r w o r t.

Wiederholt bin ich von Vielen gebeten worden ein Büchlein über Paulina, die Apostelin in Nordzululand, zu schreiben. Bisher habe ich aus Zeitmangel es nicht tun können. Wo ich jetzt im Ruhestand mich befinde, will ich es wagen ein Lebensbild der Paulina zu geben. Nicht soll damit Paulina verherrlicht werden, sondern zur Ehre Gottes soll es geschehen. An ihr soll gezeigt werden, wie an einer Bantujungfrau sich die Verheißung unseres Heilandes Jesu Christi bewahrheitet hat, die da lautet: "Wer an mich glaubt, wie die Schrift sagt, von des Leibe werden Ströme des lebendigen Wassers fließen." Joh.7,38.

Wer war Paulina? Väterlicherseits war sie aus dem königlichem Geschlecht der Swazi. Mütterlicherseits nannte sie den berühmtgewordenen Freibeuter und Gründer des großen Königreichs der Matebele, Umzilikazi, Großonkel.

Der Vater gab ihr den vielsagenden Namen unomgu-qo, die Knieende. Vor dem irdischen Zulukönig, Cetsgwayo hat sie zuerst knieen müssen, um die "Herrlichkeit" des Zulutums als Blendwerk des Satans kennen zu lernen. Als sie dann in einem Gesicht die Herrlichkeit Jesu Kristi erlebte, hat sie sich knieend gebeugt vor dem Könige aller Könige Jesus Christus und hat sich berufen lassen als Apostelin in Nordzululand .

Mit ihr habe ich noch sechs Jahre in Lemgo und Esibongweni arbeiten dürfen. Von ihr habe ich viel gelernt. Oft habe ich mir Rat bei ihr geholt.

Das,was sie mir aus ihrem Leben erzählt hat, und ich aufgeschrieben habe, möchte ich berichten. Ich möchte es in erweiterter Form tun als ich es in der Zuluausgabe getan habe. Ich möchte auch zeigen, wie sie mir in der Missionsarbeit noch treu geholfen hat

Gott schenke, daß Vielen diese Erzählung die Freudigkeit zur Missionsarbeit geben möge!

Heinrich Filter

PAUL ALTHAUS THEOLOGIAN, GERMANY, 1888–1966

Paul Althaus always saw a link between his university post and the ecclesiastical duty of preaching which is why, both in Rostock and later in Erlangen, he attached great importance to officiating as university preacher alongside his professorship. He opened his heart in the pulpit. People consistently testified to Althaus's clear and honest Christianity and his authentic style of preaching, which generated great resonance for him.

Althaus represented the fifth generation of a dynasty of pastors who originally belonged to the Reformed church. However, his grandfather converted to Lutheranism and was rooted in the Lutheran Hermannsburg revival movement. Althaus's father, Paul Althaus the Elder (1861–1925), worked as a professor of theology in Göttingen where his focus was on ecclesiastical questions. He earned his doctoral degree in Greifswald in 1896 under Hermann Cremer, a theologian from the Westphalian revival movement. He also maintained contact throughout his life with Adolf Schlatter, a theologian from a background of Swiss Pietism who taught in Greifswald and later in Tübingen.

After passing his university entrance exams in 1906, the younger Paul Althaus initially spent three semesters studying theology in Tübingen with Schlatter, followed by six semesters in his native Göttingen, mainly with his father. He spent the First World War as a medical orderly and as an army chaplain in Łódź. From October 1919 he was professor of systematic theology, first in Rostock and from 1925 in Erlangen. He remained active there as an academic theologian and church preacher until the end of his life.

A product of the euphoria of the period around the foundation of the German Reich after 1870, Paul Althaus believed that each people or *Volk* naturally formed a separate entity. This view was the result of a Christian interpretation of the anti-Napoleonic national movement and the Pietist revival movement. Taking a Christian, German people and state as a starting point, in 1933 great but problematic hopes were invested in the transformation of Germany through the new regime with Hitler as Chancellor. In 1934 Althaus signed the Ansbacher Counsel document, which he saw as the Lutheran addendum to the statements made by the Reformed and Uniate Christians, who had dominated the recent Confessing Synod at Barmen, but he also saw

it as an element of church resistance. However, the Ger Christian movement, which supported National Socialism, the document as a statement of resistance to Barmen an proval of the regime. In the years that followed, Althaus inc ingly distanced himself from the Hitler regime and ma name for himself in the Confessing Church. Indeed, after he achieved great influence and respect through his theo cal works and church activities.

A book which deserves particular mention here is Althaus's work, *The theology of Martin Luther*. He was concerned wit lowing Luther's own voice to be heard', intending that would 'ensure the living influence of Luther on the present This late work imparts Luther in a remarkable way, above a allowing him to speak for himself and thereby (Althaus is clear in his vision) serving to enhance the proclamation o Gospel. Gotthard Jasper

→ Further read

Paul Althaus: *Die Theologie Martin Luthers*, Gütersloh 1962 (Er translation: *The Theology of Martin Luther*, Minneapolis 1966).
Gotthard Jasper: *Paul Althaus (1888–1966). Professor, Prediger u triot in seiner Zeit*, Göttingen 2013.
Paul Althaus, Karl Barth, Emil Brunner. Briefwechsel 1922–1966, hard Jasper (ed.), Göttingen 2015.

The theology of Luther is an ocean

WALTER A. MAIER
RADIO EVANGELIST, USA, 1893–1950

Huston Fi

Walter A. Maier was a scholar of ancient Semitic languages, a Lutheran theologian, an author and an outstanding orator. He gained international renown as the first presenter, from 1930 to 1950, of the immensely popular radio show *The Lutheran Hour*. Maier was born to German immigrants in Massachusetts. He studied theology in the Lutheran Church – Missouri Synod and was awarded his doctorate at Harvard University. He tended to the spiritual needs of German prisoners of war in 1918. In 1922 he became Professor of Old Testament. After the Second World War, the Allied Military Government for Occupied Territories asked him to come to Germany as an advisor. In Germany he engaged with the ecclesiastical issues in the postwar years, drew up recommendations for Christian broadcasts and introduced social support for those in need. Maier died at the age of 56 in 1950.

Maier's enduring aim was 'to preach the great truths of the scriptures. Law and Gospel, sin and grace, Christ and His redemption' (William Arndt). Above all he aimed to convey the message of justification of the sinner through grace alone. In keeping with Luther's own distinction between 'two kingdoms', Maier championed the fair separation of state and church.

Amongst Maier's engagements as a public speaker were lectures on the 400th anniversary of the Catechism to 70,000 listeners (1929), on Thomas Jefferson's ideals of religious freedom (1930), on the Quadricentennial of the Augsburg Confession (1930) and an address entitled 'Back to Luther' (1933). He initiated the founding of the first Christian broadcasting station (KFUO) in St. Louis. He used this new medium of mass communication to spread the Lutheran message. The radio programme *The Lutheran Hour*, which first went out in 1930, is still on air. In 1949 a good 450 million people listened to it in 36 languages in 55 countries. Maier was thus able to reach parts of the world where there was neither freedom of speech nor freedom of religious worship; he brought Luther's reforming message to countless individuals. In 1938 the liberal Federal Council of Churches sought to have any programmes it did not represent banned

from the airwaves. In response Maier claimed his right to dom of speech and religious freedom and won the ensuing c case. *Time* magazine declared that his radio 'pulpit' had t served to preserve the heritage of liberty enjoyed by citizer the United States.

Maier had a gift for communicating the traditional tene Christian faith in a non-traditional manner. He became on the most prolific preachers of the twentieth century. At time of his death in 1950 the audience numbers for the *Luth Hour* far outstripped those of all other regular programme the history of radio.

As a pioneer of international broadcasting Walter A. Maie came a role model for all public communications of the C tian faith. Billy Graham, who applied to be his successor scribed him as the greatest evangelist of the twentieth cent *Time* magazine dubbed him the 'Chrysostom of Americar theranism'. Today the radio programme he founded still re es 800,000 listeners per week in over 30 countries, includ Germany, where it goes out as the *Lutherische Stunde*.

Daniel J. Schmidt

→ Further read
Walter Arthur Maier: *The Airwaves Proclaim Christ*, St. Louis
Paul L. Maier: *A Man Spoke, A World Listened. The Story of V A. Maier and the Lutheran Hour*, New York 1963.
The Best of Walter A. Maier, Paul L. Maier (ed.), St. Louis 198

May God give us the courage and insistence to declare with undeniable finality, 'back to Luther'!

Promotional postcard for *The Lutheran Hour*, after 1930

Carbon microphone from the studio of *The Lutheran Hour*, c.1920

'THE WHOLE WORLD IS FULL OF SERVICE TO GOD.'

WA 36, 325

After surviving a life-threatening storm, during which he vowed to St Anne that he would enter a monastery, Luther became a monk. This step implies a sense of duty which would become a model for Protestantism. In his 95 Theses Luther presents the idea that the whole life of a Christian is penance, and in his treatise on freedom of 1520 he describes the life of a Christian as one of voluntary service to God and neighbour. Based on Luther's example, people continue to honour the principle of subservient neighbourly love as a way of life. Similarly, Luther can provide the inspiration for people to devote themselves entirely to the service of an idea. Others warn that subservience may have fatal political consequences. Should we continue to serve today and, if so, whom should we serve?

EVER LORD AND SERVANT: LUTHER, DUTY AND SERVICE

CHRISTOPH DIECKMANN

My father was a pastor in Martin Luther country, not far from Eisleben, Wittenberg, Erfurt and the Wartburg. A church outing once took us to Mansfeld to visit Luther's childhood home, where my father talked to us about a pivotal moment in Martin's life. There was a dramatic engraving on the wall, depicting Luther in the thunderstorm near Stotternheim on 2 July 1505. Lightning flashes down from the black sky. Panic stricken, Luther vows to St Anne that if he survives he will become a monk. He makes his vow at the very last moment, as next to him lies the body of his friend, Alexius, who has just been struck dead by a bolt

of lightning. My father explained that the scene was a romantic composition dating from the nineteenth century – Luther's friend actually died in a different thunderstorm. 'No!' cried the pietistic nursery teacher. 'No, Pastor, it was just like in the picture! I will not let go of my Luther!'

'I will not let go of my Jesus', is the title of a chorale written by Christian Keimann in 1658. A word of Protestant warning is needed here: Luther was not a saint. However, the apparently undying cult of Luther bears witness to the fact that scrapping the Catholic saints left behind spiritual needs that could not fulfilled by 'the Word' alone. To some extent, Luther the hero took the place of Saints Sebastian, Francis of Assisi and Catherine of Alexandria.

The hagiography of Martin Luther begins in Wittenberg. In 1517 the Augustinian monk nails his 95 Theses to the door of the town's Castle Church, driving home the advent of the modern era in Europe. Next the valiant reforming hero defies the Emperor, the Pope and the Devil and creates the German Bible at the 'mighty fortress' of the Wartburg near Eisenach. He then goes on to invent the Protestant pastor's wife, music-making in the home and, indeed, the Christmas tree. He 'cannot do otherwise'. Amen.

Luther's actual life is divided into seeking and finding. The Stotternheim storm marks his calling to become a theologian, but during his first decade as a monk he is still very much Luther the seeker. He seeks to satisfy God, but sees himself as an unworthy servant. He offers service to God and subjects himself to the most rigorous practices of asceticism and prayer. He agonises and chastises himself, apparently compelled to religious fundamentalism. His father confessor, Johann von Staupitz, attempts, in vain, to moderate his behaviour.

Where Staupitz fails, however, the apostle Paul succeeds. Around 1515 the young professor Luther has his 'Tower Experience' in the Augustinian monastery in Wittenberg while reading a passage in the Letter to the Romans: 'For in it the righteousness of God is revealed from faith for faith, as it is written, "The righteous shall live by faith."' (Romans 1:17). Reading this in Latin, Luther once again experiences a sudden flash of insight, this time grammatical. The genitive, *iustificatio Dei*, does not mean the righteousness *of* God, which may be earned: God is righteous, that is, he is merciful to us, his beloved creations, without any need for us to act to earn that mercy. Luther comes to understand at this point that humans in general, and he, Martin Luther, in particular, are redeemed by this love-in-advance. Set free on the inside, he can now act on the outside. Henceforth he turns his religious zeal against the false teachers of the Gospel, those who profiteer from the sale of indulgences, and thus against the Papal Church itself.

The first of the Wittenberg Theses could be Luther's life motto: '*Dominus et magister noster Iesus Christus dicendo. Penitentiam agite. etc. omnem vitam fidelium penitentiam esse voluit.*' – 'When our Lord and Master Jesus Christ

said, "Repent", he willed the entire life of believers to be one of repentance.' (WA 1, 233; LW 31, 25). What is meant here is not ritual remorse, but rather living by the Word of God, as defined by Luther in his golden rule *On the freedom of a Christian* (1520): 'A Christian is a perfectly free lord of all, subject to none. A Christian is a perfectly dutiful servant of all, subject to all.' (WA 7, 21; LW 31, 344).

Martin Luther was a provincial man living in the late Middle Ages, with virtually no understanding of the complex fabric of the world at that time. His class-oriented thinking seems alien to us today, as, thank God, does his raging against the Jews, whom he denounced as obdurate deniers of the Saviour. Yet Luther's ethos of duty in the form of service to God was propagated through the Enlightenment to our secular democracy with its welfare state and human rights. Throughout centuries of change, Protestantism has continued to uphold Luther's highest earthly authority – the conscience. No people, no state – the individual is God's creation and counterpart, unmediated by temporal or spiritual authority. Every believer 'must obey God rather than men' (Acts 5:29). This is supported by the words of the Psalm (119:46) at the beginning of the *Augsburg Confession* (1530): *'Et loquebar de testimoniis tuis in conspectu regum et non confundebar.'* – 'I will also speak of your testimonies before kings and shall not be put to shame.'

Yet anyone who grew up in the GDR encountered an entirely different Luther beyond the Church. In the history books of the East German state he was given the defamatory title, the 'princes' lackey'. The real hero, the early bourgeois revolutionary, was the 'peasant leader', Thomas Müntzer. This follower and later adversary of Luther preached true liberation of the people. The freedom of Luther was spiritual in essence, but the combatants in the Peasants' War of 1525 understood the new teaching as a call to revolution. The princes avenged themselves with mass murder and Luther encouraged them.

We now cringe at his immoderate tone in *Against the robbing murdering thieving hordes of peasants* (1525): 'Therefore let everyone who can, smite, slay, and stab, secretly or openly, remembering that nothing can be more poisonous, hurtful or devilish than a rebel. It is just as when one must kill a mad dog; if you do not strike him, he will strike you, and a whole land with you... A pious Christian ought to suffer a hundred deaths, rather than give a hairsbreadth of consent to the peasants' cause. Therefore, dear lords... Let whoever can stab, smite, slay... If anyone thinks this too harsh, let him remember that rebellion is intolerable and that the destruction of the world is to be expected every hour.' (WA 18, 358–361; LW 46, 50–55).

It was only as an instrument of the Gospel that Luther rejected the sword, not when it was used to defend 'God-given' authority. He believed that to make war against this authority was to attack God, to question that God's purpose was served through the princes. This seemed to sanction the au-

thority of the existing political order. Luther himself was incredibly fortunate with his princely ruler and the general political climate: the Emperor was tied up fighting the Turks and Saxony's Elector Friedrich the Wise provided protection to both Luther and the Reformation. Friedrich's authority also ensured that in 1521 Luther, an outlawed heretic following the Diet of Worms, was able to vanish into the Wartburg. The highly regarded Saxon Elector had actually been offered the imperial crown but had declined it on the basis that he was too old. After this he was considered to be the most influential prince of the empire. The young Habsburg Emperor Charles V was unable to wrest the Elector's Professor Luther away from him and burn him to death, as had happened to Jan Hus in 1415.

Friedrich the Wise and Luther formed the original pairing in the Protestant alliance of throne and altar. The Reformation established state rule over the Church, the princely hand of protection becoming the Achilles heel of Protestantism. The executors of Luther's legacy behaved execrably, nationalising both him and God. Prussian militarism co-opted Luther for self-sanctification. The Nazis proclaimed him a quintessential Teuton and the German Christians of the time declared him their *Sturmbannführer*. In 1942 then German army officer and later Chancellor Helmut Schmidt was on the Eastern Front and beset by historical and moral doubts. Hitler's Operation Barbarossa reminded him of Napoleon's predatory raid of 1812. He spoke about his misgivings with a young theologian who knew Paul's Letter to the Romans by heart and quoted Chapter 13, verse 1: 'For there is no authority except from God, and those that exist have been instituted by God.' Lieutenant Schmidt felt reassured by this – for a while. The former German Chancellor gave this account in 1994 on the occasion of the 50th anniversary of the attempt to assassinate Hitler. For a long time the putschists around Stauffenberg had served the God-given authority of the criminal regime, in fulfilment of their 'military duty'.

In 1983 Luther, now a citizen of the GDR, celebrated his 500th birthday. By this point the communists of the Socialist Unity Party of Germany had rehabilitated him. He was ours, like Goethe and Bach: a pioneer of the humanist German nation which, of course, only reached full bloom under the 'Dictatorship of the Proletariat'. Meanwhile, the German Evangelical Church finally valued Luther for reasons unconnected with the state. For the first time in its history it had had to renounce power. It now saw itself as a 'Church for others', in the words of Dietrich Bonhoeffer, who resisted the powerful on grounds of Protestant conscience.

Did the 'church in socialism' prop up or topple the East German state? This is a bold question. It was not the Church's role to do either of these things. To put it rather melodramatically, the Church saw its mission as being 'to bear the cross'. It adhered to a different belief from the Marxist doctrine of salvation. Most importantly, in a much clearer and less Lutheran

way than today, the Church said NO to any ideology of violence. It taught the fundamental difference between Jesus's message of peace and the national interest. This meant that the Church gained trust and was able to become a facilitator in the revolution of autumn 1989. This is also the reason why the *peaceful* revolution was successful. Not long before this, as the people of the GDR were fleeing to the West in their hundreds of thousands, Christa Wolf had listed the indispensable servants of society, declaring that writers, doctors and pastors should stay.

The authorities attached very little importance to all this. I will never forget the reason given by the local schools inspector, a real Margot Honecker of the provinces, when she denied me permission in 1972 to do my university entrance exams and go on to study: 'You do nothing for the people, so the power of the people won't do anything for you.' Comrade R. was taking revenge for my having refused to join the socialist youth league. Today I am thankful that my parents had the Lutheran courage to say NO. Back then pastor's daughter and Free German Youth secretary, Angela Merkel, made a different choice and Ms Merkel's chancellorship was also marked by tactical conformity – until 31 August 2015, when the Christian Democrat Chancellor spoke about the refugee crisis, using the now much-quoted phrase: 'We can do it'. This truly Lutheran German sentence unites notions of penitence, duty and service.

As a child I was fascinated and frustrated by the fact that the door of the parsonage where we lived was always open. People came to the the house at all times of day. My father was always on duty, except for three weeks in the summer. Every August he wrote a note and pinned it to the door for anyone who might come knocking: 'Pastor Dieckmann will be away until:… His duties will be covered by Pastor Fischer.'

FRIEDRICH WILHELM I
MONARCH,
PRUSSIA, 1688–1740

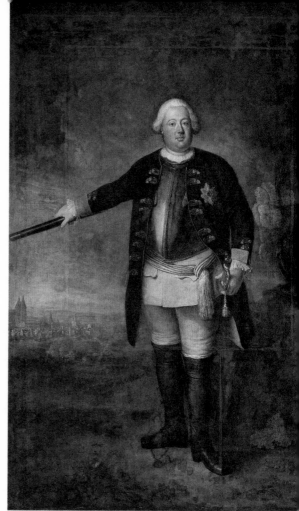

An ascetic by nature, Friedrich Wilhelm I almost completely did away with the ceremonial courtly traditions developed by his father; a tireless worker as long as he lived, he reduced pleasure in his state to a minimum and raised the level of efficiency, above all in military matters, to the maximum; an excessively strict father, he had his son's closest friend beheaded, in order to rid his heir of his 'weakness' – it is easy to understand why King Friedrich Wilhelm I of Prussia went down in history with the martial-sounding moniker 'the soldier king'. However, this picture of him should also be coloured by the fact that Friedrich Wilhelm I was a soldier king who never went to war. He believed that he would one day have to answer to his maker for every soldier who fell in any unjust war he might wage – so he chose not to declare war on any other nations.

His father, Friedrich I, had only established Prussia as a kingdom in 1701. But it was Friedrich Wilhelm I, with not the slightest interest in his father's fondness for Baroque splendour, who gave his kingdom the character that the world still associates with the name Prussia. He himself was a paragon of 'Prussian virtues': order, discipline, diligence, obedience. In full agreement with the Pietist teachings of August Hermann Francke, namely that the 'old', sinful individual had to be broken by education in order to make way for the 'new', free Christian, Friedrich Wilhelm I applied this same principle to the internal politics of Prussia. The loyal legion of compliant civil servants he created to run his administration was no less impressive than the armed forces he established.

His champions have always extolled the Prussian state for its ethos of public service. The spiritual-religious roots of this ethos lie in the Lutheran brand of Protestant Pietism, and in a sense Friedrich Wilhelm I was its incarnation. Unlike his son, still known the world over as Frederick the Great, Friedrich Wilhelm I did not see his role as monarch and hence 'the first servant of the state' in secular terms but rather as a duty arising from Pietistic Christian beliefs. There was a healthy dose of Luth[eran] legacy at work here, despite the fact that in the early sevente[enth] century the Prussian dynasty had left the Lutheran Church [for] the Reformed Church. And, in any case, Friedrich Wilhe[lm I] regarded the internal conflicts between Protestants as little m[ore] than 'sermonisers' squabbles'. At the same time the comb[ina]tion of unwavering, personal faith and intransigent author[itar]ianism – along with an active appreciation of worldly deli[ghts] such as smoking tobacco, eating, drinking and hunting (des[pite] his distaste for pomp and ceremony) – was entirely in keep[ing] with the notion Luther had of Christian princes. And the in[her]ent ambivalence in the emphasis on service and obedie[nce] which is part of the legacy of Martin Luther, is seen to par[ticu]lar effect in the figure of Friedrich Wilhelm I.

Benjamin Hasselhorn

→ Further read[ing]
Jochen Klepper: *Der Vater. Der Roman des Sol[daten]königs*, Stuttgart 1937.
Christopher Clark: *Iron Kingdom. The Rise and F[all of]Prussia*, 1600–1947, London 2006.
Preußens Herrscher. Von den ersten Hohenzoller[n bis]Wilhelm II., Frank-Lothar Kroll (ed.), Munich ²[...]

The good Lord did not put you on the throne to idle your time away, but to work.

Friedrich Wilhelm I, *Politisches Testament*, 17 Februrary 1722

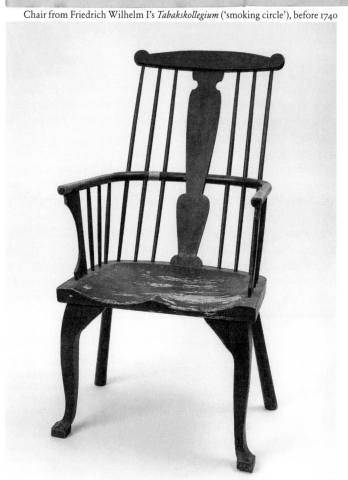

Chair from Friedrich Wilhelm I's *Tabakskollegium* ('smoking circle'), before 1740

KÄTHE KOLLWITZ ARTIST, GERMANY, 1867–1945

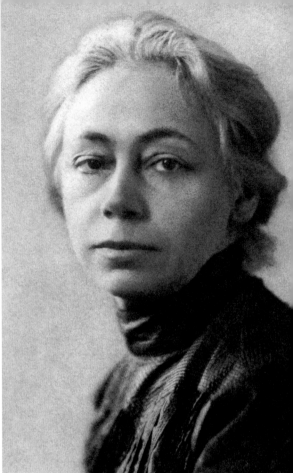

Martin Luther rarely figures in the writings of Germany's best known woman artist of the twentieth century. Yet one diary entry in 1915 reveals a deep awareness of his thinking. This is hardly surprising since Käthe Kollwitz grew up in Königsberg in the Free Evangelical Lutheran community founded by her grandfather, the theologian Julius Rupp (1809–1884). Little research has been done on the potential influence of Luther's writings on Kollwitz. However, her work ethic was unmistakably Protestant; she had absorbed it from her grandfather for whom a gift (*Gabe*) always also entailed an obligation (*Aufgabe*).

Kollwitz took drawing lessons at an early age and trained in Berlin and Munich until 1890. Soon after her marriage to Karl Kollwitz (1863–1940) and their move to Berlin in 1891, she decided to devote her gift to alleviating the suffering of social outsiders. Her print series, *A Weavers' Revolt* (1893–97), marked her first artistic success, which she consolidated with *Peasants' War*, a cycle of etchings made between 1902/03 and 1908. Following a trip to Paris in 1904 Kollwitz became increasingly interested in creating three-dimensional figures. The First World War proved to be the most significant turning point in her life and work. Her younger son, a volunteer, died in Flanders in October 1914 and Kollwitz was drawn to pacifism, which underpins many works, such as the poster *Never Again War* (1924) and the lithograph '*Seed for sowing should not be milled*' (1941). When the National Socialists came to power her critical attitudes soon saw her sidelined. In 1933 the regime obliged her to resign from the Akademie der Künste and from 1937 her work was scarcely seen in public. In 1943 she was evacuated from Berlin, first to Nordhausen and then to Moritzburg, where she died in 1945 shortly before the end of the war.

Kollwitz could be said to have engaged at least indirectly with Luther between 1899 and 1908 when she was working on images for her *Peasants' War* cycle. For her research she read the account of the peasants' uprising in the sixteenth century by the Protestant theologian Wilhelm Zimmermann (1807–1878). Like Zimmermann, Kollwitz puts the case for the uprising from the point of view of the humiliated, disenfranchised peasants; they both took issue with Luther's criticism of the peasants' continued rebellion after initial attempts at a reconciliation (1525).

Kollwitz visualises the agitation of the peasants vividly empathetically: she makes the peasants' fight our fight an horts the viewer to struggle for greater justice than history to their cause.

In plate 1 of the *Peasants' War* cycle (shown here), two peas are dragging a plough through the ground like draft cattle. picture format and dark clouds leave them no space to st up and fight for their dignity. Despite being tethered to soil, it may just be that the younger ploughman gazing u wards the distant, lighter horizon already has his own sen Luther's ideas in his treatise *On the Freedom of a Christian* (1 which the peasants related to their earthly lives in this w For Kollwitz the notion of servitude sustained by inner dom alone, as Luther expected of the faithful, was nothing s of inhumane. Annette Seeler

→ Further read
Alexandra von dem Knesebeck: Käthe Kollwitz. Die p den Jahre (*Studien zur internationalen Architektur- und geschichte*, Bd. 6), Petersberg 1998.
Käthe Kollwitz: *The diary and letters of Käthe Kollwitz*, Kollwitz (ed.), Illinois, 1988.
Annette Seeler: *AUFSTAND! Renaissance, Reformatio Revolte im Werk von Käthe Kollwitz*, Hannelore Fischer catalogue to exhibition of the same name, Cologne 20

I felt that I have no right to withdraw from the responsibility of being an advocate. It is my duty to voice the sufferings of men, the never-ending sufferings heaped mountain-high.

Käthe Kollwitz, *The Ploughmen*, 1906, plate 1 of the *Peasants' War* cycle

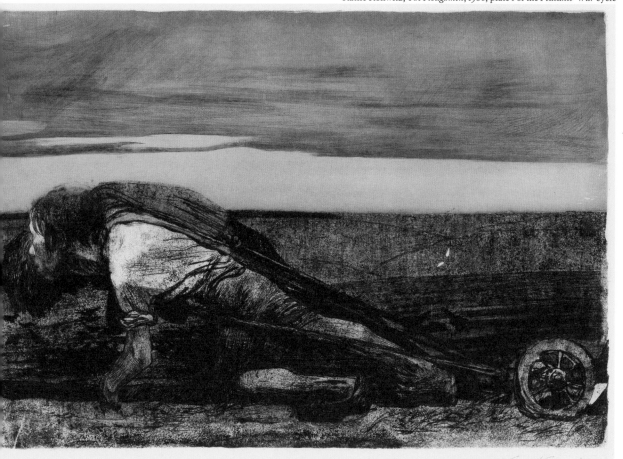

JOCHEN KLEPPER

WRITER,
GERMANY, 1903–1942

'The Night Will Soon Be Ending' – a dozen hymns by Jochen Klepper in the Lutheran hymnary attest at a glance to his importance in the development of Lutheran worship in the twentieth century. Klepper grew up in a Lutheran parsonage, where ill health overshadowed his childhood and youth. After school he studied theology, first in the conservative, Lutheran town of Erlangen and then in Breslau, where he was drawn to Luther by the systematic theologian Rudolf Hermann. In late 1926 Klepper abandoned his studies in theology and found work as a journalist and writer. In 1929 he met a widow named Johanna Stein, who was 13 years his senior and had two daughters. Klepper instantly fell in love with her. Despite pressure from relatives and their own social circles, they married in 1931.

In 1933, the year when the National Socialists seized power, Klepper published his first novel, *Der Kahn der fröhlichen Leute* ('The Happy Barge Crew'). At the same time, as a member of the Social Democratic Party of Germany, he lost his work at a radio station and as a journalist. However, in 1934 he was accepted into the Reich Literature Chamber and given a new position there. Despite this, his relations with the National Socialist regime were always difficult, and in 1937 he was expelled from the Reich Literature Chamber. Shortly before that he had published his most famous novel, *Der Vater* ('The Father'), which became a bestseller and was particularly enthusiastically received by the armed forces in Germany. *Der Vater* explores the life of Friedrich Wilhelm I and the Prussian ethos of service, which Klepper particularly associated with the spirit of Lutheranism. Friedrich Wilhelm I, the 'soldier king', is portrayed by Klepper as a monarch who is fulfilled by his sense of duty and responsibility towards his subjects, a monarch whose ascetic lifestyle and harsh upbringing ultimately equipped his own son with the qualities that saw him enter the annals of history as Frederick the Great. Klepper, who always regarded himself as a Lutheran theologian, wanted to devote his next book to Martin Luther's wife, Kath-

arina von Bora, and the Evangelical Lutheran parsonage. had already accumulated thousands of pages of notes on Lu and the history of the Reformation. Indeed, the novel wa important to him that he placed the pen nibs he had used write the opening pages in an envelope for posterity. Howe he only managed to complete one chapter.

The situation for Klepper and his family was already becom extremely difficult by then. Having been called up for mili service in 1940, he was dismissed again in 1941 for living in a ' Aryan' marriage. In 1942 he faced compulsory divorce, wh would have meant deportation for his wife and her you daughter; the older daughter had managed to leave the co try in 1939. On 10 December 1942 Jochen Klepper, his wife her daughter took their own lives together. Earlier that da wrote a final entry in his diary: 'This afternoon the negotiati with the Security Service. Now we die – but even that is up God. Tonight we shall die together. Above us in our last ho is the picture of Christ in benediction, who fights for us. C lives will end under His gaze.' Benjamin Hasselhor

→ Further read
Jochen Klepper: *Der Vater. Der Roman des Soldatenk*
Stuttgart u. a. 1937.
Jochen Klepper: *Das ewige Haus. Geschichte der Kath*
von Bora und ihres Besitzes. Roman-Fragment, Stuttgar
Markus Baum: *Jochen Klepper*, Neufeld 2011.

God also knows, however, that I will accept any-
thing from him by way of test and punishment.

Jochen Klepper's nib with envelope inscribed: 'It was with this nib that I started writing *Das ewige Haus*', before 1942

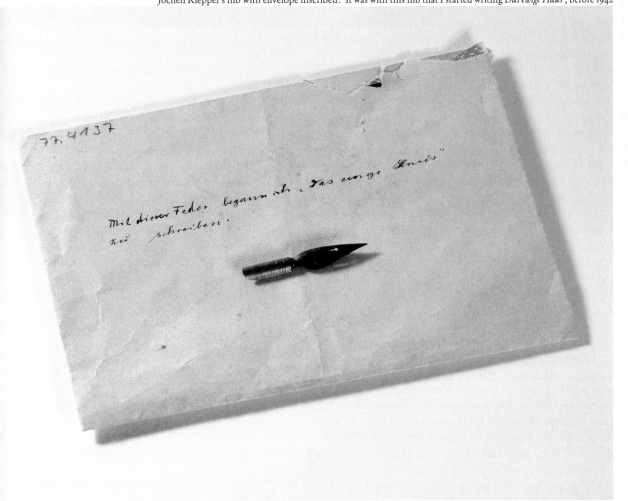

ASTRID LINDGREN
WRITER,
SWEDEN, 1907–2002

Astrid Lindgren was born in 1907 in Vimmerby, Småland. Her first children's book, which soon become known the world over, was *Pippi Longstocking* (1945–48); numerous other books followed until her last novel in 1981. Both her books and their film versions gained her consistent popularity which endures to the present day.

Sweden was shaped by Lutheran thinking until well into the twentieth century, and Lindgren's works often reference and transform religious language, symbols and topics. However, translations of her books into other languages have often blurred the religious overtones of Lindgren's own use of language. In the original Swedish of *Karlsson on the Roof*, Karlsson, seeing everything that has gone wrong, makes little of it with a laconic allusion to Luther's description of marriage as a 'worldly matter' – *'Det är en världslig sak'* (see, for instance, WA 30/III, 74; LW 46, 265). In at least one English translation this becomes 'Ah, that's a mere trifle', completely obscuring any allusion to Luther.

Mio, My Son and, even more so, *The Brothers Lionheart* contain a sophisticated web of religious themes and images. In the latter Lindgren focuses on resistance against tyranny and, in so doing, sets out a global, ethical principle centred on helping or serving, one's neighbour, which is neatly summed up in a categorical imperative: 'There are things you have to do … otherwise you aren't a human being, just a bit of filth.' This statement is an assimilation of ethical precepts that bear the stamp of Luther, or at least of Lutheran thinking. The service rendered by children – to other children and to adults, too – is Lindgren's underlying theme in her works. Pippi does not merely sidestep the adult world, she imaginatively helps Tommy and Annika and defends the weaker children. In *Ronia, the Robber's Daughter*, having found a way to reconcile the stubborn, feuding rob-

bers Matt and Borka, Ronia and Birk decide not to follow their outlaw fathers' footsteps. And in *Emil and the Great cape*, Emil does something one winter's night that none of adults dared to do: defying the severe weather, he saves fa hand Alfred from blood poisoning by driving him thro the storm to the doctor in Mariannelund. Even in the enti whimsical *Emil* stories, there is always a sense of the im tance of helping one's neighbour.

But this is not the only Lutheran theme in the third *Emil* b Lindgren also creates an unforgettable, lovingly exagger memorial to the catechetical meetings that were a special ture of the confessional culture of Sweden from the sevente century to the late nineteenth century. An important par those meetings was the congenial togetherness of church m bers sharing a 'feast' after the catechistic part of the exam tion of faith. Lindgren's last *Emil* story conveys a particul vivid impression of the interdependence of community and vice that is the enduring refrain connecting all her books.

Otfried Czaika

→ Further read

Otfried Czaika: *Jonathan unser Erlöser. Religion und tentum in Astrid Lindgrens Buch Die Brüder Löwenherz. pretationsansätze mit besonderer Berücksichtigung christ Symbole, Traditionen und Diskurse*, Munich 1996.
Werner Fischer-Nielsen: *Astrid Lindgren och kristend Utifrån Pippi, Emil och Madicken*, Stockholm 1999.
Astrid Lindgren: *A World Gone Mad: The Diaries of A Lindgren, 1939–1945*, London 2016.

There are things you have to do, otherwise
you aren't a human being, just a bit of filth.

When Emil performed a heroic feat, scenes from:
Olle Hellbom, *Emil and the Piglet*, 1973

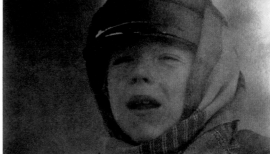

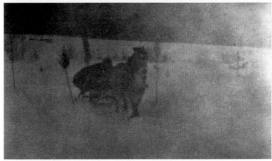

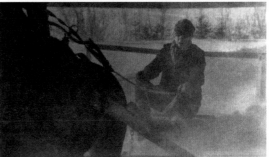

Astrid Lindgren, Swedish manuscript of *Emil and the Piglet*, 1970

AXEL C. SPRINGER
PUBLISHER, GERMANY, 1912–1985

Born in 1912, Axel Springer witnessed the decline and fall of the Weimar Republic and the rise of National Socialism. He kept his distance from the latter, no doubt drawing the strength to do so from his Lutheran upbringing and the solid grounding he received in his confirmation classes. With almost prophetic prescience, his pastor sent him on his way with the quote: 'For what will it profit a man if he gains the whole world and forfeits his soul?' (Matthew 16:26) – a maxim that Springer never forgot. As a publisher he was often the fulcrum of public controversy and conflict and he became a particular hate figure for the new leftists from the late 1960s. It may have been Luther who taught him never to deny his own convictions even in the most strident disputes. As the *homo politicus* that he became, Luther's distinction between the two kingdoms of God was of fundamental importance to Springer: the law, justice and the threat of punishment ward off chaos in this world and the gospel of grace, forgiveness and love gives comfort to fallible human beings. The two cannot be intermingled, otherwise the Gospel will become no more than 'law', an imperative enforced by the threat of penalty – and it will perish, because it no longer brings comfort. The logical consequence of this distinction is the clear separation of church and state, which have different tasks, must respect each other and must not compete with each other. It was only on this basis that Springer could properly serve both the body politic and the church. In the 1960s and 1970s he became painfully aware of the blurring of the separation of the two, which made him take even more careful note of Luther's teachings. Fighting injustice on the part of the state and society was his own, personal political mission. But he needed the Church for his conscience, his soul. He sought and, once he had moved to Berlin, ultimately found his spiritual home in the Old Lutheran Church. It was not a church that came up with suggestions for daily politics, but it did whet his conscience: Axel Springer became a churchgoer.

At the same time his soul drew comfort from Luther. Springer always had a collection of Luther's sayings to hand and a copy of Thomas à Kempis' *Imitation of Christ* (c.1418). Until his ing day he used a Bible verse calendar with specifically Lut an interpretations. So often attacked, suffering spiritual dist burdened and struck down by fate, Springer absorbed wha learnt from Luther's interpretation of the Lord's Prayer: des is a sin. He and Luther both had, in the best sense, a simple f that manifested itself in love and a desire to help others. A in Springer's case that help ranged from paying ransoms for litical prisoners in the GDR out of his own pocket to creat foundations in numerous locations, and from taking the ti to listen to any employee to actively supporting those in n In 1985 Axel Springer died in the Martin Luther Hospita Berlin. At his funeral service he was described as follows: ' was at his greatest when he came to his God as a Christian, wl he went down on his knees, begging forgiveness and receiv it, in God's church, through the sacrament that Christ crea for us.' Jobst Schöne

→ Further read

Axel Springer: *Reden wider den Zeitgeist*, Berlin and Frank am Main 1993.
An interview with Axel Springer by Renate Harpprecht, in: *Axel Springer. Neue Blicke auf den Verleger*, Mathias Döp (ed.), Hamburg 2005, 120.
Hans-Peter Schwarz: *Axel Springer. Die Biografie*, Berlin 2

The world is changed by dreams, by industriousness

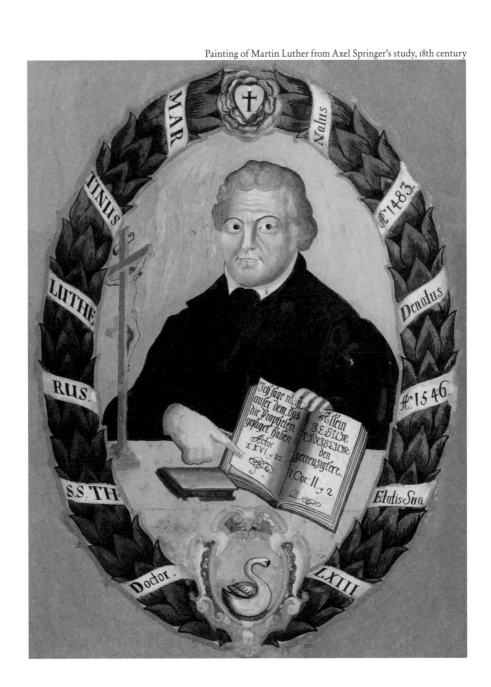

JOSÉ MÍGUEZ BONINO

THEOLOGIAN,
ARGENTINA, 1924–2012

José Míguez Bonino, a Methodist minister born in Santa Fe in northeast Argentina, was one of the leading Protestant figures in Latin America. In 1943 he enrolled as an undergraduate theology student in Buenos Aires. Following his graduation he initially worked as a pastor in Mendoza. He then attained a masters degree in the USA and returned to Buenos Aires in 1954, where he spent the next four years as Professor of Dogmatic Theology at the Evangelical University. He earned his doctorate, in ecumenical theology, at the Union Theological Seminary in New York City. Bonino later became director of the Instituto Superior Evangélico de Estudios Teológicos (ISEDET) in Buenos Aires. He was the only Protestant theologian from Latin America to be present at the Second Vatican Council (1962–65) as an observer and he served on the Central Committee of the World Council of Churches for over three decades. Bonino was also a member of the National Congress of Argentina (the legislative branch of the Government of Argentina), he was President of the Permanent Assembly for Human Rights in Argentina and also served as President of the World Council of Churches in Geneva.

In his work Bonino combined his expertise in ecumenical Christianity with liberation theology and the fight for social justice. In 1975 he published his book *Doing Theology in a Revolutionary Situation*, in which he endorsed the fight for social liberation in Latin America and the Third World. The aim was to present 'a critical and committed Christian reflection of the people who have made this struggle their own and who understand it as the concrete witness to the freedom that has been promised to man in Jesus Christ'. It was against this backdrop that José Míguez Bonino pursued his determination to 'do theology' in the revolutionary situation of Latin America.

For Bonino, evangelical ethics founded in Luther's striving freedom did not require subservient obedience to the state, rather the liberation of the individual from oppression. therefore set his sights on combining biblical reformation ology with practical social care for the weak and disadvanta During the era of the military dictatorship in Argentina (–83) Bonino attached central importance to political et and the struggle for human rights. He was a co-founder of Ecumenical Human Rights Movement in Argentina (MEL which is still fighting to uncover the fates of all the 30,00 dividuals who were disappeared during the military junta. Throughout his life Bonino sought to advance the ecumen movement, human rights and social reform. After his death 30 June 2012 he was honoured in Latin America for his serv in the field of human rights. Bonino was a leading figure in first generation of Protestant liberation theologians, who g theological and practical support to the process of social political change in Latin America. An Paenhuysen

→ Further read
José Míguez Bonino: *Doing Theology in a Revolutio Situation*, Philadelphia 1975.
José Míguez Bonino: *Toward a Christian Political E* Philadelphia 1983.

How can the message of unconditional acceptance be received unless a community of mutual free acceptance gives a content to the message?

MICHAEL HANEKE

FILM DIRECTOR,
AUSTRIA, B. 1942

Having taken a degree in philosophy, psychology and theatre studies, the Austrian film director Michael Haneke gained practical experience in film production as an editor and dramaturg. He made television dramas and worked in the theatre, before directing his first feature film in the late 1980s. Haneke's deep interest in psychological issues has shaped his work, much of which also explores the nature of violence. He has been awarded numerous international prizes for films such as *Funny Games* (1997), *The White Ribbon* (2009) and *Amour* (2012).

In his youth Michael Haneke toyed with the idea becoming a pastor. He felt the Protestant Church had an appealing 'arrogance of sorts, an elitism of sorts' arising from the obligation to face up to one's own guilt. *The White Ribbon* is a case study of the relationship between guilt and punishment, humility and humiliation. Shot in black-and-white, it depicts a north German village community shortly before the outbreak of the First World War. Life in the village is structured along rigidly authoritarian lines. The children are on the lowest rung of the hierarchy and are regularly chastised and humiliated. Luther, who was often disciplined as a child at home, advised parents to lay an apple next to their rod and to punish children for any lapses in obedience or piety (WA 41, 410). In the film the village children find their own way of defending themselves. They appear to fully absorb the Protestant ideals of their parents and go on to violently avenge the sins of their parents. It was originally planned to call the film 'The Right Hand of God'. From a historical perspective it is all too apparent that this was the generation that took Germany into National Socialism. Haneke has cited the self-defence of Adolf Eichmann as one of the catalysts that led him to make the film – until the bitter end Eichmann regarded himself as a faithful servant of his people who was only carrying out orders. Where does moral radicalism come from, particularly in Germany? Haneke also explores the Protestant parsonage as the incubator of the forcible repression of freedom of conviction. The life stories of the RAF terrorists Ulrike Meinhof and Gudrun Ensslin, both of whom came from Protestant homes, were another important point of reference for Haneke.

The Protestant idealisation of service and diligence is on linked to an extreme sense of guilt. One way of responding humiliation and of regaining self-respect is to strike out viole at others. It is therefore entirely logical that the film leads the outbreak of the First World War. The congregation s Luther's hymn 'A Mighty Fortress Is Our God', conjuring an image in the viewer's mind of people standing shoulde shoulder in the face of a common enemy. This hymn wa fact widely used by German forces in the First World Wa a nationalistic battle song. The 'ancient foe' referred to in hymn could just as well be the wartime enemy on the other of the border as followers of a different faith within one's country. As such it raises the question of Luther's hostilit Judaism. Be that as it may, in his film Haneke plays out a p ble that shows every form of fundamentalism to be a pervers of an ideal. Kristina Jaspers

→ Further read
Nahaufnahme Michael Haneke. Gespräche mit Th Assheuer, Berlin 2010.
Michael Haneke, The Art of Screenwriting No terviewed by Luisa Zielinski, *Paris Review*, issu Winter 2014.
Michel Cieutat and Philippe Rouyer: *Haneke Haneke. Gespräche mit Michael Haneke*, Berlin 20

The notion of absolute authority has a massive presence in the writings of Martin Luther

Scenes from: Michael Haneke, *The White Ribbon*, 2009

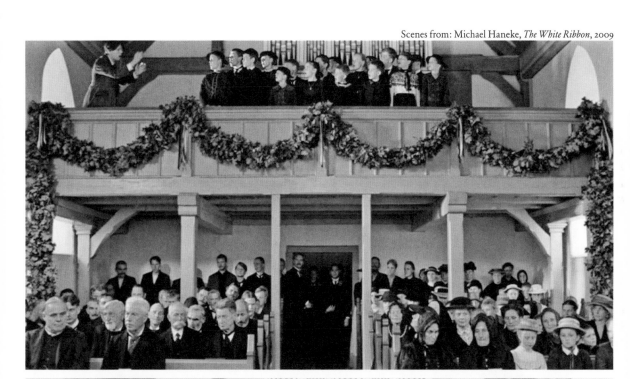

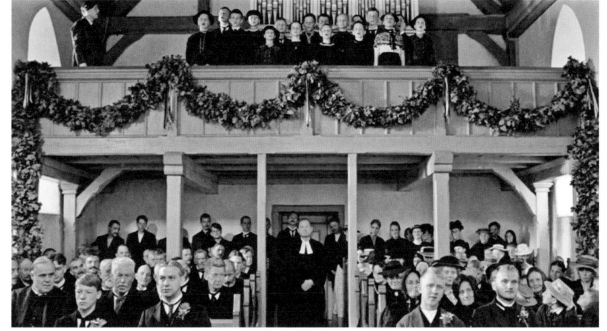

'ACCURSED BE THE LIFE, WHERE ONE LIVES ONLY FOR HIMSELF AND NOT FOR HIS NEIGHBOUR'

WA 10 I/2, 240

Loving kindness towards one's neighbour is the cornerstone of Christian ethics. This also applies to Luther's ethics. He believed that only those who were liberated by the Gospel were in a position to perform good works. However, the desire to act in the interest of our neighbour can also have mixed results, for example if we think we know what's best for them, or if views differ as to who exactly is our neighbour. What form does active charity carried out in the Lutheran spirit take? Does it tend to contradict authority or support it? Luther inspires us to think about charity and to act on it. Some people go so far as to devote their lives to it.

FROM WITTENBERG TO THE WELCOME MAT

BARBARA BEUYS

Grace – justification – the two-kingdoms doctrine: these are the key concepts that spontaneously spring to my mind in connection with Martin Luther. Charity had a long wait before it appeared on the great reformer's horizons. To put it in Luther's own vivid terms, it was languishing in darkness under the bench. Let us take that hallmark of Protestant thinking out into the light and with it that small, courageous throng of Lutherans who formed the bridgeheads for this linchpin through the centuries.

1 5 1 8 Martin Luther, monk and doctor of theology, is invited to address the Augustinian chapter meeting in Heidelberg. He talks of 'my theology' for the first time without fear of contradiction.
Thesis XIII: 'Free will, after the fall, exists in name only, and as long as it does what it is able to do, it commits a mortal sin.' (WA 1, 359–360; LW 31, 49).
Thesis XVII: 'Nor does speaking in this manner give cause for despair, but for arousing the desire to … seek the grace of Christ.' (WA 1, 361; LW 31, 51).

1 5 2 0 Having set out his ideas to the Augustinians, Martin Luther publicly proclaims his theology in two major texts: his *Treatise on Good Works* in June and *The Freedom of a Christian* in November. In so doing he lays the foundations for Protestant theology and life. He takes as his point of departure a verse from St Paul's epistle to the Christian community in Rome: 'For we hold that one is justified by faith apart from works of the law.' (Romans 3:28).

But is the Bible not filled with laws that must be enacted in the name of God? Knowing that there will be sharp thinkers who imagine they have found a loophole in his theology that will relieve them of that burden, Luther lets them speak out in person: 'If faith does all things and is alone sufficient unto righteousness, why then are good works commanded? We will take our ease and do no works and be content with faith.' But he halts them in their tracks: 'Not so, you wicked men, not so', before going on to explain the seeming contradiction (WA 7, 29–30; LW 31, 358–359).

The Christian believer has a dual nature. While there is the 'spiritual, inner, or new man' who dwells in the kingdom of God, he also has a bodily component, 'which men refer to as flesh, he is called a carnal, outward, or old man' (WA 7, 21; LW 31, 344). As long as he lives on Earth he is a human being among human beings, and, as Luther puts it, 'Here the works begin' (WA 7, 30; LW 31, 359). And Jesus Christ made it very clear in the Gospels how human beings should treat their fellow humans, their neighbours: they should always be righteous and oppose unrighteousness.

Martin Luther knew his fellow Christians. There were plenty 'who fight most actively and busily against the wrong which is done to the rich, the mighty, or their own friends, but who are quite quiet and patient when wrong is done to the poor, or to those of low estate, or to their own enemy. … They are hypocrites' (WA 6, 226; LW 44, 50). And another argument is debunked: 'And where one cannot prevent this by force and help the truth, one can at least confess the truth' (WA 6, 227; LW 44, 51).

There is no escaping the requirement to do well by all others: 'For Christ at the last day will not ask how much you have prayed, fasted, pilgrimaged, done this or that for yourself, but how much good you have done to others, even to the very least' (WA 6, 242; LW 44, 71).

1 5 4 6 In late January Luther travels to his native town of Eisleben. The counts of Mansfeld are at loggerheads with each other. There is a dire need for reconciliation, and the reformer feels it is his duty to engage in this act of charity. The negotiations take their toll on him. On 17 February the celebrated visitor to the town feels suddenly faint and has strong pains in his chest. The 62 year-old is said to have uttered a prayer: 'I bid you, Lord Jesus, may my soul be at your command.' An hour after midnight on 18 February 1546, Martin Luther died in Eisleben.

1 5 6 2 In Easter Week three mayors and 16 aldermen leave Bremen. These committed Lutherans go into exile, because the Reformed Christians have gained power over the citizens' souls and over politics in the town. The Reformed Christians – or Calvinists – are followers of Johannes Calvin in Geneva, who propounded his own reformed theology with considerable success both at home and abroad, even when Luther was still alive.

The Lutherans were now confronted with a set of rival ideas that had to be opposed uncompromisingly. This quickly led to the 'fury of the theologians', as it was known at the time. In addition, there were also bitter debates between Protestants as to whether Luther's teachings had to be preserved as they were or whether they could be allowed to continue to develop.

On the Lutheran side the battle was won by those who claimed to have access to the unchanged – orthodox – doctrine. No mention here of charity: anyone who did not pledge allegiance to orthodox Lutheranism was hounded out of Lutheran territories.

1 6 6 2 The ruling family in the Electorate of Brandenburg had gone over to the Calvinist faith in 1613, but still allowed its subjects to remain true to their Lutheran beliefs. Nevertheless, there was no end to the mutual accusations of heresy. In 1662 Elector Friedrich Wilhelm – the Great Elector – decreed that the clergy on both sides should cease to actively oppose members of the rival faith. Pastor Paul Gerhardt, whose heartfelt hymns still move the faithful today, continued undaunted: 'Lord protect us from the Calvinist poison.'

1 6 7 5 A pastor in Frankfurt, Philipp Jakob Spener, publishes *Pia Desideria; Or, Heartfelt Desires for a Godpleasing Improvement of the True Protestant Church*. This plea for reform would become the basis for a separate movement within Lutheranism, that is to say, Pietism. Spener spoke out against the rigidly devout practices of Orthodox Lutherans and demanded that the concept of charity be acted on in daily life. In Hamburg the Lutheran clergy proudly claimed to have driven all the Pietists out of the town.

1 8 4 8 Germany's first elected parliament convenes at the Paulskirche in Frankfurt am Main. The Lutheran Parish Council had vacated the church for the parliament 'with pleasure'. But there was a huge miscalculation here, because all over Germany Lutheran theologians were doing their best to derail this peaceful revolution.

In Bremen Pastor Friedrich Mallet writes that the political reformers have presented the populace with two monsters: 'popular sovereignty' and 'democracy'. In Münsingen in Swabia, Dean Sixtus Carl von Kapff declares

in a sermon that 'the worst of these democrats are hideously blood-thirsty and take devilish delight in murder and arson.'

1 8 9 9 Pastor Christoph Blumhardt Jr in Bad Boll signs up to the Social Democratic Party of Germany (SPD). The Lutheran Consistory immediately asks him to resign from his position within the church. Blumhardt complies and a year later is elected to the State Parliament in Stuttgart as an SPD member.

1 9 1 7 In the third year of the war Pastor Otto Dibelius delivers the address for the 400th Anniversary of the Reformation: 'I can greet you with good news. Directly before my departure from Berlin I heard the latest reports from the supreme commanders of the army ... over 80,000 prisoners have been taken.'

1 9 2 6 The war was lost, and Germany is now a democracy. In his book *Das Jahrhundert der Kirche* ('The Century of the Church') Otto Dibelius bemoans the situation: 'The unified, basically Christian civilisation of the West is in the process of dissipating.' Dibelius condemns all those who are hastening this: 'Internationalism, which ignores one's own nationality, is only ever morally adrift, extrinsic, superficial. ... The ideal of the Christian church cannot be an international society of the Christian kind.'

1 9 3 3 On 7 April the Reichstag passes a 'Law for the Restoration of the Professional Civil Service'. This includes an 'Aryan clause', which ensures that Jewish civil servants can be dismissed because of their 'racial origins'. A week later the Protestant theologian Dietrich Bonhoeffer publishes an essay with the title 'The Church and the Jewish Question'. According to his theological analysis, 'From the point of view of Christ's church, Judaism is never a racial concept but rather a religious one.' When a state no longer creates 'justice and order' but instead champions injustice, the Church is duty bound to take direct political action. Bonhoeffer declares that it is not enough merely to dress the wounds of the victims injured by the system. On the contrary, the Church must deliberately put a spanner in the works of that very system.
Dietrich Bonhoeffer was on firm Lutheran ground here. Because, contrary to what is still suggested today with reference to his 'two-kingdoms doctrine', Martin Luther did not give the state a free hand to govern without paying heed to the law.' In his text *Temporal Authority* (1523) he is just as unequivocal as Bonhoeffer in 1933: 'What if a prince is in the wrong? Are his people bound to follow him then too? Answer: No, for it is no one's duty to do wrong; we must obey God (who desires the right) rather than men' (WA 11, 277; LW 45, 125).

1 9 4 4 On 21 July the *Kirchliches Amtsblatt für die Evangelisch-Lutherische Landeskirche Hannover* – the official newsletter of the regional Lutheran church – recommends that pastors deliver a prayer of gratitude to God 'for having preserved the Führer's life and good health from a felonious attack'. In 1940 Dietrich Bonhoeffer joins those engaged in active resistance in Germany. He was arrested in 1943 and hanged at Flossenbürg concentration camp on the morning of 9 April 1945.

1 9 4 7 In *'Ein Wort des Bruderrates der Evangelischen Kirche in Deutschland zum politischen Weg unseres Volkes'* ('A Word from the Council of Brethren of the Evangelical Church in Germany on the Political Course Adopted by Our People'), a Protestant minority declares that the precept of the Church has to be 'No more platitudes regarding Christianity and Western civilisation, but a return to God and to one's neighbour'.

2 0 1 6 In September the Christian Social Union (CSU) proposes that 'preference should be given to immigrants from our Western Christian cultural circle'. Heinrich Bedford-Strohm, Bishop for the State of Bavaria and Chairman of the Council of the Evangelical Church in Germany, speaks out against this proposal, declaring that it is contradictory to want to keep refugees out of Europe on the basis of the 'Christian West': 'Using the word "Christian" as a way of scaring refugees away turns the crux of Christian belief on its head.' Taking in strangers and helping the weak is a key component of Christian belief in his view.

The overwhelming willingness of the people of Germany to actively accept strangers and the weak into their society, be it in the short or long term, has prevailed. To this day church communities and ecclesiastical organisations, along with other social groups, form the backbone of what has become known in Germany as the 'welcome culture'.

In so doing the majority of German Protestants and their spiritual leaders have – for the first time in history – resolutely decided to act on the precept of charity, in a historic watershed moment, which has seen people changing their earthly world more enduringly and comprehensively than ever before. And Martin Luther, with his profound trust in faith, is a fine companion on this journey: 'O it is a living, busy, active, mighty thing, this faith. It is impossible for it not to be doing good works incessantly. It does not ask whether good works are to be done, but before the question is asked, it has already done them, and is constantly doing them' (WA DB 7, 10; LW 35, 371).

KATHERINE PARR

QUEEN OF ENGLAND,
1512–1548

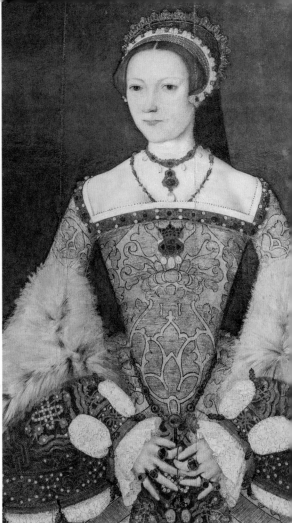

Katherine Parr was the sixth and last wife of Henry VIII. She married him – the third of her four husbands – on 1 July 1543 at Hampton Court Palace. The following year, when Henry was conducting a military campaign in France, she was temporarily appointed Regent. Not long after Henry VIII's death in 1547, she secretly married her former lover Thomas Seymour. In August 1548, at the age of 36, Katherine gave birth to a daughter at Sudeley Castle, only to die shortly afterwards of 'childbed fever'. She was buried in the chapel at Sudeley.

Since Katherine had not only internalised Martin Luther's belief system but also openly professed it, she is regarded as the first Protestant Queen of England. Her chaplains preached reform and she gathered a group of aristocratic ladies around her, who also followed Luther's teachings. In 1545 Katherine's Protestant sympathies earned her the enmity of Stephen Gardiner, Bishop of Winchester and a trusted advisor to the King. The following year the Bishop and other conservatives sought to have supporters of the Reformation arrested as heretics. Even Queen Katherine was in danger. She posed a challenge to Henry, who – for all that he had caused the Church in England to break away from Rome – still took a 'Roman' line in matters of dogma. Above all the idea that salvation is only to be achieved through faith, and not through good works, was at odds with Henry's views as a Christian monarch. But Katherine managed to placate him, and he spared her.

Even during her reign as Queen of England, Katherine Parr published books under her own name. The first was in 1544 and entitled *Psalmes or Prayers taken out of holye scripture*: it was a translation into English from Latin, very successful and often reprinted. Her second book, *Prayers or Meditations*, contains five prayers and meditations taken from *The Imitation of Christ* by Thomas à Kempis. In it Katherine describes turning away from the world and towards salvation in Christ.

In the winter of 1545–46 Katherine Parr published a book in her own right, *The Lamentation of a Sinner*, which expresses distinct-

ly Lutheran views and investigates a core topic in Luther's t ogy, namely justification through faith. She discusses conc of sin and salvation in entirely Lutheran terms, namely tha relationship between man and God, which was destroye man's sin, can only be restored by God, because God has cy on man. Charity or the good works of an individual dc in themselves bring credit; they are the fruit and consequ of faith. Since Katherine Parr was under threat as a Protes believer in the summer of 1546, she waited until the autum 1547 to publish *The Lamentation of a Sinner*, when it could c on public support. The preface was written by the huma William Cecil, later to be chief advisor to Queen Elizabe

An Paenhuysen

→ Further read

John N. King: Patronage and Piety. The Influence of erine Parr, in: *Silent but for the Word. Tudor Women trons, Translators and Writers of Religious Works*, Ma Patterson Hannay (ed.), Ohio 1985, 43–60.
Janel Mueller: A Tudor Queen Finds Voice. Kath Parr's *Lamentation of a Sinner*, in: *The Historical Rena New Essays on Tudor and Stuart Literature and Culture*, I er Dubrow and Richard Strier (eds.), Chicago 1988
Katherine Parr: *Complete Works and Correspondence* Mueller (ed.), Chicago 2011.

Truly, charity maketh
men live like angels

Katherine Parr, *The Lamentacion of a synner*, 1548

The Lamen=
tacion of a synner,
made by the moste ver=
tuous Lady quene Ca=
terine, bewailyng the
ignoraunce of her blind
life: set foorth & put in
prínt at the instant de=
sire of the right graci=
ous lady Caterine du=
chesse of Suffolke, and
the ernest request of the
right honourable Lord
William Parre, Mar=
quesse of North-
hampton.

MAX BECKMANN ARTIST, GERMANY, 1884–1950

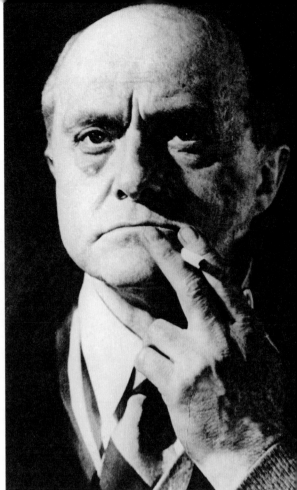

By the age of 16 Max Beckmann was an art student in Weimar and he soon gained recognition as a promising talent. As a 24-year-old, he painted works with religious motifs – these were based partly on discussions of faith with his mother-in-law Ida Tube, the widow of a theologian.

Alongside his use of dramatic themes intended to cause a stir in the art world of his time, Beckmann's preoccupation and engagement with the threatened and lost humankind of the modern age is striking. His œuvre includes two notable paintings of the Resurrection, which, in their contrasting approaches, clearly illustrate the spiritual leap that Beckmann was compelled to take by the harsh realities of war. His neo-Baroque *Resurrection* of 1908/9 is less an image of religious fervour than a highly charged, theatrical expression of his own doubts. Beckmann would never be able to rid himself entirely of the Baroque allegory of the world as theatre and the problem of a God who held the fate of all humanity in his hands. In the midst of the horrors of war, in which he had served as a medical orderly, and which drove him to a nervous breakdown, he painted a powerful allegorical anti-war work. In this second *Resurrection* (1916), Beckmann depicts himself and those around him as witnesses to events at the end of the world: under the apocalyptic symbol of a black sun, the war dead rise from their graves but can find no salvation. From this time on, driven by unwavering concern and love for his fellow beings, Beckmann expressed his profound belief in human liberty in his works, even in defiance of God. 'In my pictures I accuse God of everything he has done wrong.' For Beckmann, the process of religious renewal begun by Luther was far from complete: 'We are actually still caught up in the upheavals brought about by the Reformation.' He hoped for a 'new mystical feeling', which he had already conveyed in his works.

Beckmann was fascinated by religious and occult texts as well as Luther's Bible. While living in exile in Amsterdam, in 1941–2 he was commissioned by Georg Hartmann, owner of the Ba sche Gießerei type foundry in Frankfurt, to produce a serie hand-coloured lithographs to illustrate Luther's text of the elation of John. They were printed as a private edition in Through the seven self-portraits in the series, Beckmann i tifies himself with the visionary John: the artist himself i picted receiving the divine promise that all tears will be wi away. Beckmann's images of the Book of Revelation were a means towards self-knowledge in times he perceived as a alyptic. Despite this, he succeeded in conveying a note of co ation in his Apocalypse lithographs. 'The end is nigh', he w in his diary, 'the transformation approaches.' The colophoi the book reads: 'This book was created in the fourth year of Second World War, as the visions of the apocalyptic see came dreadful reality.' Eugen Blume

→ Further read
Friedhelm W. Fischer: *Der Maler Max Beckmann* logne 1972 (English translation: *Max Beckmann,* York 1973).
Max Beckmann: Die Realität der Träume in den B Rudolf Pillep (ed.), Leipzig 1984.
Uwe M. Schneede: *Max Beckmann. Der Maler Zeit*, Munich 2009.

My religion is defiance of God, that he has created
us thus, that we cannot love each other.

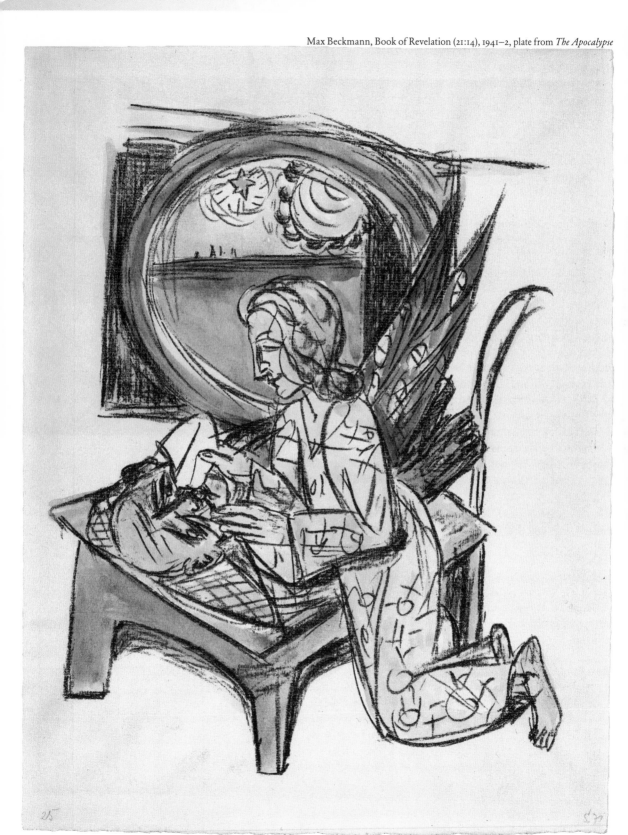

SOPHIE SCHOLL
RESISTANCE FIGHTER, GERMANY, 1921–1943

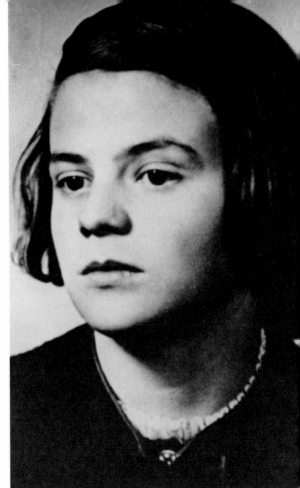

For Sophie Scholl family was the 'firm ground' that nurtured her spirit and her mind. Her mother was a Protestant, her father an atheist. But they accepted each other's religious views and were committed democrats.

In January 1934 Sophie Scholl joined the Ulm branch of the 'League of German Girls' (BDM). As a group leader she chanted National Socialist slogans and inspired the members of her group with her ideals of a just world. After 1938 she no longer occupied any important positions in the BDM. There is no saying exactly when she realised that her idealism was being exploited by a despicable regime. Whatever the case, all her statements after the outbreak of war indicate an irrevocable break with her past as a BDM leader. In April 1941 she was called up by the National Labour Service (*Reichsarbeitsdienst*). Her diaries show that by then she wanted to find her way back to God, who had once been such an important part of her life.

Over the centuries human beings have suffered in the dark night of God's absence, including Martin Luther: 'I, myself was … brought to the very depth and abyss of despair'; 'All that remains is the starknaked desire for help and a terrible groaning, but it does not know where to turn for help' (WA 18, 719; 1, 558; LW 33, 190; 31, 129). It was the most terrible realisation for Luther that God is there but does not reveal Himself. The distant God became the basis of Luther's theology. Yet help can only be found through this same God.

In December 1941 Scholl recorded her feelings about God in her diary: 'I want to cling to Him … – how terrible when He is so far away.' By the following June her relationship with God had come good: 'I know that You will … listen to me, if I cling to You.'

On 25 January 1943 Scholl travelled to Augsburg and Ulm to distribute leaflets calling for resistance to the National Socialist regime in the name of the White Rose group. Sophie, her brother Hans, Alexander Schmorell and Willi Graf had decided to secretly produce and circulate leaflets, in the hope of prompting their fellow students to resist the senseless war being waged. They demanded 'freedom of speech' and the 'protection of individual citizens' against criminal acts. On 16 February 1943 Sophie and Hans Scholl were arrested.

On the back of her indictment papers Sophie Scholl wrote the word *Freiheit* ('Freedom') twice over. On 22 February she was put to death by guillotine in München-Stadelheim prison. prison records state that 'the convicted woman was quiet composed'.

In his treatise on *The Freedom of a Christian* (1520) Luther expl the contradictory relationship between freedom and the g of God, which cannot be gained by dint of human activity he also roundly contradicts those who think this means need not concern themselves with their fellow human be 'Not so, you wicked men, not so' (WA 7, 30; LW 31, 358).

The Protestant theologian Dietrich Bonhoeffer descr Luther's grace as 'cheap grace'. For Sophie Scholl the gra God and the freedom of a Christian believer came at a price. Yet the tension between these two poles did not pre her from taking action: it cleared her mind and gave he strength to act out of love for her fellow human beings.

Barbara Beuys

→ Further read
Sophie Scholl and Fritz Hartnagel: *Damit wir un verlieren. Briefwechsel 1937–1943*, Thomas Hartnage Frankfurt am Main 2005.
Barbara Beuys: *Sophie Scholl. Biografie*, Munich 20 perback edition 2011).
Frauke Geyken: *Freya von Moltke. Ein Jahrhunde 1911–2010*, Munich [3]2015.

I could weep at the callousness of people, even leading politicians

'Freedom': note by Sophie Scholl on the back of a letter from the Chief Prosecutor of the Reich, 21 February 1943

Der Oberreichsanwalt
beim Volksgerichtshof

Berlin, den 21.Februar 1943

An die

Verwaltung des Hausgefängnisses der Geheimen
Staatspolizei, Staatspolizeileitstelle

M ü n c h e n ,
Briennerstr.50.

In der Anlage erhalten Sie Anklageschrift des Oberreichs-
anwaltes beim Volksgerichtshof Berlin vom 22. Februar 1943 gegen
Hans S c h o l l , Sophia S c h o l l und Christoph P r o b e t
zur Zustellung an die Genannten durch den Urkundsbeamten der
Geschäftsstelle des Oberlandesgerichts München, Justizinspektor
Huber.
Die Angeschuldigten sind darauf hinzuweisen, dass sie bis
Montag, den 22. Februar 1943, 8 Uhr vorm. Einwendungen gegen die
Anordnung der Hauptverhandlung erheben und Beweisanträge stellen
können.
Termin zur Hauptverhandlung ist für Montag, den 22. Februar ds.
vorgesehen, 10 Uhr vorm.

An Angeschuldigte Sophia Scholl.

JOSIAH KIBIRA BISHOP, TANZANIA, 1925–1988

Born in Bukoba, Tanzania, Josiah Kibira grew up in a region served by German missionaries. Following his conversion as a young adult, he worked for some years as a teacher before leaving his homeland to study theology in Germany and the USA. He soon rose to prominence in the recently founded Lutheran Church in Tanzania and was appointed the first African Bishop of Buhaya.

In this capacity he took part in the All-African Lutheran Conference in Addis Ababa in 1965. At that conference Kibira delivered a sensational speech, 'A Changing Church in a Living Society', in which he exhorted his fellow Lutherans in Africa, indeed all Christians in Africa, not to take their lead any longer from European and American role models. Rather than church leaders automatically adopting German, Scandinavian and North American Lutheran traditions, it was important, he told his audience, that an authentically African form of Christianity, rooted in indigenous traditions, be developed. In many ways his proposal was reminiscent of the various attempts to inculturate Christianity for heathen communities in Europe. As one of the founding fathers of the church, St Augustine endorsed the idea of proto-Christian beliefs, thereby making it possible for pre-Christian traditions to be interpreted as preparatory revelations that ultimately led to Christ. In the nineteenth century the Danish theologian Nikolai Grundtvig was still doing his utmost to have Nordic, heathen practices accepted in Christian, northern Europe as key components in its own identity. Josiah Kibira wanted the same thing for Africa.

Kibira regarded his missionary work as closely bound up with his social and political concerns. In his thinking global poverty and racial conflict were inextricably bound up in the question of God. He saw his socio-political engagement as a direct consequence of his Christian duty to love his neighbour. over he ascribed a central role to the church in the task solving social and ethnic conflicts. In 1977 he was electe first African president of the Lutheran World Federation remained in post until 1984. His appointment caught the est of the press and media, and he was able to use this inter raise public awareness of his concerns.

Those who were personally acquainted with Kibira often to his charisma and refusal to compromise. One of the s told of him remembers his intervention in a hospital run b church. When he heard that staff were refusing to clean t lets, he drove straight to the hospital and asked to see the t He then requested cleaning equipment, set to work, and stopped when everything was spotlessly clean. Then h the staff that if this work was good enough for him it wa good enough for them. His somewhat daunting deter tion recalls aspects of Martin Luther. And Josiah Kibira ed his life to spreading Luther's message, above all in pra terms in his African homeland. Benjamin Hasselh

→ Further rea
Per Larsson: *Bishop Josiah Kibira of Bukob International Perspective*, Dodoma 1992.
Bengt Sundkler and Christopher Steed: *A of the Church in Africa*, Cambridge 2000.

We live in a world which is so nice when people cooperate, live together and love one another as human beings. But to separate people is fundamentally wrong.

Shots from an interview with Josiah Kibira, filmed in 2010

KWOK PUI-LAN THEOLOGIAN, HONG KONG, B. 1952

Kwok Pui-Lan is William F. Cole Professor for Christian Theology and Spirituality at the Episcopal Divinity School in Cambridge, Massachusetts. Born in 1952, in the then British crown colony of Hong Kong, she initially studied at the Chinese University in Hong Kong and at the South East Asia Graduate School of Theology. In 1984 she moved to the United States and was awarded her doctorate at Harvard Divinity School. Kwok Pui-Lan has received numerous honours for both her scholarship and her teaching, including honorary doctorates from universities in the Netherlands and Sweden. In 2011 she was elected President of the American Academy of Religion (AAR), the largest and most influential professional body for those working in religious studies and theology.

As a consequence of her interdisciplinary approach and her incorporation of feminist and post-colonial theory into her research, Kwok has won recognition both within and beyond the field of theology. Moreover, she actively engages in intercultural issues. Her name has come to be associated with a sea change in attitudes to the history of missionary activities: what was once viewed as the story of 'white men' spreading Christianity has now become the story of local Christianities. She has also successfully alerted others to the fact that in Asia the Bible can only be read in the context of the holy scriptures of other religions. Kwok Pui-Lan's scholarly research is always bound up with her commitment to practical neighbourly love and charity. In her book *Postcolonial Imagination and Feminist Theology* (2005) she urges Christian theologians to seek out a non-violent, non-imperialist path, insisting that theology is not about merely defending one restrictive tradition. In the book Kwok questions the notion of a unified whole and suggests that Christian ideology has to be open to other religions. And she turns her attention to finding meaning for minority groups in the Bible. If those groups were allowed to arrive at their own interpretations of Biblical passages, she argues, society might stand a better chance of becoming fairer.

Kwok also scrutinises new religious and social protest movements such as the 'Occupy Wall Street' movement. She and Jörg Rieger jointly published the book *Occupy Religion. Theology of the Multitude*, in which – drawing on the work of Michael Hardt and Antonio Negri – they outline their own 'theology of the multitude'. Rieger and Kwok make a plea for a new political subject, namely the multitude that will arise from a variety of grassroots movements and theologies, in which they include feminist theology, Latin American liberation theology and the people's theology (*minjung*) that has developed in South Korea. In so doing Kwok partly taps into Luther's idea of a 'universal priesthood of believers'. Thus she presents a picture of how religion and politics could change and give new impetus to the universal quest for liberation. An Paenhuysen

→ Further read

Kwok Pui-Lan: *Introducing Asian Feminist The* Trowbridge and Wiltshire 2000.
Kwok Pui-Lan: *Hope Abundant. Third World a, digenous Women's Theology*, New York 2010.
Kwok Pui-Lan and Jörg Rieger: *Occupy Religion ology of the Multitude*, Plymouth 2012.

Occupy Religion!

'MAY GOD HELP US TO BLAST DOWN THESE WALLS OF STRAW AND PAPER'

WA 6, 407; LW 44, 126

After 1517, Luther emerged as a reformer who wanted to renew and transform the Church. Hence the continuous struggle over how the community should be structured is also part of Luther's legacy. Since the Enlightenment, frequent calls have been made to move beyond Luther, to develop his ideas further, and to continue reshaping the social and religious order. Politically and philosophically, Luther can provide a role model for resistance or a starting point for ideas that transcend his teaching. Other approaches focus on maintaining Luther's concerns by transforming them for a new era. How would the modern transformation of Luther's message look? Or have we long since moved on to other things?

SEMPER REFORMANDA

VOLKER LEPPIN

'Only those who change remain true to themselves' – Wolf Biermann's explanation of the changes in his own life resonates in many ways with the history of Protestantism. This is how the evangelical theologian Emanuel Hirsch chose to see it in any case when he spoke about 'transformation'. He was concerned primarily with acknowledging the changes brought about by the Enlightenment and defying the trite criticism that Protestantism had betrayed its own legacy as a consequence. According to Hirsch's analysis, this was not the case. Rather this was a Protestantism had proved its ability to confront the challenges of modernity. Protestantism remained true to itself, its identity was not lost.

In fact, the Reformation itself can be seen as a transformation process, during which much changed but much remained the same. The old images of Luther live on in some minds: a man of God who opposed the excessive power of the (possibly very dark) Middle Ages and established a new

church, and perhaps even modernity itself. It is quite clear that such images overtax our individual powers of comprehension – and even if we broaden their scope, they distort the events rather than make them understandable. We only need to take a quick look at the importance of the university in the early days of the Reformation and the subsequent history of Protestantism to realise that the centuries-old institution of the European university, founded shortly after 1200, played a crucial role here. It not only survived the Reformation unscathed but also became a vital engine of the movement. Thus, in the same way that such an institution is changed but not destroyed, it is true that, in many respects, the transformation rather than the rupture was the determining factor.

Luther himself was even wont to point out occasionally – when considering infant baptism – that the Reformation not only represented a rupture with the past but also continued and transformed this past. Transformation means that something remains and yet something new also emerges. Depending on how one imagines transformation, one can emphasise the conservative aspect – indeed Hirsch thought about this in the case of the Enlightenment – or the aspect of change. This is frequently the case when the Reformation is described as transformation. Understanding it in this way does not exactly mean denying its newness but describing this newness in a different way: not as something precipitous and unprepared but as something that gradually develops from the old.

The Reformation was the great change, the new approach built on the foundations of the old – and was soon constantly exposed to new transformations. Much as it was linked to the early stages of the Reformation, even the formation of religious denominations in the sixteenth century represented a vast shift: as a result of huge disputes, an increasingly narrowly defined context developed from a broad movement. This not only challenged its papal counterpart but also prompted the identification of dissenters and heretics in its own camp on the basis of very subtle differentiations. Pioneers like the Nuremberg-based reformer Andreas Osiander became victims of such claims of heresy, indeed even Philipp Melanchthon had to live with the accusation of not being Lutheran enough. In this way the Pietism movement transformed itself into a closed system; arguably it could not do otherwise. It became a religious denomination bound to certain cities and territories.

The protests against the associated entrenchments were bound to materialise. Reformed Orthodoxy and Pietism drew on the original ideas: once again, the mystics of the late Middle Ages were read as they were by Luther himself; once again the ideas surrounding an inner piety were set against an externalised church. And yet, no deep-seated, comprehensive change occurred in Protestantism. The retreat into conventicles, the concept of 'little churches within the church', also meant that the aspiration to change

the whole of Lutheranism had been abandoned: the formation of a constant alternative, rather than transformation, was the result.

Nevertheless, the effects of Pietism, in some cases hand in hand with the Enlightenment, can be felt right up to today: if it is taken as a given that Protestantism does not recognise the confessional, this is not a direct consequence of the Reformation but only of its transformation in the seventeenth and eighteenth centuries. Just as the strong emphasis on the individual in Lutheranism was able to draw on Luther's words, it only crystallised in the course of the modern-day transformation. Moreover, the relationship with the Bible changed fundamentally as a result of the Enlightenment: Scripture became a document that could be read like any other historical document and could be subject to historical criticism.

Friedrich Schleiermacher probably bears particular responsibility for ensuring that the various ideas did not drift apart and could be held together. He himself came from the latter stages of Pietism, which absorbed the Enlightenment and brought everything into balance that endured in the nineteenth century. However, he was also occasionally associated with ideas which dreamt that Protestantism was dissipating entirely into the general culture in the course of its transformation: theatre was to take the place of the sermon, music was intended to raise the heart to God. Thus a new transformation of 'cultural Protestantism' emerged, which, like other movements of change, saw itself as consistent with the Reformation and, indeed, in a certain way as its actual fulfilment.

The limits of the concept of 'transformation' also quickly become clear – particularly when we see who it was that shaped the concept: Emanuel Hirsch believed he could drive the transformation so far that he joined the Deutsche Christen (German Christians) in the 'Third Reich' and, like Martin Heidegger in the context of philosophy, thereby raised the great mystery as to how an intellectual giant could fall for such a devastating fallacy. This can no longer be called transformation – it is the disengagement from the core of the Reformation's legacy.

Such blunders make it clear that transformation in and of itself describes what happened and what is currently happening. It is a neutral term, which sometimes helps us to understand that we can only remain true to ourselves through change. But the phenomenon that this describes necessarily raises the question regarding the origin of the idea of staying true to oneself. In the history of Protestantism, transformation has repeatedly arisen as an adaptation to historical changes. This can pose a risk since it is not always clear from the outset how extensive the adaptation is and whether it involves the relinquishment of something merely non-essential or the core of the faith itself.

Such risks should not, however, blind us to the fact that the ability to transform is first and foremost one of Protestantism's great strengths. Without

the idea that transformation also belongs to its own reality, it would not have succeeded, for example, in introducing the ordination of women in the twentieth century. This development also shows that change can also lead right to the essence: the women's rights movement in general heightened the perception in Protestantism that there is no factual basis in the Bible's core message that can justify the exclusion of women from the ministry. Individual biblical quotes cited for this very purpose have proved to be temporary discriminations that must not be associated with the fundamental message of Jesus Christ, which extends across gender boundaries. Reform means getting to know the essence, the old anew; it means getting back to basics.

This is the only way that transformation can truly be a meaningful process. Change remains tied to fundamental standards which, in the case of Lutheranism, are found in the Bible and the Lutheran Confessions. Understood in this way, transformation is different to arbitrariness – and, understood in this way, aberrations such as Hirsch's can be labelled as such without having to abandon the idea of transformation. Admittedly, this also shows that when a religious community like Lutheranism actually engages with the belief that its truth is not reflected in an unvarying sameness but in change, it accepts that it must continuously negotiate what is an immutable truth and what is a changeable investiture. Attempts were even made in the course of the Enlightenment to grasp this phenomenon on a conceptual level through distinctions – such as that between the Word of God and the Bible and between public and private religion. This does not resolve the question, however, but poses one new challenge after another. The Scylla and Charybdis between which Protestantism must choose, are stubbornness, on the one hand, and a willingness to adapt to the spirit of the times, on the other. The latter has generally posed the most imminent risk for Protestantism – and yet the chance for transformation remains the great opportunity for Protestantism itself in the world, a world that appears to be increasingly withdrawing from Christianity. In the face of dwindling numbers and declining social acceptance, the real challenge facing Protestantism in 2017 is whether it will be possible once again to activate the transformative powers in such a way that new power emerges from the change.

The message from 1517 suggests that this is possible: the call to change could be accepted precisely because the Reformation did not want to abandon everything that was good, because through the appeal to the Holy Scripture it carried on the commonly accepted principles and showed a way of overcoming anything that was considered a distraction or an obstacle.

MOSES MENDELSSOHN

SCHOLAR,
GERMANY, 1729–1786

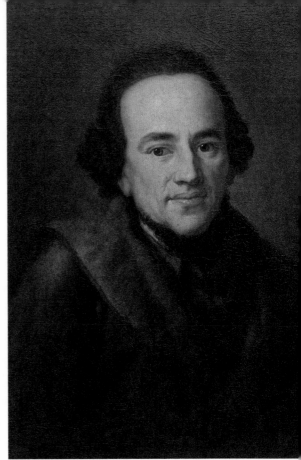

As a scholar, thinker and writer, Moses Mendelssohn succeeded in bringing together two different intellectual worlds. He was a leading influence in the Jewish Enlightenment (*Haskalah*) and, at the same time, is regarded as one of the foremost German philosophers of the eighteenth century. And it was not only scholarly Europe that held the Jewish philosopher in high regard: his authority was such that, during his visit to Europe in 1785, Venezuelan revolutionary Francisco de Miranda sought out the great scholar to discuss his political theories on the role of the state.

Admiration for Mendelssohn's development into a European intellectual figure of the first rank cannot fail to grow when considered in the light of his biography. Brought up in humble circumstances in Dessau, he attended the school run by David Frankel, the town's chief rabbi, who published the Jewish philosopher Maimonides's master work, *Guide for the Perplexed*, written shortly before 1200; Mendelssohn pored over Maimonides's work so assiduously that he would later ascribe his spinal curvature to these studies. When Frankel was summoned to Berlin, Mendelssohn followed his teacher. He lived in the poorest of conditions there but nevertheless managed to master German, Latin, Greek, French and English. He was then able to read the great classic works of Leibniz, Wolff, Rousseau, Locke and Shaftesbury and became highly renowned as a scholar throughout Europe. However, his great knowledge did not bring him wealth, and he had to earn his living as a silk manufacturer.

Two controversies, which were followed with interest by the European public, overshadowed Mendelssohn's life. The first of these was his dispute with Johann Caspar Lavater. This was initially ignited by Lavater's challenge to Mendelssohn to defend his Jewish faith or – should he fail to do this successfully – convert to Christianity. The second would eventually drive him to

his grave: Friedrich Heinrich Jacobi, who had carried on a[n] change of philosophical ideas with Mendelssohn's friend [Lessing], later published details of this and made it known tha[t] the end of his life, Lessing had become a Spinozist. As Spin[oza] had a very poor reputation at that time, Mendelssohn too[k] upon himself to defend Lessing and cast a different light on [his] friend.

Mendelssohn's name is often mentioned in the same breat[h] Luther's, because Mendelssohn, like Luther, made a transla[tion] of the Bible. This was a significant attempt to reconcile the [tra]ditions of Jewish pietism with Enlightenment teaching in [Ger]many. Mendelssohn was so deeply impressed by Luther's ge[nius] for language that he wrote: 'as regards language, I have ind[eed] stayed closer to Dr Luther than to later translators.' Men[dels]sohn's status as the most influential figure in Reform Juda[ism] in Europe and, not least, his Bible translation, led his admi[rers] who included Heinrich Heine, to see him as a 'Jewish Lut[her]' who enabled the transformation that brought Judaism [into] the modern age. Björn Pecina

→ Further read[ing]

Alexander Altmann: *Moses Mendelssohn. A Biograp[hical] Study*, London 1998.
Dominique Bourel: *Moses Mendelssohn. Begründ[er des] modernen Judentums. Eine Biographie*, Zürich 2007.
Shmuel Feiner: *Moses Mendelssohn. Ein jüdischer L[enker] in der Zeit der Aufklärung*, Göttingen 2009.

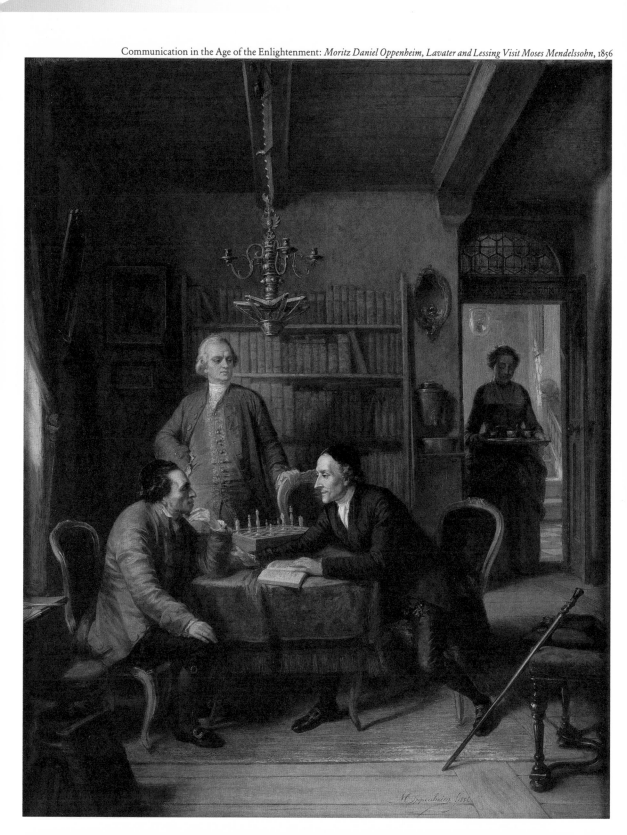

Communication in the Age of the Enlightenment: *Moritz Daniel Oppenheim, Lavater and Lessing Visit Moses Mendelssohn*, 1856

N. F. S. GRUNDTVIG

THEOLOGIAN AND POLITICIAN, DENMARK, 1783–1872

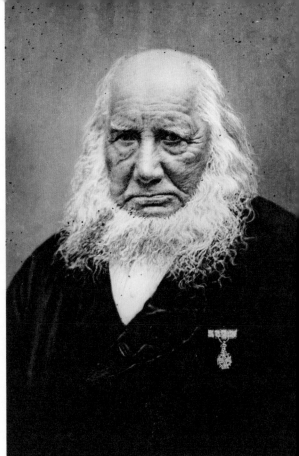

Nicolai Frederik Severin Grundtvig was born in the village of Udby on the island of Zealand, the youngest child of a pastor. He studied theology in Copenhagen and initially pursued a career as a historian. He was particularly interested in Norse and Old English literature and gained a renown in the field of Old English which endures to the present day. Grundtvig became known as an advocate for an education system which aimed to involve the common man in the political power and cultural dignity of his country. Folk high schools, colleges and adult education institutions throughout the world name Grundtvig as their model, and part of the EU Lifelong Learning Programme was named after him.

Grundtvig was also a notable poet. His hymns are very popular and few services in Danish churches – Protestant and Catholic alike – do not feature a hymn by Grundtvig. Intellectually, Grundtvig was influenced by both German idealism and British liberalism. Politically, until the late 1840s he was a loyal subject of absolute monarchy and, at the same time, an advocate of freedom of expression and religion. He served as a member of the Danish Constituent Assembly in 1848–49 and continued to be an active, liberal, national politician until 1866.

In around 1810 Grundtvig underwent a religious awakening, which marked the beginning of a continuous theological engagement with Luther. At first he was a loyal Lutheran, even describing himself around this time as 'the little Luther'. However, in about 1825 he developed a critical distance from his role model and, in particular, from Luther's scriptural principle. For Grundtvig, the central element of Christianity was not 'the dead word' (Scripture) but 'the living word', above all the Apostles' Creed professed at Baptism and the Words of Institution spoken at the Eucharist. He considered these to be the original,

authentic words of Christ, passed down orally and unchan[ged] from the earliest church communities, from generation to [gen]eration throughout the entire history of the Church. He [be]lieved that it was not through Scripture but through Bapt[ism] that the individual became part of the Church.

He therefore described the historical development of Ch[risti]anity as the story not of churches but of church communi[ties]. According to Grundtvig, the history of the world compr[ised] seven stages, the first being the Hebrew Church, the fifth [the] German (that is, Luther's) and the sixth the Nordic. The [sev]enth and future church could only be conjectured. Grund[tvig] classed Luther's Reformation as an epoch-making turn[ing] point: 'Luther was evidently a prophet'. However, for Gru[ndt]vig the history of Christianity continued after Luther, and [the] necessary transformation of Luther's message involved renc[unc]ing the rigid scriptural principle. Grundtvig died in 1872, jus[t be]fore his 89th birthday. His printed works encompass over 30,[000] pages. Jes Fabricius Møller and Anders Holm

→ Further read[ing]

N. F. S. Grundtvig. Tradition und Erneuerung, Christian Tho[e]
and Anders Pontoppidan Thyssen (eds.), Copenhagen 198[?]
N. F. S. Grundtvig: Schriften in Auswahl, Knud Eyvin B[?]
Flemming Lundgreen-Nielsen and Theodor Jørgensen [?]
Göttingen 2010.
Anders Holm: N. F. S. Grundtvig in: Nineteenth-Century L[uther]-
an Theologians, Mathew Becker (ed.), Göttingen 2016.

I am not of the opinion that we should simply continue with what Martin Luther did 300 years ago, for it is only death that stands still, life is always in motion.

In search of modern Lutheranism: magnifying glass from the estate of N. F. S. Grundtvig, 19th century

ELIZABETH CADY STANTON

WOMEN'S RIGHTS ACTIVIST, USA, 1815–1902

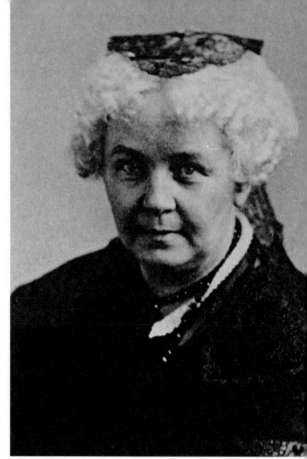

Elizabeth Cady was born in 1815, the eighth of eleven children in a well-to-do family. In 1840 she married Henry Stanton, an activist committed to the abolition of slavery. That same year they travelled to London for the World Anti-Slavery Convention, where Elizabeth Cady Stanton met the Quaker Abolitionist Lucretia Mott. Stanton and her husband initially moved to Boston, but later settled in a small town in the State of New York. Between 1842 and 1859 Stanton gave birth to seven children. Her renewed acquaintanceship with Lucretia Mott in 1848 prompted her to engage actively in politics again, and before the year was out she had written her *Declaration of Sentiments*, advocating the equality of the sexes. In 1851 Elizabeth Cady Stanton met Susan B. Anthony, and the two became leading lights in the women's movement in the United States.

Stanton regarded self-fulfilment for women, including in marriage and as mothers, as the *sine qua non* of a fair society. In her continual efforts to promote equality for women, she specifically referred to reformatory notions, such as the principle of taking responsibility for one's own life. Together with Susan B. Anthony, Stanton campaigned for the State of New York to have statutory discrimination against women repealed and made a significant contribution to the passing of acts allowing married women to own property, ensuring that mothers could be given custody of their children and establishing widows' rights. During the American Civil War (1861–65) Anthony and Stanton founded the first national political organisation for women, the Women's Loyal National League, which demanded the abolition of slavery by the US Congress. After the war, however, Stanton found herself in disagreement with her former colleagues in the League, who felt that black men (and not black women) should be given the vote. In 1869 Stanton and Anthony founded the National Woman Suffrage Association with the aim of achieving votes for women by means of a federal constitutional amendment.

Stanton was deeply Christian in her attitudes and there was a clear link to the work of Martin Luther in her striving for re-form through the transformation of life both within the Chur and in wider society. But she also regarded some of the Churc teachings as problematic. In 1888, she took issue with the male editors of the new revision of the King James Bible for, she saw it, their misogynistic translations of certain passag She set up a Revising Committee of feminist intellectuals w the intention of investigating the portrayal of women in t Bible. Stanton believed that, in its original form, the Bible played a much more positive attitude to women than she fou in English translations. She blamed scholars, translators a commentators for the predominantly sexist exegesis of the ble. Her *Woman's Bible* (1895–98) endeavoured to analyse a correct passages in the Bible that were biased against wom On 15 June 1895 Elizabeth Cady Stanton addressed the Woma Bible Revising Committee: 'This book may be read for gen tions to come, and your word will stand as well as mine, to h or hinder the development of a grand womanhood.'

An Paenhuysen

→ Further readi
Kathi Kern: *Mrs. Stanton's Bible*, Ithaca and London 2
Lori D. Ginzberg: *Elizabeth Cady Stanton. An Amer*
Life, New York 2010.
Elizabeth Cady Stanton: *Eighty Years And More 1815–1*
New York 1898.

The Bible and the Church have been the greatest stumbling blocks in the way of women's development

Elizabeth Cady Stanton, *The Woman's Bible*, Part 1, 1895

THE WOMAN'S BIBLE.

PART I.

THE PENTATEUCH.

"In every soul there is bound up some truth and some error, and each gives to the world of thought what no other one possesses."—*Cousin*.

NEW YORK.
EUROPEAN PUBLISHING COMPANY.
35 WALL STREET.
1895.

PRICE 50 CENTS.

JOHANNES BRAHMS
COMPOSER,
GERMANY, 1833–1897

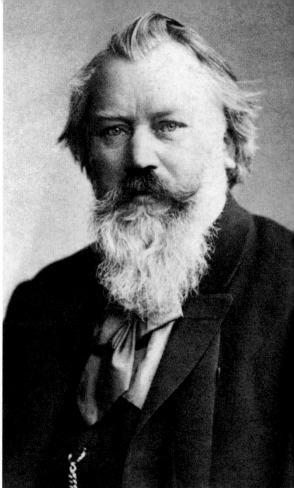

Johannes Brahms is not seen as a composer of sacred music in the traditional sense. His instrument was the piano, his mode of expression the orchestra – and when it came to choral music it was the works of Classical writers from Johann Wolfgang von Goethe to Friedrich Hölderlin and Joseph von Eichendorff that inspired him. His *Liebeslieder Waltzes* Op. 52 (1868) and the *Neue Liebeslieder* Op. 65 (1874) cycles are legendary.

Born on 7 May 1833 in Hamburg, by the age of 20 Brahms was a regular guest at the house of Robert and Clara Schumann in Düsseldorf and considered the new messiah of the music world. The composer first came to real prominence on 10 April 1868, when, aged 34, he conducted the premiere of his first great work for choir and orchestra, *A German Requiem* Op. 45, on Good Friday in Bremen. The performance took place at the Cathedral of St Peter, the city's famous two-towered landmark.

The *Requiem* is a work which has brought honour and glory both to its composer and Protestant sacred music. It remains an essential part of the repertoires of great choirs throughout the world today – and with good reason. While Heinrich Schütz had created the most powerful Protestant memento mori in chamber music style with his *Musikalische Exequien* (1636), 232 years later Brahms succeeded in composing its equal in the form of a major symphonic choral work. He created a piece which, in both language and content, provided a Lutheran-Protestant counterpoint to the classic Latin requiem. Brahms took the funeral mass and from it crafted a consolation mass – a work to give solace to the bereaved. To achieve this he used the Beatitudes from the Sermon on the Mount, together with other texts from the Old and New Testaments, and drew heavily on the Psalter. His music derives its power from the traditional forms of Romanticism, of which he was one of the boldest exponents, but it is also informed by the works of the Baroque, above all those of Johann Sebastian Bach and Georg Friedrich Handel, whose *Messiah* Brahms praised extremely highly, and the influential musical language of Giovanni Pierluigi da Palestrina.

When he was just 30 years old, Johannes Brahms settled in Vienna, from where he travelled all over Europe as pianist and conductor. During the summer months he was drawn to mountains to compose. After producing a number of sm; sacred works in his early period, such as the moving ps motet *Schaffe in mir, Gott, ein rein Herz* (*Create in me, O Go pure heart*) Op. 29, 2 (1857), the death of a friend led Brah to reach a new milestone in the form of the motet *Warur das Licht gegeben dem Mühseligen* (*Why is light given to him is in misery*) Op. 74, 1 (1878). Once again he proved himsel be a master of the art of synthesis, sensitively weaving wo from the laments of Job and the Prophet Jeremiah toge with Martin Luther's chorale, 'Mit Fried und Freud ich i dahin' ('With peace and joy I now depart'), to form a uniq cohesive work.

Following the death of Brahms on 3 April 1897 in Vienna composer friend Heinrich von Herzogenberg, to whom he always stressed his view of religion as a private matter, paid ute to his approach to the Bible as 'quintessentially Protest

Klaus-Martin Bresgott

→ Further read
Hans-Georg Klemm: *Johannes Brahms*, Heidelberg 201
Brahms-Handbuch. Wolfgang Sandberger (ed.), Kassel
Brahms and His World: Walter Frisch and Kevin C. K (eds.), Princeton 2009

I cannot cast off the inner theologian

Luther Bible from the estate of Brahms, 1833

Johannes Brahms, *'A German Requiem'* Op. 45, text manuscript, before 1868

JAMAL AD-DIN AL-AFGHANI

ISLAMIC REFORMER,
C.1838–1897

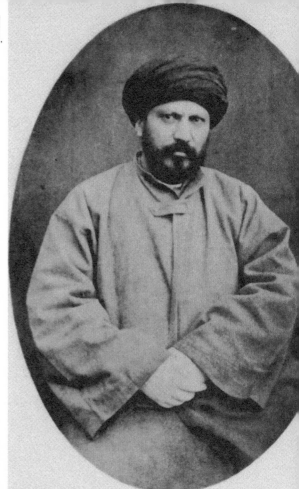

Born in Iran in 1838, Jamal ad-Din al-Afghani was one of the most important, publicly active Muslim intellectuals of his generation. He studied theology and law in Iraq and journeyed through the entire Islamic world. As a young man visiting India, he saw the consequences of colonialism and openly criticised the British and their presence as colonial governors in India, Egypt and other Islamic regions. In the 1860s al-Afghani travelled to Afghanistan, only to be banished for his political aspirations. He then went to Cairo and to Istanbul, where he taught at the university. He lived in Cairo from 1871 to 1879. Having been banished for a second time, this time from Egypt, he returned to India. Here he collated all his speeches and lectures and published them as *The Refutation of the Materialists*, which includes a spirited defence of Islam against criticism from Europe.

Along with the Islamic scholar Muhammad Abduh (1849–1905), al-Afghani was one of the most important voices in the mid-nineteenth-century Islamic world advocating reform to combat the crises ensuing from European colonial ambitions. Al-Afghani developed an interpretation of Islam that urgently proposed modernisation and education. He even expected his own students to be political activists. His commitment to the transformation of the social and religious order links him with Luther, whom he explicitly regarded as a role model for his own pursuit of reformation. Al-Afghani appeared in public, wrote for the newspapers, led opposition movements from the front and thus exerted a far-reaching influence. However, his political engagement repeatedly led to his expulsion and exile.

Al-Afghani sought to use Islam to combat imperialism at same time as instilling in it a new openness to modern i In his view any real modernisation had to start with relig reform. He regarded a return to the fundamentals of Islan the prerequisite for a future independent of the West. He th fore spoke out in favour of a new exegesis of Islamic sou which he felt would reveal the concurrences between Islam the underlying principles of modernism. In addition to urg his fellow Muslims to live uncompromisingly by the Isla Tauhid (the indivisible oneness of Allah), to cast off supe tion and religion based on phenomena from elsewhere, suc mysticism, and to engage in a new interpretation of the Sh he also made the case for modernisation in education, tech ogy and the sciences. An Paenhuysen

→ Further read
Nikki Ragozin Keddie: *An Islamic Response to Imp ism. Political and Religious Writings of Sayyid Jamā Dīn al-Afghānī*, Berkeley 1968.
Nikki Ragozin Keddie: *Sayyid Jamal ad-Din al-Afg A Political Biography*, Berkeley 1972.
Muhammad Sameer Murtaza: *Die Reformer im I Jamal Al-Din Al-Afghani – Muhammad Abduh – Q Amin – Muhammad Raschid Rida*, Bad Kreuznach

I have passed a great part of my life in the Orient with the single aim of reforming society

RUDOLF STEINER
ANTHROPOSOPHIST,
AUSTRIA, 1861–1925

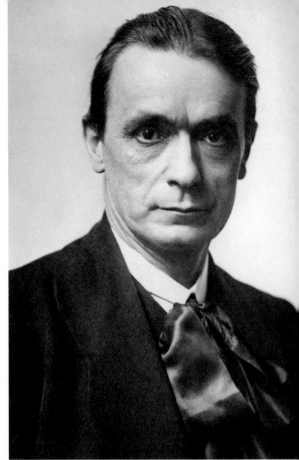

Baptised a Catholic, Rudolf Steiner was fascinated by church liturgies but also by occult experiences from childhood. His free-thinking father, on the other hand, encouraged him to take an interest in more technical matters. These contrasting influences led the young Steiner to question sensory and extrasensory reality and prompted him to renounce any materialist world view. He saw himself as a 'spiritual scientist' and was one of the first people to obtain literature published by the Theosophical Society, which had been established in New York in 1875.

Armed with a doctorate in philosophy, Steiner was made General Secretary of the Society's German section in 1902. Its global headquarters and President Annie Besant saw the esoterically construed figure of Christ as loosely connected to Jesus and expected a new incarnation of the 'cosmic Christ'. Steiner, on the other hand, saw this link with the esoterically construed Jesus as exclusive and felt that further 'incarnations' were inconceivable. These warring schools of thought led to a split in early 1913 and to the establishment of the Anthroposophical Society. Under Steiner's leadership, it was re-established as the General Anthroposophical Society in 1923. In the early 1920s, Steiner had been asked by a number of young Evangelical theologians, including Friedrich Rittelmeyer and Emil Bock, to help them set up a new church, which they called the Christian Community. Steiner formulated the spiritual basis for the community, which was founded in 1922, in three series of lectures; he also compiled all of the texts used in their services. Steiner's emphasis on Christ can be compared in some cases with the Lutheran principle of *solus Christus*. However, the esoteric interpretation of the 'being of Christ' and Jesus leads to very different spiritual contexts. This is revealed primarily in the negation of the Lutheran principle of *sola gratia*: the virtue of grace alone and the justification of the sinner were out of the question for Steiner. On the contrary, in the context of his teachings on reincarnation and karma, and definitely in the case of 'self-redemption', 'grace' is only an auxiliary factor.

Nevertheless, Steiner held Luther in very high regard. H[e] plained Luther's religious and culturally historic importa[nce] in the context of his view of time: the reformer was an ind[ivid]ual whose impulses came from the qualities of the 'fo[urth] post-Atlantean age', in which the spiritual world was still [open] to a certain degree but was also placed at the 'beginnin[g of] the fifth post-Atlantean age', during which materialism w[ould] gradually penetrate every human sphere. According to Ste[iner,] Luther's message could be interpreted as follows: 'You m[ust] distance yourselves from these works and from everyth[ing] which exists in the outside world, and find the way to the w[orld] of the spirit solely in your heart and mind.' The Lutheran [prin]ciple of 'through faith alone' should thus be understoo[d as] meaning that 'the relationship with the spiritual world [was a] purely inward one based on faith'. In this way, Steiner pr[oject]ed his anti-materialist battle onto the reformer, despite the [fact] that he had been concerned with very different theologic[al is]sues in his struggle. Werner Thiede

→ Further read[ing]

Rudolf Steiner: *Menschliche und menschheitliche En[twick]lungswahrheiten. Das Karma des Materialismus* (com[plete] works, vol. 176), Dornach 21982 (English translatio[n *As]pects of Human Evolution*, New York, London 1987)
Emil Bock et al.: *Luther. Hinweise auf die unvollende[te Ref]ormation*, Stuttgart 1983.
Werner Thiede: *Mystik im Christentum. 30 Beispie[le, wie] Menschen Gott begegnet sind*, Leipzig 2009.

Ideas become living forces

Blackboard drawings and notes by Rudolf Steiner for a lecture in Dornach, 2 October 1921

PIER PAOLO PASOLINI
FILM DIRECTOR, ITALY, 1922–1975

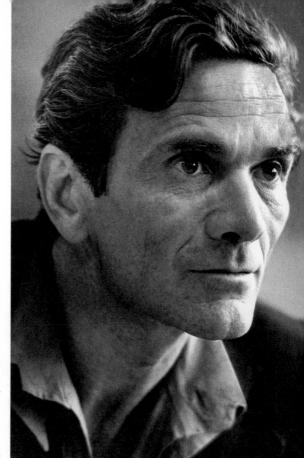

'*Io so!*' – 'I know!' This declaration opens a 1974 text by the film director and writer Pier Paul Pasolini, in which he accuses the ruling Italian Christian democrat elite of responsibility for the attacks in Brescia and Bologna of that same year and for the 1969 attack in Milan. Pasolini was articulating what many Italians at this time believed, but few dared say. This made him vulnerable to attack. Pasolini's brutally mutilated body was found in Lido di Ostia on 2 November 1975. The question as to whether his murderer had acted on behalf of shadowy background figures continues to preoccupy the Italian justice system today.

Pasolini himself used various epithets to characterise his own stance as a political commentator and journalist. He styled himself variously as 'heretic', 'corsair' and, finally, 'Lutheran'. Pasolini appropriated Luther as a free spirit who spoke out for truth and fought for change, openly and, if necessary, without back-up. Although Pasolini the corsair prided himself on his fierce independence, he was by no means a willing outsider. A staunch Communist, Pasolini was expelled from the Italian Communist Party in 1949 when his homosexuality became known. Turning his back on the dominant (white) urban bourgeois culture, Pasolini focused his attention on the cultures of the periphery, in which he attempted to uncover traces of an archaic vitality, which, he complained, had vanished in the uniformity of capitalist mass culture. His periphery was initially rural Friuli, where he grew up, later the proletarian milieu of the Roman suburbs with its small-time crooks and rent boys, whom he celebrated in books and films as *ragazzi di vita*, and, finally, the nomadic cultures of north Africa and the East.

His attitude to Christianity was ambivalent. Although he was an atheist, he recognised the Gospel as a message of liberation, and this understanding permeates his sensitive biblical film *The Gospel According to St Matthew* (1964). In stark contrast, the Church is treated with blasphemous relish in his short film *La Ricotta* (1962).

Pasolini worked intensively with dialects, sociolects and linguistic questions. Here too his focus was on the periphery, wrote his first poems in the Friulian dialect. He later acqui an intimate knowledge of the street slang of the Roman urbs. Pasolini's linguistic engagement with Luther, who t pains to translate the Bible into the vernacular, is closely lin to his own desire to make himself understood on several ferent linguistic levels (for him, film was also essentially a guage).

Over 15 years after Pasolini's death, the Milan public pros tor took the action that he had campaigned for so vehemen in his *Lettere luterane:* charges were brought against leading ures in the Italian Socialist Party (PSI) and Christian De crat Party (DC). The Italian party-political landscape fell ap Thereafter, in the form of Silvio Berlusconi, a man came power who – especially in his role as media entrepreneur – bodied the new type of fascism, which Pasolini had war against so strenuously in his final film, *Salò, or 120 Days o dom* (1975). S t e f f e n V o g t

→ F u r t h e r r e a d
Pier Paolo Pasolini: *Scritti corsari. Gli interventi più dis di un testimone provocatorio. Milan* 1975.
Pier Paolo Pasolini: *Lutheran Letters*, translated from Italian by Stuart Hood, New York 1987.
Karsten Witte: *Die Körper des Ketzers*. Pier Paolo Pas Berlin 1998.

I would call myself reformist, Lutheran, if it were possible to give some sort of meaning to these romantic epithets.

Pier Paolo Pasolini, *Lettere luterane*, 1976

trasformazione dello "sviluppo".

In attesa di una tale radicale riforma, sarebbe ((Io stesso ~~...~~ fermamente convinto)) ~~meglio abolire~~ sia la scuola d'obbligo che la televisione: perchè ogni giorno che passa è fatale sia per gli scolari che per i telespettatori...

A questo punto mi ritrovo perfettamente d'accordo con Moravia, come egli del resto si ritrova perfettamente d'accordo con me. Infatti la mia proposta di "abolizione" ancora una volta non è che la metafora di una radicale riforma: e Moravia e io, a proposito di tale riforma, non possiamo che avere le stesse idee.

Soltanto ieri, improvvisando a un dibattito con insegnanti, in un seminario tenuto a Lecce, delineavo quella che secondo me dovrebbe essere la scuola d'obbligo: e dicevo quasi esattamente le stesse cose di Moravia (aggiungevo, come materia di tale nuova scuola d'obbligo, la scuola guida, con annesso galateo stradale, problemi burocratici, ~~...~~ elementi di urbanistica, ecologia ecc. è soprattutto, aggiungerei, molte letture, molte libere letture liberamente commentate).

Quanto alla televisione la mia proposta di radicale riforma è questa: bisogna rendere la televisione partitica e cioè, culturalmente, pluralistica. E' l'unico modo perchè essa perda il suo orrendo valore carismatico, la sua intollerabile ufficialità. Inoltre, i partiti si sbranano all'interno della televisione, dietro le quinte, dividendosi (finora abiettamente) il potere televisivo. Si tratterebbe dunque di codificare, portare alla luce del sole questa situazione di fatto; rendendola ~~dunque~~ democratica. Ogni Partito dovrebbe avere diritto alle sue trasmissioni. Cosi che ogni spettatore sarebbe chiamato a scegliere e a criticare, cioè a essere coautore, anziche essere un tapino che ~~...~~, tanto più represso quanto più adulato. Ogni Partito dovrebbe avere il diritto, per esempio, al suo telegiornale: così che il telespettatore sceglie le notizie, o le confronta con le altre, cessando di subirle. Inoltre direi che ogni Partito dovrebbe gestire anche gli altri programmi (proporzionalmente alla sua rappresentanza al Parlamento). Nascerebbe una stupenda concorrenza, e il livello (anche quello spettacolare) dei programmi, salirebbe di colpo. Voila.

APPENDICE. Se l'attribuirmi un odio teologico contro il consumismo in generale, come fenomeno serioere del capitalismo, (attribuzione, ripeto, ingiusta, perchè il mio odio teologico va tutto contro il consumismo italiano, come va contro la televisione, ma contro la televisione italiana, non contro la scuola d'obbligo, ma la scuola d'obbligo italiana) mi fa meritare da parte di Moravia la qualifica di prerafaellita, è già qualcosa.

In altra occasione Moravia mi aveva dato del cattolico (quasi che i cattolici per definizione si ~~...~~ indignassero, o fossero donchisciotteschi, o scoprissero il fianco...). Prerafaellita è già una qualifica di passaggio verso quella che riterrei giusta, se queste qualifiche avessero qualche significato: cioè riformista, luterano,

15 PEOPLE
BEING IN THE
WORLD

'HE WHO LIVES HIS LIFE IN THE MIDST OF THINGS IS TRULY FREE.'

WA 20, 11; LW 15, 8

In 1525 Martin Luther, then a monk, married Katharina von Bora, a nun. In doing this the reformer laid down a very visible marker for a new relationship with the world. For him, God's creation was fallen yet good. Thus he defended the simple, physical aspects of existence. But how do Luther's ideas about worldliness operate? Do we approve only of the worldly and freedom-related consequences of the Reformation and adopt a critical attitude to Luther himself? By focusing on the world, some turn away from Luther; others turn their backs on the world and embrace Luther the mystic. What does world and worldliness mean for us today? What standpoint do we adopt in the world?

LUTHER
AND WORLDLINESS

CHRISTINE HELMER

Martin Luther knew the terror of God's judgement on sin. Like many of his contemporaries, he feared the imminent end of the world, a belief that gave a sharp and anxious edge to the moral rigour of late mediaeval ethics, regulated as they were by the complicated nexus of church canon law and imperial law. Luther's key insight into divine compassion, his understanding that Christ's mission was above all to forgive, led to a shift in attitude towards the world, which would contribute to the rise of a new epoch of global history. God's creation of the world,

Christ's incarnation in the world and the Spirit's life-giving work in the world helped Luther to articulate a life-affirming appreciation *for* the world. How did Luther maintain a positive worldliness while also admitting the world's misery and depravity? And what is Luther's relevance for a modern view of the world? In contemporary times characterised by human greed, exploitation of the marginalised and the reality of climate change, it is all the more important for theologians to take seriously God's concern for this world along with human responsibility for its ongoing existence.

There is a saying attributed to Luther that if the world were to end tomorrow, he would still plant his apple tree today. This attribution, however apocryphal it may be, reflects Luther's commitment to life and, indeed, to hope in a God whom he believed to be concerned with the flourishing of this world and of the human beings with whom God had populated it. Indeed, according to Luther, both the natural and the social worlds were created by God to promote human life and to be used and enjoyed by people (WA 42, 497, to Gen 13:2; LW 2:329). Appreciation for this life – not flight from it – characterises Luther's worldliness.

However, life in the world exists after Eden. Broken, defaced and bent towards sinning, human existence as conceived by Christian theology oscillates between despair and presumption. It is fixed inordinately upon the self. The natural world, too, is similarly awaiting redemption post-Eden. According to Luther's theology, God is at war in the world with the Devil. As prince of sin and evil, Satan actively works to destroy God's creation and all that may be thought good. In the late mediaeval world, being was marked by fear. Life was precarious, the plague a constant threat and death in childbirth an ever-present reality for most families. To this characterisation of human existence Luther added his theological idea that God accused the sinner by means of the law. Even the slightest sound of a leaf blowing in the wind could be seen to smite the conscience. But was it a sign from God or the Devil?

Even in its fallen state, however, Luther believed that the world revealed glimpses of God-created goodness. Human reason, he posited, 'is the inventor and mentor of all the arts, medicines, laws, and of whatever wisdom, power, virtue, and glory men possess in this life' (WA 39/I, 175; LW 34:137). He viewed art and music as divine gifts that affect the psyche, calm troubled souls and express joy, while social institutions, such as government and the household, serve to regulate and facilitate human relationships. Even if natural reason cannot discern their divine origins, God sustains them. Reason illuminated by faith, however, perceives God's ongoing preservation of the world and thanks the Creator who is hidden behind the creature. Sometimes, in dire situations, the Christian experiences goods that are taken away. In the midst of this unbearable tension between

faith and experience, Luther was convinced that, like Mary in Luke's *Magnificat* (WA 7, 581; to Luke 1:50; LW 21:335), the Christian still praises God. Incarnation is the most intimate way God chooses to unite with the world. As Luther writes in the Christmas hymn, 'Praise be to You, Jesus Christ', the divine Word sleeps in Mary's lap. Embodied in human flesh, the Word takes up the cruellest realities of human nature, its misery, sin and desperation. Through His own death and resurrection, Christ redeems creaturely existence and brings it back into the right relation with God. Luther insists that in Christ, God's embodiment is creation's salvation. But redemption for Luther is not a rescue *from* this world, but rather a healing of material and embodied reality, beginning with the soul and extending to the entire world.

Luther conceived of the world as the realm of human action. Here human beings, liberated by Christ from sin and selfishness, are free to act in the world for the good of their neighbours. Luther distinguishes between the ways in which people serve their neighbours using the notion of vocation (*vocatio* in Latin, *Beruf* in German). God, he argues, ordains each person with a particular purpose and calling. Exercising one's vocation as, say, a baker, teacher or soldier is not only a matter of earning an income but also of serving one's neighbours, and thus of creating community. As Max Weber argued in the early twentieth century, Luther's idea of vocation forms the historical basis of the modern emergence of the division between private religion and secular public life. When each person identified by a vocation is seen as occupying an identical status before God, there emerges the notion of a public sphere without the hierarchical distinction between a clerical elite and a lesser laity. While Weber's view has become significant in the modern narrative of secularisation, it is nevertheless anachronistic. In Luther's time, there was no political space independent of ecclesiastical (Catholic) jurisdiction. By his appeal to vocation, Luther challenged both the Church's elevation of the clergy and the theology of good works whereby the justified sinner can exhibit freedom from the self by working for the good of their neighbour.

The idea of vocation erodes clerical power and its accoutrements, specifically clerical celibacy. According to Luther, personal ways of being in the world, including sexuality, are realised not through monastic vows or priestly robes but through roles in the family. The vocation of mother or father, spouse or child, are personal vocations, to which the divine promise of partnership, which Luther sees in Genesis 2:18, is attached. Thus Luther can cheekily identify a mother as priest and bishop, responsible for serving her children in love and bringing them to knowledge of God. Luther criticises the false holiness of celibates; he argues that celibacy is an unnatural state. Only in the rarest of circumstances (Matthew 19:12) is celibacy a viable option. Chastity in marriage, not clerical celibacy, is a natural creat-

ed good. While human eyes may regard the married life as one of toil and care, the eyes of faith see it as the 'most precious jewels' (WA 10/II: 296; LW 45:39).The stench of an infant's nappy is as lovely in God's nose as the scent of incense.

In a convulsive time of political realignments, of the emptying of monasteries and their pillaging by greedy officials, and of radical rebellion by peasants to free themselves from servitude, Luther's views were sometimes less than revolutionary. His affirmative view of political rule would have destructive consequences when Lutheran theologians who had affiliated themselves with National Socialism during the Third Reich appropriated Luther's views to justify their position. They collapsed Luther's notion of God's law as a prerogative of the temporal authorities with an understanding of the orders of creation as exhibiting God's sustaining activity, twisting Luther's theology in such a way as to misperceive obedience to God as obedience to the Führer. To this day Luther's idea of the orders of creation remain tainted by this distorted theological deployment.

While Luther's ideas about politics have had a long reception history, they have their roots in the two swords idea of the Middle Ages. In his text from 1302, *Unam Sanctam*, Pope Boniface VIII had explained that God gave both the spiritual and the temporal swords to the Roman pontiff, who exercised the spiritual rule over the church and granted authority over the temporal realm to the civil authorities. In the case of Luther's own life, Pope Leo X wielded the spiritual sword of excommunication, but turned the heretic over to the Emperor for admonishing by the temporal sword, or in other words, the death sentence. Luther's own reforms regarding the world concerned what he saw as the entanglement between these two swords. His ire was provoked by the canon lawyers who for centuries had regulated sex and marriage in ways so complicated as to end up terrifying consciences. Luther drastically reformed marriage laws by demoting its sacramental status and prescribing a public ceremony. No longer under the jurisdiction of the spiritual sword, marriage would later become a matter of the civil courts, with divorce its legitimate dissolution.

Luther was also troubled by the economic changes of the early modern period, which were complicated by territorial questions concerning what should be done with church properties left empty by disbanded monastic communities and the poverty resulting from the upheaval. He commented on economic practices of the day, chastising merchants who sought to maximise profit and recommending that the temporal sword curb the exploitation rampant in the marketplace. While merchants were consigned to the temporal sword, the economic practices of Christians, so Luther thought in the early years of the Reformation, ought to be governed by biblical principles. The neighbour's good was to be at the forefront of Christian concern, even to the point of personal financial detriment (WA 6, 40–41;

LW 45:280). Sometimes Luther's altruistic suggestions were regarded as unrealistic by his wife, Katharina von Bora, who tried to preserve the family finances from Luther's carefree generosity. One practical way of addressing poverty in the church was the institution of the communal chest. The chest was placed in the church and opened at designated times in order to dispense donated money to the poor. This practice later led to the development of welfare distribution.

It may be said, then, that Luther introduced a robustly realistic understanding of the world into modern Christian theology. He knew the propensity of humans for sin and evil, yet he held to the promise of Christ's forgiveness and to the goodness of God's creation in all its particularities. It is anachronistic to find the roots of modern secularism in this; rather, it is the ground for the Christian engagement with the world in moral life and politics, in the care of the planet, and in personal relationships.

HENRY VIII
KING OF ENGLAND,
1491–1547

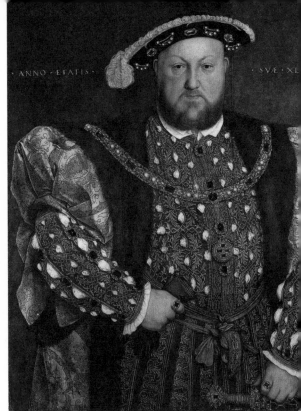

Henry VIII's relationship to Martin Luther illustrates how closely ecclesiastical-religious matters were entwined with worldly political interests in the Reformation period. In 1520 Luther caused a stir throughout Europe with his tract *De captivitate Babylonica ecclesiae*, in which he reduced the seven sacraments to three (Baptism, Penance and Communion). Henry VIII sought to refute his arguments with his *Assertio septem sacramentorum* in May 1521, for which Pope Leo X rewarded him with the title *Defensor Fidei* ('Defender of the Faith') – a title that British monarchs bear to the present day. By 1523, three editions of the *Assertio* had appeared in London and eight more in various continental towns; German translations by Thomas Murner and Hieronymus Emser were also in circulation.

Luther responded in 1522 with a theologically sophisticated Latin tract *Contra Henricum Regem Angliae* (Against King Henry of England) and a German version, more popular in tone, *Antwortdeutsch auf König Heinrichs von England Buch* (German Response to King Henry of England's Book), in which he slated 'Heyntz', as he called him, as a 'lying king'. Enraged, Henry urged the Saxon dukes in January 1523 to rein Luther in and suppress his New Testament translation (1522). Murner defended Henry with his pamphlet *Ob der König aus England ein Lügner sei, oder der Luther (Is the King of England a Liar, or is Luther?)* (1522) and was handsomely rewarded for it. In May 1525 Luther, who had been led to believe Henry was now more inclined to share his opinions, apologised to him in a letter, claiming that he had not realised that the *Assertio* had not actually been written by the King, but by evil counsellors led by Cardinal Wolsey. Henry was furious because, at a stroke, Luther had criticised his book and insulted his minister. Henry now accused Luther of unleashing the Peasants' War and of seducing a nun (Katharina von Bora); moreover, he attacked two fundamental pillars of Luther's teaching: justification by faith and the rejection of the notion of free will. Luther reacted only after Emser had translated Henry's tract into German in 1527 and implied was ready to recant: angrily, he attacked the king again in *des Königs zu England Lästerschrift (Reply to the King of Engla… Defamatory Tract)*. Henry did not respond but was pleased w Erasmus lambasted Luther for his quarrel with him in his *peraspites*. Henry also sought revenge by persecuting Luth followers in England.

When in 1534 Henry sought to annul his marriage to Cathe of Aragon, who was unable to give him a son, he solicited opinions of universities and individual scholars, including ther. Luther rejected the idea of divorce but proposed big as a possible solution.

Although Luther's theological opinions had been discusse England since 1520, the country only became receptive to Reformation after Henry's death. Henry introduced som novations – he created an English church independent of R dissolved the monasteries and seized their wealth, and ord each church to acquire an English Bible. But his reasons introducing these measures were political and secular; es tially he remained a staunch Catholic. John L. Flood

→ Further read

Neelak S. Tjernagel: *Henry VIII and the Lutherans. A Study* glo-Lutheran Relations from 1521 to 1547, St. Louis 1965.
John L. Flood: *Heinrich VIII. und Martin Luther. Ein eu* scher Streit und dessen Niederschlag in Literatur und Publi in: *Spannungen und Konflikte menschlichen Zusammenlebens deutschen Literatur des Mittelalters*, Kurt Gärtner, Ingrid K and Frank Shaw (eds.), Tübingen 1996. 3–32.
Lyndal Roper: *Martin Luther, Renegade and Prophet*, Londor

> Pastime with good company
> I love and shall unto I die

Henry VIII, *Assertio septem sacramentorum*, 1521

Martin Luther, *Contra Henricum Regem Angliae*, 1522

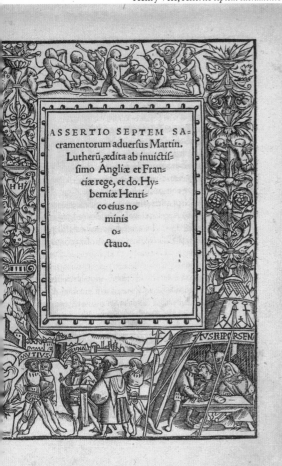

GUSTAV II ADOLF

Printed on flyers, the media revolution of the time, Luther's teachings were transported to Stockholm in the holds of merchant vessels. King Gustav I Vasa initially regarded these new ideas with suspicion, until he came to understand their great value in his construction of a new state. The Swedish monarch then started to attach great importance to Luther's teachings and actively supported young Swedish theologians who had studied in Wittenberg. These theologians translated the Bible into Swedish and ensured that the new faith was widely accepted. Gustav I broke ties with Rome and sequestered the very considerable land and properties owned by the Catholic Church. Following his death the disputes between his descendants over religion and the distribution of power led Sweden into civil war. Gustav's youngest son Karl emerged triumphant after a battle with his Catholic nephew Sigismund of Poland, in which Karl elevated the question of religion to an existential issue for the people of Sweden. On Karl's death his son, Gustav Adolf, who was still a minor, took up the fight against his Catholic cousin.

Gustav II Adolf had been brought up as an Evangelical Lutheran, although at that time Lutherans in Sweden had not yet adopted the strictly confessional Formula of Concord. His parents were even unfamiliar with some of the ideas of Jean Calvin. The young Gustav Adolf was in complete agreement with the political-religious decisions of his grandfather and father, particularly since his own claim to the crown was rooted in the *Confessio Augustana*. A year before he was born the Imperial Diet had decided that all Swedish sovereigns had to be Lutherans – which excluded the Catholic Sigismund.

Gustav Adolf fought to defend his own crown and Luth[er] Reformation with conviction and missionary zeal. Swed[ish] Catholics were regarded as potential traitors and threate[ned] with death. When the military successes of the Catholic [Em]peror in the Thirty Years' War extended the latter's territo[ry] to the Baltic Sea, and the imperial forces lent their suppor[t to] Sigismund in his struggle against Sweden, the ever-resourc[eful] Gustav Adolf shifted his theatre of war from the Baltic to [the] Holy Roman Empire. He dealt a blow to imperial domina[tion] when he defeated General Tilly, but found the tables tur[ned] on him by Albrecht von Wallenstein. Gustav Adolf's inter[ven]tion bolstered the positions and interests of numerous Pro[tes]tant princes in the Holy Roman Empire, but he never mana[ged] to realise his dream of a 'universal Evangelical union'.

Gustav Adolf's Protestant contemporaries regarded him as [a] 'saviour of freedom' – all the more so after his death at the [bat]tle of Lützen. This view of him persisted for centuries, des[pite] the concept of freedom undergoing fundamental change dur[ing] the Enlightenment. Amongst Protestants Gustav II Adolf [has] always been known as the king who wielded his sword to [de]fend Luther's achievements in this world.

Inger Schuberth

→ Further read[ing]
Michael Roberts: *Gustavus Adolphus: A history of Sweden,* 1[611–]1632 (two volumes), London 1953.
Sverker Oredsson: *Gustav II Adolf,* Malmö 2007.
Gustav Adolf, König von Schweden. Die Kraft der Erinnerung 1[632–]2007, Maik Reichel and Inger Schuberth (eds.), Dößel 2007.

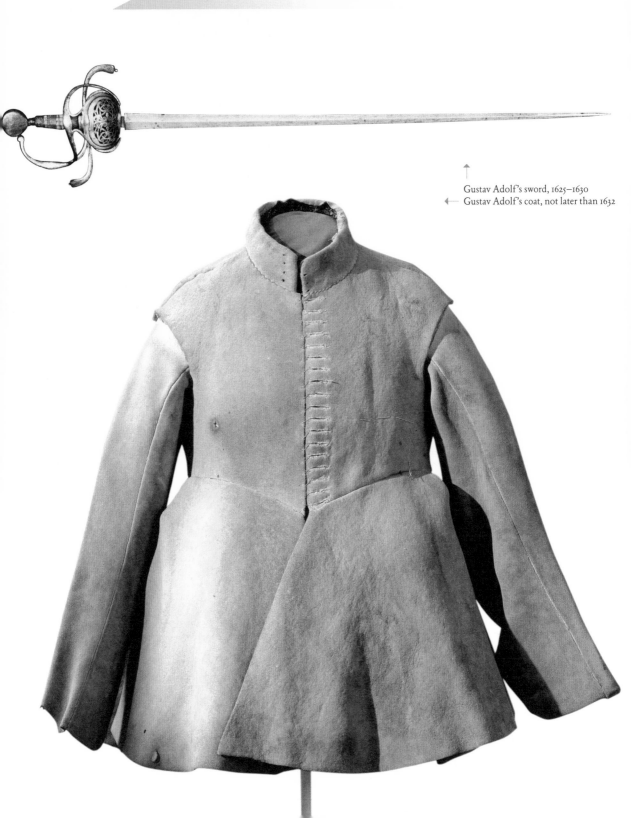

I will not countenance nor allow any talk of neutrality. God and the Devil are in conflict here.

Gustav Adolf's sword, 1625–1630
← Gustav Adolf's coat, not later than 1632

JOHANN WOLFGANG VON GOETHE
WRITER, GERMANY, 1749–1832

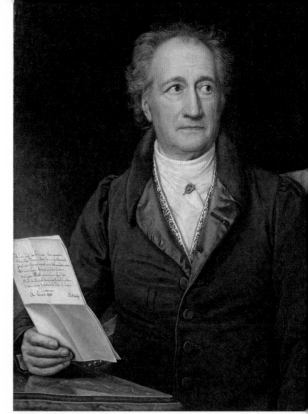

It was historian Friedrich Meinecke who divided the German nation into a 'Luther camp' and a 'Goethe camp'. In so doing he was referring to a historical situation that was coloured by the outcome of the First World War, by the decline of 'Goethean' cultural Protestantism and by a new 'theological revolution' (Kurt Nowak), which, in addition to its so-called dialectical theology, also had a decidedly Lutheran wing. But Meinecke's statement also pointed to something else, that is to say, a fundamental tension in the German mindset in which 'Goethean' worldliness, sophistication and wide cultural horizons are forever at odds with 'Lutheran' coarseness, piety and unconditionality.

Against this backdrop it is hardly surprising that Goethe did not have a particularly positive view of Luther. The only interesting thing about Luther was his character, or so Goethe wrote in a letter to his friend Karl Ludwig von Knebel in 1817. 'Everything else is confused rubbish, with which we are still daily burdened.' Goethe also appears to have been put off by Luther's intolerance, above all in theological and religious matters. Goethe's own attitudes were the diametric opposite. Indeed he regarded himself not just as a non-Lutheran, but as a 'committed non-Christian'.

Nonetheless, he was not blind to Luther's positive qualities. During the preparations for the anniversary of the Reformation in 1817 he submitted proposals for a Reformation memorial (in Berlin!). This seems to be at odds with the reference he made to 'rubbish' the same year, because his proposals take Luther entirely seriously as a theologian. They present him as a thinker following in the footsteps of St Paul but they also

show – with references to two Church Fathers, St August[ine] and St Athanasius – that Luther's aspirations were in fact [p]Christian. Goethe even started to plan a Reformation cant[ata] but that never came to fruition either.

What might be the explanation for Goethe's at least par[tial] appreciation of Luther? A connection between the two m[ay] perhaps be found in their 'worldliness'. Luther's removal [of] the qualitative distinction between the clergy and lay peo[ple], his high regard for 'ordinary' work, his warm appreciation [of] physicality and sexuality – Goethe would have understo[od] all of that. However, towards the end of his life, in 1832, Goe[the] placed particular emphasis on the positive, secular consequ[enc]es of the Reformation: 'We have no idea what we owe to Lut[her] and the Reformation in general. We have been freed of [the] shackles of narrow-mindedness, and as a consequence of [our] advancing culture have developed the capacity to return to [the] source and to grasp Christianity in all its purity.' Maybe [the] 'Goethe camp' and the 'Luther camp' are not so starkly oppo[sed] to each other as it might seem at first glance.

Benjamin Hasselhorn

→ Further read[ing]
Bernhard Suphan: Goethe und das Jubelfest der Reforma[tion,] Goethes Vorschlag zur Feier, Plan einer Reformations-Car[tata] und Entwurf zu einem Reformations-Denkmal für Berli[n,] Goethe-Jahrbuch 16 (1895), 3–12.
Jörg Baur: Martin Luther im Urteil Goethes, in: Goethe-buch 113 (1996), 11–22.

ann Wolfgang von Goethe, sketch for a monument
rking the anniversary of the Reformation, 1817

Johann Wolfgang von Goethe, draft of a cantata marking the
anniversary of the Reformation, 1817

CASPAR DAVID FRIEDRICH
ARTIST,
GERMANY, 1774–1840

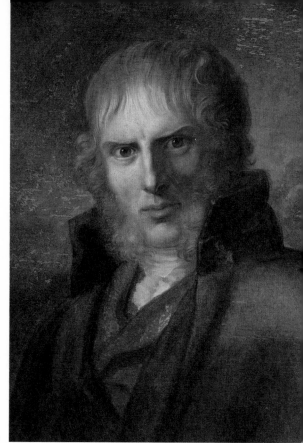

In order to fully grasp Caspar David Friedrich's deeply religious thinking, it is worth momentarily stepping back from our, often hackneyed, notions of Romantic art. Friedrich's style of painting, which we are so familiar with today, appeared strange and unsettling to his contemporaries. Many of those who first saw his paintings were openly disconcerted that Friedrich was not using his talent to lead the viewer's gaze into pleasing, harmonious landscapes or into the sublime natural world. While those early viewers expected to be able to 'step into' a painting, to explore a landscape, Friedrich's compositions confronted them with unusual, even uninviting pictorial constructs and with motivic details that seemed somehow singularly meaningful. His paintings do not present the world as the viewer knows it or wishes it. On the contrary, his views of nature are seen in compositions that, for all their subtlety, never try to hide the fact that the viewer is standing in front of a picture, a painted, finite surface. And it is, not least, this extremely contrived, even artificial pictorial mode that makes one wonder whether the painted motifs may have another, deeper significance.

The numerous crosses that Friedrich incorporated into his landscapes convey a sense of the close affinity between his kind of painting and religion. Like his art, the surviving writings of Caspar David Friedrich reveal a very traditional, Lutheran faith. He grew up in Greifswald in deeply religious surroundings; as a young boy his circle of acquaintances included Lutheran pastors and he later came into contact with highly educated theologians. As a student in Copenhagen and during the many years he spent in Dresden as an artist, it cannot have escaped Friedrich that by 1800 it was no longer possible to unthinkingly adopt traditional forms of religious painting. Indeed it could be said that his landscape paintings are nothing short of an attempt to fundamentally renew Protestant art.

What distinguishes Friedrich's art is his determination not merely to speak to the viewer through what is represented on the canvas, that is to say, traditional pictorial marks, but a to turn the act of viewing a painting into an aesthetic exp ence that can accommodate Protestant scepticism towards tures and the sense of sight. Friedrich's paintings never le one in any doubt that these are pictures, or, as he himself p done by 'human hand'. It is always perfectly clear that the v er is not confronted with nature itself, but only a picture of ture. And yet, the atmospheric effects and aesthetic quali of these paintings draw the viewer into a process of percept that goes further than merely identifying motifs or decip ing symbols. In the landscapes with crosses in particular viewer has a sense that God only reveals Himself by conc ing Himself. The paintings themselves alert the viewer to fact that what appears in them is not in fact present. In most radical of all his paintings, the *Tetschener Altar* (1807– Friedrich – in a most surprising manner – comes very close a core precept of Luther's concept of God, namely the *the gia crucis*, the theology of the Cross. Johannes Grave

→ Further readi
Werner Busch: *Caspar David Friedrich. Ästhetik und gion*, Munich 2003.
Christian Scholl: *Romantische Malerei als neue Sinn kunst. Studien zur Bedeutungsgebung bei Philipp Otto R Caspar David Friedrich und den Nazarenern*, Munich 2 Johannes Grave: *Caspar David Friedrich*, Munich 2012 glish translation: *Caspar David Friedrich*, London, N York, 2012).

You call me a misanthrope,
because I avoid society.
You err;
I love society.
Yet in order not to hate people,
I must avoid their company.

Caspar David Friedrich, *Cross in the Forest*, c.1812

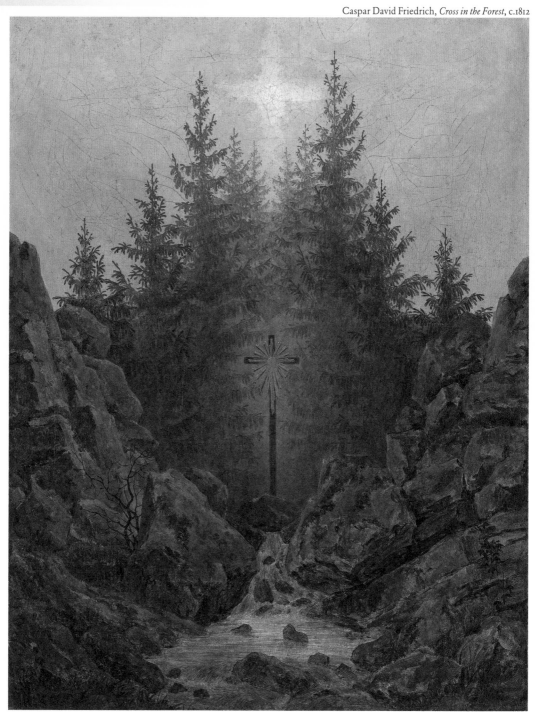

EDVARD MUNCH ARTIST, NORWAY, 1863–1944

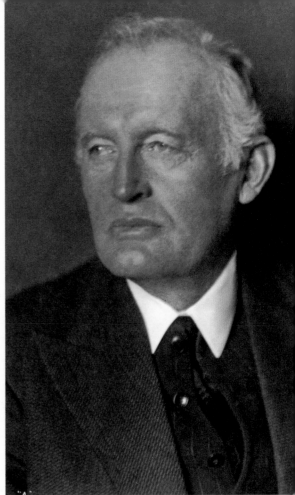

In his paintings the Norwegian artist, Edvard Munch, bared the soul of modern human beings with unprecedented candour, blazing a trail for the future of art not only in technical terms but also visually and spiritually. His ability to transform his own emotions into art allowed him to articulate existential issues that have seen his works become icons of modern consciousness. His scepticism towards the 'finished' work, his search for a visual code for his own experience, and his fixation on his own individuality and self-styling impressed not only the Expressionists but also artists such as Pablo Picasso, Andy Warhol and Joseph Beuys.

Munch's parental home was strictly Pietist, regulated by home worship, high morals and a belief in the afterlife. The early deaths of Munch's mother and of his older sister left him a sensitive, shy young boy who felt he was at the mercy of the world. His artistic breakthrough came with his moving portrait of his sister in *The Sick Child* (1885). His brooding, nervous father, a medical officer at the army headquarters in Kristiania (Oslo), had a tendency towards religious outbursts. Munch's traumatic childhood and his sense of the ubiquity of sickness and death were not solely the outcome of the losses he suffered. They were also rooted in his family's Pietist concept of sin and redemption. Looking back, Munch once described finding his father deep in impassioned prayer after an argument over the length of time unbelievers must endure the torments of Hell; Munch himself only managed to regain his equilibrium by making a drawing of his father. He had, as it turned out, stumbled on a way to productively channel his fears into art.

Munch escaped the overwhelming religious edifice of his parental home by joining a radically Bohemian set, first in Kristiania and later in Berlin. He adopted their maxims — denying God's existence and pursuing free love and the artistic representation of one's own life — but that only brought him more suffering, because he could not free himself of his 'fear of life and thoughts of eternal life'. He tried to become master of his own existence by addressing subjects such as love, jealousy and loneliness in his paintings: 'My art is self-confession. Through it I seek to clarify my relationship to the world.'

Munch increasingly came to see the world as an entity governed by metaphysics and pantheistic spirituality, with the cycle of life as a divine becoming and dying. His cycle *The F[rieze] of Life*, with depictions of existential, human situations th[at he] freely reworked and reordered, clearly embodies this world[view]. Although overpowering anxiety led Munch — 400 years [after] Luther — away from conventional belief systems, it never [sepa]rated him from the God he saw in nature and in human be[ings]. The portrait of the *Madonna*, which Munch also called '[Con]ception' and 'Loving Woman', is part of *The Frieze of Life*. [The] figure in this painting is shown, with positively religious [rever]ence, as both a saint and a sinner, as a secular goddess emb[rac]ing the beauty of pain. The sperm and the embryo on the fr[ame] point to the cycle of conception, birth and death, and re[flect] the overtly Christian subject matter in the contemporary g[uise] of the mystery of life, death and human development.

Katja Schneider

→ Further read[ing]
Ragna Stang: *Edvard Munch. The Man and His Art*, [New] York 1979 (originally published in Norwegian: *E[dvard] Munch. Mennesket og kunstneren*, Aschehoug 1977).
Edvard Munch. 1863–1944, catalogue to the exhi[bition] *Munch 150*, Milan 2013.
Atle Næss: *Edvard Munch. Eine Biografie*, Wiesbade[n 2011] (originally published in Norwegian: *Munch. En bi[ografi]*, Glydendal 2004).

God is in us and we are in God. Everything is movement and light.

Edvard Munch, *Madonna*, 1895

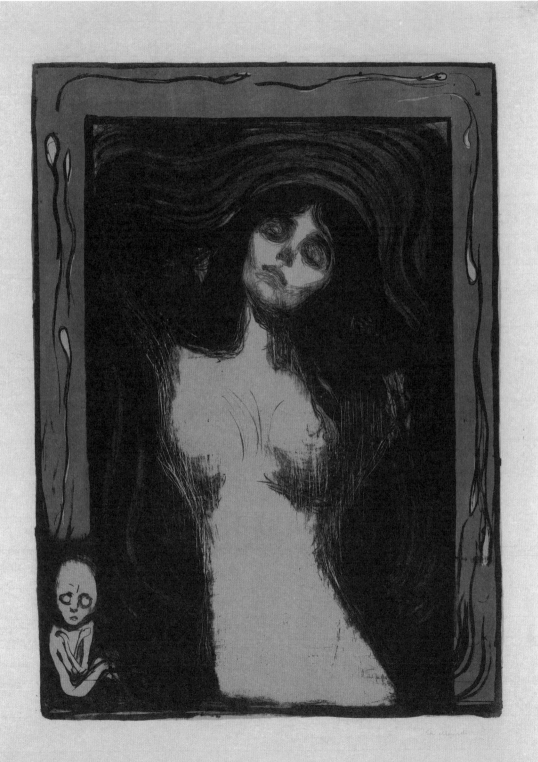

DR. SEUSS
CHILDREN'S AUTHOR,
USA, 1904–1991

Children were always ringing Dr. Seuss' doorbell. They wanted to see for themselves the man who had dreamt up *The Cat in the Hat* – whether he really did eat 'green eggs and ham' and whether his own skin might be as green as that of his grumpy 'Grinch'. Adults, who the writer and illustrator liked to describe as 'obsolete children', were also immensely curious about him as an individual. Who was Dr. Seuss? Why did he use a pen name? How did he keep coming up with new ideas? And who on earth, he was once asked, had thought him up in the first place?

Faced with questions of that kind, the reserved Theodor Seuss Geisel generally just replied with a witty deflection. If he did occasionally manage to come up with a serious answer, it was only in deference to his mother Nettie's influence. It was Nettie, the daughter of German immigrants, who gave him not only the name Seuss but also his moral standards. He also recounted that his love of language, particularly rhyming verse, came from his mother. Each evening she would read aloud to him, preferably from the Bible or from etiquette books for children such as Gelett Burgess' rhyming-verse, picture book *Goops and How to Be Them. A Manual of Manners for Polite Infants* (1900). Nettie Geisel's approach to her son's upbringing was thus firmly rooted in the Lutheran tradition, which was not only about the individual's path to salvation but also about 'life's duties, problems, successes and failures, experiences and perplexities' which, as Dietrich Bonhoeffer wrote, shape our earthly existence. Luther himself loved – and translated – Aesop's fables. He regarded them as a useful companion to the Holy Scripture and suggested that parents should read them out loud at the supper table and question their children on the meaning of the fables. That, he felt, was the best way for children to learn how to behave well in this world – that is to say, in a way that is pleasing to God.

Like his contemporary, Bonhoeffer, and like Luther so long ago, Dr. Seuss attached the greatest importance to the question of how human beings can behave well in this life and he was ▮ aware of the particular challenge of mediating values suc▮ responsibility and neighbourly love in a world torn apart by world wars. His many bestsellers, such as *Horton Hatches the* ▮ (1940), *The Cat in the Hat* (1957) and *Yertle the Turtle* (1958), w▮ were also turned into films and much translated, relied on ▮ dren's intelligence – but also on their love of fun and their ▮ ity to spot sense in nonsense. Without ostensibly preaching g▮ morals, his bizarrely lovable, unlikely heroes encourage de▮ decent behaviour. Take Horton the Elephant, for example: w▮ Mayzie, a lazy bird, asks him to sit on her egg so that she ca▮ off for a rest, he naturally agrees to help. But time passes, ▮ she doesn't come back. With his life in danger, Horton ▮ tinues to look after the egg, balancing precariously on a si▮ branch, and he stays there until in the end an elephant-▮ hatches from the egg – all because Horton is an elephant ▮ an elephant always keeps his word. Catherine Nicho▮

→ Further read▮
Judith and Neil Morgan: *Dr. Seuss & Mr. Gei*▮ Biography, New York 1996.
Donald E. Pease: *Theodor Seuss Geisel. A Portr*▮ *the Man Who Became Dr. Seuss*, Oxford 2010.
Jacob M. Held: *Dr. Seuss and Philosophy. Oh, the T*▮ *You Can Think!*, Lanham, Maryland 2011.

I'm a griffulous, groffulous groo. I'm a schmoosler! A schminkler! And a poop-poobler, too!

children's books by Dr. Seuss

'I CANNOT AND I WILL NOT RETRACT ANYTHING.

WA 7, 838; LW 32, 1

Luther's life was shaped by commitment: the posting of the 95 Theses on 31 October 1517 was an avowal against the sale of indulgences and his appearance at the Diet of Worms in 1521 demonstrated his unwavering commitment to his own theories. Almost everything Luther wrote has the character of an avowal or confession. Again and again, Luther has inspired people with the courage to profess their beliefs, even in the face of resistance and even though such commitment might contradict him or even flout Protestantism. Nevertheless, making a gesture of commitment can seem daunting and excessive. Luther's polemical zeal in his conflicts with his opponents could represent the other side of his courage to commit. To this day Luther raises the question of what is important enough to us that we will commit ourselves openly to it, regardless of the consequences.

FROM A STANDING START

DIETRICH SAGERT

The practice of the Confession of Faith is a curious one. During the service, following the invitation from the pastor: 'Let us confess our faith', the congregation *stands* and, in a peculiarly solemn tone of voice, recites an old text. From the way it is spoken, it sounds as though no-one understands it, no-one *can understand* it: the arc of meaning of what are, in any case, archaic formulations is fragmented. So you are not meant

to understand what you are saying. You just blithely entrust yourself to a text which has been handed down from time immemorial. Ultimately, there is nothing to understand, or understanding is not especially important and is in fact impeded by the manner in which the text is spoken. The Confession of Faith thus becomes an act of communal self-affirmation, backward-looking in its perspective.

It is interesting to compare the Confession of Faith with an almost identical practice in the service which follows the pastor's command, 'As our Saviour taught us, let us pray'. Again, the congregation stands and, in the same strange tone, recites the words of the Lord's Prayer. In performative terms the effect is the same. So is the Confession of Faith a prayer? Clearly not, as the Creed is not addressed to anyone. It assures those who say it together of their togetherness and excludes everyone else. If it is addressed to anyone, it is to outsiders, *those who stand outside* the congregation. Whether aimed inwards or outwards, the non-comprehension of the recited words applies equally. Those confessing their faith do not need to understand (they believe); those who are not confessing are not meant to understand. Curious.

If one were to ask serving pastors or theologians who concern themselves with such matters, one would surely be told that it is not meant this way at all. They would reply that the Creed in no way involves people incomprehensibly reciting words to assure themselves of their faith and the community of faith. Moreover, they would say, those who stand outside and do not profess their faith can and should want to understand that which they do not believe. There is an odd discrepancy here with regard to the act of professing: it has taken on a life of its own and lost its connection to the content. As a result, the possibility of unlocking this content and rethinking it is, if not completely abandoned, then surely underrated.

Yet if one considers the Creed texts, they are often so dense – poetically, theologically and philosophically – that they might really be described as essences. They are rather like treasure chests which must – and can – be carefully opened to reveal what is concealed inside. This does not necessarily have anything to do with the practice of the Confession of Faith. In fact, the act of Confession may well even hamper discovery of the treasures within, as we only find in it what we already know. The challenge and perhaps the future of Christianity may be to take this as the starting point for discovering what we do not yet know and, indeed, may perhaps never even have imagined to be possible...

From this point of view, that curious act, the Confession of Faith, is a stand-in for these as yet unrealised possibilities. The relationship between inclusion and exclusion in the act of the Confession of Faith remains problematic. In a Reformation context, this issue arose in a concentrated form in a key historical scene. The legendary wording thereby established has been

passed down through its own particular traditional narrative. At the heart of this, historically, is Martin Luther's appearance at the Diet of Worms in 1521. Through skilful but tough negotiations Friedrich the Wise, the spider at the centre of the web of German power politics, had managed to ensure that Martin Luther was allowed to appear there before Charles V. The young Spanish Emperor was the only universal power Luther could still call on after he had equated the Pope with the Antichrist and publicly burned the papal bull threatening him with excommunication.

Luther's journey to Worms was marked by spectacular preaching events in a number of towns and cities along the way. He arrived in Worms as a celebrated champion of freedom. However, when he came before the Diet he was taken by surprise by a direct demand to recant. Luther stood firm and declared that this was something he could not do and he was eventually granted a one-day period of reflection. Luther apparently seemed intimidated, speaking in uncharacteristically quiet, rather introverted tones. Even the Saxon Elector, Friedrich the Wise himself, seeing Luther at close quarters for the first time, was disappointed.

It was only his appearance on the second day that gave rise to the utterance, which was disseminated later through a Wittenberg pamphlet, to which Luther did not contribute, in the following blunt and incisive wording: '*Here I stand,* I cannot do otherwise, God help me, Amen'. This statement is still very much part of the Reformation commemorations and celebrations today. Luther saw his conscience as being captive to the Word of God. During the debate in Worms he laid claim to the truth as his own, with tumultuous consequences.

During Luther's lifetime these consequences affected the Church and the world – the inward and the outward – and, for better or worse, had direct political ramifications from which people later long shied away. His Protestant impetus resurfaced in the Germany of the 1930s in the small branch of the Lutheran Church which called itself the 'Confessing Church'. This Confessing Church distanced itself in its teaching and organisation from the Nazification of the German Christian movement, which supported the National Socialists after they seized power. At that time there was no indisputable response, even inwardly, to the question, '*Where do we stand today?*'. Yet only a few individuals honed this into '*Who stands fast?*' and responded in an actively outward-looking manner by taking the step into political resistance. For a long time, this minority was deprived of both intercession within the Church and appreciation and regard outside it.

Thirty years ago 'Protestant protest' encountered another historic situation which allowed its earlier legendary power to come to the fore once again. Through hymns such as 'Grant us Thy peace, Almighty Lord', 'Christ is arisen', 'We believe in God, the Almighty' and 'We now implore God, the Holy Ghost', individuals, who in the face of concrete political repression

could not do otherwise, gradually gained courage. With spades on the shoulders of uniforms and swords-to-ploughshares badges on jackets and bags, this courage resounded not only through redbrick cathedrals and village churches but also found its way on to the streets and eventually caused a wall to fall. Those in power had not reckoned with candles and prayers, with 'Watch and pray'.

Yet when confronted directly the power seems to drain away from the hackneyed phrases reminiscent of those in the Creed and its variations. Regardless of which part of it forms the primary focus, its clichés now only give off an inward-looking, petulant, would-be cannot-do-otherwise, which never gets beyond a pity-me, religious 'I want to stay the way I am'. Ever since, there has been something slightly shame-faced about initiatives of any kind involving Confessions of Faith. Luther would have felt compelled to throw an inkwell – at least at the soft voice whispering 'You may' inside the heads of those who want to stay the way they are.

When Martin Luther faced a thorny issue and did not want to make a decision, because he did not want to pass up on an experience, but wanted to put a stop to (or, one might say, suspend) its dogmatic confession, he sometimes used the word *fortasse* – perhaps. Perhaps means 'you never know', it means that the time for Confessions of Faith may be past and they should be suspended and, at the same time, understood as an echo chamber created from not-understanding and from the discovery of the treasures they contain. This would make room for experiences which are not yet strictly regulated by confessional theory, for experiences in which life plays a role. What remained of the Protestant here-I-stand-I-cannot-do-otherwise would then take as its point of departure the Biblical Hebrew word *hineni*, which signifies an unconditional here-I-am, devoid of any motive.

This move perhaps marks the beginning of future Confessions of Faith which are yet to be devised. These Confessions will have suspended the issues of inward and outward, inclusion and exclusion; they will no longer see differentiation as the only conceivable way to form identity. They will invent expansive terms which can freely express similarities without disparaging origins. They will no longer be spoken, only sung – and in polyphony at that. It is through such polyphony that community develops. And these new Confessions of Faith will remain small, minor confessions, for they will be forever in the making. They will remain true to their own coming into being as possibilities not yet fulfilled.

Martin Luther had at least a presentiment of this move towards the small when he wrote his *A brief instruction on what to look for and expect in the Gospels* (1522) and the *Small catechism* (1529), which gave equal weight to practice (Morning Prayer, Evening Prayer) and learning (the main sections with commentaries on the Commandments, the Creed, the Lord's Prayer etc.). He should perhaps be discovered first and foremost today as Luther *minor*,

based on his lesser writings – or by examining his writing from a minority perspective, reading it in a way that subverts its imperious tendencies.

If future Confessions of Faith wish to call a truth their own, this truth would be akin to route maps for pilgrims, a truth for everyone who has nothing to call their own except for their life, their path through it and what is expressed when they say out loud, *from a standing start*: 'Here I am'.

CHRISTINA QUEEN OF SWEDEN, 1626–1689

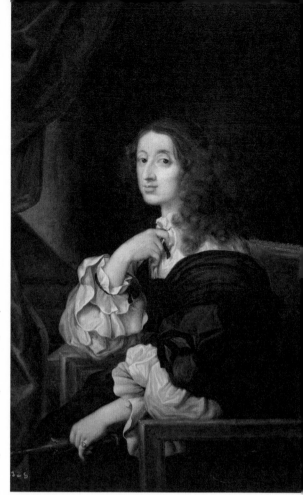

Queen Christina of Sweden is known for her patronage of the arts and learning, for her problematic relationship with the role of woman and ruler, and above all for her controversial abdication from the throne in 1654 and subsequent conversion to Roman Catholicism. Christina was the only surviving child of Gustav II Adolf and Maria Eleonora of Brandenburg. In 1630 Sweden entered the ongoing war in Germany, and by 1632 the king had lost his life at the Battle of Lützen. His daughter assumed the Swedish crown just one month short of her sixth birthday.

During Christina's minority a regency government headed by the Chancellor of the Realm Axel Oxenstierna supervised internal and foreign affairs as well as the education of the young queen. Christina's rule began in 1644, the very year that saw the initiation of the peace conferences in Münster and Osnabrück, which brought an end to the war in 1648.

The introduction of Lutheranism in Sweden in 1527 had played a significant role in the nation's development after the dissolution of the Nordic Union of Kalmar (1397–1523). By the time of Christina's birth, Sweden was a homogeneous Lutheran nation – in the words of Heinz Schilling, 'the Lutheran counterpart to Spain in the Catholic camp'. Against this background, the abdication and conversion to Catholicism of Sweden's ruler, the daughter of a perceived martyr to the Protestant cause, was a huge shock. Rome was Christina's principal residence from 1655, and she was buried in St Peter's Basilica on her death in 1689.

Although Christina produced a number of literary works, she never disclosed the background to her conversion. Nevertheless it is possible to identify some factors that may have contributed to her interest in Catholicism. Despite specific instructions that she not be exposed to Catholic or Calvinist literature in the course of her education, a catalogue of her library from 1650 shows that she did indeed have access to such works. During Christina's personal rule, the court in Stockholm witnessed an influx of foreign artists and scholars, most notable among whom was the philosopher René Descartes. She also had regular contact with diplomats from Catholic countries. In the person of Pierre Hector Chanut, a French emissary at the court of

Stockholm from 1646 to 1651, she encountered a highly lear and devout Catholic, whose example may have been of s importance for her.

Modern studies have stressed that Christina's switch to Cat icism conforms to the general pattern of aristocratic con sions in the seventeenth century. The links between Christi political and religious ideals must also be taken into acco here. A product of the age of European absolutism, she view the hereditary monarchy as the earthly reflection of a divi instituted order. Thus the strongly hierarchical character of Catholic church corresponded closely to her political ide The independence that led her to bridge geographical, con sional and social boundaries remains her defining trait.

Marie-Louise Rodén

→ Further read
Queen Christina of Sweden: Documents and Studies, Magnus Platen (ed.), Stockholm 1966.
Christina. Königin von Schweden. Catalogue to the exhib at the Kulturgeschichtliches Museum Osnabrück, 23 No ber 1997 – 1 March 1998, Stadt Osnabrück, Der Oberbü meister (ed.), Amt für Kultur und Museen Osnabrück 19
Marie-Louise Rodén: *Church Politics in Seventeenth-Cen Rome. Cardinal Decio Azzolino, Queen Christina of Sweden. the Squadrone Volante*, Stockholm 2000.

How can one be a Christian without being a Catholic?

David Casparsson Kohl, ceremonial sword for Christina of Sweden, 1648

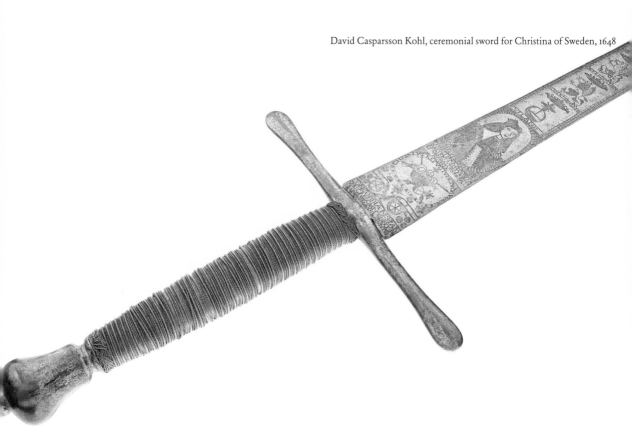

After Luther nailed his 95 Theses to a church door, his teachings rapidly reached many parts of Austria, even its mountain valleys. By 1523 the Habsburg Emperor Ferdinand I was already banning the printing and distribution of Reformation texts. Yet the Evangelical Lutheran faith spread so effectively that in some regions, such as Upper and Lower Austria, up to 80 percent of the population became Lutheran. However, things changed at a stroke after the defeat of the Protestants at the Battle of White Mountain near Prague in 1620. Ferdinand II could now issue his rigorous Reformation Patent (1624), which presented Protestants with the choice of either reverting to Roman Catholicism or leaving the country. Around 100,000 Austrian Protestants decided to seek out a new homeland, which many then found in Protestant Middle Franconia in Bavaria. Those who remained true to their Protestant beliefs but decided not to emigrate went underground as covert or crypto-Protestants. For their religious services in hidden spaces and caves they needed Bibles and prayer books, which they had to use in secret and could only acquire from audacious Bible smugglers, such as Brigitta Wallner. She was born Brigitta Haslauer in 1735 in a mountain farmhouse in Gosau am Dachstein. In 1757 she married Andreas Wallner, a woodcutter with a smallholding who was the same age as her. She soon found a way to smuggle Bibles and Lutheran texts into the country from as far away as Nuremberg, by hiding them in her back basket under more innocent wares. Her source in Nuremberg was a merchant named Tobias Kießling, who was a strong supporter of the oppressed Protestants in Austria and supplied her with Bibles and prayer books. Brigitta Wallner was caught and imprisoned several times.

After a ban against Protestantism lasting 160 years, the Paten Tolerance issued by Emperor Joseph II meant that Luthera members of the Reformed Church and Orthodox Luther could openly follow their faith in the Habsburg territor However, they did have to be officially registered as such. 26 December 1781 the Patent of Tolerance was proclaimed the high mountain valley of Gosau. None of the men of sau dared to publicly declare their allegiance to the Protest faith. Earlier expulsions of Protestants to Transylvania were very much part of their collective memory.

It fell to Brigitta Wallner to take the first step. Legend ha that she did so with the words: 'Put my name down, all h know that I am a Lutheran. I have already been thrice loc away for my faith. You can lock me away for yet a fourth ti if what you say now be not true.' This prompted her husba to sign for the whole family. Subsequently 1,053 individual tested to their Lutheran faith and had their names added the register. To this day 80 percent of the population of Go still describe themselves as members of the Protestant fait.

Hansjörg Eichmeye

→ Further readi
Das Buch zum Weg. Kirchen-, Kunst- und Kulturgeschichte am We Buches, Rudolf Leeb, Astrid Schweighofer and Dietmar Weikl (Salzburg 2008.
Geheimprotestantismus und evangelische Kirchen in der Habsburgerm chie und im Erzstift Salzburg (17./18. Jahrhundert), Rudolf Leeb, Ma Scheutz and Dietmar Weikl (eds.), Vienna and Munich 2009.

Put my name down

Books from the era of crypto-Protestantism, 18th century

Back-basket (used to smuggle Bibles), 19th century

Wallner family's certificate of conversion, Gosau, 1781

ERNST MORITZ ARNDT

HISTORIAN AND POLITICIAN, GERMANY, 1769–1860

Ernst Moritz Arndt was a glittering, multifaceted figure, replete with innate contradictions. In that sense he was a child of his time, which had its own wealth of inconsistencies. The old and the new, inertia and revolution collided with a force that often led to extremes.

Arndt was born on 26 December 1769 in Groß Schoritz on the island of Rügen in Swedish Pomerania. His mother introduced him to the teachings of the Bible early on. This experience of heartfelt, Lutheran piety shaped Arndt's character, but it also kindled his critical faculties. All his life he struggled to come to terms with traditional religious precepts and with the church as an institution. He absorbed diverse philosophical and theological currents and combined them to create a constantly changing vision of Christian faith. Despite his doubts he studied theology in Greifswald and Jena, although he found himself becoming increasingly interested in other subjects. After an extended educational tour through various European countries, in 1801 he became an independent lecturer in history and philosophy at the University of Greifswald, where he later became an associate professor (*Professor extraordinarius*).

The year 1806 marked a major watershed in Arndt's life – the old regime had just gone under, and Prussia was defeated by France at the Battle of Jena-Auerstedt. Although he had already taken issue with Napoleon in writing, in a flyer published that same year with the title *Geist der Zeit* ('Spirit of the Time'), he became a declared enemy of Napoleon. Arndt openly supported the struggle against the French domination of Europe. On a personal level he regarded Luther in his fight against Roman supremacy as a model of resolve. In the coming years Arndt's commitment to his cause grew into outright hatred of everything French and into a nationalism glorified by religion. In bellicose texts and poems such as '*Der Gott, der Eisen wachsen ließ*' ('The God who first made iron grow') he exhorted his compatriots to engage in war against France in the name of [...] dom. However, there was an irreconcilable contradiction h[...] between the Christian duty to love one's neighbour and [...] invocation of hatred and revenge as sentiments that were [...] posedly pleasing to God. It was this combination of wholl[...] compatible precepts that made his writing so explosive. Arn[...] extreme anti-French attitudes meant that he had to tempo[...]ly seek refuge in Sweden as early as 1806. Later on he trave[...] to Russia and worked with Freiherr Heinrich Friedrich Karl v[...] Stein, who was forming a group of opponents to Napoleo[...] In 1818, after the defeat of France, Arndt was appointed t[...] chair at Bonn University but was soon suspended becaus[...] his demands for a free German nation state. During the ye[...] until his reinstatement in 1840, he concentrated on churc[...] sues and matters of faith, notably supporting proposals f[...] union of the Reformed Church and the Evangelical Luthe[...] Church and advocating the introduction of a new hymn b[...] The reverential hymns that came from Arndt's pen are stra[...]ly at odds with his calls to arms, and may still be known to[...] for that very reason. Ernst Moritz Arndt died in Bonn o[...] January 1860. Sven Prietzel

→ Further read[...]

Ernst Moritz Arndt: *Erinnerungen aus dem äußeren L[...]* Leipzig 1840.

Ernst Müsebeck: *Ernst Moritz Arndt. Ein Leben[...]* Gotha 1914.

Günther Ott: *Ernst Moritz Arndt. Religion, Chr[...] tum und Kirche in der Entwicklung des deutschen Pu[...] ten und Patrioten*, Bonn 1966.

Ernst Moritz Arndt, 'Vaterlandslied' ('The German Fatherland'), 1812

LISE MEITNER PHYSICIST, AUSTRIA, 1878–1968

Lise Meitner was born in Vienna on 7 November 1878 and grew up in a liberal family with a keen interest in the arts. Her parents were non-practising Jews and the Meitner children attended Protestant religious instruction. Lise became fascinated by physics at an early age and, determined to study mathematics and physics, successfully took an external school leaving certificate in 1901 and enrolled at the University of Vienna. In early 1906 she became one of the first women to be awarded a doctorate. In the autumn of 1907 she moved to Berlin to attend lectures by Max Planck and pursue her research in the field of physics. In a converted joiner's workshop in the basement of the Chemical Institute, she and the chemist Otto Hahn embarked on a series of experiments with radioactivity – women were not allowed into the chemistry laboratories. Around the time of her move to Berlin, Lise Meitner also changed her religion. On 29 September 1908 she formally broke with Judaism and was baptised an Evangelical Lutheran. From 1912 onwards the Hahn-Meitner team pursued their research at the new Kaiser Wilhelm Institute for Chemistry in Berlin-Dahlem; Lise Meitner was by now also an assistant to Max Planck. After Hitler came to power in 1933 she was banned from holding any university teaching post because of her Jewish origins, but she was allowed to continue her work at the institute. Together with Otto Hahn and Fritz Strassmann she conducted the experiments that ultimately led to the discovery of nuclear fission in late 1938; the Nobel Prize for this work later went exclusively to Otto Hahn, by which time Lise Meitner was already in exile in Stockholm. After the Annexation of Austria by the National Socialists in March 1938, Meitner – now classed as a 'German Jewess' – had fled Germany in view of the ever increasing danger to her life. Otto Hahn kept her informed of the progress of their experiments by letter, and in early 1939 Lise Meitner and her nephew Otto Robert Frisch published a physical explanation of the process of nuclear fission. In 1960 Lise Meitner moved to Cambridge, where she died on 27 October 1968. Lise Meitner pondered matters of religion throughout her life. In one of her letters she wrote, 'I'm certainly not a Catholic and have no gift for orthodox beliefs, although there are certain passages in the Bible that have stayed with me all my life and [] powerfully affected my own ethics.' Lise Meitner had a[n en]lightened, interdenominational view of religion. She ha[d] time for religious absolutism, dogma or rituals. Her only i[nter]est was in the ethical value of religion. As a physicist she [con]cerned herself with the ethical responsibilities of a scientist [and] with the relationship between the intellect and belief. In [Ber]lin in the 1930s she was an invited guest in the Bible circle [run] by Anna von Gierke, which was made up of members of [the] *Bekennende Kirche* ('Confessing Church'), who met once a w[eek] to debate theological topics and the latest political issue[s. In] Dahlem Meitner attended services at the St.-Annen-Kirche[, and] in Stockholm she again joined a church congregation. [Her] Catholic friend Eva von Bahr-Bergius once declared that [Lise] Meitner had 'a thoroughly Protestant mindset'.

Astrid Schweighofer

→ Further read[ing]
Ruth Lewin Sime: *Lise Meitner: A Life in P[hysics]*, California 1996.
Bande der Freundschaft. Lise Meitner – Elis[abeth] Schiemann. Kommentierter Briefwechsel 1911–[] Jost Lemmerich (ed.), Vienna 2010.
Astrid Schweighofer: *Religiöse Sucher in der [Mod]erne. Konversionen vom Judentum zum Prote[stant]ismus in Wien um 1900*, Berlin 2015.

I'm certainly not a Catholic

Encounter with the 'Confessing Church': diary entry, Lise Meitner, 22 April 1936

...ratory bench for uranium fission (Hahn-Meitner-Strassmann bench), 20th century

HUGO BALL
DADAIST,
GERMANY, SWITZERLAND,
1886–1927

Having studied philosophy and history, in 1886 Hugo Ball (born in Piramasens, Germany) embarked on a doctoral thesis on Friedrich Nietzsche – only to abandon it again. Instead he went to Berlin to study with Max Reinhardt and subsequently worked as a dramaturg at the Münchner Kammerspiele, which in fact owes its name to Ball. In Munich he was able to pursue his deep interest in contemporary art and literature.

The First World War broke out. A brief visit to the front instantly revealed to Ball the madness of that carnage. In 1915 he emigrated to Switzerland, founded Dada in Zurich in protest against the war and worked as a political journalist in Bern. His analyses of the war, in particular the German burden of guilt, took him back to Luther and the Reformation. He eventually published them in a book entitled *Zur Kritik der deutschen Intelligenz* (*Critique of the German Intelligentsia*) in 1919. Following a period of intense religious studies, he countered his own radical critique in 1923 with *Byzantinisches Christentum* (*Byzantine Christianity*). However, the revised 1924 edition of his *Critique*, with the pointed, programmatic title *Die Folgen der Reformation* (*The Consequences of the Reformation*) only reinforced the condemnation he met with in Germany. He documented his thinking and edited his own diaries for *Die Flucht aus der Zeit* (*Flight Out of Time*), which was published in 1927. A wider readership came to know Ball's work when he published *Hermann Hesse. Sein Leben und sein Werk* ('Hermann Hesse: His Life and His Work') the same year. He died in Ticino in 1927.

Hugo Ball's thinking has been described as a breathless sequence of conversions. But that fails to take account of the shocking reality of the First World War, which in effect exploded in mind. Hugo Ball's trenchant polemics against Martin Lut and Immanuel Kant, against the kings of Prussia and aga Otto von Bismarck were his way of openly attacking the fe es of the German war-ideologists: 'It was back then, in Luth day, that the German bourgeoisie made a pact with feudal that outlasted all European revolutions and ultimately sou to stifle and overthrow the rest of Europe. Luther was the pr et and herald of this pact. His stance in the indulgences troversy united princes, magistrates and all the leaders of realms of the Holy Roman Empire. By relinquishing conscie to the protection of worldly princes, he helped to create t state-Pharisaism, which is symbolised by "God-willed de dence" and talk of "practical Christianity". And by his desp demeanour in the Peasants' War he betrayed the people's ca to the state bureaucracy.' Dietrich Sagert

→ Further readi
Hugo Ball: *Die Folgen der Reformation. Zur Kritik der deutsc Intelligenz*, Göttingen 2011 (English translation: *Critique of German Intelligensia*, New York 1993).
Wiebke-Marie Stock: Denkumsturz. *Hugo Ball. Eine inte tuelle Biographie*, Göttingen 2012.

Let us save ourselves from our saviours!

An anti-Lutheran avowal: icon from the estate of Hugo Ball and Emmy Henning, c.1920–1948

DIETRICH BONHOEFFER
THEOLOGIAN,
GERMANY, 1906–1945

Dietrich Bonhoeffer was born in Breslau on 4 February 1906. He studied theology in Tübingen and Berlin and earned his doctorate with a thesis on the sociology of the church in 1927. Following his *habilitation* in 1930 he studied for a year in New York. On his return to Berlin he worked in the student chaplaincy and taught at the university. He also participated in the ecumenical movement, convinced that the churches ought to attempt to persuade the powers that be not to engage in another war. By 1933 Bonhoeffer was openly critical of National Socialism and of the attempts to introduce National Socialist ideas into the Church. For Bonhoeffer Jesus Christ was the sole reference point for the Church. He was one of the founding members of the Pastors' Emergency League, which supported pastors who had been dismissed due to the Aryan Clause. He became an important, controversially radical member of the *Bekennende Kirche* ('Confessing Church'). After spending time in London as a pastor, from 1935 to 1937 he led the Confessing Church Preachers' Seminar in Finkenwalde; when this was closed down by the Gestapo in 1937 he continued with this work in illegal collective pastorates.

Although he could have chosen not to return from a trip to the USA in 1939, Bonhoeffer went back to Germany just before the outbreak of the Second World War. Obliged to serve as confidential agent in the military intelligence service, he had inside knowledge of the mounting attempts on Hitler's life and did his best to keep the outside world informed. He was arrested 1942 and hanged in Flossenbürg concentration camp on 9 April 1945. Aside from the Swiss theologian Karl Barth, Martin Luther was Bonhoeffer's most important theological reference figure. God's incarnation in the person of Jesus Christ, Christ's presence in the Church, sacraments, sermons and the community today, and our dependence on the external Word and the Bible are among the teachings of Luther that were fundamental to Bonhoeffer's thinking. In his *Ethics* Bonhoeffer names four divine mandates – 'work, marriage, government, church' – with which he makes the connection to Luther's three estates (Household, Government, Church). However, unlike Luther, he orientates his mandates towards Jesus Christ. Church and state have their own duties, but not different ethics, that is, love thine enemy for the former and legal powers and violence for the latter.

Bonhoeffer insisted that clergy in the Confessing Church ject church-political compromises and adhere to the dec tions issued by the Synods of the Confessing Church in He fought against the prevailing forms of Lutheranism, wh concluded from Luther's doctrine of justification that hum obedience to God was of secondary importance and that Evangelical Lutheran pastor could just as well be a membe the Reich Church as of the Confessing Church. Bonhoe was in no two minds: 'Whoever knowingly separates him from the Confessing Church separates himself from salvatic In stating 'Only he who is believes is obedient, and only he w is obedient believes' he sought to do justice to Luther's doctr of grace; Bonhoeffer made an absolute distinction betw Christian 'costly grace' and false, 'cheap grace'.

Christiane Tietz

→ Further read

Eberhard Bethge, *Dietrich Bonhoeffer. Eine Biogr* Munich 1978 (English translation: *Dietrich Bonhoeff Biography*, Minneapolis 1999.).
Bonhoeffer und Luther. Zentrale Themen ihrer Theo Klaus Grünwaldt, Christiane Tietz and Udo Hahn (Hannover 2007.
Christiane Tietz: *Dietrich Bonhoeffer. Theologe im W stand*, Munich 2013.

Not in the flight of ideas but only in action is freedom

Dietrich Bonhoeffer's Moravian Daily Texts, 1944

Dietrich Bonhoeffer, *Stationen auf dem Weg zur Freiheit*, 1944

Dietrich Bonhoeffer, *Neujahr 1945*

Neujahr 1945.
von Dietrich Bonhoeffer
(Prinz-Albrecht-Strasse.)

Von guten Mächten treu und still umgeben,
behütet und getröstet wunderbar, -
So will ich diese Tage mit euch leben
und mit euch gehen in ein neues Jahr. -

Noch will das alte unsre Herzen quälen,
noch drückt uns böser Tage schwere Last,
Ach, Herr, gib unsern aufgescheuchten Seelen
das Heil, für das Du uns bereitet hast.

Und reichst Du uns den schweren Kelch, den bittern
des Leids, gefüllt bis an den höchsten Rand,
so nehmen wir ihn dankbar ohne Zittern
aus deiner guten und geliebten Hand.

Doch willst du uns noch einmal Freude schenken
an dieser Welt und ihrer Sonne Glanz,
dann woll'n wir des Vergangenen gedenken
und dann gehört dir unser Leben ganz.

Laß warm und still die Kerzen heute flammen,
die du in unsre Dunkelheit gebracht,
führ, wenn es sein kann, wieder uns zusammen.
Wir wissen es, Dein Licht scheint in der Nacht.

Wenn sich die Stille nun tief um uns breitet,
so lass uns hören jenen vollen Klang
der Welt, die unsichtbar sich um uns breitet,
all Deiner Kinder hohen Lobgesang.

Von guten Mächten wunderbar geborgen
erwarten wir getrost, was kommen mag.
Gott ist mit uns am Abend und am Morgen
und ganz gewiss an jedem neuen Tag. -

66

Stationen auf dem Wege zur Freiheit.

Zucht.

Ziehst du aus, die Freiheit zu suchen, so lerne vor allem
Zucht der Sinne und deiner Seele, daß die Begierden
und deine Glieder dich nicht bald hierhin, bald dorthin führen.
Keusch sei dein Geist und dein Leib, gänzlich dir selber
unterworfen und gehorsam, das Ziel zu suchen, das ihm gesetzt ist.
Niemand erfährt das Geheimnis der Freiheit, es sei
denn durch Zucht.

Tat.

Nicht das Beliebige, sondern das Rechte tun und wagen,
nicht im Möglichen schweben, das Wirkliche tapfer ergreifen,
nicht in der Flucht der Gedanken, allein in der Tat ist die Freiheit.
Tritt aus ängstlichem Zögern heraus in den Sturm des
Geschehens, nur vom Gottes Gebot und deinem Glauben getragen,
und die Freiheit wird deinen Geist jauchzend empfangen.

'WORK IS A JOY UNTO ITSELF.'

WA 6, 120; LW 42, 146

For Luther work was part of being human, a revolutionary view at a time when it was largely seen as a punishment imposed by God. With this radical view, Luther brought about a new appreciation of work. This formed the basis of the Lutheran concept of vocation, according to which every occupation is also a 'calling'. Workaholism is Lutheran; work-life-balance is not. People consistently refer to Luther's ideas when debating the importance of work for individual identity. The great reformer's talk of a 'universal priesthood' also paved the way for women to occupy pastoral roles. Criticism of 'alienated' labour or restrictions to the freedom to choose an occupation also forms part of the debate. What value do we place on labour in our lives?

THE GOSPEL OF WORK

THEA DORN

One of the most persistent assumptions about Germans is that they are immensely hardworking. That may or may not still be the case today, but there is no doubt that our forefathers would sooner have been found toiling and labouring than merrily idling the day away. In the late twentieth century it was still possible for a band by the name of *Geier Sturzflug* (Vultures' Nosedive) to have a huge hit with a refrain along the lines of 'We're rolling up our sleeves and getting things done / yes, yes, yes, we're boosting the economy, oh what fun!' and for a blustering Federal

Chancellor by the name of Helmut Kohl to declare: 'A successful industrial nation … can't be run as a collective amusement park.' After the Second World War the rest of the world looked on in amazement as Germans – with every aspect of their lives in ruins – threw themselves into rebuilding the economy and their towns and cities. Prior to the First World War the world had taken fright when it saw that the Germans were now producing shoe soles and steel nails with the same sacramental seriousness that they had previously devoted to poetry and philosophy. Kurt Tucholsky poked fun at the 'off-to-workers' who flooded through Berlin every morning on their way 'to work, the Germans' holiest of holies', while Thomas Mann saw the 'moralizers of accomplishment', those overburdened individuals who 'labour at the edge of exhaustion' as examples of the 'modern-heroic life form'. A century earlier Johann Wolfgang von Goethe had penned the lines: 'What speeds up time for me? / Activity! What makes life long, yet less? / Idleness!'

But as we delve further into history, the picture of a nation of busy bees starts to fade. Around 1700 it was not at all out of the ordinary for a small German town with just two hundred houses to have a good thirty or forty inns, which suggests that the Germans more than deserved their reputation as drunkards, gluttons and hoodlums, which endured until into the early Modern era. So what about the famous claim by Max Weber that the spirit of capitalism, and hence the idolisation of industriousness, was a product of the Protestant ethic?

Luther, who himself ironically described his compatriots as 'foolish, drunken Germans' was industrious, extremely industrious. If he were alive today he might well have been described as a workaholic. Statisticians have produced calculations showing that, in effect, he published five pages a day on average, which amounts to a publication rate of 1,800 pages per year, and anyone who has seen the *Weimarer Ausgabe*, the collected works of Martin Luther, will be inclined to believe that the calculations could well be correct. Yet we should not image Luther frantically struggling to get his ideas down on paper. In an allusion to the digestive problems that troubled him all his life, the Reformer explained his astoundingly prolific publication record: 'When I am writing everything just flows, I never need to force things or to push.' (WA BR 2, Nr. 251, 35).

But writing was far from all that Luther did. He also preached and translated, he was a teacher, he disputed with his followers and opponents, he travelled – both on foot, tediously, and by horse-drawn cart, he took time to attend to his parishioners' needs as their spiritual adviser, and he made music. He wrote letters every day, which may or may not be included in the 1,800-page annual tally – a calculation does not alter the fact that, alongside Leibniz and Goethe, Luther had one of the most energetic intellects ever seen in Germany.

One cannot help but wonder about the driving force behind an almost manic work rate of that kind. Did Luther never cease to toil because he believed that this was the route to salvation?

The immediate answer, a resounding 'no', leads us deep into Lutheran theology. And we can only sense the real radicalism of that theology if we bear in mind that the pre-Reformation Luther had sought to follow the well-worn mediaeval path of godliness by good works – albeit not just any old how in the manner of a carefree monk cheerfully traipsing between the cloisters and the refectory. No, the young Augustinian was a fanatical gladiator of godliness. In the hope of gaining God's grace, Brother Martin went to confession, fasted, and mortified his flesh with a zeal that frightened everyone, including his father confessor. But he did not gain the elusive spiritual peace he longed for, nor the calm confidence that God would gaze benevolently upon him on the Day of Judgement. Looking back at his time in the monastery in Erfurt, Luther wrote: 'I was the most miserable person on Earth; day and night were filled with wailing and despair that no-one could help me' (WA 38, 148).

What was the problem? In a nutshell, Luther had too gloomy a picture of human beings and too stern a picture of God. The two together led him to the desperate conclusion that the accursed lump of sin – for which he took himself – would never be able, by its own efforts, to win over God, the final judge, as He implacably weighed up merits and transgressions. And the more fervently Luther attempted to climb to his destination by the most direct route, the more unworthy he felt, and the colder and more forbidding God seemed to him. Either he could yield to 'temptation', to *tentatio tristitiae*, the feeling of already having arrived in Hell in this life – or he could dare to make his radical bid for freedom from a 'merciless' world and God.

Luther was saved by a passage in the writings of St Paul, that first radical apostle of Christianity, specifically his belief, set out in his Epistle to the Romans, that human beings could only attain justification by faith and not by their own good deeds. With the help of St Paul Luther arrived at the fundamental credo of the Reformation, namely that God does not have mercy on human beings because they accomplish great, glorious or even holy things, but simply because He is in fact merciful.

But what was the impact of this audacious reassessment of all Earthly concepts of justice on the nation's work ethos, and what status did human activity now have in this new world view? Why continue to exert oneself if all one's efforts are worthless in God's eyes?

Luther drew again on the thinking of St Paul here, namely the notion that human beings should not question the status given them by the worldly hierarchy: 'Each one should remain in the condition in which he was called.' (1 Corinthians 7:20). The term translated into English here as 'condition'

is rendered by Luther as 'calling' (*Ruf*). In so doing he purloins a term from the realms of clerical or spiritual vocations, that is to say, the world of those called to the cloth or to monasticism, for which it had previously been strictly reserved. Luther had already set out his new concept of vocation in his sermon for the Day of St John the Evangelist – published in the *Christmas Postil* of 1522: 'Notwithstanding the examples and lives of all the saints every person should attend to the work entrusted to him and guard the honour of his calling. Oh, this is truly a needed and wholesome teaching.' (WA 10 I/1, 306). And even more clearly: 'God is not concerned about your works, but about your obedience. … Hence it is, that if a pious maid-servant goes forth with her orders, and sweeps the yard or cleans the stable; or a man-servant in the same spirit ploughs and drives a team: they travel direct to heaven in the right road; while another who goes to St. Jacob or to church, and lets his office and work lie, travels straight to perdition.' (WA 10 I/1, 310). In view of the spiritual torment Luther ultimately suffered as a member of a monastic order, it is easy to understand his aversion to the hubris of those who believed that God is impressed by 'holy works'. But how was it that it suddenly seemed, from what he was saying, that a person can indeed improve their chance of salvation by their own efforts if he or she dutifully 'sweeps the yard or cleans the stable'?

Luther knew that a church service was not the right place for complex theological arguments, but that it was his job to present his congregation with a straightforward, yet powerful sermon. Indeed his contemporaries were soon complaining that Luther's notion of *sola fide* – his teaching that salvation was solely to be achieved through faith and could not be earned in any other way – was ruining what was already a lax work ethic in Germany. So it is hardly surprising that, in his pulpit, Luther was keen to encourage diligence in his compatriots. Yet there was more to it than just a strategic, political ploy. Given that Luther's theology depends on the idea that I should accept the existence that is given to me, rather than desperately striving for higher blessings, then it follows that I should also uncomplainingly carry out the tasks assigned to me.

Being more familiar with 'burn out' than the 'joy of work', any such exhortation may seen naïve, even too meekly devout to us today. But is this not the best of advice? Is it not much wiser to seek peace of mind by immersing oneself, body and soul, in a task, rather than constantly regarding that task as an imposition and doing one's best to avoid it?

If there was ever anyone who was familiar with the ever-present abyss of '*tristiz*' – sadness, or depression as we might say – it was Luther. And could it not be a present-day psychiatrist talking, when Luther writes to a melancholy friend telling him that there is only one way to counter bouts of despair, namely not to brood but to carry out a fulfilling task? 'For no man dies from work,' he preached in 1525, 'but people lose their health and lives

from inactivity and idleness, for man is born to work, as birds to fly' (WA 17 I, 23).

No dour, sweaty drudge could ever have come up with such a joyous, uplifting image! For all the talk of obedience that constantly surfaces in Luther's writings, work – for him – was not some kind of forced labour executed in the name of the Lord, not a cross for a resentful penitent to bear. (It would only come to that under the auspices of some of his followers, above all the Prussian and Swabian Pietists – but that is another story …) Luther regarded the *vita activa* as the highest expression of human vitality, the best immunisation against the doubts concerning the meaning of life that constantly plague human existence, that strange condition somewhere between the animal kingdom and God. Or, to put it another way, in Luther's own words: *'Labor est demum ipsa voluptas'* – 'Work is pleasure' (WA 6, 120).

JOHANN SEBASTIAN BACH

COMPOSER,
GERMANY, 1685–1750

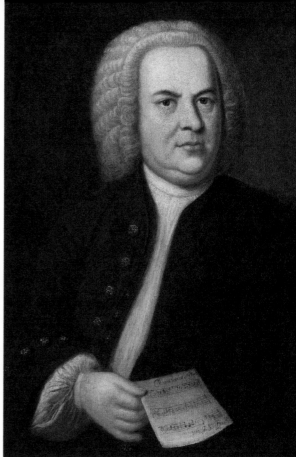

On Easter Day in 1724 and 1725 Johann Sebastian Bach's cantata *Christ lag in Todesbanden* ('Christ lay in the Bonds of Death'), one of his earliest known works, was performed in Leipzig, at St Nicholas's Church in the morning and at St Thomas's in the afternoon. The composition, each movement of which is based on the text by Martin Luther, may have been written in Mühlhausen as early as 1707/08. The hymn of the same name was published by Luther in 1524.

All that survives of this early work by Bach is a version, in the form of the original performance material, which he revised for use in Leipzig in 1724. This would have been produced by a number of copyists, supervised by Bach. The soprano part was written by principal copyist, Christian Gottlob Meißner. It includes numerous additions made by Bach himself, among them the text which was later added beneath the music in movements 2, 5 and 7. The work of producing the parts for performance was commonly divided up between copyists, evidence of the time pressure involved in organising church music, particularly for festivals. The stamp in the header indicates that the transcript of this part is held in the library of St Thomas's School in Leipzig. Bach worked tirelessly at his cantatas – the programme on Sunday after Sunday and every feast day included at least one, and there was always a clear thematic link to the hymn of the week, the sermon text or the lessons. It was Bach's ambition to organise cantatas into annual cycles, structured according to principles of theme or form. Each of the cantatas in the Leipzig cycle 1724–25, to which the aforementioned example belongs, is linked to a hymn, and both text and melody repeatedly make reference to it.

Although the cantata form, which originated in Italy, was extremely popular throughout Germany at this time and many of Bach's contemporaries were composing countless such wo it is the Bach cantata that became synonymous with the ge. It combines a very close interweaving of music and liturgy w an artistically outstanding compositional style. In his canta Bach frequently drew on both the texts and the traditio melodies of hymns written by Martin Luther. For a long ti Bach biographers assumed that these cantatas were among latest and thus most important compositions. It is only w the thorough analysis of the performance materials under en since the middle of the twentieth century that this dat has been called into question. It now appears that Bach c posed the majority of his church cantatas with extraordin creative energy during his first five years in Leipzig, from onwards. Nonetheless, he was able to make use of a numbe cantatas he had composed earlier, particularly from his ti in Weimar. He later performed these cantatas many times.

Christine Blanken

→ Further readi
Hans-Joachim Schulze: *Die Bach-Kantaten. Ei rungen zu sämtlichen Kantaten Johann Sebastian B* Leipzig und Stuttgart 2007.
Christoph Wolff: *Johann Sebastian Bach: The Lea Musician,* New York 2000.
Alfred Dürr: *Die Kantaten von Johann Sebastian I* Kassel [II]2013 (English translation: *The Cantat J.S. Bach*, Oxford 2005).

Johann Sebastian Bach, 'Christ lag in Todesbanden', 1724, choral cantata, BWV 4, soprano score

FRIEDRICH ENGELS
SOCIAL THEORIST,
GERMANY, 1820–1895

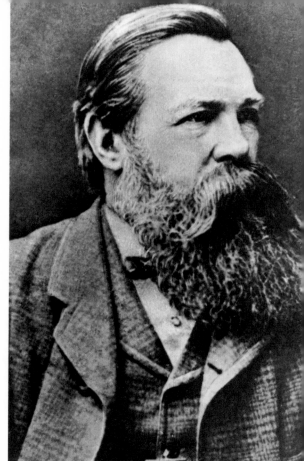

Friedrich Engels: entrepreneur, stock-market speculator, revolutionary, theorist for the socialist worker's movement, journalist and, not least, historian. The son of a wealthy textile manufacturer, he grew up in a strictly Pietist, upper-class milieu, where decency and reserve, diligence and honesty were held in high esteem. The young Engels thus experienced firsthand what Max Weber later described as the prerequisite for the birth of capitalism, that is to say, a positive, committed attitude to work that went as far back as Luther.

Engels declared that 'Labour is the source of all wealth', it is the 'prime basic condition for all human existence', indeed 'Labour created man himself.' And the definitions of work that he provided, together with Karl Marx, in various publications are unthinkable without Luther. For Marx and Engels productive activity was only really labour if it engaged all of a person's strengths and capacities, both physical and mental. If one of these components is neglected, the worker is degraded. During his employment at his father's business in Manchester, Engels increasingly came to the conclusion that the liberation of the proletariat could only come about through the abolition of private property by means of revolution.

This became the foundation of Marx and Engels's historical materialism, a view of history that led them to conclude that progress follows a set pattern and is driven by class struggles in a sequence of social manifestations. Engels drew, first, an epochal analogy between the sixteenth and the nineteenth centuries, identifying commonalities between the battles of the Reformation era and the burgeoning workers' movement in the years leading up to the 1848 Revolution. Second, he suggested that the church reforms instigated by Luther directly led to the Peasants' War of 1525. And third, he accused Luther of betraying the peasants and of having insisted, with 'fury and fanaticism' that the rebels be violently repressed.

In Engels's account of *The Peasant War in Germany*, published shortly after the failed revolution of 1848–49, his main focus is on Luther's betrayal of the peasants. The Wittenberg reformer is contrasted with theologian Thomas Müntzer, who is cast in

the role of leader of the peasant army. Luther is the 'represe[n]tive of middle-class reform', whereas Müntzer is a 'plebeian [r]olutionary' – a comparison that still held sway for Marxist [his]torians in the German Democratic Republic. However, it is cl[ear] that the late Engels also had other views on Luther, as can [be] seen in his incomplete *Dialectics of Nature*, in which the chu[rch] reformer is included in a list of 'giants in power of thou[ght,] passion and character': 'Luther not only cleaned the Auge[an] stable of the Church but also that of the German langua[ge;] he created modern German prose and composed the text a[nd] melody of that triumphal hymn which became the Mars[el]laise of the sixteenth century.' Jan Scheunemann

→ Further readi[ng]
Friedrich Engels: Germany and Switzerland, in: *The New M[oral] World, 3rd Series, No. 21*, 1843; idem: *Der deutsche Bauernkrieg* [18[..] in: MEW, Bd. 7, 327–413 (English translation: *The Peasant Wa[r in] Germany*, New York 1926); idem: *Dialektik der Natur* [1873–1883], MEW, Bd. 20, 305–568 (English translation: *Dialectics of Na[ture,]* New York 1940).
Gerhard Brendler: Zur Auffassung von Reformation und Baue[rnk]rieg bei Friedrich Engels, in: *Evolution und Revolution in der We[ltges]chichte. Ernst Engelberg zum 65.* Geburtstag, Horst Bartel (ed.), [..] Berlin 1976, 247–268.
Friedrich Dieckmann: Luther bei Marx und Engels. Die alte Fra[ge:] Reformation oder Revolution?, in: *Lettre International* 110 (Autu[mn] 2015), 7–11.

> Nothing is more terrible than being constrained to do some one thing every day from morning until night against one's will

Friedrich Engels, *Der Deutsche Bauernkrieg*, 2nd edition 1870

Plan for a book about Luther: letter from Friedrich Engels to Karl Kautsky, 1 February 1892

KÄTHE VON GIERKE

PASTOR,
GERMANY, B. 1932

The question as to whether women can hold ecclesiastical office elicits very different responses in different Christian denominations. Even within Protestantism there is no single answer. Nor do Luther's writings clarify the situation; they merely lead to one biblical passage being pitted against another. In the Lutheran Church the problem ought in fact to be resolved by referring to a core Reformation principle, namely the priesthood of all those who are baptised: 'For whoever comes out of the water of baptism can boast that he is already a consecrated priest, bishop, and pope' writes Luther in 1520 in his treatise *To the Christian Nobility of the German Nation* (WA 6, 408; LW 44, 128). But it is not that simple. The regional Lutheran Churches in Germany only gradually came to the conclusion, during the course of the twentieth century, that women, too, may be ordained as pastors. The first step came in the 1920s, when women were granted permission to study theology, and during the Second World War, when there were too few men to serve in the Church, women were allowed to carry out pastoral duties (without ordination). However, this came with the stipulation that any such women did not marry. There was nothing in the Bible to back this up; it was purely a result of the social attitudes of the time, when it was widely accepted that the duties of a wife caring for her children and family were not compatible with the demands made on a pastor caring for a congregation. When Käthe von Gierke enrolled to study theology in Tübingen in 1951, she had therefore already firmly resolved not to marry. She held out for four semesters, until a fellow student won her heart. They became engaged, secretly, in 1953. Because there now seemed little point in continuing with her university degree, that same year Käthe von Gierke changed direction and enrolled at the *Seminar für evangelischen Gemeindedienst* (Seminary for Evangelical Parish Service). After her finals, which

qualified her to take up a post as deaconess, she taught relig for three years and then spent the next nine years at the R Children's Broadcasting Service in Berlin, where she direc the series *Geschichten aus der Bibel* ('Stories from the Bib Then came the year 1968; women could now be ordained the ban on marriage was lifted. At a stroke there was a real prospect of her being able to realise her deepest wish. Hav passed all the required examinations, in 1978 Käthe von Gie became a pastor in a parish in southern Lower Saxony and ordained the following year.

Working with young people formed a particular focus of K von Gierke's work. However, she has always regarded the sp ing of God's Word through worship with the congregatio the core of her ministry. Today she is still active as a Pa Emeritus. Above all she regards her occupation (*Beruf*) as a cation' (*Berufung*), and in her view Luther's 'upgrading' of w laid the foundations for the Protestant work ethic. Moreo the idea that women should also have the right to hold offic the Church is merely a logical consequence of Luther's vi It's just that some lessons take longer to learn than others

Benjamin Hasselhorn

→ Further read

Michael Klessmann: *Das Pfarramt. Einführung in die G lagen der Pastoraltheologie*, Neukirchen-Vluyn 2012.

A pastor's work tool: dictaphone from the estate of Käthe von Gierke, late 20th century

BRUCE NAUMAN

ARTIST,
USA, B. 1941

Bruce Nauman was born into a family that believed in Martin Luther's ideal of work as an activity to which one is called, an occupation that is not a punishment but rather an opportunity to realise one's own potential in the service of God and one's neighbours. His father was not just a committed Lutheran, he was also the epitome of a believer following his calling. As Nauman recalls, he would sooner have colleagues than friends and even assiduously cultivated his network at church on Sundays. Nauman's mother, a member of the Episcopalian church, similarly embodied the Protestant work ethic that still shapes society in the United States today.

What does it mean to have or do work? This is a question that has preoccupied Nauman and many other artists in the post-industrial West since the 1960s. As a young man Nauman found it hard to accept that what he was doing in his studio was work, let alone art. Doggedly waiting for ideas, seeking and not succeeding, often with nothing to show for his efforts at the end of the day – it seemed to him an arduous struggle, until he gradually came to the realisation that this might be what art is all about: 'If you see yourself as an artist and you function in a studio and you're not a painter … if you don't start out with some canvas, you do all kinds of things – you sit in a chair or pace around. And then the question goes back to what is art?' Nauman's own answer is that 'art is what an artist does, just sitting around in the studio'.

That Nauman did anything but sit around in his studio, is clear from the performance art he produced in the late 1960s on the basis of his own ontological engagement with art. In one-hour, black-and-white videos the artist is seen in his studio, repeatedly bouncing a ball, playing a note on a violin, bouncing in a corner, walking 'with contrapposto', or walking around the pe-

rimeter of a square marked on the floor. His body becom[es] moving sculpture, his actions a process-based work of art. A more recent example of Nauman's exploration of the con[nec]tion between human activity and human existence is see[n in] his video *Work*, from 1994. The artist's head appears in two [vid]eo monitors stacked one on top of the other. It repeatedly jum[ps] into view and, to the point of exhaustion, calls out the w[ord] 'work' – at once noun and imperative – ad absurdum. The [low]er head, which is inverted, shouts out with a slight time de[lay] thus joining forces with the upper head in an inescapable cy[cle] of 'calling'. As it draws the viewer in, this action-loop – self[-im]posed and stripped of meaning – recalls a statement by M[ax] Weber: 'The Puritan wanted to work in a calling; we are for[ced] to do so.' In this compulsive process, where work seems clo[ser] to penance than a calling, there is no air to breathe and no ro[om] for manoeuvre. Work has always induced a certain ambivale[nce] in Nauman. Catherine Nichols

→ Further read[ing]
Coosje van Bruggen: *Bruce Nauman*, New York 19[]
Bruce Nauman. Catalogue Raisonné, Joan Simon []
Minneapolis 1994.
Please Pay Attention Please. Bruce Nauman's Words. [Writ]ings and Interviews, Janet Kraynak (ed.), Massachu[setts]
and London 2003.

I have work
You have work
We have work
This is work

Bruce Nauman, *Bouncing in the Corner, No. 1*, 1968, video

STEVE JOBS ENTREPENEUR, USA, 1955–2011

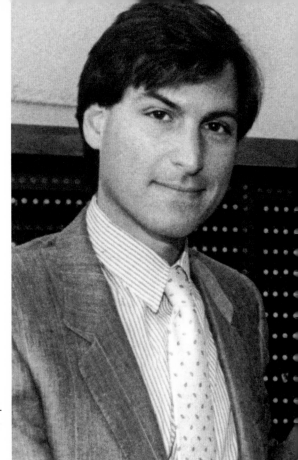

Steven P. Jobs, the celebrated college dropout and visionary co-founder of Apple Inc., cultivated the image of a rebel – a leader whose success derived largely from breaking rules and ignoring convention. All of that is true, to an extent, but the underlying characteristic that guided him like an unerring gyroscope was his respect and capacity for hard work. Work, for him, was a quasi-spiritual force in his life that arose initially from his up-bringing in a suburban middle-class Lutheran family and was reinforced by his study of Hinduism in India in his late teens and of Buddhism as a young professional in his late twenties and thirties.

Indeed, Steve Jobs often said that other than 'building great products', the only two things that really mattered to him were family and work. He travelled only when work absolutely required it, or when he wanted to take his family to visit somewhere special. Otherwise, he stayed close to home and to the office. He kept unpredictable hours at Apple's headquarters in Cupertino, California, but for most of the rest of the day he was never far from his computer in his study at home, where he was also close to his family. He was known to publicly mock other executives at Apple and elsewhere who played golf or indulged in hobbies that he believed distracted them from making the most productive use of their time and abilities.

But Jobs's penchant for hard work was not merely the reflection of a strong work ethic. His goal for himself, his family and friends, and for his company's products was to perpetuate an ongoing process of re-evaluation and improvement and, ultimately, to create *living* works that could enhance the quality of life for all. He first displayed this desire to perform such 'good works' in late adolescence when, at 19 years of age, he made a

pilgrimage to India to study under the Hindu guru Neem oli Baba, also known to followers as Maharaj-ji. The guru died before Jobs was able to meet him and after several trating months of attempting to attain 'enlightenment' o own, he came to believe that he could make a more con impact on the world by returning home to California and ing with friends to create new tools for humanity from digital technologies being pioneered in what was coming known as 'Silicon Valley'.

The obsession with creating 'good works' that could also, put it, 'make a dent in the universe' persisted throughout J adult life and manifested itself in every venture he tou For example, he insisted that, from *Toy Story* to *Finding* I and *Ratatouille*, Pixar's animated movies, which were a primarily at families with children, should always promo values of self-reliance, dedication, honesty and persever This was a consistent theme in all of Steve Jobs's endea and it stemmed from his own lifelong respect for the val individual human effort. In his mind, 'good' works were a first and foremost the product of 'hard' work.

Brent Schlender

→ Further rea
Walter Isaacson: *Steve Jobs*, New York 2011.
Brent Schlender, Rick Tetzeli: *Becoming Steve Jobs.* '
lution of a reckless upstart into a visionary leader, Londe

The first Mac: Apple Macintosh 128K, 1984

WANDA DEIFELT THEOLOGIAN, BRAZIL/USA, B. 1963

Wanda Deifelt, an ordained pastor of the Lutheran Church in Brazil, was the first ever Professor of Feminist Theology in Latin America. From 1991 to 2004 she held the Chair of Feminist Theology and Systematic Theology in São Leopoldo as well as teaching at the Escola Superior de Teologia. She has also been a visiting professor at the Emmanuel College of Victoria University in the University of Toronto, Canada, and at the Gurukul Lutheran Theological College & Research Institute in Chennai, India. She was on the advisory board for the World Council of Churches' Ecumenical Institute in Bossey, Switzerland, from 1994 to 2003 and has been teaching in the United States since 2004.

In her pastoral work and academic research as a systematic theologian, Wanda Deifelt has made a particular study of work, liberation and violence. In her essay 'Decent Work. A Brazilian Reflection', she investigates attitudes to work in her own country. She argues that the influx of Protestants in the nineteenth century led to the widespread assumption that work determines the value of an individual: 'A person is what he or she is able to produce, being valued by his or her work.' Accordingly, the indigenous population was supposed to achieve greater 'humanity' through work. The Protestants believed that a busy person had no time to think improper thoughts or to be distracted by the Devil. Ever since colonialisation in the sixteenth century, slavery in Brazil had been defended as a means of preventing sinful behaviour.

Wanda Deifelt speaks out against the misapprehension of work as punishment, which has so often played a part in Christianity in connection with the fall from grace. For his part, Luther felt strongly that work should be properly valued, and Deifelt, too, is all in favour of 'decent work': 'Decent Work is closely related to the dignity of human beings, the capacity to earn one's livelihood and live life abundantly. ... work restitutes hu-

man dignity, assures the sense of worth and recognizes the man capacity for creative transformation and sustainability.' a feminist, Deifelt also takes into account the experience women – particular the poor and the marginalised: she n that theological themes are rooted in experience and have be constantly renewed through experience.

Deifelt argues that both feminist theology and liberation ology should take the experience of oppression and discrim tion as their key to the interpretation of the Bible and theo ical discourse. She attaches particular importance to every life and physicality as hermeneutic categories and refers to body as the first reality, from which people start to relate w the world. For Deifelt this proximity in everyday experie and in the daily struggle is not confined to a critical analysi traditions of oppression, but can also help in the search for a native models and can support women in their aims.

An Paenhuysen

→ Further readi
Wanda Deifelt: *Feministische Theologie in den USA un Lateinamerika*, Berlin 2001.
Wanda Deifelt: Decent Work. A Brazilian Reflec in: *Philosophical and Spiritual Perspectives on Decent V Dominique Peccoud (ed.), Geneva 2004, 54–57.
Wanda Deifelt: For God is also the God of Bodies. bodiment and Sexuality in Martin Luther's Theo in: *Journal of Lutheran Ethics* 7/2 (February 2007) line: https://www.elca.org/JLE/Articles/529 (access November 2016).

Decent Work is closely related to the dignity of human beings

The struggle for 'decent work': Gilberto Gil, *Tropicália ou Panis et Circensis*, 1968/2008

'TO RULE THE WORLD BY THE GOSPEL WOULD BE LOOSING THE ROPES AND CHAINS OF THE SAVAGE WILD BEASTS

WA 11, 251; LW 45

The German Peasants' War of 1524–25 put Luther in a difficult position: the rebellious peasants appealed to him with their political demands. Ultimately, however, he did not stand by them, but by the aristocracy which had brutally suppressed the uprisings. Luther considered freedom to be a religious matter and not a political one. This view makes the reformer something of a role model for many people, particularly those for whom law and order in politics is important. On the other hand, Luther's political understanding of law provokes strong opposition in others. 'Law' for him was the opposite of 'Gospel': whereas law ruled the world, religion was governed by the joyful message of God's grace. What does this mean for the image we have of the world order and the laws that govern how we live together?

THE LEGAL TURN OF THE REFORMATION

JOHN WITTE, JR.

Martin Luther began the Reformation with a loud call for freedom – freedom of the church from the tyranny of the Pope, freedom of the laity from the dominance of the clergy, freedom of the conscience from the strictures of canon law and human traditions. This revolutionary call toppled many traditional church structures and practices in Germany after 1517. The mediaeval canon law books were burned. Church courts were closed. Monasteries and cloisters were confiscated. Church guilds and foundations were dissolved. Church lands were seized.

Clerical privileges were stripped. Mendicant begging was banned. Mandatory celibacy was suspended. Indulgence trafficking was condemned. Taxes to Rome were outlawed. Ties to the pope were severed. "Neither pope nor bishop nor any other man has the right to impose a single syllable of law upon a Christian man without his consent" (WA 6:536; LW 36:70), Luther wrote famously in 1520. The Bible contains all the law that is needed for proper Christian living. To subtract from the law of the Bible is blasphemy. To add to the law of the Bible is tyranny. "Wise rulers, side by side with Holy Scripture, are law enough" (WA 6:460; LW 44:203).

Such shrill rhetoric plunged Germany into an acute crisis in the 1520s. On the one hand, Luther had drawn too sharp a contrast between spiritual freedom and disciplined orthodoxy within the church. New Lutheran churches, clerics and congregants were treating their new freedom as licence for all manner of spiritual experimentation and laxness. Widespread confusion reigned over preaching, prayers, sacraments, funerals, holidays and pastoral duties. Church attendance, tithe payments and charitable offerings declined abruptly among many who took Luther's new teachings of free grace literally. On the other hand, Luther had driven too deep a wedge between the laws of church and state. Many subjects traditionally governed by the church's canon law now remained without effective governance. Local magistrates were quick to take over church properties and institutions but they offered few new laws and services in place of them. Prostitution, concubinage, gambling, drunkenness and usury thus reached new heights. Crime, delinquency, truancy and vagabondage soared. Schools, charities, hospitals and other welfare institutions fell into massive disarray. Requirements for family life, inheritance, banking and commerce became hopelessly confused. The crisis was made worse by the Peasants' War of 1524–26, which was fought in the name of Christian freedom but harshly repressed in the name of Christian order.

In response, the Lutheran reformation of theology and the church quickly broadened into a reformation of law and the state as well. From the late 1520s, Lutheran theologians cast their theological doctrines into catechisms, confessions and creeds and paid much closer attention to their legal, political and social implications. Lutheran jurists, in turn, joined the theologians in crafting hundreds of ambitious new reformation ordinances for the German cities and territories. By 1570, every major Lutheran land had comprehensive new state laws in place, governing public and private matters, spiritual and temporal life alike.

Critics of the day, and many writers since, have seen this legal turn of the Reformation as a betrayal and corruption of Luther's original message of Christian freedom. But Luther ultimately realised that he needed the law and legal profession to stabilise and enforce his reformation movement – even though he still thought jurists were "bad Christians". Radical theolog-

ical reforms had made fundamental legal reforms possible. Fundamental legal reforms, in turn, would make the radical theological reforms permanent. After 1530, the Lutheran Reformation became in its essence both a theological and a legal reform movement.

This broadened reformation effort was built on Luther's two-kingdoms theory: God has ordained two kingdoms or realms, the earthly kingdom and the heavenly kingdom, in which humanity is destined to live, Luther argued. The earthly kingdom is the realm of creation, of natural and civil life, where a person operates primarily by reason and law. The heavenly kingdom is the realm of redemption, of spiritual and eternal life, where a person operates primarily by faith and love. These two kingdoms embrace parallel heavenly and earthly, spiritual and temporal forms of righteousness and justice, government and order, truth and knowledge. These two kingdoms interact and depend on each other in a variety of ways, not least through biblical revelation and the faithful discharge of Christian vocations in earthly life. But these two kingdoms ultimately remain distinct. The earthly kingdom is distorted by sin and governed by the law. The heavenly kingdom is renewed by grace and guided by the Gospel. A Christian is a citizen of both kingdoms at once and invariably comes under the distinctive government of each. As a heavenly citizen, the Christian remains free to live fully by the light of the Word of God. But as an earthly citizen, the Christian is bound by law and called to obey the authorities that God has ordained and maintained for the governance of this earthly kingdom. Therefore spiritual freedom and equality may well coexist with political bondage and hierarchy.

For Luther, families, churches and states were the three natural orders or estates of the earthly kingdom, but only the state has formal legal authority, the power to pass laws. Citing Romans 13, he called the magistrate God's vice-regent on earth, "a great gift of God to mankind", "an image, shadow, and figure of the dominion of Christ" (WA 30/2:554; LW 46:237). The magistrate must not only pass laws on the basis God's natural law, he continued, but also exercise God's judgement and wrath against human sin and crime. Princes and magistrates are "the bows and arrows of God" (WA 31/2:394-95; LW 17:171), equipped to hunt down God's enemies in the earthly kingdom. The hand of the government official "that wields the sword and slays is not man's hand, but God's; and it is not man, but God, who hangs, tortures, beheads, slays, and fights. All these are God's works and judgements" (WA 19:626; LW 46:96).

In striking contrast to this harsh political picture, Luther also called the magistrate the "father" of the community (WA 30/1:155) who was to care for his political subjects as though they were his children. Like a loving father, the magistrate was to keep the peace and protect his subjects from threats or violations to their persons, properties and reputations. He was to deter

his subjects from abusing themselves through drunkenness, wastrel living, prostitution, gambling and other vices. He was to nurture and sustain his subjects through poor relief centres, orphanages, asylums and state-run hospitals. He was to educate them through the public school, library and lectern. He was to see to their spiritual needs by supporting the ministry of the locally established church and by encouraging their attendance and participation. He was to see to their material needs by reforming inheritance and property laws to ensure more even distribution among all children.

These twin metaphors of the Christian magistrate – as the lofty vice-regent of God and the loving father of the community – described the basics of Luther's political theory and constitutional law. For Luther, political authority was divine in origin but earthly in operation. It expressed God's harsh judgement against sin but also his tender mercy for sinners. It communicated the law of God but also the lore of the local community. The state depended on the church for prophetic direction but it took over all legal jurisdiction from the church. Either metaphor standing alone could be a recipe for abusive tyranny or officious paternalism; but both metaphors together provided Luther and his followers with the core ingredients of a robust Christian republicanism and budding Christian welfare state.

This new Lutheran political theory was reflected in the hundreds of comprehensive new state civil laws that replaced traditional church canon laws in early modern Germany and Scandinavia. Luther himself, alongside his many fellow theologians and jurists, helped to draft a lot of these laws. New church laws passed by the state established religious doctrine, liturgy, sacraments, worship, holy days, church polity, property, parsonages, endowments, tithing, burial and cemeteries. New criminal and public morality laws governed church attendance, tithe payments and Sabbath observance and prohibited blasphemy, sacrilege, witchcraft, sorcery, magic, alchemy, false oaths and similar immoral offences. New sumptuary laws proscribed immodest apparel and wasteful living as well as extravagant feasts, weddings and funerals. New entertainment laws placed strict limits on public drunkenness, boisterous celebration, gambling and other games that involved fate, luck and magic. New family laws simplified the rules for marriage formation and annulment, introduced new protections and provisions for wives and children, streamlined inheritance rules, and introduced absolute divorce on grounds of adultery, desertion and other faults, with subsequent rights to remarriage, at least for the innocent party. New school ordinances created the public state school that provided compulsory education for all persons, boys and girls alike, so that they could acquire sufficient literacy to read the Bible and function in society and prepare for their distinctive vocations. New social welfare laws, centred on the poor relief centres, provided food, clothing and shelter for the poor as well as emergency relief; larger communities added public orphanages, workhouses, boarding schools,

vocational centres, hospices and more. And, finally, new laws of civil and criminal procedure regulated the enforcement of these new state laws in state courts.

A good deal of the new state legislation in early modern Lutheran lands drew on Roman law, civil law and even mediaeval canon law prototypes, but these new laws especially reflected and reified new Lutheran teachings. Most of these laws remained in place in Germany and Scandinavia until the great legal reform and codification movements of the nineteenth century born of the Enlightenment. But the legal legacy of the Reformation can still be seen in modern laws on the family, education, social welfare, crime and church-state relations. And Luther's clarion call for 'freedom' against oppression and abuse remains as pressing and poignant today as it did 500 years ago.

THOMAS HOBBES
POLITICAL THEORIST,
ENGLAND, 1588–1679

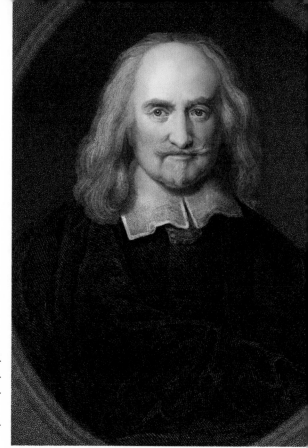

Thomas Hobbes, the son of a country vicar, went up to Oxford in 1603, where he then decided not to train for the Church after all. His real interest lay in political philosophy. After university he became a long-term tutor and secretary in the aristocratic Cavendish household. By the time civil war had broken out in England (1642–46) and the Parliamentarians (with the Puritans on their side) and Royalists were at loggerheads, Hobbes had already fled to Paris. In Paris he honed his political theory, which he then published in its final form as *Leviathan* (1651). In this treatise he radically questions not only the religious fundamentalists' concept of a nation but also that of the absolutist Royalists. In Hobbes's view politics was a purely secular matter. Moreover, any government is dependent on the agreement of the people it governs. Much criticised by his contemporaries, Hobbes has since come to be seen by leading specialists in the field as a forward thinker with a vision of modern democracy. During his own lifetime Hobbes was subjected to particular attack from Royalist bishops in the Anglican Church, although he always remained a member of the Church of England. In his dispute with Anglican church leaders he reminded them to pay closer heed to the teachings of Luther, which also held good for the established church in England. Hobbes made particular reference to Luther's text on the bondage of human will (*De servo arbitrio*, 1525), but he also attached considerable importance to Luther's concept of two kingdoms, which are expounded in his text *Temporal Authority* (*Von weltlicher Obrigkeit*, 1523). Like Luther, Hobbes believed that human beings, who are at the mercy of competing needs and diverse passions, can only find peace on Earth by obeying the edicts and decrees of a purely secular government. Furthermore, priests and the clergy should only operate within the framework of a secular constitution and under the supervision of the state. It is only when the secular authority can no longer guarantee freedom, or even sets about sabotaging it, that secular law ceases to be valid. Thus no

government can survive in the long-term without being ognised and accepted by its subjects.

Hobbes reinforced both Luther's vision of human beings a his theses on secularisation by cladding the theologically gued teachings of the reformer in an entirely new scienti vocabulary. And he found that vocabulary in Galileo's sev teenth-century, mechanistic-materialistic natural philosop In so doing Hobbes recast politics as a modern science focus on human beings and their most appropriate governmen structures, which, he felt, should primarily be designed to cure peace, promote tolerance towards those of a different op ion and establish the individual right to freedom. Few have e demonstrated with the same clarity as Hobbes that a libe constitutional state must defend its monopoly on the legitim use of physical force, for which it requires supreme legislat powers that no external, religious or fundamentalist forc should be allowed to wrench from its grasp.

<div align="right">Jürgen Overhoff</div>

→ Further readi

J. Wayne Baker: Sola Fide, Sola Gratia. The Battle for Lu in Seventeenth-Century England, in: *The Sixteenth Cent Journal* 16 (1985), 115–133.

Jürgen Overhoff: The Lutheranism of Thomas Hobbes, *History of Political Thought* 18 (1997), 604–623.

Richard Tuck: Hobbes and Democracy, in: *Rethinking Foundations of Modern Political Thought*, Annabel Brett a James Tully (eds.), Cambridge 2006, 171–190.

Thomas Hobbes, *Leviathan*, 1651

GOTTFRIED WILHELM LEIBNIZ
PHILOSOPHER, GERMANY, 1646–1716

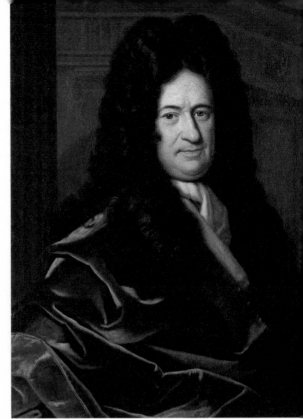

Gottfried Leibniz was one of the few lay thinkers of his time to fight for the continued theological and Christian basis of European civilisation. He was schooled in the university tradition reformed by the Wittenberg academic, Philipp Melanchthon. His education was in the proto-ecumenical school of Georg Calixtus in Lutheran Orthodoxy, from which he gained a thorough knowledge of the church fathers and mediaeval Scholastic theologians. 'Nor did I neglect', he acknowledged, 'the teachings of our theologians: and the study of their opponents, far from disturbing me, served to strengthen me in the moderate opinions of the Churches of the Augsburg Confession ...'. In his *Theodicy* (1710) Leibniz engaged seriously with Luther's most difficult book on bound choice (1525). He took a more 'churchly' view of Christian doctrine, in his case as identified by the Augsburg Confession (1530).

Based on his principle of 'sufficient reason', Leibniz developed modal arguments in his metaphysical doctrines for articulating those beliefs about God that are requisite to the concept of a good, wise and powerful Creator of this very world as the best possible one. Luther's view of cosmic order is reasoned from biblical revelation directly. Here God remains hidden also in revealedness. For Leibniz, cosmic order is reasoned *sole ratione*, philosophically, though it remains a conjecture of rational faith, not an obvious fact. In this work, he pursued the project of founding a natural theology and jurisprudence, on which to build a reformed, progressive and enlightened Christendom. He found the thinking of his close contemporaries Thomas Hobbes and Baruch Spinoza most challenging in this regard. They too continued the project of natural theology, albeit with

destabilising implications for Christendom, by working depersonalised conceptions of deity with deterministic in cations for humanity. These philosophical views correl with developments in Reformed theology, which Leibniz cised. His declared purpose was to banish false representat of God as an absolute prince. To oppose what he sarcastic called the 'absolutely absolute divine decree' of arbitrary elec for some and reprobation for others, he resorted to the C tian idea of God as trinity.

Leibniz was a pioneer in the development of historical consc ness. His much misunderstood doctrine of 'monads' – org wholes which are the 'true atoms' – was a historicised forr Aristotelian hylomorphism. This plastic doctrine enabled ecumenical attempt to reconcile Lutheran and Catholic trines of the Eucharist in a revival of the idea of impanat at the Eucharist the divine Son of God incorporates the b on the altar so that it truly becomes His body for the cong tion. In all these matters, his was a path not taken in the y that followed. Paul R. Hinlicky

→ Further read
Maria Rosa Antognazza: *Leibniz on the Trinity and carnation. Reason and Revelation in the Seventeenth Ce* New Haven and London 2007.
Paul R. Hinlicky: *Paths Not Taken. Fates of Theolog Luther through Leibniz*, Grand Rapids 2009.
Leonard S. Smith: *Religion and the Rise of History. M Luther and the Cultural Revolution in Germany 1760* Eugene 2009.

We live in the best of all possible worlds

Gottfried Wilhelm Leibniz, *Essais de Théodicée*, second half of 1707

HEINRICH VON KLEIST
WRITER,
GERMANY, 1777–1811

'Would you no longer do what is right,' Heinrich von Kleist asked his fiancée Wilhelmine von Zenge, 'if the idea of God and immortality were only a dream?' For laws, be they worldly or religious, were written by humans and, hence, are neither secure nor determinate. Indeed, throughout time and the world such laws had always been so diverse that the essence of religion or righteousness could not possibly be contained within them. But if not there, then where? This existential question preoccupied Heinrich von Kleist throughout his brief career as a writer, which began around 1800 but came to an abrupt end in 1811 when the author took his own life. In short stories such as 'The Earthquake in Chile' and 'The Marquise of O–' the plot revolves around the question of doing what is right. However, Kleist's struggle with the notion of justice before the law culminates in the novella 'Michael Kohlhaas' (1810), his longest and most complex prose work. A key part in this is played by Martin Luther.

In Kleist's novella, which is based on a historical figure, events lead the hero right to Martin Luther. Kohlhaas, whose initial quest for justice turns into a personal vendetta, has had to leave two fine, sleek horses at the border as a pledge while he obtains a 'pass', only to find on his return that they have been reduced to two 'scrawny, worn-out nags'. He seeks redress in vain, first in the law courts and then by horrendously violent means, at which point Martin Luther intervenes. On Luther's initiative a notice is posted in 'all the cities and market towns of the Electorate'. In the notice Luther accuses the 'impious' horse-dealer Kohlhaas of terrorising his fellow human beings for the sake of 'a miserable possession'. 'Filled with injustice from head to foot', this presumptuous man has risen up 'like a wolf of the desert' against his sovereign, who does not even know his name. Echoing the historical Luther in his treatise *Temporal Authority: To What Extent It Should be Obeyed* (1523), Kleist's fictitious

reformer in effect reminds Kohlhaas that, however wilfu[l] sovereign's behaviour 'every soul should be subject to the g[ov]erning authority' (WA 11, 265; LW 45, 110). When Kohlh[aas] eventually discovers Luther's placard, he is thrown into turm[oil] Kohlhaas, reduced to a thief and a murderer, twice reads [the] notice signed by the man with 'the dearest and most reve[red] name he knew'. He postpones his plan to raze Leipzig to t[he] ground and sets out for Wittenberg, determined to change [Lu]ther's opinion that he is an unjust man.

In the ensuing debate Kleist tests the reformer and his conc[ept] of justice: Is justice before God enough for human beings [Is] Christian law, as Luther claimed in his address to the insurg[ent] peasants in 1525, nothing but 'Suffering! Suffering! Cross! Cro[ss!]' (WA 18, 310; LW 46, 30)? Is resistance only allowed in mat[ters] of faith? Kleist leaves these questions unanswered. Luther [was] by no means the ultimate authority as far as the young wr[iter] was concerned. 'Who is to say,' he asked Wilhelmine, 'that [be]fore long a second Luther may not arise amongst us and t[ear] down everything the first built up?' Catherine Nich[olls]

→ Further readi[ng]
J. Hillis Miller: Laying Down the Law in Literature. K[leist,] in: idem: *Topographies*, Stanford 1995, 80–104.
Wolfgang Wittkowski: Is Kleist's Michael Kohlhaas a [Ter]rorist? Luther, Prussian Law Reforms and the Account[abili]ty of Government, in: *Historical Reflections/Reflection[s his]toriques* 26/3 (2000), 471–486.
Norbert Mecklenburg: Luther in Kleists Michael Kohl[haas,] in: idem: *Der Prophet der Deutschen. Martin Luther im Sp[iegel] der Literatur*, Stuttgart 2016, 95–104.

460 LAW

I recognise only one supreme law, righteousness,
and politics knows only its own interests.

Heinrich von Kleist, *Erzählungen. Erster Theil*, 1810

Michael Kohlhaas.

An den Ufern der Havel lebte, um die Mitte
des sechzehnten Jahrhunderts, ein Roßhändler,
Namens Michael Kohlhaas, Sohn eines
Schulmeisters, einer der rechtschaffensten zugleich
und entsetzlichsten Menschen seiner Zeit. — Die-
ser außerordentliche Mann würde, bis in sein
dreißigstes Jahr für das Muster eines guten
Staatsbürgers haben gelten können. Er besaß
in einem Dorfe, das noch von ihm den Namen
führt, einen Meierhof, auf welchem er sich durch
sein Gewerbe ruhig ernährte; die Kinder, die
ihm sein Weib schenkte, erzog er, in der Furcht
Gottes, zur Arbeitsamkeit und Treue; nicht
Einer war unter seinen Nachbarn, der sich nicht
seiner Wohlthätigkeit, oder seiner Gerechtigkeit

Kleists Erzähl. A

JACQUES LACAN PSYCHOANALYST, FRANCE, 1901–1981

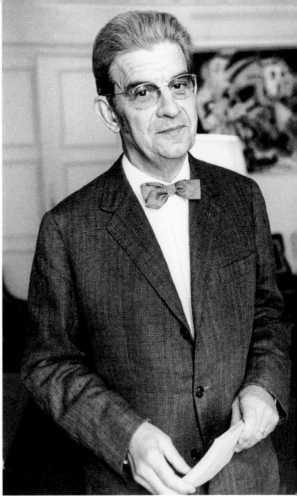

Jacques-Marie Émile Lacan was born into a conservative, Catholic family. At the Collège Stanislas, a Jesuit school in Paris, he learnt Latin and Greek and started to take an interest in philosophy. However, inspired by contemporary scientists and writers he decided to study medicine at university. In 1932 he earned his doctorate in psychiatry but soon turned his attention to psychoanalysis. His entry into international psychoanalysis was marked by a scandal. At a conference in Marienbad in 1936 he gave his by now legendary paper on the 'mirror stage', which prompted the conference chairman, Ernest Jones, to cut him off after precisely ten minutes. Lacan interpreted this interruption as a lack of respect – after all, more renowned colleagues were allowed to finish in peace – and abruptly left the town. This event marked the beginning of his subversive position towards the psychoanalytical establishment.

Lacan mainly expressed his ideas verbally in the seminars he led. He did not put pen to paper, he spoke. Every Wednesday intellectuals gathered in his *séminaire*, which he ran from 1953 to 1979 in the Sainte Anne Hospital, at the École normale supérieure, and at the Sorbonne. He used his own study at 5, rue de Lille in Paris for meetings, which could be of any duration. In his psychoanalytical research Lacan concentrated primarily on words (*parole*), because, as he put it '*L'inconscient est structuré comme un langage*' – 'The unconscious is structured like a language' – a language that has its own rules, syntax and peculiarities. For Lacan psychoanalysis was intrinsically bound up with speech: in his view it ensued from the experience of speaking.

Luther's influence on Lacan's thinking is above all evident in Seminar no. 7 in his *Ethics of Psychoanalysis* (1959–60), particularly in the chapter on 'drives and lures'. Lacan states it was Luther who introduced the notion that underlying moral acts

there is a deeper sin intrinsic to the human condition, a pass that regularly disrupts all good intentions. Lacan used Lut to take Sigmund Freud's psychoanalysis to the next level Lacan's view there was a cultural affinity between Reformat theology and Freudian-Lacanian psychoanalysis. Herman terink has identified three aspects of this affinity: first, the nial of the good' in the sense that egoism is a basic human c acteristic; second, the emphasis on problems associated w the ongoing denial of the 'evil' nature of fundamental hum passions and the concomitant dialectics between desire limitation; and, third, the distinction between the function of individual and collective conscience and the unscrupul ness of the individual conscience.

An Paenhuysen

→ Further read

Eckart Goebel: *Jenseits des Unbehagens. 'Sublimierung' von G bis Lacan*, Bielefeld 2009 (English translation: *Beyond Discon 'Sublimation' from Goethe to Lacan*, London 2012)

Herman Westerink: Eine Wende des Denkens. Jacques L und die kulturelle Vaterschaft zwischen Psychoanalyse und ormation, in: *Psyche* 66 (2012), 506–521.

Carl von Raschke: Subjectification, Salvation and the Re Luther and Lacan, in: *Theology after Lacan. The Passion for th al*, Creston Davis, Marcus Pound and Clayton Crockett (Cambridge 2015, 58–70.

Luther renewed the very basis of Christian teaching when he sought to express our dereliction, our fall in a world where we let ourselves go.

Shots from: Gérard Miller, *Rendez-vous chez Lacan*, 2012

WILLIAM WEGMAN ARTIST, USA, B. 1943

As a child William Wegman used to attend four or five Evangelical church services every Sunday. As a teenager he avidly attended catechism classes and for a time zealously devoted himself to converting his Catholic friends. He would even have loved to introduce a Jewish friend to the Good News. At some point when he was going through puberty, however, he suddenly wanted nothing more to do with the Church and faith. Aside from a brief flirtation with Catholicism as a young art student, it seems that throughout his adulthood he has consistently taken a rather distant view of religion. Yet his Lutheran upbringing is still rooted deep within him. It may be a long time since he got an A for his paper on Martin Luther, but Wegman is as preoccupied as ever with the business of law and grace.

As a participant in the ground-breaking exhibition *Live in Your Head. When Attitudes Become Form*, curated by Harald Szeemann for the Kunsthalle Bern in 1969, Wegman initially became known for his process-based sculptures. However, since the early 1970s, when he started to work with his dog, a Weimaraner named Man Ray, he has become internationally known as the conceptual artist with the dogs. With the exception of 1982 to 1985, when he was 'dogless', Wegman has made numerous photographs and films over the years in which, following in the tradition of Aesop's fables, dogs either 'play' human beings or interact with humans. In *A Spelling Lesson* (1973–74), for instance, Wegman and Man Ray sit at a desk so that Wegman can go through Man Ray's spelling. While the Weimaraner spelt 'park' and 'out' correctly, he unfortunately misspelt 'beach'. The dog licks his teacher's face to ask forgiveness for his mistake; the teacher, his master, responds graciously. He forgives the dog his mistake, but tells him to remember the correct spelling for next time.

Wegman cites Plato's dialogues as the main inspiration for his diverse 'symposia' on the philosophy of the good life. But the question-and-answer sequences in his video dramas are equally reminiscent of the catechetical form that Martin Luther popularised as a didactic method – even for the teaching of non-religious subjects. In Wegman's video *Minister* (1999) there is no mistaking his engagement with Luther's ideas. Dressed as a church minister, the artist preaches on the subject of prom[ises]. He starts by reciting the nursery rhyme 'Oh Dear! What [can] the Matter Be?', in which 'Johnny' breaks his promise to b[ring] his sweetheart a bunch of blue ribbons from the fair. The [min]ister then makes the connection between worldly Johnny'[s bro]ken promise and the promise made by God, as proclaime[d by] John the Baptist and recorded in the Gospel According [to] John. He specifically mentions the passage on the law and g[race] that was central to Luther's theology: 'For the law was g[iven] through Moses; grace and truth came through Jesus C[hrist]' (John 1:17). 'Pastor Wegman' may well believe that the pr[omis]es made by all three 'Johnnies' can never be fulfilled an[d are,] hence, false in some way. Yet at the same time he asks hi[mself] – and us – whether there is not considerable value to be f[ound] in the hope such promises kindle? Catherine Nicho[las]

→ Further rea[ding]
William Wegman. Malerei, Zeichnung, Fotografie, Vide[o], [Mar]tin Kunz (ed.), catalogue to the exhibition of the same [name,] Cologne 1990.
Peter Schjeldahl: William Wegman. The Faith of Dayd[ream,] in: idem, *Columns & Catalogues*, Great Barrington, [Massa]chusetts 1994.
William Wegman. Funney/Strange, Joan Simon (ed.), cat[alogue] to the exhibition of the same name, New Haven 2006.

William Wegman, *Minister*, 1999, video

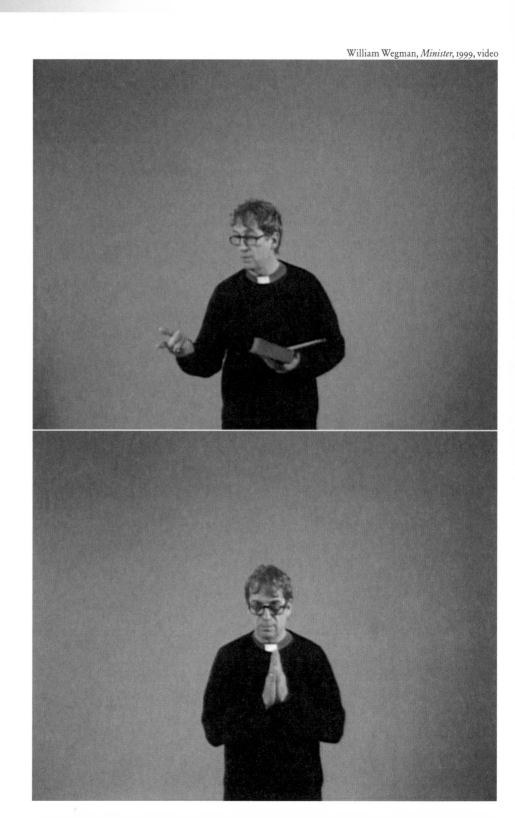

'LET WHOEVER CAN STAB, SMITE, SLAY.'

WA 18, 36; LW 46, 54

In December 1520 Luther publicly burned the papal bull threatening his excommunication. He was passionate about his message, and his writings were frequently polemical. Luther was also capable of ardent love. In particular, he loved the Gospel and anyone who helped him to defend it, whereas those who, in his opinion, opposed it, whether 'papists', Turks, rebellious peasants or Jews, were the target of his violent hate. For better or for worse, Luther's message has often aroused commensurate passion. His fervour may repel us but we may also be inspired and infected by it. Does the Protestant faith evoke passion these days? Or have other things long since become the object of our passion?

KORBINIAN

UWE TELLKAMP

The first time I saw Korbinian he didn't strike me as a passionate man, and certainly not in connection with Christian witness or faith. I avoided terms of that kind, they seemed too vast to me, not appropriate for the world I found myself in. And yet they intrigued me. We were barely 20 at the time. I was fascinated by his evident seriousness; he was studying at the Theological Seminar in Leipzig and my first sight of him was in the kitchen of a flat he and other students were renting in the Waldstrassenviertel. It was the evening of 9 November 1989. I saw a young man in oil-streaked overalls, wiping his hands – he had just been repairing a motorcycle – standing opposite me, next to my cousin Christian. They were friends and had been in prison together. Now they were listening to the radio announcements telling listeners that the Berlin Wall was open.

After that night, which no-one who lived through can ever forget, I dropped in on him occasionally in Leipzig. Korbinian came from Transylvania; his father, Roderich Krause, was a pastor in the Evangelical Church of the Augsburg Confession in Rosia near Sibiu. He had given his son his unusual

Christian name in honour of a fellow, albeit Catholic, clergyman, Korbinian Aigner. Aigner had painted hundreds of watercolours of all the different apple varieties he could get hold of. People called him the 'apple priest'. During his time in the priests' block at Dachau he bred apple trees between the sheds; the variety KZ 3, later renamed Korbinian, still exists.

In 1989 Leipzig was in uproar, as was the whole of Eastern Europe. Civil rights activists were trying to topple the old order. The universities were in turmoil. People were losing their jobs. Injustice was seeping into justice in the name of politics; it was poisoning justice, leading to new injustices. There were quarrels and squabbles everywhere. Demonstrators who had once been united against a common enemy formed breakaway groups or joined forces with parties on different sides. Korbinian said 'We have lost sight of God.' In Romania the revolution led to bloodshed. We wanted to visit Pastor Krause at the parsonage in Rosia, and on 22 December Christian and Korbinian found themselves caught up in the people's uprising in Bucharest; an East Berlin circus company on tour took them in. On Christmas Eve an ecumenical service was held in the big top – by an Orthodox priest and Korbinian, although he was not ordained yet. He was deeply moved by the piety of the Romanians and many of the artistes. An iconostasis and an altar table had been specially constructed for the service. A celebrant paced slowly forward, held up the Book of Gospels and announced the coming of Jesus amidst a throng of angels. The Romanians prayed with complete abandon, they conducted the service standing up, crossed themselves with three fingers from right to left and kissed the icons.

Whenever I visited Korbinian he talked about that service. He doubted his own faith, feeling he had not been called. 'How can I face a congregation? I don't know anything about life and I don't know anything about God. He is hidden, He doesn't reveal Himself to me, He doesn't talk to me. Did you know that some people call their conscience the "voice of God"? So, if He doesn't talk to me, like I said, that means I haven't got a conscience ...' Korbinian shook his head. He asked if I knew of Spaemann, if I'd read anything of his? Robert Spaemann, a Catholic, was a professor of philosophy in Munich. As a 14-year-old travelling on a tram, he had seen a young person insisting that a dignified old gentleman with a star of David give up his seat for him. Spaemann felt there was only one proper response in that situation: to give his own seat to the old man. But he hadn't done so. He was overcome by rage at the powers that be, who had deliberately paved the way for this triumph of inaction, this cowardice. 'Mind you', said Korbinian raising his index finger, 'he wasn't furious at himself and his own cowardice but at the people who had put him in a situation where everyone could see whether he was a coward or not. ... Actually he should have been grateful to them, if he was so interested in the truth, because

they did show him a truth, only it was not a pleasant truth. ... We hate the people who destroy the picture we have of ourselves.'

Korbinian laughed, but I felt uncomfortable. He walked up and down, and suddenly I wanted to get out of that room, back to the ordinary world that Korbinian despised and regarded as unimportant (or so I thought at the time); I wanted to plunge back into life, away from that little room, which seemed like a prison to me. I had read some of Spaemann's political texts and respected him as a thinker who did not shy away from daily politics and did not believe he would sully his spirit by engaging with those issues. One of his footnotes on Germany had given me pause for thought: he said that Germany was a community bound by laws rather than by shared values, and as such it was dangerous for it to try to become a community of shared values, which could ultimately lead to liberal totalitarianism.

Every time I met up with Korbinian he seemed lost to me. He probably would not have seen it like that, he would have objected to the word 'lost', because − as he would no doubt have said − how can anyone who has given himself to God be lost? Whenever Korbinian appeared in company and, having listened to others for a while, responded to the inevitable questions about his occupation by saying he was searching for God, he would be met with silence. People would look past him or down into their wine glasses, only to return to their discussions of house-building projects, loans, the latest goings on in the neighbourhood and their favourite football team's latest game, until Korbinian would interrupt and ask, why it was so ridiculous for him to say he was searching for God? − 'Because you will never find an answer, because you can't live from that or bring up children on it, because that's not what the present-day is about and because you won't change anything anyway', they said. Some people on the fringes of the same groups were outright cynical: 'People like that never have any fun in life.' 'Religious twaddle.' Or, mockingly, 'Let the fool be.' Or, pityingly, 'People like that always end it in the end.'

Sometimes he went to Saturn, the record store, stood in a corner and watched − exposing himself, as he put it, to normal life. He would buy a DVD, a box set of Louis de Funès, saying he wanted to invite friends for a film evening. But no-one ever had time. Or maybe he just didn't have any friends.

'The Church is weak', said Korbinian, 'especially the Protestant Church. The Church was respected when it pursued its mission with fire and a sword and a Bible in its hand. It's wrong to think it is strong, when all it's doing is giving in. ... The strict dioceses lose the fewest lambs. The Church is in danger of become a church of outsiders, as it was in the GDR, when most congregations mainly consisted of drop-outs, political outcasts, the old and the weak. And what about today? Do we see the movers and shakers in church? Will what I say − as a young man seeking God − ever register with managers, politicians or entrepreneurs, who will tell you a very different

story about good and evil? And if I were an entrepreneur, wouldn't I also be put off by the rock-a-bye-baby, be-nice-to-each-other claptrap peddled by so many pastors? And then there's the hypocrisy – pastors who are married but have affairs, pastors who know more about money than God, Catholic priests who molest children, break their vows of celibacy, the Vatican Bank that is not above speculating …'

The assembled company fell silent. We were at the home of Professor Swallowtail, as we called him, in Tschaikowskistrasse in Leipzig, an informal evening with entertainment from the Borschtsch Quartet (Christian on cello, the professor at the piano), then tea and crispbread and a disputation on a specially chosen topic.

'You sound more like a politician or a chartered accountant than a theologian', said one of the guests, who happened to be a pastor. 'Even if you're not completely wrong about certain details, what does that mean for the Church? Should we no longer take care of the weak and the outsiders? That is the core mission of the Church, Mr Krause. You'll have a hard time with your parish work if that's how you see things. And, by the way, the Church did in fact survive a very difficult time, the revolution of '89.'

'In those days the churches were packed, now they're empty', said Korbinian.

'For reasons that had nothing to do with the church', said the pastor.

'There's nothing that has not to do with the church', said Korbinian. 'Luther said that God is everywhere in the turmoil that we call history. He doesn't only inhabit forces of light, He also gives life to demons. God is not silent in times of catastrophe, He talks in those catastrophes, God's judgement in a catastrophe always focuses on our guilt, and it is always for the same reasons: arrogance, self-interest, ingratitude.'

'Luther's two-kingdoms doctrine', said the pastor. 'But what you say about the power and powerlessness of the Church reminds me of certain comments by Müntzer. You already want to realise something of God's kingdom here on Earth too, don't you?'

'Would that be so very wrong?' asked Korbinian. 'We have to fight for Him, and we also have to fight to make the Church great again.'

The pastor looked at him. Perhaps he was reminded of his own younger, tempestuous self.

'Do you remember the passage where Luther talks of "good works" that are done purely out of a sense of truly evangelical freedom? – "But where there is any doubt, he searches within himself for the best thing to do; then a distinction of works arises by which he imagines he may win favour. And yet he goes about it with a heavy heart and great disinclination. He is like a prisoner, more than half in despair, and often makes a fool of himself. Thus a Christian man who lives in this confidence toward God knows all things, can do all things, ventures everything that needs to be done, and does everything gladly and willingly, not that he may gather merits and good works,

but because it is a pleasure for him to please God in doing these things. He simply serves God with no thought of reward, content that his service pleases God.'" (WA 6, 207; LW 44, 27).

'Where was God in Auschwitz?' asked Christian.

'We'll get to theodicy another time', cried the professor, 'let's not stray from our topic.'

'But we don't have any other topics', said Korbinian. At which the professor's daughter suggested that were most certainly were other topics, such as love or the sound of a Harley-Davidson, and did not God also inhabit all Harley-Davidsons?

'I fear we will never rid ourselves of God – because we still believe in grammar, Nietzsche', said the mathematician.

Korbinian was infuriated. What the girl said seemed like blasphemy to him. She continued to needle him while we looked on (maybe we even wanted him to be needled). Korbinian tried to throw her out, but when she refused to go (after all, it was her father's apartment), he launched into a lecture on God's contrition, pointing out that God could change His mind, as we know from the famous incident in the Bible, when God spared the wicked city of Niniveh, although that went against His own word and against what the Prophet Jonah had prophesied.

'There is no God', said Christian.

In that precise moment Korbinian seemed to be happy; the gloom that often overlaid his features had disappeared.

The pastor had brought a book with him, Martin Buber's *Tales of the Hasidim*. 'Rabbi Moshe Leib wonders', said the pastor, 'why human beings have the capacity to deny God.' And he read aloud: 'There is no quality and there is no power of man that was created to no purpose. … But to what end can the denial of God have been created? This too can be uplifted through deeds of charity. For if someone comes to you and asks your help, you shall not turn him off with pious words, saying: "Have faith and take your troubles to God!" You shall act as if there were no God, as if there were only one person in all the world who could help this man – only yourself.' Amen, I thought.

AGNES VON MANSFELD

COUNTESS,
GERMANY, C.1550–1615

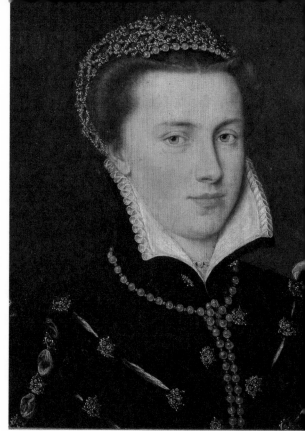

Agnes von Mansfeld was born around 1550 in the town of Mansfeld, Saxony, which meant that she never knew Luther in person. However, her family, her childhood and her whole life were shaped by Luther's legacy.

Her family had numerous connections with the Rhineland, which may well be why Agnes became a canoness in Gerresheim in 1557. It was two years later that she first encountered the Archbishop of Cologne, Gebhard Truchsess von Waldburg, at the celebrations marking peace talks between the Netherlands and Spain. It is said that the two immediately fell deeply in love. Having been invited to attend an event at Bonn Castle, Agnes then remained in the town, so that she could live not far from Gebhard.

On 19 December 1582 Gebhard issued a proclamation establishing religious parity in his Archbishopric; on 16 January 1583 he announced his conversion and 2 February he and Agnes married. Gebhard explained that he had come to this decision following intense study of reformist texts, although he was fully aware that his decision would meet with opposition. Thus the young couple left Bonn the morning after their wedding. Their travels took them via various aristocratic estates in Hessen to Arnsberg, at the heart of the Duchy of Westphalia, where they could expect a more favourable reception. Nevertheless, it was in Arnsberg that one critical observer – whose diary still survives – noted Agnes's particular eagerness to have altars and other decorations removed from churches.

By March the Pope had already appointed a new Archbishop. This kindled a military conflict, the Cologne War, in which Gebhard's opponents soon had the upper hand, because he could muster little support, even from Protestant princes. One exception was the Prince of Orange, in whose domain Gebhard and Agnes lived from 1584 to 1589. Initially they clung to the hope of returning to the Archbishopric, but when their struggle appeared increasingly futile, they moved to Strasburg, where Gebhard was already a Dean of the cathedral. In Strasburg it was not in the slightest unusual for Protestant deans to be married. Gebhard told others at the time that the climate in the Netherlands, which was detrimental to his health, had necessitated the move. In his letters from that period he repeatedly

remarks that he can only make his way through life thanks to the support of his dear, loyal Agnes. It seems that their initial passion matured into deep love and companionship.

One of Gebhard's brothers, who was also a Dean of Strasburg cathedral, stayed with Agnes and Gebhard from time to time. He, too, was in frail health, and Agnes writes in a letter of her spiritual ministrations to her brother-in-law in his last hours. She stayed by him, holding his hand, and recited passages from the Bible that would give him comfort and assurance but also struck a cautionary note.

Gebhard died in 1601 and was given a princely burial. Without her husband Agnes was no longer entitled to live in the clergy house. She left Strasburg, spent some time in Metz and was ultimately taken in by a niece – married to a Rheingraf – at Castle Grumbach. Agnes died in 1615 and was buried in the Rheingraf family crypt in the Church of Herrensulzbach.

Heidemarie Wünsch

→ Further reading

Heidemarie Wünsch: Agnes von Mansfeld (ca. 1550–1615). Die Frau Gebhard Truchseß von Waldburg, in: *Monatshefte für Evangelische chengeschichte des Rheinlandes* 47/48 (1998/99), 247–258.
Hansgeorg Molitor: *Das Erzbistum Köln im Zeitalter der Glaubenskäm (1515–1688)*, Cologne 2008.
Hansgeorg Molitor: Agnes von Mansfeld und ihr Gemahl 1589–1 Die Kurfürstin und der Kurfürst von Köln in Straßburg, in: *Das H hat Geschichte. Forschungen zur Geschichte Düsseldorfs, des Rheinlandes darüber hinaus. Festschrift für Clemens von Looz-Corswarem zum 65. burtstag*, Benedikt Maurer (ed.), Essen 2012, 585–600.

Certificate of the marriage of Gebhard Truchsess von Waldburg,
Elector of Cologne, to Agnes, Countess of Mansfeld, 2 February 1583

KARL BAUER ARTIST, GERMANY, 1868–1942

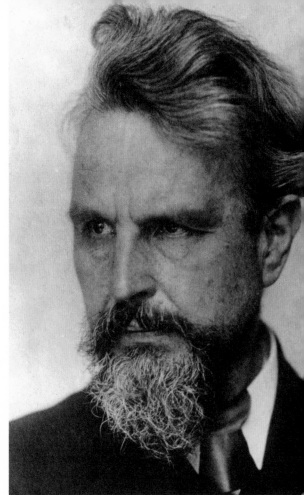

Around the turn of the twentieth century many regarded Luther as the 'most German of Germans'. What that meant can be gleaned from Heinrich von Treitschke's address on 'Luther and the German Nation', which he gave in Darmstadt on the occasion of the Luther anniversary celebrations in 1883. In this address Luther is cast in the role of spiritual Father to the founding of the German Empire in 1871. Treitschke told his audience that it was Luther's translation of the Bible into German that had laid the foundations for the political union of the Empire, which some later even called the Holy *Evangelical* Empire of the German Nation, in contrast to the former Holy *Roman* Empire of the German Nation, which had had the backing of the Roman Catholic Church but was dissolved in 1806. However, there was also a nationalist undertone to Treitschke's, comments, and he went on to suggest that Luther's reformist belief that it was faith that liberated human beings to do good works could now be seen reflected in different ethnic groupings: the 'bravely combative world view' of the Germans together with the deep conscientiousness of the 'German spirit' were, in his opinion, diametrically opposed to the 'Romance' character. Moreover, it was in this spirit that Luther had refused to retract his writings at the Diet of Worms in 1521.

Karl Bauer provided the perfect *portrait* of Luther to accompany Treitschke's *image* of Luther. Bauer specialised in producing portrait drawings of 'great men' in Germany from the past and the present. He created numerous portraits of Frederick the Great, Otto von Bismarck, Johann Wolfgang von Goethe and, of course, Martin Luther. His portraits are distinctive for the seeming liveliness of his subjects, who appear to be gazing directly at the viewer. Bauer always paid particular attention to his subjects' physiognomy; like many others in his day, he believed that the particular shapes of a subject's skull bones could provide scientifically accurate data on their nature and character. In Bauer's portraits of Luther, for instance, the prominent forehead indicates defiance and great strength of will, as he sought to demonstrate that Luther really was the 'most German of Germans'.

Karl Bauer thus shaped the image of Luther that prevailed for most German Protestants until well into the National Socialist era, and often beyond. His portraits of Luther were found on posters in parish halls, on postcards, on Confirmation certificates and on special book editions issued by monthly magazines. In the early 1920s Bauer, who lived and worked in Munich, also came to prominence as a chronicler of National Social[ism] and as the painter of portraits of Adolf Hitler. At the exhibit[ion] of state-approved art in Munich in 1933, the *Staatliche Kunst[aus]stellung*, there was even a room where portraits of Luther a[nd] Hitler, both by Bauer, were displayed side by side, as thou[gh] there were a spiritual-historical connection between them. T[his] was the catastrophic culmination of Treitschke's politicisat[ion] and heroisation of Luther: now Luther was seen as the 'prog[en]itor' of the 'total' Nationalist Socialist state. Statements by [the] reformer, such as those in his treatise *Temporal Authority. [To] What Extent It Should be Obeyed* (1523), which could only h[ave] been interpreted as a rejection of the notion of a 'total' stat[e or]der, were simply ignored. Albrecht Geck

→ Further read[ing]

Karl Bauer: *Luthers Aussehen und Bildnis. Eine physiognom[ische] Plauderei*, Gütersloh 1930.

Albrecht Geck: 'Luther als Persönlichkeit'. Die Lutherbil[dnis]se Karl Bauers (1868–1942) und das Selbstverständnis des [Pro]testantismus in der ersten Hälfte des 20. Jahrhunderts, in: [Zeit]schrift für Neuere Theologiegeschichte 18 (2011), 251–280.

Albrecht Geck: Von Cranach zur BILD-Zeitung. 500 J[ahre] Wandlungen des Lutherbildnisses als Spiegel der Kirchen- [und] Kulturgeschichte, in: *Reformatio in Nummis. Luther und d[ie Re]formation auf Münzen und Medaillen*, Elisabeth Doerk ([ed.],) Regensburg 2014, 78–103.

2

3

4

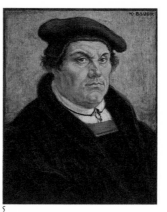

5

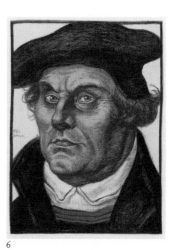

6

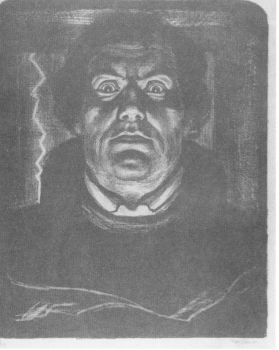

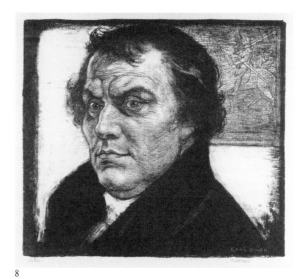

8

1	Karl Bauer, *Luther as a Young Monk*, 1929	5	Karl Bauer, *Martin Luther*, not later than 1917
2	Karl Bauer, *Martin Luther*, not later than 1917	6	Karl Bauer, *Martinus Luther*, not later than 1917
3	Karl Bauer, *Portrait of Luther in Old Age*, before 1942	7	Karl Bauer, *Luther*, not later than 1917
4	Karl Bauer, *Martin Luther*, undated	8	Karl Bauer, *Martin Luther*, not later than 1917

THOMAS MANN WRITER, GERMANY, 1875–1955

Thomas Mann kept a diary on his 'suffering from Germany'. At first in Southern France, later in Switzerland and the USA, the writer, who had been forced into exile in 1933, relentlessly sought to discern the origins of National Socialism. Day by day he meandered through German thought from the Reformation to Romanticism with the aim of grasping the 'secret union of the German spirit with the Demonic', which he suspected to be the root cause of his country's political and moral bankruptcy. Culminating in his 1947 novel *Doctor Faustus*, Mann's intellectual peregrinations centred on the 'bullnecked barbarian of God' Martin Luther. For Adolf Hitler, as Mann posited in a diary entry of 1937, was hardly a 'product of chance, an illegitimate misfortune, a mere lapse', but rather a clear reflection on Luther. Indeed, the 'anti-rational and anti-human National Socialist movement with its fixation on blood and tragedy' had consciously 'set about re-enacting the tumultuous and bloody role of Lutheranism'.

Despite this burgeoning scepticism towards the Reformer, Mann, who had grown up in the Protestant stronghold of Lübeck, consistently professed himself to be 'Luther's offspring'. In his acceptance speech for the 1929 Nobel Prize in Literature, say, he drew attention to the fact that he was not a Catholic: 'My tradition,' he claimed, 'is like that of all of you; I support the Protestant immediateness to God.' Prior to that, in his *Reflections of a Nonpolitical Man*, published in 1918, Mann had already aligned himself with the equally non-political Luther whose dualistic concept of freedom he believed to have safeguarded Germany against the bloodshed of revolution. Whereas his fellow Germans had favoured metaphysical over political freedom, nonreformed countries like France had never been able to settle. In truth, writes Mann, Luther's conservative revolution was 'an event of genuine German majesty to admire, an event and fact of the soul – actually not capable of interpretation or crit-

icism, like life'. It was 'all this at once, ... deep, defiant, fate[ful] antiprogrammatic, personal, and great'.

This 'incapability' of the Reformation to be criticised end[ed] for Mann with the rise of National Socialism, which drew mu[ch] of its legitimacy from Luther. In Mann's writings and speech[es] the Reformer was thus increasingly cast as a boor, a construct[ed] coarse caricature of a character who – like Ehrenfried Kum[pf] the theology professor in *Doctor Faustus* – fumes and rages [his] way through life in a manner 'at once clumsy and tender, for[ce]ful and driven'. Whether in the much-cited speech *German[y] and the Germans*, held on the occasion of his 70th birthday, [in] *Doctor Faustus*, or his 1949 essay on the three 'monumental [fig]ures' Martin Luther, Johann Wolfgang von Goethe and O[tto] von Bismarck, it was Luther's passion that Mann felt co[m]pelled to decry, albeit without ever exploring its origins in p[op]ular myth. In any case he was certain that he 'should not ha[ve] liked to be Luther's dinner guest' and would have felt quite [un]comfortable in the 'home of an ogre'. Catherine Nicho[las]

→ Further readi[ng]
Gerhard Kluge: Luther in Thomas Manns *Doktor Fau[stus]* in: *Luther-Bilder im 20. Jahrhundert*, Ferdinand van Ingen [&] Gerd Labroisse (eds.), Amsterdam 1984, 119–140.
Friedrich Dieckmann: *Luther im Spiegel. Von Lessing bis Th[om]as Mann*, Berlin 2016, 238–264.
Norbert Mecklenburg: Der dämonische Deutsche. Tho[mas] Manns Lutherbild, in: idem: *Der Prophet der Deutschen. M[ar]tin Luther im Spiegel der Literatur*, Stuttgart 2016, 191–211.

The specifically Lutheran, the choleric coarseness, the invective, the fuming and raging, arouses my instinctive antipathy.

Thomas Mann, *Germany and the Germans*, 1945, lecture manuscript

JULIUS STREICHER
NATIONAL SOCIALIST POLITICIAN, GERMANY, 1885–1946

For Julius Streicher passion meant hatred. To this day the 'Franconian Führer' and his anti-Semitic weekly, *Der Stürmer*, are synonymous with hate campaigns and the most primitive anti-Jewish sentiments.

Born in 1885 in Fleinhausen near Augsburg, after the First World War Julius Streicher became one of the most infamous propagandists in Franconia (Bavaria). His prominent part in the failed Munich Putsch in 1923 secured the elementary school teacher Hitler's enduring protection; he even became one of the few compatriots Hitler addressed with the familiar 'Du'. Nevertheless, even after Hitler seized power there was no prospect of Streicher becoming a leading political figure in the Reich, so he concentrated instead on Franconia and, as the regional Gauleiter, turned it into his own personal fiefdom. His reputation beyond the borders of Franconia was built on *Der Stürmer* – a widely known forum for anti-Semitic rants, denunciations and smears. Streicher saw himself as a standard bearer for the National Socialists' racial policies; he used *Der Stürmer* to popularise the notion of 'racial defilement' and to promulgate false rumours of 'ritual murders' by Jews. By encouraging his readers' to engage in bloodthirsty, pornographic fantasies, Streicher helped to make anti-Semitism socially acceptable, and it was this acceptance that ultimately led to the National Socialists' extermination camps.

One of Streicher's most infamous projects was the ideological indoctrination of children and young people, to which end he published anti-Semitic children's books at his Stürmer Verlag premises. The first publication of that kind bore the title *Trau keinem Fuchs auf grüner Heid / Und keinem Jud bei seinem Eid* ('Trust No Fox on his Green Heath / And No Jew on his Oath') – which is a travesty of a quote from Luther's *Table Talk* (WA TR 5, Nr. 6172, 522).

At the Nuremberg Trials, when leading National Socialists h to face justice, Streicher's defence strategy was to play do his propaganda activities and their impact. He maintained had never meant to incite hatred, merely to enlighten and form his readers. He even tried to claim allegiance with M tin Luther: 'Anti-Semitic views in the press have existed Germany for centuries. A book I owned, by Dr Martin Lut was confiscated. If that book were examined by counsel for t prosecution, Dr Martin Luther would certainly be beside in the dock today.' Streicher repeatedly attempted to supp his tirades of hatred in *Der Stürmer* by citing anti-Jewish c ments or texts by historic figures – from Luther to Goethe a Napoleon to Schopenhauer. Again and again he tried to ass that there was an unbroken tradition leading straight to the terminatory anti-Semitism of the National Socialists. The co took no heed of his protestations: Streicher was condemned death by hanging for crimes against humanity and execu in the early hours of 16 October 1946. Daniel Roos

→ Further readi

Bytwerk, Randal L: *Julius Streicher: Nazi Editor of the r rious anti-Semitic newspaper Der Stürmer*, New York 198

Thomas Greif: *Frankens braune Wallfahrt. Der Hesselber Dritten Reich*, Ansbach 2007.

Daniel Roos: *Julius Streicher und Der Stürmer 1923–1945 derborn 2014.

Dr Martin Luther would certainly be beside me in the dock today

Anti-Semitic children's book published by Stürmer-Verlag: Elvira Bauer, *Trau keinem Fuchs auf grüner Heid / Und keinem Jud bei seinem Eid*, third edition, 1936

OSKAR BRÜSEWITZ PASTOR, GDR, 1929–1976

On 18 August 1976 Lutheran pastor, Oskar Brüsewitz, poured petrol over himself in front of St Michael's Church in Zeitz and set himself alight. He died a few days later. His suicide was disputed, but today Brüsewitz is seen by both the Protestant and Catholic churches as a martyr, a man of God whose evangelical passion was so great that he chose death by self-immolation to arouse people. His actions did indeed galvanise many of them to engage in the resistance which eventually led to the political changes of 1989. Before dousing himself with petrol, Brüsewitz had spread posters across his car which read, 'Radio message to everyone: the Church in the GDR accuses communism of oppressing children and young people at school!'

Oskar Brüsewitz was born in East Prussia in 1929 and was sent to war at the age of 14. His family managed to flee to Osnabrück where, after the war, Brüsewitz became the youngest master shoemaker in Lower Saxony. In 1954 he moved to Weissenfels and felt himself called to ministry there. Shortly afterwards he entered the seminary in Wittenberg, but had to abandon his studies due to a stomach complaint.

At a time dominated by the GDR's anti-church position, Brüsewitz came to prominence with spectacular public actions. While working as a shoemaker in Leipzig, he portrayed Biblical scenes in his shop window and verses from the Bible in his display cases. He rented a plot of land and erected a sign saying 'Lutheran children's playground'. The state security service (Stasi) was alarmed and his church distanced itself. Disappointed with this response, Brüsewitz suffered several heart attacks and left Leipzig.

From 1964 he attended the seminary in Erfurt and in 1970 became pastor in Drossdorf-Rippicha, near the town of Zeitz. He threw himself into his work with great enthusiasm and quickly developed an active church community, attracting children and young people in particular. Not unlike Luther, he wanted to tell people about God – as a symbol of this missionary work he installed a four-metre-high neon cross at the top of the church tower which was visible to motorists on the motorway between Zeitz and Gera. Despite serious threats, he defended the glowing cross right up to his death.

It was not long before the Stasi was threatening to charge Brüsewitz with slander of the state or have him admitted to a psy-

chiatric clinic. His superintendent warned him, but Brüsew[itz] called this cowardice, saying he did not want to knuckle und[er] and submit, he wanted to fight for his God. In 1975, when t[he] ruling SED party put up posters with the slogan, 'Without G[od] and without sun, we will get the harvest done', he respond[ed] 'Without rain and without God, the whole world will go to p[ot]'. He protested passionately against compulsory military traini[ng] for all school students.

In spite of the repression he persisted with his defiant oppo[si]tion, but soon people no longer dared to attend his church. Ev[en]tually the Stasi wanted to deport him to the West and th[is] prompted Brüsewitz to plan his incendiary gesture. At the ti[me] he was reading Benedicta Kempner's book *Priester vor Hit[lers] Tribunalen* ('Priests before Hitler's tribunals'); when he died t[he] bookmark was in the chapter on Dietrich Bonhoeffer.

Wolfgang Stock

→ Further readi[ng]

Das Fanal. Das Opfer des Oskar Brüsewitz und die evangelische Kir[che], Helmut Müller-Enbergs, Heike Schmoll and Wolfgang Stock (ed[s.]), Frankfurt am Main 1993.

Zeugen einer besseren Welt. Christliche Märtyrer des 20. Jahrhunde[rts], Karl-Joseph Hummel and Christoph Strohm (eds.), Leipzig 2000[0].

Karsten Krampitz: *Der Fall Brüsewitz. Das Verhältnis von Staat u[nd] Kirche in der DDR infolge der Selbstverbrennung des Pfarrers Oskar Br[üse]witz am 18. August 1976 in Zeitz unter besonderer Berücksichtigung [der] Evangelischen Kirche der Kirchenprovinz Sachsen*, Berlin 2016.

A mighty war is raging between light and darkness

Cross made of neon tubes on the church tower in Rippicha, 1976

LARS VON TRIER
FILM DIRECTOR,
DENMARK, B. 1956

The Danish film director Lars von Trier is one of the most influential film-makers of our time. In the mid-1990s his *Dogma* manifesto, which insists on handheld cameras and only original sound, significantly contributed to the renewal of the language of film. His films have won countless awards at film festivals. Von Trier likes to play the *agent provocateur* by flouting social and religious taboos. His parents were atheists and von Trier, who was socialised in a Lutheran milieu, grew up in the belief that his father was Jewish. When he learnt in his mid-30s that the Jewish man he thought was his father was not his biological parent, he converted to Roman Catholicism. Religious issues such sin, grace and salvation are central to many of his films. In his exploration of these areas, von Trier juxtaposes different Christian concepts. This is particularly apparent in his *Golden Heart Trilogy*, in which the three female protagonists are similarly prepared to sacrifice themselves for love.

The first film in the trilogy, *Breaking the Waves* (1996), recounts the suffering of the naive Bess McNeill. She lives in a repressed, deeply religious community in Scotland and is regarded as pure and God-fearing. In her prayers she conducts an intimate dialogue with God, whose answers she herself speaks in an assumed deep voice. Bess marries the fun-loving Jan, who works on an oil rig. Bess prays that Jan may come home earlier from work. Her wish comes true, but only because of an accident that leaves Jan paralysed and bedridden. This marks the beginning of the martyrdom of Bess. Jan asks her to have sex with other men and to tell him about it afterwards. The young woman accepts this torment out of love for her husband with ruthless logicality; she prostitutes herself, suffers the worst possible abuse and dies a sacrificial death. And then a miracle occurs: Jan, no longer incurable, can walk again. Bells ring out in the heavens.

Von Trier tells his story with numerous references to the Bible and almost verbatim quotes. Bess compares herself to the sinful Mary Magdalene, but God replies, telling her that she is His 'dearly beloved'. There are even more obvious allusions the suffering of Jesus, when Bess appears as a female Christ-ure. She is mocked by children who throw stones at her a betrayed by a doctor who yields her up to her enemies. Wh she painfully tries to push her moped up a hill – her bo bruised and battered and her clothes torn – Christ carrying Cross on the way to Calvary comes to mind. In the lonelin of her dying hour Bess finally asks in despair, 'Father, why are you with me?'

Von Trier's engagement with radical Presbyterianism could h culminated in the presentation of a new Luther opera in 2 But the project was cancelled at short notice; it is now plann to present a concert performance of the first act. However, th themes continue to be a driving force in von Trier's thinki In *Nymphomaniac. Vol. I* (2013) for instance, the Lutheran rale '*Ich ruf' zu dir, Herr Jesu Christ*' in the setting for organ Johann Sebastian Bach, is heard while the female protagor describes her sexual excesses. Passion and religion are closely tertwined in the work of Lars von Trier.

Kristina Jaspers

→ Further readi
Trier über von Trier, Stig Björgman (ed.), Hamburg 2 (English translation: *Trier on von Trier*, London 200.
Charles Martig: *Kino der Irritation. Lars von Triers logische und ästhetische Herausforderung*, Marburg 200 Linda Badely: *Lars von Trier*, Chicago 2010.

The only thing that can make a person complete is loving another person

Scenes from: Lars von Trier, *Breaking the Waves*, 1996

MEGAN ROHRER PASTOR, USA, B. 1980

Megan Rohrer is the first openly transgender pastor in the Evangelical Lutheran Church in the USA. She was ordained in 2006, albeit only 'Extraordinarily', because at the time the Church still did not allow the regular ordination of non-celibate LGBTQ candidates. However, four years later the Church revised its thinking and initiated a process of reconciliation, opening its doors to pastors, including Rohrer, who had hitherto been marginalised on the grounds of their sexuality. Now there was no longer any ecclesiastical basis for the humiliations and hostilities that had so often made Rohrer's vocation a painful ordeal. In 2014 Pastor Meg was thus able to take up the call from Grace Lutheran Church in San Francisco. Her 'tears of weeping' turned into 'tears of joy'.

Rohrer's passionate commitment to the ministry has much to do with Martin Luther. Born into a Christian family that can trace its Evangelical roots back to 1648, she grew up in Sioux Falls, South Dakota, which has a strong Lutheran tradition. She loved going to Sunday School and was a loyal member of the Evangelical youth group, where she stood out early on as someone with a sense of mission and a gift for communicating complex, theological issues. Everyone assumed that she would be ordained as a pastor one day – until she was outed as a lesbian during her adolescence and excluded from the congregation. Undaunted, she studied theology and prepared for the ministry. Despite having to endure numerous, often threatening forms of discrimination at university, she never lost sight of her goal of serving a congregation of her own – above all, as she writes in her book *Queerly Lutheran* (2009), because Luther talked of the priesthood of *all* believers. Of course this is not to say that his own discriminating attitude to people with different world views can simply be ignored, and many of his texts are not for the faint-hearted – or for anyone at all nowadays. Nevertheless, it was the short, radically inclusive word 'all' that motivated Rohrer to follow her vocation and, ultimately, to truly open the doors of her own church to all comers. In a special transgender edition of her online Bible study group, *Bible Study that Does[n't] Suck*, she therefore asks whether the love of God is someho[w] not big enough to embrace *all* human beings? Was God lyi[ng] when he said that Jesus had cleansed *everyone* of their si[ns] through His death?

For Rohrer, passion is not only a feeling, an irrepressible des[ire] to spread the Word of God, but also a key theological conce[pt]. Like Luther, she places the Passion of Christ at the heart of [her] theology of grace. And like Luther, she sees Christ's Cruci[fix]ion and Resurrection as a gift and considers grace to be som[e]thing that the believer receives from God and not as someth[ing] gained through good works. However, whereas the reform[er] concluded from this that passion and in particular suffering a[re] a precious treasure insofar as they reveal the power and gra[ce] of God (WA 32, 38–39; LW 51, 208), Rohrer is more sceptic[al]. She prefers the line taken by her grandmother Darlene, w[ho] always seeks to alleviate the suffering of her grandchildren. [In] the eyes of Pastor Meg, God(dess) is more like that.

Catherine Nichols

→ Further readi[ng]
Butch Wonders: Butch in the Clergy. An Interview with Pas[tor] Megan Rohrer, 9. March 2011, online: butchwonders.com/b[log/] butch-in-the-clergy (accessed on 11 February 2017).
Jen Chien: A Shepherd Finds the Perfect Flock, 10 May 2[014] (transmitted in September 2014), online: http://kalw.org/p[ost/] shepherd-finds-perfect-flock (accessed on 11 February 2017).
Megan Rohrer: *Queerly Lutheran. Ministry Rooted in Traditi[on,]* Scripture and the Confessions, California ²2016.

My tears of weeping have turned
to tears of joy

Megan Rohrer, *Queerly Lutheran*, 2nd edition, 2016

95 PEOPLE
INNER BEING

'THE SOUL OF MAN IS SOMETHING ETERNAL.'

WA 11, 409; LW 39, 306

Luther's core message is aimed at the individual: in their inner being, people are free from all external constraints. It is not ritual or institutions that take centre stage in the Protestant faith but the personal piety of the individual. So did Luther individualise, possibly even psychologise religion? Lutheran inwardness is cherished by many as a particularly valuable element of the cultural heritage of humanity. Some are inspired by Luther's interiority to create musical and artistic works, or to engage in its further intellectual and academic exploration. Others criticise the vague, amorphous nature of Protestantism to which it gives rise. However appealing interiority might be, does it not also entail the risk of losing touch with the world and the beautiful aspects of being in it?

THE PRIMACY OF CONVICTION

CHRISTIAN GEYER

T he mysterious path leads inward. The philosopher Novalis acknowl-
edged this as he expanded upon the motto of Romanticism, thereby
allegedly encapsulating the German soul. Who would have thought
that this notion, this profession of interiority, could be used to charac-
terise both the reforming spirit of 1517 and, despite completely different
ideological portents, the zeitgeist of 2017? The transcendental philosophy
of Novalis, with its Pietistic influences, was the first attempt of international
standing to poeticise Luther's 'great historical deed of German inwardness',
as Thomas Mann described it, and accordingly to bestow a poetic lustre on
a religious world view whose salvation, to use a provocative formulation,
relies on nothing more than individual conviction (*Gesinnung*).

Now, as then, we are in thrall to interiority. The primacy of good intentions
outweighs simple, straightforward acts and renders all speech worthless.

Of what interest can the utterances of this or that actor or author be if it remains unclear whether they are well intended? It is therein, in this obsessive focus on moral self-affirmation, that the German psyche – in essence an extension of Luther's psyche – remains ensnared to this day. The fixation on questions of conviction means that the leeway for raising thought-provoking questions is shrinking. Meanwhile, a kind of liberal self-criticism is pointing the finger at the excess of good intentions in the political sphere: across the political spectrum it is suggested that – from the 'welcome policy' for refugees to minority politics – political correctness has gone too far. Where can one go from here, if the immediate response to divergent views is to level accusations of false consciousness? Rather than the outward focus of classical liberalism on human social conditions, we have apparently turned inwards and been taken in by the cult of conviction.

With his spiritual reorientation from exteriority to interiority, Martin Luther caused a caesura in the history of human mentality that, more than any other, separates the Modern era from the Middle Ages. Whereas in the mediaeval period the mysterious path always led outwards – towards ritual as the carrier of mystery, towards holders of ordained office as God's 'public relations people', towards good works as guarantees of true faith – in the Modern era it was abruptly thrown into reverse in the direction of interiority. Thereafter the economy of salvation was internally codified: faith alone, *sola fide*, in the form an internal spark of the soul rather than an external beacon, was what led to paradise. The liberal state of our time still attracts the misconception that it is the correct addressee for unalloyed happiness and joie de vivre. And this same liberal state makes it clear in its constitution that it has no interest in the interiority of its citizens: it is possible to comply with the laws without necessarily believing in the principles behind them.

To be able to fully explore of Luther's central motif of interiority, which still resonates widely today, it is impossible to avoid an in-depth theological or, more appropriate to Luther himself, in-depth theological-psychological analysis of his choice of the *homo interior*, the inner person. To do otherwise and refrain from theological contextualisation would again risk a cultural-historical reductionism that would completely miss the target of the phenomenon it promises to interrogate. This error in categorisation is frequently encountered in the literature on the 2017 anniversary of the Reformation, and one against which the church historian Volker Leppin has emphatically warned.

In the aforementioned theological sense, it should therefore be noted that it was Luther himself, in his reading of the Bible, who separated law from Gospel. This enabled him to perceive a law that is, in principle, impossible to comply with fully, namely God's commandments, as simply a pedagogical event enabling recognition of one's own sinfulness and insight into

the powerlessness of humankind. Meanwhile, the Gospel, in which those in fear of hell sought refuge with faithful trust in its promise of salvation, specifically promised Luther liberation from an approach to life anchored in the law. With this, the normative implications of Holy Scripture were set aside, in Luther's words 'put out of sight' (WA 30 III, 564). A change in conviction and all will be well: Christ appears on Judgement Day not as judge but as saviour. Luther the reformer was mainly interested here in providing relief for the embattled psyche. His concerns were, as they might be termed today, pastoral rather than dogmatic. In Luther's subsequently unavoidable renunciation of a canonically definable concept of salvation bound up with the sacraments, the latter effect was to some extent involuntary.

The psychological thrust of Luther's approach cannot be overstated. What interested him was the potential for distress inherent in such terms as conscience, law, sin and death, and the horror and fear they aroused; and he wanted to remove this psychological barb from the consciousness to enable the shift from a pedagogically valuable state of terror (law) to a state of inner serenity (Gospel). For Luther, conscience was a harmful force, an instrument wielded by the Devil to perturb the soul and specifically not an authority to be obeyed in the sense conveyed in the popular exclamation: 'Have you no conscience at all?' The true obligation articulated by conscience is inaudible and can only be believed. It is concealed behind the horror masks of God and the devil, and Luther often mistook one for the guise of the other.

When the great Luther scholar Karl Holl declared a century ago that 'Luther's religion is a "religion of conscience" in the most pronounced sense of the word', the context is significant. In the same essay, *What Did Luther Understand by Religion?* Holl notes 'Luther insists that faith in the forgiveness of sins goes "against all reason" in fact, against all "morality"' and he points out that Luther himself uses the strongest of terms in stating that 'one here acts "against one's own conscience" to overcome "God with God."' In fact, contrary to the liberal appropriation of his views, Luther maintained that the conscience should be silenced. He believed that trust in the promise of salvation of the Gospel would make it possible to ignore the dictates of conscience. For the conscience can only produce a form of thinking that conforms with the law, according to Luther a terrifying manifestation of Christian faith which must be overcome. '"Reason" and "conscience" can never bring about any other perception of God than that He recognises those who transform righteously before him,' writes Holl. The aim must be to free oneself of this illusion.

Accordingly, Luther's reading of the merciful God ultimately makes sin, law and conscience illusory. They lose their compelling effect as harmful forces: they are no longer relevant for salvation. In this respect, Luther

bought upon himself psychologisms that he had not intended to create. Because I boldly take the Gospel's message of salvation as referring to myself, from that moment on the judgement of the law no longer concerns me; it vanishes like a godless abstraction. Accordingly, becoming conscious of oneself as a believer is the decisive moment in justification, the transition from damnation to salvation. However, from a theological perspective, it is the Holy Spirit that initiates this transition: 'The basis of the new self-awareness remains at all times outside the person, and in God.' (Holl) In religious practice, access to salvation appears as a subjective production of mental energy, as an event to be set in train by the believer in the inner psychological space.

Luther as the author of a pious psychological technique? But one that can never be pious enough to prevent impious, self-serving traits showing through? Yes, absolutely! In fact, the postulate of pure conviction leads to a quandary similar to that raised by good works. One can never be immune from tinges of selfishness. Here, as there, it can be claimed that there is too much wickedness in play to merit a place in heaven – be it through good works or good intentions. And it is indeed true that as soon as one approaches things with 'hygienic' intentions, one immediately becomes aware of the bacterial cultures flourishing within. Do both cases – the initiation of inward acts of faith and performance of outward works – not always involve an element of impure intentions, with designs on selfish gain?

In other words: can anyone who begins to examine their own conviction ever really stop? It seems that every conviction could be improved through a corresponding reflexive check. Is it not always possible to attain an ever more profound faith and act in an ever more selfless way? The infinite regress to which each test of conviction leads does not exclude religion. In principle, as we know from the clinical treatment of scrupulosity, there are no limits to mental hygiene. This is the imbalance inherent in a notion of salvation that, as in Luther's case, remains programmatically rooted in interiority. And one that is fulfilled through reflexive reference to its own act of faith, rather than through participation in public rituals of grace.

This is precisely where the aforementioned paradigm shift from outward to inward, can be clearly seen. As the Protestant church historian Reinhard Schwarz has it, Luther 'liberated the justification event from the bonds of the system of sacral law governing the sacrament of Penance.' This is an escalation of reform which – in an ironic twist of ecclesiastical history – the Roman Pontiff, the Antichrist of old, appropriates 500 years later in his apostolic exhortation *Amoris laetitia (The Joy of Love)*, which confines the traditional Roman order of the sacraments within Reformation brackets: expressly for pastoral reasons – as it was then in Wittenberg, and is now in Rome. Inspired by a German theology of interiority, Francis declares that the mysterious path leads inward, to where, in a devout state of mind,

salvation can be secured. Believe and do what you want. What was said of Luther is now also said of Francis – that they want to change nothing and yet everything in the Christian faith.

Observers now ask themselves: is the Church that was torn apart over the papal Antichrist now to be reunited de facto under the aegis of the incumbent of that same office? Is Francis the Luther of 2017? Is he transforming the Catholic Church into a reformed church of conviction through a kind of historical precision landing? This would lead to the longed-for – or feared – ecumenism of return, but in reverse. Rather than wishing to compel Protestants to return to Rome, as has been customary for centuries, the Holy See is relocating to Wittenberg, completely at its ease. The outcome of a German interiority with global reach?

Which brings us back to the present. Beyond all the unfamiliarity naturally engendered through temporal distance and beyond all historical-philosophical speculation, which has always pursued a political and ideational line, from Luther to who knows where, it is the primacy of conviction that connects 1517 with 2017. In other words, it is self-evident that the attitudes of 1517 differed from those of 2017. However, precisely what connects these two dates across the intervening centuries is the notion that conviction per se, sheer intent this side of selfishness, lent and lends added force to heavenly salvation then and earthly happiness now. One question has become crucial for the persuasive power of liberal thinking: what can counteract the pull of an interiority that can no longer find a way back to the exterior?

PIETER JANSZ. SAENREDAM
ARTIST, NETHERLANDS, 1597–1665

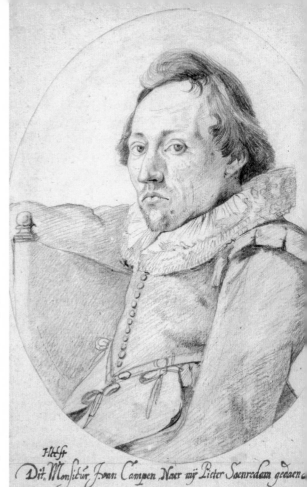

Dit, Monsieur, Jvan Campen Naer mÿ Pieter Saenredam gedaen e

Does it not sometimes seem that the figures which populate images of the predominantly Gothic vaulted interiors of Dutch churches are entering these spaces for the very first time? Take, for example, the interior views of Sint Bavo Church in Haarlem that Pieter Jansz. Saenredam painted from 1628. Here, men engaged in animated conversation stride across the transept or a side-aisle, while others view a memorial panel adorning the white wall of a side-chapel. The surprisingly bright spaces are otherwise empty. Although the sturdy pillars and thick columns provide structure, it is not easy to identify the choir or side-aisle as such. It is difficult for the viewer to decide where to focus the gaze: on the mainly plain, clear glass windows, on the glimpses of wrought grilles, on the delicate brass lamps or on the funerary hatchments with their pious inscriptions? And where are the pulpit and the altar?

This artist's work includes many more church interiors of this kind. Be they Romanesque or Gothic in style, the soaring spaces he depicts are all astonishingly light and empty. What we associate today with Christian churches of any persuasion, and would indeed expect in a Protestant or reformed church – a modest congregation, possibly singing heartily – is nowhere to be seen. But that was what happened in the nineteenth century; here in Haarlem, and elsewhere in seventeenth-century Holland, each visitor appears to be alone. In this sense, every picture seems a manifestation of Protestant interiority.

To gain an understanding of the emptiness of these spaces and the isolation of the people within them, further clarification is helpful: the iconoclasm of the Reformation was widespread in the provinces of the Netherlands, raging over many days, often recurring in recurring waves. The Dutch wars of religion were also wars of liberation against Spanish rule and its instrument of terror, the Inquisition. This conflict, which lasted for 80 years, can also be described as hand-to-hand urban warfare over the churches themselves. And what had to happen before the churches were rescued, 'cleansed', and were once more accessible and usable? Or until – after all the violent struggles over the correct faith – peace was sufficiently restored so that a baby could be baptised in a Catholic ceremony in a side room at Sint Bavo in Calvinist Haarlem?

Pieter Jansz. Saenredam was only one of many painters w specialised in interiors. However, he is particularly valued too because of his meticulous measurements and the complex of the perspective drawings he made in preparation for his pa ings of churches. He was assessor, secretary and, finally, go nor of the 70-member Guild of St Luke in Haarlem. It can concluded from this that Saenredam must have been a Calv ist. Does his inclusion in his Sint Bavo paintings of figurati stained-glass windows that had been removed from the chur in 1626 indicate that, a short time later, he was not convinc by the continuing process of eradication and waves of ico clasm? Had his fellow-believers gone too far for him? Was merely documenting a situation from the past, or had he cr ed new, apparently realistic truths? Heinrich Dilly

→ Further readi
Heinz Roosen-Runge: *"Naar het leven". Zum Wirklichkeitsge von Pieter Saenredams Innenraumbildern,* Wiesbaden 1967.
Gary Schwartz and Marten Jan Bok: *Pieter Saenredam. The F ter and his Time. Biography, Illustrations and Catalogue of all W Summaries of All Documents,* Maarssen 1990.
Das goldene Zeitalter der niederländischen Kunst. Gemälde, Sku ren und Kunsthandwerk des 17. Jahrhunderts in Holland, catalog the exhibition Der Glanz des Goldenen Jahrhunderts, Stuttgart 2

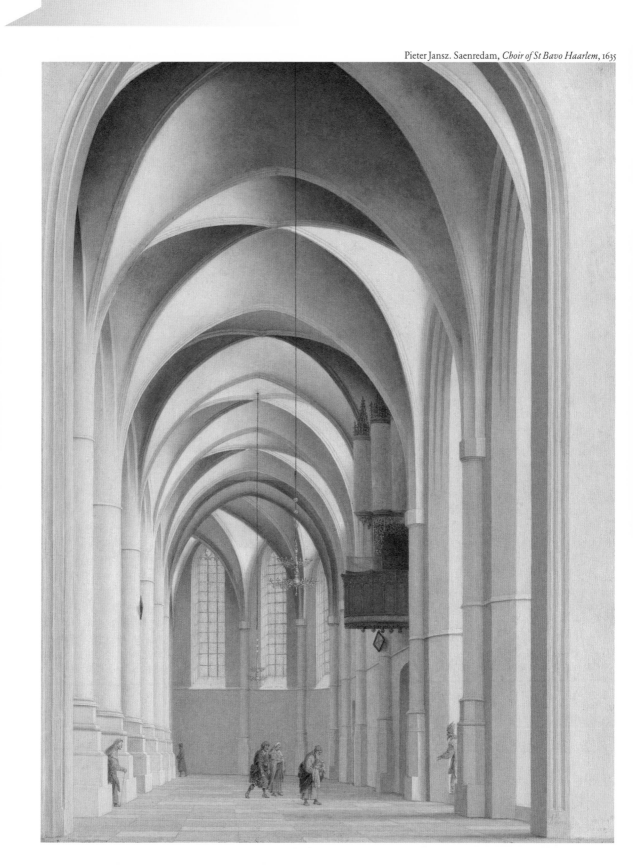

Pieter Jansz. Saenredam, *Choir of St Bavo Haarlem*, 1635

WILLIAM JAMES
PSYCHOLOGIST AND PHILOSOPHER, USA, 1842–1910

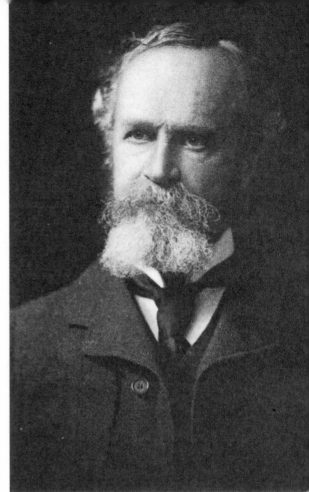

William James was born in New York in 1842. His grandfather, a Presbyterian of orthodox beliefs, emigrated from Ireland to the United States in 1789 and made his fortune in property. William and his younger brother, the renowned novelist Henry, enjoyed an international education of the highest standard, attending schools in London, Paris, Bolzano and Bonn. William James embarked on the study of medicine at Harvard in 1864. In 1867, during a stay in Germany, he attended lectures given by the physicist and physiologist Hermann von Helmholtz in Berlin. From 1872, James taught at Harvard, initially physiology and, later, psychology and philosophy. His seminal work, *Principles of Psychology*, published in 1890, laid the foundations for scientific psychology in the United States.

William James is acknowledged as a pioneer in the field of philosophy of religion and is one of the most prominent exponents of philosophical pragmatism. He regarded religion as essentially a subjective phenomenon rather than a matter of adherence to any theological doctrine. His pragmatism is a philosophy in which truth does not mean agreement of a statement with reality: from a pragmatic perspective, an idea or statement is true if it serves the purposes of human action. Truth is what works. '"The true", to put it very briefly, is only the expedient in the way of our thinking …'

James's concept of religion as a private, internal matter was strongly influenced by the Protestant culture of piety in which he grew up. In 1901 he delivered a series of lectures in Edinburgh entitled *The Varieties of Religious Experience*, in which he located religion in the feelings: 'Religion … shall mean … the feelings, acts and experiences of individual men in their solitude, so far as they apprehend themselves to stand in relation to what-

ever they may consider the divine.' However, feelings are priv[ate] and individual in nature. The decisive characteristic for Jam[es] is therefore the religious sensibility of the individual, not si[m]ply acceptance of holy scriptures or preformulated theolog[y]. James thus identified religion as what remains as emotion in [in]dividuals once externally imposed doctrines and rituals of r[e]gion are discarded. In the analysis that led him to this conc[lu]sion, he had in mind those personalities, among them Mar[tin] Luther, whose religious experience was linked with intense [per]sonal crisis, an existential and spiritual despair which radica[lly] called into question their lives as they had lived them thus [far]. 'When Luther, in his immense manly way, swept off by a stro[ke] of his hand the very notion of a debit and credit account ke[pt] with individuals by the Almighty, he stretched the soul's im[ag]ination and saved theology from puerility.'

An Paenhuysen

→ Further readi[ng]
William James: Varieties of Religious Experience. A Study [in] Human Nature, New York 1902.
James Sloan Allen: *William James on Habit, Will, Truth, [and] the Meaning of Life*, Savannah 2014.
Claudio Marcelo Viale: Sola Fide at the Core of Varie[ties?] Luther as Religious Genius in William James's Thou[ght], in: *The Pluralist* 10 (2015), 80–106.

G. K. Chesterton, *William James delivering the Gifford Lectures*, after 1901

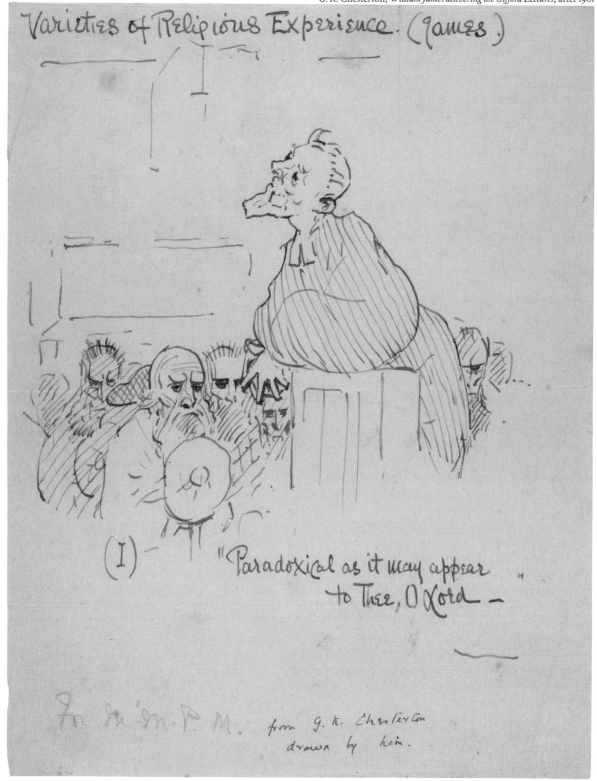

MAX REGER COMPOSER, GERMANY, 1873–1916

While still at school Max Reger accompanied the Catholic mass on the church organ in his home town of Weiden in the Upper Palatinate region of Bavaria. The boldness of the Archangel Michael, to whom the church is dedicated, was also reflected in the boy's passion for improvisation, although it was never entirely clear whether he was driven by madness or genius. In 1898 Reger remarked to his local mentor, Adalbert Lindner, 'The Protestants have no idea what they have in their chorales'. Not long afterwards he evoked astonished disbelief in the Guild of Organists when they heard his treatment of these chorales.

By this time he had studied music and had been introduced, by Hugo Riemann among others, to the art of composition and the musical cosmos of Johann Sebastian Bach. The response of the public and the music world to his work was evenly balanced between fascination and scepticism. Had it not been for Karl Straube, later organist and Cantor at St Thomas's Church in Leipzig, the music Reger composed for the organ would have appeared to be so complex as to be virtually impossible to play. Straube was able to play his organ music so masterfully that Max Reger's exuberant expressiveness and the energy of the old chorales shone through in new and spectacular ways.

Max Reger, the Catholic, who started out from a very different tradition, now fully embraced Johann Sebastian Bach. He was seized by the internal radiance of the chorales and invested them with his own late Romantic tonal language, including, in 1898, Martin Luther's 'A mighty fortress is our God', Op. 27.

Following his studies in Wiesbaden, he returned to live with his parents in Weiden between 1898 and 1901, where he matured as an organist and, through his composing, paid homage to his role model, Bach, with an intense devotion to organ music. His focus was on both the artistic work of fantasies and fugues and the organ's liturgical function.

In 1901 Reger became a lecturer at the Munich Conservatory, in 1907 he was appointed professor and musical director at the University of Leipzig and in 1911 musical director of the renowned Meiningen Court Orchestra. He had married Elsa von

Bercken, a divorced Protestant, in 1902, which had led to l excommunication. The couple adopted two daughters. At t same time he continued with a frenzy of composition: chor preludes of varying degrees of difficulty, as well as chorale c tatas, choral arrangements, chamber and piano music. The *A geistlichen Gesänge* (*Eight spiritual songs*) Op. 138 (1914) are exc tional, with the famous compositions, 'Der Mensch lebt u bestehet nur eine kleine Zeit', 'Nachtlied' and 'Unser lieb Frauen Traum', in which the frenetic madman once more vealed a deep interiority. The expression of religiosity throu carefully structured composition shows a spiritual kinship tween Reger and Luther, making the Catholic composer t herald of the Lutheran musical tradition in the new centu Apart from the opulently grandiose *Psalm 100* Op. 60 (19c some planned large-scale choral symphonic works remained finished. Excesses of work and alcohol regularly brought M Reger to the brink. He died from a heart attack in a Leipzig tel on 11 May 1916 at the age of 43.

Klaus-Martin Bresgott

→ Further readi

Max Reger. Zum Orgelwerk, Heinz-Klaus Metzger a Rainer Riehn (eds.), Munich 2002.
Max Reger. Zwischen allen Stühlen. Zehn Annähe gen, Christiane Wiesenfeldt (ed.), Sinzig 2011.
Susanne Popp: *Max Reger. Werk statt Leben. Bio phie*, Leipzig 2015.

Max Reger, *Der evangelische Kirchenchor für gemischten Chor*, 1900, WoO VI/17

KAREN BLIXEN WRITER, DENMARK, 1885–1962

In the short story 'Babette's Feast', Danish citizen and Unitarian Karen Blixen paints a harsh picture of the Lutheran approach to food. For Martine and Philippa, daughters of the founding priest of a 'pious ecclesiastic' sect in the Norwegian town of Berlevaag, food must sustain the body, and the body must sustain the soul. The two sisters, for whom 'the true reality was the New Jerusalem', consider luxury to be sinful and set 'the example of a good Lutheran life'. Their staple fare is split cod and ale-and-bread-soup. For reasons of parsimony, but also generosity, their own food 'must be as plain as possible; it was the soup-pails and baskets for their poor that signified'.

When they take Babette, a French 'papist' who 'can cook', into their household, the sisters are forced to confront something they fundamentally disapprove of, namely the art of cooking and the pleasure of eating well and serving up good food to others. Babette soon prepares split cod and ale-and-bread-soup as well as 'anyone born and bred in Berlevaag'. Her soup-pails and baskets not only strengthen the poor and the sick but also 'mysteriously' relieve their suffering. And when the time comes to celebrate the long-departed priest's hundredth birthday, she insists on preparing a feast paid for with her own money. On this occasion, the small community learns what good food and drink means: Clos Vougeot 1846, Amontillado, Veuve Clicquot 1860 (imported from Paris, of course), turtle-soup, blinis Demidoff, *cailles en sarcophage*, grapes, peaches and fresh figs (in the middle of winter).

And despite being staunch Lutherans, the guests enjoy the 'nice dinner', as Martine puts it. The more they eat and drink, the more they grow 'lighter in weight and lighter of heart'. The champagne seems 'to lift them off the ground, into a higher, purer state'. One of the guests remembers a Parisian cook (later identified as Babette), who was able to transform a meal into 'a love affair of the noble and romantic category', in which 'one no longer distinguishes between bodily and spiritual appetite or satiety'. The guests (who are 12 in number, as luck would have it) realise that they are eating grapes from the valley of Eshcol and drinking wine from the wedding of Cana. They surrender to the 'divine grace' and see 'the universe as it really is. They have been given one hour of the millennium.'

Were these Lutherans persuaded? Did Babette's supper convert them from their rigid interiority? Philippa's final words are ambiguous: 'I feel, Babette, that this is not the end. In Paradise you will be the great artist that God meant you to be! [...] Ah, how you will enchant the angels!' Does she understand that God has given Babette the talent to enchant men and women? Will she continue to wait for paradise or can she now enjoy the life that God has given her? We know what Luther would have chosen. Olivier Bauer

→ Further reading

Pierre Bühler: Le Repas, parabole du Royaume? Lecture théologique du »Festin de Babette« de Karen Blixen, in: *Le Goût. Actes du troisième colloque transfrontalier de Dijon* [1996], Gilles Bertrand (ed.), Dijon 1998, 231–237.
Olivier Bauer: *Selbst ein Protestant kann zu Tisch Vergnügen haben* [2003], online: www.academia.edu/28276359/_selbst_ein_protestant_kann_zu_tisch_vergnügen (accessed on 28 November 2016).
The Aristocratic Universe of Karen Blixen. Destiny and the Denial of Fate, Frantz Leander Hansen and Gaye Kynoch (eds.), Brighton and Portland 2003.

In this world, anything is possible

Scenes from: Gabriel Axel, *Babette's Feast*, 1987

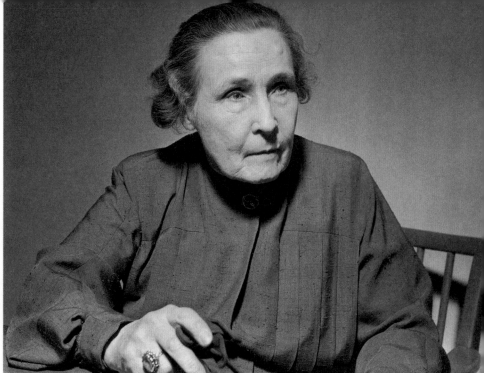

The problematic nature of what is often described as distinctively German, Luther-influenced interiority (*Innerlichkeit*) finds clear expression in Ina Seidel. She represents the religiously-secure conservative middle-class in Germany, which stood by helplessly in the face of the incipient cataclysm after 1933. Her timelessly steadfast spiritual values and emotional depth were accompanied by occasional signs of acquiescence to the new regime, culminating in the dedication of a poem to mark Hitler's 50th birthday. Nevertheless, after the Second World War, Ina Seidel was one of the few people to openly admit her mistakes.

Her extensive and complex work offers a multitude of perspectives. Victor Klemperer, the clear-thinking analyst of *The Language of the Third Reich*, alluded to this. In his diaries from before the end of the war he often mentions Seidel, describing her as an 'innerly pure writer, who imposed this requirement on herself, although some of her motifs, such as selfless sacrifice for the community, cannot entirely escape an ambivalent overshadowing'. Notably, however, Klemperer never tires of extolling her artistic qualities.

A case in point is the 1938 novel, *Lennacker*, which Klemperer read 'with ever increasing admiration'. It presents a panorama of the Protestant pastorate which is unique in German literature. Hansjakob Lennacker, a soldier who has returned, disoriented, from the front at the end of the First World War, experiences a series of fevered dreams between Christmas and the Feast of Epiphany. In his delirium he is confronted by representatives of 12 generations of his family, through whom the Gospel is proclaimed from the Peasants' War to the First World War. The episodes envisage each of his forebears in situations in which their Christian conscience is put to the test. With each

new depiction the author seeks to penetrate this essential co against a changing historical backdrop.

Government cultural bureaucrats took exception to the 'id logical' positions of this brilliantly narrated book. Some aspe of it directly contradicted the prevailing ideology. 'Blood', says at one point for example, 'Blood is only ever heathen!' T theme of *Lennacker* was further developed with a more fe nine slant focusing on mothers in the novel '*Das unverweslic Erbe*', which followed in 1954.

Born in 1885 in Halle, the daughter of a doctor, Ina Seidel w closely acquainted with the parsonage setting throughout h life. Her grandfather, Heinrich Alexander, her father-in-la Heinrich and her cousin Heinrich Wolfgang, whom she m ried at the age of 22, were all pastors and writers. When a wa ing impairment arising from her first pregnancy forced her find activities she could do sitting down, the young pasto wife began to write seriously. By the time the historical nov *Das Wunschkind* (*The Wish Child*) (1930), was published she w a favourite with the public and she remained popular for ov three decades. When she died in Ebenhausen near Munich 1974, however, little had been heard of her for some years.

Hans-Rüdiger Schwab

→ Further readi
Karl August Horst: *Ina Seidel. Wesen und Werk*, Stuttgart 19
Robert Minder: Das Bild des Pfarrhauses in der deutschen
eratur von Jean Paul bis Gottfried Benn [1959], in: idem: *K
tur und Literatur in Deutschland und Frankreich*, Frankfurt a
Main 1977, 46–75, in particular 62–66.
Ina Seidel. *Eine Literatin im Nationalsozialismus*, Anja He
(ed.), Berlin 2011.

Ina Seidel, *Lennacker.* First complete typescript with handwritten edits, before 1938

"Aber unsere Kirche - die protestantische Kirche..."
Lennacker fühlte fast mit Erstaunen, wie sehr es ihm darum zu tun
war, an dieser greifbaren Gegebenheit anzuknüpfen. Er sagte etwas
hilflos : "Sie müssen verstehen, es ist mir erst seit ich herkam
und durch meine Tante etwas über die Familie meines Vaters erfuhr,
klar geworden, dass meine Vorfahren seit Jahrhunderten der prote-
stantischen Kirche gedient haben. Auf einmal möchte ich nun
wissen, warum diese Kirche in der Gegenwart so schattenhaft und
machtlos geworden ist, dass sie für mich und meine Altersgenossen
nie mehr bedeutete, als eine der Kulissen, vor denen sich das
uneigentliche - das Vordergrundsleben menschlicher Übereinkünfte
abspielte. Sobald wir aufhörten, Kinder zu sein, zweifelten wir
nicht daran, dass es gälte, h i n t e r die Kulissen zu gelangen,
um mit der Wirklichkeit in Berührung zu kommen. Aber die ungeheure
Wirklichkeit der letzten Jahre hat mich nur einsehen lassen, dass,
wie manches andre, auch die Kirche keine Kulisse, sondern eine Er-
scheinungsform dieser Wirklichkeit ist - wennschon eine, wie mir
vorkam, nicht minder mechanisierte wie andre Gesellschaftsformen."
 "Die Neubelebung - die Wiedergeburt der Kirche," antwortete
Riemschneider mit eindringlichem Ernst, "ist ganz auf das Er-
griffenwerden ihrer einzelnen Glieder durch die Urmacht - also
durch Christus gestellt. Man pflegt von einem inneren Auge zu
sprechen - so muss es also wohl auch ein inneres Ohr geben. Die
Seele muss wieder hellhörig für den Anruf Jesu werden. Denn er ruft
jeden einzelnen an - mit d e m Wort, das nur dieses eine Herz
angeht. Wenn er zur Menge sprach, hat er nie um die Menge als sol-
che geworben : er rief in sie hinein, und das Wort, das einfältig
aus seinem Munde kam, teilte sich hundertfältig und traf jedes Herz,
wenn es ihm nur zugewandt war, eben an der Stelle, wo es zugänglich
war. M i c h meint er - mich? empfand jeder seiner Hörer und emp-

41

KAZOH KITAMORI THEOLOGIAN, JAPAN, 1916–1998

Kazoh Kitamori was a theologian, pastor, author and professor. He was born in Kumamoto, Japan in 1916. The young Kitamori was so inspired by a book on Martin Luther that he moved to Tokyo in 1935 to study at the Lutheran Theological Seminary. After graduation he continued his studies and went on to gain a doctorate in philosophy at Kyoto Imperial University. Kitamori was a professor at Tokyo Union Theological Seminary from 1949 to 1984. He published more than 40 books and had a major influence on Protestant theology in Japan. He wrote *Theology of the Pain of God*, his best-known book, in 1946 – in the immediate aftermath of the horrific events when atomic bombs were dropped on Hiroshima and Nagasaki. His ideas only became widely known in European theology after the English and German translations were published in 1965 and 1972 respectively.

When he developed his *Theology of the Pain of God*, Kitamori made reference to the Japanese-Buddhist context. His intention was to show that an ethic of pain could only become possible for Christians through the pain of God. He took as his point of departure for this the words of Jeremiah 31:20, 'Is Ephraim my dear son? Is he my darling child? For as often as I speak against him, I do remember him still. Therefore my heart yearns for him; I will surely have mercy on him, declares the Lord', which Kitamori felt were best expressed in Luther's German translation. For Kitamori, this tension between the wrath of God and the love of God was the defining characteristic of the pain of God: 'The "pain" of God reflects his will to love the object of his wrath.'

In Kitamori's theology, wrath and love are united at the cross. For humankind, the pain of God became a real historical fig-

ure in Jesus Christ. Kitamori spoke of Jesus as 'the personifi[cation] tion of the pain of God'. Both the wrath of God against sinne[rs] and His love for them culminate in the crucified Christ, so th[at] '[t]he god of the gospel causes his Son to die and suffers pain [in] that act.' However, through the cross, Christ has ensured f[or]giveness of sin for human beings. Accordingly, Kitamori wro[te] '[t]he pain of God is the forgiveness of sins.'

Kitamori understood that the Japanese Church had a spec[ial] responsibility to express the pain of God. Luther, who was [by] far the author most quoted by Kitamori, was for him the We[st]ern theologian who offered the strongest points of referen[ce] for this. In his opinion, this related not only to the interiori[ty] of the encounter with God that was central for Luther, but al[so] to Luther's 'ethic of pain', in which real love proves itself [in] sorrow and bitterness, and to his doctrine of the hidden G[od] who is manifest in wrath *and* love, in joy *and* pain.

An Paenhuysen

→ Further readin[g]
Kazoh Kitamori: *Theology of the Pain of God*, Richmo[nd] Virginia 1965.
Rudolf Weth: Über den Schmerz Gottes. Zur Theolo[gie] des Schmerzes Gottes von Kazoh Kitamori, in: *Evan[ge]lische Theologie 33* (1973), 431–436.
Akio Hashimoto: Legacy of Kitamori in Contempora[ry] Japanese Christian Thought, in: *Missio Apostolica X* (2004), 11–16.

Luther says that love proves itself not so much in sweetness and delight, but in very great sorrow and bitterness.

Kazoh Kitamori, *Theology of the Pain of God*, 1965

'THE LANGUAGES ARE THE SHEATH IN WHICH THIS SWORD OF THE SPIRIT IS CONTAINED.'

WA 15, 38; LW 45, 359

In 1521, during his stay at the Wartburg, Luther translated the New Testament from the original Greek into German in just 11 weeks. The first German version of the entire Bible followed in 1534, the result of collaboration with several of his colleagues in Wittenberg. To this day, Luther's vivid, down-to-earth language is considered groundbreaking in terms of its influence on education and literature, poetry and philosophy. His linguistic ability may inspire us, or we may dislike it and find his translation of the Bible ideologically biased. Luther's linguistic inspiration had an impact far beyond the German language and even beyond literature. Indeed, by emphasising the word and freeing the image from its religious connotations, might he have precipitated the emergence of modern art?

WRANGLING OVER PARADISE: THE AWKWARD REALITY OF SALVATION IN LANGUAGE

ALF CHRISTOPHERSEN

For Martin Luther, Satan's battle with the Word of God was a reality. It was a battle fought with force and false doctrine, cunning and perversion. As he wrote in 1524 in his *Letter to the Princes of Saxony concerning the rebellious spirit*, in order for the Word of God to be recognised for what it is 'things must go on as they always have' (WA 15, 210; LW 40, 49). Satan could also see the surging force of the raging princes. But God's adversary must admit that dissent is ultimately doomed to failure. 'In fact, he beholds and finds that (as is the nature of the Word of God) the more it is suppressed, the farther it spreads and grows' (WA 15, 211; LW 40, 50). Ac-

cording to Luther, sects and false spirits can do nothing to change the situation. Instead, they represent an acid test from which it is possible to emerge with greater strength. The power of the Divine Word prevails. Luther adopts a relatively confident and aggressive attitude towards authority: 'Let the spirits collide and fight it out. If meanwhile some are led astray, all right, such is war. Where there is battle and bloodshed, some must fall and some are wounded. Whoever fights honorably will be crowned.' (WA 15, 219; LW 40. 57).

During the late Middle Ages and at the time of the Reformation, the disputation was a tried-and-tested method of managing conflict arising from differences of opinion. Debates about controversial theological issues were conducted according to established rules in front of an audience. Thesis and antithesis collided with one another and ran the gauntlet of the assembled academic and religious public. The Heidelberg Disputation (1518) and Leipzig Disputation (1519), which addressed the core elements of Luther's reformatory insights, are legendary. The issues debated at them included, for example, the absolute supremacy of God's grace compared to any human work, justification by faith alone, (lack of) free will, the authority of the papal office and the status of indulgences. The result of both disputations was unequivocal: a shared path with Rome had assumed the character of an illusion. The basic meaning of 'dialectic' as the art of conducting incisive conversation – precisely what took place and was demonstrated at the disputations – showed that the power of language had once again given rise to new historical realities. The invention of printing also opened up new opportunities to respond to such events on a hitherto unknown scale.

Martin Heidegger also explored the intricate relationship between history and language, not least in reference to Luther. In his reflections on *Phenomenology and theology* (1970), he stresses: 'For the phenomenon most worthy of thought and questioning remains the mystery of language wherein our entire reflection has to gather itself – above all when it dawns on us that language is not a work of human beings: language speaks. Humans speak only insofar as they co-respond to language.' Heidegger postulated language as an *Urphänomen* (primal phenomenon), which is not amenable to factual proof, but can only be glimpsed 'in an unprejudiced experience of language'. However, this idiosyncratic access does not in any way lead to capitulation, as the human ability for critical thinking elicits constant questions: where, for example, is proof needed and where is 'a catching sight of and taking in' needed? Theology must clarify on the basis of the nature of the Christian faith how and what it intends to think and speak. In doing so, it must understand that thinking and speaking must not necessarily be objectifying. Instead, the instrumentalisation of language must be opposed, when the manipulation and control that reduce the complexity of worldly

phenomena become apparent. The corresponding limits of scientific, philosophical and theological language must be observed at this point. This is precisely where Marburg theologian Rudolf Bultmann comes in. Entirely familiar with Heidegger's rationale and experiments from decades of discourse with the philosopher, he wrote to him on 8 December 1970 that 'the utterance about a historical event "always" contains an utterance about its past or imminent future. – Thus, while one can understand Luther's posting of his Theses causally, for example, based on the historical conditions in which he grew up, its historical meaning can only be understood in the future that he sets in motion.' (*Rudolf Bultmann – Martin Heidegger. Briefwechsel 1925–1975*, 2009). Hence, through linguistic understanding, Bultmann transfers a historical fact into the sphere of historical significance, whereby both the effect and contemporary relevance are invoked. The question no longer concerns what actually was in the past, but the existential meaning for me, today, of that which once was. With regard to the posting of the 95 Theses in 1517, the decisive point is not that Luther personally posted his deliberations to the door of the Castle Church in Wittenberg as a proposal for a special kind of disputation, but that they went out into the world at all, in any kind of form, and created the basis for epoch-making change. At the same time, the Theses are transferred to the Kerygma, they become a proclamatory message. Thus, as Bultmann himself said of the historical Jesus, the crucial aspect is the 'That of his proclamation' – not the Jesus that is portrayed in the Gospel but the Jesus of the new interpretation of this message of redemption and how it is handled. According to Bultmann, thinking and speaking that does not objectify, asks 'about the internal logic of the event' and then asks 'what it says about the decision of the existential human being, thus in the case of the Lutheran Theses what it says about the question of justification by works or by grace'. This calls for a consistent interpretive effort, which the individual must make and which is subject to the conditions of various historical contexts. In addressing Luther's understanding of faith and the Word, Heidegger contends that: 'if considered in abstraction from the hearing person, the texts are pointless'. On 3 and 4 March 1961, he had attended a seminar given in Zurich by Gerhard Ebeling, one of the most influential and well-informed Luther researchers of the twentieth century. The discussion focused on Luther's 1536 *Disputatio de homine* ('Disputation concerning man') in particular, and man's competence as a being endowed with logic and language was under debate. Heidegger stressed that the Word of God and faith must be understood in their dialectical interaction. He believed that Luther had understood the limits of logic as he contrasted them with 'the Word of the proclamation in the experience of conscience'. The Gospel can only unfold its liberating effect through an encounter with the conscience. The struggle here is with language; the role of theology must be to define key

concepts in such a way that the individual really feels that their innermost being has been touched.

Language only works if there is someone else who can and will communicate. Luther therefore emphasises with unparalleled conciseness that it is the 'nature of the Word to be heard' *(Natura enim verbi est audiri)* (WA 4, 9). In his first lecture on the psalms, he commented on Psalm 85:8 in which the supplicant calls: 'Let me hear what God the Lord will speak, for he will speak peace to his people, to his saints; but let them not turn back to folly.' The ability of human beings to really understand God's Word depends on their linguistic ability. Luther's translation made the Bible texts accessible to broad swathes of the population. Everyone could now read these texts for themselves and examine what was written there. In human language, Luther identified man's special gift that distinguishes him from all other living creatures. He believed that the spirit of God, which is activated by faith, was bound to the proclamation of the Gospel in the sermon. The choice of language and the transparency of the words are thus critical factors in recognising the Biblical message as the Word of God. This is an ambitious task for the linguistic worlds of Christianity, but it must surely be possible to continuously update texts from many centuries ago. Otherwise they are liable to lose their innovativeness and ability to guide. This applies not only to the Biblical tradition but also to the Protestant Confessions, which include Luther's *Small Catechism* and *Large Catechism*. Terms like 'original sin', 'atonement' and 'reconciliation', for example, indicate how difficult it is to explain and showcase fundamental theological key messages so that they are not only accessible to an ever-declining circle of socialised churchgoers. How can they be interpreted and described in a way that a new understanding of being is really opened up to the modern person and is not simply dismissed or met with a lack of understanding?

Protestantism depends on its diversity, its centuries-old, tried-and-tested culture of conflict and its ability to communicate – a strength and a weakness at once. On the one hand, tradition is repeatedly under scrutiny: respected viewpoints that are believed to be certain and permanently valid are modified. On the other hand, reliable structures and institutions and convincing concepts are justifiably enforced when opinions differ. Social interaction is required. And this too reflects the creative Word of God, which precedes everything. As a result, it has been distinguished from all human speech since the beginning of the world, as it creates something directly from within itself. God speaks and it will. The Creator makes the world from His Word, which corresponds to His will. He then bears and holds it continuously in His Word.

But God also exists on the other side of the revelation in the Word. In *The bondage of the will (De servo arbitrio)* of 1525, his legendary argument with Erasmus of Rotterdam, one of the leading Humanists of the time, Luther

was adamant that God's will was beyond human judgement. To speak about the revealed, preached God was different to speaking about the unrevealed and preached God. 'To the extent, therefore, that God hides himself and wills to be unknown to us, it is no business of ours.' The superior majesty of God must be respected. 'But we have something to do with him insofar as he is clothed and set forth in his Word.' (WA 18, 685; LW 33, 139). What remains therefore is trust in the Word of the 'revealed God' (*deus revelatus*), in the sacred message, which is righteously spoken to the sinners before God; after all, according to Luther: *'Ubi verbum, ibi paradisus et omnia'* (Where the Word is, is Paradise and everything) (WA 43, 673). But realistically, the hereafter may not be that simple either, even here the discussion focuses on how it must look in detail and becomes the starting point for wrangling over Paradise.

FELICITAS VON SELMENITZ
REFORMER,
GERMANY, 1488–1558
[NOT ILLUSTRATED]

Felicitas von Münch was born in Dornburg in 1488. At the age of 19, she married Wolf von Selmenitz, the Elector of Saxony's castellan in Allstedt, and some years later the family moved to Halle and then to Glaucha. Before the violent death of her husband in a family feud in 1519, she gave birth to seven children, of whom only Georg, her second son, survived.

Three years later, at Christmas mass in St George's Church in Glaucha, she received the Eucharist in both kinds (bread and wine), thereby publicly showing her commitment to Luther's teachings. This marked the beginning of a gruelling period for the widowed Felicitas in the territory ruled by Cardinal Albrecht of Brandenburg. Not only did she have to fight for control of the family estate, she also had to contend with constant hostility from Albrecht, who considered her 'impious' attitude to Christianity to be dangerous.

Felicitas wrote a personal letter to Martin Luther describing the turbulent, highly charged situation in Halle, where the cardinal had arrested and banished considerable numbers of citizens who followed Luther's teachings. In his reply of 1 April 1528 (WA BR 4, Nr. 1248, 437–438), Luther advised Felicitas to remain as his representative in Halle, but the letter arrived too late. Felicitas and her son had already left Halle and set out for Wittenberg, where Georg had begun to study law in 1527 and Felicitas came into direct contact with the leading reformers. She continued and extended her intensive personal study of the Bible. Her numerous handwritten marginal annotations testify to the extent of her engagement with the Bible and the writings of the Reformation. The Selmenitz family library contains books with handwritten dedications from Martin Luther, Caspar Cruciger, Justus Jonas and Johannes Bugenhagen to the 'honourable, virtuous woman and dear friend Felicitas von Selmenitz'.

Felicitas studied the first complete translation of the Bible, published in 1534, in meticulous detail – her copy contains Luther's personal handwritten dedication and visible traces of her close reading. The small red hearts and angel figures she inserted be witness to both her engagement with the text and the conso tion and hope that Luther's language provided for the w owed Felicitas in her difficult situation.

An outbreak of plague in 1535 forced her to leave Wittenberg ar after several extended sojourns along the route, she eventual made her way back to Halle. In September 1547, six years aft Cardinal Albrecht's departure from the town, the Reformatic was finally established in Halle. Felicitas died in 1558 at the a of 70, and was buried in the Stadtgottesacker cemetery in H le by her son Georg, who also erected a magnificent memori to honour her and their family.

The valuable private library accumulated by Felicitas and Geo includes a unique collection of volumes with inscriptions fro contemporary reformers and traces of their owners' person reading. In 1580, it was the first donation to be preserved in t holdings of the historic Marienbibliothek Protestant library Halle and documents the highly significant role Luther's tra lation of the Bible played in the spread of the Reformation.

Franziska Kuschel

→ Further readir

450 Jahre Marienbibliothek zu Halle an der Saale. Kostbarkeiten und P ritäten einer alten Büchersammlung, Heinrich L. Nickel (ed.), Ha 2002, 225, No. 46.
Die Bibliothek der Felicitas von Selmenitz und ihres Sohnes Georg v Selmenitz. Eine Büchersammlung aus der Reformationszeit in der Ma enbibliothek zu Halle an der Saale, Freundeskreis der Marienbibliothe zu Halle e. V. (ed.), Halle 2014.
Franziska Kuschel: "Starke Frauen" der Reformation. Ausgewäh Biogramme, in: Eine starke Frauengeschichte. 500 Jahre Reformatio Simona Schellenberger (ed.), companion volume to the exhibiti of the same name, Beucha 2014, 29–35.

Der Apostel

welchen er ausleget vnd bezeuget das Reich Gottes / vnd prediget
jnen von Jhesu / aus dem Gesetz Mosi / vnd aus den Propheten / von
frue morgen an bis an den abend / Vnd etliche fielen zu / dem das er
saget / etliche aber gleubten nicht.

Da sie aber vnternander mishellig waren / giengen sie weg / als
Paulus ein wort redet. Das wol der Heilige Geist gesaget hat durch
den Propheten Jsaiam zu vnsern Vetern / vnd gesprochen / Gehe hin
zu diesem volck / vnd sprich / Mit den ohren werdet jrs hören / vnd
nicht verstehen / vnd mit augen werdet jrs sehen / vnd nicht erkennen /
Denn das hertz dieses volcks ist verstockt / vnd sie hören schwerlich
mit ohren / vnd schlummern mit jren augen / auff das sie nicht der mal
eins sehen mit den augen / vnd hören mit den oren / vnd verstendig
werden im hertzen / vnd sich bekeren / das ich jnen hülffe. So sey es
euch kund gethan / das den Heiden gesand ist dis Heil Gottes / vnd
sie werdens hören. Vnd da er solchs redet / giengen die Jüden hin /
vnd hatten viel fragens vnter jnen selbs.

Paulus aber bleib zwey jar jnn seinem eigen gedinge / vnd nam
auff alle die zu jm einkamen / prediget das Reich Gottes /
vnd lerete von dem Herrn Jhesu / mit aller
freidigkeit / vnverboten.

Vorrede

Ende der Apostel Ge-
schichte.

Vorrede auff die Epistel XCIX
Sanct Pauli zu den Römern.

Jese Epistel ist das rechte
heubtstücke des newen Testaments /
vnd das aller lauterste Euangelion /
welche wol wirdig vnd werd ist / das
sie ein Christen mensch nicht allein
von wort zu wort auswendig wisse /
sondern teglich damit vmbgehe / als
mit teglichem brod der seelen / Denn
sie nimer kan zu viel vnd zu wol gelesen
odder betrachtet werden / vnd je mehr
sie gehandelt wird / jhe köstlicher sie
wird / vnd bas schmecket. Darumb ich
auch meinen dienst dazu thun wil / vnd durch diese Vorrede einen ein
gang dazu bereiten / so viel mir Gott verlihen hat / damit sie deste bas
von jdermanverstanden werde / Denn sie bisher mit glosen vnd man
cherley geschwetz vbel verfinstert ist / die doch an jr selbs ein helles
liecht ist / fast gnugsam / die gantze Schrifft zu erleuchten.

Auffs erste / müssen wir der sprache kündig werden / vnd wissen /
was Sanct Paulus meinet / durch diese wort / Gesetz / Sünde / Gna-
de / Glaube / Gerechtigkeit / Fleisch / Geist / vnd der gleichen / sonst ist
kein lesen nütz daran. Das wörtlin / Gesetz / mustu hie nicht verstehen
menschlicher weise / das eine lere sey / was für werck zu thun odder zu
lassen sind / wie es mit menschen gesetzen zugehet / da man dem gesetz
mit wercken gnug thut / obs hertz schon nicht da ist / Gott richtet
nach des hertzen grund / darumb foddert auch sein Gesetz des hertzen
grund / vnd lesset jm an wercken nicht benügen / sondern straffet viel
mehr die werck on hertzen grund gethan / als heuchley vnd lügen /
daher alle menschen lügner heissen / Psalm. cvij. darumb / das keiner
aus hertzen grund Gottes Gesetz helt noch halten kan / denn jeder-
man findet bey sich selbs vnlust / zum guten vnd lust zum bösen. Wo
nu nicht ist freie lust zum guten / da ist des hertzen grund nicht am
Gesetz Gottes / da ist denn gewislich auch sünde vnd zorn verdie-
net bey Gott / ob gleich auswendig viel guter werck vnd ehrbars le-
ben scheinen.

Daher schleusst Sanct Paulus am andern Capitel / das die Jü-
den alle sünder sind / vnd spricht / das alleine die theter des Gesetzes
gerecht sind bey Gott / Wil damit / das niemand mit wercken des Ge-
setzes theter ist / sondern sagt viel mehr zu jnen also / Du lerest / man
solle nicht ehebrechen / vnd du brichest die ehe. Jtem / worinnen du
einen andern richtest / darinnen verdammestu dich selbs / weil du eben
das selbige thust / das du richtest / Als solt er sagen / Du lebest eusser-
lich fein jnn des Gesetzes wercken / vnd richtest / die nicht also leben /
vnd weissest jderman zu leren / Den splitter sihestu jnn der andern au-
ge / aber den balcken jnn deinem auge wirstu nicht gewar / Denn ob
du wol auswendig das Gesetz mit wercken heltest / aus furcht der
straffe / odder liebe des lohns / so thustu doch alles / on freie lust vnd
liebe zum Gesetz / sondern mit vnlust vnd zwang / woltest lieber an-
ders thun.

JOHANN GOTTFRIED HERDER
WRITER AND THEOLOGIAN, GERMANY, 1744–1803

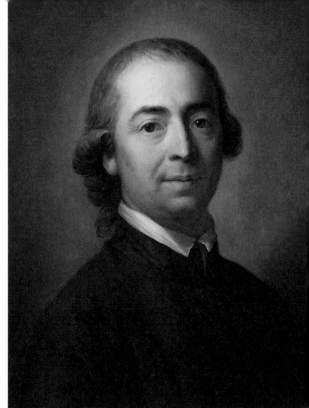

Johann Gottfried Herder, born in 1744 in the small East Prussian town of Mohrungen, first worked as a preacher in Riga, before moving on to Bückeburg after lengthy travels. He settled finally in Weimar in 1776, where he fulfilled the duties of Pastor and General Superintendant until his death in 1803. He moved to Weimar on the suggestion of Johann Wolfgang von Goethe, whom he had first met in Strasburg. As a literary theorist and philosopher of history and language, Herder exerted untold influence during the Romantic era and until the height of Historicism – far beyond the circles of his readers and admirers. Although he had a wide knowledge of Luther's writings, he only ever referred to him as an example or as a foil for his own ideas and insights.

Like his more enlightened contemporaries, Herder believed that humankind was still on the path to its own truth. However, Herder did not see that path as a straight line in a teleology construed on the present. On the contrary, he was of the opinion that the all-embracing, divine process of education and the human process of learning takes places in a wide variety of places in very different, albeit interconnected and intertwined sequences of events, each of which has its own entirely individual, incalculable meaning that can only be uncovered through patient engagement with its particular linguistic realms and ideas. In Herder's thinking, each new cultural evolution begins with catastrophic upheavals and new departures, in which creative individuals – that is to say, reformers – lay foundations that are themselves capable and in need of continuing development. Among these, pride of place is occupied by language and religion. And by this point at the latest, it is clear that Herder primarily modelled his historical and philosophical ideal of a reformer on his own, intuitive image of Luther.

By the sheer strength of his genius and personality, Luther had ensured that certain impulses for reform and the reforming aims of Christians in the late Middle Ages had in effect change the course of history. Through his publications and above by translating the Bible, he prepared the way for the pure, si ple religion of Jesus Christ to emerge gradually from the ce turies-old sediment of the bedrock of the Christian religic And he was only able to achieve all of this because, in a through all he did, he imbued the German language with a n cultural viability and capacity for reflection. Wherever Luth connected with people, he created new readers, and ever aft that – as Herder pointedly commented – every German auth had 'to write in an Evangelical, Protestant, Lutheran manne Herder wanted to pay due homage to Luther as a thinker wh had operated within the constraints of his own time. Howe er, he was hindered by the glib acceptance of Reformation sights or dictums as the norm or legitimising authority for t present day, because that in fact reduced accounts of a dram ic epoch in history (which is only comprehensible in its ow original context) to no more than 'fripperies for all times'.

Martin Ohst

→ Further readi

J. G. Herder: Herder on Social and Political Culture (Cambric Studies in the History and Theory of Politics), F. M. Barna (ed.), Cambridge 2010.

Heinrich Bornkamm: *Luther im Spiegel der deutschen Geiste schichte*, Göttingen ²1970.

Martin Ohst: Herder und Luther, in: *Luther. Zwischen den ten*, Christoph Markschies and Michael Trowitzsch (eds.), bingen 1999, 119–137.

It was Luther who awakened and
freed the slumbering giant of the
German language

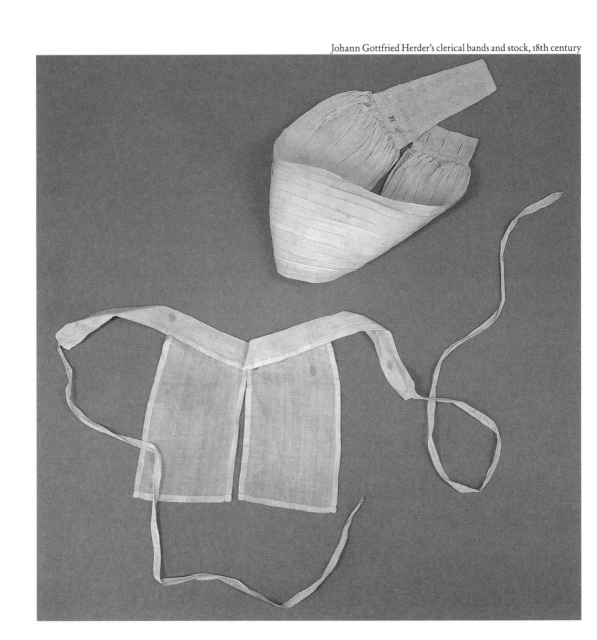

Johann Gottfried Herder's clerical bands and stock, 18th century

MARTIN BUBER

PHILOSOPHER OF RELIGION,
AUSTRIA, ISRAEL,
1878–1965

Martin Buber is regarded today as the most important thinker of German-speaking Jewry. He was born in Vienna in 1878 and grew up with his grandparents in Lemberg (now Lviv, Ukraine). Salomon Buber, his grandfather, was a prominent Orthodox figure of the Jewish Enlightenment. Thus Martin Buber had a thorough knowledge of the original Hebrew text of the Bible and it was not until he began to read Jewish translations that he became conscious of his irritation with many biblical narratives. However, when he got to know Luther's German Bible, 'the charm of the language reined in [his] anger'.

After his early engagement with cultural Zionism, which led to the establishment of the Jüdische Verlag publishing house in Berlin and the Hebrew University in Jerusalem, Buber turned his attention to research into Hasidism: *The Tales of Rabbi Nachman* (1906), his first published book, made the literature of this Eastern European Jewish culture widely known. In 1916 he began to develop his philosophy of dialogue (*I and Thou*, 1923), based on which he – like Luther – concentrated primarily on speech and forms of address in the translation of the Bible he embarked on in 1925: 'We wish to break through to the spokenness of the Word, to its having been spoken.' Buber initially collaborated on this with his young friend Franz Rosenzweig, who was already seriously ill and died prematurely in 1929. Rosenzweig was particularly insistent that they begin by attempting to revise Luther's translation. However, differences rapidly became clear – Luther had almost exclusively followed the Latin text and only referred in passing to the Hebrew text. There were also discrepancies in content: Buber considered that, for Luther, 'the actual statement had been subjugated to the dogma

of "logos", "the speech of God", and the primary purpose translation is to render that which impelled it, that is, Chri perceptible. We, however, felt compelled to liberate the actu spoken, speakable statement (...) enslaved in writing, so th its voice could again be heard; let it say whatever it has to s the world will listen.' Buber and Rosenzweig strove to transf the form and meaning of the original Hebrew text, and th ideas from the rabbinical tradition of interpretation, into t German language, to which end they were ready to 'go to t limits of the German language – without overstepping them After the National Socialists seized power in 1933, Buber playe a major part in preserving the core content of German-Jewis culture in the Schocken bookshop and publishing house. I continued to teach in the Jewish adult education centre in Fra furt until he had to emigrate to Palestine in 1938, where he l came actively involved in politics and advocated peaceful c existence between Palestinians and Jews. After the Secon World War, Buber was one of the first to advocate rapproch ment with post-war Germans and became the foremost figu in the dialogue between Jews and Christians. Martin Bub died in Jerusalem in 1965. Andreas Losch and Bernd Witte

→ Further readin

Maurice Friedman: *Begegnung auf dem schmalen Gr Martin Buber – ein Leben*, Münster 1999.
Martin Buber: *Schriften zur Bibelübersetzung* (Mart Buber Werkausgabe [MBW], Bd. 14), Ran HaCoh (ed.), Gütersloh 2012.
Karl-Josef Kuschel: *Martin Buber. Seine Herausfor rung an das Christentum*, Gütersloh 2015.

Luther's translation of the Bible may be beautiful, but it is not true.

Martin Buber, *Warum und wie wir die Schrift übersetzen*, c.1938

neue Ehrfurcht vor dem Wort bezeigt", eine Ehrfurcht, die notwendig auch unser Lesen, unser Verstehen, und also unser "Übersetzen" erneuert hat.

Das war es: dort, bei Luther, ist das wirkliche, das gesprochene Wort unter die Herrschaft des Dogmas vom "Worte Gottes", dem Logos, getan, und es kommt im Übersetzen nur darauf an, alles wahrnehmbar zu machen, was angeblich Ihn, den Christus, "treibt"; wir aber wussten uns in keine andre Pflicht genommen als das wirkliche, gesprochene und sprechbare Wort, das in der Schrift gefangen liegt, zu befreien und wieder in die Welt zu ~~tönen~~ treten zu lassen; sage es was es sagen mag, die Welt ~~soll es~~ ihrer Stunde solls hören.

4.

"Dolmetschen", sagt Luther in einer seiner Tischreden, "soll nicht allein sein, denn einem einzigen fällt nicht allzeit gut und eigentlich Wort zu." Er hat daher mehrere befragt, Christen ~~und~~ auch Juden. Aber mehrere sind zuweilen weniger als einer. Unsre Arbeit konnte nur von zweien geleistet werden, und zwar von zweien, von denen einer schrieb und einer las, und dieser zweite, der Leser ~~und~~ Prüfer und Ändrer, musste die Eigenschaften haben, die Rosenzweig in dieser letzten Phase seines Lebens hatte: den Wagemut ~~des Menschen~~, der bis zu den Grenzen seiner Sprache vorgestossen war, ~~und~~ die Hingebungsfähigkeit des Gläubigen, der bis zum Eingehn in die geglaubte Einheit nichts mehr wollte als dem, woran er glaubte, mit den letzten Kräften zu dienen, und die unendliche Geduld des aktiven Märtyrers. Durch diese Eigenschaften ist das Unmögliche möglich geworden: er, der den Kopf nicht mehr frei tragen, nicht mehr ~~~~ drehen konnte, las mit einer unerhörten Kraft und Ausdauer die ~~~~ Entwürfe, Reinschriften, Korrekturen, die ich ihm sandte; er, dessen ~~~~ Mund ~~~~ mit Stummheit geschlagen war, dessen Arm in einer Schlinge lag, dessen Hände sich nicht rührten, dessen Finger sich kaum noch zu bewegen ~~konnten~~ vermochten, füllte – mit Hilfe seiner Frau, die ihm gleichsam zu einem zweiten, aktionsfähigen Körper geworden war – Bogen um Bogen mit seinen Bemerkungen: Beanstandungen, Hinweise, Änderungsvorschläge; oft ging um ein

MARCEL DUCHAMP

ARTIST,
FRANCE, 1887–1968

Marcel Duchamp, the epitome of an avant-garde strategist, *the* artist of the twentieth century, was born on 28 July 1887 in the French rural district of Blainville-Crevon. His artistic engagement with Cubism subsequently led him into the speculative realm of ideas that could survive entirely without their hitherto customary material expression as paintings or sculptures: he started to cast off the shackles of 'the entire, "psycho-plastic" past'.

Having begun to deliberate along these lines in 1912, Duchamp produced a work that – besides still being one of the most puzzling phenomena in the history of art – paved the way for 'ideas art' and its later derivations. This new work, which he repeatedly returned to between 1915 and 1923 but never completed, was *The Bride Stripped Bare by Her Bachelors, Even (The Large Glass)*. The title draws attention not only to the unsettling role of language, but also to the meanings of words *per se*. This poetic use of language deliberately reinforces the barrier to meaning that has already been created by the hermeticism of the composition. Language shoulders the task of derailing or at least decelerating instant interpretation. By definition that deceleration or delay generates a productive scepticism regarding the truth that is supposedly concealed within the work: 'The notion of true and not true is complete nonsense.' In so saying Duchamp is at one with Luther's 'desacralisation' of the image, which, for the first time, granted the viewer the right to the interpretation of his or her choice. Duchamp challenged the art of his time with something that was intended to go beyond the 'retina'. On his visits to major European museums in 1912 he had seen enough to convince him that up until the early nineteenth century, art had solely 'served the intellect' and that it had always been about thinking. 'Fra Angelico did not consider himself an artist, he wasn't making art', commented Duchamp, he was a craftsman 'working for the good Lord'.

In his works Duchamp revealed a mode of artistic thought th the poet Novalis describes as an 'internal enciphering forc which intrinsically connects with words. The prerequisite f that had been Luther's unburdening of the image; this ul mately led to a new concept of art, which Duchamp availe himself of more radically than anyone else. It has rightly bee suggested that artistic modernity started with Luther's word 'images are neither one thing nor the other, neither good n wicked. One may have them or not' (WA 10 III, 35).

The industrial products presented as 'readymades' – such Duchamp's *Bottle Rack* (1914) – in what now seems, with hir sight, to have been a sensational innovation, originally serve Duchamp merely as objects casting shadows that transporte his thoughts into the fourth dimension: 'in a certain sense the instigated an openness to things other than the materials of d ly life'. It has been said that Duchamp never intended to crea a caesura in the development of European art. On the contra he was merely building on the Renaissance concept of art as *sa mentale* (Leonardo da Vinci) – as the province of the mind that underpinned Luther's separation of image and dogma.

Eugen Blume

→ Further readin
Robert Lebel: *Sur Marcel Duchamp*, Paris and London 19
(English translation: *Marcel Duchamp*. New York 1959).
Luther und die Folgen für die Kunst, Werner Hofmann (ed.),
talogue to the exhibition of the same name, Munich 1983.
Dieter Daniels: *Duchamp und die anderen. Der Modellfall ei
künstlerischen Wirkungsgeschichte in der Moderne*, Cologne 19

This antisense interested me a lot on the
poetic level, from the point of view of the
sentence.

Marcel Duchamp, *Rotoreliefs*, 1935

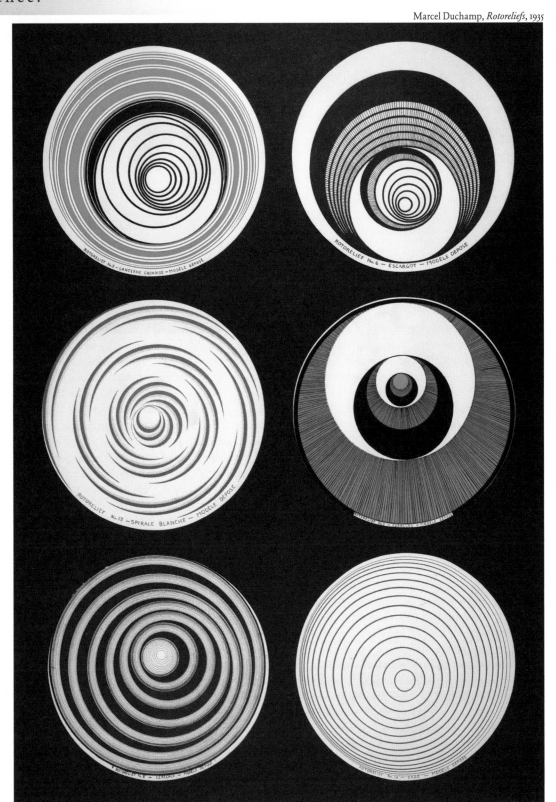

NELLY SACHS
WRITER,
GERMANY, SWEDEN,
1891–1970

Nelly Sachs was born in Berlin in 1891. She wrote her first poetry in an impressionist style when she was just 17 years old. During the 1920s her poems were published in several periodicals. She responded to the growing power of National Socialism in the 1930s by engaging with themes focusing on her Jewish roots, Hasidism and the Kabbalah in her writing. With the aid of Swedish author Selma Lagerlöf, she and her mother escaped into exile in Sweden in 1940, and she became a Swedish citizen in 1952. Nelly Sachs was awarded the Nobel Prize for Literature in 1966 for her 'outstanding lyrical and dramatic writing, which interprets Israel's destiny with touching strength.' Apart from some time spent as a patient in sanatoriums and psychiatric hospitals, Nelly Sachs continued to live in Stockholm until her death in 1970.

A life lived under constant threat, followed by exile in Sweden, precipitated a stylistic and linguistic caesurea in her writing and her language underwent a fundamental transformation. She no longer wrote lyrics in the late romantic style: her elegiac tone became more matter-of-fact. The catastrophe of the Shoah demanded a completely new form of language, a language for what she called *Durchschmerzung*, enduring the all-pervasive pain of existence. Formulating this process succinctly, she stated 'my metaphors are my wounds'. She transformed the words of grief and remembrance into poetic testimony for the living and the dead. *In the Habitations of Death* (1947), her first collection of poems written in exile, was dedicated to her 'dead brothers and sisters'. Nelly Sachs's lyrics of 'flight and metamorphosis' are poetic works that move in a cosmic dimension between the present and the past, the living and the dead.

Nelly Sachs owned an edition of Martin Luther's German translation of the Bible. In her *Elegies on Traces in the Sand* cycle, written in 1943, she references passages she had underlined in her copy: 'He made my mouth like a sharp sword; in the shado of his hand he hid me; he made me a polished arrow; in h quiver he hid me away.' (Isa. 49:2) Thus she made a direct co nection between Martin Luther and her interest in creating new form of existence through language. Luther was inspire by the idea of transforming Holy Scripture through translatio into a Bible for all people. It was important for him to find a la guage whose words and imagery would evoke associations wit the daily realities of his contemporaries: accordingly, he cho an accessible, colloquial German not intended for silent stud but to be read aloud.

For Nelly Sachs, language was an essential of life, vital for h survival in exile. However, she did not regard this as a reso tion. In her poem *Chorus of the Wanderers* she counts herse among the many forced to carry their fate as exiles with the as a burden into their new countries. 'We wanderers / drag wi us as baggage the ways we have come – / We are clothed in ra from the lands where we rested – / We feed from the cauldro of a language learned through tears ...' An Paenhuysen

→ Further readir

Nelly Sachs: *Gedichte 1940–1950*, Matthias Weichelt (ed.); *Gedic. 1951–1970*, Ariane Huml and Matthias Weichelt (eds.), Frankft am Main 2010 (In English translation: *The seeker, and other poer* New York 1970).
Flucht und Verwandlung. Nelly Sachs, Schriftstellerin, Berlin/Stockho Eine Bildbiographie, Aris Fioretos (ed.), Berlin 2010.
Chiara Conterno: Nelly Sachs. Stimmen, Chöre und Psalmen, *Die andere Tradition. Psalm-Gedichte im 20. Jahrhundert*, Chiara C terno (ed.), Vienna 2014, 136–160.

We feed from the cauldron of a
language learned through tears

Typewriter from the estate of Nelly Sachs, before 1970

WON YONG JI THEOLOGIAN, SOUTH KOREA, 1924–2012

Lutheranism is a relatively new phenomenon in South Korea. Although Catholic missionaries arrived as early as the eighteenth century and various Reformed Church communities actively engaged in missionary work in the nineteenth century, the first Lutheran communities were not established there until the twentieth century. The driving force behind this was the conservative Lutheran Church – Missouri Synod. However, the majority of Korean Protestants – the second largest denominational group after Buddhism in South Korea – are members of Reformed and Pentecostalist churches. Since the 1970s and 1980s in particular, South Korea has experienced a huge influx of Protestant missionaries, and Evangelical Christianity there is now known for its mega-churches – with some even listed in the Guinness World Records for the tens, even hundreds of thousands in their congregations.

By comparison the number of Lutherans is rather more modest; currently there are around 5,000 registered members of the Lutheran Church in South Korea. The foundations for Lutheranism in South Korea were laid in 1958 by four missionaries. Only one of them was Korean by birth: Won Yong Ji. From the outset he actively contributed to the development of a Korean Lutheranism as a pastor in a Lutheran community and as joint-organiser of Lutheran newspapers and radio broadcasts. He attached particular importance to setting up Lutheran theological training in South Korea and he regarded the translation of the Luther's message into his own mother tongue as the key to developing Lutheran Christianity in his own country. Luther himself realised that a German translation of the Bible was the only way to bring the Word of God to his own people in a way

that they understood, and Ji felt that the translation of Luther works into Korean was similarly essential. He published twelve volumes, having translated most of the six thousand texts himself. He also found a way to mark Reformation Day in South Korea: each October he presented a Luther Lecture at the Luther Study Institute he founded at the Luther University. Few could match Ji's devotion to Luther.

However, unlike many other devotees of Luther in the last five hundred years, his interest was not in the man but in his message, above all its theological meaning as a clarion call to missionary activity. At the same time, he combined his own missionary aims with his desire to mediate between Eastern and Western civilisation. Thus he adopted not only the contents of Luther's teachings, but also his use of language – as a means of making connections, as a form of communicating, and as the vehicle for a message. Benjamin Hasselhorn

→ Further reading

Won Yong Ji: *A History of Lutheranism in Korea. A Personal Account*, St. Louis 1991.

Hyun Sub Um: *Cherishing the Memory of Dr. Won-Yong Ji*, January 2013, online: http://concordiatheology.org/2013/cherishing-the-memory-of-dr-won-yong-ji/ (accessed on November 2016).

Jin-Seop Eom: The Korean Lutheran's Perspective on Lutheranism and Lutheran Identity, in: *Missio Apostolica* 22 (20) 270–293.

> It was my long-cherished dream to introduce Martin Luther and his thoughts to Korea through his own writings

SIBYLLE LEWITSCHAROFF

WRITER,
GERMANY, B. 1954

More harmful than the Flood, in Martin Luther's eyes, was the linguistic confusion that descended on humankind with the building of the Tower of Babel. Whereas God's first punishment had affected only Noah's contemporaries, the Babylonian division of languages and speakers would persist until the end of the world. Luther described this as the 'origin and cause of all unhappiness and disunity'. Moreover, when people cannot use language to communicate, hatred and mistrust ensue, as do economic and political discord. In his view, the only hope people had of overcoming this 'division of languages' was to trust in Jesus Christ. By talking to all men and women in the new language of the Gospel, the Saviour 'tears down the wall' between human beings (WA 42, 413; LW 2, 215).

Sibylle Lewitscharoff shares the reformer's view of the pervasive power of language to separate and unite people. As a writer highly regarded for her potent language, Lewitscharoff admires the poetic artistry of the translation of the Bible by Martin Luther's, who, 'feasting on and ennobling the language of the people', was determined to make the Holy Scripture accessible to all. The lyricism of his translations of the Psalms and the Song of Solomon inspired her own writing. And it was through the 'smouldering blackness of the holes gaping between Luther's paratactic sentences' that she found a way into the dreamfully different, fervently religious world she has explored in all her novels, from *Pong* (1998) to *Montgomery* (2003), *Consummatus* (2006), *Apostoloff* (2009), *Blumenberg* (2011) and her most recent publication, *Das Pfingstwunder* (2016).

It was as a God-fearing child that Lewitscharoff first encountered the 'wordquake Luther' through her Pietist grandmother's sonorous singing voice and loving narrations. Since then Luther's language – alongside that of Homer, Franz Kafka and Samuel Beckett – has been an important benchmark for her. However, she cannot help but associate the reformer with his chilling articulation of his hatred of Jews. Indeed, Lewitscharoff regards Luther's attempts to Christianise the Old Testament, whether by exegesis or his choice of vocabulary, as far from inconsequential. In so doing, Luther 'in effect pulled the Bible out from underneath the Jews'. There is no way around reading such a gesture as a terrible omen of the future.

Lewitscharoff – like Luther – is drawn to the idea of a lingu tic utopia, such as the 'miracle of Pentecost', which recurs her *Pfingstwunder*. However naïve it might be, the fantasy overcoming the primordial division of Babel, the fraughtne of communication across countries and cultures, is somethi the author holds dear. Yet in Lewitscharoff's novel, it is not t disciples who 'talk in tongues' but a gathering of Dante schola who have congregated on the Aventine Hill in Rome at Wl suntide. In contrast to the Bible, they are not bidden by Gc Nor do they seek to spread the glad tidings. Regardless of the origins or faith, the scholars speak in their own language ar yet are understood by all the others. To anyone listening, 'erything that lives and has a voice merges with and into everything else; everything, really every last thing' seems to be cluded. Catherine Nichols

→ Further readi

Sibylle Lewitscharoff, Edition Text + Kritik, no. 204, Car Spoerhase (ed.), Munich 2014.

Sibylle Lewitscharoff: Von der Wortgewalt, in: *Denn wir ha Deutsch. Luthers Sprache aus dem Geist der Übersetzung*, Marie ise Knott, Thomas Brovot and Ulrich Blumenbach (ed.), lin 2015, 19–30.

Kai Nonnenmacher: Der Flug der Danteforscher. Gesprä mit Sibylle Lewitscharoff zum kommenden Dante-Roman *L Pfingstwunder*, in: *Romanische Studien* 2 (2015), 315–328.

Luther whipped up a tremendous storm of language, a darkly menacing, succulent German

Sibylle Lewitscharoff and Friedrich Meckseper, *Babel, Confusion of Tongues*, 2017

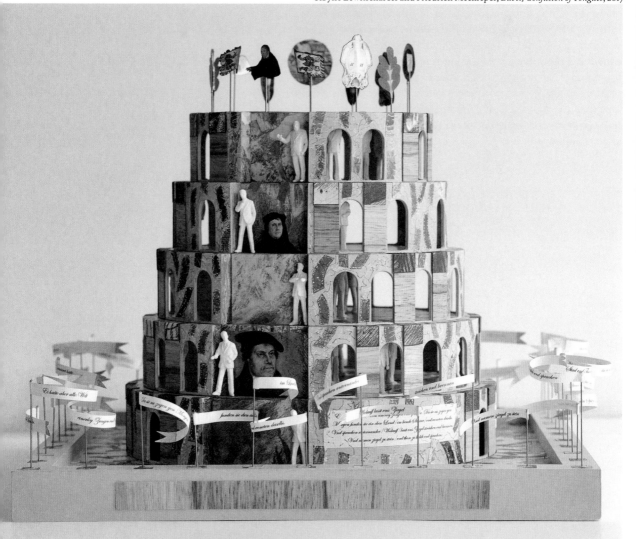

'MY CONSCIENCE IS CAPTIVE TO THE WORD OF GOD.'

WA 7, 838; LW 32, 113

At the Diet of Worms in 1521, Luther refused to retract his writings and faced excommunication and an imperial ban as a result. He was convinced that no external power has the right to demand something from us that goes against our conscience. For it is through the conscience that God calls us back to Him. Conscience is at the heart of Luther's religion. The individual's inner conviction prevails over the demands of external institutions – this message can trigger strong resistance and means that our conscience can also get us into serious trouble. Is our conscience still 'captive to the Word of God'? Are we really always guided by our conscience when we make decisions? And how far are we prepared to go to follow it?

SCIENCE AND CONSCIENCE

MICHAEL GROSSHEIM

The young doctoral candidate in the Medical Faculty presented his supervisor with his findings from weeks of ultracentrifuge experiments. The professor frowned, muttering, 'Not very pretty findings'. Then, reaching for a pen, he added some figures to the list and handed the paper back with the words, 'Now *these* are pretty findings!' Dumbfounded, the candidate accepted the list with its handwritten corrections. When he submitted his thesis it contained the 'pretty findings' dreamt up by the professor of medicine, and he was awarded his PhD.

This is a true story, albeit not typical – neither of science in general nor medicine in particular. Clearly anyone hearing of it is immediately filled with a sense of outrage – but we should be wary of being drawn into hasty generalisations, such as speculation about the dubious influence of the pharmaceuticals industry on medical research. That may be a factor in the wider picture, but in this particular case there is a more pressing issue, a

glaring discrepancy. On one hand there is the duty of any professor to seek out and uphold the *truth*; on the other hand there is a lack of conscience on the part of one individual, who openly and blatantly ignores his duty. A second, historic example casts a different light on the same topic. On 20 August 1934 it was decreed that all professors in Germany were to take an oath pledging 'loyalty and allegiance to the Führer of the German Empire and People, Adolf Hitler'. Aside from those who had already emigrated or been dismissed, and not counting the theologian Karl Barth, who enjoyed a certainty immunity as a Swiss citizen, only one professor refused to take that oath: Kurt von Fritz (1900–1985), professor of Greek in Rostock. He wrote to the university at the time: 'Moreover, since, as I hear, the implications of the oath are being discussed, I regard it as my duty, before taking this oath, to inform the authorities before whom it is to be taken that, in my view, an oath of allegiance to the head of state cannot, by definition, impose any obligations that would be in conflict with the duty of a university teacher, to the best of his knowledge and in accordance with his conscience, only ever to teach the truth.' The National Socialist authorities responded by 'retiring' the recalcitrant professor, who regarded his own conscience and the truth as the highest authorities in this world; he went into exile not long afterwards.

The example of Kurt von Fritz is of such significance because he was the only German professor, whose conscience would not allow him to take that new oath for Hitler and who was prepared to face the consequences. We should not underestimate the existential ramifications of his response, which cannot be equated with acts of resistance against the state in our own time; in a pluralist society there are always (larger or smaller) social groups ready to stand by any individual making a protest, with the result that he or she is not faced with the threat of the radical isolation they would suffer in a totalitarian society.

Furthermore, both of these cases – the present-day physician and the Greek scholar in the past – show that in science and academia there are crucial factors that have little to do with being up-to-date with the latest research or being familiar with methodologies, that is to say, conventional intellectual virtues. Astonishingly – despite certain well known cases of academic plagiarism having come to public attention in recent years – it appears that these factors still only play a secondary role, for instance in the appointment of young researchers.

It seems that the 'sixty-four thousand dollar question' here is 'How do you feel about the truth?' In daily life we have to be careful how we handle the truth. Above all, we have to ration it carefully, for the sake of our fellow human beings' feelings. By contrast, the sciences – in a culturally very one-sided manner – basically do not have to take any such considerations into account. Sociologist Clemens Albrecht has summed up what science is, or

ought to be: 'Science is an autonomous realm of action, the single, sole purpose of which is to generate new knowledge. Science's only master is the truth – not political ideology, a nation, a religion, it is not just a way of increasing the GNP or securing locations and certainly not of raising dividends.' Kurt von Fritz understood that; the professor of medicine cited at the outset did not. And there are many people involved with science today, either on the inside or the outside, who similarly fail to understand it.

What does all this have to do with Luther? When the above-described examples are considered from this perspective, it seems pertinent to remind ourselves of Luther's appearance at the Imperial Diet of Worms in 1521. The imperial orator berated Luther for his arrogance in claiming that he, as a lone individual, had access to the truth. Luther responded by explaining that his conscience would specifically not allow him any such conceit; however, as an authority that had to be obeyed, his conscience also made it impossible for him to retract his writings, as was demanded of him. He was prepared to accept excommunication and an imperial ban.

What might his actions mean to us today, particularly in view of the connection between conscience and science? The resonances that still come down to us from Luther in our own time are less genuinely religious than *habitual*. And the young Martin Heidegger made a similar connection – not in his guise as a National Socialist university rector in 1933–34, but as the theoretical philosopher who, from 1919 to 1929, was preoccupied with the question as to how phenomenology could find its way to 'things themselves'. In his 1923 lecture 'Ontology – the Hermeneutics of Facticity' Heidegger starts by naming Luther as one of his great sources of inspiration, to whom he owed much. It is unusual for a philosopher to pay homage in that way, all the more so a philosopher who was brought up in a Catholic milieu. Heidegger's respect for Luther is expressed in rather more specific terms shortly afterwards, when he refers to the 'spirit of Luther' not only in philosophy but also in science. For Heidegger that spirit is all about 'open questioning', which is 'not frightened in advance by possible consequences'. Merely asking requires courage, because it is generally taken as a confession of not-knowing, that is to say, of inadequacy. Radically open questioning, in Heidegger's sense, requires even more courage, since it involves more than just asking the usual questions (in the expectation of the usually desired answers). As Heidegger suggests, open questioning can have consequences that can intimidate the questioner. Is it a good idea to ask this question? Or would I do better to take account of whichever scientific turn (linguistic, spatial, iconic, emotional …) is currently in vogue in my field?

In the age of 'connectivity' and 'impact factors', Anyone posing radically open questions risks being despised as a scientific troublemaker or dismissed an outsider who can safely be ignored. Science is like any other social arena; it is shaped by majority and minority opinions, by power plays and coer-

cion. Yet phenomena such as common sense, the mainstream and dominant schools (to the point of scientific monocultures) are in fact dangerous opponents for any notion of science. Only constant rivalry between different approaches —in the humanities and social sciences at least — can ensure that a traditionalism does not take hold, which merely administers that which is 'correct' or 'obvious', and ensures that it is never in danger of being criticised or even tested. Such traditionalism may, at any given time, enjoy the support of most scholars and thereby gain a veneer of respectability — yet it stands in stark contrast to the fundamental notion of science, at whose very core lies the constant questioning of all its aspects.

As Luther demonstrated, an individual's conscience can become a source of strength, which helps him or her to overcome the debilitating anxiety that can befall anyone who glimpses the potential consequences of posing a question. However, if the conscience as the driving force behind individual troublemakers largely ceases to function and 'recognition by the recognised' (Helmuth Plessner), which is largely hostile to innovation, comes to dominate, then science can only stagnate. In any such self-satisfied circles, where critique and self-scrutiny are merely rhetorical conceits, the consequence, which can creep up wholly unnoticed, is what Jean-Paul Sartre described as 'classicism', a condition to which *any* society may succumb. To quote Sartre: 'There is classicism when a society has taken on a relatively stable form and when it has been permeated with the myth of its perpetuity ... when the power of the religious and political ideology is so strong and the prohibitions so rigorous that in no case is there any question of discovering new countries of the mind.' The search for new intellectual territories has become obsolescent, because it is already clear what is right, and because the latter no longer needs to justify itself. In a classicist society all well-meaning people are of the same opinion; this harmony is affirmed and nurtured in social rituals. I no longer have to have read the books I pass an opinion on — as long as my opinion is the same as the opinion of the circle I move in. There is no need to substantiate what the group thinks, what 'one' thinks. 'One' does not have a bad conscience.

In those circumstances, as Sartre goes on to say, the act of reading – which should in fact equate to a willingness to confront new, surprising, disturbing ideas – is reduced to no more than a 'ceremony of *recognition* analogous to the bow of salutation, that is, the ceremonious affirmation that author and reader are of the same world and have the same opinions about everything.' In all likelihood it was just such a state of complacent torpor with which Luther found himself confronted in the realms of religion, and which he then countered with a conscience-driven courage that, ever since, has served as a shining example in other realms and epochs.

WILLIAM SHAKESPEARE
WRITER,
ENGLAND, 1564–1616

William Shakespeare lived in the aftermath of the English Reformation, a historical turning point enabled by Luther's Reformation, and no English work reflects on Luther's impact more profoundly than Shakespeare's *Hamlet* (1600). Walter Benjamin claimed that *Hamlet* expresses 'both the philosophy of Wittenberg and a protest against it'. The play identifies Hamlet as a student of Wittenberg, but the duality that Benjamin discerns must be recognised in more essential elements: Hamlet's sensitivity to the fallenness of his world, his melancholy and his vexed conscience.

Luther's theology emphasises the incapacity of human works to achieve salvation; redemption of fallen existence occurs only through faith in God's gratuitous intervention. Hamlet articulates a Lutheran sense of his world as fallen: to him, Denmark is 'an unweeded garden … things rank and gross in nature possess it merely'. Hamlet's perspective is coloured by a Lutheran pessimism, but a corresponding redemptive faith proves elusive. A sense of fallen creation without faith may lapse into melancholy. Luther was known to struggle with melancholia as does Hamlet, who refers to his 'weakness' and 'melancholy' as he reproaches himself for inaction.

Hamlet's melancholy afflicts his response to his father's ghost, who demands the most urgent action: revenge. There is another Reformation tension here: the ghost emerges from Purgatory, the 'prison house' where his sins are 'burnt and purged away', but Hamlet, consistent with Luther's rejection of this mediaeval doctrine, does not easily accept the ghost's status. Hamlet must test the ghost to discover whether he is 'honest' or a 'devil' before he can act on his demand. Theological uncertainty combines with melancholy to paralyse Hamlet through much of the play.

The fictional prince and the historical reformer differ most starkly in the way they appeal to conscience. Hamlet alludes to the 1521 Diet of Worms as he describes Polonius's corpse: 'A certain convocation of politic worms are e'en at him. Your worm is your only emperor for diet.' At the historical Diet, Luther affirmed the authority of his conscience as he refused to retract his teachings: 'my conscience is captive to the Word of God' (WA 7:838; LW 54:14). Hamlet lacks such resounding faith, and his conscience remains clouded with melancholy. In his famous soliloquy, 'To be, or not to be', Hamlet posits conscience without faith as a disabling condition: 'conscience does make cowards of us all'. His cryptic identification of the dead body with the Diet of Worms reinforces a sense of diseased conscience and action turned 'awry'. In the final act of the play, a more resolute Hamlet recovers an active sense of conscience to empower his revenge: 'is't not perfect conscience, To quit him with this arm?' Yet this remains a conscience without grace, resulting in revenge without redemption: a series of 'carnal, bloody, and unnatural acts'. Hamlet lives and dies in a Lutheran world deprived of divine justification. Jennifer R. Rust

→ Further reading

Walter Benjamin: *Ursprung des deutschen Trauerspiels*, Berlin 1928 (English translation: *The Origin of German Tragic Drama*, London 1998).

Jennifer R. Rust: Wittenberg and Melancholic Allegory: The Reformation and Its Discontents in Hamlet, in: *Shakespeare and the Culture of Christianity in Early Modern England*, Dennis Taylor and David N. Beauregard (eds.), New York 2003, 260–286.

Raymond Waddington: Lutheran Hamlet, in: *English Language Notes* 27 (1989), 27–42.

To be, or not to be...

Scene from: Kenneth Branagh, *Hamlet*, 1996

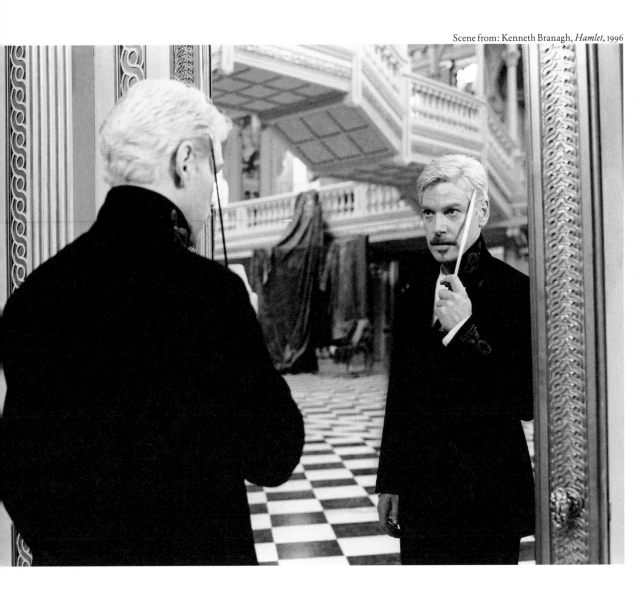

MARIE DURAND
HUGUENOT, FRANCE, 1711–1776

During 38 years of captivity, Marie Durand persisted in singing the psalms, worshipping God, teaching the faith, and writing to ensure the survival of fellow women and children prisoners. Carved into the stone in the centre of the fortress tower in southern France, where they were imprisoned for their faith, was one word: '*Résister*'. 'Resist' – resist tyranny, it implied. Attributed to Marie Durand, this call to resist helped to make her a heroic figure in the struggle for freedom of conscience and worship.

The celebrated prisoner of the Tour de Constance, near the Camargue, was not, herself, a political insurgent. Instead, Marie Durand was an activist in the sense that it took the full force of her life to resist powers that would bind her conscience and constrain her worship of God. She had been arrested for professing the 'so-called Reformed Religion' in 1730 when she was not yet 20. She refused to abjure her faith and remained in prison until 1768 when her health was failing and her release was ordered. These facts alone suggest her indomitable spirit. From her smuggled correspondence, we know more about her. Marie Durand suffered loss, confinement, poor health and recurring despair. But that did not separate her from God, to whom she prayed for mercy and deliverance, even when she lost the capacity to hope for it, and whom she praised as the source of all that is, even when her own life was stripped of almost everything.

King Louis XV's Royal Declaration of May 1724 had called for the execution of all preachers and the imprisonment of all those who professed the Reformed faith or baptised their children, married or comforted a dying person within the faith. Marie Durand's older brother Pierre was ordained in 1726. He preached, celebrated the Lord's Supper and performed 400 marriages. When he eluded the authorities, they arrested his father, then his sister Marie and, finally, his mother-in-law. In 1732, he wa[s] betrayed and arrested. At his trial he explained, 'I do not believ[e] it was ever the King's intention to forbid his subjects to worshi[p] God according to their conscience'. He reportedly walked t[o] his execution singing the psalms.

Two hundred years later, the call '*Résister*' reverberated amon[g] French Protestants, motivating them and freedom fighters t[o] join in resisting tyranny and virulent anti-Jewishness.

For Marie Durand, her brother and many of the mid-twentiet[h] century freedom fighters, to resist was not to revolt but to def[y] idolatrous encroachments on God, including those sanctione[d] by legal and religious authorities. This fundamental protest is [the] wellspring of Protestant faith. It is more than a political stance[;] it arises from an undeniable experience of standing before th[e] living God. Luther's testimony of conscience, 'Here I stand, [I] cannot do otherwise', echoes in Durand's life. '*Résister*' – resis[t] tyranny and seek, with the full force of one's life, to live rightl[y] before God. K r i s t i n e A . C u l p

→ F u r t h e r r e a d i n[g]
André Chamson: *La Tour de Constance*, Paris 1970.
*Lettres de Marie Durand (1711–1776) Prisonnière à la Tour [de]
Constance de 1730 à 1768*, 2nd ed., Étienne Gamonnet (ed[.])
Montpellier 1998.
Kristine A. Culp: *Vulnerability and Glory: A Theological A[c-]
count*, Louisville 2010.

Resist!

RESISTER, 18th century, later plaster cast of the word carved into the stone of the Tour de Constance

KARL HOLL CHURCH HISTORIAN, GERMANY, 1866–1926

Luther's image as a theologian in the twentieth century was primarily shaped by Karl Holl. A church historian in Tübingen and Berlin, Holl was the leading thinker in the transition from critical historicism to the renewal of Luther's religion of conscience. After 1921 this led to the 'Luther renaissance' in Germany and the northern reaches of Lutheranism. Holl positioned Lutheranism in a grand, comparative overview of Western-Latin, Eastern-Greek and Russian Orthodox Christianities.

For Holl the 'young Luther's' theology of justification held the keys to his religion of conscience. He expounded Luther's 'experience of justification' and 'doctrine of eternal election' theocentrically (from above) and existentially (from below): justification is anchored in God's plan as the epitome of His greatness, sanctity and sole efficacy. In His holy will to love, God has set self-sustaining, creaturely life apart from Himself – in its absolute contradiction (through sinfulness) to Him – in order to impart His righteousness to it. It is thus precisely through conflicts between Himself and His creatures that God leads the latter to a free, selfless community of will with Himself. The antinomy of God's wrath at unavoidable evil points in fact to the existing conscience as the location of certitude. In the bold move that recognises God's greatness in the conflict and yet submits to God's rejection (*resignatio ad infernum*), the certainty of election is revealed to the conscience; it is reserved only for those who are 'strong'. The awareness that one is an 'instrument' acquiescent to the all-determining God – that is to say, not a sense of blessedness but rather of sacrificial love for one's God and one's neighbour concealed in anger and conflict – describes the working of this religion of conscience. This resolution of the certitude question also contains the nucleus of Luther's early ethics and his early, reforming view of the church: *resignatio* to God's will means making the transition into the kingdom of God, into an invisible community, which will take in the weak Christians on whose behalf the strong Christians enter. This is Holl's understanding of the general priesthood and sovereignty of the baptised. It was only in the shadow of the German defeat in 1918, which many saw as a judgement on Protestant-Prussian culture and the established Evangelical Lutheran Church, that Holl worked out his 1921 programmatic thesis of a reformist religion of conscience: 'Luther's religion is a religion of conscience in the most pronounced sense of the word. … It issues from a particular kind of conscientious experience – namely his unique experience of the conflict between a keen sense of responsibility and the unconditional, absolute validity of the divine will – and rests on the conviction that in the sense of obligation which impresses its demands so irresistibly upon the human will, divinity reveals itself most clearly.' Holl then expanded this thesis into an outline of Luther's religion of conscience and reformist ethics, a prefiguration of what later came to be known as Luther's two-kingdoms doctrine, a church theory and an overview of the cultural significance of Lutheranism and the Reformed Church. Heinrich Assel

→ Further reading

Karl Holl: *Gesammelte Aufsätze zur Kirchengeschichte*, vol. 1: Luther, Tübingen 1921 (several expanded and revised versions, most recently: ⁷1948).

Heinrich Assel: Karl Holl als Zeitgenosse Max Webers und Ernst Troeltschs. Ethikhistorische Grundprobleme einer prominenten Reformationstheorie, in: *Zeitschrift für Kirchengeschichte* 127 (2016), 211–248.

Heinrich Assel: The Luther Renaissance, in: *The Oxford Encyclopedia of Martin Luther*, Derek Nelson and Paul R. Hinlicky (eds.), New York 2017 (in press).

Luther's religion is a religion of conscience in the most pronounced sense of the word

Origin of the Luther Renaissance: letter from Karl Holl to Adolf Jülicher, undated, possibly late summer 1909

PROF. HOLL CHARLOTTENBURG 1909
 LEIBNIZSTR. 44.

HENNING VON TRESCKOW

ARMY OFFICER,
GERMANY, 1901–1944

Henning von Tresckow was one of the few Lutherans to be part of the 'conscientious rebellion' of military officers against Adolf Hitler. In his view the National Socialists had betrayed the ideals of Prussia. In 1943, when his two sons were confirmed, he addressed the assembled company – and posterity, as it emerged, due to his complicity in the rebellion: 'The concept of freedom can never be separated from the true spirit of Prussia. That spirit is a synthesis between constraint and freedom, between natural self-subordination and properly executed dominance, between pride in one's own and understanding for the Other, between rigour and compassion. … It is only through this synthesis that we may fulfil the German and European obligations of the spirit of Prussia – and the "Prussian dream"!'

When Tresckow spoke these words, which, with his emphasis on the 'spirit of Prussia' and use of the now contaminated notion of 'dominance', may sound anomalous today, he had long been aware of the implications of participating in the conspiracy. His legacy consisted in remaining true to a particular understanding of 'the spirit of Prussia', a concept closely linked with the spirit of Evangelical Christianity.

Tresckow associated this synthesis of freedom and obligation not only with Prussian traditions but also with the traditions of Lutheranism – which was as equivocal and dangerous a path in the sixteenth century as it was in the twentieth. It would be hard to find a more telling demonstration of this than the resistance of the very Wehrmacht officers who initially welcomed the ascendancy of Hitler's regime, in the hope that it would make the German nation stronger. It was only during the course of the Second World War, with the ever-mounting evidence of the deeply malicious nature of the regime, that they actively turned against it. The relatively long delay before the decision was made was largely due to the spirit of Prussia alluded to by Tresckow, since Hitler had specifically laid claim to that Prussian tradition himself. For Henning von Tresckow and his fellow conspirators, however, it increasingly became obvious that this was a false claim, and it was the Prussian tradition of non-compliance – which is vital when professional duty cannot be reconciled with the demands of conscience – that guided them in their decision to conspire against their leader.

The importance of individual conscience in the assassination attempt on 20 July 1944, when the plan was to murder Hitler and topple the National Socialist regime, was all too clear to Tresckow. And, in full awareness of the political futility of the conspiracy, it was he who was utterly convinced that it was vital to take action, whatever the circumstances, because this had long since ceased to be a political matter but one of individual conscience: 'The assassination has to happen. … The point is no longer political, the point is that the German resistance risked a decisive move in the eyes of the world and of history.' When news reached him that the assassination attempt had failed, he immediately faced up to the consequences and, in order to prevent the National Socialists from extracting any information from him in an interrogation, took his own life.

Benjamin Hasselhorn

→ Further reading

Joachim Fest: *Staatsstreich. Der lange Weg zum 20. Ju[li]* Berlin 1994 (English translation: *Plotting Hitler's Dea[th]* New York 1997).
Bodo Scheurig: *Henning von Tresckow. Ein Preuße geg[en]* *Hitler*, München 2004.
Peter Hoffmann: Oberst i. G. Henning von Tresck[ow] und die Staatsstreichpläne im Jahr 1943, in: *Vierteljah[r]* *hefte für Zeitgeschichte* 55 (2007), 331–364.

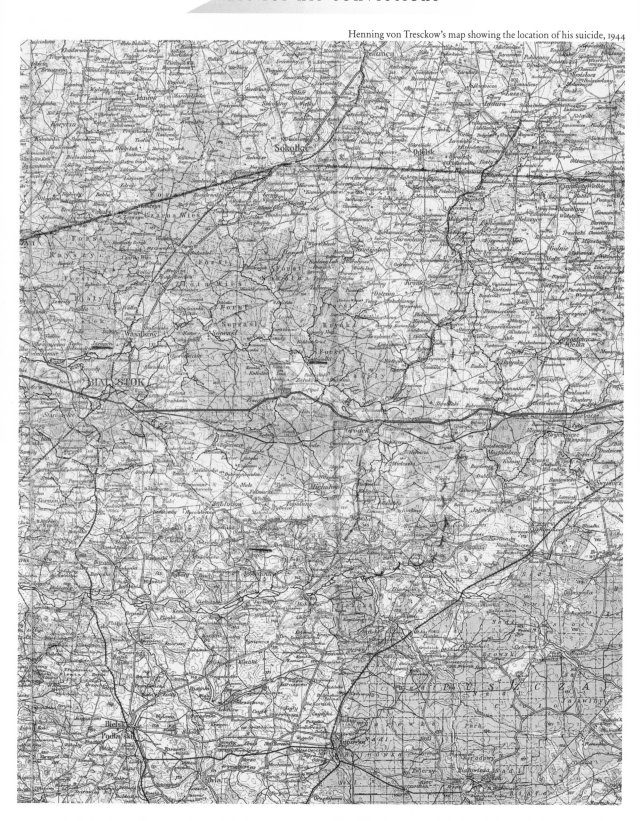

EDWARD SNOWDEN

IT-SPECIALIST AND
WHISTLEBLOWER,
USA, B. 1983

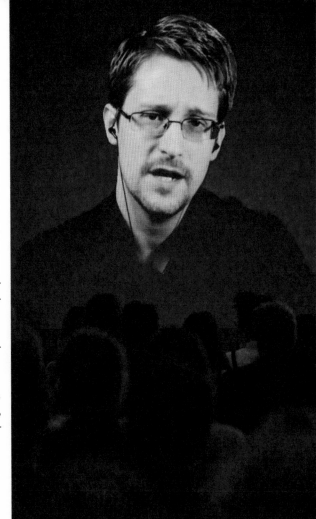

He must be the world's best known whistleblower: an ex-employee at the Central Intelligence Agency (CIA) and an ex-contractor at the National Security Agency (NSA) in the United States, in 2013 Edward Snowden released classified documents into the public domain, thereby causing a major, global controversy. He regarded his own actions as essential, in order to alert the public at large to the extent of the surveillance to which the entire population was already subject by the secret services. Celebrated by some as a hero and pursued by others as a traitor, he fled the country and in 2013 sought and was granted temporary asylum in Russia. Since then the public debate has revolved not only around the documents released by Snowden, but above all the question as to how his actions should be judged.

In Germany there is one minor byway in this debate, where the question has arisen as to whether Snowden's actions make him something of a modern Luther. Parallels are drawn between the two: Snowden, like Luther before him, challenged the greatest super-power of his own time. Luther took on the Church and Snowden took on the United States of America; both were originally part of their respective establishments with insider knowledge and both used the latest communications methods to convey their determination to change the prevailing system; both knew from personal experience that the authorities were riding rough-shod over the population and neither could square that with his own conscience; both were persecuted for their efforts but then found opponents to the super-powers who took them under their wing.

Of course not everyone accepts these parallels; above all they can become skewed through the identification of not only the main protagonists but also the other players: President Barack Obama's counterpart would be Pope Leo X, and the 'modern' Friedrich the Wise (Friedrich III, Elector of Saxony, Luther's most influential supporter) would find his equivalent in the Russian President, Vladimir Putin. What is problematic about this parallel is not so much the awkward distribution of 'good' and 'evil' – both Luther and Snowden are, and no doubt always will be, highly controversial figures – but the fact that history never truly repeats itself, that events cannot be viewed wholly in abstract, without their original context. Any such comparisons should not therefore be overworked and, accordingly, any attempts to hail Snowden as a new Luther appear to make little sense. And yet, something of the existential impact of Luther is discernible in the figure of Edward Snowden, for Snowden's actions show that Luther's decision to follow his conscience – 'Here I stand, I can do no other' – is by no means merely a thing of the past. Taking personal responsibility for one's own actions – with reference to one's 'conscience' – is just as much part of life today as it was 500 years ago, and Snowden's case demonstrates that taking one's responsibility seriously can still have the most bitter consequences. Benjamin Hasselhorn

→ Further reading

Ist Snowden der moderne Luther? Interview mit Antje Vollmer, 16. August 2013, online: www.evangelisch.de/inhalte/87444/16-08-2013/ist-snowden-der-moderne-luther (accessed on 16 November 2016).

Anne Käfer: Freiheit oder Sicherheit? Vom Sinn und Nutzen der politischen Ethik Luthers für die Beurteilung des 'Falles Edward Snowden', in: *Deutsches Pfarrerblatt* 114/4 (2014), S. 210–213.

Mark Hertsgaard: *Bravehearts: Whistle-Blowing in the Age of Snowden*, New York 2016.

Citizens with a conscience are not going to ignore wrong-doing simply because they'll be destroyed for it: the conscience forbids it.

Book burning 2.0?: Destroyed logic board of a HP Compaq 8200 Elite PC, used to inspect data provided by Edward Snowden, early 21st century

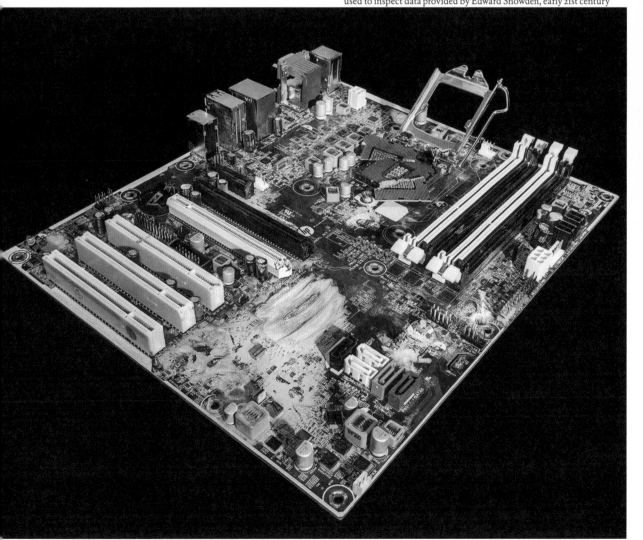

'EVERYTHING RESTS ON FAITH.'

WA 16, 262

As a monk, Luther was tortured by the idea of a punitive God who judged people by their works. His intensive study of the Bible made him realise that faith, and not works, was critical to human salvation. Luther considered faith to be the most important thing. After all, he wrote, faith means setting one's heart on something, it means putting one's trust in it. Many people are impressed by Luther's faith and make sacrifices to preserve it. Yet faith also involves doubt, leading many to take a more critical stance. This criticism is sometimes expressed respectfully, other times more trenchantly. What do we believe in today? What place does Luther's faith have in the sea of faiths that surround us?

LUTHER'S VISION OF FAITH

EBERHARD STRAUB

P ersonas and spiritual movements such as Martin Luther and the Reformation do not have to make sense from our own present-day perspective, only in the context of their own contemporaries and environment. Every epoch is immediate to God, and its significance does not lie in that which eventuates from it, but rather in its unique character, in its unique self. This was one of the precepts underpinning Leopold von Ranke's *History of the Reformation in Germany* (first published in German as *Deutsche Geschichte im Zeitalter der Reformation*, 1839–47). In this master work – also a literary tour de force – Ranke resisted the well estab-

lished tendency to concentrate on the *modern* traits of Luther and the Reformation, that is to say, he ignored the temptation to focus on the contribution of the latter to European history as the history of a *modernity* that has constantly repeated itself in every new era. However, as Friedrich Engels mockingly pointed out, 'modern' and 'modern society' are in themselves empty and indeterminate concepts which superficial thinkers readily resort to, and Engels, for one, seriously doubted whether these terms could ever become a philosophical category. Nevertheless, the early Christians very soon regarded themselves as *moderni*, as opposed to the *antiqui*, namely, 'the old' or the heathens of the past. 'Mediaeval' believers felt that they had been transported into a new era by Christ and the New Covenant, an era in which each individual would lay aside the old Adam and, with the help of Christ – the new Adam – become a new person. Everything becomes new through Christ, which is why, ever since His advent, newness has been considered pleasing.

The 'mediaeval' period, now regarded by many as murky, or even darkly gloomy, because of its supposed lack of enlightenment, was in fact a colourful, mercurial time filled with surprises emanating from either the moderns or the *hodierni*, who – as self-aware inhabitants of their own present day – sometimes felt impelled to sideline their more 'antiquated' contemporaries. Their efforts did not always meet with success, because the *via antiqua* – the old, tried-and-tested methods – still had it in them to derail the new tendencies of the *via moderna* as nothing more than fads. Modern, modes and modish have always been intrinsically interconnected – which is why no-one has ever succeeded in formulating an even semi-convincing definition of 'modern'. And, as Friedrich Engel's objections confirm, it was not necessary to wait for Postmodernism to confirm this. Therefore the many definitions of 'modern' prove to be of little value in our endeavours to understand Martin Luther, his historical status and, above all, his vision of faith. He saw it as his special mission to spread the Word of God, its truth and the life it gives, as the risen Christ commanded his disciples: 'Go therefore and make disciples of all nations ... teaching them to observe all that I have commanded you. And behold, I am with you always, to the end of the age.' (Matthew 28:19-20). Thus Martin Luther consciously followed in the disciples' footsteps, trusting in the liberating power of the living Word, which can save all those on the worlds' ship of fools who are afflicted by distress and disappointment.

Faith, said Luther, frees us. However, the freedom of the Christian has nothing to do with the present-day yearning for self-fulfilment or with modernity's rationalist, scientific, technological search for emancipation. Christian faith is neither modern, premodern nor unmodern. It can – as Luther memorably affirmed – be alive in any age and can induce metanoia (change) within an individual, which specifically encourages that individ-

ual to turn his or her attention to the outside world. Because, through Christians, the world – as an ordered state or society– has a stake in the redemptive truth. Luther's proclamation of the present and merciful God, who, through Jesus Christ, saves each one of us and the world, settled all kinds of unrest that had troubled Christians for generations, in each of whose souls the drama of God and the sinner had played out. Since time immemorial, long before the beginnings of Christianity, the act of faith had always been a dramatic process of salvation. In the late Middle Ages, well before Luther, mystics and lay communities following the incipient *devotio moderna*, with its new approach to piety, had already taken the mysterious path into their own inner worlds. Because it is only there that the living Word can take effect. Of course each individual has to learn how to listen to the language of God, how to ask in the language that God understands, and how to answer the questions that might arise in the cordial or painful dialogues ensuing from his or her discipleship of Christ.

It is in absolute inwardness that the free spirit is entirely independent, because it is in God, in truth and only in the truth that the spirit enjoys independence. The believer is touched by the *splendor veritatis*, the illuminating, enlightening, gleaming radiance of the truth. It transmits joy, because in it the truth is revealed in all its beauty. God, the truth and beauty were all one and the same for Luther. The old beliefs seemed still new to him, because the Holy Ghost constantly rejuvenates. None of this was at odds with traditional teachings. Luther – disciple of the Lord, preacher, literary scholar and master of the spoken word – was not the 'unique genius' described by enthusiastic humanists. Yet, if the internal takes precedence over the external, the conscientious Christian may also view the Church as an external factor. In which case the Church inevitably has to become the internal, invisible realm of those called by the Holy Ghost, which reveals itself externally as little as Christ. However, in historical terms, this radical internalisation marked a departure from the traditional belief of all Christians – including those in the East – in the Church of Christ as vital to salvation and hence holy, the Church which can only be one and all-encompassing. Roman Christians, Greeks and Russians all agreed that faith in a personal, living God, who became Man in Christ, is dependent on visible, symbolic forms, the highest of which is the holy Church, in which the praying and solemnizing *communio* assumes an actual form. There is no salvation for them outside of the Church.

Luther and other reformers took issue with this. In their view the Church no longer had the sole right, or the absolute power it had traditionally enjoyed since the Apostles, to determine the meaning of the scriptures. They thus flouted the hitherto unchallenged convention that, over the centuries, the collective efforts of the generations would lead, little by little, to a better understanding of divine scriptures and of the truth contained within

them. Luther and his fellow reformers were philologists and humanists, who only wanted to work with the pure urtext, the unfalsified Word in all its clarity and beauty. Having developed this aesthetic need in their scrutiny of classical Latin texts by writers such as Virgil and Horace, they now felt the same need in their reading of the Bible, the ultimate, classical text for the *moderni*, which they deemed far superior to all the books of the *antiqui*, not because it schooled good taste, but because it could help individuals not lose themselves in life, thereby failing to cast off confusion and repent from their sins. From now on, the reformers declared, the scriptures alone, in certain circumstances even a single word, were to be the sole authority in questions of faith. Inevitably the inward faith of these highly cultured, linguistically sophisticated Christians soon started to be obscured by the dust of pedantic erudition and of unworldly academic argument. For the new, highest authority – the pure, reinstated Word of God – did not instigate order; instead it led to vexation and terrible pangs of conscience. The initially tentative, then gradually more resolute, text-critical assertions by the reformers shattered the authority of the Holy Scriptures, which allowed a range of mutually contradictory readings. The Christian philologist Martin Luther had not reckoned with that.

Over time pious philologists, filled with academic zeal, gradually turned the Bible into a historical text, as unreliable and obscure as many a venerable history book. Textual and historical critiques did not necessarily smooth the path for believer; if anything they led believers straight into the same doubts that once plagued Pontius Pilate, who, confronted with the truth, asked 'What is truth?' (John 18: 38). These critiques unsettled ordinary Christians, who were pitied by humanists and philological scholars for their lack of culture and learning. Philipp Melanchthon had no idea what a pitiful only-Latinist believed, not to mention those without any understanding of grammar. After all, God had used Greek to communicate with humankind. The joyful tidings were reduced to homework! This was an outrage to all those who pinned their hope on Christ and, through Him, on a merciful God. The inward Protestants – mystics, pietists, lyricists, composers – protested at this new externalisation of faith: not against a despotic church but against unwanted tutelage in the name of philological correctness. The tensions between Protestants attenuated changing philosophical and aesthetic notions of reason, nature, humanity and, ultimately, a culture that touches everything and meets the needs of all who thirst. In that context specifically Christian belief was often only deemed worthy of consideration in so far as it could be equated with natural religion, a religion of reason or, preferably, the promise of pure humanity, which Goethe, Schiller and the German Idealists addressed so eloquently.

This development led to multiple transformations in doctrine, which made the 'nature of Christianity' (Adolf Harnack) and its suitability for the Mod-

ern era increasingly questionable. Aesthetic movements and schools of philosophy – long since relegated to history and known only to historians – failed in their ambitious attempts to arrive at a consensus on goodness, truth and beauty. Our modern age lost its way a long time ago. But that need not rattle Christians. When the Gospels were first written down, the Christians knew they were in the minority, derided by worldly know-it-alls as fools in Christ. The laicist and anti-religious fundamentalism that is fighting for dominance in Western Europe today can, in fact, provide new strength for Christianity – as it unravels uncertainly in numerous directions – and for Christians, who, sure of their own opposition to this world, are called by Christ to bear witness to the truth and the Holy Spirit. This aspiration is an irritant to many of their contemporaries, but those who answer that calling, can achieve the immense freedom of a Christian believer not to become a victim of our own time and its whims. That is what Martin Luther's faith tells us.

PAUL GERHARDT
THEOLOGIAN AND POET,
GERMANY, 1607–1676

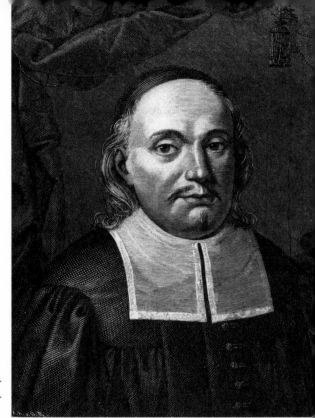

No theologian-poet made a greater contribution to the Evangelical Lutheran hymnbook than Paul Gerhardt. He heightened the expressive power of Christian faith, incorporated the core Lutheran tenet of the justification of the sinner into his work and thought, and wrote texts that enabled believers to connect with their faith on a new emotional level, in church and in domestic worship alike. Luther's emphasis on the personal relationship of the individual to God is surely expressed most memorably in the hymns of Paul Gerhardt.

Born in Gräfenhainichen in 1607 and an orphan by the age of 14, Gerhardt enrolled at the Prince's State School in Grimma in 1622. He matriculated at Wittenberg University in 1628, where August Buchner, the Professor of Rhetoric in Wittenberg, encouraged him to pursue his interest in German poetry, and he acquired a deep knowledge and appreciation of Luther's confessional writings.

In 1643 Gerhardt took a position as a tutor in Berlin, where he met Johann Crüger, Cantor at the Nikolaikirche; their subsequent collaboration had a defining influence on the development of the Lutheran hymnary. Crüger set Gerhardt's words to music and included many of their hymns in his *Praxis pietatis melica*. Eighty-eight hymns with words by Paul Gerhardt had been published by 1661. While Luther had written of the justification of human beings, for all their distantness to God, Gerhardt reinforced this belief in his texts by assuring the faithful of their certain election. In that sense the much-cited description of Gerhardt as 'the other Luther' is certainly apt.

Gerhardt was ordained in 1651 and oversaw the parish clergy in the town of Mittenwalde. Although his wife, Anna Maria Berthold, gave birth to five children, only one son survived his parents. In 1657 Gerhardt was recalled to the Nikolaikirche in Berlin. After the devastation of the Thirty Years' War, the Elec-tor, Friedrich Wilhelm, was keen to find a way to integrate an give parity to non-Lutherans in his Electorate. Accordingly, i 1656 he had removed the obligation to recognise the Formul of Concord, which repudiated other Reformed doctrines, an in 1662 and 1664 two Edicts of Tolerance were issued with th intention of officially securing peace between Lutheran an Reformed clergy. Gerhardt feared that Luther's influence w. under threat and, troubled by theological differences, was n willing to accept members of the Reformed Church as his brot ers and sisters in Christ. For all the gentle accessibility of h lyrics as populist homilies for countless believers, his dogma cally astute defence of the freedom of the Gospel against th Elector's interventions was harsh and ruthlessly logical. H was removed from his post in 1666, but the protests of ordina citizens and the municipality saw him reinstated. In support these efforts the new Cantor at the Nikolaikirche, Johann Geo Ebeling, published 120 hymns by Paul Gerhardt in a collecte edition. However, Gerhardt's conscience would not allow hi to resume his position – he felt duty bound to quash his opp nents. After the death of his wife, he accepted a position as p tor in the Saxon town of Lübben, where he died in 1676, a deep contemplative poet and man of God. Jonathan Stoll

→ Further readin
Christian Brunners: Paul(us) Gerhardt, in: *Komponisten u. Liederdichter des Evangelischen Gesangbuches*, Wolfgang Herl (ed.), Göttingen 1999, 110–112.
"Unverzagt und ohne Grauen". Paul Gerhardt, der 'andere' Luth Albrecht Beutel and Winfried Böttler (eds.), Berlin 2008.

Oh, write this promise
in your hearts

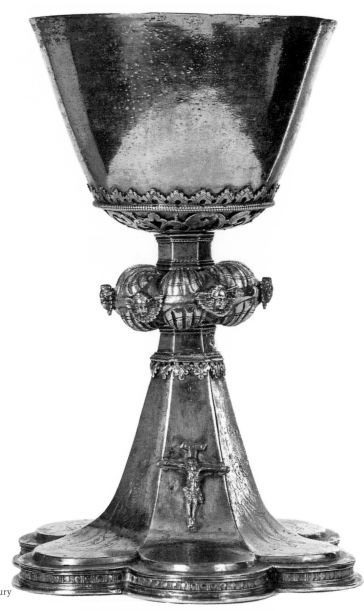

Communion chalice used by Paul Gerhardt, 17th century

SIR SAYYID AHMAD KHAN
RELIGIOUS THINKER, INDIA, 1817–1898

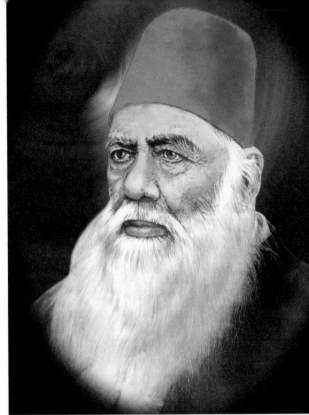

Sir Sayyid Ahmad Khan is connected to Martin Luther by the topic of faith: salvation is by faith alone, not by works or adherence to a particular creed. Born to an aristocratic Delhi family, he joined the East India Company in 1837 and rose to the highest rank open to Indians, a loyalty attested by his knighthood. Although he is frequently cited as an educationalist, Sir Sayyid is broadly recognised as the father of Islamic modernism. The author of important religious works, including commentaries on the Bible and Qur'an and a series of essays on the life of Muhammad, Khan was also a student of Christian theology. One result of this was his belief that the Qur'an inspired the Protestant Reformation; he even speculated that, had he lived longer, Luther would have become a Muslim. Khan's basic premise is that the Enlightenment would not have occurred had Europeans not read Muslim Neoplatonists like Ibn Rushd and Ibn Sina. It was the encounter with Muslims that had accelerated the Reformation in Germany, he argued, and had Luther conceded to anti-Trinitarian thinkers, such as Borrhaus, Denck, and Haetzer, the Christian religion would indeed have returned to its pristine condition. Although one hesitates to attribute Khan's view of faith directly to Luther, it is impossible to discuss Khan's trajectory in isolation from his sustained dialogue with Protestant theology. Nevertheless, it is important not to overlook the fact that changes were already underway in India in relation to the boundaries of orthodoxy. Whereas many called for more reified exclusivity, Khan insisted that Islam is universally inclusive by definition: the hope of eternal bliss is determined by belief in the One God – regardless of its expression – and not in the ascription to a particular dogma. And although many as-

pects of Khan's exegesis are original, his methods proceed in continuity with the mainstream writings of his Naqshbandiyy ancestors like Shah Wali Allah (1703–1763), the vanguard of r forms no less dramatic than Luther's. The latter called for th democratisation of scripture through vernacular translatio: opposition to shrine-based elitism and the rejection of pract es that appeared to deify the Prophet. But for Khan, the see of reform was salvation by faith. This engendered confidenc to release established doctrines and boldly explore scriptur from new perspectives. Although his journey was unique, Kha arrived at a conclusion in some ways similar to Luther, namel that all who, like Abraham, believe in the One God are certai to receive salvation, whether or not they live according to th shar'ia – of Moses, Jesus or Muhammad. They both agree th one is saved by faith, but for the former grace flows through th atoning sacrifice of Jesus and for the latter it flows through th eternal words expressed in the Qur'an. Charles Ramsey

→ Further readir
Christian Troll: *Sayyid Ahmad Khan. A Reinterpr tion of Muslim Theology*, Delhi 1978.
Hafeez Malik: *Sir Sayyid Ahmad Khan and Mus Modernization in India and Pakistan*, New York 1980
Daniel Brown: *Rethinking Tradition in Modern Islas Thought*, Cambridge 1996.

The greatest of all boons conferred by Islam on Christi-
anity is the spirit of resistance which it breathed into
the Christians against the exorbitant power of the Popes

D. MARTINI LVTHERI PRAE
MONITIO AD CHRISTIA-
num Lectorem.

INITIO admonēdus est lector Christianus, contra Mahometi furores, præmunitionem hanc piam & salutarem tenendā esse. Ecclesia Christi profitetur doctrinam traditā per primos patres, prophetas, filiū Dei & apostolos. Hæc & prima est, & consentiens, & cōfirmata resuscitatione mortuorum, & alijs inusitatis euentibus, quos imitari diabolica potentia nō potest. Agnoscimus igitur Ecclesiæ doctrinam esse à Deo æterno cōditore omnium rerum traditam, & sine hoc uerbo nullas religiones recipiendas esse. Porro Mahometus palàm fatetur, se prophetarum & apostolorum scripta abijcere, ac prorsus gignere aliud doctrinæ genus. Quare hæ recentes fabulæ Mahometi nihilo plus mouere aut turbare Christianos possunt, quàm ueteres furores Aegyptij, qui boues, seles, serpentes, tanqǔ numina colebant, & ab eis auxiliū petebant.

Has superstitiones nihil dubiū est, fuisse multo recentiores, quàm uocem diuinam traditā Nohæ & eius filijs. Semper igitur nobis, qui scimus hoc uerbum per prophetas, Christum, & apostolos traditum, uerè primum & diuinum esse, tenenda est regula, Nullas religiones sine hoc uerbo recipiendas esse. Vt abominamur Aegyptias superstitiones, Corybantum tympana, aut baccharum ululatus: sic Mahometi deliria abominanda sunt, quia pariter sunt extra prophetarum et apostolorum uerbum ac doctrinam. Nam Ecclesia uera Dei, extructa est super uerbum prophetarum & apostolorum: nec ullus usquàm Dei populus cogitandus est, qui non amplectitur nec audit prophetarum & apostolorum scripta.

Hac sententia, quæ est uerissima & certissima, primum præmuniendi sunt animi contra furores Mahometi. Deinde eruditus conferre doctrinarū genera potest. Quid aliud dicit Mahometus, quàm quod ethnicæ religiones tradebant? Nihil adfirmat de remissione peccatorum, euomit blasphemias in filium Dei, non docet quid sit peccatum, non monstrat causas humanarum calamitatum, nihil potest dicere de uera inuocatione in fide: deniqǔ eam doctrinam quæ propria est Euangelij, totam abijcit. Ideo facile potest intelligi, & pugnare Mahometum cùm prima doctrina tradita per prophetas & apostolos, & tantum particulam doctrinæ rationis humanæ de lege, seu de mo-

α 2 ribus

RICARDA HUCH WRITER, GERMANY, 1864–1947

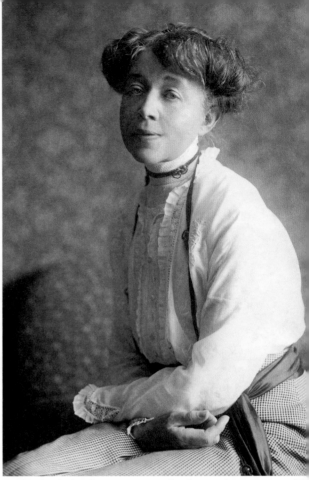

Ricarda Huch was the *grande dame* of German literature in the early twentieth century. Born into an upper-class family in Braunschweig in 1864, by the turn of the century she had already made a name as a poet and historical novelist. She studied history in Zurich and, after becoming one of the first German women to be awarded a doctorate, flouted convention by earning her own living as a writer. She was liberal, a member of the educated elite, conservative in her thinking and a nationalist whose ideals were shaped by the German-speaking empire in the Middle Ages. She was anti-feminist and her writing reflects her *faible* for artistic geniuses, heroes and revolutionaries. After the National Socialists seized power and progressively 'Nazified' both the state and society, Huch withdrew from the Prussian Academy with a courageous resignation letter. It was only thanks to her age and her status as a highly regarded writer that she was not persecuted for her openly critical attitude to the regime; however it became increasingly difficult for her to find publishers for her work in her native country. In 1947, in the aftermath of the Second World War, Ricarda Huch opened the first All-German Writers Congress in Berlin as honorary president. Not long afterwards she developed pneumonia as she fled East Germany on her way to her daughter's family in the West and died from complications in Schönberg in the Taunus.

Around the age of 50 Huch turned her attention to theological-philosophical topics. She published collections of narrative essays with the aim of spreading God's Word by translating old Christian and Protestant ideas into modern terminology and concepts, thereby giving them a new comprehensibility and credibility.

One of those collections, published in 1916, was *Luthers Glaube. Briefe an einen Freund* ('Luther's Faith: Letters to a Friend'). Although it did not initially have the impact on the wider public that Huch had hoped for, Ernst Troeltsch declared that while it was 'untheological … it was religious through and through', and to this day it is held in high esteem by many theologians in

academic circles. In a sequence of 24 letters the narrator – like Scheherazade – does everything she can to beguile a rationalist sceptic so that she can win him over to her world view and save him from his one-sided intellectualism. The reader of these letters finds views rooted in German Romanticism that also incorporate the nineteenth century's critical attitudes to Christianity and are intended to show that faith and knowledge are entirely compatible, if the timeless core of Luther's thinking is appropriately translated. God is thereby elevated to the principle underlying everything and Christ is elevated to an ideal type. As a writer living in the modern age, Huch had no choice but to transpose the divine spirit into the innermost realms of human beings. In view of humankind's advanced intellectual development, she saw no alternative to the abstractions she devised. The outcome was a book containing her own, very personal world view – *Weltanschauung* – her interpretation of 'what we actually still should and can think when we hear or read Luther's words'. Heike Fielmann

→ Further reading

Ricarda Huch: *Luthers Glaube*. Briefe an einen Freund, Leipzig 1916.
Cordula Koepke: Ricarda Huch. *Ihr Leben und ihr Werk*, Frankfurt am Main and Leipzig 1996.
Heike Fielmann: Ricarda Huch, in: *Frauenprofile des Luthertums*, Inge Mager (ed.), Gütersloh 2005, 73–98.

I am very much a believer,
but I'm not religious.

Ricarda Huch, *Luthers Glaube*, 1916

To the extent that Western filmmakers express a religious faith at all, Catholics seem to be somewhat overrepresented (Bresson, Ford, Hitchcock, Rohmer, Scorsese etc.). Important Protestant filmmakers seem fewer. In fact their only truly famous representative is Ingmar Bergman. I will refrain from speculating whether this is just a coincidence or if it reflects differing theological views on the image. However, I would claim, notwithstanding Ingmar Bergman's powerful and highly influential imagery, that his cinema is deeply rooted in the written word, indicative of his Protestant upbringing. 'Sola Scriptura' is a central Lutheran idea, and in writing his screenplays, in addition to other books, keeping diaries and being a prolific writer of letters, Bergman appears to have subscribed to this principle. Indeed, Bergman's adversaries have often accused his films of being too 'literary'. The facts are briefly these: the son of a clergyman, Bergman grew up in a milieu where churchgoing, sermons and various religious services abounded. That many of his films deal with theological questions is something of an understatement, as reflected not least by several titles being direct quotations from the Bible. One of these titles, *The Seventh Seal* (1957), earned Ingmar Bergman the status of being cinema's religious philosopher par excellence. Another Bible-quoting title, *Through a Glass Darkly* (1961), was the first film in his so-called 'trilogy on the silence of God'. At the end of the film, a father and his son are shown talking together, clearly for the first time in a long time. When the son declares that it is impossible to believe in God, the father replies that love is proof of God's existence. St John's assertion that 'God is Love', echoed by St Paul in his Corinthians I, from which the title of the film is taken, can also be comprehended in reverse: if God is absent, or silent, it is because there is no love – without love, no God. A variation on the same theological theme is the subject of Bergman's next film *Winter Light* (1963). Here a clergyman is beset by doubt. His liturgical duties are reduced to empty rituals and the pastoral care

he offers to members of his congregation takes the form of inept introspection. In the final scene of the film he is about to hold a service. But only one person has turned up – his mistress, at that an overt atheist. To the cantor's and the churchwarden's surprise, the pastor declares that the service will go ahead regardless, and the film ends with him addressing the empty pews 'Holy, holy, holy is the Lord God Almighty. Heaven and earth are filled with his glory.'

This is a very Bergmanesque ending. Given the horrific things that have happened during the course of the film, the closing lines seem deeply ironic. Where is the glory of which the pastor speaks? Yet the new expression on his face suggests that now and for the first time, he actually believes what he is saying. Bergman has been referred to as a 'Protestant atheist' but, whether he himself believed or not, his work is undoubtedly deeply rooted in a Christian and specifically Lutheran tradition.

Jan Holmberg

→ Further reading

Ingmar Bergman: *Bilder*, Köln 1991. (English translation *Images: My life in film*, New York, London 1994)
Im Bleistift-Ton. Ein Werk-Porträt in einem Band, Renate Bleibtreu (ed.), Frankfurt a. M. 2002 Wahre Lügen.
Bergman inszeniert Bergman, Kristina Jaspers, Nils Warnecke and Rüdiger Zill (ed.s), Berlin 2012.

A human being carries his or her own holiness, which lies within the realm of the earth.

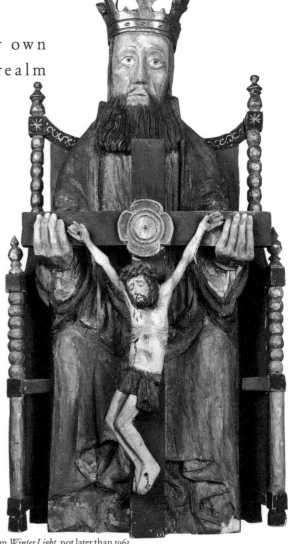

Per Axel Lundgren, altar figure from *Winter Light*, not later than 1963

Scene from: Ingmar Bergman, *Winter Light*, 1963

MARY DALY
THEOLOGIAN,
USA, 1928–2010

Born in Schenectady in New York State in 1928, Mary Daly was the only child of working-class parents and grew up during the Great Depression. After attending a Catholic high school she studied at St. Mary's College in Notre Dame, Indiana. In 1954 she was awarded her first doctorate in Catholic theology. From 1959 to 1966 she taught Catholic theology and philosophy at the University of Fribourg and concurrently earned her second and third doctorates in these two disciplines.

In 1967 Mary Daly took up a teaching post at the Jesuit, Catholic university of Boston College. Two years later, when the college attempted to deny the passionate feminist tenure, the students protested vociferously at her treatment. From 1970 onwards, when women were allowed to study theology, Mary Daly insisted (until her enforced retirement) that no male students be admitted to her theology classes. Mary Daly died in 2010 at the age of 81.

Daly's first book, *The Church and the Second Sex* (1968), was one of the first feminist critiques of Catholicism and almost led to her dismissal from Boston College. She became an 'iconoclast', who confronted the doctrinal system of Christian theology with accusations of misogyny. She then went on to create her own, feminist religion, which she set out in 1973 in *Beyond God the Father*, expounding her fundamental critique of the Catholic church and exhorting its women members to leave. She took the view that the symbolic figure of God the Father in Heaven legitimised the oppression of women. And she identified God as 'be-ing', as an intransitive verb that does not take an object: in this way, God ceases to be a thing.

In *Gyn/ecology* (1978) Daly listed and analysed what she regarded as the patriarchy's systematic crimes against women: the immolation of widows in India, the binding of women's feet in China, genital mutilation in Africa, the burning of witches in Europe, American gynaecology following in the footsteps of Nazi medical atrocities. Mary Daly's path led her out of the Christian Church, as she increasingly positioned herself outside both the religious and the academic mainstream. She regarded institutional religion as beyond repair and felt that not even reformed theology had been able to undermine the status quo of patriarchal society. In her *Wickedary* (1987), a humorous lexicon, Martin Luther appears in two entries, as an example of a misogynistic 'windbag' and as a 'snivelard', who complained that Eve had spoiled everything for Adam. Later on Daly described herself as 'post-Christian'.

However, as feminist theologian Caryn D. Riswold has suggested, both Luther and Daly can be seen as 'political theologians'. They were both iconoclasts. In Daly's opinion politics and religion could hardly have been more closely connected. At times her utopia of a largely man-free society elicited howls of protest and the black, lesbian writer Audre Lorde accused her of racism, among other things. Nonetheless there can be no doubt that Mary Daly made an immense contribution to women's liberation in the twentieth century. An Paenhuysen

→ Further reading

Mary Daly: *The Church and the Second Sex*, New York 1968
Mary Daly: *Pure Lust*, Boston 1984.
Caryn D. Riswold: *Two Reformers. Martin Luther and Mary Daly as Political Theologians*, Eugene 2007.

> Why indeed must 'God' be a noun?
> Why not a verb – the most active and
> dynamic of all?

Audio tape with a recording of Mary Daly's lecture 'Pure lust', 1986

Mary Daly et al, *Websters' First New Intergalactic Wickedary of the English Language*, new edition, 1998

GREGOR HOHBERG PASTOR, GERMANY, B. 1968

How would you describe religious belief in the twenty-first century? Pluralistic and interfaith is Pastor Gregor Hohberg's answer. He has become increasingly convinced of this since 2002, when he accepted the call from the Evangelical congregation of St. Petri – St. Marien in Berlin. As he explains, his church is frequented not only by members of the congregation and the faithful, but also by tourists and the homeless, by workers taking a midday break, by individuals coming to meditate, and even by Muslims seeking a quiet place to pray since there are no mosques in the historic centre of the city. Hohberg's interaction with the many people who come to the Marienkirche prompted him to look at Luther's church and to ask: what is its role in the largely secular, cultural landscape of a modern industrial nation like Germany?

While Hohberg's question is not uncommon, his answer is: the House of One – an interfaith place of prayer and study in the heart of Berlin, in which a church, a synagogue and a mosque would be grouped around a central meeting area. Hohberg's co-founder, Imam Kadir Şancı, has described it as house-sharing for religions, with each of the three faiths having its own room, but coming together in the communal living room and kitchen. The idea for this global first came in 2009, not far from the Marienkirche, at Petriplatz, once a bustling square but now reduced to a car park. However, following archaeological excavations, which exposed the foundations of what must be the oldest church in Berlin, this location has recently been upgraded to an 'ancient religious site'. Hohberg began to wonder what could be done with a site like this? What kind of buildings did central Berlin still lack? What could be done to promote peaceful coexistence in the city? And what about saving the world? Can architecture do that? With these questions in mind he embarked on his mission to conceive an interfaith building, soon joining forces with Berlin architects Kuehn Malvezzi, his fellow theologians Kadir Şancı, Tovia Ben-Chorin and his successor Andreas Nachama, and numerous other interested parties – including Christians, Muslims, Jews, people of other faiths and people with no faith at all.

This building endeavour – as yet still awaiting sufficient funding – is intended to make a 'prophetic statement'. It draws inspiration from Aleksandr Solzhenitsyn's novel *In the First Circle* (1968). Solzhenitsyn's characters dream of constructing a worldly cathedral, which will prevent society's value systems from falling apart by providing a space for silence, quietude, astonishment and longing. Another equally important source of inspiration was the 'World House' imagined by Martin Luther King Jr., where 'black and white, Easterner and Westerner, Gentile and Jew, Catholic and Protestant, Moslem and Hindu … must learn somehow to live with each other in peace'. In the story of the House of One, Martin Luther is conspicuous by his absence, for he was hardly a trailblazer when it came to interfaith tolerance. And yet, as a courageous thinker who would gladly invite opponents to a disputation, as a down-to-earth advocate of charity and love, the reformer is very much a beacon of light for Gregor Hohberg. Catherine Nichols

→ Further reading

The House of Prayer and Learning. Designs for the sacred building of tomorrow (multilingual edition), Gregor Hohberg and Roland Stolte (eds.), Berlin 2013.

Ulrich Gutmair: Ein Haus für alle, in: taz, 25 January 2015, online: www.taz.de/!5022706 (last accessed on 12 February 2017).

Adrienne E. Hacker Daniels: Sanctuar(ies) for Sanctuary. A Rhetorical Analysis of Berlin's House of One, in: *Communication and the Global Language of Faith*, idem (ed.), Lanham, Maryland 2016.

We have to show that it is possible for us
to build a house together

Kuehn Malvezzi, *Modell des House of One für Berlin*, 2012

'GRACE EXALTS.'

WA 1, 361; LW 31, 50

The most important message contained in Luther's 95 Theses is that we cannot buy salvation. Moreover, we can do absolutely nothing to earn our own salvation. All we can do is trust in God's grace. Luther's treatment of this message was ambivalent. On the one hand, he called for acceptance of God's will and endurance of pain, suffering and death. On the other hand, he often neglected to practise acceptance himself, while struggling with internal afflictions, and wrangling with God and the Devil. Luther's teaching on grace inspires people to perform works of charity. Others are critical of its ambiguity: if I do not have to do anything to get to Heaven, can I simply sit back and do nothing? Or am I only free to do good works through God's grace?

HAVE MERCY ON ME

DIRK PILZ

God's grace, distant Word. Not distant like something alien that can be made one's own, not distant like unexplored territories that can be entered, possibly even occupied: grace is distant in that it is both an aspiration and an obligation.

'So then it depends not on human will or exertion', Paul writes to the Romans, 'but on God, who has mercy', (Romans 9:16). Everything depends on the latter – and nothing depends on the former. It seems that this blunt opposition embodies everything that, since Martin Luther, has come to be

accepted as the Reformation concept of the grace of God. In a nutshell, it could be said, as theologian Eberhard Jüngel has argued, that Catholic doctrine celebrates grace as a force that itself enacts human works, whereas the Reformation's *sola gratia* – meaning, through grace alone – attests to both the enduring dependence of the sinner on the merciful Lord and the undeserved, freely given care bestowed on the sinner by God. Grace as liberating freedom rather than performative power: that was the foundation of Reformation thinking.

This contains within it, among other things, the constant danger of reducing the grace that comes from God to *cheap grace*, as Dietrich Bonhoeffer and, before him, Søren Kierkegaard pointed out. Kierkegaard, not unreasonably, took the liberty of ironically commenting that were he active today, Luther would certainly have applauded human beings' achievements or, as he, generally referred to them, works. But Bonhoeffer sharply reminded his readers that 'it is only when one submits to God's law that one may speak of grace'. Grace that seeks to justify the sin rather than the sinner is cheap grace. 'Costly grace is the gospel which must be sought again and again, the gift which must be asked for, the door at which a man must knock.' Grace is that which I, as a believer, do not have, do not understand, that which I cannot make my own, which remains external to me, alien, and yet entirely constitutes me, enables me.

Bonhoeffer thus referred to the fact that grace calls us into discipleship, into obedience – in a contradictory relationship with God, in which I am both passive and active. Grace is therefore both that which I seek and that which is *found to me*. 'He who finds God, will find that God has been with the seeker all along', writes philosopher Robert Spaemann in his mediations on the Psalms, 'and he will even still register the experience of god's distantness as a painful manifestation of His proximity.' In that sense grace initiates a relationship with God that is a *contradictory union*, a fractured harmony of belief and that which is believed, which does not coalesce in a simple chord, but rather allows things diverse and not-reconcilable to resonate together.

Luther was fully aware of this contradictory union from the outset. It was probably in 1515 that he made a note in the margins of his copy of the sermons of Johannes Tauler: *nuda fides in Deum*, that is to say, salvation consists in yielding up one's own will in all things 'and in naked belief in God' (WA 9, 102). In Luther's view, we are pure matter, formed by God. However, this mystic notion of the believer becoming empty before and in God, which Luther evidently found in the writings of Tauler and his mentor Johann von Staupitz, sails close to the notion of cheap grace, which induces mere passivity in the sinner and seeks to justify the sin, not the sinner.

Yet Luther – strikingly – does not come to a halt at this point. Both in a later letter to the Württemberg reformer Johannes Brenz (1531) and in his

Table Talk, he declares that Christian righteousness is not a righteousness 'that is within us and adheres to us', like a virtue or a possession, 'but is an external righteousness outside of us, namely Christ Himself' (WA TR 6, no. 6602, 71). That is to say, it is *outwith me* – and yet *entirely mine*.

Thus grace is not merely bestowed upon us, it is not simply a composite of a gift from God and naked belief, it is an occurrence that takes place between God and sinners and as such comes with the obligation to allow that occurrence to occur. That is the reason why in 1530, in core passages in his revised translation of the Bible, Luther no longer translates the Latin verb *iustificare* with the static German verb *rechtfertigen* (to justify), but with the dynamic *gerechtmachen*, meaning 'to make right or just'. He takes the presence of the verb *facere* in *iustificare* as an indication of the enactment of an occurrence and interprets it in terms of a relationship: it is Christ that makes right, it is faith that *perceives* and *presumes*, that is to say, allows Christ's actions to take effect. Luther thus repeatedly makes reference to the effects that the believed Gospel produces. It 'cleanses hearts'; as a 'living, busy, active, mighty thing' (WA DB 7, 10; LW 35, 371) it liberates the conscience and, in so doing, *makes* a new life. In Luther's thinking this new life is, however, always the *old* life, that is to say, the life the Creator originally intended for His creation. In the context of sin, that is to say, the termination of immediate closeness to God, this creation is 'corrupted in the extreme and grievously damaged' by root sin (*peccatum radicale*), which denotes – more clearly than the traditional concept of *peccatum originale* – what original sin means, namely 'unbelief in the inmost heart' (WA DB 7, 7; LW 35, 368). However, faith in the Gospel 'brings it about that we are formed once more according to that familiar and indeed better image, because we are born again into eternal life … that we may live in God and with God and be one with Him, as Christ says' (WA 42, 48; LW 1, 64).

In Luther's argument this effect generates life that is renewed from its roots, and this newness also sees the believer being released from his or her passivity, being freed for *active love*. That is not a feat by which grace may be earned, but it is also not the simple receipt of grace, for that would mean having to endure it like a burden. As Bonhoeffer said, new life follows the call to obedience: 'Christianity without discipleship is always Christianity without Christ. It remains an abstract idea, a myth … .' The risk of Christianity turning into exactly that – as it has in so many ways in the Evangelical Lutheran Church today – was already very evident to Luther. He wrote that righteousness was ours because it had been given to us by God in his mercy but that it is nevertheless alien to us, because we have not earned it (WA 39 I, 109; LW 34, 179). In this context, alien, or *alienus*, indicates that it is outwith myself, it belongs to another, namely God. In the same vein, St Augustine talked of *indumentum gratiae*, the garment of grace, which not only covers the whole person but makes that person whole, by dint of its

alienness. On one hand it is a garment, laid onto the person from the outside and covering that person's exterior; on the other hand it is the very covering that makes the person, as a creation, visible and, hence, real.

This concept of grace also embodies the aspirations of grace: it aims to topple existing conditions – grace comes about in a *changed* life. That is the meaning of the statement addressed by St Paul to the Galatians: 'I have been crucified with Christ. It is no longer I who live, but Christ who lives in me' (Galatians 2:20). However, this specifically does not describe a condition but rather the occurrence of grace, which is not concludable in *this* life. In other words, I have a new life but I still always remain attached to my old life; God forgives me in His mercy, and yet I am a sinner.

Luther tried to sustain this tension in the theology of grace, for, were it to be abandoned, the abyss of cheap grace would open up, and grace would become a mere gift. He therefore consistently reiterated that the search for God's grace was all about 'imploring, desiring, searching' (WA 18, 522; LW 14,196; Psalm 143:1). And, for Luther, one's whole being had to be involved in the desire for grace. Grace is thus also something that can be *terrifying*. It bursts in on one; it changes not only a person's feelings and thinking, but that person's *entire being*.

It was in this vein that Ludwig Wittgenstein remarked that 'a confession has to be part of your new life'. Moreover, since making a confession amounts to imploring for mercy, this supplication must involve one's whole existence. However, I am not able make my supplication as I wish; I always fail. Wittgenstein explains his own situation: 'I never more than half succeed in expressing what I want to express. Indeed not even so much, but perhaps only one tenth. … My writing is often nothing but stammering.'

The consequence of this stammering is that faith is 'in a sense' brought back 'down to earth', down into the situation of the believer, into the situation of the human being who is separated from God, the sinner who turns in prayer to God as his or her wellspring. And the most appropriate speech mode in this situation is in fact stammering.

'Stammering' thus refers not simply to the inability to find the right words, it is not just about struggling to speak and to express oneself: it also means praying, and that means giving space to silence. The person who stammers tolerates the space between the syllables, does not regard them as malfunctions, or as failures, but as the only possible form of prayer. Consequently this is a form of speech that not only reckons with silence, it aims for it, specifically for that silence *between* the syllables, without which no supplicant may come before God. And it is precisely that silence that makes every prayer into a confessional plea, because the hope of the occurrence of grace is expressed in 'imploring, desiring, searching'. The praying human being thus becomes aware of his or her situation and stammers in the knowledge that all talking turns to silence before God; knowing that, as a sinner, one

is separated from God, the supplicant confesses his or her condition before God: because I am God's creation, supplication is the only possible form of prayer.

Hence, the fact that the original reference to grace in the Hebrew Bible is anchored in prayer is not without significance. For the constantly repeated entreaty 'Have mercy on me' corresponds to the movement of grace. In my prayer I ask that the addressee, God, may show Himself to be merciful. This request also expresses the fundamental peculiarity of every faith, namely that I do not know who the addressee is – I only know it, as St Paul put it, 'in hope'. May distant grace be close. Thus no other prayer more precisely reflects the relationship of the believer to the believed than this 'Have mercy on me'. I can never be certain of receiving grace; I am certain anew every time I pray, otherwise not at all.

HEINRICH SCHÜTZ
COMPOSER, GERMANY, 1585–1672

As a counterpoint to the Catholic requiem, *Musicalische Exequien* (1636) is the Protestant memento mori par excellence. It is a work that perfectly epitomises Heinrich Schütz – the *Musicus poeticus* and 'father of German modern music'. Together with the motet composed for Martin Luther's chorale 'Verleih uns Frieden gnädiglich' ('Peace in mercy send us') from *Geistliche Chormusik* (*Sacred choral music*) (1648) and the melodic grace prayer 'Aller Augen warten auf Dich, Herre' ('The eyes of all look to you') in *Zwölf geistlichen Gesängen* (*Twelve sacred songs*) (1657), it is evidence of Schütz's deep connection to Martin Luther.

The composer, now celebrated as the master of old music, was an avant-garde figure in his day and a proponent of a musical ecumenism that appeared inconceivable in a political context. As a staunch Protestant he was, of course, also a European, who, with the support of his masters, the Saxon electors, was able to put the religious and political limitations of his time into perspective. He first became familiar with the Calvinist music culture as a choirboy at the court in Kassel. He then moved to Venice, the heartland of Catholic church music, to study with Giovanni Gabrieli. His time in Venice influenced his *Psalmen Davids* (*Psalms of David*) (1619), which were considered to be the template for a new music. They were also deemed to be a political statement, made on his own behalf and that of his Saxon masters, who were Protestants by then. Giovanni Gabrieli would have liked Schütz to have succeeded him as the organist at San Marco. But Schütz initially remained in Dresden, accompanying Johann Georg I wherever his diplomatic mission took him, for example, the *Kurfürstentag* (meeting of electors) in 1627 in Mühlhausen and the Leipzig Colloquy (an assembly of the Protestant Electors and estates) in 1631.

Fascinated by the theatrics of Claudio Monteverdi, Schütz returned from a second sojourn in Italy in 1628–29 with a new musical form – *Kleine geistliche Konzerte* (*Little sacred concertos*) (1636–39) for solo voices, organ and small instrumental ensembles. With their virtuoso form requiring concertante skills and a small ensemble adapted to the constraints of war, these works became a template for Lutheran music. Of course Heinrich Schütz had also set the *Cantiones sacrae* (1625) to music. These were texts from the Catholic emperor's breviary. Schütz's gift for imbuing all of these texts with a particularly musical expression and for silencing religious conflict with his music ensured his presence in both Lutheran and ecumenical circles. The startling vividness of his music mirrored Martin Luther's graphic use of language. Luther's psalm translations have undoubtedly found their most beautiful expression and most emotional brilliance in Heinrich Schütz's many musical renderings. He himself saw this gift as a grace, of which he was conscious during his entire lifetime, including in his uncomplaining acceptance of many personal misfortunes. Klaus-Martin Bresgott

→ Further reading

A Heinrich Schütz Reader: Letters and Documents in Translation, Gregory S. Johnston (ed.), Oxford 2013.

Martin Gregor Dellin: *Heinrich Schütz. Sein Leben, sein Werk, seine Zeit*, Munich 1987.

Sven Hiemke: *Heinrich Schütz*. Geistliche Chormusik, Kassel 2015.

Heinrich Schütz, *Musicalische Exequien*, 1636, SWV 279–281

Musicalische Exequien

Wie solche bey herrlicher vnd hochansehnlicher Leichbestattung/

Deß weylandt Hochwolgebornen Herrn/

Herrn HEINRICHEN

deß Jüngern vnd Eltisten Reußen/ Herrn von Plauen / Röm.
Kays. Majt. gewesenen Rahts / Herrn zu Gretz/Cranichfeldt/
Gera/Schletz vnd Lobenstein/etc. nunmehr Christ-
seligen Andenckens

Jüngsthin den 4 Monatstag Februarii zu Gera/ vor vnd
nach der Leichpredigt gehalten/vnd ihrer wolseligen Gnaden/bey
ders lebzeiten wiederholten begehren nach / in eine stille verdackte Orgel
angestellet vnd abgesungen worden/

Mit 6. 8. vnd mehr Stimmen zugebrauchen/

Auch

Mit beygefügten zwiefachen Basso Continuo den einem vor die
Orgel/ dem andern vor den *Dirigenten* oder vor den *Violon*, bey wel-
chem vor her ein absonderlich Verzeichnüß/ deren in diesem Wercklein
begrieffenen Musicalischen Sachen/sampt den Ordinantzen
oder Anstellungen/ an den gönstigen Leser/
zubefinden.

Zu vnterthänigem letzten Ehren Gedächtnüs auff begehren
In die Music versetzet / vnd in Druck gefertiget
Durch
Heinrich Schützen Churf. Sächs. CapellMeistern.

QVINTVS.

Gedruckt zu Dreßden/ bey Wolff Seyffert/ Im Jahr/

1 6 3 6.

WILHELM LÖHE
THEOLOGIAN,
GERMANY, 1808–1872

Wilhelm Löhe is considered to be the founder of a dedicated Lutheran diakonia. Born in 1808 in Fürth in modern-day Franconia, the devout theology student initially participated in Pietist associations during his time at the University of Erlangen, as the liberal institutional church did not satisfy his spiritual needs. On returning from Berlin, where he studied for a time, he passed his theological examinations with distinction in 1830. He worked initially as a pastor and later as a parish administrator in various parishes in the Nuremberg area. He set up Bible societies and societies of the poor, as he saw the spiritual and material needs of those years as inseparably linked.

From the mid-1830s, Löhe turned to the confessional Lutheranism of his time. Influenced by an in-depth reading of Luther's writings, the Lutheran orthodoxy and close contacts with Lutheran Free Churches throughout Germany, Löhe's diaconal work – unlike that of Johann Hinrich Wichern or Philipp Jakob Spener – was firmly in the service of the Lutheran Church. As a pastor of a still-united state church (*Landeskirche*), he saw the Lutheran Church as a true embodiment of the one, sacred and all-encompassing Church. This resulted in serious disputes with the church authorities, which are said to have pushed Löhe to the brink of converting to the Old Lutherans in Prussia.

In 1837 Löhe accepted the position of pastor in the village of Neuendettelsau in Middle Franconia. He initiated diaconal, missionary and liturgical projects with huge creative energy and reflected upon them in a comprehensive body of literature. In 1844 he published *Pastoraltheologie* in which the diakonia is understood not to come from Christ but from the Church and – with reference to the Acts of the Apostles 6:6 – from the ordained ministry. Just one year later, Löhe published *Drei Bücher von der Kirche*. In these three books, he sees the Church as a divinely instituted community and constituted by Word and Sacrament. Löhe learned from Luther that God's mercy is not given arbitrarily, but is constantly available: it remains bound to God's promise and the clergy, who are called to distribute the 'means of grace' (Word and Sacrament). This occurs to all intents and purposes in the Lutheran mass, whose structure Löhe explored in several writings and essays on the order of service. According to the early Christian model of the sermon Holy Communion (*communio*) is superseded as the 'objective' of the Lutheran service.

Against this background, Löhe's diakonia proves to be not only a diakonia 'from the altar' but also 'to the altar'. It practises altruism not only through a commitment to care but also through Word and Sacrament, that is the ecclesiastical service. A prerequisite for this is that those performing the diaconal acts themselves lead a liturgical life. In 1854 Löhe set up a deaconess motherhouse in Neuendettelsau, where young women were educated and given instruction in cathechism and the liturgy. They gathered several times a day for services in the institution's chapel where they prayed for themselves and the people in their care. Wilhelm Löhe died in 1872. The deaconess motherhouse he founded in Neuendettelsau today employs a staff of around 7,000. Wolfgang Fenske

→ Further reading
Erika Geiger: *Wilhelm Löhe (1808–1872). Leben – Werk – Wirkung*, Neuendettelsau 2003.
Wilhelm Löhe (1808–1872). Seine Bedeutung für Kirche und Diakonie, Hermann Schoenauer (ed.), Stuttgart 2008.
Roland Liebenberg: *Wilhelm Löhe (1808–1872). Stationen seines Lebens. Mit Bilddokumenten und einer Bibliographie zur Löheforschung*, Leipzig 2011.

God wants people to give his grace through people

SØREN KIERKEGAARD

THEOLOGIAN AND PHILOSOPHER, DENMARK, 1813–1855

Apart from some short trips to Berlin, Søren Kierkegaard spent the entire forty-two and a half years of his life in Denmark, in fact in Copenhagen. He often changed his place of residence within the city, but he never lived more than a few hundred metres away from the residence of the Danish monarch, who is still the head of the established Danish Lutheran Church today. He spent the 1830s cheerfully working away at his studies. A breathtaking flood of publications saw him become Denmark's leading philosopher and novelist by the 1840s – above all as someone who urged others to take Christianity more seriously than he felt was the case for most of his contemporaries. He wanted to persuade others that being a Christian is about more than objective membership of a state-approved, bourgeois institution; it is an ongoing, subjective struggle for a truth to live and die by. Christianity is not about the masses, it concerns the individual. In the 1850s Kierkegaard commented that, of all things, it was the church and the clergy that made it possible for (if not suggested to) the masses to be a mass, rather than individuals following in the footsteps of the disciples of Jesus, with all that that implied. In so doing Kierkegaard became both a church critic and a church defender, which soon proved too much for his debilitated constitution.

And Luther? While Kierkegaard of course regarded Luther as the theological norm, in his ten years of study he paid only marginal attention to Luther's writings. And for all their almost uninterrupted affinity and compatibility with Luther's thinking, his own writings contain very few indications that he read Luther's most important, reformist publications. But every Sunday from 1847 Kierkegaard read a sermon by Luther. Why? Because it was in the sermons that he discovered the driving force behind Luther's achievements: faith and the experience of grace underpinned all that Luther did and wrote – not the other way round. Moreover faith puts the human being into the happy position of also wanting to shape his or her freedom. But it was at this very point that Kierkegaard was faced with a dilemma regarding Luther. Whenever he scrutinised the Lutheranism of his own time, he could see nothing but decay. And he endlessly sought the seed of that decay in the life and work of Luther himself. He accepted Luther's insistence on *sola fide* (through faith alone) and on *sola gratia* (through grace alone), but only insofar as these two principles are applied as critical correctives to the overestimation of human capabilities and works. But what happens, he asked, if this corrective becomes normative? Then grace comes to be taken 'in vain' and discipleship – in the sense of a life of faith – becomes obsolete. Kierkegaard believed accordingly that a new Reformation was needed as soon as the transition from corrective to normative had been completed. However, he also stressed that he himself was not a Reformer, merely an acute observer who was keen to act as a 'corrective'. He regarded it as his duty, for which he felt ideally equipped, to be a thorn in the side of the inertia of contemporary Christianity. Unlike Luther he escaped the fate of his position ever becoming normative. Harald Steffes



→ Further reading

Hermann Deuser: Kierkegaard and Luther. Kierkegaard's 'One Thesis', in: *The Gift of Grace. The Future of Lutheran Theology*, edited by Niels Henrik Gregersen et al., Minneapolis 2004, 205–212.

Harald Steffes: Luther und Kierkegaard. Oder: Der Reformator und das Polizeitalent, in: *Erinnerte Reformation. Studien zur Luther-Rezeption von der Aufklärung bis zum 20. Jahrhundert*, Christian Danz and Rochus Leonhardt (eds.), Berlin and New York 2008, 169–200.

Lee C. Barrett: Kierkegaard's Appropriation and Critique of Luther and Lutheranism, in: *A companion to Kierkegaard*, Jon Stewart (ed.), West Sussex 2015 180-192



Grace is what is serious — my works are merely a jest

A critique of Luther's doctrine of grace: Søren Kierkegaard's journals, 1850

HEINRICH NAZARENUS
CARPENTER,
SOVIET UNION, 1911–1998

Of the 250 pastors who served the Evangelical Lutheran Church in the Soviet Union, 200 were liquidated under Stalin. This number shows at a glance what Christianity had to contend with in the Soviet Union. The October Revolution in 1917 already saw Lenin's Bolsheviks taking an anti-Christian line. Initially the main brunt of this was borne by the Orthodox Church and, after Stalin came to power, it seemed at first that the Evangelical Lutheran Church would be spared – even expressly tolerated. Remarkably, the Evangelical Lutheran Church was able to hold synods in 1924 and again in 1928. However, in the late 1920s Evangelical Christians increasingly found themselves subject to widespread repression, with day-to-day constraints being imposed on the Church and believers deported to forced the labour camps known as the 'Gulags'. Exactly how many people perished in the Soviet Union for their Lutheran faith will never be fully known; but the number of recorded cases is already devastating.

Against this backdrop it is all the more surprising that, despite all kinds of repressive measures, a scattering of Lutheran 'home congregations' came into being in Kazakhstan, right in the middle of the Soviet Gulag system. While Christians were suffering persecution – or perhaps precisely because of this – there was a succession of Lutheran revival movements in the 1920s and 1930s. The Lutheran community in Karaganda, which arose in the wake of these revivals, was led by a skilled carpenter, Heinrich Nazarenus. He was from the ethnic group of Volga Germans, who were conscripted into the Red Army during the Second World War. Nazarenus spent most of the war in labour camps, while his wife and two sons fought for survival in the Kazakh Steppe. Both his sons died. When the war was over Nazarenus returned to his wife and started to build up a Lutheran community, secretly at first and then on sufferance. With-

out Bibles or liturgical texts – or only fragments thereof – in 1948 Heinrich Nazarenus recreated, and committed to paper, a Lutheran order of service largely from memory. For the next 20 years this order of service was followed in Karaganda and the surrounding parishes. Up to 1500 people gathered each Sunday; they had to be divided into three 'sittings', because of the space constraints in the room where they worshipped.

In an obituary Heinrich Nazarenus was likened to Job in the Old Testament, an innocent man struck down by tragedy but who, in all his suffering, never lost his faith in God. Nazarenus was cited as proof of God's grace, which Luther had placed at the centre of Christian theology; in times of persecution and suffering Nazarenus always clung firmly to Luther's teachings. After the collapse of the Soviet Union Heinrich Nazarenus emigrated to Germany, where he spent the rest of his life in quiet seclusion. Benjamin Hasselhorn

→ Further reading
Mitmenschlichkeit, Zivilcourage, Gottvertrauen. Evangelische Opfer von Nationalsozialismus und Stalinismus, Björn Mensing and Heinrich Rathke (eds.), Leipzig 2003.
Heinrich Rathke: Fremd im eigenen Land. Die Erfahrungen evangelischer Rußlanddeutscher in der Sowjetunion zu Zeiten äußerster Entfremdung und Entwurzelung, in: *Tauwetter, Eiszeit und gelenkte Dialoge*, Karl Eimermacher and Astrid Volper (eds.), Paderborn 2006, 1005–1032.

It is important that Jesus
continues to walk with us

Heinrich Nazarenus, *Gottesdienstbuch*, 1948

Ordnung des Gottesdinstes

Der Anfang zum heutigen Gottes-
dienst geschehe im namen Gottes
des Vaters des Sohnes und des Heili-
gen Geistes. amen mit dem Lied. N°
Verlesung der Lektion: ?
Ehre sei dem Vater und dem Sohne
und dem heiligen Geiste. amen
Gesang: Wie es war am anfang wie es ist
und sein wird von Ewigkeit zu
Ewigkeit amen.
In dem Herrn geliebte; wir sind
hier versamelt Gott im geist und
in der Wahrheit Anzubeten, ihm
für alle seine wohltaten zu danken
und ihn um alles was uns an
Leib und Seele Not tut zu bitten;
so lasset uns zuvor im bewustsein
unserer unwürdigkeit, ihm

JOSEPH RATZINGER

THEOLOGIAN AND POPE EMERITUS,
GERMANY, B. 1927

Joseph Ratzinger's biographers describe the details of the pontiff's birth with greater precision than usual. Pope Benedict XVI was: 'Born Joseph Aloisius Ratzinger on Holy Saturday, 16 April, at 4.15 a.m. in Marktl am Inn, Upper Bavaria, in the rural district of Altötting, in the dioceses of Passau, christened at 8.30 a.m. on the same day.'

He began studying philosophy and theology in 1946, and was ordained a priest in 1951. Following a university career as a professor of dogmatic theology and history of dogma, Ratzinger was appointed first Archbishop of Munich and then Cardinal in rapid succession in 1977. In 1981, Pope John Paul II appointed him Prefect of the Congregation for the Doctrine of the Faith and President of the Pontifical Biblical Commission and the International Theological Commission. He was elected Pope on 19 April 2005 and took the name Benedict XVI. He omitted the tiara, the symbol of worldly power, in the coat of arms, and had it replaced by a simple mitre. In 2006, he abolished the title of 'Patriarch of the West'. He wrote four encyclicals and a three-volume history on the life of Jesus. On 11 February 2013, following a reign of eight years, he announced his retirement, the second reigning pontiff to do so in the history of the papacy – a decision with far-reaching consequences for the papal office.

As Prefect of the Congregation for the Doctrine of Faith, Ratzinger took an interest in ecumenism and the Protestant faith. He was the first pope to take part in a Protestant service. He felt most closely connected to the Lutheran churches he saw as not having completely abandoned their Catholic legacy, particularly with regard to Luther's theology of grace, despite all of the differences that divided the two faiths. As a teacher of theology and an academic, he sought dialogue on the interpretation of the fundamental Protestant confession texts. For Ratzinger, the language in Luther's translation of the Bible was the 'real unifying power of Lutheranism'. Ratzinger was Archbishop of Munich and Freising when the 450th anniversary of the Augsburg Confession, written by Philipp Melanchthon and presented to the Emperor in 1530, was celebrated. As the most important Lutheran Confession, the Augsburg Confession was an attempt to prevent a split in the church. Its recognition as an expression of Catholic faith, something the Catholic Church has failed to provide hitherto, is considered a key requirement in overcoming the split between the two faiths. In his writings at the time, Ratzinger called for a contemporary interpretation, which would have to decide between a 'more *ecclesiastical* or more *revolutionary*' approach. In his later *Jesus* trilogy, he addresses the theological issues relating to grace, which clearly show his affinity with certain articles in the Augsburg Confession. Ratzinger, who wrote his doctoral dissertation on St Augustine, shares the understanding to be found in Article 20 of the Augsburg Confession, invoking the Father of the Church, that God's unconditional mercy can only be experienced by faith and is not associated with good works. Like Luther, he sees the sinful individual through Jesus Christ in the mercy of God. Eugen Blume

→ Further reading
Joseph Kardinal Ratzinger: *Salz der Erde. Christentum und katholische Kirche im neuen Jahrtausend. Ein Gespräch mit Peter Seewald*, München 2004 (English translation: *Salt of the Earth: Christianity and the Catholic Church at the End of the Millennium. An Interview with Peter Seewald*, 1997)
Thorsten Maaßen: *Das Ökumeneverständnis Joseph Ratzingers*, Göttingen 2011.
Joseph Ratzinger – Benedikt XVI.: *Jesus von Nazareth, 3 vols.* Freiburg i. Br. 2007–2012 (English translation: *Jesus of Nazareth, 3 vols.*, New York 2007-2012).

In Luther's experience of faith, the focus is on God's mercy towards us.

Joseph Ratzinger, plan for university seminar on dogmatics entitled 'Roman Catholic recognition of the *Confessio Augustana*?', 1976

Univ. Regensburg SS 1976
Fachbereich Kath. Theologie
Prof. Dr. Joseph Ratzinger
Dogmatisches Hauptseminar (11 232)
Katholische Anerkennung der Confessio Augustana?
Lektüre der CA auf dem Hintergrund der neueren Diskussion
2 st., Do 17.15-18.45 PT
6.5., 13.5., 20.5., 3.6., 24.6., 1.7., 8.7., 15.7., 22.7., 29.7.

A. GLIEDERUNG UND BASISLITERATUR

(alle Abkürzungen nach IATG = S.Schwertner, Internationales Abkür-
zungsverzeichnis für Theologie und Grenzgebiete, Berlin-New York
1974)

Texte:

CA, Apologie u.a. in: Die Bekenntnisschriften der evangelisch-lutheri
schen Kirche, 6.Aufl., Göttingen 1967 (lat. und dt.).

Lutherische Bekenntnisse. Textauswahl und Einleitungen: E.Mühl-
haupt, in: Bekenntnisse der Kirche. Bekenntnistexte aus zwanzig
Jahrhunderten, hrg. von H.Steubing in Zusammenarbeit mit J.F.Goeters,
H.Karp und E.Mühlhaupt, Wuppertal 1970, 38-118 (nur deutsch).

Confutatio Confessionis Augustanae, in: CR 27, 81-184 (lat.),
189-228 (dt.)

Tridentinum, Texte in DS

Vatikanum II, Texte in LThK, Erg-Bde. u.a.

Allgemeine Literatur (für alle Referatgruppen einschlägig):

E.Schlink, Theologie der lutherischen Bekenntnisschriften, 2.Aufl.,
München 1946.

L.Grane, Die Confessio Augustana. Einführung in die Hauptgedanken
der lutherischen Reformation, Göttingen 1970 (dän. 1959).

H.Fagerberg, Die Theologie der lutherischen Bekenntnisschriften
von 1529 bis 1537, Göttingen 1965.

Referatgruppen und Referate:

1. Vorgeschichte, Entstehung und Bedeutung der Confessio Augustana

Einleitungen zu den Texten und allgemeine Literatur.

B.Moeller, Augustana-Studien, in: ARG 57 (1966) 76-94 (und die
wichtigste hier angeführte ältere Literatur).

W.Maurer, Ökumenizität und Partikularismus in der Protestantischen
Bekenntnisentwicklung (1931), in: ders., Kirche und Geschichte.
Gesammelte Aufsätze, hrg. von E.-W.Kohls und G.Müller, Göttingen
1970, 186-212.

Ders., Motive der evangelischen Bekenntnisbildung bei Luther und
Melanchthon, in: Reformation und Humanismus. Festschrift Robert
Stupperich, Witten 1969, 9-43.

(1a eventuell: Rezeptionsgeschichte der Confessio Augustana)

- 2 -

II. Referatgruppe: Rechtfertigung

2. Präsentation der Texte

CA (Art. III, IV, VI, XXVIII, XX); dazu die allgemeine Literatur

3. Confutatio und Apologie IV (unter Einbeziehung von Trient)

Confutatio, Apologie (Art.IV), Trient (DS 1520-1583)

4. Die These von V.Pfnür

V.Pfnür, Einig in der Rechtfertigungslehre? Die Rechtfertigungslehre
der Confessio Augustana (1530) und die Stellungnahme der katholi-
schen Kontroverstheologie zwischen 1530 und 1535 (VIEG 60), Wies-
baden 1970. Dazu die Rezensionen.

5. Melanchthon und Luther

Th.Beer, Der fröhliche Wechsel und Streit, Leipzig 1974.

P.Hacker, Das Ich im Glauben bei Martin Luther, Graz 1966.

E.Bizer, Fides ex auditu. Eine Untersuchung über die Entdeckung
der Gerechtigkeit Gottes durch Martin Luther, 3.Aufl., Neukirchen-
Vluyn 1966.

(III. Referatgruppe eventuell: Kirche und kirchliches Leben)
CA (Art. VII, VIII, XIII, XV, XXI, XXIII)

IV. Referatgruppe: Kirchliches Amt

6. Confessio Augustana und Apologie

CA (Art. V, XIV, XXVIII), Apologie

7. Confutatio, Trient und Vatikanum II

Confutatio, Trient (DS 1763-1778), Vatikanum II

V. Referatgruppe: Eucharistie

8. Confessio Augustana und Apologie

CA (Art. X, XXII, XXIV), Apologie

9. Confutatio und Trient

Confutatio, Trient (DS 1635-1661, 1725-1734, 1738-1759, 1760)

10. Luther

Eucharistieverständnis in: De captivitate Babylonica ecclesiae
praeludium (1520) und Formula missae et communionis pro ecclesia
(1523)

VI. Referatgruppe: Auswertung

11. Der Beschluß von Teil1 und Teil 2 der CA in seinem Verhältnis
zum Text und zur Vorrede der Schmalkaldischen Artikel (mit
Melanchthons Vorbehalt bei der Schlußunterzeichnung)

CA (Bekenntnisschriften 83c-83d, 133-137)
Schmalkaldische Artikel (ebd. bes. 429-433, 463f)

- 3 -

12. Die These von V.Pfnür zur Anerkennung der Confessio Augustana
und deren Diskussion

V.Pfnür, Anerkennung der Confessio Augustana durch die katholische
Kirche? Zu einer aktuellen Frage des katholisch-lutherischen
Dialogs, in: Int.kath.Zeitschr. "Communio" 4 (1975) 298-307.

Stellungnahmen von P.Hacker ebd. 5 (1976) 95f; Th.Beer-M.Habitzkij,
ebd. 189-192.

Replik von V.Pfnür ebd. 5 (1976) (erscheint demnächst)

13. Das Einigungsmodell des Bundes für evang.-kath.Wiedervereinigung

Bausteine für die Einheit der Christen 15 (1975) Heft 58, 9-20,
Heft 59, 3-22.

B. BIBLIOGRAPHISCHE HINWEISE

Die einschlägigen Lexika, Editionen und Handbücher findet man bei:
A.Raffelt, Proseminar Theologie. Einführung in das wissenschaftliche
Arbeiten und in die theologische Buchkunde (Theologisches Seminar),
Freiburg-Basel-Wien 1975, 125ff, 138ff, 145f, 148ff.

Bibliographien:

I. Reformationszeit

BDG (Lit. bis 1960)
IOB
ARG (seit 1972: Beiheft-Literaturbericht)
RHE
ThRv
AHP
LuJ

II. Ökumenische Theologie

IOB (Lit. 1962 bis zuletzt 1969)
ThRv
EThL
außerdem in Fachzeitschriften (US, ÖR, Cath(M), Irén., Ist., JES,OiC)

C. TECHNISCHE HINWEISE

Die Referate dürfen insgesamt höchstens 5 Seiten (DIN A 4, Schreib-
maschine engzeilig!) umfassen.

Sie müssen spätestens 1 Woche vor Seminartermin (fertig geschrieben)
abgegeben werden.

Sie werden allen Teilnehmern vervielfältigt zur Verfügung gestellt.
Sie müssen enthalten: eine Darstellung des Themas (Inhaltsverzeich-
nis, Literaturverzeichnis, Text, Anmerkungen) und eine thesenartige
Zusammenfassung, - dies alles auf der Grundlage einer eigenen Text-
analyse im Zusammenhang mit der angeführten Basisliteratur und der
mit Hilfe der bibliogr.Hinweise selbst gefundenen Literatur.

Protokolle dürfen höchstens 1 Seite (engzeilig) umfassen.

Die Seminarnote setzt sich zusammen aus der Benotung des Referates
und der Mitarbeit im Seminar.

Die Basisliteratur steht im Semesterapparat Prof. Ratzinger.

JOHN WOO
FILM DIRECTOR,
CHINA, B. 1946

Virtuosic mastery of the tropes of gangster movies plus a decidedly Christian attitude to the moral principles that come into play in this genre are the backbone of the films of Hong Kong director John Woo. His output in the 1980s and 1990s could even be described as a genre in its own right: spectacular action movies with complex morals, characters and emotional depths. He has never tried to disguise the fact that he sees himself above all as a religious film-maker, possibly even a missionary of sorts, with a message of peace and love for the world. In view of the extreme outbursts of violence in his films, their positively balletic shoot-outs and stylised explosions, that self-image may seem surprising or even downright irritating. But any irritation only ensues from a fundamental misreading of Woo's intentions: his aim is to romanticise not the violence but the heroes in his action movies. For Woo, brutality on the big screen is a means to demonstrate that the worst violence, even evil, can be transcended by love of one's neighbour and nobility of spirit.

The backdrops of his films – the darkest depths of the Hong Kong underworld – and the heroisation of ruthless contract killers reflect in fact a positively Lutheran concept of grace. The 'works' of his protagonists will not determine whether they will receive God's grace or not; the director's focus here is on their faith – a faith that they themselves cannot put into words, but which comes across through the camera lens, above all in Woo's frequent use of close-ups. His approach is rooted in his own background: after fleeing from mainland China to Hong Kong his family spent years on the streets in abject poverty. It was only a true 'gift of grace' from a Lutheran couple in the United States that put the family back on its feet again; the American couple also paid John's fees at a Christian school for six years. Filled with the desire to do justice to that unexpected gift, he decided that after school he would train to become a missionary. However, aware of his love of film, his teachers advised him to pursue a career in the arts. This may well have been a second gift of grace for John Woo in the short span of his life so far.

One of his most famous gun battles – which he later cited in *Mission: Impossible II* – is fought out in a church in *The Killer* (1989). The house of God is progressively destroyed by gunfire; white doves flutter around the combatants. The destruction of the church and the dying men symbolise the hell Woo's protagonists lived in – a hell that was of their own making as the inexorable consequence of their violent lives. The doves, so often seen in Woo's movies, represent not only the indestructible ties between humans and God but also the good that is in his characters and, hence, their ultimate salvation.

Tim Lindemann

→ Further reading

Christopher Heard: *Ten Thousand Bullets. The Cinematic Journey of John Woo*, Los Angeles 2000.
Michael Bliss: *Between the Bullets. The Spiritual Cinema of John Woo*, Lanham 2002.
John Woo. Interviews, Robert K. Elder (ed.), Mississippi 2005.

God is welcoming, no matter if it's a good man
or a bad man, everyone is welcome.

Scene from: John Woo, *The Killer*, 1989

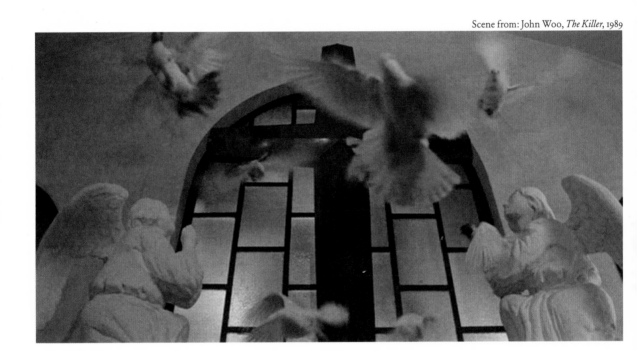

LIST OF EXHIBITED WORKS WITH PHOTOGRAPH CREDITS*

95 TREASURES CHAPTER 1
LUTHER'S INNER TRANSFORMATION

* Unless otherwise stated, all reproductions
 were provided by the lenders.

Martin Luther's *95 Theses*
Printer: Jacob Thanner, Leipzig 1517
Original title: Amore et studio elucidande veritatis. Hec subscripta disputabuntur Wittenburge Presidente R. P. Martino Luther Eremita / no AugUstiano Artiu[m] S. Theologie Magistro …
Letterpress on paper, 40 × 28 cm
Biblioteka Uniwersytecka, Wrocław
[On display from May to August 2017, not illustrated here]

101 Anonymous master from the Cranach Workshop
The Mass of St Gregory with Cardinal Albrecht of Brandenburg
1520–30
Oil on panel, paint layers transferred to a new panel, 150.2 × 110 cm
Bayerische Staatsgemäldesammlungen, Alte Pinakothek, Munich, inv. no. 6270
Photo: © bpk/ Bayerische Staatsgemäldesammlungen

103 Franz Timmermann
Fall and Redemption
c.1540
Oil on pine panel, 55 × 59.2 cm
Wallraf-Richartz Museum & Fondation Corboud, Cologne, inv. no. 3475
Photo: © Rheinisches Bildarchiv Köln, rba_c014446

105 Albrecht Dürer
Man of Sorrows by the Column
1509
Sheet from the 'Engraved Passion'
Copper engraving, 11.9 × 7.5 cm
Kunstsammlungen der Veste Coburg, inv. no. I,15,3
[On display from May to August 2017]

 Albrecht Dürer
Man of Sorrows by the Column
1509
Sheet from the 'Engraved Passion'
Copper engraving, 11.8 × 7.4 cm
Kupferstich-Kabinett, Staatliche Kunstsammlungen Dresden, inv. no. A 733
[On display from August to November 2017, not illustrated here]

107 Erasmus of Rotterdam
Annotations to the New Testament
Printer: Johann Froben, Basel 1519, second edition
Original title: DES. ERASMI RO / TERODAMI IN NOVVUM TESTAMENTVM / ab eodem denuo recognitum, Annotationes, / ingenti nuper accessione per auto / rem locupletatae. / BASILEA ANNO M.D.XIX.
Letterpress on paper, 32.5 × 22 × 5 cm
Stiftung Luthergedenkstätten in Sachsen-Anhalt, inv. no. Kn fl 171/241
Photo: Thomas Bruns

109 *Ecclesia and Synagoga*
Liebfrauenkirche Trier, 13th century
Stone and plaster, 190,192 × 49,44 × 40,38 cm
Museum am Dom, Trier
Photos: © Rheinisches Bildarchiv Köln, rba_113852 and 113851
[Copies on display]

111 *Martin Luthers personal copy of a Hebrew Bible with annotations*
Printer: Gersom ben Moshe Soncino, Brescia 1494
Letterpress on paper, 17 × 11.5 × 7 cm
Staatsbibliothek zu Berlin – Preußischer Kulturbesitz, Hand-schriftenabteilung, shelf mark 8° Inc. 2840, Bl. 4 v – 5 r

113 *Panel from the Vlíněves Altar with St Adalbert and Jan Hus*
Bohemian School, after 1510
Oil on panel, transferred to canvas, 68 × 48.5 cm
The Lobkowicz Collections, Nelahozeves, Prague, inv. no. LR 5144

115 Martin Luther
On the Freedom of a Christian
Printer: Johann Rhau-Grunenberg, Wittenberg 1520
Original title: Von der Freyheyt eynisz Christenmenschen. Martinus Luther. Vuittembergae. Anno Domini 1520.
Letterpress on paper, 19.8 × 15 × 0.5 cm
Stiftung Luthergedenkstätten in Sachsen-Anhalt, inv. no. Kn D 69

117 Martin Luther
On the Babylonia Captivity of the Church
Printer: Melchior Lotter the Younger, Wittenberg 1520
Original title: DE CAPTIVITATE BABYLONICA ECCLESIAE, Praeludium Martini Lutheri. Vuittembergae.
Letterpress on paper, 21.2 × 15.4 × 0.5 cm
Stiftung Luthergedenkstätten in Sachsen-Anhalt, inv. no. Ag 4° 191c

119 Leo X
Bull Threatening Excommunication
Papal Bull *'Exsurge Domine'*, 15 June 1520
Printer: Giacomo Mazzochi, Rome, 1520
Letterpress on paper, 18.8 × 14 cm
Landesarchiv Thüringen – Hauptstaatsarchiv Weimar, shelf mark LATh-HStA Weimar, Ernestinisches Gesamtarchiv, shelf mark Reg. N. 13 Bl. 1–10

121 *Luther's cowl*
Wittenberg, first half of the 16th century
Woollen cloth, length 145 cm
Stiftung Luthergedenkstätten in Sachsen-Anhalt, inv. no. K 373
Photo: Thomas Bruns

131 *Piggy bank*
 16th century
 Location of find Altmarkt, Dresden
Earthenware, green glaze, 4 × 10 × 3.5 cm
Landesamt für Archäologie Sachsen, inv.no. S.: 215/64
Photo: © Landesamt für Archäologie Sachsen, Ursula Wohmann

133 *Tough-pitch copper ingot*
 Germany, 16th century
Copper, diameter c.47–49 cm
Mansfeld-Museum im Humboldt-Schloss Hettstedt,
inv. no. 5497/16/5419
Photo: Sebastian Görtz, Erlebniswelt Museen e.V.

135 *Tripod cooking pots from Martin Luther's birth house*
 Central Germany, c. 1500
Earthenware, glazed, height 16–20 cm, rim diameter 14–16.5 cm,
base diameter 16–20 cm, lid: height 6 cm, diameter 13 cm
Landesamt für Denkmalpflege und Archäologie – Landesmuseum
für Vorgeschichte – Sachsen-Anhalt, inv. no. 2004:9232a/8, 10, 15,
16, 20, 29; 2004:9232f/29
Photo: © Landesamt für Denkmalpflege und Archäologie
Sachsen-Anhalt, Juraj Lipták

137 *Two Witches Cooking up a Storm*
 Printer: Arnoldus de Colonia, Leipzig 1495
Woodcut illustration from *De lamiis et phitonicis mulieribus*
by Ulrich Molitor
Letterpress and woodcut on paper, 21.3 x 13.8 cm
Herzog August Bibliothek Wolfenbüttel, shelf mark A: 64.11 Quod. (4)
[Facsimile on display]

139 *Figure of the Christ Child from Martin Luther's*
 birth house in Eisleben
 Central Germany, first half of the 16th century
Earthenware, white, 4.3 × 2 cm
Landesamt für Denkmalpflege und Archäologie – Landesmuseum
für Vorgeschichte – Sachsen-Anhalt, inv.no. 1034:7:453
Photos: © Landesamt für Denkmalpflege und Archäologie
Sachsen-Anhalt, Andrea Hörentrup

141 *Marbles and bird-shaped whistle from*
 Martin Luther's birth house
 Mansfeld, Central Germany, c.1500
Earthenware, diameter marbles c.1.1–1.5 cm,
height bird-shaped whistle 6.5 cm
Landesamt für Denkmalpflege und Archäologie – Landesmuseum
für Vorgeschichte – Sachsen-Anhalt, inv. no. 2004:9232g/3–5,
2004:9232g/10
Photos: © Landesamt für Denkmalpflege und Archäologie
Sachsen-Anhalt, Juraj Lipták

143 *Punishment paddle*
 Lübeck, 14th century
Wood, length 53 cm
die Lübecker Museen – St. Annen-Museum, inv. no. 1589 a–f
Photo: St. Annen-Museum/ Fotoarchiv der Hansestadt Lübeck

145 *Epitaph for Martin Luther's teacher Lehrer Johannes Ledener*
 Mansfeld, Central Germany, 1505
Non-ferrous metal, 22 × 34 × 0.5 cm
Evangelische Kirchengemeinde Mansfeld
Photo: Hagen Immel

147 Wendelin Tieffenbrucker, aka Vendelio Venere
 Lute
 Padua, c.1580,
 modified: Joseph Joachim Edlinger, Prague, 1732
Wood, gut strings and ivory, 112.5 × 35 × 35 cm
Museum für Musikinstrumente Leipzig, inv. no. 492
Photo: Marion Wenzel, Universität Leipzig

149 Paul Müllner the Elder (attributed)
 Large sceptres from the University of Wittenberg
 Nuremberg, 1509
Silver, partly fire-gilded, length 87 cm each
Zentrale Kustodie der Martin-Luther-Universität Halle-Wittenberg,
inv. no. MLU-Ku 2 A, MLU-Ku 2 B
Photo: Markus Scholz

157 Lucas Cranach the Elder
 Martin Luther Wearing a Doctor's Cap
 1521–24
Mixed media on panel, 40.3 × 26.5 cm
Private collection
Photo: Human Bios International AG

159 *Pomander*
 Rhineland or Northern Germany, late 15th century
Silver, perforated, engraved, partially gilded, and enamel,
diameter 5 cm
Bayerisches Nationalmuseum, Munich, inv. no. MA 3072
© Bayerisches Nationalmuseum, photo: Marianne Stöckmann
(open pomander)

161 *Animal bones from Martin Luther's birth house*
 Mansfeld, Central Germany, first half of the 16th century
2.2–11.2 cm
Landesamt für Denkmalpflege und Archäologie – Landesmuseum
für Vorgeschichte – Sachsen-Anhalt, inv. no. 2004:9232 s/90
Photo: © Landesamt für Denkmalpflege und Archäologie
Sachsen-Anhalt, Juraj Lipták

163 *Toilet seat*
 Konstanz, late Middle Ages
Wood, 117.5 × 32 cm
Archäologisches Landesmuseum Baden-Württemberg, Konstanz,
inv. no. 1996-40-9008-1
Photo: Matthias Hoffmann

191 Lucas Cranach the Elder (workshop)
The Holy Trinity
c.1516–18
Oil on hardwood panel, 41 × 28 cm
Kunstsammlungen der Veste Coburg, inv. no. M.158

193 *Johann von Staupitz*
Anonymous, c.1520
Tempera on panel, 52 × 41.7 cm
Kunstsammlungen der Erzabtei St. Peter, inv. no. M 863

195 Lucas Cranach the Elder
Charity
after 1536
Oil on panel, 50.2 × 33 cm
Musée national d'histoire et d'art Luxembourg, inv. no. 1948-003/001
Photo: MNHA/ Tom Lucas

197 *Saint Elizabeth*
c.1510, Aschaffenburg
Limewood, carved and painted in polychrome, height 107 cm
Museen der Stadt Aschaffenburg, inv. no. MSA Dep. 1/1955

199 Ovid
Remedia amoris
Printer: Jacob Thanner, Leipzig 1503
Original title: Publii Ouidii Nasonis Sulmonensis duo libri
continentes Remedia amoris
Letterpress on paper, 21.5 × 16cm
Universitätsbibliothek Leipzig, shelf mark Poet.lat. 195-m

201 Lucas Cranach the Elder
Venus with Cupid Stealing Honey
1530
Mixed media on beech panel, 58 × 38 cm
Statens Museum for Kunst, Kopenhagen, inv. no. KMSsp719
Photo: Statens Museum for Kunst, Kopenhagen, www.smk.dk,
public domain

203 Albrecht Dürer
Madonna and Child at the Breast
1503
Oil on lime panel, 24.1 × 18.3 cm
Kunsthistorisches Museum Wien, Gemäldegalerie, inv. no. GG 846
Photo: © akg-images/ Erich Lessing

205 Lucas Cranach the Elder
Katharina von Bora
c.1525
Oil and tempera on beech panel, diameter 11 cm
Staatliche Museen zu Berlin, Gemäldegalerie, inv. no. 637
© Staatliche Museen zu Berlin, Preußischer Kulturbesitz, photo:
Volker-H. Schneider

207 *Gold ring from the Luther House Wittenberg*
First half of the 16th century
Gold, cast and with repoussé decoration, height 2.4 cm,
diameter 1.9 cm
Landesamt für Denkmalpflege und Archäologie – Landesmuseum
für Vorgeschichte – Sachsen-Anhalt, inv. no. 667:130:1
Photo: © Landesamt für Denkmalpflege und Archäologie
Sachsen-Anhalt, Juraj Lipták

215 Lucas Cranach the Elder
Portrait of Hans Luther
1527
Body colour on oil-soaked paper, 19.6 × 18.2 cm
Albertina, Vienna, inv. no. 26156
Photo: © akg-images
[Not on display]

217 Hermann Bote
Till Eulenspiegel
Printer: Johannes Grieninger, Straßburg, 1519
Origina title: Ein kurtzweilig lesen von Dil Ulen / spiegel geboren
vß dem land zû Brunßwick. Wie er / sei[n] leben volbracht hat.
xcvi. seiner geschichten.
Letterpress and woodcut on paper, 18.5 × 13.5 × 2 cm
Forschungsbibliothek Gotha der Universität Erfurt, shelf mark
Poes 8° 2014/5
Photo: © Forschungsbibliothek Gotha der Universität Erfurt
[On display from May to August 2017]

Hermann Bote
Till Eulenspiegel
Printer: Melchior Sachs, Erfurt 1532
Original title: Ein kurtzweilig lesen von Dil Ulen / spiegel geboren
vß dem land zû Brunßwick. Wie er / sei[n] leben volbracht hat.
xcvi. seiner geschichten.
Letterpress and woodcut on paper, 20.5 × 15.7 × 2.3cm
Bayerische Staatsbibliothek, Munich, shelf mark Rar. 1641
[On display from August to November 2017, not illustrated here]

219 *St George Fighting the Dragon*
Mansfeld, Central Germany, before 1497
Limewood (relief) and oakwood (case), 132 × 132 × 24 cm
Evangelische Kirchengemeinde Mansfeld
Photo: Thomas Bruns

221 Hans Herman after a drawing by
Hans Holbein the Younger
Martin Luther as Hercules Germanicus
1519 or 1522
Woodcut, coloured, with letterpress, 34.5 × 22.6 cm
Pasted into: Heinrich Brennewald and Johannes Stumpf: *Schweizer
Chronik*, Zentralbibliothek Zürich, shelf mark Ms. A2, S. 150
[Facsimile on display]

289 *Martin Luther's last will and testament*
Wittenberg, 6 January 1542
Manuscript on paper, 34 × 21 cm
Evangélikus Orzágos Múzeum, Budapest
[On display from August to November 2017]

 Martin Luther's last will and testament
 1542, contemporary copy with annotation by
 Philipp Melanchthon
Manuscript on paper, 31.5 × 21.4 cm
Landesarchiv Thüringen – Hauptstaatsarchiv Weimar, shelf mark
LATh-HStA Weimar, Ernestinisches Gesamtarchiv, shelf mark Reg.
N 182, Bl. 10–14
[On display from August to November 2017, not illustrated here]

291 Lucas Cranach the Elder
 The Golden Age
 c.1530
Oil on oak panel, cradled, 75 × 103.5 cm
Nasjonalmuseet for kunst, arkitektur og design, Oslo,
inv. no. NG.M.00519
Photo: Anne Hansteen Jarre/ Nasjonalmuseet for kunst, arkitektur
og design/ The National Museum of Art, Architecture and Design

The portraits of the People presented on pages 300 to 576 are not dis-
played in the exhibition.

300 Albert Edelfelt, *Mikael Agricola*, in: Zachris Topelius:
Lukemisia lapsille, 1907, photo: National Library of Finland

301 Mikael Agricola
 ABC Book
 c.1549
Original title: Abckiria
Letterpress on paper, fragment, 15 × 11.4 × 0.3 cm
Uppsala universitetsbiblioteket, shelf mark Sv. Rar. 10:233
Photo: The national portal Alvin, developed and maintained by
Uppsala University Library in cooperation with Gothenburg
University Library and Lund University Libraries [http://www.
alvin-portal.org]

302 Antoine Pesne, *August Hermann Francke*, c.1750,
© Franckesche Stiftungen zu Halle, photo: Klaus E. Göltz

303 *Model of Francke's orphanage and adjacent buildings*
 First third of the 18th century
Wood, pasteboard, straw, 31 × 86 × 58 cm
Kunst- und Naturalienkammer, Franckesche Stiftungen zu Halle
an der Saale, shelf mark R-Nr. 1111
© Franckesche Stiftungen zu Halle, photo: Klaus E. Göltz

304 *Fyodor Mikhailovich Dostoyevsky*, c.1879, photo: © bpk

305 Fyodor Dostoyevsky
 A Writer's Diary
 1877
Manuscript for typesetting, hand-written by Anna Grigoryevna
Dostoyevskaya, numbering and corrections by Fyodor Dosto-
yevsky
Paper, lined, written both sides, 21.2 x 13.9 cm
Pushkinsky Dom, Institute of Russian Literature, St. Petersburg,
shelf mark 29481

306 *Karl May*, c.1910, photo: © akg-images

30 *Winnetou III*
 1965
Film (excerpt), 1965, director: Harald Reinl
Rialto Film GmbH
Photo: © ullstein bild – Röhnert
[Film still illustrated here]

Oskar Max Fuchs
Karl May's 'Silver Gun' (original, duplicate)
1896, 1920
Wood, iron and brass tacks, length 119.5 cm
Karl-May-Museum Radebeul
Photo: © Photoatelier Meissner, Radebeul

308 *Wilhelm II*, c.1910, photo: © bpk/ Neue Photographische
Gesellschaft

309 *Protector medal of the Order of St John with Marian Cross
of the German Order from the estate of Wilhelm II*
Goldsmith to the court of Berlin, 1913
Gold, enamel paint, translucent enamel, 11.5 × 6.5 cm
Property of the House of Hohenzollern, SKH Georg Friedrich
Prinz von Preußen, Burg Hohenzollern
Photo: Verwaltung Burg Hohenzollern, Roland Beck

310 *Frieda Keysser*, 1894/95, photo: Strehlow-Wieckert private
collection, Berlin

311 Frieda Keysser
Diary
1898–1957
Abridged version
Manuscript on paper, open 21.4 × 33 × 2 cm
Strehlow-Wieckert private collection, Berlin
Photo: Thomas Bruns

Frieda Keysser
Diary
1898–1917
Manuscript on paper, 25.5 × 20.5 × 2.1 cm
Strehlow-Wieckert private collection, Berlin
Photo: Thomas Bruns

312 *Elisabeth Noelle-Neumann*, 1976, photo: © ullstein bild
– Sven Simon

313 Elisabeth Noelle-Neumann
Die Schweigespirale
Langen-Müller, Munich 1980
Offset on paper, 22 × 14 × 3.5 cm
Private collection

Elisabeth Noelle-Neumann
Die Schweigespirale
before 1980
Manuscript on paper, 29.7 × 21 cm
Private archives of Elisabeth Noelle, Piazzogna

314 *Martin Luther King*, 1967, photo: © akg-images/ AP

315 *Posting of Martin Luther King's List of Demands
on the door of Chicago City Hall*
10 July 1966
Photograph
John Tweedle Foundation
Photo by John Tweedle @John Tweedle Foundation. All Rights
Reserved

322 Albrecht Dürer, *Self-portrait with Fur-Trimmed Robe*, 1500,
photo: © bpk/ Bayerische Staatsgemäldesammlungen

323 Albrecht Dürer
The Last Supper
1523
Woodcut, 21.2 × 29.8 cm (trimmed)
Kupferstich-Kabinett, Staatliche Kunstsammlungen Dresden,
inv. no. A 1878-2
Photo: Herbert Boswank
[On display from August to November 2017]

Albrecht Dürer
The Last Supper
1523
Woodcut, 21.5 × 30.4 cm
Staatliche Museen zu Berlin, Kupferstichkabinett, inv. no. B-195
[On display from May to August 2017, not illustrated here]

324 Lucas Cranach the Younger, *The Last Supper*, 1565, detail,
original in St. Johanniskirche in Dessau, photo: Jürgen M. Pietsch,
Spröda, courtesy of St. Johanniskirche in Dessau

325 Lucas Cranach the Younger
Man of Sorrows
after 1537
Oil on beech panel, 85.5 × 57.5 cm
Kunstsammlungen der Veste Coburg on permanent loan from
the Oberfrankenstiftung, inv. no. M.419
Photo: Kunstsammlungen der Veste Coburg

326 *Henry Melchior Mühlenberg*, after a portrait by Jacob
Eichholtz, c.1880, photo: The Preservation Society of Newport
County

327 Carl Heinrich von Bogatzky
Güldenes Schatz=Kästlein der Kinder Gottes
Halle an der Saale 1761
Letterpress on paper, 9.5 × 11 × 7 cm
Courtesy of the Krauth Memorial Library, The Lutheran Theolog-
ical Seminary at Philadelphia, inv. no. BV 4810.B64

328 Eduard Magnus, *Felix Mendelssohn Bartholdy*, 1846, photo:
© bpk/ Staatsbibliothek zu Berlin

329 *Metronome from the estate of Felix Mendelssohn Bartholdy*
19th century
Wood and metal, 22.5 × 11 × 11 cm
Staatsbibliothek zu Berlin – Preußischer Kulturbesitz, Musikabtei-
lung mit Mendelssohn-Archiv, shelf mark MA BA 20

Felix Mendelssohn Bartholdy
Symphony No. 5, Op. 107 'Reformation'
1830
Green half-leather binding with gilt spine, manuscript on manu-
script paper, 31.5 × 23 cm
Staatsbibliothek zu Berlin – Preußischer Kulturbesitz, Musikab-
teilung mit Mendelssohn-Archiv, shelf mark Mus.ms.autogr.
Mendelssohn Bartholdy, shelf mark F. 26, Faszikel 1, Bl. 3-10
[On display from May to August 2017]

Felix Mendelssohn Bartholdy
Verleih uns Frieden gnädiglich
1831, chorale, MWV A 11
Manuscript on manuscript paper, 22 × 29 cm
Staatsbibliothek zu Berlin – Preußischer Kulturbesitz, Musikab-
teilung mit Mendelssohn-Archiv, shelf mark Mus.ms.autogr.
Mendelssohn Bartholdy, F. 23, Faszikel 1, Bl. 3–10

330 *Friedrich Nietzsche*, c.1875, photo: © akg-images

331 *Nietzsche family's Luther Bible*
Printer: Cansteinische Bibel-Anstalt, Halle an der Saale 1818
Original title: Die Bibel, oder die ganze Heilige Schrift des
alten und neuen Testaments / nach der deutschen Uebersetzung
D. Martin Luthers
Letterpress on paper with inscription by Friedrich Nietzsche on p. 1,
33 × 13.5 × 8.5 cm
Klassik Stiftung Weimar, Herzogin Anna Amalia Bibliothek,
shelf mark C 338
Photo: Klassik Stiftung Weimar, 2012

Friedrich Nietzsche
Also sprach Zarathustra
Insel-Verlag, Leipzig 1908
Original title: Also sprach Zarathustra. Ein Buch für alle
und keinen
Letterpress on paper, 38 × 26 × 3 cm
Klassik Stiftung Weimar/ Herzogin Anna Amalia Bibliothek,
shelf mark 7341-C
Photo: Klassik Stiftung Weimar, 2012

*Volume nine of the collected works of
Johann Wolfgang von Goethe* (from Nietzsche's library)
Cotta, Stuttgart and Augsburg 1854
Letterpress on paper, 15.8 × 11.6 × 3 cm
Klassik Stiftung Weimar, Herzogin Anna Amalia Bibliothek,
shelf mark C 581-e[1]
Photo: Klassik Stiftung Weimar, 2012

332 *Paulina Dlamini*, possibly 1938, photo: Archiv des ELM
Hermannsburg, HMIN G 11

333 Heinrich Filter
Ich diente zwei Herren
before 1969
Typescript, 27.7 x 21 cm
Killie Campbell Collections, University of KwaZulu-Natal,
South Africa
[Facsimile on display]

334 *Paul Althaus*, between 1958 and 1963, photo: Sonntagsblatt/
Archiv

335 *Harmonium from the estate of Paul Althaus*
Story u. Clark, Chicago; in the family estate since 1894
Wood, velvet, ivory, 142 × 120 × 62 cm
Private collection of Eberhard Petersen, Bonn
Photo: Mirja Karoline Petersen

336 *Walter A. Maier*, 1947, photo: courtesy of Concordia
Historical Institute, St. Louis, Missouri

337 *The Lutheran Hour*
after 1930
Promotional postcard, 8.3 × 14 cm
Private collection
Photo: Thomas Bruns

Carbon microphone from the studio of 'The Lutheran Hour'
c.1920
Metal, 20.32 × 16.51 × 13.97 cm
Concordia Historical Institute St. Louis, Missouri
Photo: courtesy of Concordia Historical Institute,
St. Louis, Missouri

344 Antoine Pesne, *Friedrich Wilhelm I*, 1729, photo: © bpk/
Stiftung Preußische Schlösser und Gärten Berlin-Brandenburg

345 Friedrich Wilhelm I
Politisches Testament
Potsdam, 17 February 1722
Manuscript on paper, 24 × 19 cm
Geheimes Staatsarchiv Preußischer Kulturbesitz, Berlin,
shelf mark BPH Urkunden III 1, Nr. 19 Politisches Testament
Friedrich Willhelm I

*Chair from Friedrich Wilhelm I's Tabakskollegium
('smoking circle')*
Berlin, before 1740, covered in the 19th century
Wood, partly turned, varnished, 118.5 × 61.5 × 43 cm
Property of the House of Hohenzollern, SKH Georg Friedrich
Prinz von Preußen, Burg Hohenzollern, inv. no. Schloss
Grunewald, Raum-Nr. 9
Photo: Thomas Bruns

346 *Käthe Kollwitz*, c.1915, photo: © bpk/ Hänse Herrmann

347 Käthe Kollwitz
The Ploughmen
1906
Plate 1 from the *Peasants' War* cycle
Etching and aquatint, 30.5 × 44.4 cm
Sprengel Museum Hannover, inv. no. PHz 1483
Photo: © bpk/ Sprengel Museum Hannover/ Michael Herling/
Benedikt Werner/ Aline Gwose

348 *Jochen Klepper*, c.1937, photo: © akg-images

349 *Jochen Klepper's nib with envelope inscribed:*
 'It was with this nib that I began to write "Das ewige Haus"'
 before 1942
Metal, manuscript on paper, envelope 11.4 x 16 cm,
length of nib 4.2 cm
Deutsches Literaturarchiv Marbach, shelf mark 77.4137
© DLA Marbach, photo: Jens Tremmel

350 *Astrid Lindgren*, 1978, photo: © akg-images/
TT News Agency

351 Astrid Lindgren
 Emil and his Clever Pig
 1970
Original title: Än lever Emil i Lönneberga
Typescript with handwritten notes, 29.7 × 21 cm
Kungliga biblioteket Stockholm, shelf mark L 230:4:1:4

 Emil and the Piglet
 1973
Original title: Emil och griseknoen
Film (excerpt), director: Olle Hellbom
© Studio 100 Media
[Film stills illustrated here]

352 *Axel Springer*, c.1970, photo: © akg-images

353 *Portrait of Martin Luther from the estate of Axel Springer*
 Anonymous, 18th century
Reverse glass painting, 31 × 24 cm
Axel Springer SE, Berlin

354 *José Míguez Bonino*, August 1976, photo: World Council of
Churches, Van Appelghem, A 738-24

355 *Typewriter from the estate of José Míguez Bonino*
 20th century
9 × 30 × 33 cm
Private collection
Photo: Néstor Míguez

356 *Michael Haneke*, 2009, photo: © Eric Catarina/
Gamma-Rapho/ laif

357 *The White Ribbon*
 2009
Film (excerpt), director: Michael Haneke
© X Filme Creative Pool Entertainment GmbH
[Film stills illustrated here]

364 Master John (attributed), *Katherine Parr*, c.1545, photo:
© ullstein bild – Prisma / TPX

365 Katherine Parr
 The Lamentacion of a synner
 Printed: In Fletestrete at the signe of the Sunne ouer
 agaynst the conduyte by Edvvarde VVhitchurche,
 London 1548
Original title: The Lamentacion of a synner, made by the moste
vertuous Lady quene Caterine, bewailyng the ignoraunce of her
blind life: set foorth & put in print at the instant desire of the right
gracious lady Caterine duchesse of Suffolke, and the ernest request
of the right honourable Lord William Parre, Marquesse of
Northampton
Letterpress on paper, 13.7 × 9.7 × 1.2 cm
Folger Shakespeare Library, Washington DC, shelf mark
STC 4828/HH48/21
Photo: Used by permission of the Folger Shakespeare Library
under a Creative Commons Attribution-ShareAlike 4.0
International License

366 *Max Beckmann*, 1948, photo: © akg-images

367 Max Beckmann
 Book of Revelation (21:4)
 1941–42
25th plate from the book *Apocalypse*
Lithograph, hand-coloured, 33.2 × 26.3 cm
Sprengel Museum Hannover, inv. no. Gr. 1965,217,25
© VG Bild-Kunst, Bonn 2017, photo: © bpk/ Staatsgalerie Stuttgart

368 *Sophie Scholl*, before 1943, photo: © Deutsches Historisches
Museum, Berlin

369 *Note by Sophie Scholl on the back of a letter*
 from the Chief Prosecutor of the Reich
 Munich, 21 February 1943
Manuscript on paper, 29.5 x 20.9 cm
Institut für Zeitgeschichte, Munich, shelf mark ED 474
Photos: Institut für Zeitgeschichte, Archiv, IfZArch ED 474 / 3
[Facsimile on display]

370 *Josiah Kibira*, undated, photo: LWF Photo Archives

371 *Bishop Kibira of Bukoba*
 2010
Documentary film (excerpt)
© Kibira Films International
[Film stills illustrated here]

372 *Kwok Pui-Lan*, 2006, photo: Episcopal Divinity School,
Cambridge, Massachusetts, USA

373 *Umbrella from the Occupy Movement in Hong Kong*
 2014
Yellow nylon, length 82 cm, diameter 105 cm
Kwok Pui-Lan, Massachusetts, USA
Photo: Thomas Bruns

95 PEOPLE CHAPTER **4**
BEEING IN THE WORLD

404 Anthony van Dyck (workshop), *Gustav II Adolf of Sweden*, undated, photo: © bpk/ Bayerische Staatsgemäldesammlungen

405 *Gustav Adolf's sword*
Germany, 1625–1630
Worn at the Battle of Lützen 1632
Wood, steel, gilded, gold, 115.6 cm (blade 92.9 cm)
Livrustkammaren, Stockholm, inv. no. 11661
Photo: © Livrustkammaren, Stockholm

Gustav Adolf's coat
not later than 1632
Worn at the Battle of Lützen 1632
Elk leather, 69–79.2cm
Livrustkammaren, Stockholm, inv. no. 31123
Photo: © Livrustkammaren, Stockholm

406 Joseph Karl Stieler, *Johann Wolfgang von Goethe*, 1828, photo: © bpk/ Bayerische Staatsgemäldesammlungen

407 Johann Wolfgang von Goethe
Sketch for a monument marking the anniversary of the Reformation
1817
From the estate of Goethe
Manuscript on paper, 21.2 × 12.4 cm
Klassik Stiftung Weimar, Goethe-und-Schiller-Archiv, shelf mark 25/W 3143, Bl. 7 gamma
[On display from June to August 2017]

Johann Wolfgang von Goethe
Draft of a cantata marking the anniversary of the Reformation
1817
Manuscript on paper, 33,4 × 20,2 cm
Klassik Stiftung Weimar, Goethe-und-Schiller-Archiv, shelf mark 25/W 1853, Bl. 9–11
[On display from August to November 2017
Sheet 10 illustrated here]

Johann Wolfgang von Goethe
Sketch for a monument marking the anniversary of the Reformation
1817
From the estate of Goethe
Manuscript on paper, 33.3 × 20.5 cm
Klassik Stiftung Weimar, Goethe-und-Schiller-Archiv, shelf mark 25/W 3143, Bl. 4 alpha
[On display from May to June 2017, not illustrated here]

408 Gerhard von Kügelgen, *Caspar David Friedrich*, 1806–1809, Photo: © bpk/ Hamburger Kunsthalle/ Elke Walford

409 Caspar David Friedrich
Cross in the Forest
c.1812
Oil on canvas, 42 x 32 cm
Staatsgalerie Stuttgart, acquired 1956, inv. no. 3803
Photo: bpk/ Staatsgalerie Stuttgart
[On display from May to August 2017]

410 *Edvard Munch*, 1933, photo: Anders Beer Wilse/ Norsk Folkemuseum

411 Edvard Munch
Madonna
1895–1902
Lithograph, hand-coloured with chalk and ink wash, 60.5 × 44.2 cm
Staatliche Graphische Sammlung München, inv. no. 229263 D
Photo: © Staatliche Graphische Sammlung München
[On display from May to August 2017]

Edvard Munch
Madonna
1895
Lithograph, chalk, ink wash, with scraper, 60,8 × 44.2 cm
Kupferstich-Kabinett, Staatliche Kunstsammlungen Dresden, inv. no. A 1916-592
[On display from August to November 2017, not illustrated here]

412 *Theodor Seuss Geisel*, 1976, photo: Steve Larson/ Denver Post/ Getty Images

413 Dr. Seuss
Fox in Socks. A Tongue Twister for Super Children
Collins and Harvill, London and Glasgow 1966
Offset on paper, 23.2 × 16.8 cm
Private collection
Photo: Thomas Bruns

Dr. Seuss
The Cat in the Hat
Random House, Boston 1957
Offset on paper, 23.6 × 17.2 cm
Stiftung Luthergedenkstätten in Sachsen-Anhalt, inv. no. s 1195/12180
Photo: Thomas Bruns

Dr. Seuss
Kto zje zielone Jajka Sadzone?
Media Rodzina, Poznań 2004
Offset on paper, 22.5 × 16.5 cm
Stiftung Luthergedenkstätten in Sachsen-Anhalt, inv. no. s 1195/12182
Photo: Thomas Bruns

Dr. Seuss
Prosciutto e uova verdi
Giunti Editore, Florence and Milan 2016
Offset on paper, 22.5 × 15.5 cm
Stiftung Luthergedenkstätten in Sachsen-Anhalt, inv. no. s 1195/12183
Photo: Thomas Bruns

Dr. Seuss
Thidwick the Big-hearted Moose (Japanese edition)
Kaisei-Sha, Tokyo 2009
Offset on paper, 24 × 28 cm
Stiftung Luthergedenkstätten in Sachsen-Anhalt,
inv. no. s 1195/12185
Photo: Thomas Bruns

Dr. Seuss
The Cat in the Hat Comes Back (Hebrew edition)
Keter Publishing, Jerusalem 1979
Offset on paper, 23.3 × 16.8 cm
Private collection
Photo: Thomas Bruns

Dr. Seuss
Horton Hatches the Egg (Russian edition)
Kyrlia-Myrlia, n.p. 2008
Offset on paper, 21.6 × 16.6 cm
Stiftung Luthergedenkstätten in Sachsen-Anhalt,
inv. no. s 1195/12181
Photo: Thomas Bruns

Dr. Seuss
The Sneetches and Other Stories
HarperCollins Children's Books, New York 1998
Druck auf Papier, 22.5 × 16.4 cm
Private collection
[Not illustrated here]

Dr. Seuss
*Quomodo Invidiosulus nomine Grinchus Christi
natalem abrogaverit*
Bolchazy-Carducci Publishers, Wauconda, Illinois 1999
Offset on paper, 27.7 × 20.4 cm
Stiftung Luthergedenkstätten in Sachsen-Anhalt,
inv. no. s 1195/12186
[Not illustrated here]

Dr. Seuss
Il Paese di Solla Sulla
Giunti Editore S. p., Florence and Milan 2005
Offset on paper, 27.9 × 20.1 cm
Private collection
[Not illustrated here]

Dr. Seuss
C'est bon de faire des bonds
Ulysses Press, Berkeley 2015
Offset on paper, 23.5 × 17.1 cm
Stiftung Luthergedenkstätten in Sachsen-Anhalt,
inv. no. s 1195/12184
Not illustrated here

420 Sebastien Bourdon, *Christina of Sweden*, 1653, photo:
© akg-images/ Erich Lessing

421 David Casparsson Kohl
Ceremonial sword for Christina of Sweden
Sweden, 1648
Steel, brass wire, 120.5 × 23.6 cm
Livrustkammaren, Stockholm, inv. no. 5666
Photo: Erik Lernestål, Livrustkammaren, Stockholm

423 *Back-basket (used to smuggle Bibles)*
Upper Austria, 19th century
Wood, 62 × 58 × 37 cm
Evangelisches Museum Oberösterreich, Rutzenmoos

Der Psalter mit kurzen Summarien
Johann Andreas Endterische Handlung, Nuremberg, 1762
Letterpress on paper, 14 × 9 × 3.5 cm
Evangelisches Museum Oberösterreich, Rutzenmoos

Wallner family's certificate of conversion
Gosau, 1781
Print and manuscript on paper, 10 × 16 cm
Evangelisches Museum Oberösterreich, Rutzenmoos

Evangelisch-Augspurgische Kirchenmusic
Printer: Johann Christoph Wagner, Augsburg 1730
Letterpress on paper, 16 × 7 × 3.5 cm
Evangelisches Museum Oberösterreich, Rutzenmoos

D. Martin Luthers Kleiner Katechismus
Christian Gottlob Hilscher, Dresden and Leipzig 1688
Letterpress on paper, 15 × 9 × 4.5 cm
Evangelisches Museum Oberösterreich, Rutzenmoos

Erkandtniß der Warheit zur Gottseligkeit
Johannes Beck, Etrusburg 1722
Letterpress on paper, 22 × 18 × 12.5 cm
Evangelisches Museum Oberösterreich, Rutzenmoos
All photos: © Otto Saxinger, A – 4082 Aschach

424 August Weger, *Ernst Moritz Arndt*, c.1850, photo:
© akg-images

425 Ernst Moritz Arndt
Vaterlandslied (The German Fatherland)
Bound manuscript of Arndt's poetry 1859
Manuscript on paper, 32.3 × 19.5 × 3 cm
Universitäts- und Landesbibliothek Bonn, shelf mark S 819
[On display from May to August 2017]

Ernst Moritz Arndt
Gedichte. Zweiter Theil
Eichenberg, Frankfurt am Main 1818
Letterpress on paper, 20 × 15 × 3 cm
Niedersächsische Staats- und Universitätsbibliothek Göttingen,
shelf mark 8 P GERM IV, 3214:2
[On display from August to November 2017, not illustrated here]

448 *Wanda Deifelt*, December 1998, photo: World Council of Churches, Black, A 7073-64

449 Gilberto Gil
Tropicália ou Panis et Circensis
1968, 2008
Vinyl LP, 31.5 × 31.5 cm
Stiftung Luthergedenkstätten in Sachsen-Anhalt,
inv. no. s 1195/12194
Photo: Thomas Bruns

456 James Posselwhite, *Thomas Hobbes*, 1859, after a painting by William Dobson (1660), photo: akg/ Science Photo Library

457 Thomas Hobbes
Leviathan
Printed: for Andrew Crooke, at the Green Dragon
in St. Pauls Church-yard, London 1651
Original title: LEVIATHAN / Or / THE MATTER, FORME / and
POWER of A COMMON= / WEALTH ECCLESIASTICALL /
and CIVIL / By THOMAS HOBBES / of MALMESBVRY
Letterpress on paper, 27 cm x 17 cm
British Library, London, shelf mark 522.k.6
Photo: © The British Library Board
[Facsimile on display]

458 Bernhard Francke, *Gottfried Wilhelm Leibniz*, undated, © bpk

459 Gottfried Wilhelm Leibniz
Essais de Théodicée
Second half of 1707
Manuscript by scribe with handwritten notes
by Gottfried Wilhelm Leibniz
Manuscript on paper, 31.1 × 19.7 cm
Gottfried Wilhelm Leibniz Bibliothek – Niedersächsische
Landesbibliothek, Hannover, shelf mark LH I, 1, 1 Bl. 21–22

460 Anton Graff, *Heinrich von Kleist*, c.1808, photo: © bpk/
Staatliche Kunstsammlungen Dresden/ Hans-Peter Klut

461 Heinrich von Kleist
Erzählungen. Erster Theil
Realschulbuchhandlung, Berlin 1810
Letterpress on paper, 16.3 × 10.6 × 2.3 cm
Stadtarchiv Nördlingen, Wissenschaftliche Bibliothek,
shelf mark LB 155/1

462 *Jacques Lacan*, 1967, photo: BOTTI/ Gamma-Rapho/
Getty Images

463 *Rendez-vous chez Lacan*
2012
Documentary film (excerpt), director: Gérard Miller
Éditions Montparnasse, Paris
[Film stills illustrated here]

464 *William Wegman*, 2011, photo: Ben Hider/ Getty Images

465 William Wegman
Minister
1999
Video
Courtesy Electronic Arts Intermix (EAI), New York
[Video stills illustrated here]

472 Lower Rhine Master, *Agnes von Mansfeld*, second half of
the 16th century, photo: © Stiftung Schloss Friedenstein Gotha

473 *Certificate of marriage of Gebhard Truchsess von Waldburg,
Elector of Cologne, to Agnes, Countess of Mansfeld*
Bonn, 2 February 1583
Manuscript on paper, 30.7 × 41 cm
Museum Wasserburg Anholt, Fürstlich Salm-Salm'sches Archiv
– Bestand Grumbach – shelf mark Urk. F 11, Nr. 6
Photos: © Andreas Lechtape

474 *Karl Bauer*, undated, photo: © DLA Marbach

475 Karl Bauer
Luther as a Young Monk
1929
Pastel, framed 45 × 40.5 × 4.5 cm
Archiv der Evangelischen Kirche im Rheinland, Düsseldorf,
shelf mark 8 SL 046
Photo: Archiv der Evangelischen Kirche im Rheinland 8SL 046
(Bildarchiv), 59_00071
[Fig. 1]

Karl Bauer
Martin Luther
not later than 1917
Etching, 18.3 × 13.5 cm
Stiftung Luthergedenkstätten in Sachsen-Anhalt, inv. no. 8452 grfl II g
Photo: Thomas Bruns
[Fig. 2]

Karl Bauer
Portrait of Luther in Old Age
before 1942
Oil, 23 × 16.5 cm
Institut für Kirchliche Zeitgeschichte des Kirchenkreises
Recklinghausen (IKZG-RE)
Photo: Thomas Bruns
[Fig. 3]

Karl Bauer
Martin Luther
in commemoration of the consecration of the
German Church in Helsinki, Finland, undated
Colour reproduction of the painting, 24.1 × 17.9 cm
Stiftung Luthergedenkstätten in Sachsen-Anhalt, inv.-no. 9991 grfl II g
Photo: Thomas Bruns
[Fig. 4]

Karl Bauer
Martin Luther
not later than 1917
Colour reproduction of the painting, 24.2 × 19.6 cm
Stiftung Luthergedenkstätten in Sachsen-Anhalt, inv. no. 8456 grfl II g
Photo: Thomas Bruns
[Fig. 5]

Karl Bauer
Martinus Luther
from the Munich journal *Jugend*, not later than 1917
Colour reproduction, 30.5 × 22.8 cm
Stiftung Luthergedenkstätten in Sachsen-Anhalt, inv. no 8462 grfl II g
Photo: Thomas Bruns
[Fig. 6]

Karl Bauer
Luther
Künstlerbund Karlsruhe, not later than 1917
Lithograph, 36.0 × 40.8 cm
Stiftung Luthergedenkstätten in Sachsen-Anhalt, inv. no. 8464 grfl II g
Photo: Thomas Bruns
[Fig. 7]

Karl Bauer
Martin Luther
Künstlerbund Karlsruhe, not later than 1917
Lithograph, 36 × 40.8 cm
Stiftung Luthergedenkstätten in Sachsen-Anhalt, inv. no. 8463 grfl II g
Photo: Thomas Bruns
[Fig. 8]

Karl Bauer
Luther
Teubners Verlag i. Leipzig, not later than 1917
Etching, 26.6 × 19.5 cm
Stiftung Luthergedenkstätten in Sachsen-Anhalt, inv. no. 8461 grfl II g
[Not illustrated here]

Karl Bauer
Martin Luther
not later than 1917
'created for the "Religiöse Kunst" association in Berlin'
Etching, 24.2 × 20.3 cm
Stiftung Luthergedenkstätten in Sachsen-Anhalt, inv. no. 8457 grfl II g
[Not illustrated here]

Karl Bauer
Martin Luther
not later than 1917
UND WENN DIE WELT VOLL TEUFEL WAER / UND WOLLT
UNS GAR VERSCHLINGEN / SO FUERCHTEN WIR UNS
NICHT SO SEHR / ES SOLL UNS DOCH GELINGEN
Polychrome proof, hand press, 42.4 × 30.3 cm
Stiftung Luthergedenkstätten in Sachsen-Anhalt, inv. no. 8460 grfl II g
[Not illustrated here]

Karl Bauer
Martin Luther
not later than 1917
Luther's head from mural in the Dreifaltigkeitskirche in Görlitz,
photograph of the painting, 17.1 × 11.9 cm
Stiftung Luthergedenkstätten in Sachsen-Anhalt, inv. no. 8471 grfl II g
[Not illustrated here]

Karl Bauer
Martin Luther
Verlag für Volkskunst, Stuttgart (life-size colour print),
1917
Photograph of the charcoal study for head in Luther painting
for Verlag für Volkskunst,
photo, 15.1 × 12 cm
Stiftung Luthergedenkstätten in Sachsen-Anhalt, inv. no. 8468 grfl II g
[Not illustrated here]

Karl Bauer
Martinus Luther Anno 1517
from: *Religiöse Kunst* 2/3 (1917), Verlag des Vereins
für religiöse Kunst in der ev. Kirche, Berlin
Reproduction from a sketch, 21.6 × 16.2 cm
Stiftung Luthergedenkstätten in Sachsen-Anhalt, inv. no. 8455 grfl II g
[Not illustrated here]

Karl Bauer
Dr. Martin Luther
Verlag für Volkskunst, Richard Keutel, Stuttgart, undated
Colour reproduction of the painting, 17.9 × 11.8 cm
Stiftung Luthergedenkstätten in Sachsen-Anhalt, inv. no. 8389 grfl II g
[Not illustrated here]

476 *Thomas Mann*, 1955, photo: © Bildarchiv Pisarek/ akg-images

477 Thomas Mann
Germany and the Germans
1945
Lecture held in the Library of Congress, Washington DC
Manuscript on paper, 26.7 × 20.3 cm
ETH Zürich, Thomas-Mann-Archiv, shelf mark
A-I-Mp V68 Nr. 2 grün
Photo: ETH-Bibliothek Zürich, Thomas-Mann-Archiv, and
courtesy of S. Fischer Verlag GmbH, Frankfurt am Main

478 *Julius Streicher*, c.1925, photo: © bpk/ Heinrich Hoffmann

479 Elvira Bauer
*Trau keinem Fuchs auf grüner Heid /
Und keinem Jud bei seinem Eid*
Stürmer-Verlag, Nuremberg 1936, third edition
Offset on paper, 19.5 × 24.7 × 1.5 cm
Stiftung Luthergedenkstätten in Sachsen-Anhalt,
inv. no. s 1195/12174
Photo: Thomas Bruns

480 *Oskar Brüsewitz*, 1976, photo: © picture-alliance/ dpa / Karl-Adolf Zech

481 Oskar Brüsewitz
Cross made of neon tubes from the church tower in Rippicha
before 1976
410 × 290 × 11 cm
Stiftung Haus der Geschichte der Bundesrepublik Deutschland, Zeitgeschichtliches Forum Leipzig
Reproduction (2017) on display, Stiftung Luthergedenkstätten in Sachsen-Anhalt
Photo: © Karl-Adolf Zech
Photo of the funeral of Pastor Oskar Brüsewitz on 26 August 1976
[illustrated at the bottom of the page]

482 *Lars von Trier*, 2011, photo: © picture alliance/ dpa/ Serge Haouzi – Patrice Lapo

483 *Breaking the Waves*
1996
Film (excerpt), director: Lars von Trier
© Zentropa Entertainments ApS
[Film stills illustrated here]

484 *Megan Rohrer*, 2015, photo: Vince Donovan

485 Megan Rohrer
Queerly Lutheran: Ministry Rooted in Tradition, Scripture and the Confessions
Wilgefortis, San Francisco 2016, second edition
Offset on paper, 22.9 × 15.3 cm
Private collection
Photo: Thomas Bruns

Megan Rohrer
Bible Study that Doesn't Suck
2016
YouTube clip
© Megan Rohrer
[Not illustrated here]

95 PEOPLE CHAPTER **5**
INNER BEEING

494 Jacob van Campen, *Pieter Jansz. Saenredam*, 1628, photo: © bpk/ The Trustees of the British Museum

495 Pieter Jansz. Saenredam
Choir of St Bavo, Haarlem
1635
Oil on oak panel, 48.2 × 37.1 cm
Staatliche Museen zu Berlin, Gemäldegalerie, inv. no. 898B
© Gemäldegalerie, Staatliche Museen zu Berlin, Preußischer Kulturbesitz, photo: Jörg P. Anders

496 *William James*, 1902, photo: © akg-images/ IAM

497 Gilbert Keith Chesterton
Varieties of religious experience: William James delivering the Gifford Lectures in 1901–1902
after 1901
Drawing on paper, 25.1 × 20.5 cm
Houghton Library, Harvard University, Autograph File, C
Photo: Autograph File, C, Houghton Library, Harvard University
[Facsimile on display]

498 *Max Reger*, 1913, photo: © akg-images

499 Max Reger
'Der evangelische Kirchenchor für gemischten Chor.' Vierzig leicht ausführbare geistliche Gesänge zu allen Festen etc.
1900, WoO VI/17
No. 8 'Mit Fried und Freud ich fahr dahin'
Autograph printer's score, 27.6 × 17.5 cm
Universal Edition AG, Vienna, inv. no. L1.UE.423
Photo: © courtesy of UNIVERSAL EDITION A.G., Vienna

500 *Karen Blixen*, 1931, photo: © akg-images

501 *Babette's Feast*
1987
Original title: *Babettes gæstebud*
Film (excerpt), director: Gabriel Axel
Concorde Home Entertainment GmbH
[Film stills illustrated here]

502 *Ina Seidel*, 1954, photo: © bpk/ Felicitas Timpe

503 Ina Seidel
Lennacker. Das Buch einer Heimkehr
before 1938
First complete typescript with handwritten edits
Manuscript on paper, 29.6 × 21 cm
Deutsches Literaturarchiv Marbach, shelf mark 75.1083, Bl. 41
© DLA Marbach, photo: Jens Tremmel

504 *Kazoh Kitamori*, undated, photo: Tokyo Union Theological Seminary

505 Kazoh Kitamori
Theology of the Pain of God
Knox, Richmond 1965
Offset on paper, 21 × 14.5 × 2.3 cm
Private collection
Photo: Thomas Bruns

513 *Luther Bible with hand-written annotations by Felicitas von Selmenitz*
Printer: Hans Lufft, Wittenberg 1534
Original title: Biblia: das ist: die / gantze Heilige Sch- / rifft Deudsch. / Mart. Luth.
Letterpress and manuscript on paper, 33 × 23 × 12 cm
Evangelische Marktkirchengemeinde Halle, Marienbibliothek, shelf mark B I. 19. Fol.
[On display from May to August 2017]

Luther Bible from the estate of the Selmenitz family
Printer: Hans Lufft, Wittenberg 1541
Original title: Biblia: das ist / Die gantze Heilige / Schrifft: Deudsch / Aufs New zugericht. / D. Mart. Luth.
Letterpress and manuscript (handwritten annotations by Luther Georg von Selmenitz) on paper, 39 × 29 × 12 cm
Evangelische Marktkirchengemeinde Halle, Marienbibliothek, shelf mark B I.20 Fol.
[On display from August to November 2017, not illustrated here]

514 Anton Graff, *Johann Gottfried Herder*, 1785, photo: © bpk/ Das Gleimhaus, Halberstadt/ Ulrich Schrader

515 *Johann Gottfried Herder's clerical bands*
c.1800
Fine linen batiste, 14.8 × 119 cm
Freies Deutsches Hochstift, Frankfurter Goethe-Museum, inv. no. IV-1986-37a
Photo: INT zur Megede
[On display from May to August 2017, not illustrated here
The stock (18th century) illustrated here is not on display]

Johann Gottfried Herder's clerical bands
c.1800
Fine linen batiste, 14.8 × 119 cm
Freies Deutsches Hochstift, Frankfurter Goethe-Museum, inv. no. IV-1986-37b
[On display from August to November 2017, not illustrated here]

516 *Martin Buber*, 1954, photo: © bpk/ Felicitas Timpe

517 Martin Buber
Warum und wie wir die Schrift übersetzen
c.1938
Manuscript on paper, 28 × 22 × 0.5 cm
From the collections of The National Library of Israel, shelf mark Signatur ARC. Ms. Var. 350 003 46 a
Photo: © Martin Buber archive, The National Library of Israel

518 *Marcel Duchamp*, 1938, photo: © akg-images/ Denise Bellon

519 Marcel Duchamp
Rotoreliefs
1934
6 cardboard discs, offset lithographs, offset lithographs, printed in colour, diameter 20 cm each
Staatliches Museum Schwerin/ Ludwigslust/ Güstrow inv. no 18297 Gr
© The Estate of Marcel Duchamp/ VG Bild-Kunst, Bonn 2017, photo: Gabriele Bröcker

520 *Nelly Sachs*, undated, © bpk/ Riwkin

521 *Typewriter from the estate of Nelly Sachs*
before 1970
13.3 × 31 × 30 cm
Kungliga biblioteket Stockholm
Photo: Jens Östmann

522 *Won Yong Ji*, June 1990, photo: World Council of Churches, Williams, A 4834-13

523 Won Yong Ji
Luther's Works (in Korean)
Concordia Press, Seoul 1981–1989
12 volumes, letterpress on paper, 23 × 16 × 2.5–5 cm each
Stiftung Luthergedenkstätten in Sachsen-Anhalt, inv. no. S 1198/12279
Photo: Thomas Bruns

524 *Sibylle Lewitscharoff*, 2009, photo: © picture-alliance/ ZB/ Arno Burgi

525 Sibylle Lewitscharoff and Friedrich Meckseper
Babel, Confusion of Tongues
2017
Blank by Modellbau Monath + Menzel
Plastic, painted, metal, paper, 26 × 35 × 35 cm
Private collection of Sybille Lewitscharoff, Berlin
Photo: Susanne Schleyer/autorenarchiv.de

532 John Taylor (attributed), *William Shakespeare*, c.1600–1610, photo: akg-images/ Pictures from History

533 *Hamlet*
1996
Film (excerpt), director: Kenneth Branagh
Licensed by Warner Bros. Entertainment Inc.
Photo: Licensed by Warner Bros. Entertainment Inc.
All Rights Reserved.
[Film still illustrated here]

534 *Marie Durand*, mid-19th century, etching after a drawing by Jeanne Jacqueline Goy, photo: Deutsches Hugenotten-Museum, Bad Karlshafen

535 *RESISTER*
18th century, later plaster cast of the word carved into the stone of the Tour de Constance
22 × 49 × 1 cm
Deutsches Hugenotten-Museum, Bad Karlshafen, inv. no. 0184

536 *Karl Holl*, c.1900, photo: © akg-images

537 Karl Holl
Letter to Adolf Jülicher
undated, possibly late summer 1909
Manuscript on paper, 19 × 14.9 cm
Universitätsbibliothek Marburg, shelf mark Nachlass Adolf Jülicher
Ms. 695/552

538 *Henning von Tresckow*, 1944, private collection

539 *Henning von Tresckow's map with location of his suicide marked in*
1944
Printed on paper with handwritten markings, 42.8 × 59.5 cm
Private collection of Uta v. Aretin
© Lexip GmbH, photo: Patrick Art

540 *Edward Snowden*, 2016, photo: Kayana Szymczak/ NYT/ Redux/ laif

541 *Destroyed logic board of a HP Compaq 8200 Elite PC, used to inspect data provided by Edward Snowden*
Early 21st century
25 × 40 × 2 cm
The Guardian News and Media Archive, London, inv. no. 2014/002 8.5
© SDTB, Photo: C. Kirchner, loaned by Guardian News & Media Archive, London, GB

548 Ludwig Buchhorn, *Paul Gerhardt*, c.1810, photo: © akg-images

549 *Communion chalice used by Paul Gerhardt*
17th century
Metal, height 22 cm, diameter 13.5–16 cm
Paul-Gerhardt-Kirchengemeinde Lübben
Photo: Magnus Brunkhorst, Lübben (Spreewald)

550 *Sir Sayyid Ahmad Khan*, undated, photo: © ullstein bild – Pictures from History

551 *Qur'an with a preface by Luther*
Printer: Johann Oporinus, Basel 1543
Original title: Machvmetis saracenorum principis, eiusque successorum vitae, ac doctrina, ipseque alcoran
Letterpress on paper, 31 × 23 × 8 cm
Stiftung Luthergedenkstätten in Sachsen-Anhalt, inv. no. Kn fl 118/172
Photo: Thomas Bruns

552 *Ricarda Huch*, 1914, photo: © akg-images

553 Ricarda Huch
Luthers Glaube
Insel-Verlag, Leipzig 1916
Letterpress on paper, 20 × 13 × 2.5 cm
Private collection
Photo: Thomas Bruns

554 *Ingmar Bergman*, 2002, photo: Bengt Wanselius

555 Per Axel Lundgren
Altar figure from 'Winter Light'
not later than 1963
Balsa wood, 110 × 60 × 30 cm
Private collection
Photo: Deutsche Kinemathek, © Marian Stefanowski

Winter Light
1963
Original title: Nattvardsgästerna
Film (excerpt), director: Ingmar Bergman
© AB Svensk Filmindustri
Photo: Nattvardsgästerna/Winter Light, © 1963 AB Svensk Filmindustri
[Film still illustrated here.]

556 *Mary Daly*, 1989, photo: Lane Turner/ The Boston Globe/ Getty Images

557 *Audio tape with a recording of Mary Daly's lecture 'Pure lust'*
1986
Plastic, 7 × 10.9 × 1.2 cm
Private collection of Eveline Ratzel, Karlsruhe
Photos of tapes: Thomas Bruns

 Mary Daly et al.
 *Websters' First New Intergalactic Wickedary
 of the English Language*
 Beacon Press, Boston 1998, new edition
Offset on paper, 24 × 17 × 2.5cm
Private collection
Photo: Thomas Bruns

558 *Gregor Hohberg*, 2016, photo: © Klemens Renner

559 Kuehn Malvezzi
 Model of The House of One for Berlin
 2012
Model by Shortcut-Modellbau for Kuehn Malvezzi
Limewood, 22 × 25 × 16.5 cm
Stiftung House of One
Photo: © michel-koczy.com

566 Christoph Spetner, *Heinrich Schütz*, c.1650, photo: © bpk

567 Heinrich Schütz
 Musicalische Exequien
 Printer: Seyffert, Dresden 1636, SWV 279–281
Original title: Musicalische Exequien Wie solche bey herrlicher
vnd hochansehnlicher Leichbestattung / Deß weylandt Hochwol-
geborenen Herrn / Herrn Heinrichen deß Jüngern vnd Eltisten
Reußen / Herrn von Plauen / Röm. Kays. Majt. Gewesenen Raths
… nunmehr Christseligen Andeckens … den 4 Monatstag Februarii
zu Gera / vor vnd nach der Leichpredigt gehalten / vnd ihrer wolsli-
gen Gnaden / bey dero lebzeiten wiederholten begehren nach / in
eine … Orgel angestellet vnd abgesungen worden
Letterpress on paper, 19 × 15 × 1.2 cm
Evangelische Marktkirchengemeinde Halle, Marienbibliothek,
shelf mark V 181 (4)

568 *Wilhelm Löhe*, c.1860, photo: © bpk

569 *Communion set for home communion
 from the estate of Wilhelm Löhe*
 mid-19th century
Metal, wood, silk, cotton, embroidery, case 10 × 37.5 × 17.8 cm
Zentralarchiv, Diakonie Neuendettelsau, shelf marks 096.01 and
096.02

570 *Søren Kierkegaard*, 1840, photo: © bpk

571 Søren Kierkegaard
 Journals
 1850
Manuscript on paper, 21.5 × 18.3 × 2.2 cm
Det Kongelige Biblioteket, Kopenhagen, Søren Kierkegaards Arkiv,
shelf mark A, pk. 24

572 *Heinrich Nazarenus*, undated, photo: private collection of
Dr. Heinrich Rathke, Schwerin

573 Heinrich Nazarenus
 Gottesdienstbuch
 1948
Manuscript on paper, 19.5 × 15.1 × 0.4 cm
Private collection of Dr. Heinrich Rathke, Schwerin
Photo: Thomas Bruns

574 *Joseph Ratzinger*, 1998, photo: © akg-images/
picture-alliance/ dpa

575 Joseph Ratzinger
 *Plan for university seminar on dogmatics entitled
 'Katholische Anerkennung der Confessio Augustana?'*
 1976
Typescript with handwritten notes, 29.7 × 21 cm
Institut Papst Benedikt XVI., Regensburg, shelf mark IPB S 19/1–3

576 *John Woo*, 2008, photo: © picture-alliance/ dpa/
Imaginechina Zhu

577 *The Killer*
 1989
Film (excerpt), director: John Woo
Golden Princess Amusement Co Ltd.
[Film still illustrated here]

LENDERS TO THE EXHIBITION

We would like to thank the following museums, public collections, libaries, archives and private collectors for their generous loans:

International Institute of Social History, Amsterdam
Uta v. Aretin
Museen der Stadt Aschaffenburg
Stadtarchäologie, Kunstsammlungen und Museen Augsburg
Deutsches Hugenotten-Museum, Bad Karlshafen
The Walters Art Museum, Baltimore
HMB – Historisches Museum Basel
The Magnes Collection of Jewish Art and Life, University of California, Berkeley
Axel Springer SE, Berlin
Evangelisches Landeskirchliches Archiv in Berlin
Friedrich Christian Flick Collection im Hamburger Bahnhof, Berlin
Geheimes Staatsarchiv Preußischer Kulturbesitz, Berlin
Rialto Film GmbH, Berlin
Sibylle Lewitscharoff, Berlin
Staatliche Museen zu Berlin, Gemäldegalerie
Staatliche Museen zu Berlin, Kupferstichkabinett
Staatsbibliothek zu Berlin – Preußischer Kulturbesitz, Handschriftenabteilung
Staatsbibliothek zu Berlin – Preußischer Kulturbesitz, Musikabteilung mit Mendelssohn-Archiv
Stiftung House of One, Berlin
Strehlow-Wieckert, Berlin
X Filme Creative Pool Entertainment GmbH, Berlin
Schweizerisches Literaturarchiv (SLA), Bern
Eberhard Petersen, Bonn
Universitäts- und Landesbibliothek Bonn
Bibliothèque Royale de Belgique, Brussels
Evangélikus Orzágos Múzeum, Budapest
Szépművészeti Múzeum, Museum of Fine Arts, Budapest
Warner Bros. Entertainment Inc., Burbank, California
Haus Hohenzollern, SKH Georg Friedrich Prinz von Preußen, Burg Hohenzollern
Churchill Archives Centre, Cambridge
Harvard University, Cambridge, Massachusetts
Evangelisch-Lutherische Stiftskirchengemeinde Chemnitz-Ebersdorf
Adler Planetarium, Chicago, Illinois
John Tweedle Foundation, Inc., Chicago, Illinois
Kunstsammlungen der Veste Coburg
Wallraf-Richartz Museum & Fondation Corboud, Cologne
Leather Stalking Books, Cooperstown NY
Det Kongelige Biblioteket, Copenhagen

Statens Museum for Kunst, Copenhagen
The Lobkowicz Collections, Czech Republic
Rudolf Steiner Archiv, Dornach
Kupferstich-Kabinett, Staatliche Kunstsammlungen Dresden
Archiv der Evangelischen Kirche im Rheinland, Düsseldorf
Wartburg-Stiftung Eisenach
Angermuseum Erfurt
Evangelisches Augustinerkloster, Erfurt
Museo Nazionale del Bargello, Florence
Freies Deutsches Hochstift, Frankfurter Goethe-Museum
Forschungsbibliothek Gotha der Universität Erfurt
Niedersächsische Staats- und Universitätsbibliothek Göttingen
Concorde Home Entertainment GmbH, Grünwald
Evangelische Marktkirchengemeinde Halle, Marienbibliothek
Franckesche Stiftungen zu Halle an der Saale
Landesamt für Denkmalpflege und Archäologie – Landesmuseum für Vorgeschichte – Sachsen-Anhalt, Halle an der Saale
Zentrale Kustodie der Martin-Luther-Universität Halle-Wittenberg
Gottfried Wilhelm Leibniz Bibliothek – Niedersächsische Landesbibliothek, Hannover
Sprengel Museum Hannover
Käthe von Gierke, Hardegsen
Mansfeld-Museum im Humboldt-Schloss Hettstedt
Golden Princess Amusement, Hong Kong
Museum Wasserburg Anholt, Fürstlich Salm-Salm'sches Archiv, Isselburg
Thüringer Universitäts- und Landesbibliothek Jena
The National Library of Israel, Jerusalem
Badisches Landesmuseum, Karlsruhe
Eveline Ratzel, Karlsruhe
Staatliche Kunsthalle Karlsruhe
Kibira Films International
Killie Campbell Collections, University of KwaZulu-Natal, South Africa
Archäologisches Landesmuseum Baden-Württemberg, Konstanz
Bach-Archiv Leipzig
Museum der bildenden Künste Leipzig
Museum für Musikinstrumente Leipzig
Universitätsbibliothek Leipzig
British Library, London
The Guardian News and Media Archive, London
The National Archives UK, London-Kew
Paul-Gerhardt-Kirchengemeinde Lübben
die Lübecker Museen – St. Annen-Museum
Musée national d'histoire et d'art Luxembourg
Colección Banco Santander, Madrid
Evangelische Kirchengemeinde Mansfeld

Land Sachsen-Anhalt, Landesverwaltungsamt, Dokumentations
 stelle zur Erfassung von Kulturvermögen,
 Förderverein Schloss Mansfeld e. V.
Deutsches Literaturarchiv Marbach
Universitätsbibliothek Marburg
Kwok Pui-Lan, Massachusetts
MOTB
Bayerisches Nationalmuseum, Munich
Bayerische Staatsbibliothek, Munich
Bayerische Staatsgemäldesammlungen, Alte Pinakothek, Munich
Deutsches Museum, Munich
Institut für Zeitgeschichte, Munich
Staatliche Graphische Sammlung München
Studio 100 Media, Munich
Zentralarchiv, Diakonie Neuendettelsau
Electronic Arts Intermix (EAI), New York
The Morgan Library & Museum, New York
Stadtarchiv Nördlingen, Wissenschaftliche Bibliothek
Nasjonalmuseet for kunst, arkitektur og design, Oslo
Heinz Nixdorf MuseumsForum, Paderborn
Éditions Montparnasse, Paris
Krauth Memorial Library, The Lutheran Theological Seminary
 at Philadelphia
Privatarchiv Elisabeth Noelle, Piazzogna
Plymouth City Council (Arts & Heritage)
Karl-May-Museum Radebeul
Institut für Kirchliche Zeitgeschichte des Kirchenkreises Reckling-
hausen (IKZG-RE)
Institut Papst Benedikt XVI., Regensburg
Megan Rohrer
Biblioteca Nazionale Centrale, Rome
Evangelisches Museum Oberösterreich, Rutzenmoos
Landesamt für Archäologie Sachsen
Landesarchiv Sachsen-Anhalt
Kunstsammlungen der Erzabtei St. Peter, Salzburg
Dr. Heinrich Rathke, Schwerin
Staatliches Museum Schwerin/Ludwigslust/Güstrow
Concordia Historical Institute St. Louis, Missouri
Pushkinsky Dom, Institute of Russian Literature, St Petersburg
AB Svensk Filmindustri, Stockholm
Kungliga biblioteket Stockholm
Livrustkammaren, Stockholm
Riksarkivet, Stockholm
Staatsgalerie Stuttgart
Toledo Museum of Art, Toledo,Ohio
Evangelische Kirchengemeinde Torgau
Museum am Dom, Trier
Grundtvigs Mindestuer, Udby
Uppsala universitetsbiblioteket

Österreichische Nationalbibliothek, Vienna
Universal Edition AG, Vienna
Folger Shakespeare Library, Washington DC
Klassik Stiftung Weimar, Goethe-und-Schiller-Archiv
Klassik Stiftung Weimar/ Herzogin Anna Amalia Bibliothek
Landesarchiv Thüringen – Hauptstaatsarchiv Weimar
Gesellschaft der Musikfreunde in Wien
Kunsthistorisches Museum Wien
Wienbibliothek im Rathaus, Magistrat der Stadt Wien
Evangelische Stadtkirchengemeinde, Lutherstadt Wittenberg
Evangelisches Predigerseminar, Lutherstadt Wittenberg
Herzog August Bibliothek Wolfenbüttel
Biblioteka Uniwersytecka, Wrocław
ETH Zürich, Thomas Mann Archives
Stiftung Sammlung E. G. Bührle, Zurich
Zentralbibliothek Zürich
Zentropa Entertainments ApS

We would also like to express our gratitude to all lenders who prefer
to remain anonymous.

ACKNOWLEDGEMENTS

We would like to thank all employees of the Stiftung Luthergedenkstätten in Sachsen-Anhalt and all those who supported us in the organisation of the exhibition and publication of the accompanying book. In addition to the contributors and the persons mentioned in the colophon, we would like to express our particular gratitude to the following:

Joachim Abrell
Rainer Allmann
Karen Angne
Tina Ayvasky
Felix Barthel
Bodo-Michael Baumunk
Dr. Katrin Bedenig
Olaf Beier
Oliver van den Berg
Jörg Berndt
Jens Beutmann
Prof. Dr. Dr. h. c. Otto Biba
Ulrike Binding
Friederike Böcher
Prof. Dr. Anne Bohnenkamp-Renken
Kenneth Branagh
Susanna Brogi
Prof. Dr. Ulrich Bubenheimer
Dr. Stephanie Buck
Prof. Dr. Peter Burschel
Dr. Christofer Conrad
Alex D'Attoma
Professor Wanda Deifelt
Jochen Desel
Bernhard Draz
Dr. Björn Egging
Ulrike Eichmeyer-Schmidt
Prof. Dr. Michael Eissenhauer
Bill Elsey
Dr. Ester Fábry
Anke Fiebiger
Hannelore Fischer
Robbie Fischer
Dr. Stefan Flesch
Bianca Folger
Julie Franklin
Carsten Fromm
Wang Fu
Iris Geisler
Lukas Gloor
Dr. Ronald Göbel

Robert Gommlich
Daniel Görres
Sebastian Görtz
Dr. Gerhard Graulich
Walter Hacker
Mary Haegert
Michael Haneke
Dr. Babette Hartwieg
Samuel Hasselhorn
Johann Hausstätter
Monika Hegenberg
Anja Helbing
Ethan Henderson
Dr. Mareike Hennig
Tina Marie Herbert-Hasselhorn
Michaela Hermann
Karl-Uwe Heußner
Prof. Dr. Gunnar Heydenreich
Gregor Hohberg
Erik Höök
Taewoo Kang
Hans-Wilhelm Kasch
Frank Kästner
Sylke Kaufmann
Victor Kégli
Katrin Keller
Thomas Kemme
Josiah Kibira
Dr. Katja Kleinert
Prof. Dr. Alexander Koller
Dr. Stefan Krabath
Kramer
Dr. Miriam Krautwurst
Joachim Kreutner
Dr. Roland Krischel
Dr. Karl Krueger
Dr. Duco van Krugten
Marcel Krumbiegel
Knut Kruppa
Klemens Kühn
Werner Kutz
Rainer Laabs
Christian Lagé
Dr. Kerstin Langwagen
Dr. Mathis Leibetseder
Robin Leipold
Dr. Stefan Litt
Prof. Dr. Thomas Litt
Dr. Valentina Longo

Ivana Lovrekovic
Dieter Lücke
Dr. Monika Lücke
Norbert Ludwig
Håkan Lundgren
Barbara Martinkat
Felix Meister
Dr. Guido Messling
Dr. Christof Metzger
Néstor Míguez
Rachel Misrati
Rona Mockry
Philippa Mole
Ella Molenaar
Prof. Dr. Thomas Müller-Bahlke
Robert Noack
Dr. Nils Ohlsen
Dr. Karin Orchard
Prof. Dr. Eef Overgaauw
Mike Peters
Ralph Pietschmann
Andrea Plödt
Prof. Dr. Susanne Popp
Dr. Martina Rebmann
Dr. Jürgen Reiche
Saskia Richter
Dr. Thomas Richter
Prof. Dr. Ralph Röber
Frank Roder
Dr. Kornelia Röder
Matthias Röhrborn
Megan Rohrer
Dr. Michael Roth
Henrike Rucker
Dr. Christian Schaller
Dr. Martin Schawe
Stefan Schimmel
Patricia Schlemper
Horst Schmidt
Rolf Schmidt
Dr. Roland Schmidt-Hensel
Barbara Schneider-Kempf
Prof. Dr. Gury Schneider-Ludorff
Karin Schnell
Dr. Claudia Schnitzer
Dr. Susanne Schuster
Hanne Schweiger
Dr. Bettina Seyderhelm
Tino Sieland

Petra Simon-Weiser
Claude Sorgeloos
Dr. Wilfried Sponsel
Dr. h. c. Friede Springer
Ursula Stock
Dr. Andreas Strobl
Annekathrin Teichmann
Frithjof Timm
Anders Toftgaard
Simonette dela Torre
Dr. Tatjana Tzarkova
Leena Uusitalo
Dr. Claus Veltmann
Dr. Hartmut Voelkel
Andrea Wähning
Frank Walther
Wolfgang Wanko
Karen Warlich
Rik Watkinson
Oliver Weiser
Steffi Weißhaupt
Professor Timothy J. Wengert
Dr. Matthias Weniger
Dr. Armin Wenz
Dr. Victoria Wenzel-Böhm
Irina Widany
Dr. Magnus Wieland
Helena Lissa Wiessner
Erdmann von Wilamowitz-Moellendorf
Ben Wizner
Veronika Wolf
Joachim Zirkler
Dr. Bettina Zöller-Stock

CONTRIBUTORS

Prof. Dr. Heinrich Assel, Greifswald, Professor of Systematic Theology, Ernst-Moritz-Arndt-Universität Greifswald.

Professor Olivier Bauer, Lausanne, Professor of Practical Theology, Université de Lausanne.

Dr. Raphael Beuing, Munich, art historian, Head of the Department of Weapons, Timepieces, Scientific Instruments and Base Metals, Bayerisches Nationalmuseum, Munich.

Dr. Barbara Beuys, Cologne, historian and novelist.

Dr. Christine Blanken, Leipzig, musicologist, Head of Research Section II, 'The Bach Family', Bach-Archiv Leipzig.

Prof. Dr. Eugen Blume, Ribnitz-Damgarten, fine arts scholar, Director of the Hamburger Bahnhof – Museum für Gegenwart – Berlin until 2016.

Klaus-Martin Bresgott M.A., Berlin, German scholar, art historian and conductor, Cultural Affairs Manager, Cultural Office of the Council of the Evangelical Church in Germany (EKD).

PD Dr. Alf Christophersen, theologian, Lutherstadt Wittenberg and Munich, Deputy Director and Director of Studies in Theology, Politics and Culture, Evangelische Akademie Sachsen-Anhalt.

Professor Kristine A. Culp, Chicago, Illinois, Associate Professor of Theology, University of Chicago.

Professor Otfried Czaika, Karlstad, Sweden, Professor of Church History, Norwegian School of Theology, Oslo.

Christoph Dieckmann, Berlin, novelist and journalist.

Prof. Dr. Thorsten Dietz, Marburg, Professor of Systematic Theology, Evangelische Hochschule TABOR, Marburg.

Prof. Dr. Heinrich Dilly, Halle (Saale), Retired Professor of Art History, Martin-Luther-Universität Halle-Wittenberg.

Thea Dorn, Berlin, novelist.

Hansjörg Eichmeyer, Vöcklabruck, Austria, theologian, Retired Dean and Co-founder of the Evangelisches Museum Oberösterreich, Rutzenmoos.

Dr. Wolfgang Fenske, Berlin, theologian, Director, Library of Conservatism, Berlin.

Dr. Heike Fielmann, Hamburg, German scholar and historian.

Professor John L. Flood, Amersham, England, Professor Emeritus of the German, Institute of Modern Languages Research, University of London.

Prof. Dr. Albrecht Geck, Recklinghausen, Extraordinary Professor of Church History, Osnabrück University and Director of the Institut für Kirchliche Zeitgeschichte des Kirchenkreises Recklinghausen (IKZG-RE).

Dr. Daniel Gehrt, Gotha, historian, Research Associate, Gotha Research Library.

Prof. Dr. Horst-Jürgen Gerigk, Heidelberg, Professor Emeritus of Russian Literature and General Literary Studies, Ruprecht-Karls-Universität Heidelberg.

Christian Geyer, Frankfurt am Main, Editor *Frankfurter Allgemeine Zeitung.*

Prof. Dr. Johannes Grave, Bielefeld, Professor of Historical Image Studies/Art History, Universität Bielefeld.

Prof. Dr. Michael Großheim, Hamburg, Professor of Phenomenological Philosophy, University of Rostock.

Prof. Dr. Norbert Grube, Zurich, Professor of Educational and School History, Zentrum für Schulgeschichte, Zurich University of Teacher Education.

Mirko Gutjahr, Lutherstadt Wittenberg, archaeologist, Research Associate at the Stiftung Luthergedenkstätten in Saxon-Anhalt and Curator of the National Special Exhibition *Luther! 95 Treasures – 95 People.*

Dr. Dr. Benjamin Hasselhorn, Lutherstadt Wittenberg, historian and theologian, Research Associate at the Stiftung Luthergedenkstätten in Saxon-Anhalt and Curator of the National Special Exhibition *Luther! 95 Treasures – 95 People.*

Professor Christine Helmer, Evanston, Illinois, Professor of German and Religious Studies, Northwestern University, Evanston and Chicago.

Professor Paul Hinlicky, Salem, Virginia, Tise Professor of Lutheran Studies, Roanoke College in Salem.

Dr. Anders Holm, Copenhagen, Associate Professor of Systematic Theology, University of Copenhagen.

Professor Bo Kristian Holm, Aarhus, Associate Professor of Systematic Theology and Director of the LUMEN Interdisciplinary Center for the Study of Lutheran Theology and Confessional Societies, Aarhus University.

Dr. Jan Holmberg, Stockholm, film historian, CEO of the Ingmar Bergman Foundation, Stockholm.

Dr. Holger Jacob-Friesen, Karlsruhe, art historian, Director of the Science Department, Staatliche Kunsthalle Karlsruhe.

Prof. Dr. Gotthard Jasper, Uttenreuth, Professor Emeritus of Political Science, Friedrich-Alexander-Universität Erlangen-Nürnberg.

Kristina Jaspers, Berlin, art historian and philosopher, curator at the Deutsche Kinemathek Berlin.

Prof. Dr. Tom Kleffmann, Kassel, Professor of Systematic Theology, University of Kassel.

Robert Kluth, Berlin, historian, student teacher of history and philosophy.

Prof. Dr. Dietrich Korsch, Kassel, Professor Emeritus of Systematic Theology, Philipps-Universität Marburg.

Dr. Hartmut Kühne, Berlin, church historian and exhibition organizer.

Franziska Kuschel, Halle (Saale), art historian, State Office for Heritage Management and Archaeology – State Museum of Prehistory – Sachsen-Anhalt, Halle.

Daniel Leis, Lutherstadt Eisleben, art historian, Director of Museums and Collections at the Stiftung Luthergedenkstätten in Saxon-Anhalt.

Prof. Dr. Volker Leppin, Tübingen, Professor of Church History, Eberhard-Karls-Universität Tübingen.

Prof. Dr. Athina Lexutt, Gießen, Professor of Church History and History of Theology, Justus-Liebig-Universität Gießen.

Tim Lindemann, Berlin, film studies scholar and author.

Dr. Andreas Losch, Bern, theologian, Research Associate at the Center for Space and Habitability, Universität Bern.

Dr Charlotte Methuen, Glasgow, Senior Lecturer for Church History, Department of Theology and Religious Studies, University of Glasgow.

PD Dr. Stefan Michel, Leipzig, Reader in Church History, Theological Department Universität Leipzig and Head of Research Group for Editing Project *Letters and files on the church policies of Frederick the Wise and John the Steadfast 1513 to 1532. The Reformation in the context of early modern state formation*, Sächsische Akademie der Wissenschaften zu Leipzig.

Lisa Minardi, Trappe, Pennsylvania, historian and Director of The Speaker's House, Home of Frederick Muhlenberg, Trappe.

Professor Jes Fabricius Møller, Copenhagen, historian, Professor (temporary) at The Grundtvig Study Centre, Aarhus University.

Martin Mosebach, Frankfurt am Main, novelist.

Prof. Dr. Herfried Münkler, Berlin, Professor of Political Theory, Humboldt-Universität zu Berlin.

Dr. Catherine Nichols, Berlin and Lutherstadt Wittenberg, literature and fine arts scholar, Curator of the National Special Exhibition *Luther! 95 Treasures – 95 People*.

Prof. Dr. Helmut Obst, Halle (Saale), Professor Emeritus of Ecumenism, Religious Studies and Confessional Studies, Martin-Luther-Universität Halle-Wittenberg.

Prof. Dr. Martin Ohst, Wuppertal, Professor of Historic and Systematic Theology, Bergische Universität Wuppertal.

Prof. Dr. Jürgen Overhoff, Münster, Professor of Historical Research in Education, Westfälische Wilhelms-Universität Münster.

Kathrin Oxen, Lutherstadt Wittenberg, theologian, Head of the Zentrum für evangelische Predigtkultur of the Evangelical Church in Germany (EKD), Wittenberg.

Dr. An Paenhuysen, Berlin, curator and historian.

Dr. Matthias Paul, Mansfeld, theologian, Pastor of the Evangelical Church Parish of Mansfeld.

PD Dr. Björn Pecina, Halle (Saale), Reader in Systematic Theology, Martin-Luther-Universität Halle-Wittenberg.

Prof. Dr. Dirk Pilz, Berlin, literary scholar, Visiting Professor and Academic Head of the Cultural Journalism Programme, Berlin University of the Arts, Co-founder and Editor of www.nachtkritik.de.

Professor Michel Polfer, Luxemburg, historian and archaeologist, Director of the Musée National d'Histoire et d'Art, Luxembourg.

Sven Prietzel, Berlin, historian.

Professor Charles Ramsey, Lahore, Pakistan, Assistant Professor of Religion and Public Policy, Forman Christian College (A Chartered University), Lahore.

Dr. Stefan Rhein, Lutherstadt Wittenberg, classical philology scholar, Chairman and Director of the Stiftung Luthergedenkstätten in Saxon-Anhalt.

Professor Marie-Louise Rodén, Kristianstad, Sweden, Professor of History, Kristianstad University.

Dr. Daniel Roos, Munich, historian, Head of Division, Bavarian State Chancellery, Munich.

Professor Jennifer Rust, St. Louis, Missouri, Associate Professor of English Literature, Saint Louis University.

Dr. Dietrich Sagert, Berlin, cultural studies scholar and theatre director, Instructor in the Art of Speaking/Rhetoric, Zentrum für evangelische Predigtkultur of the Evangelical Church in Germany (EKD).

Dr. Jan Scheunemann, Halle (Saale), historian, State Office for Heritage Management and Archaeology – State Museum of Prehistory – Sachsen-Anhalt, Halle.

INDEX OF QUOTATIONS

All quotations located at the beginning of the essays and in the speech bubbles of the '95 People' have been adapted to conform to contemporary diction. The original quotation (or translation thereof) can be found in the following list.

The quotations of Martin Luther are cited in accordance with the Weimar Edition (WA) of Luther's Works: *D. Martin Luthers Werke: Kritische Gesamtausgabe*, Weimar: Hermann Böhlau, 1883 ff, and, where possible, with the American Edition: *Luther's Works in 55 Volumes* (LW), St Louis, Missouri and Philadelphia: Fortress Press and Concordia Publishing House, 1957.

345 SERVICE
'The whole world is full of service to God.'
Original version: 'Sic sol man lernen, wie mundus totus vol gots dienst ist.' WA 36, 325

345 FRIEDRICH WILHELM I
'The good Lord did not put you on the throne to idle your time away, but to work.'
Original version: '… der liebe Gott hat euch auf den thron gesetzt nicht zu faullentzen, sondern zur arbeitten und seine Lender wohll zu Regieren …'
Friedrich Wilhelm I: Politisches Testament 1722, Geheimes Staatsarchiv Preußischer Kulturbesitz Berlin, shelf mark BPH, Urk. III. 1, Nr. 19, cited in: *Die politischen Testamente der Hohenzollern*, Richard Dietrich (ed.), Cologne et al. 1986, 222–243, quotation 224.

347 KÄTHE KOLLWITZ
'I felt that I have no right to withdraw from the responsibility of being an advocate. It is my duty to voice the sufferings of men.'
Original version: 'Ich fühlte, daß ich mich doch nicht entziehen dürfte der Aufgabe, Anwalt zu sein. Ich soll das Leiden der Menschen, das nie ein Ende nimmt, das jetzt bergegroß ist, aussprechen.'
Käthe Kollwitz: *Die Tagebücher 1908–1943* [5 January 1920], Jutta Bohnke-Kollwitz (ed.), Munich 2012 (first edition Berlin 1989), 449.

349 JOCHEN KLEPPER
'God also knows, however, that I will accept anything from him by way of test and punishment.'
Original version: 'Gott weiß aber auch, daß ich alles von ihm annehmen will an Prüfung und Gericht, wenn ich nur Hanni und das Kind notdürftig geborgen weiß.'
Diary entry by Jochen Klepper from 8 December 1942, in: Jochen Klepper: *Unter dem Schatten deiner Flügel. Aus den Tagebüchern 1932–1942*, Stuttgart 1956, 1131.

351 ASTRID LINDGREN
'There are things you have to do, otherwise you aren't a human being, just a bit of filth.'
Original English translation: 'There are things you have to do even if they're dangerous, otherwise you aren't a human being but just a bit of filth.'
Astrid Lindgren: *The Brothers Lionheart* [1973], trans. Joan Tate, Oxford 2009, 46 [original quotation in Swedish].

353 AXEL C. SPRINGER
'The world is changed by dreams, by industriousness'
Original version: 'Die Welt wird verändert durch Träume, durch Fleiß.'
An interview with Axel Springer by Renate Harpprecht, 1970, in: *Axel Springer – Neue Blicke auf den Verleger*, Matthias Döpfner (ed.), Hamburg 2005, 210.

355 JOSÉ MÍGUEZ BONINO
'How can the message of unconditional acceptance be received unless a community of mutual free acceptance gives a content to the message?'
Original version: 'How can the message of unconditional acceptance be received unless a community of mutual free acceptance gives a content to the message?'
Interview with José Míguez Bonino, Trinity Institute Conference 1986, available online as a video recording at http://moltmanniac.com/love-the-foundation-of-hope-part-4/ (accessed on 12 February 2017).

357 MICHAEL HANEKE
'The notion of absolute authority has a massive presence in the writings of Martin Luther'
Original version: 'Die Verabsolutierung der Obrigkeit … das findet man sehr massiv in den Schriften von Luther.'
Nahaufnahme Michael Haneke. Gespräche mit Thomas Assheuer, Berlin 2010, 157.

358 CHARITY
'Accursed be the life, where one lives only for himself and not for his neighbour.'
Original version: 'Vermaladeyt sey das leben, das im einer allein lebet unnd nicht seinem nechsten.' WA 10 I/2, 240

365 KATHERINE PARR
'Truly, charity maketh men live like angels.'
Original version: 'He that dwelleth in charity dwelleth in God: truly, charity maketh men live like angels; and of the most furious, unbridled, carnal men maketh meek lambs.'
Katherine Parr: The Lamentation of a Sinner [1547], in: *Complete works and correspondence*, Janel Mueller (ed.), Chicago 2011, 443–485, quotation 457.

367 MAX BECKMANN
'My religion is defiance of God, that he has created us thus, that we cannot love each other.'
Original version: 'Ich werfe in meinen Bildern Gott alles vor, was er falsch gemacht hat. … Meine Religion ist Hochmut vor Gott, Trotz gegen Gott. Trotz, daß er uns so geschaffen hat, daß wir uns nicht lieben können.'
Max Beckmann in conversation with Reinhard Piper, 1919, cited in: Reinhard Piper: *Nachmittag, Erinnerungen eines Verlegers*, Munich 1950, 33.

369 SOPHIE SCHOLL
'I could weep at the callousness of people, even leading politicians.'
Original version: 'Und ich könnte heulen, wie gemein die Menschen auch in der großen Politik sind, wie sie ihren Bruder verraten um eines Vorteils willen vielleicht.'
Letter from Sophie Scholl to Fritz Hartnagel, 29 May 1940, in: Sophie Scholl, Fritz Hartnagel: *Damit wir uns nicht verlieren. Briefwechsel 1937–1943*, Thomas Hartnagel (ed.), Frankfurt am Main 2005, 175.

371 JOSIAH KIBIRA

'We live in a world which is so nice when people cooperate,
live together and love one another as human beings.
But to separate people is fundamentally wrong.'

Original version: 'We live in a world which is so nice when people
cooperate, live together and love one another as human beings. But
to separate people is fundamentally wrong.'

Poster with Josiah Kibira's quotation, c.1980, online: africanactivist.
msu.edu/image.php?objectid=32-131-690 (accessed on 12 February 2017).

373 KWOK PUI LAN

'Occupy Religion!'

Original version: 'Occupy Religion'

Kwok Pui-Lan and Jörg Rieger: *Occupy Religion. Theology of the Multi-
tude*, Plymouth 2012.

374 TRANSFORMATION

'May God help us to blast down these walls of straw
and paper.' LW 44, 126

Original version: 'Nu helff uns got und geb uns der Basaunen eine,
do mit die mauren Hiericho wurden umbworffenn, das wir disze stroe-
ren und papyren mauren auch umbblassen …' WA 6, 407

381 MOSES MENDELSSOHN

'Despotism of any kind incites rebellion'

Original version: 'Despotismus von jeder Art reizt zur Widersetzlich-
keit.'

Moses Mendelssohn: Vorbericht, in idem: *Morgenstunden oder Vorle-
sungen über das Daseyn Gottes, Erster Theil*, Berlin 1785, no page numbers.

383 N. F. S. GRUNDTVIG

'I am not of the opinion that we should simply continue
with what Martin Luther did 300 years ago, for it is only
death that stands still, life is always in motion.'

Original German translation: 'Ich bin nicht der Meinung, dass wir
dabei verbleiben sollen, was Martin Luther vor 300 Jahren getan hat,
denn nur der Tod bleibt stehen. Das Leben bewegt sich immer.'

N. F. Grundtvig: *Kirkelige Leilighedstaler*, C. J. Brandt (ed.), Copenha-
gen 1877, 471 [original quotation in Danish].

385 ELIZABETH CADY STANTON

'The Bible and the Church have been the greatest blocks
in the way of women's development'

Original version: 'So far from woman owing what liberty she does
enjoy, to the Bible and the church, they have been the greatest block
in the way of her development.'

Elizabeth Cady Stanton: The Degraded Status of Woman in the Bible,
in: *Free Thought Magazine* 14 (1896), 539–544, quotation 541.

387 JOHANNES BRAHMS

'I cannot cast off the inner theologian'

Original version: 'Den inneren Theologen aber kann ich nicht los-
werden.'

Johannes Brahms: *Briefwechsel*, vol. 1, Max Kalbeck (ed.), Berlin 1907,
199.

389 JAMAL AD-DIN AL-AFGHANI

'I have passed a great part of my life in the Orient
with the single aim of reforming society'

Original version: 'I have passed a great part of my life in the Orient
with the single aim of uprooting fanaticism, the most harmful mala-
dy of this land, of reforming society and establishing there the bene-
fits of tolerance.'

Jamal ad-Din al-Afghani: Letter, enclosed to: Currie to Salisbury, 12
December 1895, The National Archives, London-Kew, shelf mark FO
60/594.

391 RUDOLF STEINER

'Ideas become living forces'

Original version: 'Die Ideen werden Lebensmächte.'

Rudolf Steiner: Die Philosophie der Freiheit [1893], in: *Rudolf Steiner
Gesamtausgabe. Schriften*, vol. 4, ed. Rudolf-Steiner-Nachlaßverwal-
tung, Dornach [16]1995, 270.

393 PIER PAOLO PASOLINI

'I would call myself reformist, Lutheran, if it were possible
to give some sort of meaning to these romantic epithets.'

Original version: 'Preraffaellita è già una qualifica di passaggio verso
quella che, quanto a me, riterrei giusta: cioè riformista, luterano, se
fosse attribuibile qualche significato a queste qualifiche romanzesche.'

Pier Paolo Pasolini: *Lettere luterane*, Turin, first edition 1976, 178.

394 WORLD

'He who lives his life in the midst of things
is truly free.' LW 15, 8

Original version: 'Neque enim contemnit foeliciter mundum, qui
vivit solitarius et extra homines, non is aurum, qui abiicit aut qui ab-
stinet a pecuniis ut Franciscani sed qui in mediis rebus versatur neque
tamen earum affectibus rapitur.' WA 20, 11

403 HEINRICH VIII

'Pastime with good company
I love and shall unto I die'

Original version: 'Pastime with good company / I love and shall un-
to I die.'

Heinrich VIII: Pastime with good company [1518]: British Library,
London, shelf mark Ms. 31922.

405 GUSTAV II ADOLF

'I will not countenance nor allow any talk of neutrality.
God and the Devil are in conflict here.'

Original version: 'Ich will von keiner neutralität nichts wissen noch
hören. Seine Liebden muß Freund oder Feind sein. Wenn ich an ihre
Grenze komme, so muß Sie kalt oder warm sich erklären. Hier streit-
et Gott und der Teufel.'

Gustav Adolf in conversation with the Brandeburgish Delegate Hans
von Wilmersdorf, July 1630, cited in: *Karl Gustav Helbig: Gustav Adolf
und die Kurfürsten von Sachsen und Brandenburg 1630–1632*, Leipzig
1854, 14.

407 JOHANN WOLFGANG VON GOETHE

'We have again the courage to stand
with firm feet upon God's earth'

Original version: 'Wir wissen gar nicht, fuhr Goethe fort, was wir Luthern und der Reformation im allgemeinen alles zu danken haben. Wir sind frei geworden von den Fesseln geistiger Borniertheit, wir sind infolge unserer fortwachsenden Kultur fähig geworden, zur Quelle zurückzukehren und das Christentum in seiner Reinheit zu fassen. Wir haben wieder den Mut, mit festen Füßen auf Gottes Erde zu stehen und uns in unserer gottbegabten Menschennatur zu fühlen.'

Johann Peter Eckermann: *Gespräche mit Goethe in den letzten Jahren seines Lebens*, vol. 3. Leipzig, 1848, 372–373.

409 CASPAR DAVID FRIEDRICH

'You call me a misanthrope
because I avoid society.
You err;
I love society.
Yet in order not to hate people,
I must avoid their company.'

Original version: 'Ihr nennt mich Menschenfeind, / Weil ich Gesellschaft meide. / Ihr irret euch, / Ich liebe sie. / Doch um die Menschen nicht zu hassen, / Muß ich den Umgang unterlassen.'

Caspar David Friedrich: Aphorismen über Kunst und Leben, in: *Caspar David Friedrich in Briefen und Bekenntnissen*, Sigrid Hinz (ed.), Berlin 1984, 82.

411 EDVARD MUNCH

'God is in us and we are in God.
Everything is movement and light.'

Original English translation: 'God is in us and we are in God … Primeval light is everywhere and goes everywhere life is – everything is movement and light –'

Edvard Munch: Diary entry, around 1895, Munch Museet, Oslo, shelf mark T2787, cited in: Shelley Wood Cordulack: *Edvard Munch and the Physiology of Symbolism*, New Jersey et al. 2002, 103 [original quotation in Norwegian].

413 DR. SEUSS

'I'm a griffulous, groffulous groo. I'm a schmoosler!
A schminkler! And a poop-poobler, too!'

Original version: 'I'm a griffulous, groffulous groo. I'm a schmoosler! A schminkler! And a poop-poodler, too!'

The Cat in the Hat, TV-Special, Columbia Broadcasting System (CBS), 1971 (song: 'I'm a Punk').

414 COMMITMENT

'I cannot and I will not retract anything.' LW 32, 113

Original version: '… revocare neque possum nec volo quicquam …' WA 7, 838

421 CHRISTINA, QUEEN OF SWEDEN

'How can one be a Christian without being a Catholic?'

Original version: 'Comment peut-on être chrétien sans être catholique?'

Apologies. Christine, Reine de Suède, edited and annotated by Jean François de Raymond, Paris 1994, 281.

423 BRIGITTA WALLNER

'Put my name down'

Original version: 'Schreib meinen Namen auf, von mir weiß jeder, dass ich eine Lutherische bin.'

Brigitta Wallner, statement at the signing of the certificate of conversion, 1781, oral tradition, cited in different versions, inter alia: *Chronik der Pfarrgemeinde Gosau*, Leopold Temmel (ed.), [Gosau] 1984, 23; *Renaissance und Reformation*, catalogue to the exhibition of the same name, Karl Vocelka (ed.), Linz 2010, No. 26.5, 645.

425 ERNST MORITZ ARNDT

'It is from fire that the Spirit has been created'

Original version: 'Aus Feuer ist der Geist geschaffen., / Drum schenkt mir süßes Feuer ein!'

Ernst Moritz Arndt: Das Feuerlied [1817], in: idem: *Werke*, Teil 1: Gedichte, Berlin et al. 1912, 177–178, quotation 177.

427 LISE MEITNER

'I'm certainly not a Catholic'

Original version: 'Sicher bin ich keine Katholikin und habe keine Bega[b]ung für einen orthodoxen Glauben, obwohl mich manche Bibelworte durch meine [sic!] ganzes Leben begleitet und meine ethische Einstellung stark beeinflusst haben.'

Letter from Lise Meitner to Christel Allers, 22 February 1955, Churchill Archives Centre Cambridge, The Papers of Lise Meitner, shelf mark MTNR 5/26 A, part 3 of 3.

429 HUGO BALL

'Let us save ourselves from our saviours!'

Original version: 'Erlösen wir uns von den Erlösern!'

Hugo Ball: *Zur Kritik der deutschen Intelligenz*, Bern 1919, 34.

431 DIETRICH BONHOEFFER

'Not in the flight of ideas but
only in action is freedom'

Original version: '… nicht in der Flucht der Gedanken, allein in der Tat ist die Freiheit.'

Dietrich Bonhoeffer: Stationen auf dem Weg zur Freiheit. Tat [1944], in: idem: *Werke*, Eberhard Bethge (ed.), vol. 8, Gütersloh 1998, 570. (English translation: idem: *Ethics*, translated by Neville Horton Smith, New York 1995)

432 LABOUR

'Work is a joy unto itself.' LW 42, 146

Original version: 'Labor est demum ipsa voluptas.' WA 6, 120

439 JOHANN SEBASTIAN BACH

'I had to work hard'

Original version: 'Ich habe fleißig seyn müssen; wer eben so fleißig ist, der wird es eben so weit bringen können.'

Johann Sebastian Bach, cited in: Johann Nikolaus Forkel: *Über Johann Sebastian Bachs Leben, Kunst und Kunstwerke*, Leipzig 1802 (reprinted Frankfurt a. M. 1950), 45.

475 KARL BAUER

'What a character rich in contraries our Reformer was'

Original version: 'Was für eine an Gegensätzen reiche Natur war doch unser Reformator.'

Karl Bauer: *Luthers Aussehen und Bildnis. Eine physiognomische Plauderei*, Gütersloh 1930, 38.

477 THOMAS MANN

'The specifically Lutheran, the choleric coarseness, the invective, the fuming and raging arouses my instinctive antipathy.'

Original version: 'Das Deutsche in Reinkultur, das Separatistisch-Antirömische, Anti-Europäische befremdet und ängstigt mich, auch wenn es als evangelische Freiheit und geistige Emanzipation erscheint, und das spezifisch Lutherische, das Cholerisch-Grobianische, das Schimpfen, Speien und Wüten, das fürchterlich Robuste, verbunden mit zarter Gemütstiefe und dem massivsten Aberglauben an Dämonen, Incubi und Kielkröpfe, erregt meine instinktive Abneigung.'

Thomas Mann: Deutschland und die Deutschen [1945], in: idem: *Gesammelte Werke in 12 Bänden*, vol. 11, Oldenburg 1960, 1133.

479 JULIUS STREICHER

'Dr Martin Luther would certainly be beside me in the dock today'

Original version: 'Es wurde bei mir zum Beispiel ein Buch beschlagnahmt von Dr. Martin Luther. Dr. Martin Luther säße heute sicher an meiner Stelle auf der Anklagebank, wenn dieses Buch von der Anklagevertretung in Betracht gezogen würde.'

Der Prozeß gegen die Hauptkriegsverbrecher vor dem Internationalen Gerichtshof Nürnberg, vol. 12, Nürnberg 1947, 346.

481 OSKAR BRÜSEWITZ

'A mighty war is raging between light and darkness'

Original version: 'Obwohl der scheinbare tiefe Friede, der auch in die Christenheit eingedrungen ist, zukunftverprechend ist, tobt zwischen Licht u. Finsternis ein mächtiger Krieg.'

Oskar Brüsewitz: Abschiedsbrief an die Schwestern und Brüder des Kirchenkreises Zeitz, 18 August 1976: BStU, MfS, BV Halle, shelf mark AP, No. 2950/76, 63.

483 LARS VON TRIER

'The only thing that can make a person complete is loving another person'

Original English translation: 'But Bess twists the concepts and says that the only thing that can make a person complete is loving another person.'

Lars von Trier: *Trier on von Trier*, Stig Björkman (ed.), trans. Neil Smith, London 2004, 180 [original quotation in Swedish].

485 MEGAN ROHRER

'My tears of weeping have turned to tears of joy'

Original version: 'My tears of weeping have turned to tears of joy.'

David-Elijah Nahmod: Pastor Megan Rohrer Makes History, in: *PQ Monthly*, 18 March 2014, online: www.pqmonthly.com/pastor-megan-rohrer-makes-history/18850 (accessed on 12 February 2017).

488 INTERIORITY

'The soul of man is something eternal.' LW 39, 306

Original version: 'Denn die seele des menschen ist eyn ewig ding uber alles, was zeyttlich ist.' WA 11, 409

495 PIETER JANSZ. SAENREDAM

'True doctrine and sanctity'

Original version: 'Doctrina Vera, Et Sanctitas'

Pieter Jansz. Saenredam, Interior of the Church of St Bavo at Haarlem, 1630, Musée du Louvre, Paris, reproduced in: Gary Schwartz and Marten Jan Bok: *Pieter Saenredam. The Painter and his Time. Biography, Illustrations and Catalogue of all Works, Summaries of All Documents*, Maarssen 1990, 260.

497 WILLIAM JAMES

'The relation goes direct from heart to heart, from soul to soul, between man and his maker.'

Original version: 'The relation goes direct from heart to heart, from soul to soul, between man and his maker.'

William James: *The Varieties of Religious Experience* [1902], Cambridge et al. 1985, 32.

499 MAX REGER

'Whoever wants to know what I want and who I am must investigate what I have composed so far'

Original version: 'Wer wissen will, was ich will, wer ich bin, der soll sich das ansehen, was ich bis jetzt geschrieben habe – wird er nicht klug daraus, versteht er's nicht, so ist's nicht meine Schuld!'

Max Reger: open letter of 5 September 1907, in: Die Musik 7/1 (1907/08), 10–14 (reprinted in: Hermann Wilske: *Max Reger – Zur Rezeption in seiner Zeit*, Wiesbaden et al. 1995, 359).

501 KAREN BLIXEN

'In this world anything is possible'

Original version: 'In this world anything is possible.'

Karen Blixen: Babette's Feast, in: Isak Dinesen (Karen Blixen): *Anecdotes of Destiny*, London 1958, 23–70, quotation 62.

503 INA SEIDEL

'It is always only individuals who are directly seized by the Spirit'

Original version: 'Immer sind es nur einzelne, die unmittelbar vom Geist ergriffen werden und ihn zu verwirklichen streben.'

Ina Seidel: *Lennacker. Das Buch einer Heimkehr*, Stuttgart 1938, 620.

539 HENNING VON TRESCKOW

'The moral value of a human being only starts
to accrue when he is prepared to die for his convictions'

Original version: 'Der sittliche Wert eines Menschen beginnt erst dort, wo er bereit ist, für seine Überzeugung sein Leben zu geben.'

Henning von Tresckow, 1944, cited in: Fabian von Schlabrendorff: *Begegnungen in fünf Jahrzehnten*, Tübingen 1979, 235.

541 EDWARD SNOWDEN

'Citizens with a conscience are not going
to ignore wrong-doing simply because
they'll be destroyed for it: the conscience forbids it.'

Original version: 'Citizens with a conscience are not going to ignore wrong-doing simply because they'll be destroyed for it: the conscience forbids it.'

Edward Snowden: NSA whistleblower answers reader questions, in: *The Guardian*, 17 June 2013, online: www.theguardian.com/world/2013/jun/17/edward-snowden-nsa-files-whistleblower (accessed on 12 February 2017).

542 FAITH

'Everything rests on faith.'

Original version: 'Denn an dem Glauben ist alles gelegen, darauff stehet das gancze Christliche leben.' WA 16, 262

549 PAUL GERHARDT

'Oh, write this promise in your hearts'

Original version: 'Das schreib dir in dein Herze, / du hochbetrübtes Heer, / bei denen Gram und Schmerze / sich häuft je mehr und mehr; / seid unverzagt, ihr habet / die Hilfe vor der Tür; / der eure Herzen labet / und tröstet, steht allhier.'

Paul Gerhardt: Wie soll ich dich empfangen [1653], Verse 6 (*Evangelisches Gesangbuch*, No. 11).

551 SIR SAYYID AHMAD KHAN

'The greatest of all boons conferred by Islam
on Christianity is the spirit of resistance
which it breathed into the Christians against
the exorbitant power of the Popes.'

Original version: 'The greatest of all boons conferred by Islam on Christianity is the spirit of resistance which it breathed into the Christians against the exorbitant power of the Popes, under which they had so long g'roaned.'

Sir Sayyid Ahmad Khan: *Essay on the question whether Islam has been beneficial or injurious to human society in general, and to the Mosaic and Christian dispensations*, London 1870, 25.

553 RICARDA HUCH

'I am very much a believer, but I'm not religious.'

Original version: 'Ich bin zwar sehr gläubig, aber nicht religiös.'

Letter from Ricarda Huch to Marie Baum, June 1915, cited in: Marie Baum: *Leuchtende Spur. Das Leben Ricarda Huchs*, Heidelberg 1950, 205.

555 INGMAR BERGMAN

'A human being carries his or her own holiness,
which lies within the realm of the earth.'

Original English translation: 'I believe a human being carries his or her own holiness, which lies within the realm of the earth; there are no otherworldly explanations.'

Ingmar Bergman: *Images. My Life in Film*, New York 1990, 238 [original quotation in Swedish].

557 MARY DALY

'Why indeed must 'God' be a noun? Why not a verb –
the most active and dynamic of all?'

Original version: 'Why indeed must 'God' be a noun? Why not a verb – the most active and dynamic of all?'

Mary Daly: *Beyond God the Father. Toward a Philosophy of Women's Liberation* [1973], Boston 1985, 33.

559 GREGOR HOHBERG

'We have to show that it is possible for us
to build a house together'

Original version: 'Es muss sich zeigen, dass es gelingen kann, auch gemeinsam ein Haus zu bauen.'

Carsten Dippel: Drei Religionen, ein Haus, in: Deutschlandfunk, 1 March 2016, online: www.deutschlandfunk.de/berlin-drei-religionen-ein-haus.886.de.html?dram:article_id=347045 (accessed on 12 February 2017).

560 GRACE

'Grace exalts.' LW 31, 50

Original version: 'Lex humiliat, gratia exaltat.' WA 1, 361

567 HEINRICH SCHÜTZ

'I will sing of the mercies of the Lord'

Original version: 'Ich will von Gnade singen.'

Schütz-Werke-Verzeichnis 186.

569 WILHELM LÖHE

'God wants people to give his grace through people'

Original version: 'Gott will den Menschen seine Gnade durch Menschen austeilen.'

Wilhelm Löhe: Kirche und Amt. Neue Aphorismen [1851], in: idem: *Gesammelte Werke*, vol. 5: *Die Kirche im Ringen um Wesen und Gestalt*, Part 1, Klaus Ganzert (ed.), Neuendettelsau 1954, 537.

571 SØREN KIERKEGAARD

'Grace is what is serious – my works are merely a jest'

Original English translation: 'Grace is what is serious – my works are merely a jest.'

Kierkegaard's Journals and Notebooks, Volume 8: Journals NB21-NB25, Niels Jørgen Cappelorn et al. (eds), Princeton and Oxford 2015, 601 [original quotation in Danish].

573 HEINRICH NAZARENUS

'It is important that Jesus continues to walk with us'

Original version: 'Wichtig ist, daß Jesus weiter mit uns geht.'

Marianne and Heinrich Rathke: *Gott hat mich wachsen lassen in dem Lande meines Elends. Unsere Erfahrungen und Erlebnisse mit den hinter den Ural verschleppten Rußlanddeutschen in Kasachstan und Mittelasien 1972–2001*, (unpublished typescript), Schwerin 2001, 39.

575 **JOSEPH RATZINGER**

'In Luther's experience of faith, the focus is
on God's mercy towards us.'

Original version: 'Von Luthers Glaubenserfahrung her liegt der Schwerpunkt auf der gnädigen Zuwendung Gottes zu uns.'

Joseph Ratzinger: welcome address at the celebratory mass marking the 450th anniversary of the *Confessio Augustana* in the Church of St. Anna in Augsburg, in: idem: Joseph Ratzinger. *Gesammelte Schriften*, Gerhard Ludwig Müller (ed.), vol. 8/2: *Kirche – Zeichen unter den Völkern*, Freiburg i. Br. 2010, 909–911, quotation 910.

577 **JOHN WOO**

'God is welcoming, no matter if it's
a good man or bad man, everyone is welcome.'

Original version: 'God is welcoming, no matter if it's a good or bad man, everyone is welcome.'

Robert Elder: *John Woo – Interviews*, Jackson 2005, 79.

Special National Exhibition
Luther! 95 Treasures – 95 People
Augusteum, Lutherstadt Wittenberg
 13 May – 5 November 2017
Stiftung Luthergedenkstätten in Sachsen-Anhalt
 The exhibition is under the patronage of
 the Federal President of Germany.

Director:	Dr. Stefan Rhein
Project Management:	Daniel Leis
Curators:	Mirko Gutjahr
	Dr. Dr. Benjamin Hasselhorn
	Dr. Catherine Nichols
	Dr. Katja Schneider
Academic advisory group:	Prof. Dr. Dr. Johannes Schilling, Kiel (chair)
	Prof. Dr. Ulrich Barth, Halle
	Prof. Dr. Volker Leppin, Tübingen
	Prof. Dr. Wolfgang Schenkluhn, Halle
	Prof. Dr. Heinz Schilling, Berlin
	Günter Schuchardt, Eisenach
	Gisela Staupe, Dresden
Academic collaborators:	Prof. Dr. Otfried Czaika
	Dr. Wolfgang Fenske
	Dr. Hartmut Kühne
	Dr. An Paenhuysen
	Dr. Daniel J. Schmidt
	Dr. Astrid Schweighofer
	PD Dr. Susanne Wegmann
	Dr. Armin Wenz
	Helena Lissa Wiessner
Financial management:	Thomas Bechstein
Loans:	Christin Kaaden
	Inga Nake
Exhibition assistants:	Karola Polcher
	Diana Sirp
Exhibition technology:	Andreas Schwabe
Restoration and records:	Karin Lubitzsch

Sponsors:

 Die Beauftragte der Bundesregierung
für Kultur und Medien

SACHSEN-ANHALT

Exhibition design:	STUDIO NEUE MUSEEN Andreas Haase (Leitung) Marie Gloger Carsten Henrion Mona Leinung Henrik Miers Victor Reichert Felix Schwan Axel Watzke	Transport:	hasenkamp Holding GmbH (in cooperation with partners)
		Insurance:	Kuhn & Bülow Versicherungsmakler GmbH
		Communication, marketing, education and service:	
		Management:	Florian Trott Carola Schüren
Exhibition construction:	Walther Expointerieur GmbH & Co. KG, Coswig	Public relations:	Florian Trott Carola Schüren Thomas Spindler (CAB Artis, Bamberg)
Exhibition set-up:	Abrell & van den Berg Ausstellungsservice GbR	Umbrella brand campaign:	Nina Mütze ('Luther 2017' State Office)
Media design:	Eidotech GmbH, Berlin		
Media stations:	formfatal, Berlin Felix Barthel, Berlin molekyl – Büro für Gestaltung, Halle ('Martin Luther's Universe')	Online communication and social media:	Andrea Fußstetter
		Tourism marketing:	Paulina Wielinski
		Events:	Michael Dieminger Dr. Dr. Benjamin Hasselhorn
Speakers:	Frank Roder, Hamburg Alex D'Attoma, Berlin and Hamburg	Cultural education:	Claudia Meißner (Manager) Christin Berndt Ilona Hensel Christin Nagy
Copy-editing (German):	Almut Otto, Berlin		
Copy-editing (English):	Sarah Quigley, Berlin		
Translations into English:	Ann Marie Bohan, Dublin Anna Grant, Edinburgh Heather Stacey, Edinburgh	Service office:	Dr. Bettina von Frommannshausen Sandra Reinefahl
		Visitor service:	Employees of the Communications and Mediation department of the Stiftung Luthergedenkstätten in Sachsen-Anhalt
		Corporate design of umbrella brand:	kleiner und bold, Berlin
		Audio guide:	Antenna International™, Berlin Coordination: Antje Günther

COLOPHON PUBLICATION

This book is published to accompany the
Special National Exhibition
Luther! 95 Treasures – 95 People
Augusteum, Lutherstadt Wittenberg
13 May – 5 November 2017

Published by:	Stiftung Luthergedenkstätten in Sachsen-Anhalt
Concept and editing:	Mirko Gutjahr Dr. Dr. Benjamin Hasselhorn Dr. Catherine Nichols Dr. Katja Schneider
Image procurement and rights:	Inga Nake Diana Sirp
Image editing:	Inga Nake
Copy-editing (German edition):	Almut Otto, Berlin
Copy-editing (English edition):	Susan Cox, Co Leitrim, Ireland
Translations from German:	Ann Marie Bohan, Dublin Anna Grant, Berwickshire, Scotland Fiona Elliott, Edinburgh Heather Stacey, Edinburgh George Wolter, Halle
Translations into German:	Kurt Rehkopf, Hamburg
Translations from French:	Patrick Kremer, Bordeaux

Design: cyan ^Berlin (Daniela Haufe and Detlef Fiedler)

Lithography: hausstætter herstellung, Berlin

Project management
 Hirmer: Kerstin Ludolph

Production
 Hirmer: Sophie Friederich

Printing and
 binding: Passavia Druckservice, Passau

Paper: Fly Cream, 115 g/m²

Cover:
Lucas Cranach the Elder and Younger, 'Reformation Altarpiece' 1548, predella, St Mary's Church, Wittenberg, © jmp-bildagentur, J. M. Pietsch, Spröda, courtesy of Stadtkirche Wittenberg

Quote on back jacket and cover:
Martin Luther: *A Letter to the Princes of Saxony Concerning the Rebellious Spirit* (1524), WA 15, 219; LW 40,47

All quotations from the works of Martin Luther in the book are taken from the Weimarer Ausgabe (WA) of Luther's works: *D. Martin Luthers Werke. Kritische Gesamtausgabe*, Weimar 1883 ff. The English quotations, where available, are taken from: *Luther's Works*, 55 volumes, St. Louis, Minneapolis 1957 ff.

The German National Library lists this publication in the German National Bibliography. Detailed bibliographic information is available online at: http://dnb.de.

Printed in Germany

ISBN 978-3-7774-2803-1 (German trade edition)
ISBN 978-3-7774-2804-8 (English trade edition)
 www.hirmerpublishers.com